PRINT READING ARCHITECTURE AND CONSTRUCTION TECHNOLOGY

Second Edition

Print Reading for Architecture and Construction Technology

Second Edition

David A. Madsen Alan Jefferis

THOMSON

DELMAR LEARNING

Australia • Canada • Mexico • Singapore • Spain • United Kingdom • United States

Print Reading for Architecture and Construction Technology
Second Edition

David Madsen, Alan Jefferis

Vice President, Technology
and Trades SBU:
Alar Elken
Editorial Director:
Sandy Clark
Senior Acquisitions Editor:
James Devoe
Senior Development Editor:
John Fisher

Marketing Director:
Dave Garza
Channel Manager:
Dennis Williams
Marketing Coordinator:
Casey Bruno
Editorial Assistant:
Tom Best
Production Director:
Mary Ellen Black

Production Manager:
Andrew Crouth
Production Editor:
Stacy Masucci
Technology Project Manager:
Kevin Smith
Technology Project Specialist:
Linda Verde

Library of Congress Cataloging-in-Publication Data:

Madsen, David A.

 Print reading for architecture and construction technology / David A. Madsen, Alan Jefferis.-- 2nd ed.

 p. cm.

 Includes index.

 ISBN 1-4018-5167-3

 I. Jefferis, Alan. II. Title.

 T379.M23 2004

 692'.1--dc22

 2004021106

Notice to the Reader

Table of Contents

Preface

Print Reading for Architecture and Construction Technology is a practical comprehensive workbook that is easy to use and understand. The text can be used as presented, following a logical sequence of learning activities for residential, architectural, and construction technology print reading, or the chapters can be rearranged to accommodate alternate formats for traditional or individualized instruction. This is the only training and reference material students need for architectural and construction technology print reading.

PREREQUISITES

An interest in print reading for architecture and construction technology, along with basic arithmetic, written communication, and reading skills, are the only prerequisites required. Students who begin with an interest in architecture and construction technology can end with the knowledge and skills required to read complete sets of working drawings for residential and light-commercial construction projects.

MAJOR FEATURES

PRACTICAL

Printing Reading for Architecture and Construction Technology provides a practical approach to reading prints as related to current common practices. One excellent and necessary foundation of print reading training is the emphasis on standardization and quality architectural and construction print examples. When students become professionals in the construction industry, this text can go along as a valuable desk reference.

REALISTIC

Chapters contain realistic examples, actual prints, illustrations, related tests, and print reading problems based on actual architectural prints. The examples demonstrate recommended presentation with actual architectural prints used for reinforcement.

PRACTICAL APPROACH TO PROBLEM SOLVING

The professional in the construction technology industry is responsible for accurately reading and interpreting architectural prints. This workbook explains how to read actual industry prints and interpret code requirements in a knowledge-building format; one concept is learned before the next is introduced. Print-reading problem assignments are presented in order of difficulty and in a manner that provides students with a wide variety of print reading experiences. The concepts and skills learned from one chapter to the next allow students to read complete sets of working drawings in residential and light-commercial architecture. The prints are presented as designs in a manner that is consistent with actual architectural office practices. Students must be able to think through the process of print reading with a foundation of how prints and related construction components are implemented. The goals and objectives of each problem assignment are consistent with recommended evaluation criteria based on the progression of learning activities.

PRINTS PREPARED USING COMPUTER-AIDED DESIGN AND DRAFTING (CADD)

Computer-aided drafting is here to stay and is used in architectural drafting applications. This print reading workbook is written and presented with current CADD technology standards. This is an advantage as students proceed into a construction career in the 21st century. All of the print reading examples and problems are prepared using CADD in a manner that displays the highest industrial standards.

CODES AND CONSTRUCTION TECHNIQUES

National codes such as the IRC, UBC, CABO, SBC, and BOCA are introduced throughout the text as related to specific instruction and applications. Construction techniques differ throughout the country. This text clearly acknowledges the difference in construction methods and introduces the format used to read complete sets of working prints for each method of construction. The print reading problem assignments are designed to provide drawings that involve a variety of construction alternatives.

FUNDAMENTAL THROUGH ADVANCED COVERAGE

This text can be used in the Architectural Drafting or Building Construction Technology curriculum that covers the basics of residential architecture in a 1- or 2-term sequence. In this application, students use the chapters directly associated with reading a complete set of working prints for a residence. The balance of the text can remain as reference for future study or as a valuable desk reference. The workbook can also be used in the comprehensive architectural construction technology program where a four- to five-term or semester sequence of residential and light-commercial construction skills and theory is required. In this application, students can expand on the primary objective of reading a complete set of residential prints followed by light-commercial projects. Additional coverage is also provided in the following areas:

- ■ energy-efficient construction techniques.
- ■ heating and cooling thermal-performance calculations.
- ■ structural load calculations.

COURSE PLAN

Architectural and construction technology print reading is the primary emphasis of many technical drafting and construction technology curriculums, while other programs offer only an exploratory course in this field. This text is appropriate for either application. The content of this text reflects the common elements in a comprehensive architectural and construction technology curriculum and can be used in part or totally.

SECTION LENGTH

Chapters are presented in individual learning segments that begin with elementary concepts and build until each chapter provides complete coverage of each topic. Instructors can choose to present lectures in short, 15-minute discussions or divide each chapter into 40–50-minute lectures.

APPLICATIONS

Special emphasis has been placed on providing realistic print reading examples and problems. The examples and problems have been supplied by architects, consulting engineers, and architectural designers. Each problem solution is based on the step-by-step layout procedures provided in the chapter discussions. Problems are given in the order of complexity so that students are exposed to a variety of print reading experiences. Problems require you to go through the same thinking process that a professional construction worker is faced with daily, including reading symbols, notes, finding and interpreting information, and many other activities. Chapter tests provide a complete coverage of each chapter and can be used for student evaluation or as study and review questions.

INSTRUCTOR'S GUIDE

The instructor's guide contains test and problem solutions.

LIST OF REVIEWERS

We would like to give special thanks and acknowledgment to the many professionals who reviewed the manuscript of this text in an effort to help us publish the best *Print Reading for Architecture and Construction Technology* text:

Joseph Dusek, Triton College, Grove, Illinois

Wels Musgrave, Mohave Community College, Kingman, Arizona

Gilbert Atkins, Mercer County Vocational Technical Center, Princeton, West Virginia

Charles Case, ITT Technical Institute, Indianapolis, Indiana

Victor Marshall, Washington-Holmes Vocational Technical Center, Chipley, Florida

Michael Price, Walters State Community College, Morristown, Tennessee

The quality of this text is also enhanced by the support and contributions from architects, designers, engineers, and vendors. The list of contributors is extensive and acknowledgment is given at each figure illustration; however, the following individuals and companies gave an extraordinary amount of support:

Alan Mascord, Jon Epley, and Ron Palma, Alan Mascord Design Associates, Inc.

Dan Kovac, Piercy and Barclay Designers, Inc.

Ken Smith, Architect, & Associates, Inc.

Wally Grainer, Sunridge Designs

E. Henry Fitzgibbon, AIA, Soderstrom Architects, PC

TO THE STUDENT

This *Print Reading for Architecture and Construction Technology* workbook is designed for you, the student. The development and format presentation has been tested in actual conventional and individualized classroom instruction. The information presented is based on architectural and construction standards, drafting room practice, and trends in the building construction industry. This text is designed to be comprehensive coverage of architectural and construction technology print reading. Use the text as a learning tool while in school and take it along as a desk reference when you enter the profession. The amount of written text is complete but kept to a minimum. Examples and illustrations are used extensively. Many students learn best by studying examples. Here are a few helpful hints.

1. **Read the Text.** The text is intentionally designed to be easy to read. It gives information in as few and easy-to-understand words as possible. Do not pass up the reading because the text helps you to clearly understand the prints that you read.

2. **Look Carefully at the Examples.** The figure examples are presented in a manner that is consistent with architectural and construction technology standards. Look at the examples carefully and attempt to understand their specific applications. If you can understand why something is done a certain way, it is easier to read the actual prints. Print reading is often like doing a puzzle; you might need to carefully search the print to find the desired information.

3. **Use the Text as a Reference.** Few professionals know everything about standard practices, techniques, and concepts, so always be ready to use the reference if you need to verify how specific applications are handled. Become familiar with the use and definitions of technical terms. It is difficult to memorize everything in this text, but after studying and using the concepts, applying print reading skills should become second nature.

4. **Learn Each Concept and Skill Before You Continue to the Next.** The text is presented in a logical learning sequence. Each chapter is designed for learning development, and chapters are sequenced so print reading knowledge develops from one chapter to the next. Print reading problem assignments are presented in the same learning sequence as the chapter content and also reflect progressive levels of difficulty.

5. **Do the Chapter Tests.** Each chapter has a test at the end. Answering these test questions gives you an opportunity to review the material that you just studied. This reinforcement helps you to learn the material fully.

6. **Do the Print Reading Problems.** There are several print reading problems after each chapter test. These problems require that you answer questions as you read actual architectural and construction technology prints. There is no substitute for reading actual prints. The practice of print reading becomes easier when you have had a chance to read several prints. By the time you complete the print reading problems, the content covered in the preceding chapter will be easier for you to identify on future prints.

Introduction to Architectural and Construction Technology Print Reading

CHAPTER OVERVIEW

This chapter covers the following topics:

- About prints
- Sheet sizes, title blocks, and borders
- Lines on architectural drawings
- Lettering on an architectural drawing

- How do you find information on prints?
- Test
- Exercises

Architecture is the art and science of building construction. Architectural drawings, known as plans, are prepared by professional architects or designers for any home or commercial building before the actual construction can begin. Home building is referred to as residential construction, and commercial construction is any building for business or industrial purposes.

ABOUT PRINTS

This text refers to the reproduction of architectural drawings as *prints*. Blueprint is an old term now generally used in the construction business when referring to prints. Blueprinting is an old method that results in a print with a dark blue background and white lines. You can find some of these in a museum or in a company's drawing archives. The reproduction methods commonly used today are the diazo and photocopy processes.

THE DIAZO PRINT PROCESS

Diazo prints are also known as blue-line prints because the resulting print is generally blue lines on a white background. The diazo process is an inexpensive way to make copies from any type of translucent material. The diazo print is made using a printing process that uses ultraviolet light passing through a translucent original drawing to expose a chemically coated paper or print material underneath. The light does not pass through the lines of the drawing. Thus the chemical coating beneath the lines remains unexposed. The print material is then exposed to ammonia vapor, which activates the remaining chemical coating to produce the blue lines. Diazo materials are also available that make black or brown lines. The diazo print process is demonstrated in Figure 1–1.

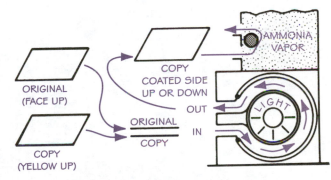

Figure 1–1 The diazo print process.

PHOTOCOPY PRINTS

The photocopy process is gaining wide use for copying engineering and architectural drawings. These copy machines are much like the copier found in the traditional office setting. The only difference is that the capacity allows the copying of large drawings. The popularity of these machines is growing because there is no need for coated copy materials or the possible hazards of ammonia.

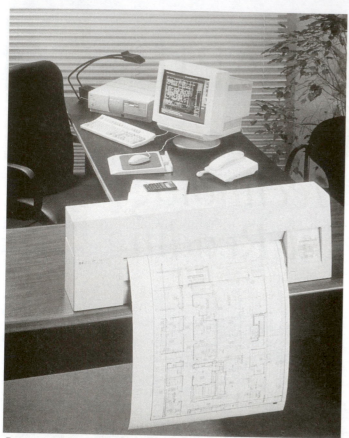

Figure 1–2(a) A desktop color inkjet plotter. *Photo courtesy of Hewlett-Packard Company.*

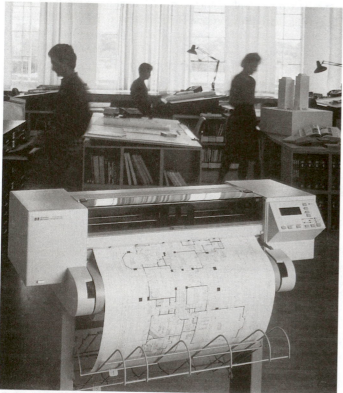

Figure 1–2(b) High-resolution monochrome inkjet plotter in use. *Photo courtesy of Hewlett-Packard Company.*

PRINTS CREATED FROM A COMPUTER-AIDED DESIGN AND DRAFTING (CADD) SYSTEM

Once a drawing has been created on a computer-aided design and drafting system, a drawing can be made. This drawing is called a hard copy. A hard copy is actually any printout of a document that has been created on a computer. A printer or plotter is a piece of equipment that is connected to the computer for the purpose of making the hard copy. There are several different types of printers and plotters used in the architectural industry. These pieces of equipment vary from the small, sheet-size desktop models shown in Figure 1–2(a) to the large-format models shown in Figure 1–2(b).

SHEET SIZES, TITLE BLOCKS, AND BORDERS

All professional drawings have title blocks. Standards have been developed for the information in the title block and on the sheet adjacent to the border so the drawing is easier to read and file than drawings that do not follow a standard format.

SHEET SIZES

Architectural drafting offices generally use sheet sizes (in inches) of 8–1/2 × 11, 12 × 18, 18 × 24, 22 × 34, 24 × 36, 28 × 42, 30 × 42, 30 × 48, or 36 × 49. Standard sheet sizes generally fold into 8–1/2 × 11 format.

Sheet sizes used in architectural drafting are often different, but they can be the same as sheet sizes recommended by the American National Standards Institute (ANSI). This depends on the practice followed in a specific architectural office. Table 1–1 shows the standard ANSI-recommended sheet sizes

TABLE 1–1 STANDARD ANSI INCH DRAWING SHEET SIZES	
SHEET SIZE	DIMENSIONS (INCHES)
A	8–1/2 x 11 or 11 x 8–1/2
B	17 x 11
C	22 x 17
D	34 x 22
E	44 x 34
F	40 x 28

Metric sheet sizes vary from 420 × 594 mm to 841 × 1189 mm. Roll sizes vary in width from 18"–48". Metric roll sizes range from 297 to 420 mm wide. The International Standards Organization (ISO) has established standard metric drawing sheet sizes (Table 1–2).

TABLE 1–2 STANDARD METRIC DRAWING SHEET SIZES		
SHEET SIZE	DIMENSIONS (MM)	DIMENSIONS (INCHES)
A0	1189 x 841	46.8 x 33.1
A1	841 x 594	33.1 x 23.4
A2	594 x 420	23.4 x 16.5
A4	420 x 297	16.5 x 11.7
A5	297 x 210	11.7 x 8.3

ZONING

Some companies use a system of numbers along the top and bottom margins and letters along the left and right margins, called *zoning*. Zoning allows the drawing to be read like a road map. For example, the reader can refer to the location of a specific item as D-4, which means that the item can be found at or near the intersection of D across and 4 up or down. Zoning can be found on architectural drawings for large commercial projects.

ARCHITECTURAL DRAFTING TITLE BLOCKS

Title blocks and borders are normally preprinted on drawing paper. Most architectural drafting firms use one basic sheet size with preprinted borders and title blocks.

Architectural drawing title blocks are generally placed along the right side of the sheet, although some companies place them across the bottom of the sheet. Each company uses a slightly different title block design, but the same general information is found in almost all blocks.

■ Drawing number. This can be a specific job or file number for the drawing.

■ Company name, address, and phone number.

■ Project or client. This is an identification of the project by company or client name, project title, or location.

■ Drawing name. This is where the title of the drawing can be placed. For example, MAIN FLOOR PLAN or ELEVATIONS. Most companies omit this information from the title block and place it on the face of the sheet below the drawing.

■ Scale. Some company title blocks provide a location for the general scale of the drawing. On any view or detail on the sheet that differs from the general scale, the scale of that view must be identified below the view title and both placed directly below the view. Most companies omit the scale from the title block and place it on the sheet directly below the title of each individual plan, view, or detail.

■ Drawing or sheet identification. Each sheet is numbered in relation to the entire set of drawings. For example, if the complete set of drawings has eight sheets, each consecutive sheet is numbered 1 of 8, 2 of 8, 3 of 8, and so on, to 8 of 8. Commercial drawings are often divided into major divisions, such as A (architectural), S (structural), M (mechanical), and P (plumbing).

■ Date. The date noted is the date on which the drawing or project is completed.

■ Drawn by. This is where the drafter, designer, or architect that prepared this drawing places his or her initials or name.

■ Checked by. This is the identification of the individual that approves the drawing for release.

■ Architect or designer. Most title blocks provide the identification of the individual that designed the structure.

■ Revisions. Many companies provide a revision column in which drawing changes are identified and recorded. Where changes are made on the face of the drawing after it has been released for construction, a circle with a revision number or letter accompanies the change. This revision number is keyed to a place in the drawing title block where the revision number, revision date, initials of the individual making the change, and an optional brief description of the revision are located.

Figure 1–3 shows a typical architectural title block and its elements. The location of specific items might differ slightly, and some companies require more detailed information.

LINES ON ARCHITECTURAL DRAWINGS

Drafting is a universal graphic language that uses lines, symbols, and notes to describe a structure to be built. Certain lines are drawn thick so they stand out clearly from other information on the drawing. Other lines are drawn thin. Thin lines are not necessarily less important than thick lines, but they are subordinate for identification purposes.

OUTLINES

In architectural drafting outline lines are used to define the outline and characteristic features of architectural plan components, but the method of presentation can differ slightly from one office to another. The following techniques are alternatives for outline line presentation:

■ One popular technique is to enhance certain drawing features so they stand out clearly from other items on the drawing. For example, the outline of floor plan walls and partitions or beams in a cross section can be drawn thicker than other lines so that they are more apparent than the other lines on the drawing. See Figure 1–4.

■ Another technique is for all lines of the drawing to be the same thickness. This method does not differentiate one type of line from another. See Figure 1–5(a). This technique can use dark shading to accentuate features, such as walls in floor plans, as shown in Figure 1–5(b).

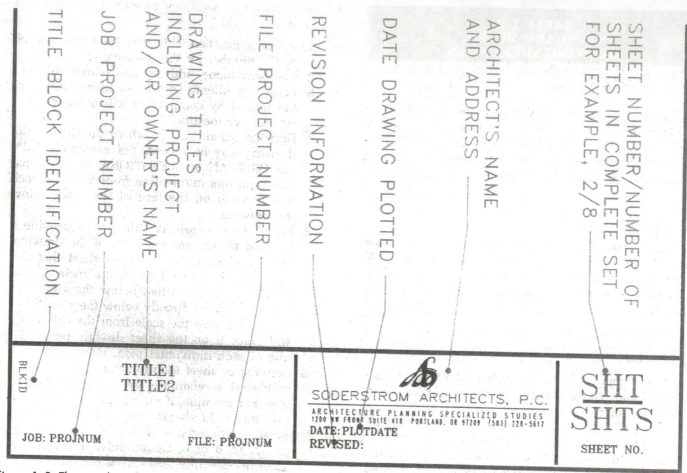

TITLE BLOCK IDENTIFICATION

JOB PROJECT NUMBER

DRAWING TITLES
INCLUDING PROJECT
AND/OR OWNER'S NAME

FILE PROJECT NUMBER

REVISION INFORMATION

DATE DRAWING PLOTTED

ARCHITECT'S NAME
AND ADDRESS

SHEET NUMBER/NUMBER OF
SHEETS IN COMPLETE SET
FOR EXAMPLE, 2/8

BLKID

TITLE1
TITLE2

JOB: PROJNUM FILE: PROJNUM

SODERSTROM ARCHITECTS, P.C.
ARCHITECTURE PLANNING SPECIALIZED STUDIES
1200 NW FRONT SUITE 410 PORTLAND, OR 97209 (503) 228-5617
DATE: PLOTDATE
REVISED:

SHT
—
SHTS

SHEET NO.

Figure 1–3 The sample architectural title block and its components. *Courtesy Soderstrom Architects.*

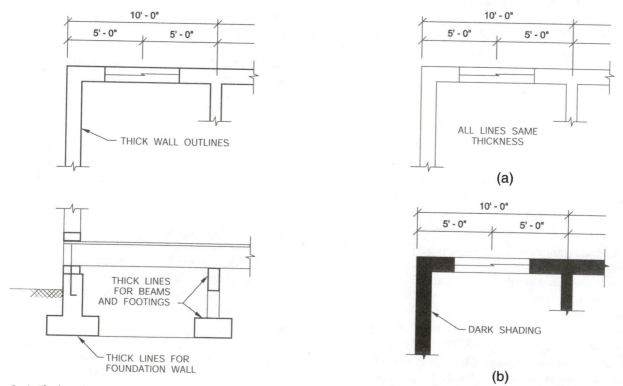

THICK WALL OUTLINES

ALL LINES SAME THICKNESS

(a)

THICK LINES FOR BEAMS AND FOOTINGS

THICK LINES FOR FOUNDATION WALL

DARK SHADING

(b)

Figure 1–4 Thick outlines.

Figure 1–5 (a) All lines are the same thickness. (b) Accent with wall shading.

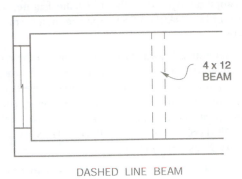

Figure 1–6 Dashed lines are used to represent the beam and header above.

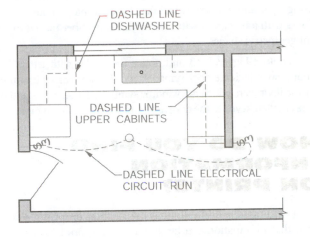

Figure 1–7 Dashed lines are used to represent upper kitchen cabinets, a dishwasher under the cabinet, and an electrical circuit run.

DASHED LINES

In architectural drafting dashed lines are used to show drawing features that are not visible in relationship to the view or plan. These dashed features can be subordinate to the main emphasis of the drawing. Examples of dashed line representations include beams and headers, as shown in Figure 1–6; and upper kitchen cabinets, undercounter appliances (dishwasher), or electrical circuit runs, as shown in Figure 1–7.

EXTENSION AND DIMENSION LINES

Extension lines show the extent of a dimension, and dimension lines show the length of the dimension and terminate at the related extension lines with slashes, arrowheads, or dots. The dimension numeral in feet and inches is placed above and near the center of the solid dimension line. Figure 1–8 shows several dimension and extension line examples.

LEADER LINES

Leader lines are used to connect notes to related features on a drawing. Figure 1–9 shows several examples.

BREAK LINES

Two types of break lines are the long break line and the short break line. The type of break line normally associated with architectural drafting is the long break line. Break lines are used to terminate features on a drawing when the extent of the feature has been clearly defined. Figure 1–10(a) shows several examples. The short break

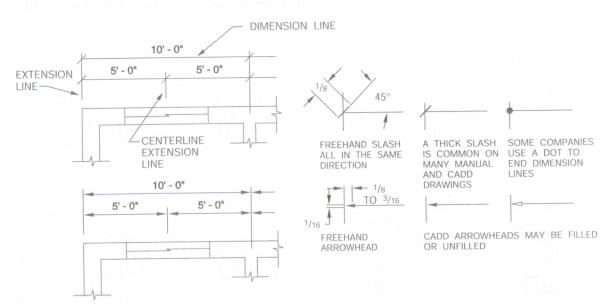

Figure 1–8 Dimensions and extension lines.

line can be found on some architectural drawings. This line, as shown in Figure 1–10(a), is an irregular line and may be used for a short area. Breaks in cylindrical objects, such as steel bars and pipes, are shown in Figure 1–10(b).

An architectural drawing showing a variety of lines is displayed in Figure 1–11.

LETTERING ON AN ARCHITECTURAL DRAWING

Lettering is used on an architectural drawing to provide written information. Architectural lettering is generally done with all uppercase letters, and abbreviations are commonly used to save space and drafting time. Refer to the list of abbreviations in the appendix of this text for clarification of abbreviations. Lettering is shown in the form of title block information, drawing titles, room labels and related information, specific notes, general notes, and schedules.

Specific notes are also known as local notes. Specific notes can be placed close to the item or connected to the item being identi-

fied with a leader line. These notes placed on the drawing relate to a specific application or describe a specific feature, such as 3" CONC. FILLED GUARD POST. Specific notes are shown in Figure 1–11.

A general note is information that applies to the entire drawing. General notes can be found individually anywhere on the drawing or, more commonly, they are grouped together in convenient areas of the drawing away from drawing components. General notes can be grouped together and have such titles as GENERAL NOTES, NOTES, FRAMING NOTES, or MISCELLANEOUS NOTES, as shown in Figure 1–12.

Schedules are charts of information used to describe such items as doors, windows, appliances, materials, fixtures, hardware, concrete reinforcing, and finishes. Schedules help keep drawings clear of unnecessary notes. Items in the schedules are keyed to the drawing with identification letters, numbers, and symbols. When using door and window schedules, for example, the key can label doors with a letter and windows with the number placed in different geometric shapes.

Look at Figure 1–13 and notice the circles with letters by the floor plan, which are door symbols, and the hexagons with numbers by the floor plan, which are window symbols. These letters and numbers are then keyed to the door and window schedules in Figure 1–14.

HOW DO YOU FIND INFORMATION ON PRINTS?

Print reading is basically finding information on prints. You have seen that information can be displayed on a print in the form of lines, notes, and schedules. These items are located either in the title block or in the *field* of the drawing. The *field of the drawing* is anywhere within the border lines outside the title block. As you will learn later, many items on the drawings are made up of symbols. If you know the information you are looking for is usually displayed

Figure 1–9 Sample leader lines.

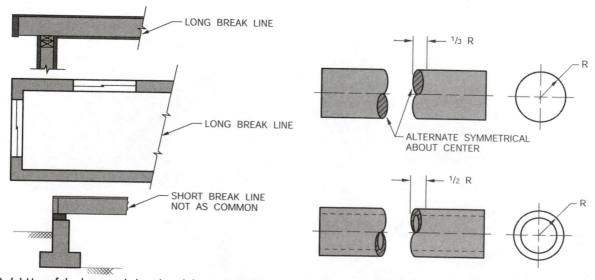

Figure 1–10 (a) Use of the long and short break lines. (b) Solid and tubular cylindrical breaks.

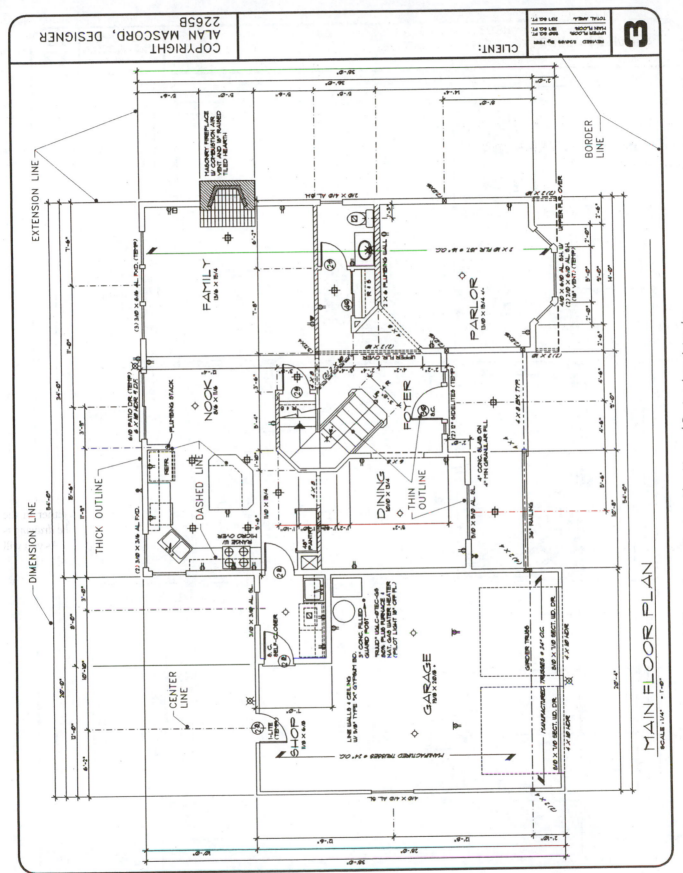

Figure 1–11 A floor plan showing a variety of different forms. Courtesy Alan Mascord Design Associates, Inc.

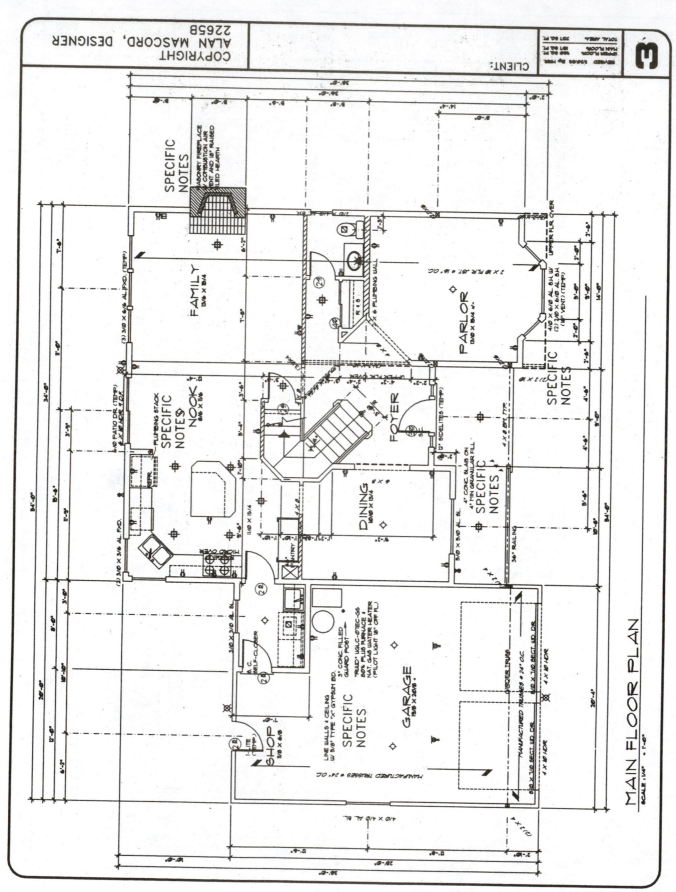

MAIN FLOOR PLAN
SCALE: 1/4" = 1'-0"

Figure 1–12 Specific notes shown on a floor plan. *Courtesy Alan Mascord Design Associates, Inc.*

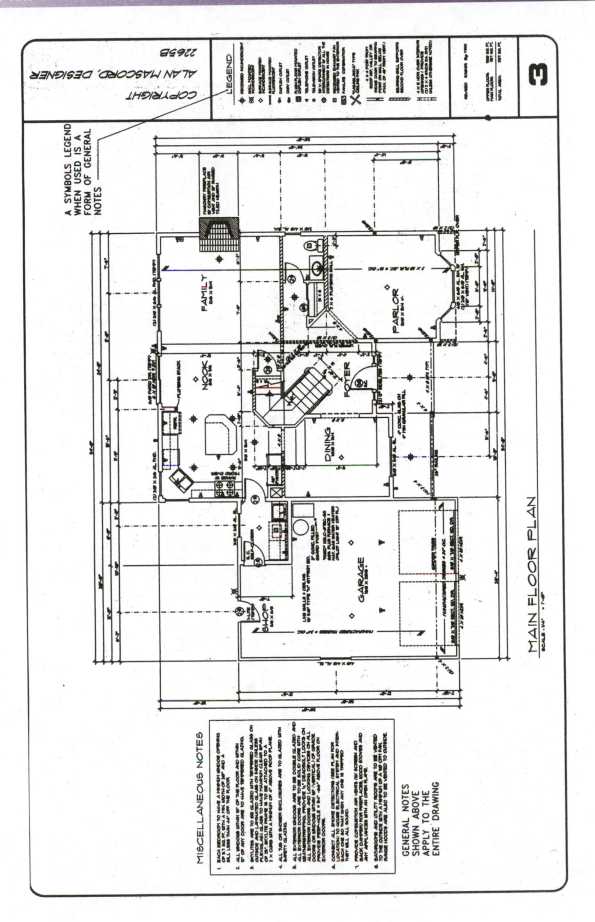

Figure 1–13 (a) A floor plan with general notes displayed. (b) Typical general notes. *Courtesy Alan Mascord Design Associates, Inc.*

MISCELLANEOUS NOTES

1. EACH BEDROOM TO HAVE A MINIMUM WINDOW OPENING OF 5.7 SQ. FT. WITH A MIN. WIDTH OF 20" AND A SILL LESS THAN 44" OFF THE FLOOR.

2. ALL WINDOWS WITHIN 18" OF THE FLOOR AND WITHIN 12" OF ANY DOOR ARE TO HAVE TEMPERED GLAZING.

3. SKYLITES ARE TO BE GLAZED WITH TEMPERED GLASS ON OUTSIDE AND LAMINATED GLASS ON INSIDE (UNLESS PLEXIGLAS). GLASS TO HAVE MAXIMUM CLEAR SPAN OF 25". SKYLITE FRAME IS TO BE ATTACHED TO A 2 × CURB WITH A MINIMUM OF 4" ABOVE ROOF PLANE.

4. ALL TUB OR SHOWER ENCLOSURES ARE TO BE GLAZED WITH SAFETY GLAZING.

5. ALL EXTERIOR WINDOWS ARE TO BE DOUBLE GLAZED AND ALL EXTERIOR DOORS ARE TO BE SOLID CORE WITH WEATHERSTRIPPING. PROVIDE ½" DEADBOLT LOCKS ON ALL EXTERIOR DOORS AND LOCKING DEVICES ON ALL DOORS OR WINDOWS WITHIN 10' (VERTICAL) OF GRADE. PROVIDE PEEP-HOLE @ 54" -66" ABOVE FLOOR ON EXTERIOR DOORS.

6. CONNECT ALL SMOKE DETECTORS (SEE PLAN FOR LOCATION) TO HOUSE ELECTRICAL SYSTEM AND INTER-CONNECT EACH ONE SO THAT WHEN ANY ONE IS TRIPPED THEY WILL ALL SOUND.

7. PROVIDE COMBUSTION AIR VENTS (W/ SCREEN AND BACK DAMPER) FOR FIREPLACES, WOOD STOVES AND ANY APPLIANCES WITH AN OPEN FLAME.

8. BATHROOMS AND UTILITY ROOMS ARE TO BE VENTED TO THE OUTSIDE WITH A MINIMUM OF A 90 CFM FAN. RANGE HOODS ARE ALSO TO BE VENTED TO OUTSIDE.

Figure 1–13(b) General notes enlarged. *Courtesy Alan Mascord Design Associates, Inc.*

as a symbol, then you need to look for that symbol in a location where it is often found. Information in the form of symbols is discussed as related to specific applications throughout this book. For now, here are some general rules to follow on architectural prints:

- Scan the entire drawing while looking at the general layout. This allows you to become familiar with the major parts of the drawing and should quickly tell you if you are looking at the correct print. For example, if you want to look at the main floor plan, you should not be looking at the sheet labeled FOUNDATION PLAN, unless they happen to be next to each other.

- Look at the title block to find general information related to the project, such as the architect's name, client's name, project title, drawing number, and sheet number.

- Look at the drawings on the print for a quick understanding of what is included. For example, if you are looking at

a floor plan, look at the title, the room layout, the major features, and the overall dimensioning format.

- Read the general notes to get a good understanding of the construction specifications and other information that relates to the entire drawing.

- Now that you have a good understanding of the major features found on the drawing, take more time to look for the specific information that you seek.

If you follow these basic guidelines, you normally gain a quick understanding of what the print includes, and in many cases you are able to find the information needed. Sometimes, however, the drawing might be very complex and the information needed is difficult to find. When this happens, print reading can be time consuming. After you study this text and when you gain experience reading a variety of prints, you will normally be able to read a print quickly and interpret the information given.

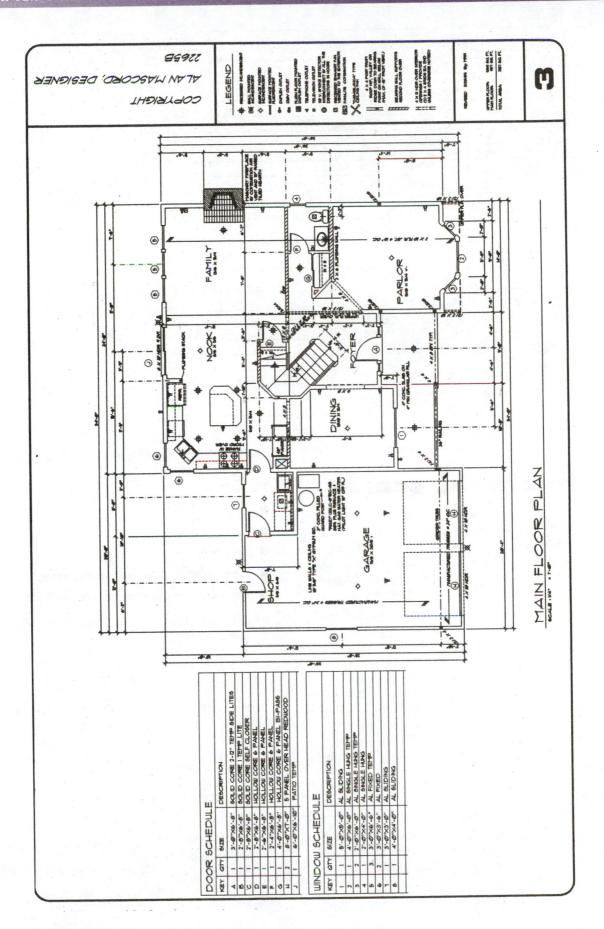

Figure 1–14(a) This drawing shows how the door and window schedules are keyed to the floor plan. *Courtesy Alan Mascord Design Associates, Inc.*

DOOR SCHEDULE

KEY	QTY	SIZE	DESCRIPTION
A	1	3'-0"X6'-8"	SOLID CORE 2-12" TEMP SIDE LITES
B	1	2'-8"X6'-8"	SOLID CORE 1 TEMP LITE
C	1	2'-8"X6'-8"	SOLID CORE SELF CLOSER
D	1	2'-8"X6'-8"	HOLLOW CORE 6 PANEL
E	1	2'-6"X6'-8"	HOLLOW CORE 6 PANEL
F	1	2'-4"X6'-8"	HOLLOW CORE 6 PANEL
G	1	4'-0"X6'-8"	HOLLOW CORE 6 PANEL BI-PASS
H	2	8'-0"X7'-0"	5 PANEL OVER HEAD REDWOOD
J	1	6'-0"X6'-10"	PATIO TEMP

WINDOW SCHEDULE

KEY	QTY	SIZE	DESCRIPTION
1	1	5'-0"X5'-0"	AL SLIDING
2	1	4'-0"X6'-0"	AL SINGLE HUNG TEMP
3	2	2'-0"X6'-0"	AL SINGLE HUNG TEMP
4	1	2'-0"X4'-0"	AL SINGLE HUNG
5	3	3'-0"X6'-6"	AL FIXED TEMP
6	2	3'-0"X3'-6"	AL FIXED
7	1	3'-0"X3'-0"	AL SLIDING
8	1	4'-0"X4'-0"	AL SLIDING

Figure 1–14(b) Schedules and reference symbols enlarged. *Courtesy Alan Mascord Design Associates, Inc.*

ARCHITECTURAL SCALES

Architectural objects are generally very large. For this reason, it is impossible to make the drawings full size. As a result, scales are used to fit floor plans, elevations, and architectural details to available sheet sizes. Scales are measuring instruments used to draw objects at full, reduced, or enlarged sizes. The notation for the drawing reduction or enlargement is also referred to as the scale of the drawing.

The measuring instruments and the scales used to create architectural drawings are explained in the following discussion. When you read prints you will see the scale notations given with each drawing. Keep in mind that it is inappropriate for you to actually measure prints using a scale instrument. This is referred to as scaling to the print. All necessary information needs to be found without the need to scale the print. Prints should not be scaled, because possible drawing inaccuracies in the drawing and prints can slightly shrink or enlarge from the original drawing. A properly created print has the information you need in the form of drawing, dimensions, and notes.

SCALE NOTATION

The scale of a print is usually noted in the title block or below the view that differs in scale from that given in the title block. Prints are scaled so the object represented can be illustrated clearly on standard sheet sizes. It would be difficult, for example, to draw a house full-size, thus, a scale that reduces the size of such large objects must be used.

The scale selected depends on:

■ actual size of the structure.

■ amount of detail shown.

■ sheet size selected.

■ amount of dimensions and notes required.

■ common practice that regulates certain scales.

The following scales and their notation are frequently used on architectural drawings:

1/8" = 1'-0"	3/8" = 1'-0"	1–1/2" = 1'-0"
3/32" = 1'-0"	1/2" = 1'-0"	3" = 1'-0"
3/16" = 1'-0"	3/4" = 1'-0"	12" = 1'-0"
1/4" = 1'-0"	1" = 1'-0"	

The following are scales used in civil drafting:

1" = 10'	1" = 50'	1" = 300'
1" = 20'	1" = 60'	1" = 400'
1" = 30'	1" = 100'	1" = 500'
1" = 40'	1" = 200'	1" = 600'

METRIC SCALE

According to the American National Standards Institute (ANSI), the International System of Units (SI) linear unit commonly used on drawings is the millimeter. On drawings where all dimensions are in either inches or millimeters, individual identification of units is not required. However, the drawing shall contain a note stating: Unless otherwise specified, all dimensions are in inches [or millimeters, as applicable]. Where some millimeters are shown on an inch-dimensional drawing, the millimeter value should be followed by the symbol mm. Where some inches are shown on a millimeter-dimensional drawing, the inch value should be followed by the symbol "

Metric symbols:

millimeter	=	mm	dekameter	=	dam
centimeter	=	cm	hectometer	=	hm
decimeter	=	dm	kilometer	=	km
meter	=	m			

Some metric-to-metric equivalents:

10 millimeters	=	1 centimeter
10 centimeters	=	1 decimeter
10 decimeters	=	1 meter
10 meters	=	1 dekameter
10 dekameters	=	1 hectometer
10 hectometer	=	1 kilometer

Some metric-to-United States customary equivalents:

1 millimeter	=	0.03937 inch
1 centimeter	=	0.3937 inch
1 meter	=	39.37 inches
1 kilometer	=	0.6214 mile

Some United States customary-to-metric equivalents:

1 mile	=	1.6093 kilometers	=	1609.3 meters
1 yard	=	914.4 millimeters	=	0.9144 meter
1 foot	=	304.8 millimeters	=	0.3048 meter
1 inch	=	25.4 millimeters	=	0.0254 meter

To convert inches to millimeters, multiply inches by 25.4.

One advantage of metric scales is that any scale is a multiple of 10; therefore, reductions and enlargements are easily performed. In most cases no mathematical calculations should be required when using a metric scale. To avoid the possibility of error, avoid multiplying or dividing metric scales by anything but multiples of ten. Some metric scale calibrations are shown in Figure 1–15.

ARCHITECT'S SCALE

There are 11 different architect scale combinations. On 10 of them, each inch represents a foot and is subdivided into multiples of 12 parts to represent inches and fractions of an inch. The 11th scale is the full scale with a 16 in the margin. The 16 means that each inch is divided into 16 parts, and each part is equal to 1/16 inch. Figure 1–16 shows an example of the full architect's scale; Figure 1–17 shows the fraction calibrations.

Look at the architect's scale examples in Figure 1–18. Note the form in which scales are expressed on a drawing. The scale is expressed as an equation of the drawing size in inches or fractions of an inch to one foot. For example: 3" = 1'–0", 1/2" = 1'–0", or 1/4" = 1'–0".

Some parts of a set of drawings are traditionally drawn at a certain scale. For example:

■ Floor plans for most residential structures are drawn at 1/4" = 1'–0".

■ Although some applications can require a larger or smaller scale, commercial buildings are often drawn at 1/8" = 1'–0" when they are too large to draw at the same scale as a residence.

■ Exterior elevations are commonly drawn at 1/4" = 1'–0", although some architects prefer to draw the front or most important elevation at 1/4" = 1'–0" and the balance of the elevation at 1/8" = 1'–0".

■ Construction details and cross sections can be drawn at larger scales to help clarify specific features. Some cross sections can be drawn at 1/4" = 1'–0" with clarity, but complex cross sections require a scale of 3/8" = 1'–0" or 1/2" = 1'–0" to be clear.

■ Construction details can be drawn at any scale between 1/2" = 1'–0" and 3" = 1'–0", depending on the amount of information presented.

CIVIL ENGINEER'S SCALE

Some prints are created using the civil engineer's scale to draw site plans, maps, or subdivision plats, or to read existing land documents. Most land-related plans, such as construction site plans, are drawn using the civil engineer's scale, although some are drawn with an architect's scale. Common architect's scales used are 1/8" = 1'–0", 3/32" = 1'–0", and 1/16" = 1'–0". Common civil engineer's scales used for site plans are 1" = 10', 1" = 50', and 1" = 100'. The table in Figure 1–19 shows some of the many scale options available when you are using the civil engineer's scale. Keep in mind that any multiple of 10 is available with this scale.

The 10 scale is used in civil drafting for scales of 1" = 10' or 1" = 100' and so on (see Figure 1–19). The 20 scale is used for scales such as 1" = 2', 1" = 20', or 1" = 200'.

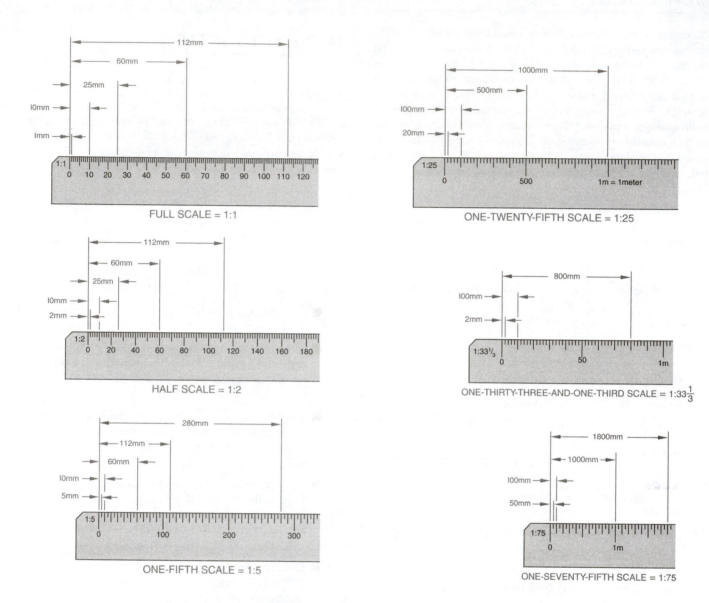

Figure 1–15 Common metric scale calibrations and measurements.

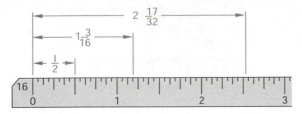

Figure 1–16 Full (1:1) or 12" = 1'–0" architect's scale.

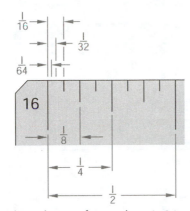

Figure 1–17 Enlarged view of an architect's 16 scale.

The remaining scales on the civil engineer's scale can be used in similar fashion. The 50 scale is popular in civil drafting for drawing plats of subdivisions. Figure 1–20 shows scales that are commonly used on the civil engineer's scale, with sample measurements.

PROPERLY FOLDING PRINTS

Architectural drawings are generally created on large sheets. It is necessary to fold the architectural prints properly when they must be mailed or filed in a standard file cabinet. Folding large prints is much like folding a road map. Folding is done in a pattern of bends that puts the title block and sheet identification on the front. Using the proper method to fold prints also aids in unfolding and refolding prints. Figure 1–21 shows how large prints are folded.

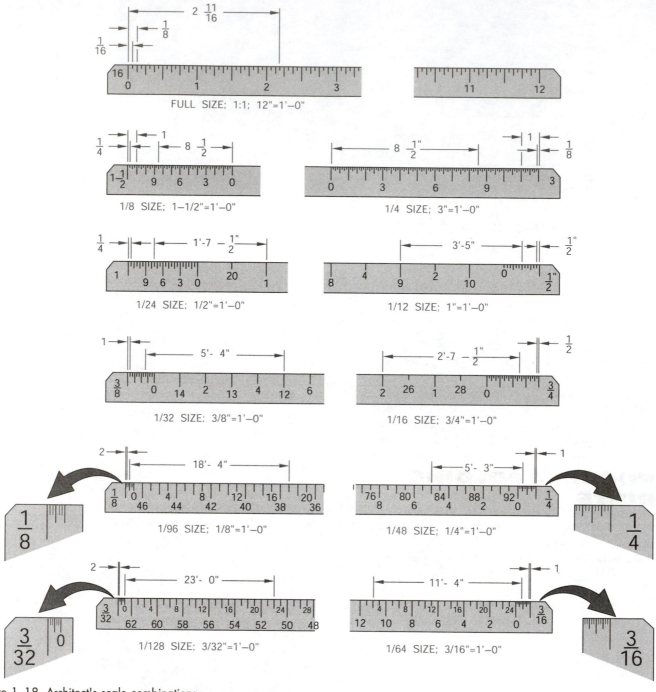

Figure 1–18 Architect's scale combinations.

Divisions	Ratio	Scales Used with This Division			
10	1:1	1" = 1"	1" = 1'	1" = 10'	1" = 100'
20	1:2	1" = 2"	1" = 2'	1" = 20'	1" = 200'
30	1:3	1" = 3"	1" = 3'	1" = 30'	1" = 300'
40	1:4	1" = 4"	1" = 4'	1" = 40'	1" = 400'
50	1:5	1" = 5"	1" = 5'	1" = 50'	1" = 500'
60	1:6	1" = 6"	1" = 6'	1" = 60'	1" = 600'

Figure 1–19 Civil engineer's scale in units of 10.

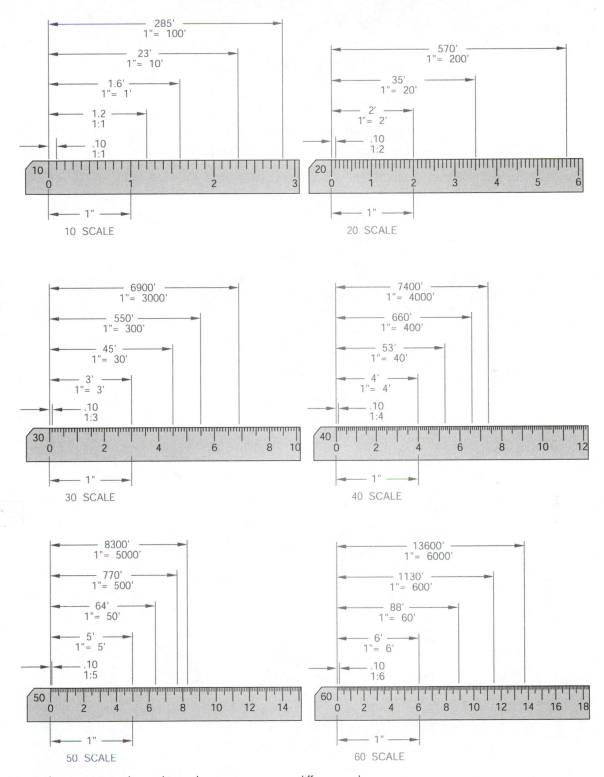

Figure 1–20 Civil engineer's scales and sample measurements at different scales.

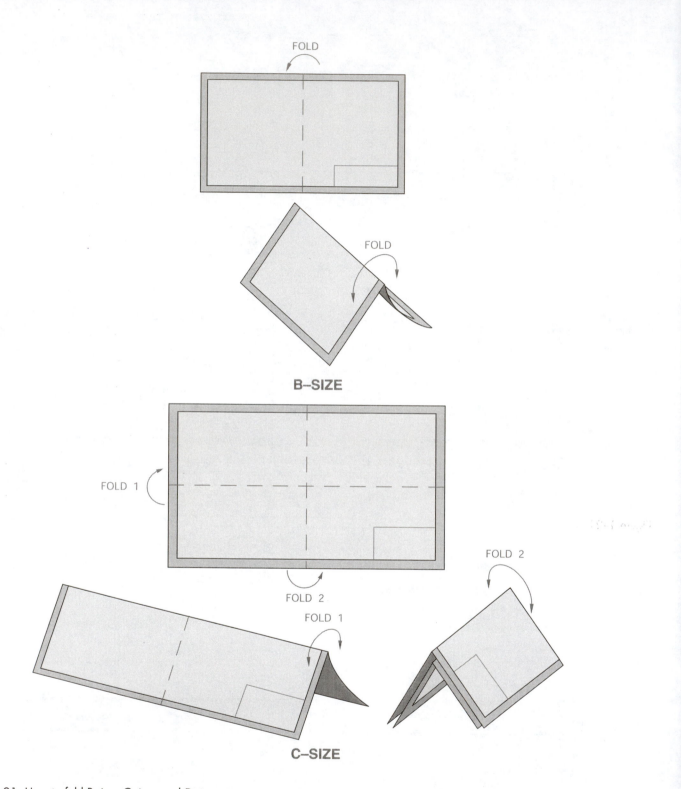

Figure 1–21 How to fold B-size, C-size, and D-size prints.

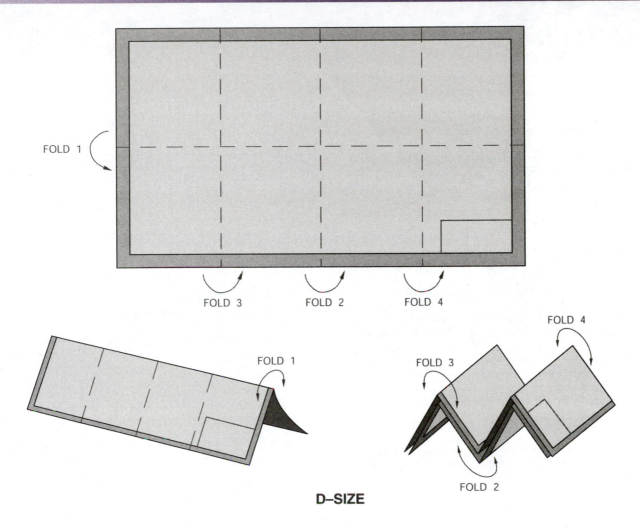

D–SIZE

Figure 1–21 (continued)

CHAPTER 1 TEST

Fill in the blanks below with the proper word or short statement as needed to complete the sentence or answer the question correctly.

1. _____ is an old term that is generally used in the construction business when referring to prints.

2. The reproduction methods commonly used today are the _____ and _____ processes.

3. Diazo prints are also known as _____ prints because the resulting print is generally blue lines on a white background.

4. When a diazo copy is made, the ultraviolet light passes through the drawing paper and only the chemical behind the lines or letters remains. The _____ then activates the remaining chemical to produce the blue lines.

5. State at least three reasons that the popularity of photocopying is increasing for copying architectural drawings.

 _____ .

6. List at least three standard drawing sheet sizes. _____

 _____ .

7. A system of numbers along the top and bottom margins and letters along the left and right margins used to locate items on the drawing is called _____
 _____ .

8. List at least four items represented by dashed lines on an architectural drawing. _____

 _____ .

9. Specific notes are also known as _____
 _____ .

10. Define specific notes. _____

 _____ .

11. Define general notes. _____

 _____ .

12. Define schedules. _____

 _____ .

13. Briefly describe in your own words five general rules you can use to find information on an architectural drawing:

Rule 1: _____

 _____ .

Rule 2: _____

 _____ .

Rule 3: _____

 _____ .

Rule 4: _____

 _____ .

14. Define hard copy. _____

 _____ .

15. Define scales. _____

 _____ .

16. Why is it inappropriate for you to actually measure prints using a scale instrument? _____

 _____ .

17. Identify the scale that is used to draw floor plans for most residential structures. _____
 _____ .

18. List at least two types of drawings that are created using a civil engineer's scale. _____
 _____ .

19. Give two reasons why a print might need to be folded.

 _____ .

20. Why is print folding done in a pattern of bends much like a road map? _____

 _____ .

CHAPTER 1 PROBLEMS

PROBLEM 1–1 Given the title block on this page, fill in the blanks identifying the type of information requested at each location.

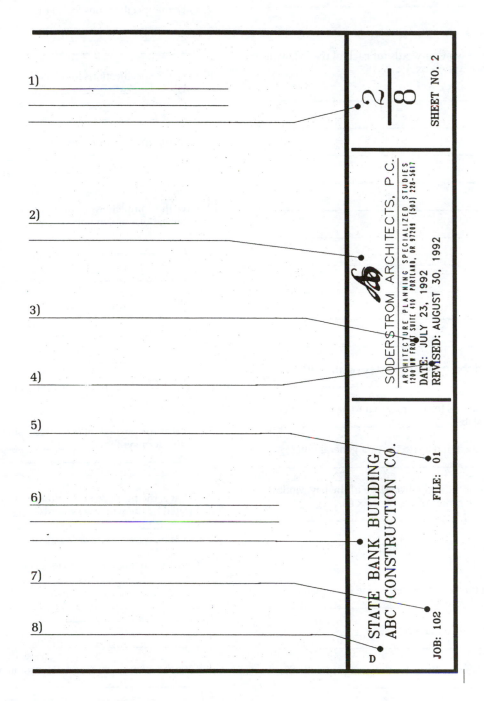

1) _____

2) _____

3) _____

4) _____

5) _____

6) _____

7) _____

8) _____

SHEET NO. 2

SODERSTROM ARCHITECTS, P.C.

ARCHITECTURE PLANNING SPECIALIZED STUDIES
1200 NW FRONT SUITE 410 PORTLAND, OR 97209 (503) 228-5617

DATE: JULY 23, 1992
REVISED: AUGUST 30, 1992

STATE BANK BUILDING
ABC CONSTRUCTION CO.

FILE: 01

JOB: 102

D

Problem 1–1 *Courtesy Soderstrom Architects.*

PROBLEM 1–2 Answer the following questions as you read the partial floor plan given on page 23:

1. Give the sizes of the following rooms:

 Parlor _____ .

 Dining _____ .

2. Give the complete word or words for each of the following abbreviations (see Appendix A):

 AL _____ .

 BM _____ .

 CONC. _____ .

 FLR _____ .

 JST _____ .

 MIN _____ .

 OC _____ .

 SH _____ .

 TEMP _____ .

 W/ _____ .

3. Give the size and spacing of the joists over the parlor. _____ .

4. Give the specifications for the material to be used under the 4" concrete slab. _____ .

5. Is the note described in d a specific or a general note? _____ .

6. Give the dimension from the front face of the bay window in the parlor to the center of the two 2 × 6s. _____ .

PROBLEM 1–3 Answer the following questions as you read the partial floor plan on page 24:

1. Are the notes in the box at the left of the floor plan specific or general notes? _____ .

2. What is the size of the garage? _____ .

3. Does the floor plan size given for the garage include the shop? _____ .

4. What is the dimension from the front face of the garage to the girder truss? _____ .

5. Give the specifications for the construction members used in the ceiling of the garage between the front face of the garage and the girder truss. _____ .

6. Give the specifications for the construction members used in the ceiling of the garage from the girder truss to the back wall of the garage. _____ .

7. Give the specifications for all the exterior windows and doors. _____ .

8. Give the specifications for all bathroom and utility room fans. _____ .

9. Give the specifications provided for the furnace and hot-water heater. _____ .

10. Give the complete word or words for each of the following abbreviations or symbols:

 SQ _____ .

 FT _____ .

 CFM _____ .

 @ _____ .

 % _____ .

PROBLEM 1–4 Answer the following questions as you read the partial floor plan on page 25:

1. What is the purpose of the letter inside the circles located by the door symbols? _____ .

2. What is the purpose of the number inside the hexagons located by the window symbols? _____ .

3. Give the quantity, size, and description of the G doors. ___ _____ .

4. Give the quantity, size, and description of the three windows. _____ .

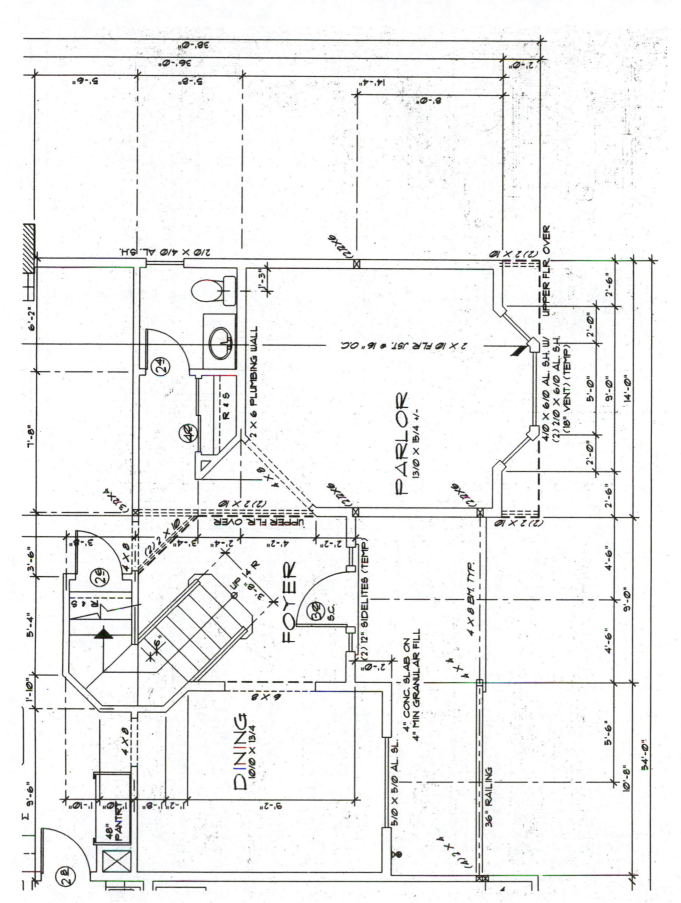

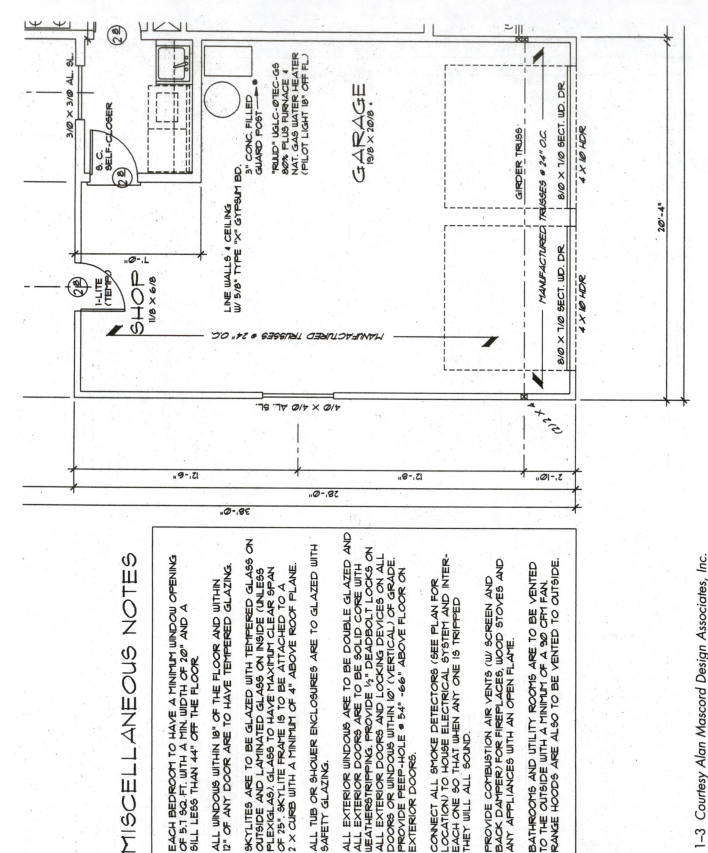

MISCELLANEOUS NOTES

1. EACH BEDROOM TO HAVE A MINIMUM WINDOW OPENING OF 5.7 SQ. FT. WITH A MIN. WIDTH OF 20" AND A SILL LESS THAN 44" OFF THE FLOOR.

2. ALL WINDOWS WITHIN 18" OF THE FLOOR AND WITHIN 12" OF ANY DOOR ARE TO HAVE TEMPERED GLAZING.

3. SKYLITES ARE TO BE GLAZED WITH TEMPERED GLASS ON OUTSIDE AND LAMINATED GLASS ON INSIDE (UNLESS PLEXIGLAS). GLASS TO HAVE MAXIMUM CLEAR SPAN OF 25". SKYLITE FRAME IS TO BE ATTACHED TO A 2 X CURB WITH A MINIMUM OF 4" ABOVE ROOF PLANE.

4. ALL TUB OR SHOWER ENCLOSURES ARE TO GLAZED WITH SAFETY GLAZING.

5. ALL EXTERIOR WINDOWS ARE TO BE DOUBLE GLAZED AND ALL EXTERIOR DOORS ARE TO BE SOLID CORE WITH WEATHERSTRIPPING. PROVIDE ½" DEADBOLT LOCKS ON ALL EXTERIOR DOORS AND LOCKING DEVICES ON ALL DOORS OR WINDOWS WITHIN 10' (VERTICAL) OF GRADE. PROVIDE PEEP-HOLE @ 54" -66" ABOVE FLOOR ON EXTERIOR DOORS.

6. CONNECT ALL SMOKE DETECTORS (SEE PLAN FOR LOCATION) TO HOUSE ELECTRICAL SYSTEM AND INTER-EACH ONE SO THAT WHEN ANY ONE IS TRIPPED THEY WILL ALL SOUND.

7. PROVIDE COMBUSTION AIR VENTS (W/ SCREEN AND BACK DAMPER) FOR FIREPLACES, WOOD STOVES AND ANY APPLIANCES WITH AN OPEN FLAME.

8. BATHROOMS AND UTILITY ROOMS ARE TO BE VENTED TO THE OUTSIDE WITH A MINIMUM OF A 90 CFM FAN. RANGE HOODS ARE ALSO TO BE VENTED TO OUTSIDE.

Problem 1-3 *Courtesy Alan Mascord Design Associates, Inc.*

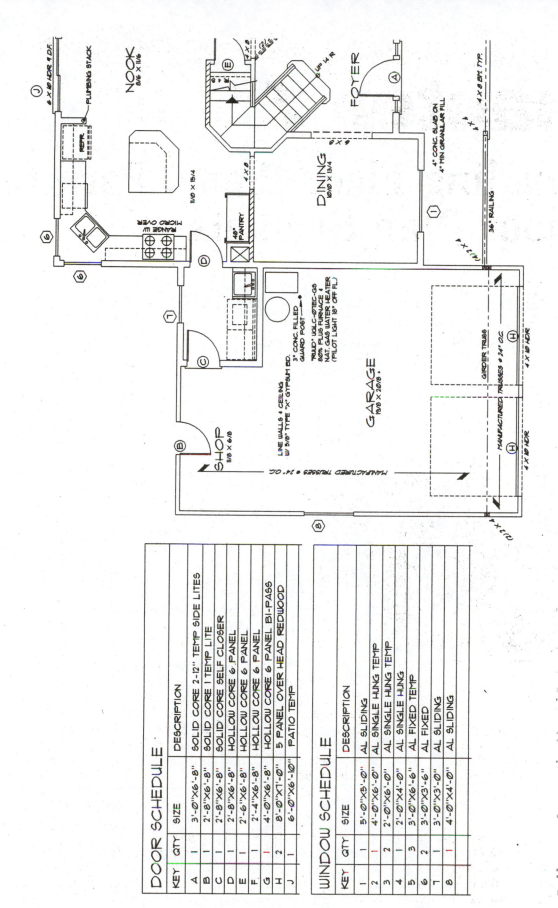

Problem 1–4 Courtesy Alan Mascord Design Associates, Inc.

CHAPTER 2

Reading Site Plans

CHAPTER OVERVIEW

This chapter covers the following topics:

- Understanding legal descriptions
- Metes and bounds system
- Rectangular survey system
- Lot and block system
- Site plan requirements
- Topography
- Reading site plans

- Metrics in site planning
- Reading the grading plan
- Site analysis plan
- Reading subdivision plans
- Test
- Problems

UNDERSTANDING LEGAL DESCRIPTIONS

Virtually every piece of property in the United States is described for legal purposes; such descriptions are referred to as *legal descriptions*. Every legal description is unique and cannot be confused with any other property. Legal descriptions of properties are filed in local jurisdictions, generally county or parish courthouses. Legal descriptions are public records and can be reviewed at any time.

This chapter deals with site plan characteristics and requirements. A site is an area of land generally one plot or construction lot in size. The term site is synonymous with plot and lot. A plat is a map of part of a city or township showing some specific area, such as a subdivision made up of several individual lots. There are usually many sites or plots in a plat. Some dictionary definitions, however, do not differentiate between plot and plat.

There are three basic types of legal descriptions: metes and bounds, rectangular survey system, and lot and block.

METES AND BOUNDS SYSTEM

Metes, or measurements, and bounds, or boundaries, can be used to identify the perimeters of any property. This is referred to as the metes and bounds system. The metes are measured in feet, yards, rods (rd), or surveyor's chains (ch). There are 3' (914 mm) in 1 yard, 5.5 yards or 16.5' (5029 mm) in one rod, and 66' (20,117 mm) in one surveyor's chain. The boundaries can be a street, fence, or river. Boundaries are also established as bearings, directions with reference to one quadrant of the compass. There are 360° in a circle or compass, and each quadrant has 90°. Degrees are divided into minutes and seconds. There are 60 minutes (60') in 1° and 60 seconds (60") in 1 minute. Bearings are measured clockwise or counterclockwise from north or south. For example, a reading 45° from north to west is labeled N 45° W. See Figure 2–1. If a bearing reading requires great accuracy, fractions of a degree are used. For example, S 30° 20' 10" E reads from south 30 degrees 20 minutes 10 seconds to east.

The metes and bounds land survey begins with a monument, known as the point-of-beginning (POB). This point is a fixed location and in times past has been a pile of rocks, a large tree, or an iron rod driven into the ground. Figure 2–2 shows an example of a site plan that is laid out using metes and bounds, and the legal description for the plot is given.

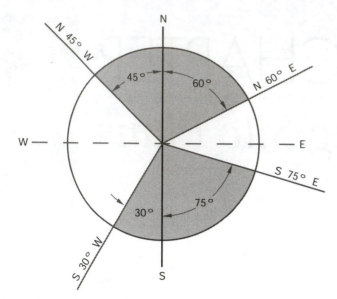

Figure 2–1 Determining bearings.

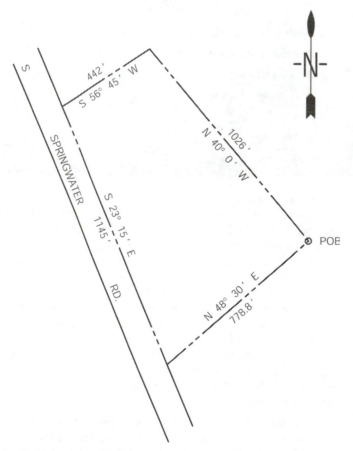

Figure 2–2 Metes and bounds plot plan and legal description for the plot.

RECTANGULAR SURVEY SYSTEM

The states in an area of the United States starting with the western boundary of Ohio to the Pacific Ocean, and including some south-

eastern states were described as public land states. Within this area the U.S. Bureau of Land Management devised a system for describing land known as the rectangular survey system.

Parallels of latitude and meridians of longitude were used to establish areas known as great land surveys. Lines of latitude, also called parallels, are imaginary parallel lines running east and west. Lines of longitude, also called meridians, are imaginary lines running north and south. The point of beginning of each great land survey is where two basic reference lines cross. The lines of latitude, or parallels, are termed the baselines, and the lines of longitude, or meridians, are called principal meridians. There are 31 sets of these lines in the continental United States, with 3 in Alaska. At the beginning, the principal meridians were numbered, and the numbering system ended with the sixth principal meridian passing through Nebraska, Kansas, and Oklahoma. The remaining principal meridians were given local names. The meridian through one of the last great land surveys near the West Coast is named the Willamette Meridian because of its location in the Willamette Valley of Oregon. The principal meridians and baselines of the great land surveys are shown in Figure 2–3.

Townships

The great land surveys were broken down into smaller surveys known as townships and sections. The baselines and meridians were divided into blocks called townships. Each township measures 6 miles square. The townships are numbered by tiers running north-south. The tier numbering system is established either north or south of a principal baseline. For example, the fourth tier south of the baseline is labeled Township Number 4 South, abbreviated T. 4 S. Townships are also numbered according to vertical meridians, known as ranges. Ranges are established either east or west of a principal meridian. The third range east of the principal meridian is called Range Number 3 East, abbreviated R. 3 E. Now combine T. 4 S. and R. 3 E. to locate a township or a piece of land 6 miles by 6 miles, or a total of 36 square miles. Figure 2–4 shows the township just described.

Sections

To further define the land within a township 6 miles square, the area was divided into units 1 mile square, called sections. Sections in a township are numbered from 1 to 36. Section 1 always begins in the upper-right corner, and consecutive numbers are arranged as shown in Figure 2–5. The legal descriptions of land can be carried one stage farther. For example, Section 10 in the township given would be described as Sec. 10, T. 4 S., R. 3 E. This is an area of land 1 mile square. Sections are divided into acres. One acre equals 43,560 sq. ft., and one section of land contains 640 acres.

In addition to dividing sections into acres, sections are divided into quarters, as shown in Figure 2–6. The northeast one-quarter of Section 10 is a 160-acre piece of land described as NE 1/4, Sec. 10, T. 4 S., R. 3 E. When this section is keyed to a specific meridian, it can be only one specific 160-acre area. The section can be broken further by dividing each quarter into quarters, as shown in Figure 2–7. If the SW 1/4 of the NE 1/4 of Section 10 were the

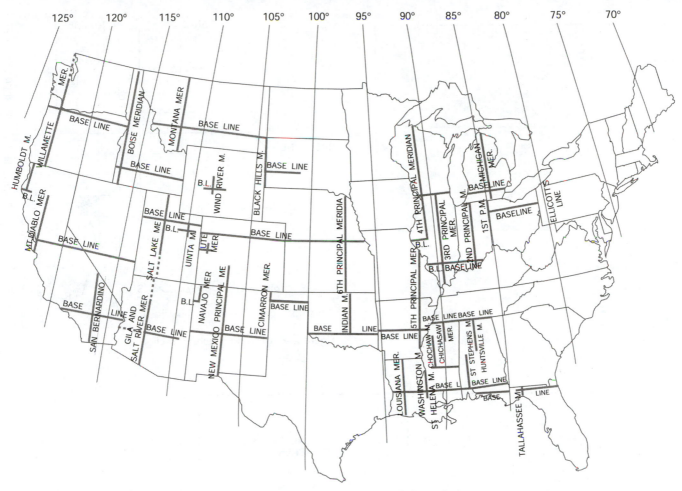

Figure 2–3 Principal meridians and baselines of the great land survey (not including Alaska).

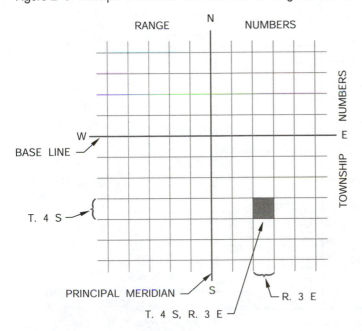

Figure 2–4 Townships.

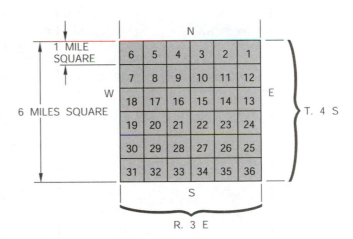

Figure 2–5 Sections.

desired property, you would have 40 acres known as SW 1/4, NE 1/4, Sec. 10, T. 4 S., R. 3 E. The complete, rectangular system legal description of a 2.5-acre piece of land in Section 10 reads: SW 1/4, SE 1/4, SE 1/4, SE 1/4 Sec. 10, T. 4 N., R. 8 W. of the San Bernardino Meridian, in the County of Los Angeles, State of California. See Figure 2–8.

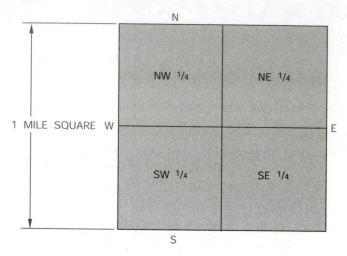

Figure 2–6 Section quarters.

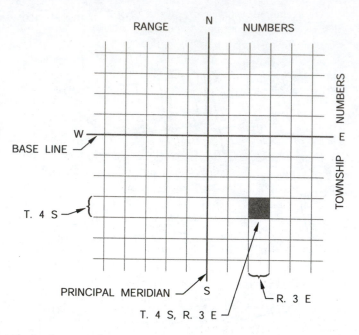

Figure 2–7 Dividing a quarter section.

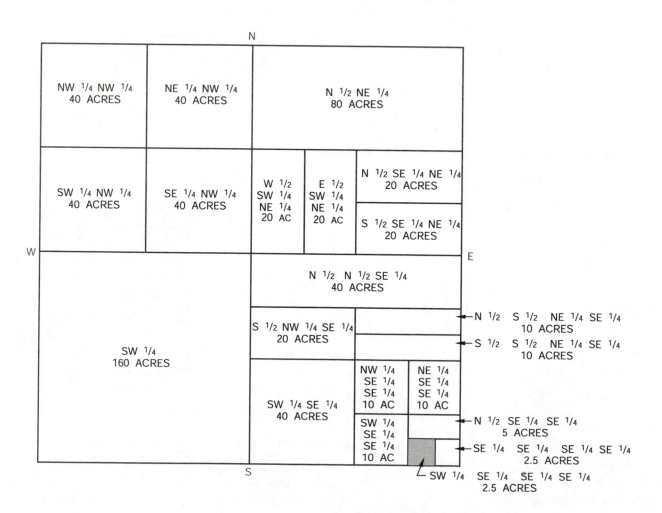

Figure 2–8 Sample divisions of a section.

The rectangular survey system can be used to describe very small properties by continuing to divide a section of a township. Often the township section's legal description can be used to describe the location of the point of beginning of a metes and bounds legal description, especially when the surveyed land is an irregular site or plot within the rectangular survey system.

LOT AND BLOCK SYSTEM

The lot and block legal description system can be derived from either the metes and bounds or the rectangular system. Generally, when a portion of land is subdivided into individual building sites, the subdivision is established as a legal plot and recorded as such in the local county records. The subdivision is given a name and broken into blocks of lots. A subdivision can have several blocks, each divided into a series of lots. Each lot can be 50' × 100', for example, depending on the zoning requirements of the specific area. Figure 2–9 shows an example of a typical lot and block system. A typical lot and block legal description might read: LOT 14, BLOCK 12, LINCOLN PARK NO. 3, CITY OF SALEM, STATE. This lot is the shaded area in Figure 2–9.

SITE PLAN REQUIREMENTS

A site plan, also known as a plot or lot plan, is a map of a piece of land that can be used for any number of purposes. Site plans might show a proposed construction site for a specific property. Sites might show topography with contour lines, or the numerical value of land elevations might be given at certain locations. Site plans are also used to show how a construction site will be excavated and are then known as grading plans. Site plans can be drawn to serve any number of required functions; all have some similar characteristics, which include showing the following:

- a legal description of the property based on a survey.
- property line bearings and directions.
- north direction.
- roads and easements.
- utilities.
- elevations.
- map scale.

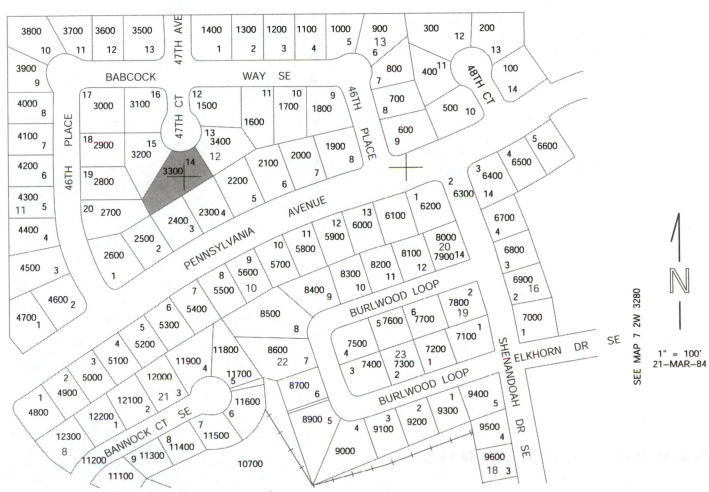

Figure 2–9 Part of a lot and block subdivision. *Courtesy GLADS Program.*

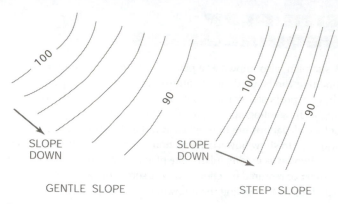

Figure 2–10 Contour lines showing both gentle and steep slopes.

Plats are maps that are used to show an area of a town or township. They show several or many lots and can be used by a developer to show a proposed subdivision of land.

TOPOGRAPHY

Topography is a physical description of a land surface showing its variation in elevation, known as relief, and locating other features. Surface relief can be shown with graphic symbols that use shading methods to accent the character of land. The differences in elevations can also be shown with contour lines. Site plans that require surface relief identification generally use contour lines. These lines connect points of equal elevation and help show the general lay of the land.

A good way to visualize the meaning of contour lines is to look at a lake or ocean shoreline. When the water is high during the winter or at high tide, a high-water line establishes a contour at that level. As the water recedes during the summer or at low tide, a new lower-level line is obtained. This new line represents another contour. The high-water line goes all around the lake at one level, and the low-water line goes all around the lake at another level. These two lines represent *contours,* or lines of equal elevation. The vertical distance between contour lines is known as *contour interval.* When the contour lines are far apart, the contour interval shows relatively flat or gently sloping land. When the contour lines are close together, the contour interval shows land that is much steeper. Contour lines are broken periodically, and the numerical value of the contour elevation above sea level is inserted. Figure 2–10 shows sample contour lines. Figure 2–11 shows a graphic example of land relief in pictorial form and contour lines of the same area.

Figure 2–12 shows a site with contour lines. Site plans do not always require contour lines showing topography. Verify the requirements with the local building codes. In most instances the only contour-related information required is property corner elevations, street elevation at a driveway, and the elevation of the finished floor levels of the structure. Additionally, slope can be defined and labeled with an arrow.

READING SITE PLANS

Site plan requirements vary by jurisdiction: city, county, or state. Some site plan elements are similar around the country. Guidelines for site plans can be found at a local building office or building per-

PICTORIAL

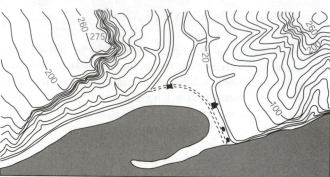

Figure 2–11 Land relief pictorial and contour lines. *Courtesy U.S. Department of the Interior, Geological Survey.*

mit department. Some agencies, for example, require that the plot plan be drawn on paper of a specific size, such as 8–1/2" × 3–1/4". Typical site plan items include the following:

- site plan scale.
- legal description of the property.
- property line bearings and dimensions.
- north direction.
- existing and proposed roads.
- driveways, patios, walks, and parking areas.
- existing and proposed structures.
- public or private water supply.
- public or private sewage disposal.
- location of utilities.
- rain and footing drains, and storm sewers or drainage.
- topography, including contour lines or land elevations at lot corners, street centerline, driveways, and floor elevations.
- setbacks, which are the minimum distance from the property lines to the front, rear, and sides of the structure.
- specific items on adjacent properties that might be required.
- existing and proposed trees that might be required.

Figure 2–13 shows a site plan layout that is used as an example at a local building department. Figure 2–14 shows a basic site plan for a proposed residential addition.

The method of sewage disposal is generally an important item shown on a site plan drawing. There are a number of alternative methods of sewage disposal, including public sewers and private systems. Chapter 18 gives more details of sewage disposal methods. The site plan representation of a public sewer connection is shown in Figure 2–15. A private septic sewage disposal system is shown in a site plan in Figure 2–16.

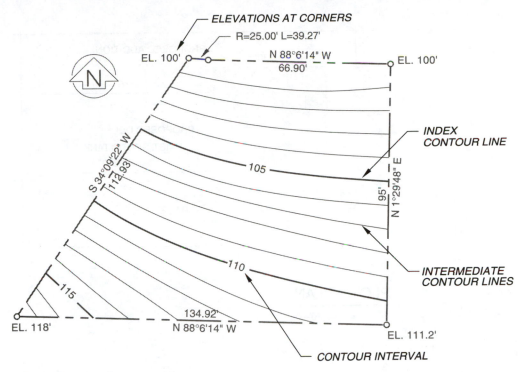

Figure 2–12 Site plan with contour lines.

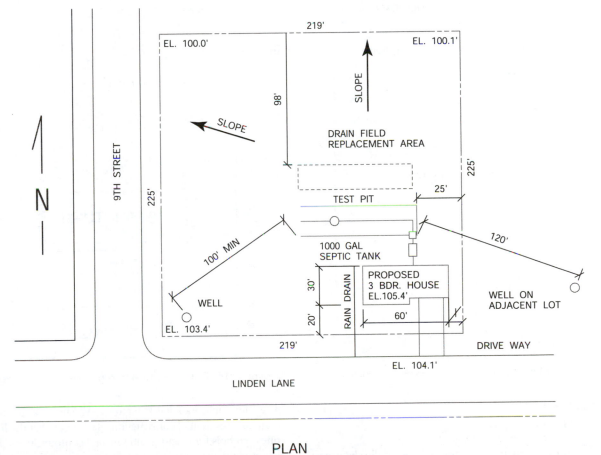

PLAN
SCALE 1" = 60'

Figure 2–13 Recommended typical site plan layout.

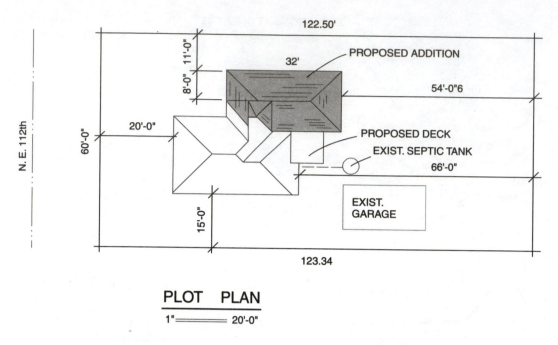

PLOT PLAN

1"═══════ 20'-0"

LEGAL:

LOT #3
BLOCK F1
VIEW RIDGE
MULTNOMAH COUNTY

Figure 2–14 Sample site plan showing existing home and proposed addition.

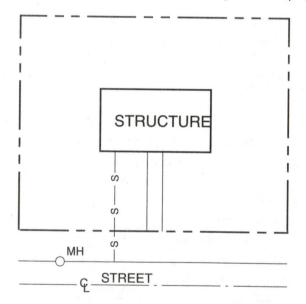

Figure 2–15 Plot plan showing a public sewer connection.

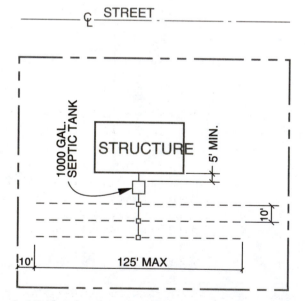

Figure 2–16 Plot plan showing a private septic sewage system.

READING THE GRADING PLAN

Grading plans are construction drawings that generally show existing and proposed topography. The outline of the structure can be shown with elevations at each building corner and the elevation given for each floor level. Figure 2–17 shows a detailed grading plan for a residential construction site. Notice that the legend identifies symbols for existing and finished contour lines. This particular grading plan provides retaining walls and graded slopes to accommodate a fairly level construction site from the front of the structure to the extent of the rear yard. The finished slope repre-

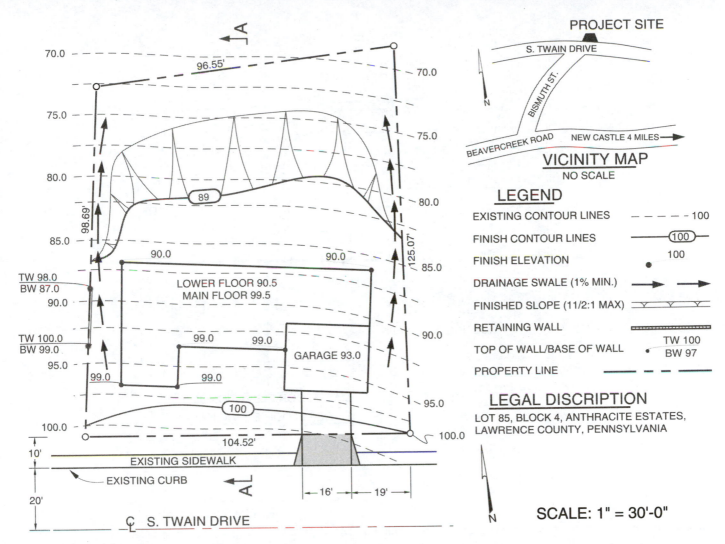

Figure 2–17 Grading plan.

sents an embankment that establishes the relationship of the proposed contour to the existing contour. This particular grading plan also shows a proposed irrigation and landscaping layout.

Grading plan requirements can differ from one location to the next. Some grading plans might also show a cross section through the site at specified intervals or locations to evaluate the contour more fully. This cross section is called a profile. A profile through the grading plan in Figure 2–17 is shown in Figure 2–18.

SITE ANALYSIS PLAN

In areas or conditions where zoning and building permit applications require a design review, a site analysis plan might be required. The site analysis provides the basis for the proper design relationship of the proposed development to the site and to adjacent properties. The degree of detail of the site analysis is generally appropriate to the scale of the proposed project. A site analysis plan, shown in Figure 2–19, often includes the following:

- a vicinity map showing the location of the property in relationship to adjacent properties, roads, and utilities.
- site features, such as existing structures and plants on the property and adjacent property.
- scale.
- north direction.
- property boundaries.
- slope shown by contour lines or cross sections, or both.
- plan legend.
- traffic patterns.
- solar site information if solar application is intended.
- pedestrian patterns.

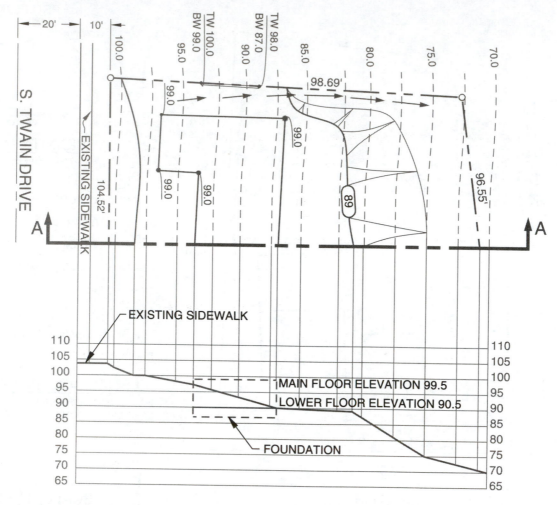

Figure 2–18 Constructing a profile from the grading plan in Figure 2–17.

READING SUBDIVISION PLANS

Local requirements for subdivisions should be confirmed because procedures vary, depending on local guidelines and zoning rules.

Some areas have guidelines for minor subdivisions that differ from major subdivisions. The plat required for a minor subdivision can include

- legal description.
- name, address, and telephone number of applicant.
- parcel layout with dimensions.
- direction of north.
- all existing roads and road widths.
- number identification of parcels, such as Parcel 1, Parcel 2.
- location of well or proposed well, or name of water district.
- type of sewage disposal (septic tank or public sanitary sewers). Name of sewer district.
- zoning designation.

- size of parcels in square feet or acres.
- slope of ground. (Arrows pointing downslope.)
- setbacks of all existing buildings, septic tanks, and drainfields from new property lines.
- all utility and drainage easements.
- any natural drainage channels. Indicate direction of flow and whether drainage is seasonal or year-round.
- map scale.
- date.
- building permit application number, if any.

Figure 2–20 shows a typical subdivision of land with three proposed parcels.

A major subdivision might require more detailed plats than a minor subdivision. Some of the items that can be included on the plat or in a separate document are:

- name, address, and telephone number of the property owner, applicant, and engineer or surveyor.
- source of water.

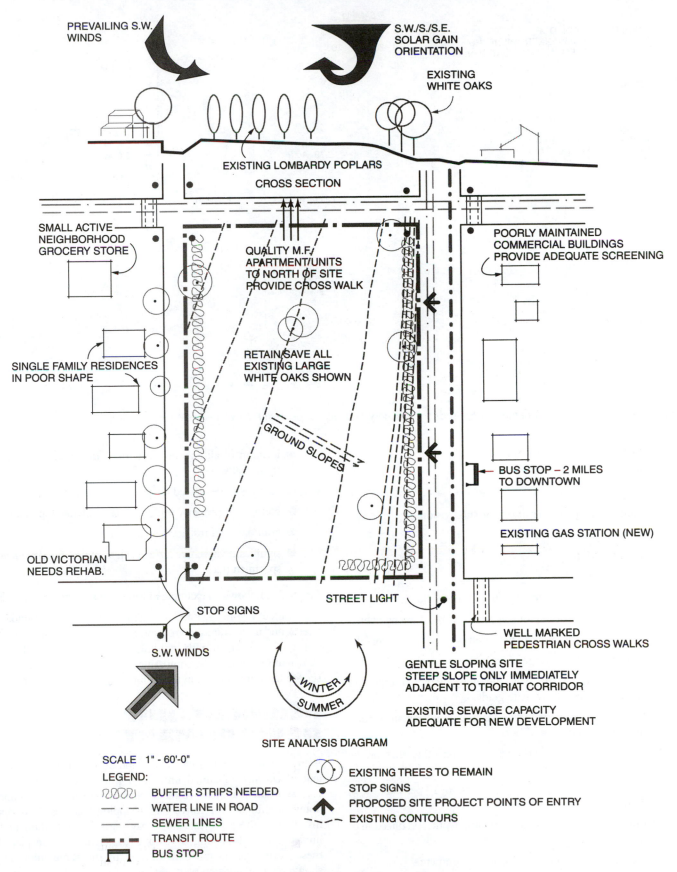

PREVAILING S.W. WINDS

S.W./S./S.E. SOLAR GAIN ORIENTATION

EXISTING WHITE OAKS

EXISTING LOMBARDY POPLARS

CROSS SECTION

SMALL ACTIVE NEIGHBORHOOD GROCERY STORE

POORLY MAINTAINED COMMERCIAL BUILDINGS PROVIDE ADEQUATE SCREENING

QUALITY M.F. APARTMENT/UNITS TO NORTH OF SITE PROVIDE CROSS WALK

SINGLE FAMILY RESIDENCES IN POOR SHAPE

RETAIN/SAVE ALL EXISTING LARGE WHITE OAKS SHOWN

GROUND SLOPES

BUS STOP – 2 MILES TO DOWNTOWN

OLD VICTORIAN NEEDS REHAB.

EXISTING GAS STATION (NEW)

STOP SIGNS

STREET LIGHT

WELL MARKED PEDESTRIAN CROSS WALKS

S.W. WINDS

WINTER

SUMMER

GENTLE SLOPING SITE STEEP SLOPE ONLY IMMEDIATELY ADJACENT TO TRORIAT CORRIDOR

EXISTING SEWAGE CAPACITY ADEQUATE FOR NEW DEVELOPMENT

SITE ANALYSIS DIAGRAM

SCALE 1" - 60'-0"

LEGEND:

〰️ BUFFER STRIPS NEEDED
— · — WATER LINE IN ROAD
— — SEWER LINES
— ·· — TRANSIT ROUTE
⊐ BUS STOP

⊙ EXISTING TREES TO REMAIN
● STOP SIGNS
⬆ PROPOSED SITE PROJECT POINTS OF ENTRY
– – – EXISTING CONTOURS

Figure 2–19 Site analysis plan. *Courtesy Planning Department, Clackamas County, Oregon.*

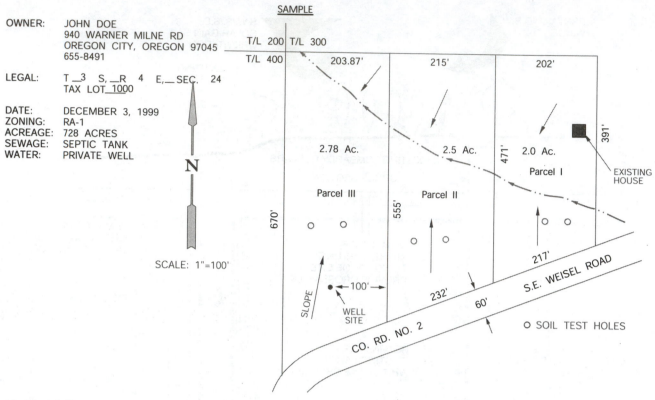

Figure 2–20 Subdivisions with three proposed lots. *Courtesy Planning Department, Clackamas County, Oregon.*

- method of sewage disposal.
- existing zoning.
- proposed utilities.
- name of the major partitions or subdivision.
- date the drawing was made.
- legal description.
- north arrow.
- vicinity sketch showing location of the subdivision.
- identification of each lot or parcel and block by number.
- gross acreage of property being subdivided or partitioned.
- dimensions and acreage of each lot or parcel.
- streets abutting the plat, including name, direction of drainage, and approximate grade.
- streets proposed, including names, approximate grades, and radius of curves.
- legal access to subdivision or partition other than public roads.
- contour lines at 2' intervals for slopes of 10 percent or less, 5' intervals if slopes exceed 10 percent.
- drainage channels, including width, depth, and direction of flow.
- locations of existing and proposed easements.
- location of all existing structures, driveways, and pedestrian walkways.
- all areas to be offered for public dedication.
- contiguous property under the same ownership, if any.
- boundaries of restricted areas, if any.
- significant vegetative areas, such as major wooded areas or specimen trees.

Figure 2–21 shows an example of a small major subdivision plat.

Look at Figure 2–21 and notice that only property boundaries, streets, and utilities are shown. Now, as you look at Figure 2–21 find Lot 2. The plot plan with building site information for Lot 2 is shown in Figure 2–22. By comparing the plat and plot plan, you can see the kind of information that is found on both types of prints.

PLANNED UNIT DEVELOPMENT

A creative and flexible approach to land development is a *planned unit development*. Planned unit developments can include such uses as residential areas, recreational areas, open spaces, schools, libraries, churches, or convenient shopping facilities. Developers involved in these projects must pay particular attention to the impact on local existing developments. Generally, the plats for these developments must include all of the same information shown on a subdivision plat, and:

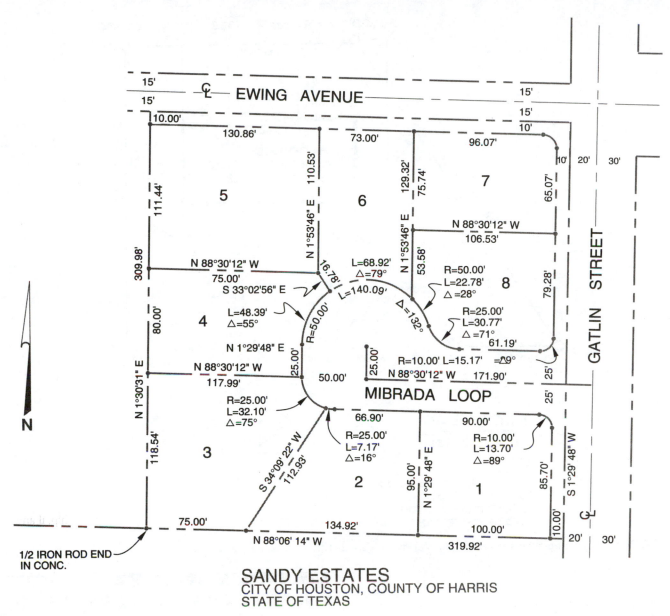

Figure 2–21 Small major subdivision plat.

- detailed vicinity map, as shown in Figure 2–23.
- land use summary.
- symbol legend.
- special spaces such as recreational and open spaces or other unique characteristics.

Figure 2–24 shows a typical planned unit development plan. These plans, like any proposed site plan, might require changes before the final drawings are approved for development.

There are several specific applications for a site plan. The applied purpose of each is different, although the characteristics of each type of site plan may be similar. Local districts have guidelines for the type of plan required. Be sure to evaluate local guidelines before preparing a site plan for a specific purpose. To get a plot plan accepted, prepare it in strict accordance with the requirements.

A variety of plot plan-related templates and CADD programs are available that can help make the preparation of these plans easier.

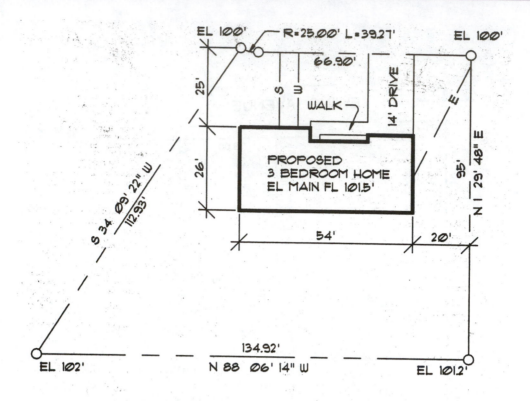

PLOT PLAN

SCALE: 1"=20'

LEGAL:
LOT 2 SANDY ESTATES
CITY OF HOUSTON,
COUNTY OF HARRIS,
STATE OF TEXAS

Figure 2–22 A plot plan from the subdivision plat shown in Figure 2–17.

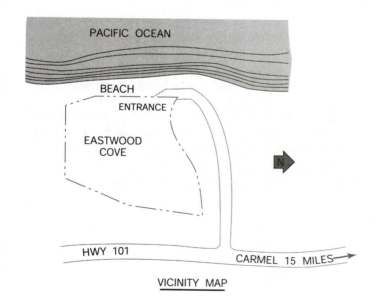

Figure 2–23 Vicinity map.

METRICS IN SITE PLANNING

The recommended metric values used in site plans based on surveying, excavating, paving and concrete construction are as follows:

QTY		UNIT AND SYMBOL
SURVEYING	Length	meter (m) and kilometer (km)
	Area	square meter (m²), hectare (ha), and square kilometer (km²)
	Plane Angle	degree (°), minute ('), second ("), and percent (%)
EXCAVATING	Length	millimeter (mm) and meter (m)
	Volume	cubic meter (m³)
PAVING	Length	millimeter (mm) and meter (m)
	Volume	cubic meter (m³)
CONCRETE	Length	millimeter (mm) and meter (m)
	Area	square meter (m²)
	Volume	cubic meter (m³)

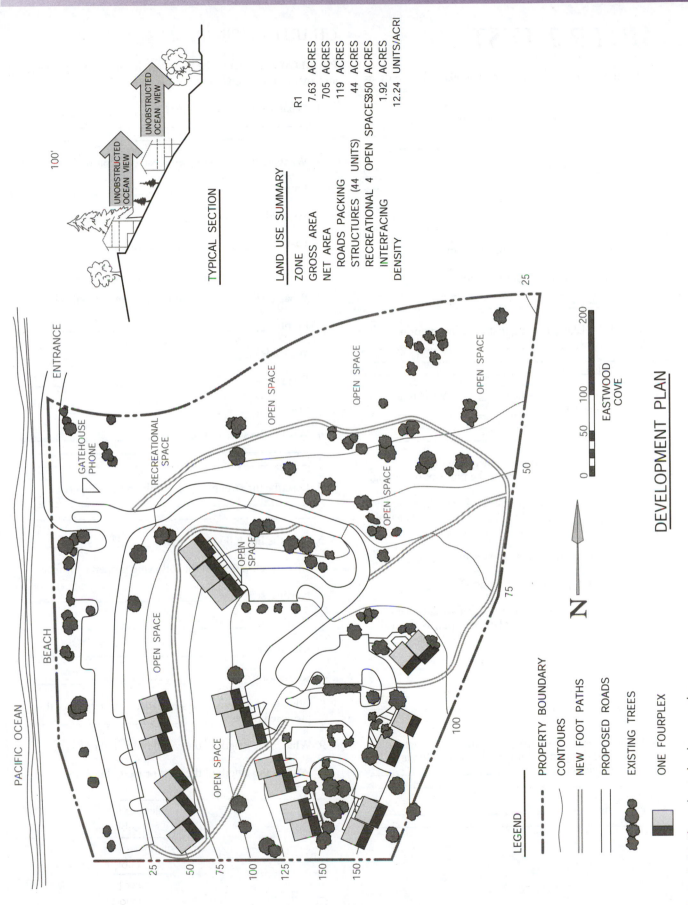

TYPICAL SECTION

100'

UNOBSTRUCTED OCEAN VIEW

UNOBSTRUCTED OCEAN VIEW

LAND USE SUMMARY

ZONE	R1	
GROSS AREA	7.63	ACRES
NET AREA	705	ACRES
ROADS PACKING	119	ACRES
STRUCTURES (44 UNITS)	44	ACRES
RECREATIONAL 4 OPEN SPACES	350	ACRES
INTERFACING	1.92	ACRES
DENSITY	12.24	UNITS/ACRI

PACIFIC OCEAN

BEACH

ENTRANCE

GATEHOUSE PHONE

RECREATIONAL SPACE

OPEN SPACE

OPEN SPACE

OPEN SPACE

OPEN SPACE

OPEN SPACE

OPEN SPACE

OPEN SPACE

OPEN SPACE

25 50 75 100 125 150 150

25 50 75 100

N

EASTWOOD COVE

0 50 100 200

DEVELOPMENT PLAN

LEGEND

—··—··— PROPERTY BOUNDARY

——— CONTOURS

═══ NEW FOOT PATHS

═══ PROPOSED ROADS

EXISTING TREES

ONE FOURPLEX

Figure 2-24 Planned unit development plan.

CHAPTER 2 TEST

Fill in the blanks with short complete statements or words as needed:

1. Define plot plan as discussed in this chapter. _____

_____ .

2. Name the three types of legal descriptions: _____

_____ .

3. Metes, or _____ ,
and bounds, or _____ ,
may be used to identify the perimeters of any property.

4. Define bearings as discussed in this chapter. _____

_____ .

5. How would you label a bearing that is 30° from north toward the east? _____

_____ .

6. How would you label a bearing that is 47° 30' 12" from south toward the west? _____

_____ .

7. The metes and bounds land survey begins with a _____
_____ known as the point-of-beginning.

8. A township, in the rectangular system of describing land, is a piece of land _____ by _____ , or a total of _____ square miles.

9. How many sections are there in a township? _____ .

10. How many acres are there in one section? _____ .

11. Name the type of legal description that is associated with a lot within a named subdivision of land that may be divided into several blocks, and each block divided into lots. _____

_____ .

12. Define topography as discussed in this chapter. _____

_____ .

13. Explain the difference in slope of the land when contour lines are spaced far apart as compared to when they are spaced close together. _____

_____ .

14. Define grading plan. _____
_____ .

CHAPTER 2 PROBLEMS

PROBLEM 2–1 Refer to the Plot Plan shown on the following page and answer the following questions:

1. What is the legal description? _____

_____ .

2. What are the following setbacks to the proposed structure?

 Front _____ .

 West side _____ .

 East side _____ .

 Rear _____ .

3. What are the following minimum required setbacks?

 Front _____ .

 West side _____ .

 East side _____ .

 Rear _____ .

4. What is the scale of this plot plan? _____
_____ .

5. Describe the structure to be built on this property. _____

_____ .

6. Give the finish floor elevation. _____ .

7. Give the elevations at the following property corners:

 Northwest _____ .

 Northeast _____ .

 Southwest _____ .

 Southeast _____ .

8. What is the name of the street that runs in front of this proposed home? _____ .

9. What is the length of the south property line? _____ .

10. What is the length of the west property line? _____ .

S.W. LOMA VISTA STREET

EL 100.0'

EL 100.0'

4" CONC DRIVE

LEGAL DESCRIPTION

LOT 55, WICHER HEIGHTS NO. 2
SW 1/4 SE 1/4 SECTION 19 T1S R1W
WASHINGTON COUNTY, OREGON

NORTH

SITE PLAN
SCALE 1/8"=1'-0"

20'

35'

52'

PROPOSED ONE STORY
SINGLE FAMILY RESIDENCE

FIN. FLOOR EL 101.0'

LINE OF REQUIRED SETBACKS

5'

5'

5'

15'

5'

87.5'

10'

34'-6'

EL 102.0'

EL 101.0'

67.20'

Problem 2-1

PROBLEM 2–2 Refer to the Grading Plan shown on the following page and answer the following questions:

1. What is the legal description for this property? _____
_____ .

2. What is the minimum front setback? _____ .

3. What are the minimum side yard setbacks? _____ .

4. What is the width of the public sanitary sewer easement?
_____ .

5. Give the west property line length and bearing. _____
_____ .

6. Give the east property line length and bearing. _____
_____ .

7. Give the south property line length and bearing. _____
_____ .

8. What is the contour interval? _____ .

9. How often are contour lines labeled? _____ .

10. What is the difference between the contour lines that are labeled and those that are not labeled? _____
_____ .

11. What is the entry floor elevation? _____ .

12. What is the lower finish floor elevation? _____ .

13. What is the upper finish floor elevation? _____ .

14. How do the site work contour lines differ from the natural contour lines? _____
_____ .

15. What is the height of the highest retaining wall? _____ .

16. What is the difference in elevation between the garage finish floor and the entry finish floor? _____ .

17. What is the difference in elevation between the upper finish floor and the lower finish floor? _____ .

18. What are the driveway specifications? _____ .

19. What is the elevation of the highest contour line shown on this plan? _____ .

20. What is the elevation of the lowest contour line shown on this plan? _____ .

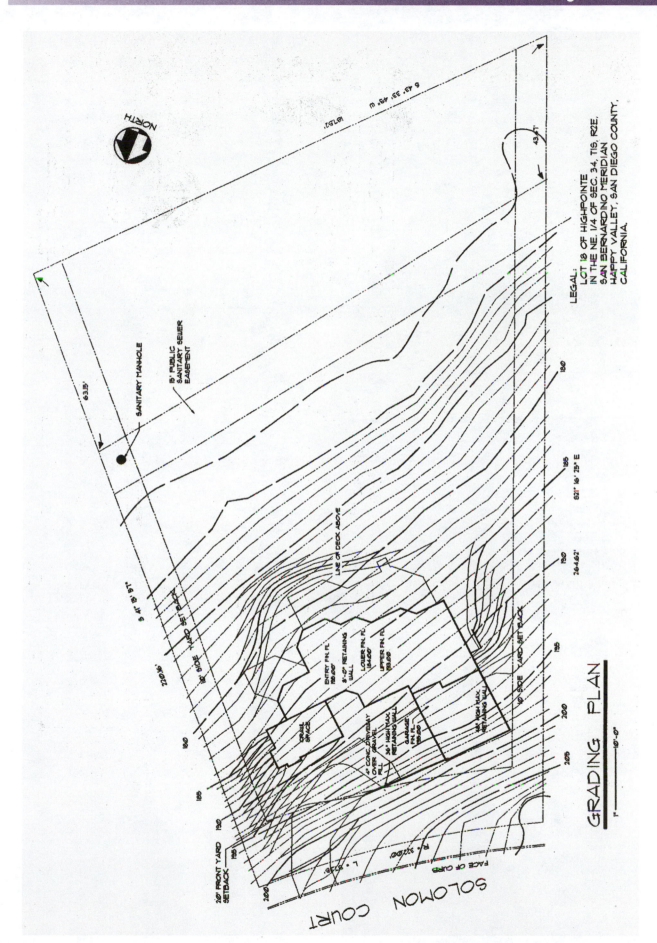

NORTH

S 43° 33' 45" W

187.57'

63.15'

SANITARY MANHOLE

15' PUBLIC
SANITARY SEWER
EASEMENT

S 41° 15' 51" E

220.36'

180

185

180

26.62'

S21° 16' 25" E

195

180

10' SIDE YARD SET BACK

LINE OF DECK ABOVE

ENTRY FN. FL.
195.00'

8'-0" RETAINING
WALL

LOWER FN. FL.
184.00'

UPPER FN. FL.
193.00'

GARAGE
FN. FL.
195.00'

36" HIGH MAX.
RETAINING WALL

14" HIGH MAX.
RETAINING WALL

10' SIDE YARD SET BACK

CRAWL
SPACE

4" CONC. DRIVEWAY
OVER GRAVEL
FILL

200

205

195

190

185

180

175

R = 322.00'

L = 91.5'

FACE OF CURB

200

195

190

20' FRONT YARD
SETBACK

43.71'

LEGAL:
LOT 18 OF HIGHPOINTE
IN THE NE. 1/4 OF SEC. 34, T15, R2E,
SAN BERNARDINO MERIDIAN
HAPPY VALLEY, SAN DIEGO COUNTY,
CALIFORNIA.

GRADING PLAN

1" ————— 10'-0"

SOLOMON COURT

Reading Floor Plans, Part 1: Floor Plan Symbols

CHAPTER OVERVIEW

This chapter covers the following topics:

- Representation practices
- Wall symbols
- Door symbols
- Window symbols
- Schedules
- Cabinets, fixtures, and appliances
- Floor plan materials

- Stairs
- Fireplaces
- Solid-fuel-burning appliances
- Room titles
- Other floor plan symbols
- Test
- Problems

The floor plans communicate the overall construction requirements to the builder. Symbols are used on floor plans to describe items associated with living in the home, such as doors, windows, cabinets, and plumbing fixtures. Other symbols that are more closely related to the construction of the home include electrical circuits and material sizes and spacing. Figure 3–1 shows a typical complete floor plan.

Figure 3–2 shows that floor plans are the representation of an imaginary horizontal cut made approximately 4' (1220 mm) above the floor line. Residential floor plans are generally drawn at a scale of 1/4" = 1'–0".

In addition to knowing the proper symbols when reading plans, you should be familiar with the standard products the symbols represent. Products used in the structures, such as plumbing fixtures, appliances, windows, and doors, are usually available from local vendors. Occasionally special items must be ordered from a factory far enough in advance to ensure delivery to the job site at the time needed.

WALL SYMBOLS

WALL REPRESENTATION PRACTICES

There are a variety of opinions regarding how walls are drawn on a floor plan. Practices range from drawing all exterior walls thicker than interior walls, for contrast, to drawing all exterior and interior walls the same thickness for convenience, and because, with manual drafting, it is difficult to draw exact thicknesses. A common practice with CADD applications is to draw the floor plan walls the exact thickness of the construction materials. This is because the CADD system is extremely accurate for drafting. Some architectural CADD programs provide the exact construction materials and then set up the wall symbols to match.

When the thickness of walls is drawn to the exact construction dimensions, the material used establishes these values. Exterior walls can be built using 2 × 4 or 2 × 6 studs. Studs are the vertical construction members used for framing walls and partitions, and the nominal size of the construction member before milling is 2 × 4 or 2 × 6. The milling process makes the finished member 1–1/2" × 3–1/2" and 1–1/2" × 5–1/2". The metric equivalents of these lumber dimensions are 40 × 90 mm and 40 × 150 mm. Exterior and interior construction materials are then applied to the

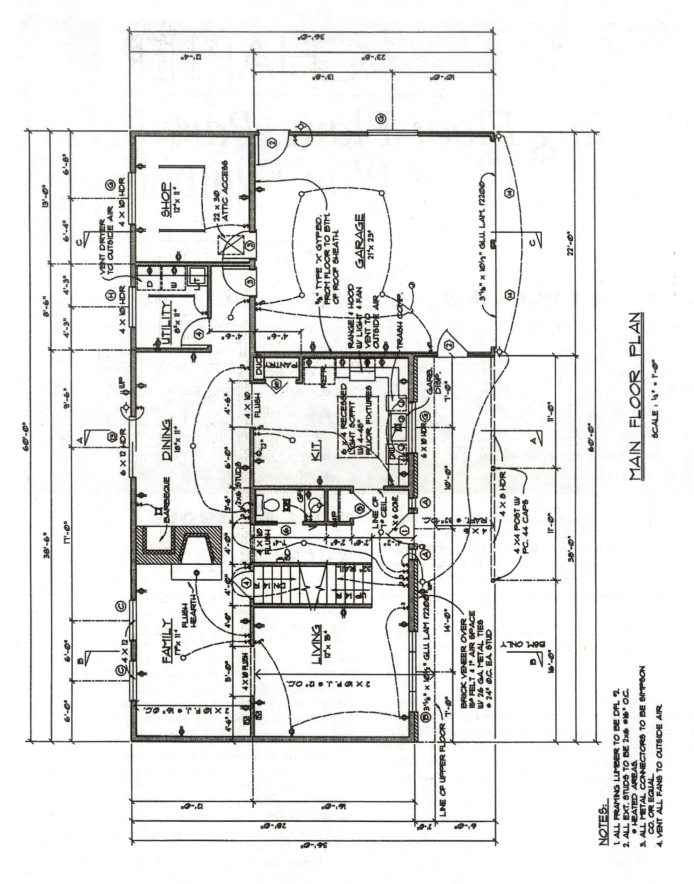

Figure 3–1 Study complete floor plans like those shown in (a), (b), and (c) to become familiar with reading prints. (a) Main floor plan.

UPPER FLOOR PLAN

SCALE : 1/4" = 1'-0"

Figure 3–1(b) Second floor plan.

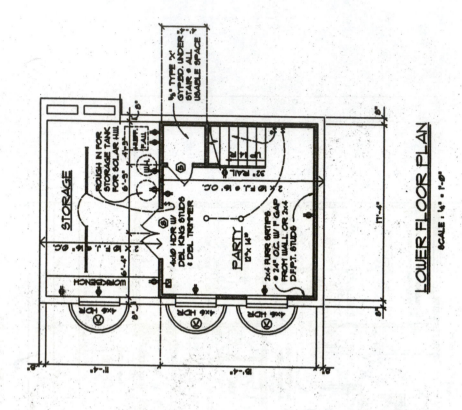

LOWER FLOOR PLAN

SCALE : ¼" = 1'-0"

WINDOW SCHEDULE

SYM.	SIZE	MODEL	ROUGH OPEN	QUAN
A	1'-0"x5'-0"	JOB-BUILT	5'-2¼"x5'-5½"	2
B	6'-0"x5'-0"	W205 CSM	4'-2¼"x5'-5½"	1
C	4'-0"x5'-0"	W205 CSM	4'-2¼"x5'-5½"	2
D	4'-0"x3'-0"	W203 CSM	4'-2¼"x3'-5½"	2
E	3'-0"x3'-0"	2N3 CSM	3'-5¼"x3'-5½"	2
F	6'-0"x4'-0"	G64 SLDG	6'-0½"x4'-0½"	1
G	5'-0"x3'-0"	G336 SLDG	5'-0½"x3'-0½"	4
H	4'-0"x3'-0"	G436 SLDG	4'-0½"x3'-0½"	1
J	4'-0"x2'-0"	A41 AWN	4'-0½"x2'-0½"	3
K	4'-0"x2'-0"	G42 SLDG	4'-0½"x2'-0½"	3

DOOR SCHEDULE

SYM.	SIZE	TYPE	QUAN
1	3'-0"x6'-8"	S.C. R.P. METAL INSULATED	1
2	3'-0"x6'-8"	S.C. FLUSH-METAL INSUL.	2
3	2'-8"x6'-8"	S.C.-SELF CLOSING	2
4	2'-6"x6'-8"	H.C.	5
5	2'-0"x6'-8"	H.C.	5
6	2'-6"x6'-8"	POCKET	2
7	2'-6"x6'-8"	POCKET	1
8	FR.2'-6"x6'-8"	H.C.	1
9	5'-0"x6'-8"	BI-PASS	2
10	3'-0"x6'-8"	BI-FOLD	1
11	4'-0"x6'-8"	BI-FOLD	1
12	2'-0"x6'-8"	SHATTER PROOF	1
13	6'-0"x6'-8"	WOOD FRAME-TEMP. SLDG GL.	1
14	9'-0"x7'-0"	OVERHEAD GARAGE	2

WALL AREAS *		2715 SQ. FT.
WINDOWS		250 SQ. FT.
SKYLITES		10 SQ. FT.
DOORS		77 SQ. FT.
TOTAL OPENINGS		337 SQ. FT.
% OPENINGS		15%

*BASEMENT EXCLUDED.

Figure 3–1(c) Basement floor plan with schedules.

Figure 3–2 Establishing the floor plan representation.

studs. Typical exterior and interior construction is shown in Figure 3–3.

EXTERIOR WALLS

Exterior wood frame walls are generally shown 6" thick at a 1/4" = 1'–0" scale, as seen in Figure 3–4. Exterior walls 6" thick are common when 2 × 4 studs are used. The 6" (150 mm) is approximately equal to the thickness of wall studs plus interior and exterior construction materials. When 2" × 6" (50 mm × 150 mm) studs are used, the exterior walls can be thicker. The wall thickness depends on the type of construction. If the exterior walls are to be concrete or masonry construction with wood framing to finish the inside surface, they are drawn substantially thicker, as shown in Figure 3–5. Exterior frame walls with masonry-veneer construction

applied to the outside surface are drawn an additional 4" (100 mm) thick, with the masonry veneer represented as 4" (100 mm) thick over the 6" wood frame walls, as seen in Figure 3–6.

INTERIOR PARTITIONS

Interior walls, known as partitions, are frequently drawn 5" (125 mm) thick when 2 × 4 (50 × 100 mm) studs are used with drywall applied to each side. Walls with 2 × 6 (50 × 150 mm) studs are generally used behind a toilet to accommodate the soil pipe. Occasionally masonry veneer is used on interior walls and is drawn in a manner similar to the exterior application shown in Figure 3–6. In many architectural offices wood frame exterior and interior walls are drawn the same thickness to save time.

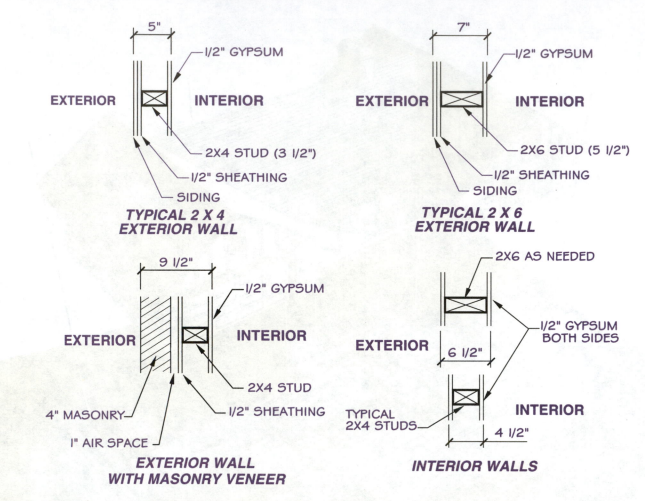

Figure 3–3 Typical exterior and interior construction.

WALL SHADING

Several methods are used to shade walls, which is done so the walls stand out clearly from the balance of the drawing. Some walls are shaded very darkly for accent; others are shaded lightly for a more subtle effect, as shown in Figure 3–7. Other wall-shading techniques include closely spaced thin lines, wood grain effect, or the use of colored pencils.

Office practice that requires light wall shading may also use thick wall lines to help accent the walls and partitions so they stand out from other floor plan features. Figures 3–7(a) and 3–8 show how walls and partitions appear when outlined with thick lines.

PARTIAL WALLS

Partial walls are used as room dividers where an open environment is desired, such as guard rails on balconies or adjacent to a flight of stairs. Partial walls require a minimum height above the floor of 36" (915 mm) and are often capped with wood, or may have decorative spindles that connect to the ceiling. Partial walls are differentiated from other walls by wood grain or very light shading and should be defined with a note that specifies the height, as shown in Figure 3–9.

GUARDRAILS

Guardrails are used for safety on balconies, lofts, stairs, and decks over 30" (760 mm) above the next lower level. Residential guardrails are noted on floor plans as at least 36" (915 mm) above the floor and may include a note specifying that intermediate rails should not have more than a 6" (150 mm) open space. The minimum space helps ensure that small children do not fall through the rails. Decorative guardrails are also used as room dividers, especially in a sunken area or to create an open effect between two rooms. Figure 3–10 shows guardrail designs and how they are indicated on a floor plan.

DOOR SYMBOLS

Exterior doors are drawn on the floor plan with the sill shown on the outside of the house. The sill is commonly drawn as a projection. See Figure 3–11.

The interior door symbol, as shown in Figure 3–12, is drawn without a sill. Interior doors should swing into the room being entered and against a wall. Interior doors are usually slabs, but may be the raised panel type or have glass panels.

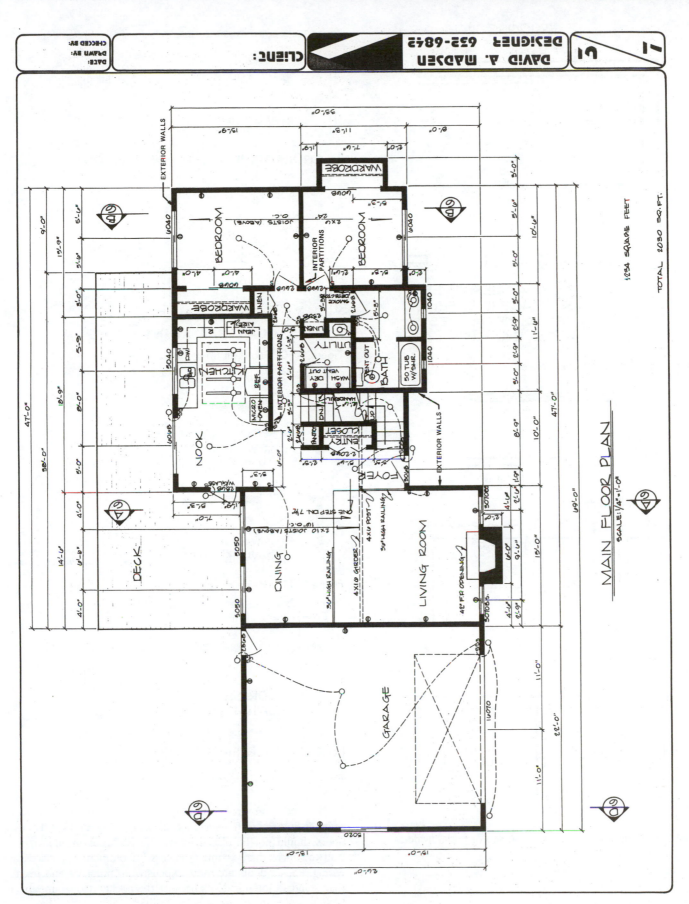

Figure 3–4 Typical floor plan. *Courtesy Madsen Designs.*

Figure 3–5 Concrete and exterior wall.

8" CONC. WALL

2 × 4 FURRING W/1" AIR SPACE OR 2 × 4 D.F.P.T. STUDS @ 16" O.C.

Figure 3–6 Exterior masonry veneer.

BRICK VENEER OVER 1" AIR SPACE W/15# FELT & 26 GA. METAL TIES @ 24" O.C. EA. STUD.

DARK WALL SHADING

LIGHT WALL SHADING

Figure 3–7 Wall shading.

Figure 3–8 Thick lines used on walls and partitions.

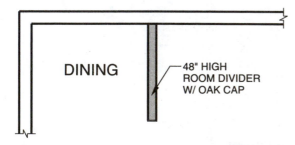

DINING

48" HIGH ROOM DIVIDER W/ OAK CAP

Figure 3–9 Partial wall used as a partition or room divider.

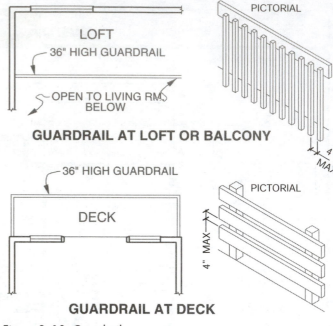

PICTORIAL

LOFT

36" HIGH GUARDRAIL

OPEN TO LIVING RM. BELOW

GUARDRAIL AT LOFT OR BALCONY

4" MAX

36" HIGH GUARDRAIL

DECK

PICTORIAL

4" MAX

GUARDRAIL AT DECK

Figure 3–10 Guardrails.

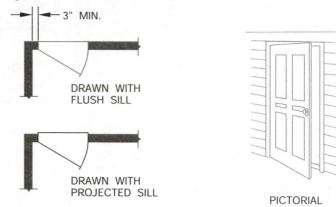

3" MIN.

DRAWN WITH FLUSH SILL

DRAWN WITH PROJECTED SILL

PICTORIAL

Figure 3–11 Exterior door.

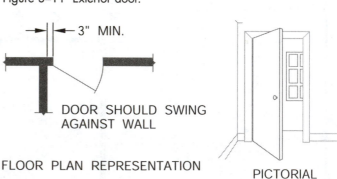

3" MIN.

DOOR SHOULD SWING AGAINST WALL

FLOOR PLAN REPRESENTATION

PICTORIAL

Figure 3–12 Interior door.

Pocket doors are commonly used when space for a door swing is limited, as in a small room. Look at Figure 3–13. Pocket doors should not be placed where the pocket is in an exterior wall or where there is interference with plumbing or electrical wiring. Pocket doors are more expensive to purchase and install than standard interior doors because the pocket door frame must be built while the house is being framed.

A common economical wardrobe door is the bipass door, as shown in Figure 3–14. Bifold wardrobe or closet doors are used when complete access to the closet is required. Sometimes bifold doors are used on a utility closet that houses a washer and dryer or other utilities. See Figure 3–15. Bifold wardrobe doors often range in size from 4'–0" through 9'–0" (1220–2745 mm) wide, in 6" (150 mm) intervals.

Double-entry doors are common where a large, formal foyer design requires a more elaborate entry than can be achieved by one door. The floor plan symbol for double-entry and French doors is the same; therefore, the door schedule should clearly identify the type of doors to be installed.

Sliding glass doors are made with wood or metal frames and tempered glass for safety. Figure 3–16 shows the floor plan symbol for both a flush and a projected exterior sill representation. These doors are used to provide glassed-in areas and are excellent for access to a patio or deck. Sliding glass doors typically range in size from 5'–0" through 12'–0" (1525–3660 mm) wide.

French doors are used in place of sliding glass doors when a more traditional door design is required. Sliding glass doors are associated with contemporary design and do not take up as much floor space as French doors. French doors may be purchased with wood *mullions* and *muntins* (the upright and bar partitions, respectively) between the glass panes or with one large glass pane and a removable grill for easy cleaning. See Figure 3–17. French doors range in size from 2'–4" through 3'–6" (710–1065 mm)wide. Doors may be used individually, in pairs, or in groups of three or four. The three- and four-panel doors typically have one or more fixed panels, which is often specified on the plan.

Double-acting doors are often used between a kitchen and eating area so the doors swing in either direction for easy passage. See Figure 3–18. Common sizes for pairs of doors range from 2'–6" through 4'–0" wide in 2" increments.

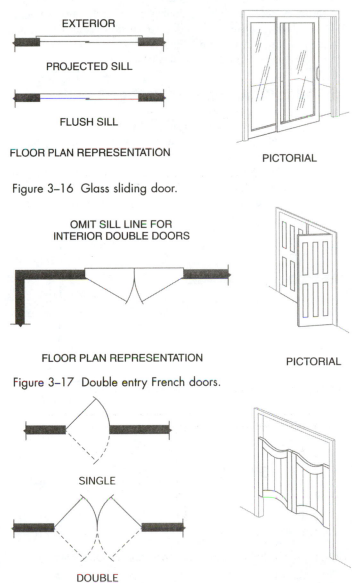

Figure 3–16 Glass sliding door.

Figure 3–17 Double entry French doors.

Figure 3–18 Double-acting doors.

Figure 3–13 Pocket door

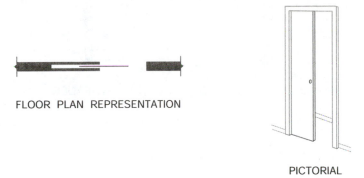

FLOOR PLAN PRESENTATION

Figure 3–14 Bipass door.

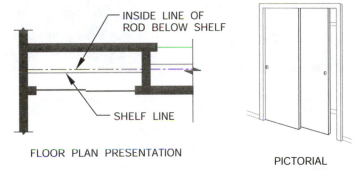

FLOOR PLAN PRESENTATION

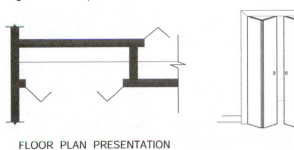

Figure 3–15 Bifold door.

Dutch doors are used when it is desirable to have a door that can be half-open and half-closed. The top portion can be opened and used as a pass-through. Look at Figure 3–19. Dutch doors range in size from 2'-6" through 3'-6" (760–1065 mm) wide in 2" (50 mm) increments.

Accordion doors can be used for closets or wardrobes, and they are often used as room dividers where an openable partition is needed. Figure 3–20 shows the accordion door floor plan symbol. Accordion doors range in size from 4'-0" through 12'-0" (1220–3660 mm) in 1 ft. (305 mm) increments.

The floor plan symbol for an overhead garage door is shown in Figure 3–21. The dashed lines show the size and extent of the garage door when open. The extent of the garage door may be shown when the door might interfere with something on the ceiling.

Garage doors range in size from 8'-0" through 16'-0" (2440–4880 mm) wide. An 8'-0" door is the minimum for a single car width. A 9'-0" (2745 mm) door is common for a single door. A 16'-0" door is common for a double-car door. Door heights are typically 7'-0" (2135 mm) high, although 8'-0" to 10'-0" (2440–3050 mm) high doors are available.

WINDOW SYMBOLS

Windows are represented with a sill on the outside and inside. The sliding window, as shown in Figure 3–22, is a popular 50-percent openable window. Notice that windows can be drawn with exterior sills projected or flush, and the glass pane can be drawn with single or double lines by the preference of the specific architectural office. Some offices draw all windows with a projected sill and one

line to represent the glass; they then specify the type of window in the window schedule.

Casement windows can be 100-percent openable and are best used where extreme weather conditions require a tight seal when the window is closed, although these windows are in common use everywhere. See Figure 3–23.

The traditional double-hung window has a bottom panel that slides upward, as shown in Figure 3–24. Double-hung wood frame windows are designed for energy efficiency and are commonly used in traditional as opposed to contemporary architectural designs. It is very common to group double-hung windows together in pairs of two or more.

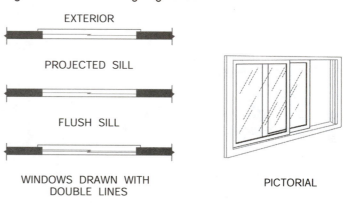

DRAWN WITH DASHED
LINES TO DENOTE OPEN DOOR ——— HEADER

Figure 3–21 Overhead garage door.

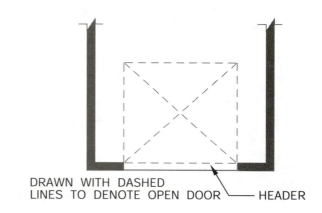

EXTERIOR

PROJECTED SILL

FLUSH SILL

WINDOWS DRAWN WITH
DOUBLE LINES

PICTORIAL

Figure 3–22 Horizontal sliding window.

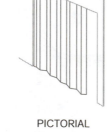

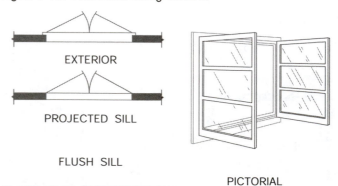

EXTERIOR

PROJECTED SILL

FLUSH SILL

FLOOR PLAN REPRESENTATION

PICTORIAL

Figure 3–23 Casement window.

FLOOR PLAN REPRESENTATION

PICTORIAL

Figure 3–19 Dutch doors.

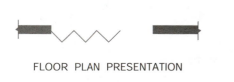

FLOOR PLAN PRESENTATION

PICTORIAL

Figure 3–20 Accordion door.

Awning windows are often used below a fixed window to provide ventilation. Another common use places awning windows between two different roof levels; this provides additional ventilation in vaulted rooms. These windows are hinged at the top and swing outward, as shown in Figure 3–25. Hopper windows are drawn in the same manner; however, they hinge at the bottom and swing inward. Jalousie windows are used when a louvered effect is desired, as seen in Figure 3–26.

Fixed windows are popular when a large unobstructed area of glass is required to take advantage of a view or to allow solar heat gain. Figure 3–27 shows the floor plan symbol for a fixed window.

Bay windows are often used when a traditional style is desired. Figure 3–28 shows the representation of a bay. Usually the sides are built at 45° or 30°. The depth of the bay is usually between 18" and 24" (460–610 mm). The total width of a bay is limited by the size

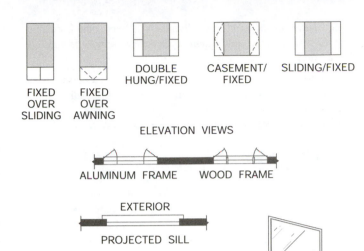

ELEVATION VIEWS

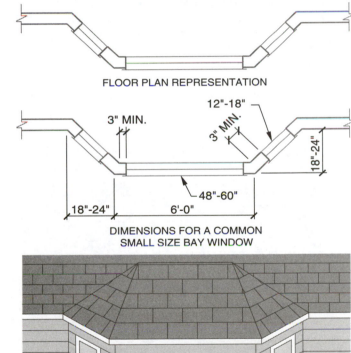

Figure 3–27 Options for fixed windows Fixed part of combination windows is shaded for reference.

DIMENSIONS FOR A COMMON SMALL SIZE BAY WINDOW

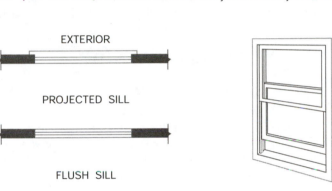

Figure 3–24 Double-hung window.

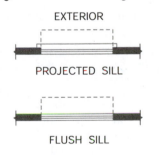

Figure 3–25 Awning window.

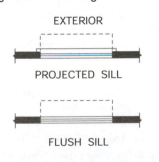

Figure 3–26 Jalousie window.

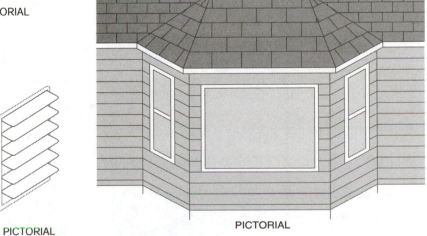

Figure 3–28 Bay window.

of the center window, which is typically a fixed panel, double-hung, or casement window. Bays can be either premanufactured or built at the job site.

A garden window, as shown in Figure 3–29, is a popular style for utility rooms or kitchens. Garden windows usually project between 12" and 18" (305–460 mm) from the residence. Depending on the manufacturer, either the side or top panels may open.

SKYLIGHTS

When additional daylight is desirable in a room or for natural light to enter an interior room, consider using a skylight. Skylights are available as fixed or openable. They are made of plastic in a dome shape or are flat and made of tempered glass. Tempered, doublepane, insulated skylights are energy efficient, do not cause any distortion of view, and generally are not more expensive than plastic skylights. Figure 3–30 shows how a skylight is represented in the floor plan.

SCHEDULES

Numbered symbols used on the floor plan key specific items to charts known as schedules. Schedules are used to describe such items as doors, windows, appliances, materials, fixtures, hardware, and finishes. See Figure 3–31. Schedules help keep drawings clear of unnecessary notes because the details of the item do not appear on the drawing, but are found on another part of the sheet or on another sheet. There are many different ways to set up a schedule, but it may include any or all of the following information about the product:

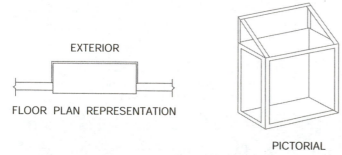

Figure 3–29 Garden Window.

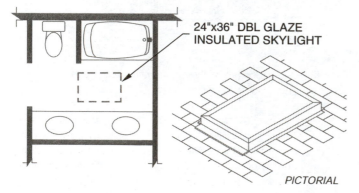

Figure 3–30 Skylight representation.

- vendor's name.
- product name.
- model number.
- quantity.
- size.
- rough opening size.
- color.

SCHEDULE KEY

When doors and windows are described in a schedule, the items must be keyed from the drawing to the schedule. The key can be to label doors with a number and windows with a letter and enclose the letters or numbers in different geometric figures, such as the following:

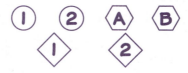

See also Figure 3–32. As an alternative method, you may see a divided circle for the key, the letter D for door or W for window above the dividing line, and the number of the door or window, using consecutive numbers, below the line, as shown:

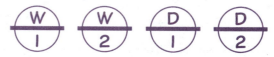

The exact method of representation depends upon individual company standards.

Schedules are also used to identify finish materials used in different areas of the structure. Figure 3–33 shows a typical interior finish schedule.

Door and window sizes can also be placed on the floor plan next to their symbols. This method, as shown in Figure 3–34, is easy but cannot be used when specific data must be identified. The sizes are the numbers next to the windows and doors in Figure 3–34. Notice the first two numbers indicate the width. For example, 30, or 3/0, means 3'–0". The second two numbers indicate the height: 68, or 6/8, means 6'–8". A 6040, or 6/0 × 4/0, window means 6'–0" wide by 4'–0" high, and a 2868, or 2/8 × 6/8, door means 2'–8" wide by 6'–8" high. Standard door height is 6'–8". Some drafters use the same system in a slightly different manner by presenting the sizes as $2^8 \times 6^8$, meaning 2'–8" wide by 6'–8" high, or with actual dimensions, such as 2'–8" × 6'–8". This simplified method of identification is better suited for development housing in which doors, windows, and other items are not specified on the plans as to a given manufacturer. These details are included in a description of materials or specification sheet for each individual house. The principal reason for using this system is to reduce drafting time by omitting schedules. The building contractor may be required to submit alternative specifications to the client so that actual items may be clarified.

WINDOW SCHEDULE

SYM	SIZE	MODEL	ROUGH OPEN	QUAN.
A	1' 3 5'	JOB BUILT	VERIFY	2
B	8' 3 5'	W 4 N 5 CSM.	8'-0$^3/_4$ 3 5'-0$^7/_8$	1
C	4' 3 5'	W 2 N 5 CSM.	4'-0$^3/_4$ 3 5'-0$^7/_8$	2
D	4' 3 3^6	W 2 N 3 CSM.	4'-0$^3/_4$ 3 3'-6$^1/_2$	2
E	3^63 3^6	2 N 3 CSM.	3'-6$^1/_2$ 3 3'-6$^1/_2$	2
F	6' 3 4'	G 64 SLDG.	6'-0$^1/_2$ 3 4'-0$^1/_2$	1
G	5' 3 3^6	G 536 SLDG.	5'-0$^1/_2$ 3 3'-6$^1/_2$	4
H	4' 3 3^6	G 436 SLDG.	4'-0$^1/_2$ 3 3'-6$^1/_2$	1
J	4' 3 2'	A 41 AWN.	4'-0$^1/_2$ 3 2'-0$^7/_8$	3

(a)

DOOR SCHEDULE

SYM	SIZE	TYPE	QUAN.
1	3' 3 6^8	S.C. RP. METAL INSULATED	1
2	3' 3 6^8	S.C. FLUSH METAL INSULATED	2
3	2^8 3 6^8	S.C. SELF CLOSING	2
4	2^8 3 6^8	HOLLOW CORE	5
5	2^6 3 6^8	HOLLOW CORE	5
6	2^6 3 6^8	POCKET SLDG.	2

(b)

Figure 3–31 Window and door schedule.

WINDOW SCHE				DOOR S		
○	QUAN.	SIZE	TY	⬡	QUAN.	SIZE
A	2	3° x 4°		1	1	3°
B	1	6° x 4°		2	3	
C	3	6° x 3°		3	1	
D	2	3° x 4		4	2	

Figure 3–32 Method of keying windows and doors from the floor plan to the schedules.

INTERIOR FINISH SCHEDULE

ROOM	FLOOR					WALLS				CEIL.		
	VINYL	CARPET	TILE	HARDWOOD	CONCRETE	PAINT	PAPER	TEXTURE	SPRAY	SMOOTH	BROCADE	PAINT
ENTRY					●							
FOYER		●				●			●	●		●
KITCHEN		●					●			●		●
DINING			●			●			●		●	●
FAMILY		●				●			●			●
LIVING		●				●			●		●	●
MSTR. BATH			●				●			●	●	
BATH #2			●				●			●		●
MSTR. BED		●				●			●		●	●
BED #2		●							●	●		●
BED #3		●							●			●
UTILITY	●					●			●	●		●

Figure 3–33 Finish schedules.

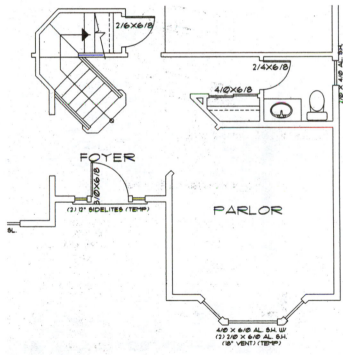

Figure 3–34 Simplified method of labeling doors and windows.
Courtesy Alan Mascord Design Associates, Inc.

Some plans show the window sizes given by the window symbol, as previously discussed, and show door sizes with a symbol like that in Figure 3–35(a). The number 30 inside the circle designates the door width as 3'–0". The door height is a standard 6'–8". This is an example of the symbol:

Some architects and designers key the window specifications to a specific manufacturer's product by giving the catalog number next to the window symbol, as shown in Figure 3–35(b). Notice the general note that describes the manufacturer information. You must get a copy of the manufacturer's catalog to know the exact size and other related installation and construction information.

When reading a set of plans, you should know specific details about doors and windows: standard size, material, type of finish, energy efficiency, and style. This information is available through vendors' specifications. In many cases you need to obtain copies of vendors' specifications from the architect or supplier to ensure the proper product is installed. Figure 3–36 shows a typical page from a door catalog that shows styles and available sizes. Figure 3–37 is a page from a window catalog that describes the sizes of a particular product. Notice that specific information is given for the rough-opening (framing size), finish size, and amount of glass. Vendors' catalogs also provide construction details and actual specifications for each product, as shown in Figure 3–38. This information is important to the print reader to help ensure proper installation.

CABINETS, FIXTURES, AND APPLIANCES

Cabinets are found in kitchens, baths, dressing areas, utility rooms, bars, and workshops. Specialized cabinets, such as desks or built-in dressers, may be found in bedrooms. In general, the cabinets that are drawn on floor plans are built-in units.

KITCHENS

In conjunction with cabinets, you can locate fixtures, such as sinks, butcher block cutting board countertops, lighting, and appliances, such as the range, refrigerator, dishwasher, trash compactor, and garbage disposer. Figure 3–39 shows the floor plan view of the kitchen cabinets, fixtures, and appliances. Sometimes upper cabinets are shown, as in Figure 3–40.

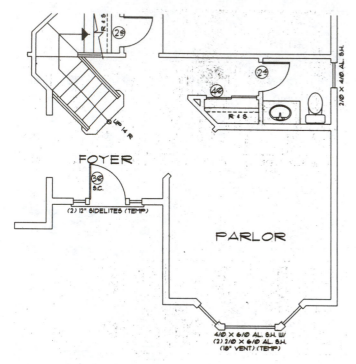

Figure 3–35(a) A simplified method of labeling door size. *Courtesy Alan Mascord Design Associates, Inc.*

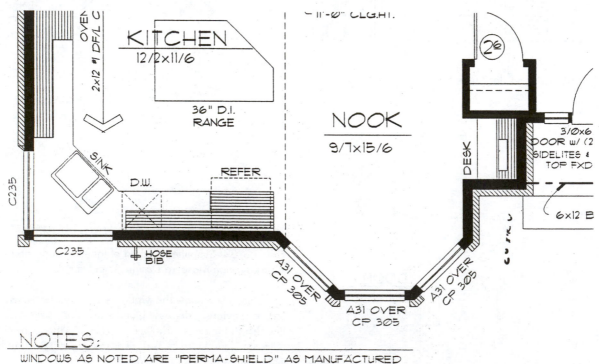

Figure 3–35(b) Labeling windows with manufacturer's catalog number. *Courtesy of Piercy and Barclay Designers, Inc.*

Doors with Beveled, Leaded Glass

Widths: 3'0"—single; 6'0"—double.
Heights: 6'8", 6'10", 7'0".

Embossed Doors

Widths: 2'8", 2'10", 3'0"—single; 5'4", 5'8", 6'0"—double.
Heights: 6'6", 6'8", 6'10",7'0".
NA: Certain styles not available in sizes as marked.

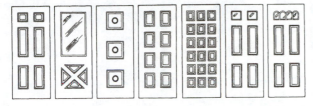

Figure 3–36 Sample from a door catalog page. *Courtesy Ceco Entry Systems, Inc., a United Dominion Company.*

Arch Top Vent Units

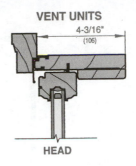

VENT UNITS

4-3/16"
(106)

HEAD

JAMB

SILL

Figure 3–38 Vendor catalog details. *Courtesy Marvin Windows.*

	(803) (749) (730)	(905) (851) (832)	(1 006) (953) (933)
Masonry	2' 7⅝"	2' 11⅝"	3' 3⅝"
Opening	2' 5½"	2' 9½"	3' 1½"
Frame	2' 4¾"	2' 8¾"	3' 0¾"

Short Side	34¾" (1 035) (1 003) (984)	42¾" (1 238) (1 207) (1 187)	46¾" (1 340) (1 308) (1 289)	50¾" (1 441) (1 410) (1 391)

3' 4¾" 3' 3½" 3' 2¾" — 2939, 3339, 3739

4' 0¾" 3' 11½" 3' 10¾" — 2947, 3347, 3747

4' 4¾" 4' 3 ½" 4' 2¾" — 2951, 3351, 3751

4' 8¾" 4' 7 ½" 4' 6¾" — 2955, 3355, 3755

Figure 3–37 Sample from a window catalog page (additional sizes available). *Courtesy Marvin Windows.*

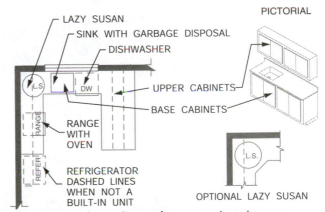

LAZY SUSAN
SINK WITH GARBAGE DISPOSAL
DISHWASHER
PICTORIAL
L.S
DW
UPPER CABINETS
BASE CABINETS
RANGE
RANGE WITH OVEN
REFER.
REFRIGERATOR DASHED LINES WHEN NOT A BUILT-IN UNIT
L.S.
OPTIONAL LAZY SUSAN

Figure 3–39 Kitchen cabinets, fixtures, and appliances.

The range should have a hood with a light and fan and a note indicating how the fan will vent. Some ranges do not require a hood because they vent through the floor or wall. Vent direction should be specified on the plan. The garbage disposer is labeled with a note or with the abbreviation G.D.

Pantries are popular and may be displayed as shown in Figure 3–41. A pantry may also be designed to be part broom closet and part shelves for storage. Figure 3–42 shows a typical floor plan representation and cabinet sizes for a kitchen layout.

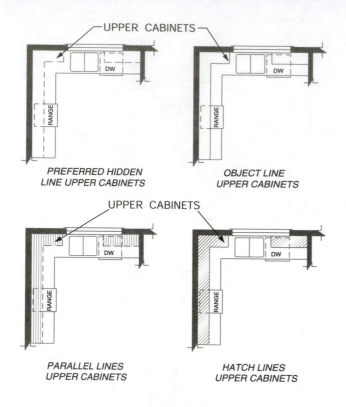

Figure 3–40 Alternative upper-cabinet floor plan symbols.

BATHROOMS

Bathroom cabinets and fixtures are shown in several typical floor plan layouts in Figure 3–43. The vanity can be any length depending on the space available. The shower can be smaller or larger than the one shown depending on the vendor. Verify the size for a prefabricated shower unit before you install one. Showers built on the job can be any size or design. They are usually lined with tile, marble, or other materials. The common size of tubs is 30" × 60", but larger and smaller tubs are available. Sinks can be round, oval, or other shapes.

Often, because of cost considerations, the space available for bathrooms is minimal. Figure 3–44 shows some minimum sizes.

Figure 3–41 Small kitchen pantry. Kitchen pantries can also be big enough to walk into through a standard swing interior door.

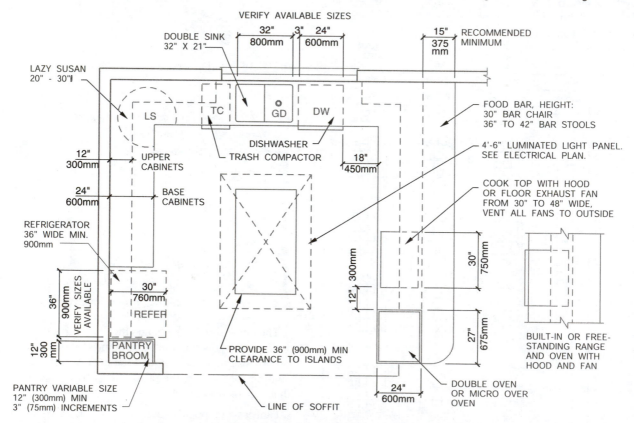

VERIFY FIXTURE AND APPLIANCE DIMENSIONS WITH PRODUCT SPECIFICATIONS. VERIFY DESIGN AND DIMENSIONS FOR DISABLED ACCESS WITH THE MANUAL OF ACTS AND RELEVANT REGULATIONS FOR THE AMERICANS WITH DISABILITIES ACT.

Figure 3–42 Standard kitchen cabinet, fixture, and appliance sizes.

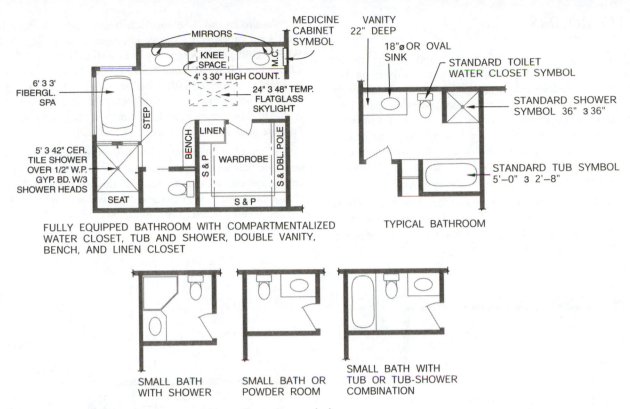

Figure 3–43 Layout of bathroom cabinet and fixture floor plan symbols.

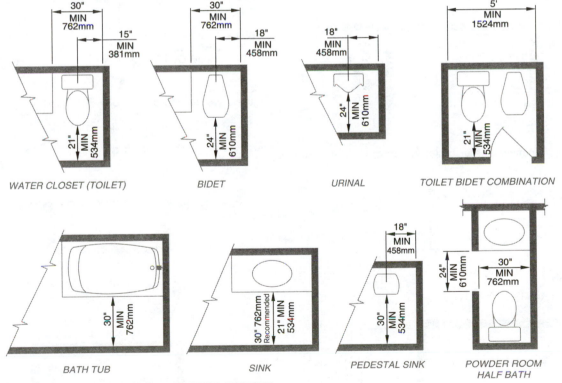

METRIC DIMENSIONS ARE PROVIDED FOR DESIGN REFERENCE.

VERIFY FIXTURE SIZES WITH PRODUCT SPECIFICATIONS.

VERIFY DESIGN AND DIMENSIONS FOR DISABLED ACCESS WITH THE MANUAL OF ACTS AND RELEVANT REGULATIONS FOR THE AMERICANS WITH DISABILITIES ACT. AND LOCAL CODE REQUIREMENTS.

Figure 3–44 Minimum bath spaces. All dimensions are IRC minimums.

UTILITY ROOMS

The symbols for the clothes washer, dryer, and laundry tray are shown in Figure 3–45(a). The clothes washer and dryer symbols may be shown with dashed lines if these items are not part of the construction contract. The minimum recommended space for a washer and dryer is shown in Figure 3–45(b). Stacked washer and dryer units can occupy a smaller space. Ironing boards can be built into the laundry room wall or attached to the wall surface, as shown in Figure 3–46. A note to the electrician is given if power is required for the unit or an adjacent outlet is provided.

The furnace and hot-water heater are sometimes placed together in a location central to the house. They can be placed in a closet, as shown in Figure 3–47. These utilities can also be placed in a separate room, the basement, or the garage.

Wardrobes and closets are utilitarian in nature because they are used for clothes and storage. Bedroom closets may be labeled WARDROBE. Other closets may be labeled ENTRY CLOSET, LINEN CLOSET, or BROOM CLOSET, for example. Wardrobe or guest closets should be provided with a shelf and pole. The shelf and pole may be shown with a thin line to represent the shelf and a dashed or centerline to show the pole, as in Figure 3–48. Sometimes two dashed lines are used to symbolize the shelf and pole.

When a laundry room is below the bedroom area, a chute can be provided from a convenient area near the bedrooms through the ceiling and into a cabinet directly in the utility room. The cabinet should be above or next to the clothes washer. Figure 3–49 shows a laundry chute noted in the floor plan.

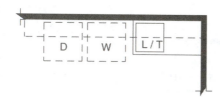

Figure 3–45(a) Washer, dryer, and laundry tray.

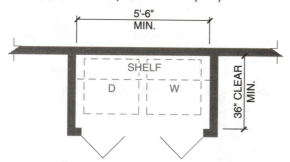

Figure 3–45(b) Minimum washer and dryer space.

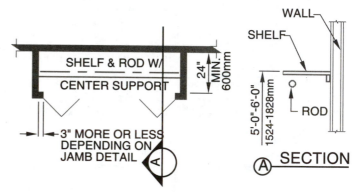

Figure 3–48 Standard wardrobe closet and a walk-in wardrobe.

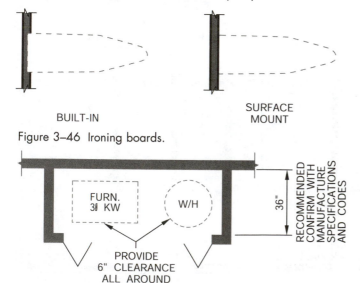

BUILT-IN

SURFACE MOUNT

Figure 3–46 Ironing boards.

Figure 3–47 Furnace and water heater.

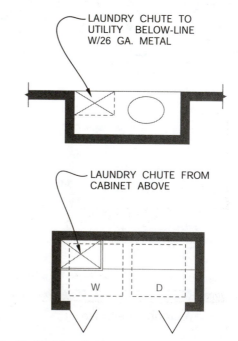

Figure 3–49 Laundry chute.

FLOOR PLAN MATERIALS

FINISH MATERIALS

Finish materials used in construction can be identified on the floor plan with notes, characteristic symbols, or key symbols that relate to a finish schedule. The key symbol is also placed on the finish schedule next to the identification of the type of finish needed at the given location on the floor plan. Finish schedules can also be set up on a room-by-room basis. When flooring finish is identified, the easiest method is to label the material directly under the room designation, as shown in Figure 3–50. Other methods include using representative material symbols and a note to describe the finish materials, as shown in Figure 3–51.

Figure 3–50 Room labels with floor finish material.

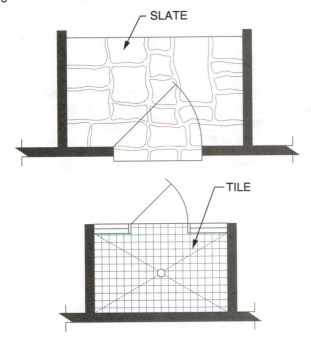

Figure 3–51 Finish material symbols.

STRUCTURAL MATERIALS

Structural materials are identified on floor plans with notes and symbols. The symbolic representation of a specific header size over a garage door opening is a dashed line. See Figure 3–52. Other specific header sizes can be shown as a note over a window, as in Figure 3–52.

Ceiling beams are generally shown with dashed lines and labeled as shown in Figure 3–53. Construction members, such as beams, joists, rafters, or headers, that are labeled on the floor plan are considered at ceiling level unless otherwise specified. Construction members located in the floor are shown in the foundation plan or as part of the floor plan.

Ceiling joists, trusses, or roof joists for a vaulted ceiling are identified in the floor plan by an arrow that shows the direction and extent of the span. Ceilings are generally considered flat unless specified as *vaulted*, which means a sloping ceiling. The size and spacing of the members are noted along the arrow, as shown in Figure 3–54. Notice in the section at the beam in Figure 3–54 that the ceiling joists are over the beam, which leaves the beam exposed. The exposed beam can be made of quality material for a natural appearance, or it may be wrapped with gypsum wallboard or other material for a finished appearance.

When it is not desirable to expose a beam in the room, the joists intersect flush with the bottom of the beam. To accomplish such an intersection, steel joist hangars are often used, as labeled in Figure 3–55. A number of structural connectors can be used in residential construction to connect joists to walls. The best thing to do is obtain a vendor's catalog from a company that manufactures structural connectors and become familiar with the many construction methods shown as examples in the catalog.

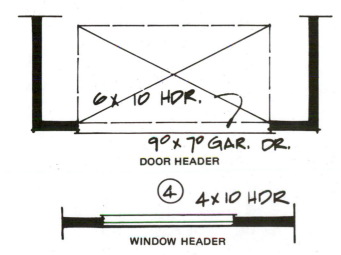

Figure 3–52 Header representation and notes.

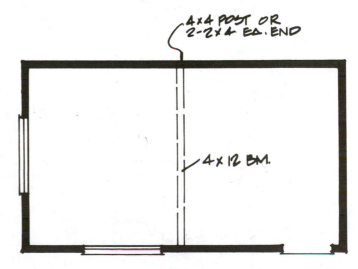

Figure 3–53 Beam and post representation and note.

All construction members that relate directly to the floor plan but are not clearly identified in cross sections or details are shown and labeled on the floor plan. A great deal of information is included, and it is often difficult to include all the necessary data without crowding the drawing. This extensive information provides a challenge to the print reader.

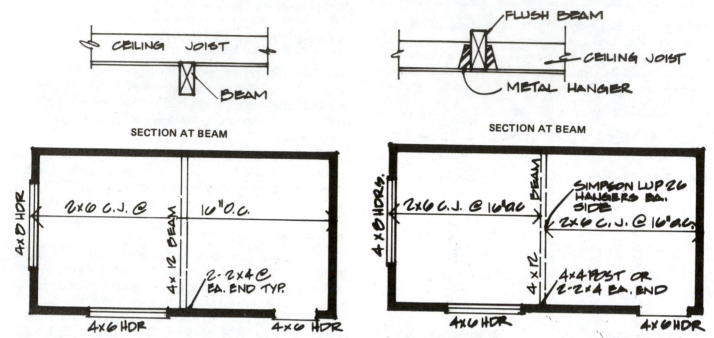

Figure 3–54 Identification of joists and joists over beam.

Figure 3–55 Identification of joists with joist hangers used at beam for a flush ceiling.

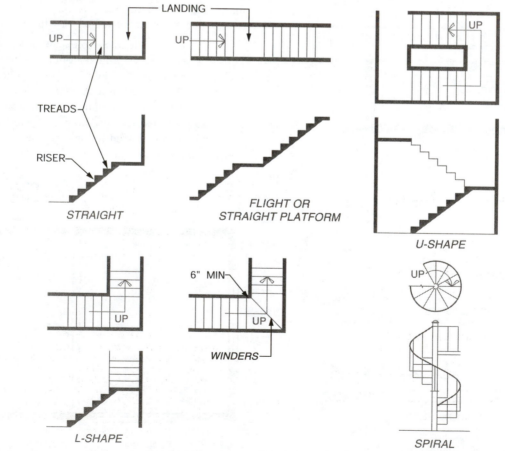

Figure 3–56 Stair types.

STAIRS

There are many different stair types that can be used in architectural design and construction. The type of stair used often depends on the space available and the total height between floors. Figure 3–56 shows several different stair types.

STAIRS ON FLOOR PLANS

Stairs are shown on floor plans by the width of the tread, the direction and number of risers, and the lengths of handrails or guardrails.

Abbreviations used are DN for down, UP for up, and R for risers. The note 14R means there are 14 risers in the flight of stairs.

Figure 3–57 shows a stair representation in the upper and lower floor plans, so you can see the DN and UP abbreviations used with the related directional arrow. This illustration also provides you with a typical stair cross section displaying typical stair terminology and construction members.

Figure 3–58 shows a common straight stair layout with a wall on one side and a guardrail on the other. Figure 3–59 shows a flight of stairs with guardrails all around at the top level and a handrail run-

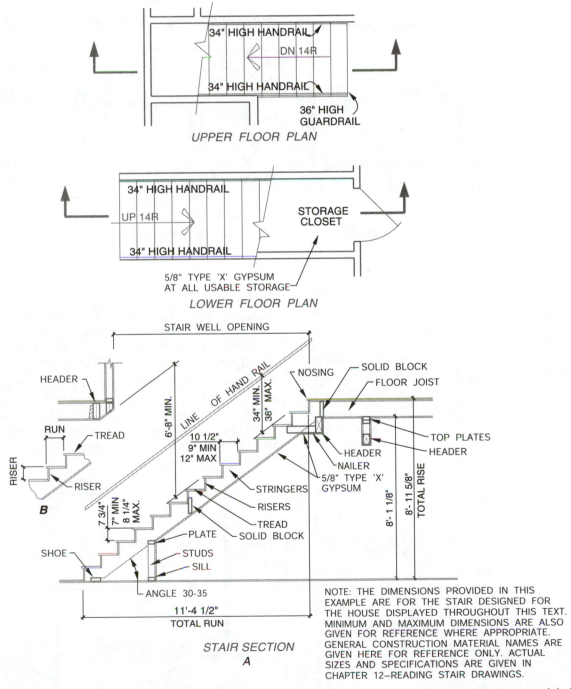

Figure 3–57 Stair floor plan representations and stair cross-sections with stair components and minimum requirements labeled. (a) The full stair section. (b) A partial section with the tread and riser terminology.

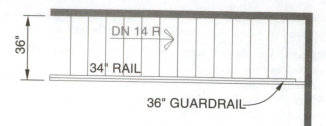

Figure 3–58 Stair with a wall on one side and a guardrail on the other.

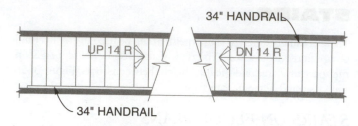

Figure 3–61 Stairs up and down in the same area.

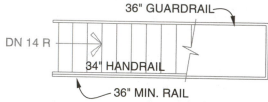

Figure 3–59 Stairs with guardrails all around.

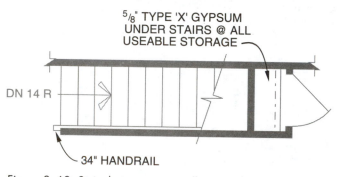

Figure 3–60 Stairs between two walls.

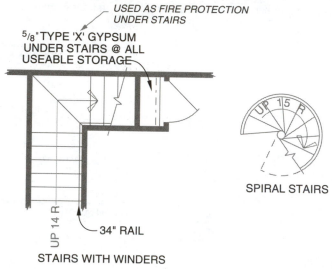

Figure 3–62 Winder and spiral stairs.

ning down the stairs. Figure 3–60 shows stairs between two walls. Notice also the common practice that the stairs are drawn broken with a long break line at approximately midheight. Figure 3–61 shows parallel stairs with one flight going up and the other down. This situation is common when access from the main floor to both the second floor and basement is designed for the same area.

Stairs with winders and spiral stairs can be used to conserve space. Winders are used instead of a landing to turn a corner. The winder must be no smaller than 6" (150 mm) at the smallest dimension. Spiral stairs should be at least 30" (760 mm) wide from

the center post to the outside, and the center post should have a 6" (150 mm) minimum diameter. Spiral stairs and custom winding stairs can be manufactured in several designs. Figure 3–62 shows plan views of winder and spiral stairs.

When a room is either sunken or raised, there is one step or more into the room. The steps are noted with an arrow, as shown in Figure 3–63. The few steps up or down do not require a handrail unless there are over three risers, but provide a handrail next to the steps when there are four or more. The guardrail shown in Figure 3–63 is for decoration only.

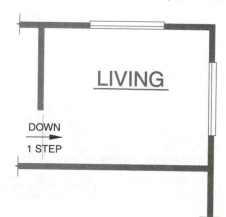

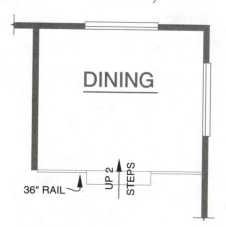

Figure 3–63 Sunken or raised rooms.

FIREPLACES

Fireplaces are commonly used in residential design and construction. Fireplaces can be built using masonry, wood frame, or a combination. Figure 3–64 shows a typical single-masonry fireplace with commonly used minimum dimensions.

TABLE 3–1 FIREPLACE DIMENSIONS

OPENING WIDTH	OPENING HEIGHT	UNIT WIDTH
36	24	22
40	27	22
48	30	25
60	33	25

FLOOR PLAN

Figure 3–65 shows several typical fireplace floor plan representations. Common fireplace opening sizes in inches are shown in the table:

STEEL FIREPLACES

Fireplace fireboxes made of steel are available from various manufacturers. The fireplace shown on the floor plan may look the same whether the firebox is prefabricated of steel or constructed of masonry materials. See Figure 3–66.

There are also insulated fireplace units made of steel that can be used with wood framed chimneys. These units are often referred to as zero clearance. *Zero clearance* means the insulated metal fireplace unit and flue can be placed close to a wood frame structure. Verify building codes and vendor's specifications before construction. See Figure 3–67. Figure 3–68 shows some common sizes of available fireplace units.

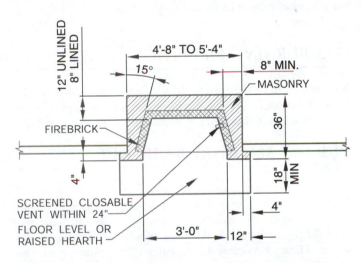

Figure 3–64 Single masonry common and minimum fireplace dimensions, not generally shown on the plan.

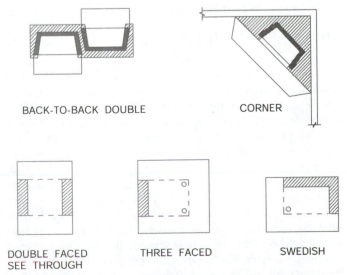

BACK-TO-BACK DOUBLE　　　　CORNER

DOUBLE FACED SEE THROUGH　　　THREE FACED　　　SWEDISH

Figure 3–65 The floor plan representation of typical masonry fireplaces.

Figure 3–66 Manufactured firebox framed in masonry.

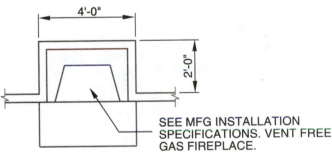

SEE MFG INSTALLATION SPECIFICATIONS. VENT FREE GAS FIREPLACE.

NOTE MAY ALSO READ:
DIRECT-VENT GAS, SELF-VENTING GAS, OR VENT-FREE GAS FIREPLACE

Figure 3–67 Manufactured firebox in wood frame.

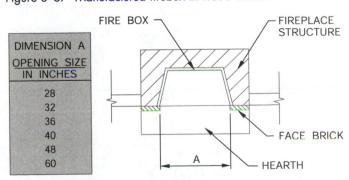

DIMENSION A OPENING SIZE IN INCHES
28
32
36
40
48
60

Figure 3–68 Prefabricated fireplace opening sizes. *Courtesy Heatilator, Inc.*

WOOD STORAGE

Firewood can be stored near the fireplace. A special room or an area in a garage next to the fireplace may be ideal. A wood compartment built into the masonry next to a fireplace opening can also be provided for storing a small amount of wood. The floor plan representation of such a wood storage box is shown in Figure 3–69.

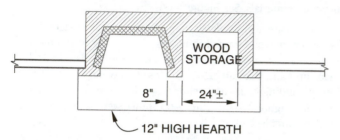

Figure 3–69 Wood storage built into the masonry structure.

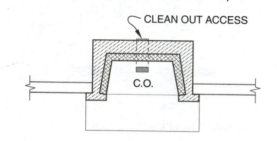

Figure 3–70 Fireplace cleanout.

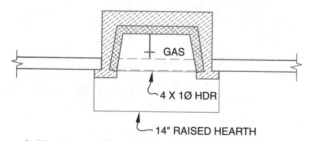

Figure 3–71 Gas supply to the fireplace.

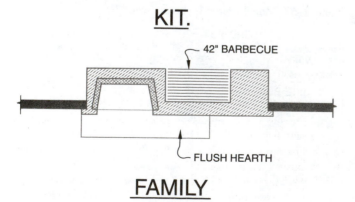

Figure 3–72 Barbecue built into the masonry fireplace structure.

FIREPLACE CLEANOUT

When there is easy access to the base of the fireplace, you may see a cleanout (CO). The cleanout is a small door in the floor of the fireplace firebox that allows ashes to be dumped into a hollow cavity built into the fireplace below the floor. Access to the fireplace cavity to remove the stored ashes is provided from the basement or outside the house. Figure 3–70 shows a fireplace cleanout noted in the plan view.

COMBUSTION AIR

Building codes require that combustion air be provided to the fireplace. Combustion air is outside air supplied in sufficient quantity for fuel combustion. The air is supplied through a screened duct that is built by masons from the outside into the fireplace combustion chamber. By providing outside air, this venting device prevents the fireplace from using the heated air from the room, thus maintaining indoor oxygen levels and keeping heated air from going up the chimney.

GAS-BURNING FIREPLACE

Natural gas can be provided to the fireplace either for starting the wood fire or for fuel to provide flames on artificial logs. The gas supply should be noted on the floor plan, as shown in Figure 3–71.

BUILT-IN MASONRY BARBECUE

The floor plan representation for a barbecue is shown in Figure 3–72. A built-in barbecue can be purchased as a prefabricated unit set into the masonry structure that surrounds the fireplace. There can be gas or electricity supply to the barbecue as a source of heat for cooking. As an alternative, the barbecue unit can be built into the exterior structure of a fireplace for outdoor cooking. The barbecue can also be installed separately from a fireplace, although there is some cost savings when the cooking unit is combined with the fireplace structure.

MULTILEVEL FIREPLACES

In two- or three-story homes, it is common to have a fireplace structure that is constructed up through all levels with a chimney exiting at the roof. In this situation, a fireplace can be placed at each floor if the design is appropriate. The fireplace on the first floor is represented similar to the example in Figure 3–64, except that additional width is needed for the flues of all stacked fireplaces to extend to the top of the chimney. A flue is a heat-resistant, incombustible enclosed passageway in a chimney that carries combustion products from the fireplace. The flue lining within a chimney is made from square, rectangular, or round firebrick or fireclay products, or round double- or triple-insulated steel for zero-clearance fireplaces. There must be a separate flue for each fireplace. This means that the fireplace structure and the chimney need to be sized large enough to house the fireplaces and the flues running up

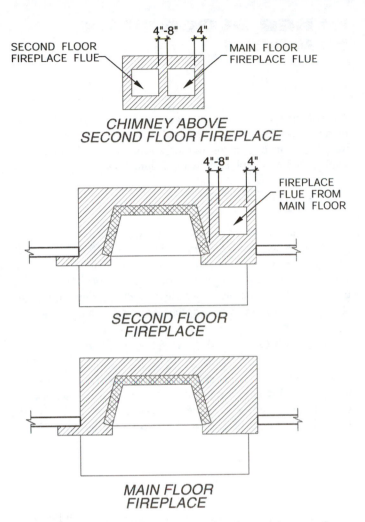

Figure 3–73 Floor plan drawing of a fireplace at the main floor, at the second floor, and beyond the second floor.

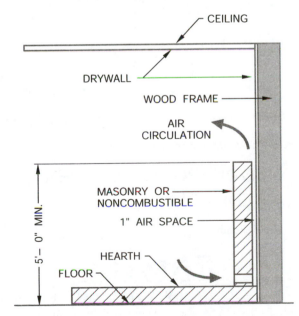

Figure 3–74 Air circulation around wall protection.

in the same structure. Figure 3–73 shows the floor plan drawing of a fireplace at the main floor and the second floor, and the chimney beyond the second floor. If a third-floor fireplace is used, an additional flue would be added to the structure. The size of each flue and the dimensions of the fireplace structure and the chimney should be given. The chimney above the second floor can taper to a smaller size than the fireplace structure, but it needs to be large enough to house the flues with minimum masonry material surrounding. Installation of zero-clearance flues for metal fireplaces should be based on the manufacturer's specifications. Flues must be designed to provide proper ventilation and draft for the fireplace. Draft is a current of air and gases through the fireplace and chimney. The size of the flue is determined by the size of the fireplace opening and the chimney height. Flues for custom designs and multistory chimney heights should be confirmed with the masonry contractor, masonry supply, or fireplace manufacturer.

SOLID FUEL-BURNING APPLIANCES

Solid fuel-burning appliances are items such as airtight stoves, freestanding fireplaces, fireplace stoves, room heaters, zero-clearance fireplaces, antique stoves, and fireplace inserts for existing masonry fireplaces. This discussion shows the floor plan representation and minimum distance requirements for the typical installations of some approved appliances.

Appliances that comply with nationally recognized safety standards can be noted on the floor plan with a note like the following:

ICBO APPROVED WOOD STOVE AND INSTALLATION REQUIRED [ICBO = INTERNATIONAL CONFERENCE OF BUILDING OFFICIALS.]

VERIFY ACTUAL INSTALLATION REQUIREMENTS WITH VENDORS' SPECIFICATIONS AND LOCAL FIRE MARSHAL OR BUILDING CODE GUIDELINES.

GENERAL RULES (VERIFY WITH LOCAL FIRE MARSHAL OR BUILDING CODE GUIDELINES)

Floor Protection. Combustible floors must be protected. Floor protection material shall be noncombustible, with no cracks or holes, and strong enough not to crack, tear, or puncture with normal use. Materials commonly used are brick, stone, tile, and metal.

Wall Protection. Wall protection is critical whenever solid fuel-burning units are used in a structure. Direct application of noncombustible materials does not provide adequate protection. When solid fuel-burning appliances are installed at recommended distances from combustible walls, a 1" (25 mm) airspace is necessary between the wall and floor to the noncombustible material, plus a bottom opening for air intake and a top opening for air exhaust to provide positive air change behind the structure. This helps reduce superheated air adjacent to combustible material, as shown in Figure 3–74. Noncombustible materials include brick, stone, and

tile over cement asbestos board. Minimum distances to walls should be verified with regard to vendors' specifications and local code requirements.

Combustion Air. Combustion air is generally provided by a screened closable vent installed within 24" (600 mm) of the solid fuel-burning appliance.

Air Pollution. Some local areas have initiated guidelines that help control air pollution from solid-fuel-burning appliances. The installation of a catalytic converter or other devices may be required. Check with local regulations.

Figure 3–75 shows floor plan representations of common wood stove installations.

A current trend in housing is to construct a masonry alcove within which a solid fuel unit is installed. The floor plan layout for a typical masonry alcove is shown in Figure 3–76. Strict code compliance is critical in these installations to avoid overheating of the space.

ROOM TITLES

Rooms are labeled with a name on the floor plan. Generally, the lettering is larger than that used for other notes and dimensions. See Figure 3–77. The interior dimensions of the room are often lettered under the title, as shown in Figure 3–78.

OTHER FLOOR PLAN SYMBOLS

HOSE BIBB

A hose bibb is an outdoor water faucet to which a garden hose can be attached. Hose bibbs are found at locations convenient for watering lawns or gardens and for washing a car. The floor plan symbol for a hose bibb is shown in Figure 3–79.

CONCRETE SLAB

Concrete slabs used for patio walks, garages, or driveways can be noted on the floor plan. A typical example is 4" (100 mm) THICK CONCRETE WALK. Concrete slabs used for the floor of a garage should slope toward the front to allow water to drain. The amount of slope is 1/8"/ft minimum (see Figure 3–80). Calling for a slight slope on patios and driveway aprons is also common.

ATTIC AND CRAWL SPACE ACCESS

Access is necessary to attics and crawl spaces. The crawl space access may be placed in any convenient location, such as a closet or hallway. The minimum size of the attic access must be 22" × 30" (560 mm × 760 mm). The crawl access should be 22" × 30" if

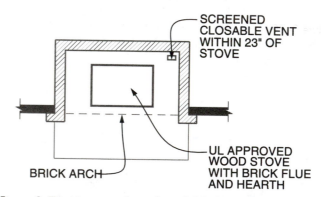

Figure 3–76 Masonry alcove for solid fuel-burning stove.

LIVING ROOM KITCHEN
BEDROOM BATH

Figure 3–77 Room titles.

Figure 3–78 Room title with room sizes noted.

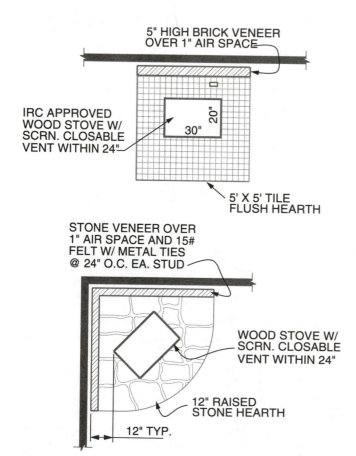

Figure 3–75 Wood stove floor plan samples.

located in the floor. The attic access may include a folding ladder (disappearing stairs) if the attic is to be used for storage. A minimum of 30" must be provided above the attic access. Crawl space access can be shown on the foundation plan when it is constructed through the foundation wall. A typical crawl space and attic access note is shown in Figure 3–81.

FLOOR DRAINS

Floor drains should be used in any location where water can accumulate on the floor, such as the laundry room, bathroom, or garage. The easiest application of a floor drain is in a concrete slab floor, although drains may be designed in any type of floor construction. Figure 3–82 shows a floor drain in a shower and in a utility room.

CROSS SECTION SYMBOL

The location on the floor plan where a cross section is taken is identified with symbols known as cutting-plane lines. These symbols place an imaginary cutting plane through the structure at a particular location. The cross sectional view relating to the cutting-plane line is usually found on another sheet. The arrows of the cutting plane are labeled with a letter, which is used to identify the cross sectional view. Figure 3–83 shows a cross section symbol (cutting-plane line). A number of methods are used in industry to label sections. The example in Figure 3–83 shows the basic

method. Other methods of identifying cutting planes and cross sections are more elaborate. Figure 3–83 shows three optional methods that are commonly used. The identification usually includes a letter designating the section and a number designating the drawing sheet where the letter is to be found. The identification letters and numbers can read from the right side or bottom of the sheet. The method used depends on company practice.

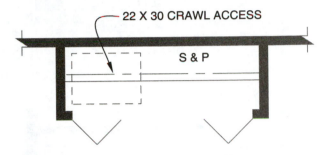

Figure 3–81(a) Crawl space access and related note.

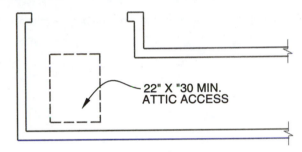

Figure 3–81(b) Attic access symbol and related note.

Figure 3–82(a) Shower symbol showing floor drain.

Figure 3–79 House bibb symbol.

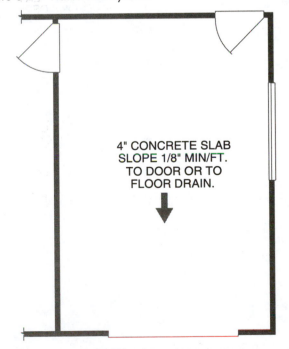

Figure 3–80 Garage slab note.

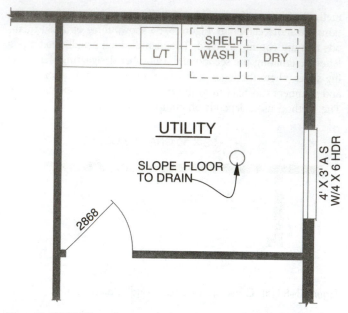

Figure 3–82(b) Floor drain symbol (symbol can also be square).

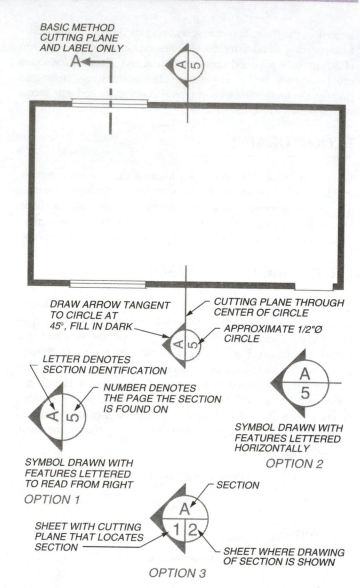

Figure 3–83 Options for the cutting plane line symbol.

CHAPTER 3 TEST

Fill in the blanks below with the proper word or short statement as needed to complete the sentence or answer the question correctly.

1. Residential floor plans are generally drawn at a scale of ____ _____ .

2. Numbered symbols used on the floor plan key specific items to charts known as _____ _____ .

3. Identify at least six items that may be found in schedules. _____ _____ _____ .

4. What is the meaning of the numbers 3068 placed on the floor plan next to a door symbol? _____ _____ _____ .

5. Describe the meaning of this set of numbers placed next to a window symbol on the floor plan: 6'–0" × 3'–6". _____ _____ _____ .

6. Why is it important to have the vendor's catalog or specifications available when reading prints that specify specific products in the window and door schedules? _____ _____ _____ _____ _____ .

7. What does the abbreviation G.D. represent? _____ _____ .

8. Why do you think it would be a good idea to verify the exact size of a prefabricated shower before installation? ____ _____ _____ _____ _____ .

9. List a reason the clothes washer and dryer might be shown on the floor plan with dashed lines. _____ _____ _____ .

10. List at least three names that may be given to closets on a floor plan. _____ _____ _____ .

11. List at least four ways finish materials can be represented on a floor plan. _____ _____ _____ _____ _____ .

12. Describe how a header is shown and specified on the floor plan. _____ _____ _____ .

13. What does the abbreviation HDR represent? _____ _____ _____ .

14. Explain how ceiling joists or trusses are represented and labeled on a floor plan. _____ _____ _____ .

15. Identify two ways discussed in this chapter that represent how ceiling joists might intersect with a beam. _____ _____ _____ .

16. Discuss one good way to learn about the construction methods used when building with structural connectors. _____ _____ _____ _____ _____ .

17. The minimum stair tread length is _____ .

18. Individual stair risers may range between _____ " in height, and risers should not vary more than _____ ".

19. A clear height of _____ is the minimum amount of headroom required for the length of the stairs.

20. Stairs with over _____ risers require handrails.

21. If you have stairs with 14 risers, how many runs are there? _____ .

22. If each individual run is 10" in the stairs from question 21, what is the total run? Give your answer in feet and inches, and show your calculations: _____ _____ .

23. What does the term "zero clearance" mean? _____ _____ .

24. What does the abbreviation CO mean as related to fireplace construction? _____ _____ .

25. What is combustion air? _____ _____ .

26. Give four examples of solid fuel-burning appliances. _____ _____ _____ _____ .

27. What does the abbreviation ICBO mean? _____

_____ .

28. Why is strict code compliance so important when dealing with the construction of fireplaces or the installation of solid fuel-burning appliances? _____
_____ .

29. What does the abbreviation HB represent? _____

_____ .

30. The location on the floor plan where a cross section is taken is identified with symbols known as _____

_____ .

CHAPTER 3 PROBLEMS

PROBLEM 3–1 Answer the following questions as you read the floor plan drawing on page 79.

1. Identify the type of wall shading used in this floor plan.
_____ .

2. Describe the brick veneer. (Change any abbreviations and symbols to whole words.) _____

_____ .

3. Describe the type of windows and the manufacturer used in this plan. _____

_____ .

4. Describe the entry door, sidelights, and window above. (Change any abbreviations and symbols to whole words and sizes to feet and inches.) _____

_____ .

5. What type and size of door is used on the pantry? _____
_____ .

6. What is the kitchen ceiling height? _____ .

7. What are the inside kitchen dimensions? _____
_____ .

8. Describe the type and size of the doors located at the master suite. _____
_____ .

9. What size and spacing of exterior studs are used in the construction of this house? (Change any abbreviations and symbols to whole words.) _____

_____ .

10. What size and spacing of interior studs are used in the construction of this house? (Change any abbreviations and symbols to whole words.) _____

_____ .

11. What size of beam is used between the kitchen and family room? _____ .

12. Give the specifications of the headers that are used over all openings in bearing walls, except where otherwise noted. (Change any abbreviations and symbols to whole words.)

_____ .

13. Give the specifications for the ceiling joists over the kitchen and family room. (Change any abbreviations and symbols to whole words.) _____
_____ .

14. Give the specification provided for the crawl space access and identify its location. _____

_____ .

15. How many hose bibbs can you count? _____ .

16. What is the size of the header between the entry and the living room? _____ .

PROBLEM 3–2 Answer the following questions as you read the floor plan drawing on page 80.

1. Give the location, quantity, size, and description of door A.

_____ .

2. Give the location, quantity, size, and description of door G.

_____ .

3. Give the location, quantity, size, and description of door H.

_____ .

4. Give the location, quantity, size, and description of window 3.

_____ .

5. Give the location, quantity, size, and description of window 8.

_____ .

6. Describe the posts holding up the ends of the girder truss in the garage. _____

_____ .

7. Describe the ceiling construction members in the garage from the girder truss to the black wall. _____

_____ .

8. Describe the joists over the parlor that extend toward the back of the house. _____

_____ .

9. Give the specifications of the material used on the walls and ceiling in the garage. _____

_____ .

10. What is placed in front of the water heater and furnace to protect from automobile damage? _____

_____ .

11. Describe the floor used at the entry before you go into the foyer. _____

_____ .

12. What is the purpose of the 2 × 6 plumbing wall? _____

_____ .

13. How many risers are there in the stairs? _____

_____ .

14. What size are the garage door headers? _____

_____ .

PROBLEM 3–3 Answer the following questions as you read the floor plan drawing on page 81.

1. Describe the cooking unit in the kitchen. _____

_____ .

2. Give the door size, type, and header specifications as you exit the nook. _____

_____ .

3. Give the complete fireplace specifications. _____

_____ .

4. What does the symbol used for the fireplace hearth represent? _____
_____ .

5. What is the size of the door that leads to the area under the stairs? _____ .

6. Give the specifications provided for the windows in the family room. _____

_____ .

PROBLEM 3–4 Answer the following questions as you read the floor plan drawing on page 82.

1. Describe the type and size of doors located at the washer/dryer space. _____

_____ .

2. Describe the type and size of the door entering bath 1. ____

_____ .

3. Give the size and location of the attic access. _____

_____ .

4. From what direction in this floor plan do the stairs run?
_____ .

5. How many risers are there in the stairs? _____
_____ .

6. How many runs are there in the stairs? _____
_____ .

7. If each individual stair tread (run) is 10", what is the length of the total run? Show your calculations. _____

_____ .

8. Explain what the note 4×10 BM. IN CLG. means. _____

_____ .

PROBLEM 3–5 Answer the following questions as you read the floor plan drawing on page 83.

1. Give the title of this drawing. _____
_____ .

2. Identify the scale that was used to create the original drawing. _____
_____ .

3. Give the size of the garage door(s). _____
_____ .

4. List the specifications for the beams used in the garage.

_____ .

5. What does the term FLUSH mean that is associated with beams in the interior of the house? _____
_____ .

6. Where do the stairs to the second floor start? _____
_____ .

7. Locate the crawl access. _____
_____ .

8. Where is the water heater and furnace? _____
_____ .

9. Give the fireplace opening size and other non-dimensional specifications provided. _____
_____ .

10. List the size of the bi-fold doors shown. _____
_____ .

11. Provide the wall and ceiling specification for the garage.

_____ .

12. What are the interior dimensions of the dining room? ____
_____ .

PROBLEM 3–6 Answer the following questions as you read the floor plan drawing on page 84.

1. How many square feet are there in this floor plan? _____
_____ .

2. Give the number of pocket doors found in this plan. _____
_____ .

3. Provide the specifications for the tub in Bath 2. _____
_____ .

4. Give the number of risers in the stairs. _____
_____ .

5. Give the specification of the opening to the open area below.

_____ .

6. Identify the size of the beam in the Bedroom. _____
_____ .

7. Give the specifications of the window in the Games Room.

_____ .

8. Identify the plumbing fixtures in the Master Bath. _____
_____ .

9. What are the specifications of the wall between the Laundry Room and Bath 2? _____
_____ .

10. Give the interior dimensions for the Games Room. _____
_____ .

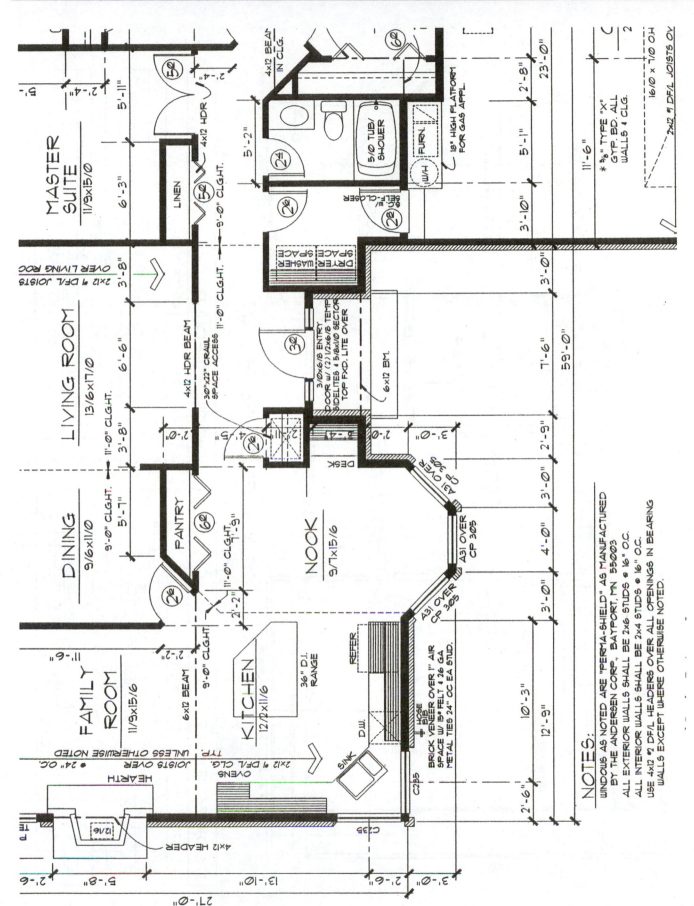

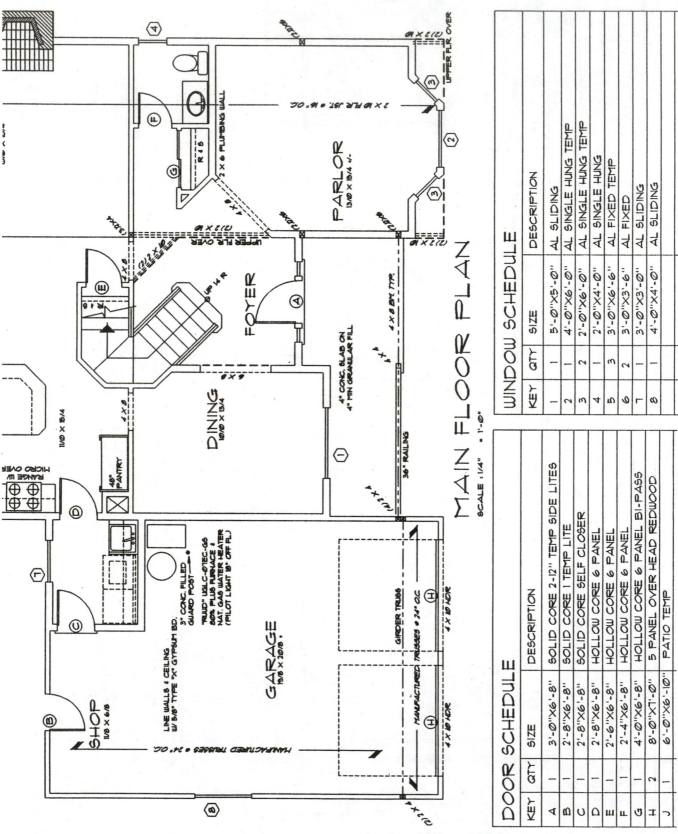

MAIN FLOOR PLAN
SCALE :1/4" = 1'-0"

WINDOW SCHEDULE

KEY	QTY	SIZE	DESCRIPTION
1	1	5'-0"X5'-0"	AL SLIDING
2	1	4'-0"X6'-0"	AL SINGLE HUNG TEMP
3	2	2'-0"X6'-0"	AL SINGLE HUNG TEMP
4	1	2'-0"X4'-0"	AL SINGLE HUNG
5	3	3'-0"X6'-6"	AL FIXED TEMP
6	2	3'-0"X3'-6"	AL FIXED
7	1	3'-0"X3'-0"	AL SLIDING
8	1	4'-0"X4'-0"	AL SLIDING

DOOR SCHEDULE

KEY	QTY	SIZE	DESCRIPTION
A	1	3'-0"X6'-8"	SOLID CORE 2-12" TEMP SIDE LITES
B	1	2'-8"X6'-8"	SOLID CORE 1 TEMP LITE
C	1	2'-8"X6'-8"	SOLID CORE SELF CLOSER
D	1	2'-8"X6'-8"	HOLLOW CORE 6 PANEL
E	1	2'-6"X6'-8"	HOLLOW CORE 6 PANEL
F	1	2'-4"X6'-8"	HOLLOW CORE 6 PANEL
G	1	4'-0"X6'-8"	HOLLOW CORE 6 PANEL BI-PASS
H	2	8'-0"X7'-0"	5 PANEL OVER HEAD REDWOOD
J	1	6'-0"X6'-10"	PATIO TEMP

Problem 3-2

FAMILY
13/6 × 15/4

MASONRY FIREPLACE
w/ COMBUSTION AIR
VENT AND 18" RAISED
TILED HEARTH

(3) 3/0 × 6/6 AL. FXD. (TEMP)

NOOK
8/6 × 11/6

6/0 PATIO DR. (TEMP)
6 × 10 HDR 1 D.F.

PLUMBING STACK

KITCHEN
11/0 × 15/4

REFR

(2) 3/0 × 3/6 AL. FXD.

RANGE W/
MICRO OVER

DINING
10/0 × 13/4

48" PANTRY

4 × 8

2/0 × 4/0 AL. S.H.

2 × 6 PLUMBING WALL

(2) 2 × 10
FLR OVER

FILLED POST

GLC-ØTEC-GS
IS FURNACE
S WATER HEATER
IGHT 18" OFF FL)

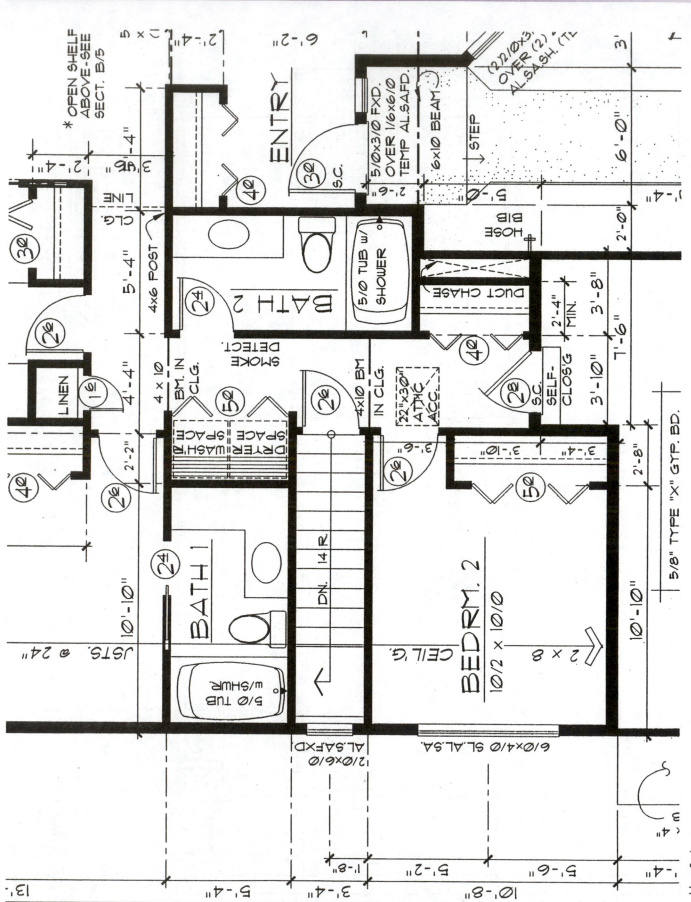

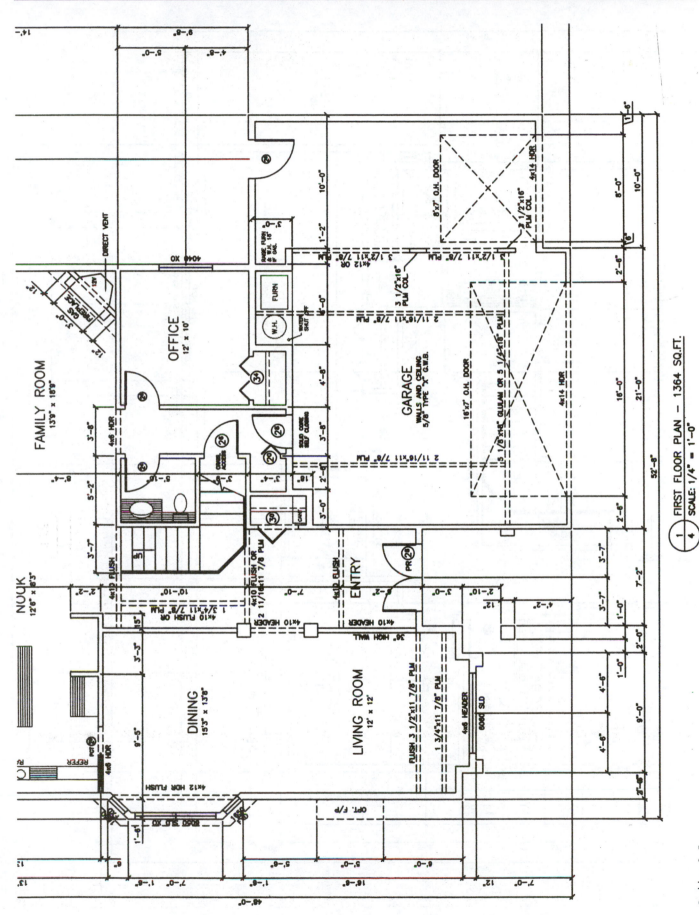

FIRST FLOOR PLAN – 1364 SQ.FT.
SCALE: 1/4" = 1'-0"

Problem 3–5

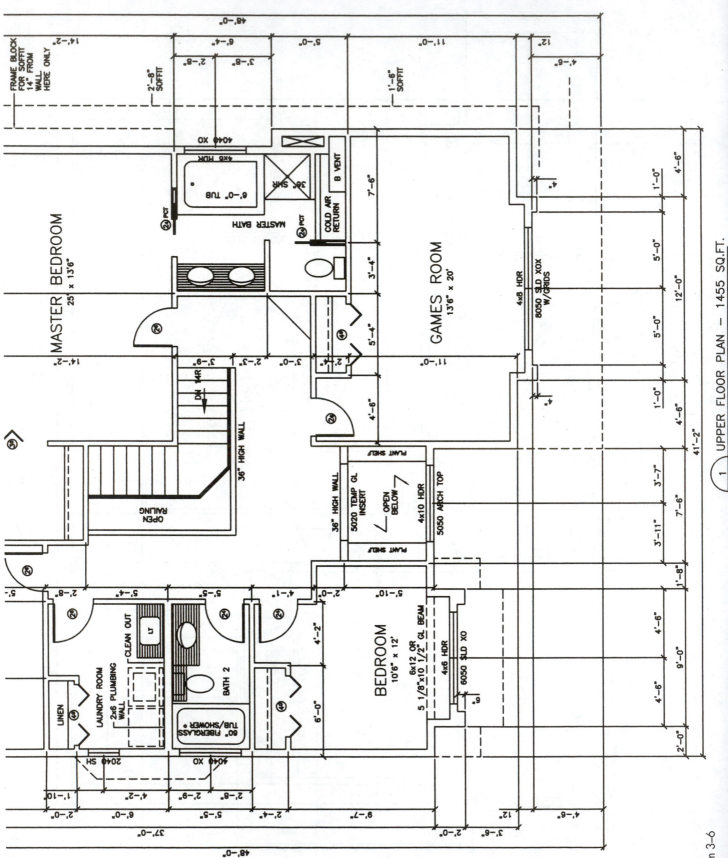

1 UPPER FLOOR PLAN — 1455 SQ.FT.

Reading Floor Plans, Part 2: Floor Plan Dimensions

CHAPTER OVERVIEW

This chapter covers the following topics:

- Aligned dimensions
- Floor plan dimensions
- Dimensioning floor plan features
- Notes and specifications

- Reading metric dimensions
- Test
- Problems

ALIGNED DIMENSIONS

The dimensioning system most commonly used in architectural drafting is known as aligned dimensioning. With this system dimensions are placed in line with the dimension lines and read from the bottom or right side of the sheet. Dimension numerals are centered on and placed above the solid dimension lines. Figure 4–1 shows a floor plan that has been dimensioned using the aligned dimensioning system.

FLOOR PLAN DIMENSIONS

Dimensions on the drawing are made up of three parts: the extension lines, dimension lines, and dimension numerals. The extension lines project from the plan and continue slightly beyond the last dimension line to show the extent of the dimension. The dimension lines are used to display the length of the dimension and for placement of the dimension numeral. See Figure 4–2.

Dimension lines terminate at extension lines with dots, arrowheads, or slash marks, depending on the specific office practice. See Figure 4–3. Dimension numerals are displayed in feet and inches for all lengths over 12". Inches and fractions are used for units less than 12".

Foot units are followed by the foot (') symbol and inch values by the inch symbol ("). Applications vary among companies, and it is possible to find some prints with the feet and inches symbols omitted.

EXTERIOR DIMENSIONS

The overall dimensions on frame construction are understood to be given to the outside of the stud frame of the exterior walls. The reason for locating dimensions on the outside of the stud frame is that the frame is established first, and windows, doors, and partitions are usually put in place before sheathing and other wall-covering material is applied. Another construction option is for the exterior dimensions to be to the outside face of the exterior sheathing. This depends on the preferred construction method. Figure 4–4(a) shows an example of the construction used where the exterior dimension is to the outside face of studs, as compared with the outside face of the sheathing in Figure 4–4(b). Your floor plan dimensioning practice is the same either way. The contractor determines the actual construction method.

The first line of dimensions on the plan is the smallest distance from the exterior wall to the center of windows, doors, and partition walls. The second line of dimensions generally gives the distance from the outside walls to partition centers. The third line of dimensions is usually the overall distance between two exterior walls. See Figure 4–5. This method of applying dimensions eliminates the need for workers to add dimensions at the job site and reduces the possibility of error.

This textbook shows dimensions placed from the outside face of exterior stud walls to the center of interior walls and partitions to the center of doors and windows. Many architectural offices, however, use a different dimensioning system. They place dimensions

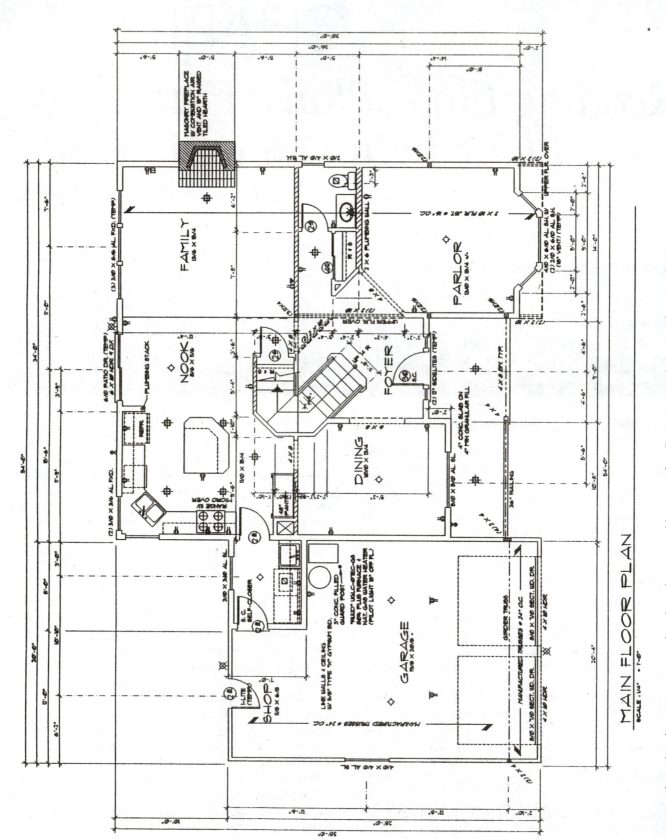

Figure 4–1 Floor plan dimensions are used to show the size and location of walls, partitions, doors, windows, and other construction items. *Courtesy Alan Mascord Design Associates, Inc.*

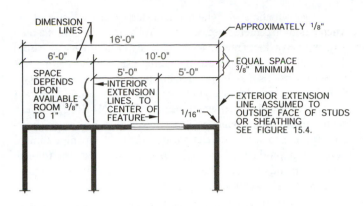

Figure 4–2 Recommended spacing of dimension lines.

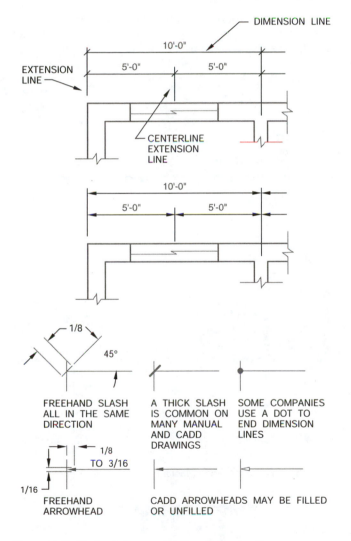

Figure 4–3 Methods for terminating dimension lines.

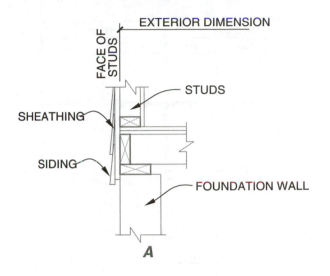

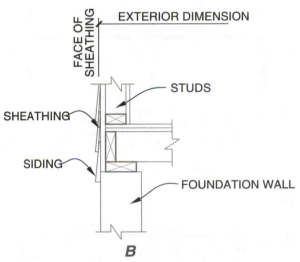

Figure 4–4 (a) An example of the construction used when exterior dimensions are to the outside face of studs. (b) Construction used when exterior dimensions are to the outside face of sheathing.

INTERIOR DIMENSIONS

Interior dimensions locate all interior partitions and features in relationship to exterior walls. Figure 4–6 shows some common interior dimensions. Notice how they relate to the outside walls.

STANDARD FEATURES

Some interior features that are considered standard sizes may not require dimensions. Figure 4–7 shows a situation in which the drafter elected not to dimension the depth of the pantry because it is directly adjacent to a refrigerator that has an assumed depth of 30" (760 mm). Notice that the refrigerator width is given because many different widths are available. The base cabinet is not dimensioned because cabinets are typically 24" (600 mm) deep. When there is any doubt, check with the architect or designer.

from the outside and inside face of studs between exterior and interior walls, followed by dimensions from the outside face of exterior studs to the center of doors and windows, as shown in Figure 4–5. Both methods provide an overall dimension as the last dimension.

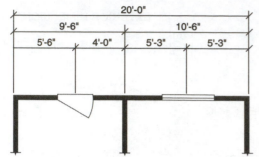

DIMENSIONING FROM OUTSIDE FACE OF EXTERIOR STUDS
TO THE CENTER OF INTERIOR WALLS, DOORS, AND WINDOWS

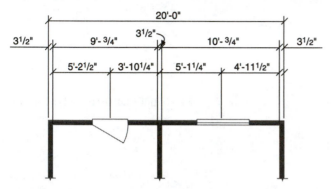

DIMENSIONING FROM THE OUTSIDE AND INSIDE FACE OF STUDS
BETWEEN EXTERIOR AND INTERIOR WALLS, FOLLOWED BY
DIMENSIONS FROM THE OUTSIDE FACE OF EXTERIOR STUDS TO
THE CENTER OF DOORS AND WINDOWS

Figure 4–5 Placing exterior dimensions.

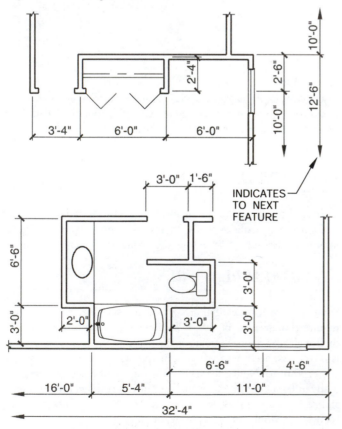

Figure 4–6 Placing interior dimensions.

Other situations in which dimensions can be assumed are when a door is centered between two walls, as at the end of a hallway, or when a door enters a room and the minimum distance from the wall to the door is assumed. See the examples in Figure 4–8. Some dimensions may be provided in the form of a note for standard features, as seen in Figure 4–9. The walls around a shower need not be dimensioned when the note, 36" SQUARE SHOWER, defines the inside dimensions. The shower must be located, however. Be sure to verify the exact rough (framed) opening dimensions for a product of this type before the walls are framed. Different manufacturers often have different specifications for a standard 36" shower, for example.

One of the best ways to learn how to read dimensions is to study and evaluate existing plans.

When reference is made to a 6" wall, for example, the actual wall thickness might not be exactly 6". For example, an exterior wall with 2 x 4 stud framing would measure 3–1/2" (stud) + 1/2"

Figure 4–7 Assumed dimensions.

DOOR CENTERED IN
HALLWAY, ASSUMED

MINIMUM DISTANCE
DOOR TO WALL, ASSUMED

Figure 4–8 Assumed location of features without dimensions given.

Figure 4–9 Standard items dimensioned with a specific note.

interior drywall + 1/2" sheathing + 1/2" to 1" exterior siding. If 2 × 6 studs are used, these measure 5–1/2". Information about metric dimensions is provided later in this chapter. The following are some additional standard sizes for you to consider:

- exterior heated walls: 6" (150 mm).
- exterior unheated finished walls: 5 (130 mm) (garage/shop).
- exterior unheated walls interior unfinished: 5" (garage/shop).
- interior: 4" (100 mm).
- interior plumbing (toilet): 6" (150 mm).
- hallways: 36" (900 mm) minimum clearance.
- entry hallways: 42"–60" (1060–1500 mm).
- bedroom closets: 24" (600 mm) minimum depth; 48" (1200 mm) length.
- linen closets: 14"–24" (350–600 mm) deep (not over 30" (760 mm)).
- base cabinets: 24" (600 mm) deep; 15"–18" (380–460 mm) wide bar; 24" (600 mm) deep island with 12" (300 mm) minimum at each side of cooktop; 36" (900 mm) minimum from island to cabinet (for passage, 48" (1200 mm) is better on sides with an appliance).
- upper cabinets: 12" (600 mm) deep.
- washer/dryer space: 36" (900 mm) deep, 5' × 6" (1680 mm) long minimum.
- stairways: 36" (900 mm) minimum wide; 9" (230 mm) minimum to 12" (300 mm) tread. Review Chapter 12 for detailed information.
- fireplace.

PLUMBING

- kitchen sink: double, 32" × 21"; triple, 42" × 21".
- vegetable sink and/or bar sink: 16" × 16" or; 16" × 21".
- laundry sink: 21" × 21".
- bathroom sink: 19" × 16", oval; provide 9" from edge to wall and about 12" between two sinks; 36" minimum length.
- toilet space: 30" wide (minimum); 24" clearance in front.
- tub: 32" × 60" or 32" × 72".
- shower: 36" square; 42" square; or combinations of 36", 42", 48", and 60" for fiberglass; any size for ceramic tile.
- washer/dryer: 2'–4' square (approximately).

Metric values of above products vary, depending on manufacturer, and are generally in even modules.

APPLIANCES

- forced air unit: gas, 18" square (minimum) with 6" space all around; cannot go under stair; electric, 24" × 30" (same space requirements as gas).
- water heater: gas, 18"–22" diameter; cannot go under stair.
- refrigerator: 36" wide space; approximately 27" deep; 4" from wall; 4" from base cabinet.
- stove/cooktop: 30" × 21" deep.
- built-in oven: 27" × 24" deep.
- dishwasher: 24" × 24"; place near upper cabinet to ease putting away dishes.
- trash compactor: 15" × 24" deep; near sink, away from stove.
- broom/pantry: 12" minimum × 24" deep, increasing by 3" increments.
- desk: 30" × 24" deep (minimum); out of main work triangle.
- built-in vacuum: 24"–30" diameter.

Metric values of above products vary, depending on manufacturer, but are generally in even modules.

DOORS

- entry: 36" × 6'–8"; 42" × 8'.
- sliders or French: 5', 6', 8' (double); 9', 10' (triple); 12' (four-panel).
- garage, utility, kitchen, and bedrooms on custom houses: 2'–8".
- bedrooms and bathrooms of nice houses: 2'–6".
- bathrooms closets: 2'–4".
- garage 8' × 7', 9' × 8', 16' × 7', and 18' × 7'.

WINDOWS

- living, family: 8'–10'.
- dining, den: 6'–8'.
- bedrooms: 4'–6'.
- kitchens: 3'–5'.
- bathrooms: 2'–3'.
- sliding: 4', 5', 6', 8', 10', 12'.
- single-hung: 24", 30", 36", 42".
- casement: same as sliding.
- fixed/awning: 24", 30", 36", 42", 48".
- fixed/sliding: 24", 30", 36", 42", 48".
- picture 4', 5', 6', 8'.
- bay: 8'–10' total; sides, 18"–24" wide.

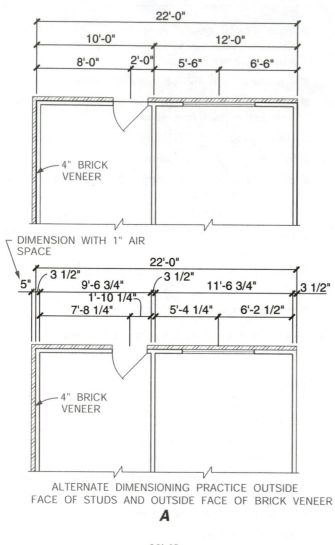

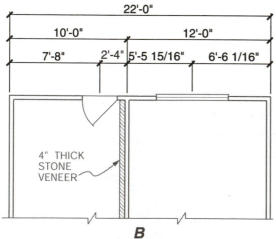

Figure 4–10 Dimensioning (a) brick exterior veneer; (b) interior stone veneer.

DIMENSIONING FLOOR PLAN FEATURES

MASONRY VENEER CONSTRUCTION

The discussion thus far has provided examples of floor plan dimensioning for wood framed construction. Other methods of residential construction include masonry veneer, structural masonry, concrete block, and solid concrete. Masonry veneer construction is the application of thin (4") masonry, such as stone or brick, to the exterior of a wood framed structure. This kind of construction provides a long-lasting, attractive exterior. Masonry veneer may also be applied to interior frame partitions where the appearance of stone or brick is desired. Brick or stone may cover an entire wall that contains a fireplace, for example. Occasionally either material may be applied extending to the lower half of a wall, with another material extending to the ceiling for a contrasting decorative effect. Masonry veneer construction is dimensioned on the floor plan in the same way as wood framing, except that the veneer is dimensioned and labeled with a note describing the product. See Figure 4–10.

CONCRETE BLOCK AND STRUCTURAL MASONRY CONSTRUCTION

Concrete blocks are made in standard sizes and can be solid or have hollow cavities. Concrete block can be used to construct exterior or interior walls of residential or commercial structures. Some concrete blocks have a textured or sculptured surface to provide a pleasant exterior appearance. Most concrete block construction must be covered, such as by masonry veneer, for a finished look. Some structures use concrete block for the exterior bearing walls and wood framed construction for interior partitions. Standard concrete blocks are 8" (190 mm) wide.

Dimensioning concrete block construction is different from wood framed construction in that each wall, partition, and window and door opening is dimensioned to the edge of the feature, as shown in Figure 4–11. While this method is most common, some prints dimension the concrete block structure in the same way as wood framed construction. To do so, the prints must contain specific information in notes or section views about wall thicknesses and openings. Some practices use the abbreviation MO to identify masonry openings.

Structural masonry, also referred to as *reinforced masonry,* is normally a blend of materials that are manufactured at high temperatures and generally have higher compressive strength than concrete block or poured concrete. Structural masonry is attractive in appearance and does not normally need to be covered with wood frame or other masonry products. In combination with certain insulation, the standard 4–5/8" (120 mm) reinforced masonry wall can have R-values up to 20. Structural masonry floor plan drawings are similar to those for concrete block, except that the standard unit is 4–5/8" wide rather than 8" (200 mm) wide.

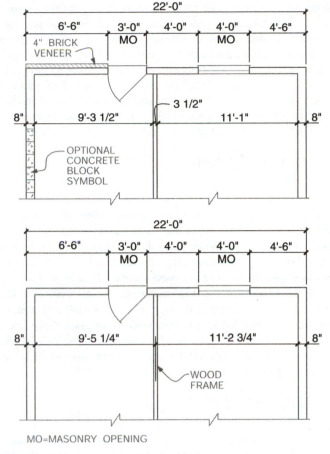

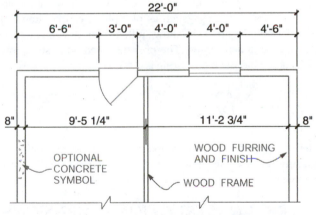

Figure 4–11 Dimensioning concrete block construction.

Figure 4–12 Dimensioning solid concrete construction.

SOLID-CONCRETE CONSTRUCTION

Solid-concrete construction is used in residential and commercial structures. In residences it is mostly limited to basements and subterranean homes. Concrete is poured into forms that mold the mixture to the shape desired. When the concrete cures (hardens), the forms are removed and the structure is complete, except for any surface preparation that may be needed.

Masonry veneer can be placed on either side of concrete walls for a good appearance. Wood framing and typical interior finish

materials can also be added to the inside of concrete walls. The wood framing attached to concrete walls is in the form of furring, which is usually nailed in place with concrete nails. *Furring* is wood strips which are fastened to the studs or interior walls and ceilings and on which wall materials are attached. Furring is used on masonry walls to provide airspace and a nailing surface for attaching finish wall materials. Furring attached to masonry is pressure-treated or foundation-grade wood or galvanized steel. Standard interior finish materials such as drywall or paneling may be added to the furring. Solid-concrete construction is typically dimensioned the same as concrete block construction. See Figure 4–12.

NOTES AND SPECIFICATIONS

Notes on plans are either specific or general. *Specific notes* relate to specific features within the floor plan, such as the header size over a window opening. A specific note is often connected to a feature with a leader line. Specific notes are also called *local notes,* because they identify isolated items. Common information that may be specified in the form of local notes is:

1. Window schedule. Place all windows in a schedule, grouped by type (such as sliding, fixed, awning) from largest to smallest. Window size and type can also be placed directly on the floor plan.

2. Door schedule. All doors in schedule, grouped by type (such as solid core, slab, sliding, bifold) from largest to smallest. Door size and type can be placed directly on the floor plan.

3. Room names in the center of all habitable rooms with the interior size below.

4. Appliances such as a furnace, water heater, dishwasher, compactor, stove, and refrigerator. Items that can be distinguished by shape, such as toilets and sinks, do not need to be identified.

5. All tubs, showers, or spas, giving size, type and material.

6. Fireplace or solid-fuel-burning appliance. Specify vent within 24" (610 mm), hearth, U.L.-approved materials, and wood box.

7. Stairs, giving direction of travel, number of risers, and rail height.

8. All closets with shelves, S&P (shelf and pole), linen, broom, or pantry.

9. Specify attic and crawl access openings.

10 One-hour firewall between garage and residence with 5/8" (16 mm) type X gypsum board from floor to ceiling.

11. On multilevel structures, "line of upper floor," balcony above, line of lower floor, or other projections of one level beyond another.

12 Codes and construction methods for additional local notes.

General notes apply to the drawing overall rather than to specific items. General notes are commonly lettered in the *field* of the drawing. The field is any open area that surrounds the main views. A common location for general notes is the lower-right or -left corner of the sheet, but they can be in other places. Some typical general notes are seen in Figure 4–13.

Some specific notes that are too complex or take up too much space can be placed with the general notes and keyed to the floor plan with a short identification such as the phrase see NOTE #1 or SEE NOTE 1, or with a number within a symbol such as ① or ⚠.

Written specifications are separate notes that identify the quality, quantity, or type of materials and fixtures to be used in the entire project. Specifications for construction are prepared in a format different from drawing sheets. Specifications can be printed in a format that categorizes each phase of the construction and indicates the precise methods and materials to be used. Architects and designers may publish specifications for a house so that the client and contractor knows exactly what the home will contain, even including the color and type of paint.

READING METRIC DIMENSIONS

The unit of measure commonly used is the millimeter (mm). Canada is one country that uses metric dimensioning.

When materials are purchased from the United States, it is often necessary to make a hard conversion to metric units. This means that the typical inch units are converted directly to metric. For example, a 2 × 4 that is planed to 1–1/2 × 3–1/2 converts to 38 × 89 mm. When making the conversion from the imperial inch to millimeters, use the formula 25.4 × inch = millimeters.

The preferred method of metric dimensioning is called a soft conversion, where common metric modules are used. This means that the lumber is milled directly to metric units. The 2 × 4 lumber is 40 × 90 mm using soft conversion. This method is much more convenient when drawing plans and measuring in construction. When plywood thickness is measured in metric units, 5/8" thick equals 17 mm and 3/4" thick equals 20 mm. The length and width of plywood also changes from 48 × 96 to 1200 × 2400 mm. Modules for architectural design and construction in the United

States are typically 12" or 16". In countries using metric measurement, the dimensioning module is 100 mm. For example, construction members may be spaced 24" on center (O.C.) in the United States, but the spacing in Canada is 600 mm O.C. The spacing between studs at 16" O.C. in the United States is 400 mm O.C. in Canada. These metric modules allow the 1200 × 2400 mm plywood to fit exactly on center with construction members. Interior dimensions are also designed in 100-mm increments. For example, the kitchen base cabinet measures 600 mm deep.

READING METRIC UNITS ON A DRAWING

When reading metric dimensions on a drawing, all dimensions within dimension lines are in millimeters, and the millimeter symbol (mm) is omitted. When more than one dimension is quoted, the millimeter symbol (mm) is found only after the last dimension. For example, the size of a plywood sheet reads 1200 × 2400 mm, or the size and length of a wood stud reads 38 × 89 × 600 mm. The millimeter symbol is omitted in the notes associated with a drawing except when referring to a single dimension, such as the thickness of material or the spacing of members. For example, a note might read 90 × 1200 BEAM, the reference to a material thickness, 12 mm gypsum, or the spacing of joists, 400 mm O.C.

METRIC SCALES

When drawings are produced in metric, the floor plans, elevations, and foundation plans are generally drawn at a scale of 1:50 rather than the 1/4" = 1'–0" scale used in the imperial system. Larger-scale drawings, such as construction details, are often drawn at a scale of 1:5. Small-scale drawings, such as plot plans, can be drawn at a scale of 1:500. Figure 4–14 shows a floor plan drawn completely using metric dimensioning. The preferred method of soft conversion is used, and the metric scale is 1:50.

METRIC STANDARDS AND SPECIFICATIONS

Refer to Appendix A for a complete list and examples of metric standards and specifications for architectural design and construction materials.

METRIC CONSTRUCTION DIMENSIONS

The chart on page 94 gives a comparison of metric and inch construction modules. These are not a direct conversion of metric and inches, but a relationship between the metric and inch standard based on soft conversion.

GENERAL NOTES:

1. ALL PENETRATIONS IN TOP OR BOTTOM PLATES FOR PLUMBING OR ELECTRICAL RUNS TO BE SEALED. SEE ELECTRICAL PLANS FOR ADDITIONAL SPECIFICATIONS.
2. PROVIDE 1/2 " WATER PROOF GYPSUM BOARD AROUND ALL TUBS, SHOWERS, AND SPAS.
3. VENT DRYER AND ALL FANS TO OUTSIDE AIR THRU VENT WITH DAMPER.
4. INSULATE WATER HEATER TO R-11. W.H. IN GARAGE TO BE ON 18" HIGH PLATFORM.
5. PROVIDE 1-HOUR FIREWALL BETWEEN GARAGE AND RESIDENCE WITH 5/8" TYPE 'X' GYPSUM BOARD FROM FLOOR TO BOTTOM OF SHEATHING.

Figure 4–13 Some typical generic notes.

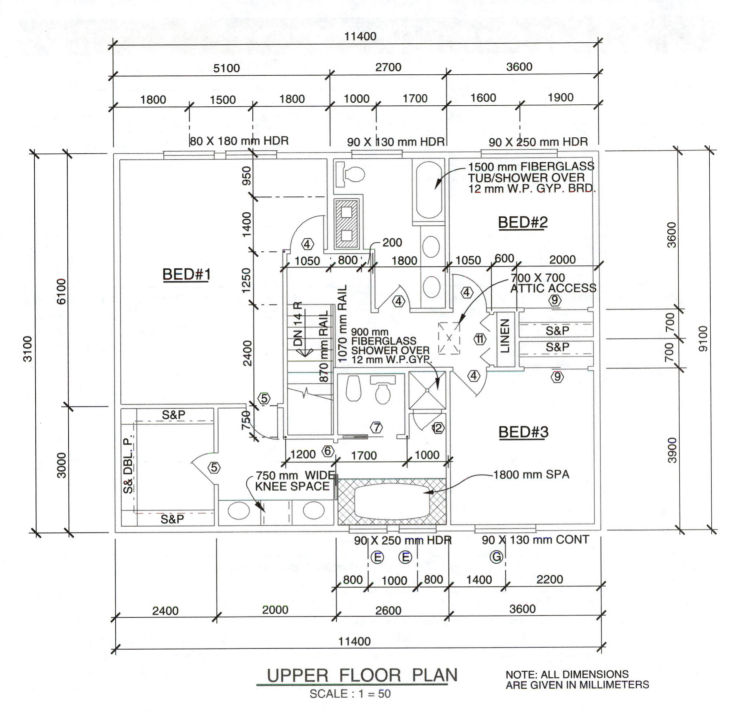

UPPER FLOOR PLAN
SCALE : 1 = 50

NOTE: ALL DIMENSIONS
ARE GIVEN IN MILLIMETERS

Figure 4–14 Floor plan drawn using metric dimensioning.

CONSTRUCTION MODULE CONVERSIONS

OBJECT	METRIC (mm)	INCHES OR FEET	COMMENTS
Construction modules	100	4"	
	600	24" or 2'	
Standard brick	90 x 57 x 190	4" x 2" x 8"	
Mortar joints	10	3/8" and 1/2"	
Concrete block	200 x 200 x 400	8" x 8" x 16"	
Sheet metal	tenths of a millimeter	gage	
Drywall, plywood, and	1200 x 2400	4' x 8'	Thicknesses are in inches, so
	1200 x 3000	4' x 10'	fire, rigid insulation, acoustic, and thermal ratings will not have to be recalculated.
Batt insulation	400	16"	Thicknesses are in inches, so
	600	24"	thermal values will not have to be recalculated.
Door height	2050 or 2100	6'–8"	
	2100	7'–0"	
Door width	750	2'–6"	
	800	2'–8"	
	850	2'–10"	
	900 or 950	3'–0"	
	1000		
Cut glass	mm	feet and inches, thickness is already in mm	

According to the Brick Institute of America (BIA), the American Society for Testing Materials (ASTM E835/E835M, *Standard Guide for Modular Construction of Clay and Concrete Masonry Units*) establishes dimensions for these products based on the basic 100 mm building module. Many common brick sizes are within a couple of millimeters of metric modular sizes. Nearly all common bricks can fit within a 100 mm vertical module by using a 10 mm joint. Appendix A displays common brick sizes in inches and in metric conversion. Owing to the size of concrete blocks, however, they must be resized for metric applications to a module 200×200×400 mm.

CHAPTER 4 TEST

Fill in the blanks below with the proper word or short statement as needed to complete the sentence or answer the question correctly.

1. Fully explain how dimension numerals are displayed on an architectural drawing. _____ _____ _____ _____ .

2. Show the foot symbol. _____ .

3. Show the inch symbol. _____ .

4. Why is it possible to have a drawing that does not show the foot and inch symbols on dimension numerals? _____ _____ _____ _____ .

5. The overall dimensions on frame construction are understood to be given to the _____ stud frame of the exterior walls.

6. Dimensions are normally given to the _____ of windows, doors, and interior partitions.

7. Identify at least two situations in which items may not be dimensioned on a drawing. _____ _____ _____ .

8. Why is it important to verify the exact rough (framed) opening dimensions for a product before the walls are framed? _____ _____ _____ .

9. The application of thin masonry, such as stone or brick, to the exterior of a wood-framed structure is called _____ _____ _____ .

10. Give an example of a specific note. _____ _____ _____ .

11. Give an example of a typical general note. _____ _____ _____ .

12. Describe construction specifications. _____ _____ _____ _____ .

13. What is the situation on a print where you see a number inside of a triangle next to a feature? _____ _____ _____ _____ .

14. Define soft conversion when dealing with metric values. _____ _____ .

15. Identify the value that is commonly used when prints are created in metric. _____ _____ .

CHAPTER 4 PROBLEMS

PROBLEM 4–1 Answer the following questions as you read the floor plan drawing on page 98:

1. Describe how the brick veneer is shown, and give the specifications provided. _____

_____ .

2. Give the dimensions of the portion of the master bath that projects out from the rest of the house. _____

_____ .

3. What is the size of the whirlpool tub? _____
_____ .

4. What is the size of the shower? _____
_____ .

5. Describe the material used to finish the shower. _____

_____ .

6. Describe the construction materials used as a shower door and between the shower and tub. _____

_____ .

7. Give the total dimension from the outside wall of the master bath to the center of the wall behind the water closet. (Show your calculations.) _____

_____ .

8. Give the specifications of all construction components of the decor column. (Change all abbreviations and symbols to whole words.) _____

_____ .

9. What size beam runs from the decor column to the outside wall of the master bath? _____ .

10. Give the dimensions of the water closet compartment.
_____ .

PROBLEM 4–2 Answer the following questions as you read the floor plan drawing on page 99:

1. Give the exterior dimensions of the fireplace. _____
_____ .

2. How far does the living room project out past the dining room? _____
_____ .

3. What is the width of the living room as measured from the center of the master suite wall to the outside of the upper left corner of the living room? (Show your calculations.)

_____ .

4. What is the length of the living room as measured from the outside wall to the center of the opposite wall? (Show your calculations.) _____

_____ .

5. Give the complete specifications of the joists over the living room. _____

_____ .

6. How far is the fireplace from the upper left outside corner of the living room? _____ .

7. What are the interior dimensions of the living room? _____
_____ .

8. How does the builder know where to frame in the 2'–6" door that goes into the dining room? _____

_____ .

PROBLEM 4–3 Answer the following questions as you read the floor plan drawing on page 100:

1. What are the exterior dimensions of the garage (overall width × depth measured from wall at bedroom 3)? _____
_____ .

2. Give the size and specifications of the garage door. _____

_____ .

3. What is the size of the garage door header? _____
_____ .

4. Describe the type and location of the attic access. _____

_____ .

5. Give the dimensions of bedroom 3 from the outside of the garage wall to the center of the wardrobe closet and from the garage side of the wall to the center of the wall at bedroom 2. _____

_____ .

6. Describe the construction material used on the walls and ceiling of the garage. _____

_____ .

7. Give the location dimension for the 2"–8" door with one tempered light found in the garage. _____
_____ .

8. Fully describe the joist over the garage. _____

_____ .

PROBLEM 4–4 Answer the following questions as you read the floor plan drawing on page 101.

1. Give the width of the garage doors. _____ .

2. Calculate the overall width of the garage. Show your calculations. _____ .

3. Calculate the distance from the lower-right corner of the garage horizontally to the center of the entry doors. Show your calculations. _____ .

4. Calculate the vertical distance from the lower-left corner of the garage to the sill of the entry door (outside face of the wall at the entry doors). Show your calculations. _____
_____ .

5. Give the specifications of the door from the garage into the house. _____ .

6. Name the type of note identified in Question number 5.
_____ .

PROBLEM 4–5 Answer the following questions as you read the floor plan drawing on page 102.

1. Give the overall width and depth of the house from the given dimensions, excluding soffits. _____ .

2. Give the overall dimensions of the GAMES ROOM, including the window projection. Make your calculations from the given exterior dimensions. Show your calculations. _____

_____ .

3. Provide a specific note given for soffit construction. _____

_____ .

4. Give the vertical distance from the lower-left corner of the bedroom (excluding the window projection) to the center of the 2 × 6 PLUMBING WALL. Show your calculations.

_____ .

5. Calculate the vertical distance from the outside face of the wall with the 5050 ARCH TOP to the center of the interior partition of the WARDROBE at the top end of the stair opening. Show your calculations. _____

_____ .

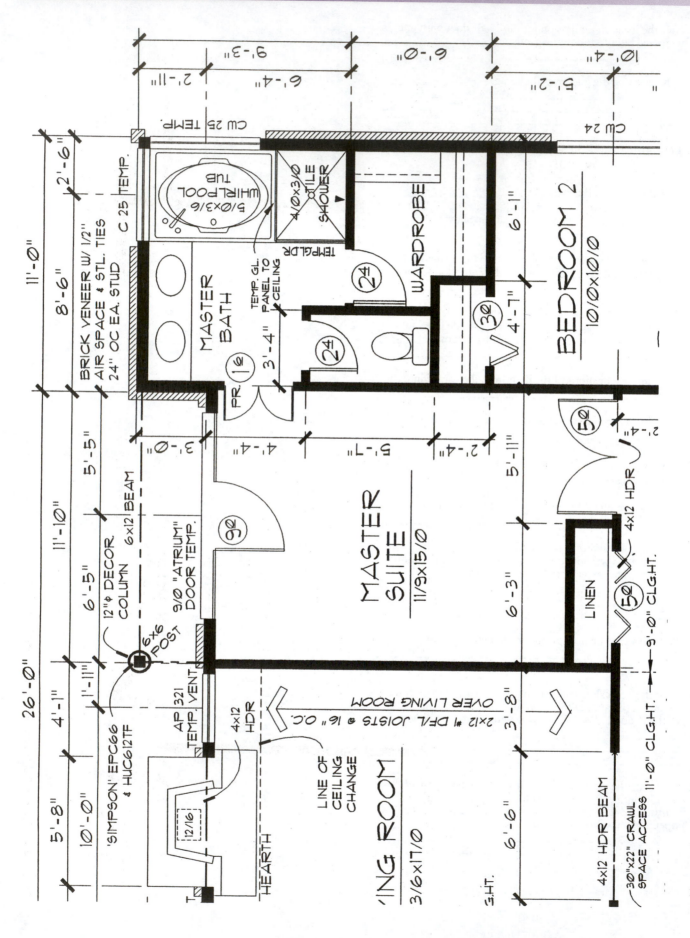

Problem 4-1 *Courtesy Piercy and Barclay Designers, Inc.*

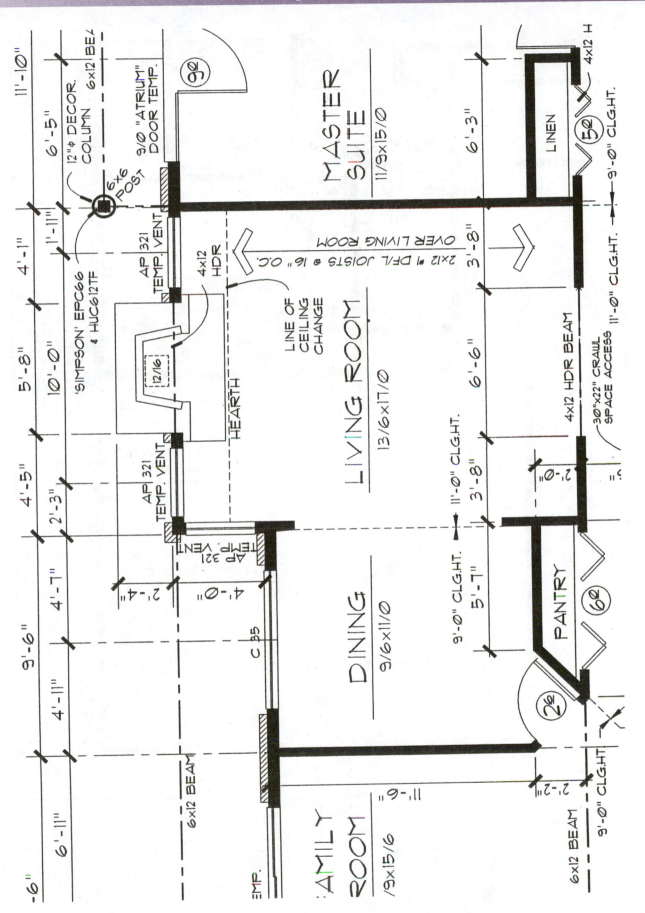

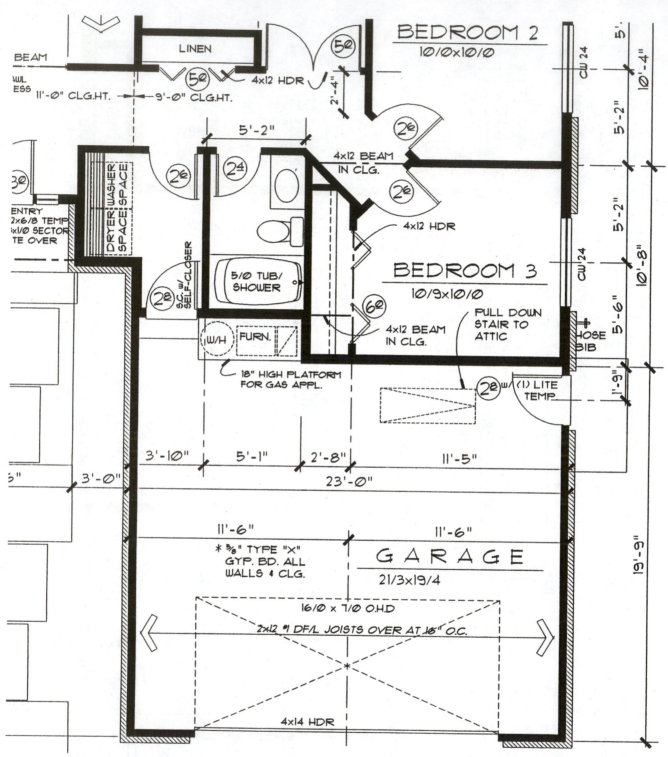

Problem 4–3 *Courtesy Piercy and Barclay Designers, Inc.*

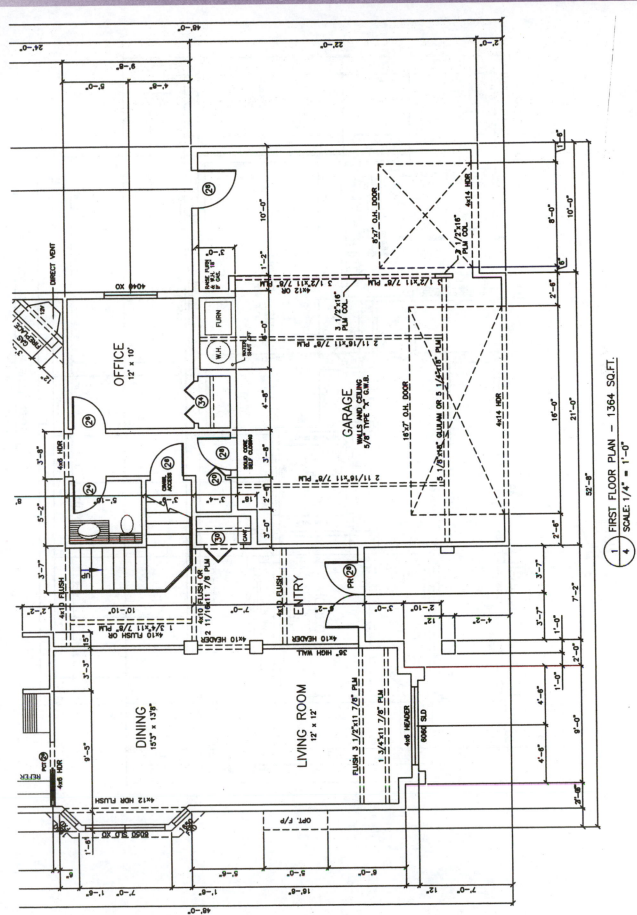

FIRST FLOOR PLAN – 1364 SQ.FT.
SCALE: 1/4" = 1'-0"

Problem 4-4

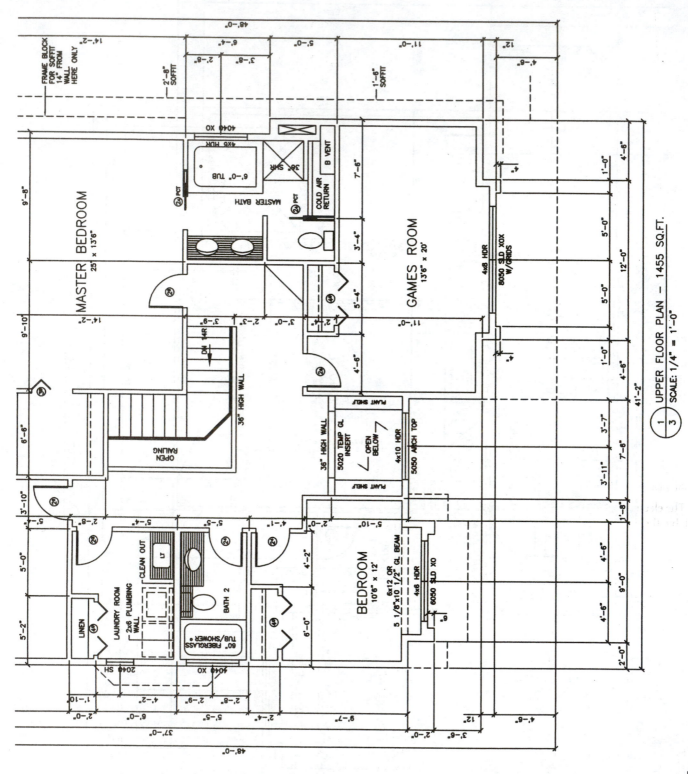

1 UPPER FLOOR PLAN – 1455 SQ.FT.
3 SCALE: 1/4" = 1'-0"

Problem 4-5

Reading Floor Plans, Part 3: Electrical, Plumbing, and HVAC

CHAPTER OVERVIEW

This chapter covers the following topics:

- Electrical plans
- Reading plumbing plans
- Heating, ventilating, and air conditioning (HVAC)
- HVAC plans

- Central vacuum systems
- Test
- Problems

ELECTRICAL PLANS

National electrical code requirements dictate the size of some circuits and the placement of certain outlets and switches within the home.

The electrical plans display all of the circuits and systems to be used by the electrical contractor during installation. Electrical installation for new construction occurs in these three phases:

- Temporary—the installation of a temporary underground or overhead electrical service near the construction site and close to the final meter location.
- Rough-in—when the electrical boxes and wiring are installed. Rough-in happens after the structure is framed and covered with roofing. The electrical meter and permanent service are hooked up.
- Finish—the installation of the light fixtures, outlets and covers, and appliances. This is one of the last construction phases.

Electrical plans may be placed on the floor plan with all the other symbols, information, and dimensions (as discussed in Chapters 14–16). This is a common practice on simple floor plans where the addition of the electrical symbols does not overcomplicate the drawing. Electrical plans are also drawn on a separate sheet that displays the floor plan walls and key symbols, such as doors, windows, stairs, fireplaces, cabinets, and room labels. This chapter takes the latter approach but provides discussion on how both methods might be used. CADD provides an excellent tool for creating electrical plans after the floor plans have been drawn. Floor plan layers that are not needed may be turned off or frozen while the electrical layer is turned on to create the electrical plan. It is easy to create a separate drawing from the key elements of the base drawing in this manner.

Following are definitions of typical terms related to electrical plans and construction. A basic understanding of terminology is important before beginning the electrical drawing.

ELECTRICAL TERMS AND DEFINITIONS

It is important to be familiar with key electrical terminology to help you understand this chapter and communicate effectively.

Ampere: A measurement of electrical current flow. Referred to by its abbreviation: *amp* or *amps*.

Boxes: A box equipped with clamps, used to terminate a conduit. Also known as an *outlet box*. Connections are made in the box, and a variety of covers are available for finish electrical. A premanufactured box or casing is installed during electrical rough-in to house the switches, outlets, and fixture mounting. See Figure 5–1 and *electrical work*.

Breaker: An electric safety switch that automatically opens a circuit when excessive amperage occurs. Also referred to as a *circuit breaker*.

Circuit: The various conductors, connections, and devices found in the path of electrical flow from the source through the components and back to the source.

Conductor: A material that permits the free motion of electricity. Copper is a common conductor in architectural wiring.

Conduit: A metal or fiber pipe or tube used to enclose one or more electrical conductors.

Distribution panel: Where the conductor from the meter base is connected to individual circuit breakers, which are connected to separate circuits for distribution to various locations throughout the structure. Also known as a *panel.*

Electrical work: The installation of the wiring and fixtures for a complete residential or commercial electrical system. The instal-

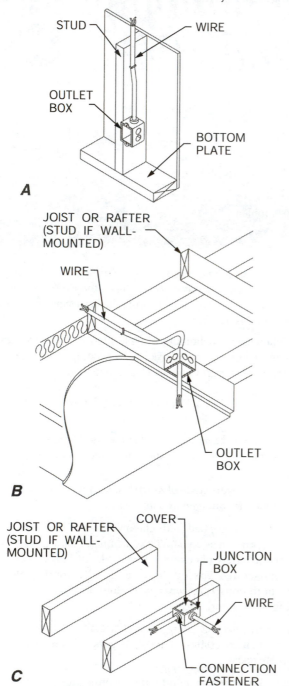

A

B

C

Figure 5–1 Installation of outlets and junction box. (A) Outlet box. (B) Lighting outlet. (C) Junction box.

lation of the wiring is referred to as the *rough-in.* Rough-in takes place after the framing is completed and the structure is *dried-in.* Dried-in refers to installing the roof or otherwise making the building dry. The light fixtures, outlets, and all other final electrical work are done when the construction is nearly complete. This is referred to as the *finish electrical.* The rough-in and finish electrical make up the electrical work.

Ground: An electrical connection to the earth by means of a rod.

Junction box: A box that protects electrical wiring splices in conductors or joints in runs. The box has a removable cover for easy access. See Figure 5–1.

Lighting outlet: An electrical outlet that is intended for the direct connection of a lighting fixture. See Figure 5–1.

Meter: An instrument used to measure electrical quantities. The electrical meter for a building is where the power enters and is monitored for the electrical utility.

Meter base: The mounting base on which the electrical meter is attached. It contains all of the connections and clamps.

Outlet: An electrical connector used to plug in devices. A *duplex outlet,* with two outlets, is the typical wall plug.

Switch leg: The electrical conductor from a switch to the electrical device being controlled.

Volt: The unit of measure for electrical force.

Watt: A unit measure of power.

ELECTRICAL SYMBOLS

Electrical symbols are used to show the lighting arrangement desired in the home. This includes all switches, fixtures, and outlets, as seen in Figure 5–2.

Switch symbols are generally placed perpendicular to the wall and read from the right side or bottom of the sheet. Look at Figure 5–3.

Figure 5–4 shows several typical electrical installations with switches to light outlets. The switch leg or electrical circuit line is usually dashed and shown in a curve.

When special characteristics are required, such as a specific size fixture, a location requirement, or any other specification, a local note that briefly describes the situation may be applied next to the outlet, as shown in Figure 5–5.

Figure 5–6 shows some examples of typical electrical layouts. Figure 5–7 shows a bath layout. Figure 5–8 shows a typical kitchen electrical layout. Figure 5–9 shows a set of electrical floor plans with an electrical symbol legend and related electrical notes. Figure 5–9(a) shows the first floor electrical plan. The second floor electrical plan notes and the electrical legend is displayed in Figure 5–9(b). Figure 5–9(c) shows the basement electrical plan.

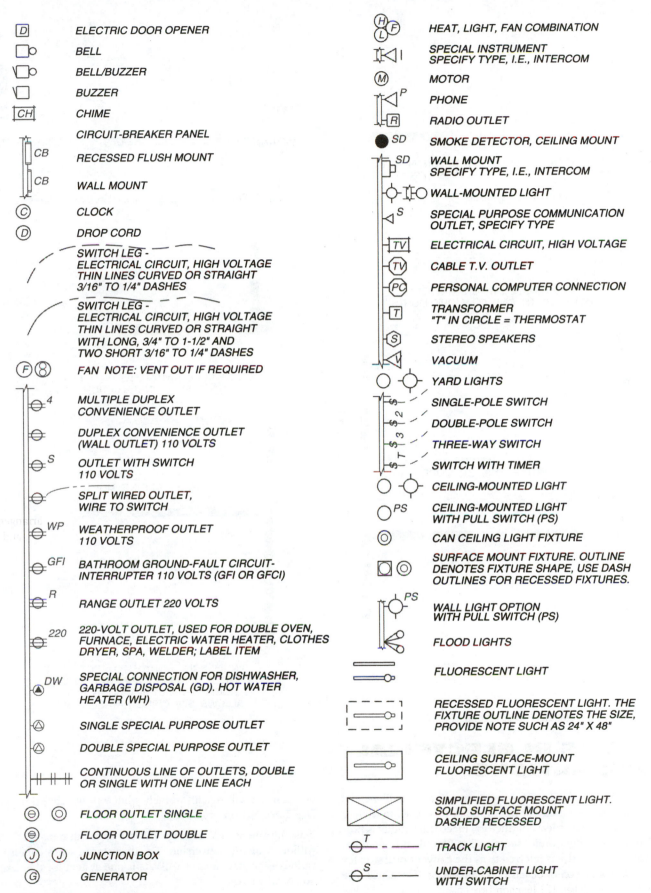

Symbol	Description
D	ELECTRIC DOOR OPENER
	BELL
	BELL/BUZZER
	BUZZER
CH	CHIME
	CIRCUIT-BREAKER PANEL
CB	RECESSED FLUSH MOUNT
CB	WALL MOUNT
C	CLOCK
D	DROP CORD
	SWITCH LEG - ELECTRICAL CIRCUIT, HIGH VOLTAGE THIN LINES CURVED OR STRAIGHT 3/16" TO 1/4" DASHES
	SWITCH LEG - ELECTRICAL CIRCUIT, HIGH VOLTAGE THIN LINES CURVED OR STRAIGHT WITH LONG, 3/4" TO 1-1/2" AND TWO SHORT 3/16" TO 1/4" DASHES
F	FAN NOTE: VENT OUT IF REQUIRED
4	MULTIPLE DUPLEX CONVENIENCE OUTLET
	DUPLEX CONVENIENCE OUTLET (WALL OUTLET) 110 VOLTS
S	OUTLET WITH SWITCH 110 VOLTS
	SPLIT WIRED OUTLET, WIRE TO SWITCH
WP	WEATHERPROOF OUTLET 110 VOLTS
GFI	BATHROOM GROUND-FAULT CIRCUIT-INTERRUPTER 110 VOLTS (GFI OR GFCI)
R	RANGE OUTLET 220 VOLTS
220	220-VOLT OUTLET, USED FOR DOUBLE OVEN, FURNACE, ELECTRIC WATER HEATER, CLOTHES DRYER, SPA, WELDER; LABEL ITEM
DW	SPECIAL CONNECTION FOR DISHWASHER, GARBAGE DISPOSAL (GD). HOT WATER HEATER (WH)
	SINGLE SPECIAL PURPOSE OUTLET
	DOUBLE SPECIAL PURPOSE OUTLET
	CONTINUOUS LINE OF OUTLETS, DOUBLE OR SINGLE WITH ONE LINE EACH
	FLOOR OUTLET SINGLE
	FLOOR OUTLET DOUBLE
J	JUNCTION BOX
G	GENERATOR
H L F	HEAT, LIGHT, FAN COMBINATION
	SPECIAL INSTRUMENT SPECIFY TYPE, I.E., INTERCOM
M	MOTOR
P	PHONE
R	RADIO OUTLET
SD	SMOKE DETECTOR, CEILING MOUNT
SD	WALL MOUNT SPECIFY TYPE, I.E., INTERCOM
	WALL-MOUNTED LIGHT
S	SPECIAL PURPOSE COMMUNICATION OUTLET, SPECIFY TYPE
TV	ELECTRICAL CIRCUIT, HIGH VOLTAGE
TV	CABLE T.V. OUTLET
PC	PERSONAL COMPUTER CONNECTION
T	TRANSFORMER "T" IN CIRCLE = THERMOSTAT
S	STEREO SPEAKERS
	VACUUM
	YARD LIGHTS
S	SINGLE-POLE SWITCH
S 2	DOUBLE-POLE SWITCH
S 3	THREE-WAY SWITCH
S T	SWITCH WITH TIMER
	CEILING-MOUNTED LIGHT
PS	CEILING-MOUNTED LIGHT WITH PULL SWITCH (PS)
	CAN CEILING LIGHT FIXTURE
	SURFACE MOUNT FIXTURE. OUTLINE DENOTES FIXTURE SHAPE, USE DASH OUTLINES FOR RECESSED FIXTURES.
PS	WALL LIGHT OPTION WITH PULL SWITCH (PS)
	FLOOD LIGHTS
	FLUORESCENT LIGHT
	RECESSED FLUORESCENT LIGHT. THE FIXTURE OUTLINE DENOTES THE SIZE, PROVIDE NOTE SUCH AS 24" X 48"
	CEILING SURFACE-MOUNT FLUORESCENT LIGHT
	SIMPLIFIED FLUORESCENT LIGHT. SOLID SURFACE MOUNT DASHED RECESSED
T	TRACK LIGHT
S	UNDER-CABINET LIGHT WITH SWITCH

Figure 5-2 Common electrical symbols.

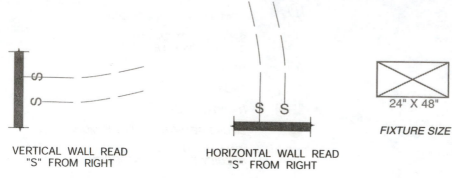

VERTICAL WALL READ "S" FROM RIGHT

HORIZONTAL WALL READ "S" FROM RIGHT

FIXTURE SIZE

24" X 48"

OUTLET HEIGHT

48"

SPECIFIC NOTE

VENT TO OUTSIDE AIR

Figure 5–3 Placement of switch symbols.

Figure 5–5 Special notes placed with electrical fixtures.

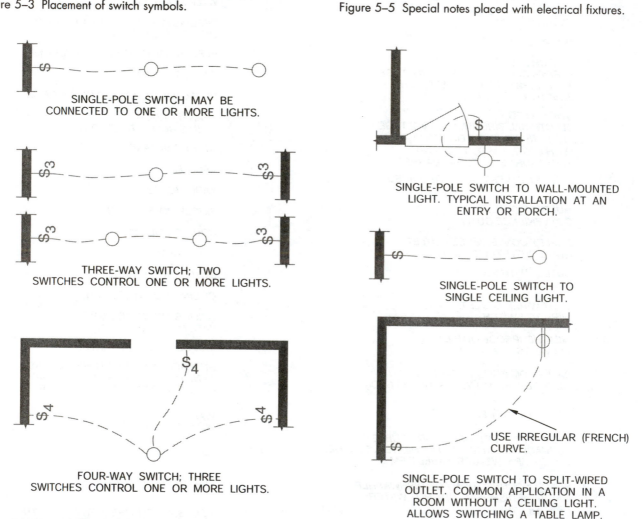

SINGLE-POLE SWITCH MAY BE CONNECTED TO ONE OR MORE LIGHTS.

THREE-WAY SWITCH; TWO SWITCHES CONTROL ONE OR MORE LIGHTS.

FOUR-WAY SWITCH; THREE SWITCHES CONTROL ONE OR MORE LIGHTS.

Figure 5–4 Typical electrical installations.

SINGLE-POLE SWITCH TO WALL-MOUNTED LIGHT. TYPICAL INSTALLATION AT AN ENTRY OR PORCH.

SINGLE-POLE SWITCH TO SINGLE CEILING LIGHT.

USE IRREGULAR (FRENCH) CURVE.

SINGLE-POLE SWITCH TO SPLIT-WIRED OUTLET. COMMON APPLICATION IN A ROOM WITHOUT A CEILING LIGHT. ALLOWS SWITCHING A TABLE LAMP.

METRICS IN ELECTRICAL INSTALLATIONS

Electrical conduit designations are expressed in millimeters. *Electrical conduit* is a metal or fiber pipe or tube used to enclose a single or several electrical conductors. Electrical conduit is produced in decimal inch dimensions and is identified in nominal inch sizes. *Nominal size* is referred to as the conventional size; for example, a 0.500" pipe has a 1/2" nominal size. The actual size of a conduit will remain in inches but will be labeled in metric (see Table 5–1 on page 112).

Existing American Wire Gage (AWG) sizes will remain the same without a metric conversion. The diameter of wires conforms to various gaging systems. The AWG is one system for the designation of wire sizes.

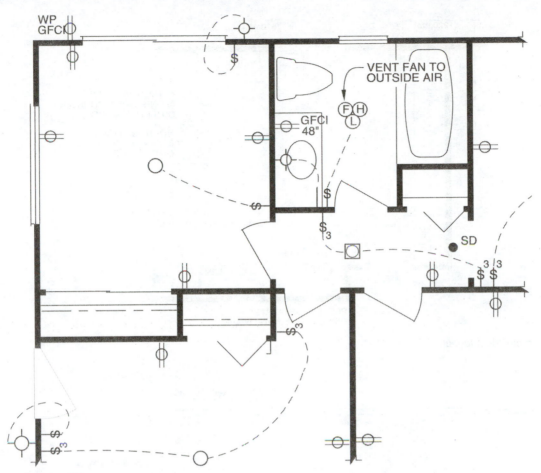

Figure 5–6 Typical electrical layouts.

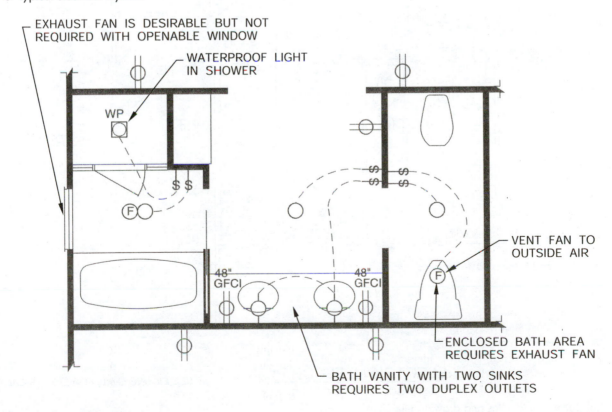

Figure 5–7 Bath electrical layout.

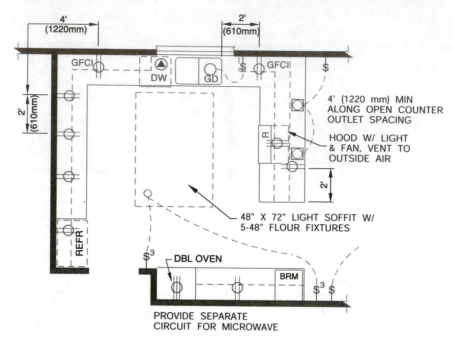

Figure 5–8 Kitchen electrical layout.

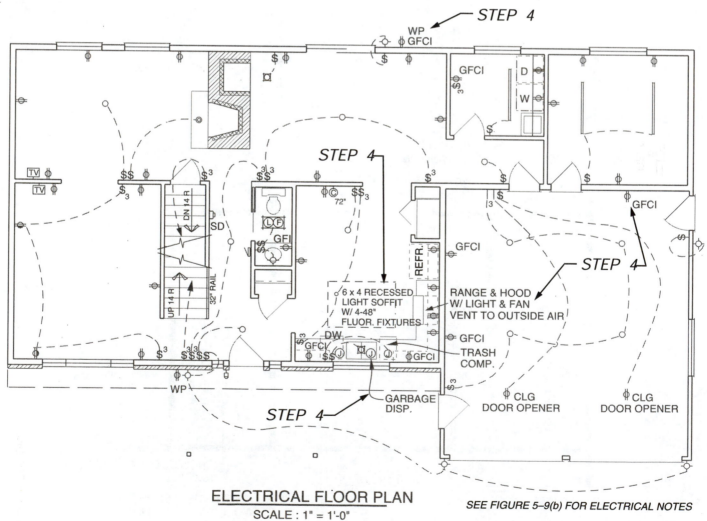

ELECTRICAL FLOOR PLAN
SCALE : 1" = 1'-0"

SEE FIGURE 5–9(b) FOR ELECTRICAL NOTES

Figure 5–9(a) Lettering the notes and drawing title.

ELECTRICAL NOTES:

1. ALL GARAGE AND EXTERIOR PLUGS AND LIGHT FIXTURES TO BE ON GFCI CIRCUIT.

2. ALL KITCHEN PLUGS AND LIGHT FIXTURES TO BE ON GFCI CIRCUIT.

3. PROVIDE A SEPARATE CIRCUIT FOR MICROWAVE OVEN.

4. PROVIDE A SEPARATE CIRCUIT FOR PERSONAL COMPUTER. VERIFY LOCATION WITH OWNER.

5. VERIFY ALL ELECTRICAL LOCATIONS W/ OWNER.

6. EXTERIOR SPOTLIGHTS TO BE ON PHOTO-ELECTRIC CELL W/ TIMER.

7. ALL RECESSED LIGHTS IN EXTERIOR CEILINGS TO BE INSULATION COVER RATED.

8. ELECTRICAL OUTLET PLATE GASKETS SHALL BE INSTALLED ON RECEPTACLE, SWITCH, AND ANY OTHER BOXES IN EXTERIOR WALL.

9. PROVIDE THERMOSTATICALLY CONTROLLED FAN IN ATTIC WITH MANUAL OVERRIDE (VERIFY LOCATION W/ OWNER).

10. ALL FANS TO VENT TO OUTSIDE AIR. ALL FAN DUCTS TO HAVE AUTOMATIC DAMPERS.

11. HOT WATER TANKS TO BE INSULATED TO R-11 MINIMUM.

12. INSULATE ALL HOT WATER LINES TO R-4 MINIMUM. PROVIDE AN ALTERNATE BID TO INSULATE ALL PIPES FOR NOISE CONTROL.

13. PROVIDE 6 SQ. FT. OF VENT FOR COMBUSTION AIR TO OUTSIDE AIR FOR FIREPLACE CONNECTED DIRECTLY TO FIREBOX. PROVIDE FULLY CLOSEABLE AIR INLET.

14. HEATING TO BE ELECTRIC HEAT PUMP. PROVIDE BID FOR SINGLE UNIT NEAR GARAGE OR FOR A UNIT EACH FLOOR (IN ATTIC).

15. INSULATE ALL HEATING DUCTS IN UNHEATED AREAS TO R-11. ALL HVAC DUCTS TO BE SEALED AT JOINTS AND CORNERS.

UPPER FLOOR ELECTRICAL PLAN

SCALE : 1/4" = 1'-0"

ELECTRICAL LEGEND

Symbol	Description	Symbol	Description
○	110 CONVENIENCE OUTLET	$\3	THREE-WAY SWITCH
GFI	110 C.O. GROUND FAULT INTERRUPTER	LHF	LITE, HEATER, & FAN
WP:	110 WATER PROOF	S.D.	SMOKE DETECTOR
●	110 HALF HOT	▽	VACUUM
Ⓙ	JUNCTION BOX	○	CEILING MOUNTED LITE FIXTURE
⊕	220 OUTLET	⊙	CAN CEILING LITE FIXTURE
$	SINGLE POLE SWITCH	⊹	WALL MOUNTED LITE
▢	RECESSED LITE FIXTURE		
P.C.	LITE ON PULL CHORD		
⋎	SPOT LITES		
Ⓢ	STEREO SPEAKER		
⒜	PHONE OUTLET		
Ⓣⓥ	CABLE T.V. OUTLET		
====	48" SURFACE MOUNTED FLOURESCENT LITE FIXTURE		

Figure 5-9(b) Lettering the notes and drawing title.

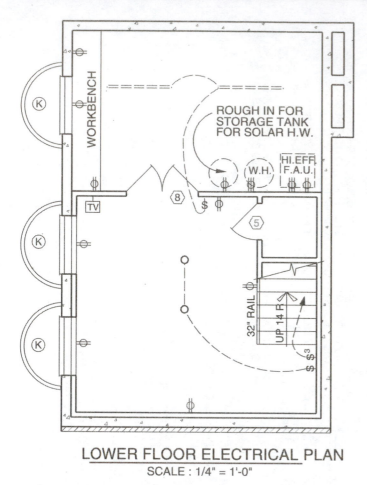

LOWER FLOOR ELECTRICAL PLAN
SCALE : 1/4" = 1'-0"

Figure 5–9(c) The basement electrical plan for sample home used in this book.

READING PLUMBING PLANS

There are two classifications of piping: industrial and residential. Industrial piping is used to carry liquids and gases used in the manufacture of products. Steel pipe with welded or threaded connections and fittings is used in heavy construction.

Residential piping is called plumbing and carries fresh water, gas, or liquid and solid waste. The pipe used in plumbing can be made of copper, plastic, galvanized steel, or cast iron.

Copper pipes have soldered joints and fittings and are used for carrying hot or cold water. Plastic pipes have glued joints and fittings and are used for vents and for carrying fresh water or solid waste. Many contractors are replacing copper pipe with plastic piping for both hot and cold water. One example is a plastic pipe with the chemical name of polybutylene (PB), also known as poly pipe. Some concerns have been addressed about the strength and life expectancy of PB pipe in construction. Plastic polyvinyl chloride (PVC) pipe has been used effectively for cold-water installations. Corrosion-resistant plastic piping is available in a thermoplastic with the chemical name postchlorinated polyvinyl chloride (CPVC). While metal piping loses heat, CPVC pipe retains insula-

TABLE 5–1 CONDUIT SIZE CONVERSION

INCH	METRIC (MM)	INCH	METRIC (MM)
1/2	16	2–1/2	63
3/4	21	3	78
1	27	3–1/2	91
1–1/4	35	4	103
1–1/2	41	5	129
2	53	6	155

tion and saves energy. CPVC piping lasts longer than copper pipe because it is corrosion-resistant, it maintains water purity even under severe conditions, and it does not cause condensation, as copper does. Plastic pipe is considered quieter than copper pipe, and it costs less to buy and install.

Steel pipe is used for large-distribution water piping and for natural-gas installations. Steel pipe is joined by threaded joints and fittings or grooved joints. The steel pipe used for water is galvanized. *Galvanized pipe* is steel pipe that has been cleaned and dipped in a bath of molten zinc. The steel pipe used for natural-gas applications is protected with a coat of varnish. This pipe is commonly referred to as *black pipe* because of its color. Steel pipe is strong, rugged, and fairly inexpensive. However, it is more expensive than plastic and copper pipe, and labor costs for installation are generally higher, because of the threaded joints.

Corrugated stainless steel tubing (CSST) is also used for natural-gas piping. CSST is a flexible piping system that is easier and less expensive to install than black pipe. This type of pipe comes in rolls that allow the plumbing contractor to run pipe through walls and under floors nearly as easily as electric wire. The flexible piping system is easy to cut with traditional pipe cutters and has easy-to-assemble fittings and fixtures.

Stainless steel piping is commonly used in chemical, pollution control, pharmaceutical, and food industries because of its resistance to corrosion. Stainless steel is also sometimes used for water piping in large institutional and commercial buildings.

Cast-iron pipe is commonly used to carry solid and liquid waste as the sewer pipe that connects a structure with a local or regional sewer system. Cast-iron pipe can also be used for the drain system throughout the structure to help reduce water flow noise substantially in the pipes. It is more expensive than plastic pipe but can be worth the price if a quiet plumbing system is desired.

Residential plans may not require a complete plumbing plan. The need for a complete plumbing plan should be verified with the local building code. In most cases, the plumbing requirements can be clearly provided on the floor plan in the form of symbols for fixtures and notes for specific applications or conditions. The plumbing fixtures are found in their proper locations on the floor plans at a typical scale of 1/4" = 1'-0".

Templates with a large variety of floor plan plumbing symbols are available.

Other plumbing items to be added to the floor plan include floor drains, vent pipes, and sewer or water connections. Floor drains are shown in their approximate locations, with a note identifying size, type, and slope to drain. Vent pipes are shown in the wall where they are to be located and labeled by size. Sewer and water service lines are located in relationship to the position in which these utilities enter the home. The service lines are commonly found on the plot plan. In the situation described here, where a very detailed plumbing layout is not provided, the plumbing contractor is required to install plumbing of a quality and in a manner that meets local code requirements and are economical. Figure 5–10 shows plumbing fixture symbols in plan, frontal, and profile view. Figure 5–11 shows a complete residential floor plan with the plumbing symbols highlighted for your reference.

PLUMBING TERMS AND DEFINITIONS

To understand the contents of this chapter, and to communicate effectively, it is important for you to understand key plumbing terminology.

Cleanout: A fitting with a removable plug that is placed in plumbing drainage pipe lines to allow access for cleaning out the pipe.

Drain: Any pipe that carries wastewater in a building drainage system.

Fitting: A standard pipe part such as a coupling, elbow, reducer, tee, and union; used for joining two or more sections of pipe together.

Hose bibb: A faucet that is used to attach a hose.

Lavatory: A fixture that is designed for washing hands and face, usually found in a bathroom.

Main: The primary supply pipe, also called *water main* or *sewer main,* depending on its purpose.

Plumbing fixture: A unit used to contain and discharge waste. Examples of fixtures are sinks, lavatories, showers, tubs, and water closets.

Plumbing system: The plumbing system of a building has these elements:

■ water supply pipes.

■ fixtures and fixture traps.

■ soil, waste, and vent pipes.

■ drain and sewer.

■ storm water drainage.

Plumbing wall: The walls in a building where plumbing pipes are installed.

Potable water: Drinking water, which is free from impurities.

Riser: A water supply pipe that extends vertically one story or more to carry water to fixtures.

Rough-in: Installation of the plumbing system before the installation of fixtures.

Run: The portion of a pipe or fitting continuing in a straight line in the direction of flow in which it is connected.

Sanitary sewer: A sewer that carries sewage without any storm, surface, or groundwater.

Sewer: A pipe, normally underground, that carries wastewater and refuse.

Soil pipe: A pipe that carries the discharge of water closets or other similar fixtures.

Soil stack: A vertical pipe that extends one or more floors and carries discharges of water closets and other similar fixtures.

Stack: A general term referring to any vertical pipe for soil waste or vent piping.

Storm sewer: A sewer used for carrying groundwater, rainwater, surface water, or other nonpolluting waste.

Trap: A vented fitting that provides a liquid seal to prevent the emission of sewer gases without affecting the flow of sewage or wastewater.

Valve: A fitting that is used to control the flow of fluid or gas.

Vanity: A bathroom lavatory fixture that is freestanding or in a cabinet.

Vent pipe: The pipe installed to ventilate the building drainage system and to prevent drawing liquid out of traps and stopping back pressure.

Waste pipe: A pipe that carries only liquid waste free of fecal material.

Waste stack: A vertical pipe that runs one or more floors and carries the discharge of fixtures other than water closets and similar fixtures.

Water closet: A water-flushing plumbing fixture, such as a toilet, that is designed to receive and discharge human excrement. This term is sometimes used to mean the compartment where the fixture is located.

Water-distributing pipe: A pipe that carries water from the service to the point of use.

Water heater: An appliance used for heating and storing hot water.

Water main: See *Main.*

Water meter: A device used to measure the amount of water that goes through the water service.

Water service: The pipe from the water main or other supply to the water-distributing pipes.

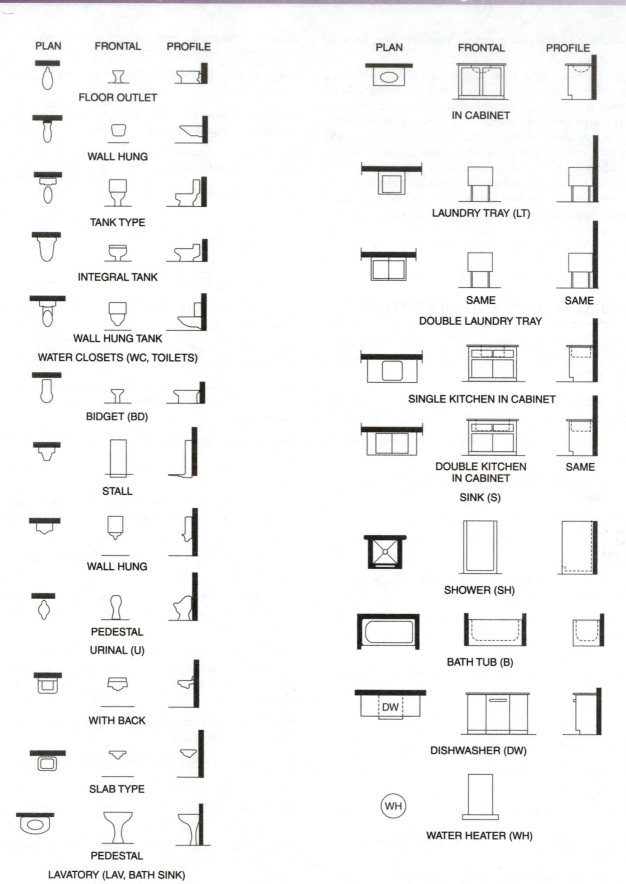

Figure 5–10 Common plumbing fixture symbols.

Figure 5–11 A complete residential floor plan with the plumbing symbols highlighted. *Courtesy Piercy and Barclay, Inc.*

PLUMBING SCHEDULES

Plumbing schedules are similar to door, window, and finish schedules. Schedules provide specific information regarding plumbing equipment, fixtures, and supplies. The information is condensed in a chart so the floor plan is not unnecessarily crowded with information. Figure 5–12 shows a typical plumbing fixture schedule.

Other schedules may include specific information regarding floor drains, water heaters, pumps, boilers, or radiators. These schedules generally key specific items to the floor plan with

complete information describing size, manufacturer, type, and other specifications as appropriate.

Mortgage lenders may require a complete description of materials for the structure. Part of the description often includes a plumbing section in which certain plumbing specifications are described, as shown in Figure 5–13.

PLUMBING FIXTURE SCHEDULE

LOCATION	ITEM	MANUFACTURER	REMARKS
MASTER BATH	36" F.G. SHR. COLOR BIDET C.I. SR. COLOR LAV. COLOR W. C.	HYTEC K-4868 K-2904 K-3402-PBR	M2620 BRASS K1940 BRASS M4625 BRASS PLAS. SEAT
BATH #2	KEG STYLE TUB C.I. COLOR PED. LAV. COLOR W.C.	KOHLER KOHLER K3402-PBR	M2850 BRASS M4625 BRASS PLAS. SEAT
BATH #3	URINAL F.G. SHOWER C.I. LAVS.	K-4980 HYTEC K2904	M2620 BRASS M4625 BRASS
KITCHEN	C.I. 3 HOLE SINK	K5960	M7531 BRASS
WATER HTR.	82 GAL. ELEC.	MORFIO	P & T VALVE
UTILITY	F.G. LAUN. TRAY	24 X21	D2121 BRASS

Figure 5–12 A typical plumbing fixture schedule.

PLUMBING DRAWINGS

Plumbing drawings usually are not shown on the same sheet as the complete floor plan. The only plumbing items shown on the floor plans are fixtures, as previously explained. The plumbing drawing is often placed over an outline of the floor plan showing all walls, partitions, doors, windows, plumbing fixtures, and utilities.

Plumbing drawings are prepared by the architectural office or in conjunction with a plumbing contractor. In some situations, when necessary, plumbing contractors work up their own rough sketches or field drawings. Plumbing drawings are made up of lines and symbols that show how liquids, gases, or solids are transported to various locations in the structure. Plumbing lines and features are drawn thicker than wall lines so they are clearly distinguishable. Symbols identify types of pipes, fittings, valves, and other components of the system. Sizes and specifications are provided in local or general notes. Figure 5–14 shows some typical plumbing piping symbols. Certain abbreviations are commonly used in plumbing drawings, as shown in Figure 5–15.

PLUMBING						
FIXTURE	NUMBER	LOCATION	MAKE	MANUFACTURER'S FIXTURE ID NUMBER	SIZE	COLOR
SINK						
LAVATORY						
WATER CLOSET						
BATHTUB						
SHOWER OVER TUB △						
STALL SHOWER △						
LAUNDRY TRAYS						

△ □ Curtain rod △ □ Door □ Shower pan: material _____

Water Supply: □ public; □ community system; □ individual (private) system. ★

Sewage disposal: □ public; □ community system; □ individual (private) system. ★

★ Show and describe individual system in complete detail in separate drawings and specifications according to requirements.

House drain (inside): □ cast iron; □ tile; □ other _____ ; House sewer (outside): □ cast iron; □ tile; □ other _____

Water piping: □ galvanized steel; □ copper tubing; □ other _____ ; Sill cocks, number _____

Domestic water heater: type _____ ; make and model _____ ; heating capacity _____

_____ gph 100° rise; Storage tank: material _____ ; capacity _____ gallons.

Gas service: □ utility company; □ liq. pet. gas; other _____ ; Gas piping: □ cooking: □ house heating.

Footing drains connected to: □ storm sewer; □ sanitary sewer; □ dry well; Sump pump; make and model _____

_____ ; capacity _____ ; discharges into _____

Figure 5–13 Form for description of plumbing materials.

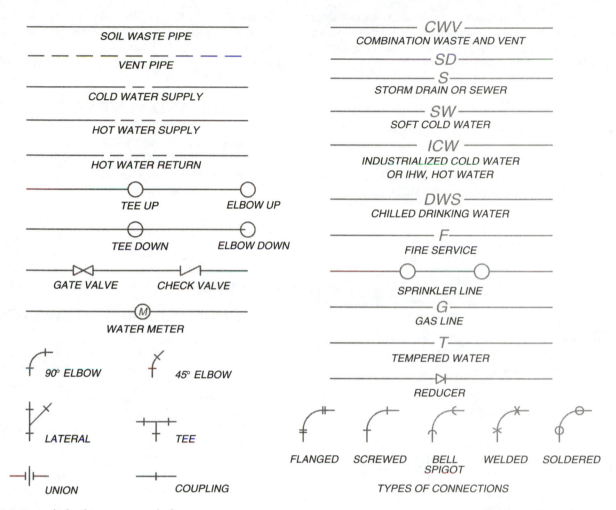

Figure 5–14 Typical plumbing pipe symbols.

WATER SYSTEMS

Water supply to a structure begins at a water meter for public systems or from a water storage tank for private well systems. The water supply to the home or business, known as the main line, is generally 1" plastic pipe. This size can vary in relationship to the service needed. The plastic main line joins a copper line within a few feet of the structure. The balance of the water system piping is usually copper pipe, although plastic pipe is increasing in popularity for cold-water applications. The 1" main supply often changes to 3/4" pipe where a junction is made to distribute water to various specific locations. From the 3/4" distribution lines, 1/2" pipe usually supplies water to specific fixtures; for example, the kitchen sink. Figure 5–16 shows a typical installation from the water meter of a house with distribution to a kitchen. The water meter location and main line representation are generally shown on the plot plan. Verify local codes regarding the use of plastic pipe.

There is some advantage to placing plumbing fixtures back to back when possible. This practice saves materials and labor costs. Plumbing fixtures one above the other aids in an economical installation for two-story buildings. Figure 5–17 shows a back-to-back bath situation. If the design allows, another common

CURRENT		MCS	
CW	Cold water supply	WC	Water closet (toilet)
HW	Hot water supply	LA	Lavatory (bath sink)
HWR	Hot water return	B	Bathtub
HB	Hose bibb	S	Sink
CO	Cleanout	U	Urinal
DS	Downspout	SH	Shower
RD	Rain drain	DF	Drinking fountain
FD	Floor drain	WH	Water heater
SD	Shower drain	DW	Dishwasher
CB	Catch basin	BD	Bidet
MH	Manhole	GD	Garbage disposal
VTR	Vent through roof	CW	Clothes washer

Figure 5–15 Some typical plumbing abbreviations.

installation may be a bath and laundry room next to each other or to provide a common plumbing wall. See Figure 5–18. If a specific water temperature is required, that specification can be applied to the hot-water line, as shown in Figure 5–19.

HOSE BIBBS

Hose bibbs are faucets that are used to attach a hose. Outside hose bibbs require a separate valve that allows the owner to turn off the water to the hose bibb during freezing weather. The separate valve must be located inside a heated area and is generally under a cabinet where a sink is located, such as in the kitchen or bathroom.

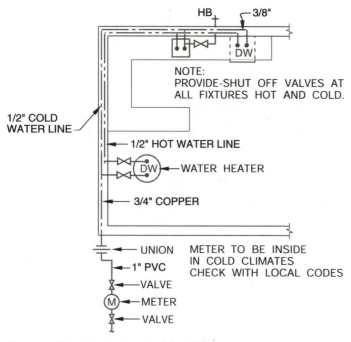

Figure 5–16 Partial water supply system.

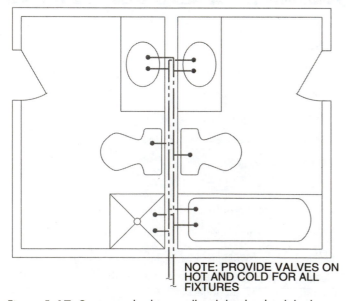

Figure 5–17 Common plumbing wall with back-to-back baths.

This provides easy access to the valve. Frost-proof hose bibbs do not require a separate inside valve, but the stem must extend through the building insulation into an open heated or semiconditioned space to avoid freezing. Notice the hose bibb (HB) symbol on the print in Figure 5–21.

DRAINAGE AND VENT SYSTEMS

The drainage system provides for the distribution of solid and liquid waste to the sewer line. The vent system allows a continuous flow of air through the system so gases and odors can dissipate and bacteria do not have an opportunity to grow. These pipes throughout the house are generally made of PVC, although the pipe from the house to the concrete sewer pipe is commonly 3" or 4" cast iron. Drainage and vent systems, as with water systems, are drawn with thick lines using symbols, abbreviations, and notes. Figure 5–20 shows a sample drainage vent system. Figure 5–21 shows a house plumbing plan.

ISOMETRIC PLUMBING DRAWINGS

Isometric drawings may be used to provide a three-dimensional representation of a plumbing layout. Especially for a two-story structure, an isometric drawing provides an easy-to-understand pictorial drawing. Figure 5–22 shows an isometric drawing of the system shown in plan view in Figure 5–20. Figure 5–23 shows a detailed isometric drawing of a typical drain, waste, and vent system. Figure 5–24 shows a single-line isometric drawing of the detailed isometric drawing shown in Figure 5–23. Figure 5–25 shows a detailed isometric drawing of a hot- and cold-water supply system. Figure 5–26 shows a single-line isometric drawing of the same system.

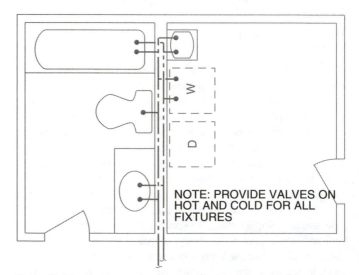

Figure 5–18 Common plumbing wall with a bath and laundry back to back.

——— – – ——— – – ——— 120° ——— – – ———

Figure 5–19 Hot-water temperature.

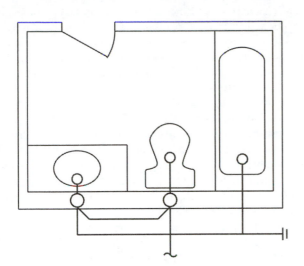

Figure 5–20 Drainage and vent drawing.

SEWAGE DISPOSAL

Public Sewers. Public sewers are available in and near most cities and towns. The public sewers are generally located under the street or an easement adjacent to the construction site. In some situations the sewer line may have to be extended to accommodate another home or business in a newly developed area. The cost of this extension may be the responsibility of the developer. The cost of this construction usually includes installation expenses, street repair, sewer tap, and permit fees. Figure 5–27 shows an illustration of a sewer connection and the plan view usually found on the plot plan.

Private Sewage Disposal: A Septic System. The septic system consists of a storage tank and an absorption field and operates as follows. Solid and liquid waste enters the septic tank where it is stored and begins decomposition into sludge. Liquid material, or effluent, flows from the tank outlet and is dispersed into a soil-absorption field, or drain field (also known as leach lines). When the solid waste has effectively decomposed, it also dissipates into the soil-absorption field.

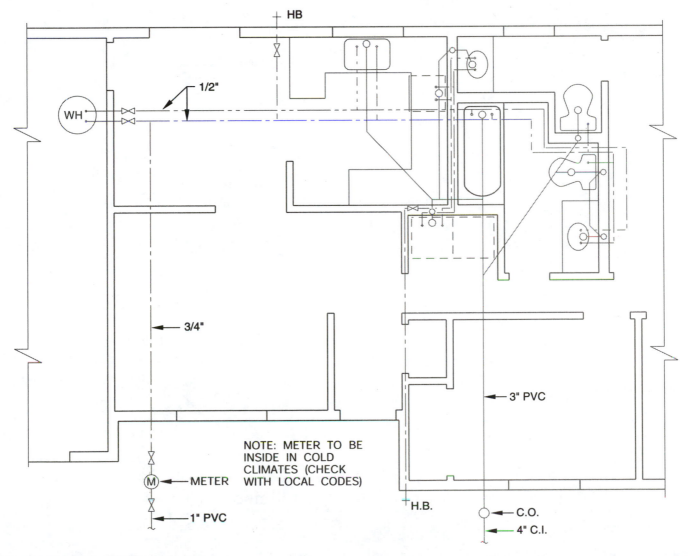

Figure 5–21 Residential plumbing plan.

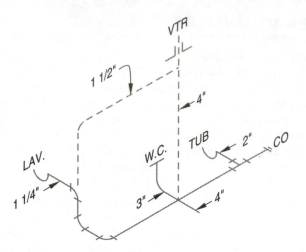

Figure 5–22 Single-line isometric drawing of a drainage and vent system.

The characteristics of the soil must be verified for suitability for a septic system by a soil-feasibility test, also known as a percolation test. This test will determine if the soil will accommodate a septic system. The test should also identify certain specifications that should be followed for system installation. The U.S. Veterans Administration (VA) and the U.S. Federal Housing Administration (FHA) require a minimum of 240' of field line. Verify these dimensions with local building officials. When the soil characteristics do not allow a conventional system, there may be some alternatives, such as a sand-filter system, which filters the effluent through a specially designed sand filter before it enters the soil absorption field. Check with your local code officials before installing such a system. Figure 5–28 shows a typical serial septic system. The serial system allows one drain field line to fill before the next line is used. The drain field lines must be level and must follow the contour of the land perpendicular to the slope. The drain field should be at least 100' from a water well, but verify the distance with local codes. There is usually no minimum distance to a public water supply.

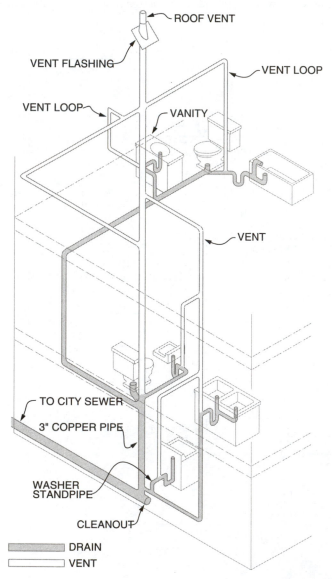

Figure 5–23 Detailed isometric drawing of a drain, waste, and vent system.

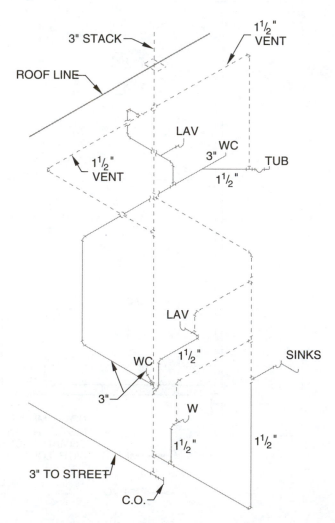

Figure 5–24 Single-line isometric drawing of a drain, waste, and vent system.

METRICS IN PLUMBING

Pipe is made of a wide variety of materials identified by trade names; the nominal sizes are related only loosely to actual dimensions. For example, a 2" galvanized pipe has an inside diameter of about 2–1/8" but is called 2" pipe for convenience. Since few pipe products have even inch dimensions that match their specifications, there is no reason to establish even metric sizes. Metric values estab-

lished by the International Organization for Standardization relate nominal pipe sizes (NPS) in inches to metric equivalents, referred to as diameter nominal (DN). The following equivalents relate to all plumbing, natural gas, heating, oil, drainage, and miscellaneous piping used in buildings and civil works projects.

In giving a metric pipe size, it is recommended that DN precede the metric value. For example, the conversion of a 2–1/2" pipe to metric is DN65.

The standard thread for thread pipe is the National Standard Taper Pipe Threads (NPT). The thread on 1/2" pipe reads

Figure 5–25 Detailed isometric drawing of a hot- and cold-water system.

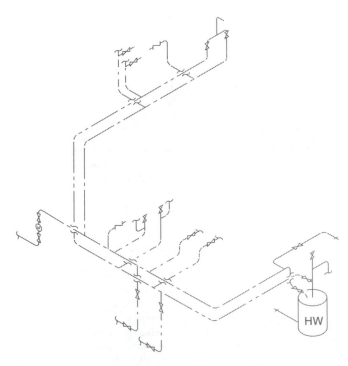

Figure 5–26 Single-line isometric drawing of a hot- and cold-water system

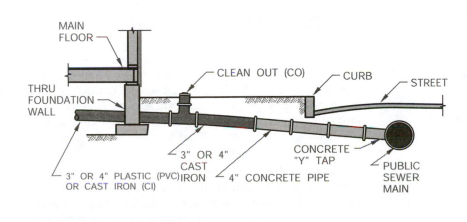

SECTION VIEW

Figure 5–27 Public sewer system.

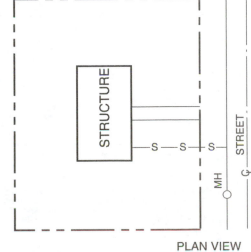

PLAN VIEW

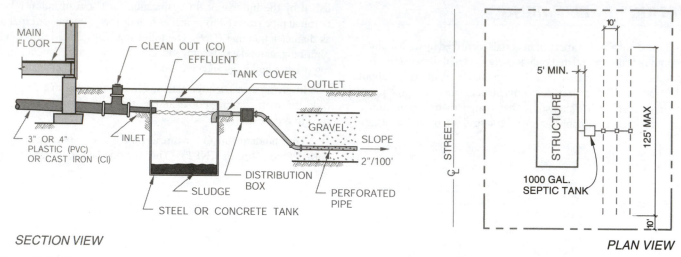

SECTION VIEW

PLAN VIEW

Figure 5–28 Septic sewer system.

LEGEND

──────	W	SANITARY WASTE ABOVE SLAB
─ ─ ─ ─	W	SANITARY WASTE BELOW SLAB
─────	HW	DOMESTIC HOT WATER
─ ─ ─ ─	V	VENT
─── ───	CW	DOMESTIC COLD WATER
──G──	G	GAS (NATURAL)
──A──	A	COMPRESSED AIR
──VA──	VA	LABORATORY VACUUM
──CW_A──	CW_A	COLD WATER (ASPIRATOR)
──DI──	DI	DEIONIZED WATER
─◁▷─◁▷─		GATE VALVE/GLOBE VALVE
──▷──		PIPE REDUCER
──⊕──		SPRINKLER HEAD
Ⓒ		CONNECT TO EXISTING
Ⓔ		EXISTING TO REMAIN
Ⓡ		RELOCATE EXISTING
⊗		REMOVE EXISTING

CONNECTION SCHEDULE Ⓐ

SYMBOL	DESCRIPTION	CW	HW	W	V	REMARKS
S-1	SINK	1/2"	1/2"	2"	1-1/2"	STAINLESS
S-2	SINK	1/2"	1/2"	2"	1-1/2"	STAINLESS
WSF-1	WATER SUPPLY FITTING	1/2"	1/2"	—	—	ASPIRATOR
WSF-2	WATER SUPPLY FITTING	1/2"	1/2"	—	—	DEIONIZED WATER

Ⓐ PLUMBING FIXTURES ONLY - G, VC AND A
BRANCH SIZES NOTED ON 2/M1. VERIFY
CONNECTION REQUIREMENTS WITH FIXTURES
FURNISHED.

NOTES

② PROVIDE GATE VALVE IN BRANCH BEFORE TAKEOFF.

③ MOUNT ALL PIPING BELOW COUNTER TIGHT TO WALL

④ PROVIDE HARD CONNECTION FROM GAS OUTLET
TO 3/8" NPT HOOD GAS COCKS. PROVIDE MISC.
FITTINGS AS REQUIRED. VERIFY EXACT CONNECTION
LOCATIONS WITH ACTUAL HOOD FURNISHED BY OWNER.

Figure 5–29 Some common plumbing symbols, a schedule, and general notes. *Courtesy System Design Consultants.*

1/2–14NPT, where 14 is threads per inch. The metric conversion affects only the nominal pipe size—1/2" in this case. The conversion of the 1/2–14NPT pipe thread to metric is DN15–14NPT.

SPECIAL SYMBOLS, SCHEDULES, AND NOTES ON A PLUMBING DRAWING

As with any other drawing, plumbing information can be provided in the form of special symbols, schedules, and general notes. Figure 5–29 shows special symbols in a *legend*, and an example of a plumbing connection schedule and general notes. Architectural and mechanical engineering offices often place a legend on the drawing for reference. The legend displays symbols used on the drawing. The legend and many general notes are often saved as a *block* for insertion in any drawing when needed.

HEATING, VENTILATING, AND AIR CONDITIONING (HVAC) PLANS

CENTRAL FORCED-AIR SYSTEMS

One of the most common systems for heating and air conditioning circulates the air from the living spaces through or around heating or cooling devices. A fan forces the air into sheet metal or plastic pipes called *ducts*, and the ducts connect to openings called *diffusers*, or *air supply* registers. Warm air (WA) or cold air (CA) passes through the ducts and registers to enter the rooms and either heats or cools them as needed.

Air then flows from the room through another opening into the return duct, or return-air register (RA). The return duct directs the air from the rooms over the heating or cooling device. If warm air is required, the return air is passed over either the surface of a combustion chamber (the part of a furnace where fuel is burned) or a heating coil. If cool air is required, the return air passes over the surface of a cooling coil. Finally, the conditioned

air is picked up again by the fan and the air cycle is repeated. Figure 5–30 shows the air cycle in a forced-air system.

Heating Cycle. If the air cycle just described is used for heating, the heat is generated in a furnace. Furnaces for residential heating produce heat by burning fuel oil or natural gas, or from electric heating coils. If the heat comes from burning fuel oil or natural gas, the combustion (burning) takes place inside a combustion chamber. The air to be heated does not enter the combustion chamber but absorbs heat from the outer surface of the chamber. The gases given off by combustion are vented through a chimney. In an electric furnace, the air to be heated is passed directly over the heating coils. This type of furnace does not require a chimney.

Cooling Cycle. If the air from the room is to be cooled, it is passed over a cooling coil. The most common type of residential cooling system is based on two principles:

1. As liquid changes to vapor, it absorbs large amounts of heat.

2. The boiling point of a liquid can be changed by changing the pressure applied to the liquid. This is the same as saying that the temperature of a liquid can be raised by increasing its pressure and lowered by reducing its pressure.

Common refrigerants can boil (change to a vapor) at very low temperatures, some as low as 21°F below zero.

The principal parts of a refrigeration system are the cooling coil (evaporator), compressor, condenser, and expansion valve. Figure 5–31 shows a diagram of the cooling cycle. The cooling cycle operates as warm air from the ducts is passed over the evaporator. As the cold liquid refrigerant moves through the evaporator coil, it picks up heat from the warm air. As the liquid picks up heat, it changes to a vapor. The heated refrigerant vapor is then drawn into the compressor, where it is put under high pressure. This causes the temperature of the vapor to rise even more.

Next, the high-temperature, high-pressure vapor passes to the condenser, where the heat is removed. This is done by blowing air over the coils of the condenser. As the condenser removes heat, the vapor changes to a liquid. It is still under high pressure, however. From the condenser, the refrigerant flows to the expansion valve. As the liquid refrigerant passes through the valve, the pressure is reduced which lowers the temperature of the liquid even farther so that it is ready to pick up more heat.

The cold, low-pressure liquid then moves to the evaporator. The pressure in the evaporator is low enough to allow the refrigerant to boil again and absorb more heat from the air passing over the coil of the evaporator.

Forced-Air Heating Plans. Complete plans for the heating system may be needed when applying for a building permit or a mortgage depending upon the requirements of the local building jurisdiction or the lending agency. If a complete heating layout is required, it is prepared by the architect, mechanical engineer, or heating contractor.

When forced-air electric, gas, or oil heating systems are used, the warm-air outlets and return-air locations can be shown as in Figure 5–32. Notice the registers are normally placed in front of a window so that warm air is circulated next to the coldest part of the room. As the warm air rises, a circulation action is created as the air goes through the complete heating cycle. Cold-air returns are often placed in the ceiling or floor of a central location.

A complete forced-air heating plan shows the size, location, and number of BTUs dispersed to the rooms from the warm-air supplies. BTU stands for British Thermal Unit, which is a measure of heat. The location and size of the cold-air return and the location, type, and output of the furnace are also shown.

The warm-air registers are sized in inches, for example, 4 × 12. The size of the duct is also given, as shown in Figure 5–33. The note 20/24 identifies a 20" × 24" register and a number 8 next to a duct labels an 8"-diameter duct. This same system may be used as a central cooling system when cool air is forced from an air conditioner through the ducts and into the rooms. WA denotes warm air, and RA is return air. CFM is cubic feet per minute, the rate of airflow.

PROVIDING DUCT SPACE

When ducted heating and cooling systems are used, the location of the ducts often becomes a serious consideration. The ducts are placed in a crawl space or attic when possible. When ducts cannot be confined to a crawl space or attic, they must be run inside the occupied areas of the home or building. The designer and building contractor try to conceal ducts when they must be placed in locations where they could be seen. There are several ways to conceal ducts.

When they run parallel to structural members, ducts can be placed within the space created by the structural members. This is referred to as running the ducts in the *joist space, rafter space,* or *stud space*; these terms identify the type of construction members used. This works when the duct size is equal to or smaller than the size of the construction members. In the case of return-air ducts, the construction members and enclosing materials can be used as the duct plenum. When this can be done, no extra framing is needed to be done to conceal the ducts. When ducts must be exposed to occupied areas, they are normally enclosed by framing covered with gypsum or other finish material. When ducts are run in an area, such as an unfinished basement, it is possible to leave them exposed.

When possible, ducts are run in the ceiling of a hallway, because they can be framed and finished with a lowered ceiling. The minimum ceiling height in hallways can be 7'–0" (2134 mm). Bathrooms and kitchens can also have a minimum ceiling height of 7'–0" (2134 mm), though this is normally undesirable. The typical ceiling height in habitable rooms is approximately 8' (2440 mm), but a ceiling can be as low as 7'–6" (2286 mm) for at least 50 percent of the room, with no portion less than 7'–0" (2134 mm). This information is valuable, because it tells you how low ceilings can be framed down to provide space for ducts. When running ducts along a ceiling creates a problem with ceiling height, the wall framing needs to be higher to give enough floor-to-ceiling height.

When ducts must be run between floors, they need to be run in an easily concealed location, such as in a closet or in the stud space. The stud space can be used for ducts that are 3–1/2" deep for

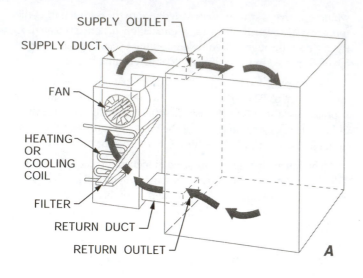

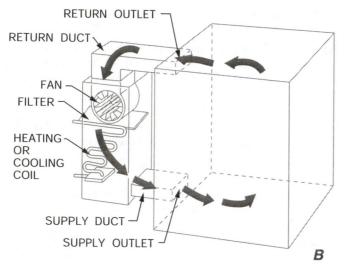

Figure 5–30 (a) Downdraft forced-air system heated-air cycle. (b) Updraft forced-air system heated-air cycle.

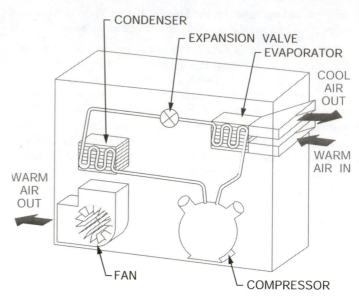

Figure 5–31 Schematic diagram of a refrigeration cycle. *From Lang*, Principles of Air Conditioning, *3rd Ed.*

2 × 4 studs, 5–1/2" deep for 2 × 6 studs, or 7–1/2" deep for 2 × 8 studs. If the duct can be run up through a closet, it can be framed in and covered in a chase. A *chase* is a continuous recessed area built to carry or conceal ducts, pipes, or other construction products. If the duct cannot be located in a convenient place for concealment, it might need to be framed into the corner of a room, although this is normally not preferred. The framing for a chase is shown on the floor plan as a wall surrounding the duct to be concealed, and a note is usually placed that indicates the use, such as CHASE FOR 22 × 24 RETURN DUCT.

Hot-Water Systems. In a hot-water system, the water is heated in an oil- or gas-fired boiler and then circulated through pipes to radiators or convectors in the rooms. The boiler is supplied with water from the fresh-water supply for the house. The water is circulated around the combustion chamber, where it absorbs heat.

In a one-pipe system, one pipe leaves the boiler and runs through the rooms of the building and back to the boiler. The heated water leaves the supply, is circulated through the outlet, and is returned to the same pipe, as shown in Figure 5–34. In a two-pipe system, two pipes run throughout the building. One pipe supplies heated water to all of the outlets. The other is a return pipe that carries the water back to the boiler for reheating, as seen in Figure 5–35.

Hot-water systems use a pump, called a circulator, to move the water through the system. The water is kept at a temperature between 150° and 180°F in the boiler. When heat is needed, the thermostat starts the circulator, which supplies hot water to the convectors in the rooms.

HEAT-PUMP SYSTEMS

The heat pump is a forced-air central heating and cooling system. It operates using a compressor and a circulating-refrigerant system. Heat is extracted from the outside air and pumped inside the structure. The heat pump supplies up to three times as much heat per year for the same amount of electrical consumption as a standard, electric forced-air heating system. In comparison, this can result in a 30 to 50 percent annual energy savings. In the summer the cycle is reversed and the unit operates as an air conditioner. In this mode, the heat is extracted from the inside air and pumped outside. On the cooling cycle the heat pump also acts as a dehumidifier. Figure 5–36 shows a graphic example of how a heat pump works.

ZONE-CONTROL SYSTEMS

A zoned-heating system requires one heater and one thermostat per room. No ductwork is required, and only the heaters in occupied rooms need be turned on.

One of the major differences between a zoned and a central system is flexibility. A zoned-heating system allows the home occupant to determine how many rooms are heated, how much energy is used, and how much money is spent on heat. A zoned system

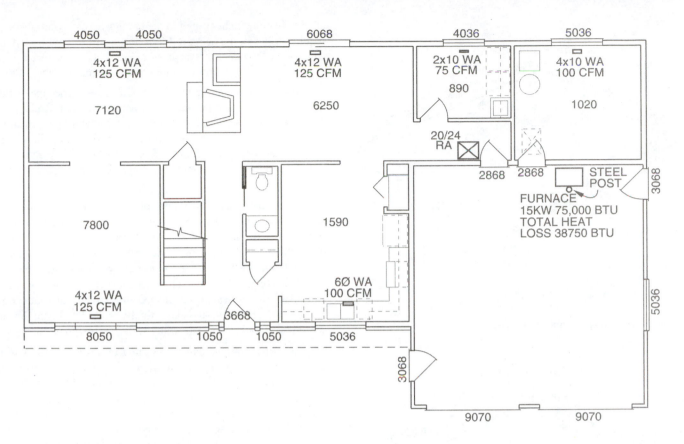

Figure 5–32 Simplified forced-air plan.

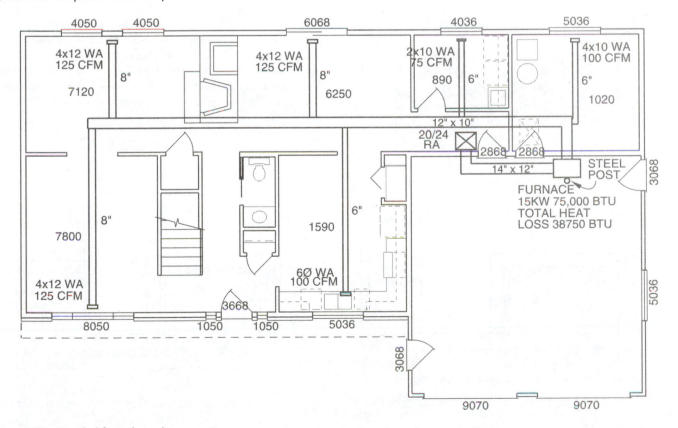

Figure 5–33 Detailed forced-air plan.

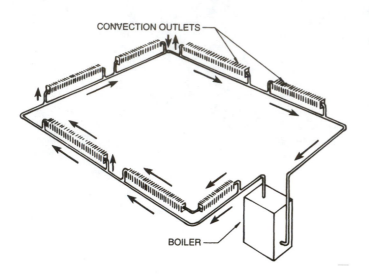

Figure 5–34 One-pipe hot-water system.

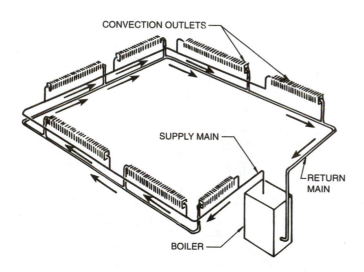

Figure 5–35 Two-pipe hot-water system.

allows the home to be heated to the family's needs; a central system requires using all the heat produced. If the airflow is restricted, the efficiency of the central system is reduced. There is also a 10 to 15 percent heat loss through ductwork in central systems.

Regardless of the square footage in a house, its occupants normally use less than 40 percent of the entire area on a regular basis. A zoned system is very adaptable to heating the 40 percent of the home that is occupied using automatic controls that allow night setback, day setback, and nonheated areas. The homeowner can save as much as 60 percent on energy costs through controlled heating systems.

There are typically two types of zone heaters: baseboard and fan. Baseboard heaters have been the most popular type for zoned heating systems for the past several decades. They are used in many different climates and under various operating conditions. No ducts, motors, or fans are required. Baseboard units have an electric heating element that creates a convection current as the air around the unit is heated. The heated air rises into the room and is replaced by cooler air that falls to the floor. Baseboard heaters should be placed on exterior walls under or next to windows.

Fan heaters are generally mounted in a wall recess. A resistance heater is used to generate the heat, and a fan circulates the heat into the room. These units should be placed to circulate the warmed air in each room adequately. Avoid placing the heaters on exterior walls because the recessed unit reduces or eliminates the insulation in that area.

Heat pumps may require a split system in very large homes. Split systems are also possible using zoned heat in part of the home and central heat in the balance of the structure. An alternative is to install a heat pump for the areas used most often and zoned heaters for the remainder of the house. This is also an option for additions to homes that have a central system. Zoned heat can be used effectively in an addition so that the central system is not overloaded or required to be replaced.

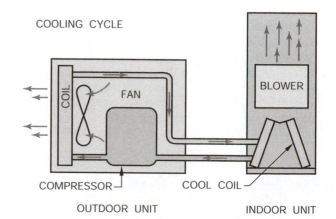
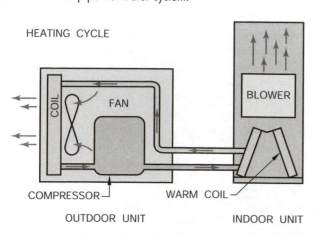

Figure 5–36 Heat-pump heating and cooling cycle. *Courtesy Lennox Industries, Inc.*

RADIANT HEAT

Radiant heating and cooling systems provide a comfortable environment by means of controlling surface temperatures and minimizing excessive air motion within the space. Warm ceiling panels are effective for winter heating because they warm the floor surfaces and glass surfaces by direct transfer of radiant energy. The surface temperature of well-constructed and properly insulated floors will be 2°F to 3°F above the ambient air temperature, and the inside surface temperature of glass will be increased significantly. As a result of these heated surfaces, downdrafts are minimized to the point where no discomfort is felt.

Radiant heat systems generate operating-cost savings of 20 to 50 percent annually compared to conventional convective systems. This saving is accomplished through lower thermostat settings. Savings also result from the superior, cost-effective design inherent in radiant-heating products.

Radiant heat can be achieved with oil- or gas-heated hot-water piping in the floor or ceiling; to electric coils, wiring, or elements either in or above the ceiling gypsum board; and transferred to metal radiator panels generally mounted by means of a bracket about an inch below the ceiling surface. A recent evolution of the radiant panel concept is a lightweight, quick-response, totally zone-controlled panel system that can be mounted directly to the ceiling surface, on joists, or placed in a suspended ceiling grid. The radiant solid-state heating panels are available in a full range of sizes and voltages that are ideal for both remodeling and new construction applications as primary or auxiliary heating.

THERMOSTATS

The thermostat is an automatic mechanism for controlling the amount of heating or cooling given by a central- or zoned-heating or cooling system. The thermostat floor plan symbol is shown in Figure 5–37.

The location of the thermostat is an important consideration to the proper functioning of the system. For zoned-heating or cooling units, thermostats can be placed in each room, or a central thermostat panel that controls each room can be placed in a convenient location. For central heating and cooling systems there can be one or more thermostats depending upon the layout of the system or the number of units required to service the structure. For example, a very large home or office building can have a split system that divides the structure into two or more zones. Each individual zone has its own thermostat.

Several factors contribute to the effective placement of the thermostat for a central system. A good location is near the center of the structure and close to a return-air duct for a central forced-air system, where an average temperature reading can be achieved. There should be no drafts that would adversely affect temperature settings. The thermostat should not be placed in a location where sunlight or a heat register would cause an unreliable reading. A thermostat should not be placed close to an exterior door where temperatures can change quickly. Thermostats should be placed on inside partitions rather than on outside walls where a false temperature reading could also be obtained. Avoid placing the thermostat near stairs or a similar traffic area where significant bouncing or shaking could cause the mechanism to alter the actual reading.

Programmable microcomputer thermostats are also available that effectively help reduce the cost of heating or cooling. Some units automatically switch from heat to cool while minimizing temperature deviation from the setting under varying load conditions. These computers can be used to alter heating and cooling temperature settings automatically for different days of the week or different months of the year.

HEAT RECOVERY AND VENTILATION

Sources of Pollutants. Air pollution in a structure is the principal reason for installing a heat recovery and ventilation system. A number of sources can contribute to an unhealthy environment within a home or business.

■ Moisture in the form of relative humidity can cause structural damage, as well as health problems, such as respiratory ailments. The source of relative humidity is the atmosphere, steam from cooking and showers, and individuals, who can produce up to 1 gal. water vapor per day.

■ Incomplete combustion from gas-fired appliances or wood-burning stoves and fireplaces can generate a variety of pollutants, including carbon monoxide, aldehydes, and soot.

■ Humans and pets can transmit bacterial and viral diseases through the air.

■ Tobacco smoke contributes chemical compounds to the air.

■ Formaldehyde is found in carpets, furniture, and the glue used in construction materials, such as plywood and particle board, as well as some insulation products.

■ Radon is a naturally occurring radioactive gas that breaks down into compounds that are *carcinogenic* (cancer-causing) when large quantities are inhaled over a long period of time. Radon may be more apparent in a structure that contains a large amount of concrete or in certain areas of the country.

■ Products, such as those available in aerosol-spray cans, and craft materials, such as glues and paints, can contribute a number of toxic pollutants.

Air-to-air Heat Exchangers. Government energy agencies, architects, designers, and contractors around the country have been evaluating construction methods that are designed to reduce energy consumption. Some of the tests have produced superinsulated, vapor-barrier-lined, airtight structures. The result has been a

Figure 5–37 Thermostat floor plan sysmbol.

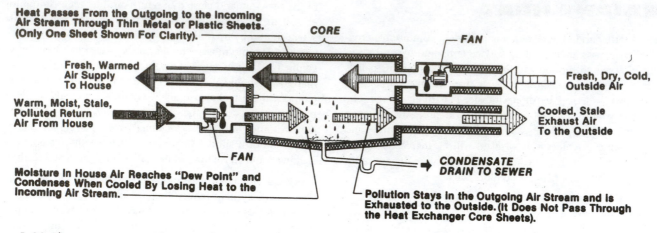

Figure 5–38 The components and function of an air-to-air heat exchanger.

dramatic reduction in heating and cooling costs; however, the air quality in these houses has been significantly reduced and may even be harmful to health. In essence, the structure does not breathe and the stale air and pollutants have no place to go. A recent technology has emerged from this dilemma in the form of an air-to-air heat exchanger. In the past the air in a structure was exchanged by leakage through walls, floors, ceilings, and around openings. Although this random leakage was no insurance that the building was properly ventilated, it did ensure a certain amount of heat loss. Now, with the concern of energy conservation, it is clear the internal air quality of a home or business cannot be left to chance.

An air-to-air heat exchanger is a heat-recovery and ventilation device that pulls polluted, stale warm air from the living space and transfers the heat in that air to fresh, cold air being pulled into the house. Heat exchangers do not produce heat—they only exchange heat from one airstream to another. The heat transfer takes place in the core of the heat exchanger, which is designed to avoid mixing the two airstreams to ensure that indoor pollutants are expelled. Moisture in the stale air condenses in the core and is drained from the unit. Figure 5–38 shows the function and basic components of an air-to-air heat exchanger.

The recommended minimum effective air-change rate is 0.5 air changes per hour (ach). Codes in some areas of the country have established a rate of 0.7 ach. The American Society of Heating, Refrigeration, and Air Conditioning Engineers, Inc. (ASHRAE) recommends ventilation levels based on the amount of air entering a room. The recommended amount of air entering most rooms is 10 cubic ft. per minute (cfm). The rate for kitchens is 100 cfm and bathrooms is 50 cfm. Mechanical exhaust devices vented to outside air should be added to kitchens and baths to maintain the recommended air-exchange rate.

The minimum heat exchanger capacity needed for a structure can be determined easily. Assume a 0.5 ach rate in a 1,500 sq. ft. single-level, energy-efficient house and follow these steps:

1. Determine the total floor area in sq.. ft. Use the outside dimensions of the living area only.

 30' × 50' = 1,500 sq. ft.

Figure 5–39 A vacuum outlet floor plan symbol.

2. Determine the total volume within the house in cubic ft. by multiplying the total floor area by the ceiling height.

 1,500 sq. ft. × 8' = 12,000 cu. ft.

3. Determine the minimum exchanger capacity in cfm by first finding the capacity in cubic feet per hour (cfh). Multiply the house volume by the ventilation rate required from the exchanger.

 12,000 cu. ft. × 0.5 ach = 6,000 chf

4. Convert the cfh rate to cfm by dividing the cfh rate by 60 min.

 6,000 cfh ÷ 60 min. = 100 cfm

A percentage of capacity loss because of mechanical resistance should be considered by the system designer.

CENTRAL VACUUM SYSTEMS

A well-designed system requires only a few outlets to cover the entire home or business, including exterior use. The hose plugs into a wall outlet and the vacuum is ready for use. A central canister stores the dust and debris from the house or business and is generally located in the garage or in a storage area. The floor plan symbol for vacuum cleaner outlets is shown in Figure 5–39. The central unit may be found in the garage or storage area as a circle that is labeled Central Vacuum System.

HVAC SYMBOLS

Over a hundred HVAC symbols can be used in residential and commercial heating plans. Only a few of the symbols are typically used in residential HVAC drawings. Figure 5–40 shows some common HVAC symbols. Sheet-metal conduit template and heating and air-conditioning templates are timesaving devices that are used to help improve the quality of drafting for HVAC systems. Custom HVAC CADD programs are also available to help improve drafting productivity. CADD applications are discussed later.

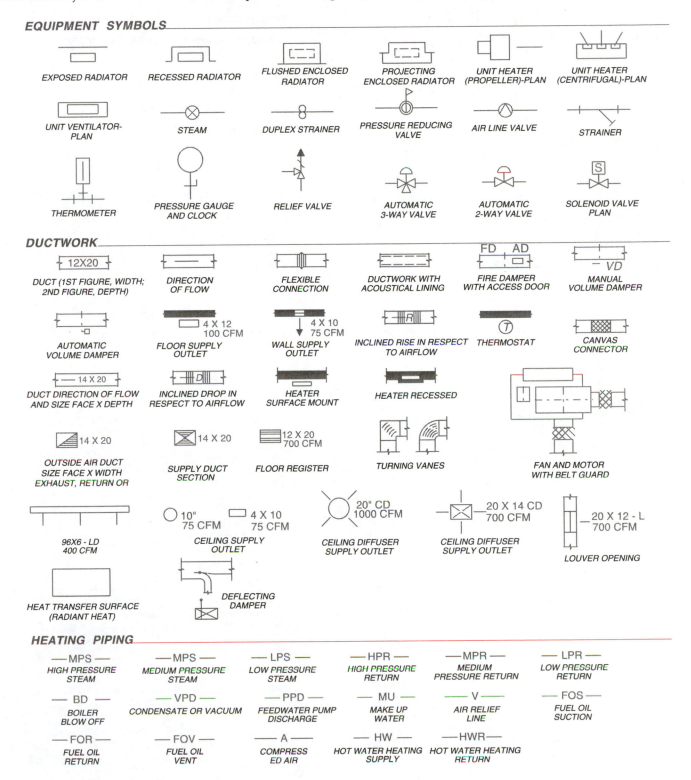

Figure 5–40 Common HVAC symbols.

REFRIGERATION SYMBOLS

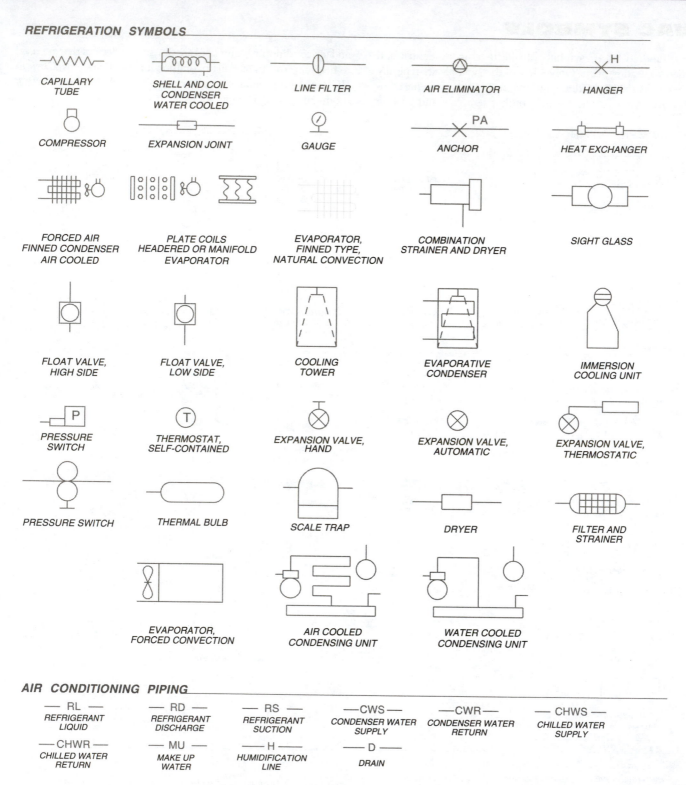

CAPILLARY
TUBE

SHELL AND COIL
CONDENSER
WATER COOLED

LINE FILTER

AIR ELIMINATOR

HANGER

COMPRESSOR

EXPANSION JOINT

GAUGE

ANCHOR

HEAT EXCHANGER

FORCED AIR
FINNED CONDENSER
AIR COOLED

PLATE COILS
HEADERED OR MANIFOLD
EVAPORATOR

EVAPORATOR,
FINNED TYPE,
NATURAL CONVECTION

COMBINATION
STRAINER AND DRYER

SIGHT GLASS

FLOAT VALVE,
HIGH SIDE

FLOAT VALVE,
LOW SIDE

COOLING
TOWER

EVAPORATIVE
CONDENSER

IMMERSION
COOLING UNIT

PRESSURE
SWITCH

THERMOSTAT,
SELF-CONTAINED

EXPANSION VALVE,
HAND

EXPANSION VALVE,
AUTOMATIC

EXPANSION VALVE,
THERMOSTATIC

PRESSURE SWITCH

THERMAL BULB

SCALE TRAP

DRYER

FILTER AND
STRAINER

EVAPORATOR,
FORCED CONVECTION

AIR COOLED
CONDENSING UNIT

WATER COOLED
CONDENSING UNIT

AIR CONDITIONING PIPING

— RL —
REFRIGERANT
LIQUID

— RD —
REFRIGERANT
DISCHARGE

— RS —
REFRIGERANT
SUCTION

—CWS—
CONDENSER WATER
SUPPLY

—CWR—
CONDENSER WATER
RETURN

— CHWS —
CHILLED WATER
SUPPLY

—CHWR—
CHILLED WATER
RETURN

— MU —
MAKE UP
WATER

—H—
HUMIDIFICATION
LINE

—D—
DRAIN

Figure 5–40 (continued)

CHAPTER 5 TEST

Fill in the blanks below with the proper word or short statement as needed to correctly complete the sentence or answer the question.

1. What does the abbreviation GFI mean? _____ _____ _____ .

2. What is the purpose of a GFI? _____ _____ _____ .

3. Each enclosed bath or laundry room should have an _____

4. Describe how a special characteristic, such as a specific size of fixture, a location requirement, or any other specification, might be listed on the floor plan drawing with an element of the electrical layout. _____ _____ _____ _____ .

5. For capacity of service, the average single-family residence should be equipped with a _____ service entrance.

6. Name the two classifications of piping _____ _____ _____ .

7. In most cases, the plumbing requirements can be clearly provided on the floor plan in the form of _____ for fixtures and _____ for specific applications or conditions.

8. How are floor drains identified on the floor plan? _____ _____ _____ .

9. Plumbing drawings are made up of lines and symbols that show how _____ are transported to various locations in the structure.

10. Describe the function of the drainage system. _____ _____ _____ _____ _____ .

11. Describe the function of the vent system. _____ _____ _____ _____

12. Name at least two types of sewage-disposal systems. _____ _____ _____ _____ .

13. What does the abbreviation HVAC mean? _____ _____ _____ .

14. Explain the basic principle behind the complete cycle of the central forced-air system. _____ _____ _____ _____ _____ _____ _____ _____ _____ .

15. Name two types of hot-water heating systems. _____ _____ _____ .

16. In a forced-air system, why are registers normally placed in front of a window? _____ _____ _____ .

17. Describe a common location for the cold-air return in a central forced-air system. _____ _____ .

18. Name the three items shown in a forced-air heating plan for dispersement to the rooms from the warm-air supplies. _____ _____ _____ .

19. Describe the basic principle behind the heat-pump system's heating and cooling cycles. _____ _____ _____ _____ _____ _____ .

20. List at least four advantages of the zone-control system compared to the central system. _____ _____ _____ _____ _____

21. How much heat loss commonly occurs through the duct-work in a central system? _____ .

22. Radiant heating and cooling systems provide a comfortable environment by means of controlling surface temperatures and minimizing excessive _____ within the space.

23. Define thermostat. _____

_____ .

24. Several factors contribute to the effective placement of the thermostat for a central system; name at least four.

_____ .

25. Identify at least five sources of pollutants in a structure.

_____ .

26. Describe the function of an air-to-air heat exchanger.

_____ .

27. List at least four advantages of a central vacuum system.

_____ .

28. Mechanical exhaust devices vented to outside air should be added to _____ and _____ to maintain the recommended air-exchange rate.

CHAPTER 5 PROBLEMS

PROBLEM 5–1 Answer the following questions as you read the floor plan drawing on page 131.

1. Identify the locations of the ground fault interrupters.

_____ .

2. How many square surface-mounted fixtures are located in the kitchen? _____ .

3. How many three-way switch circuits are in this partial plan?
_____ .

4. Describe the light fixture located in the utility room.

_____ .

5. Describe the location of the four-way switch, and explain the arrow at the end of the switch leg connected to that switch. _____

_____ .

6. Describe the outlet behind the dryer space. _____

_____ .

7. How many duplex convenience outlets are there in the kitchen? _____ .

8. What does the abbreviation D.W. mean? _____
_____ .

9. What does the abbreviation P.C. mean? _____
_____ .

10. Is the kitchen sink single or double? _____
_____ .

11. What does the abbreviation WH mean? _____
_____ .

12. Where is the WH located, and what are the specifications associated with it? _____

_____ .

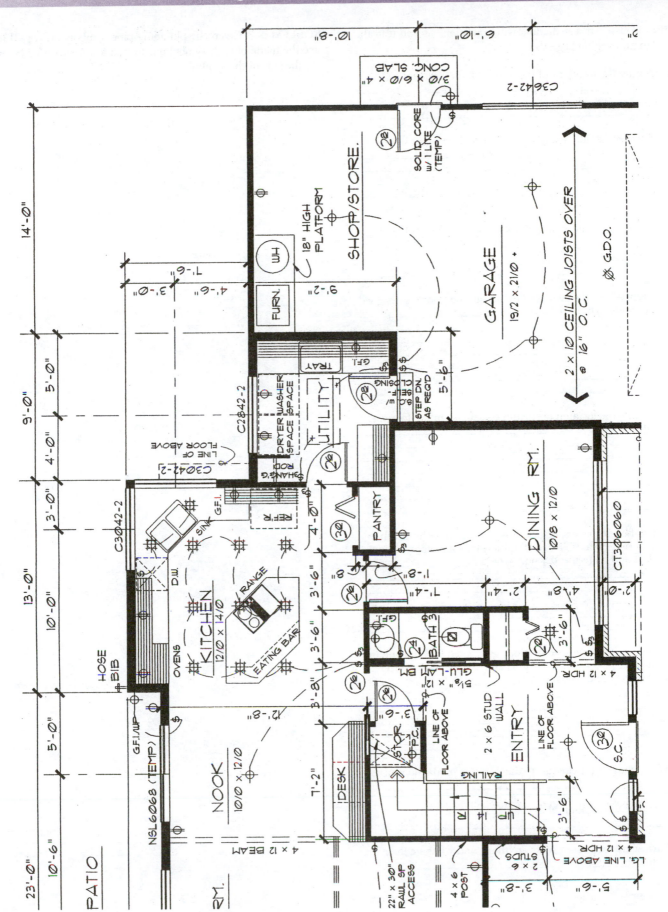

PROBLEM 5–2 Answer the following questions as you read the floor plan drawing on page 135.

1. Identify the locations of the ground-fault interrupters.

 _____ .

2. Describe the difference between the exhaust fans in bath 1 and in bath 2. _____

 _____ .

3. Describe the light fixture in bedroom 2. _____

 _____ .

4. Describe how the switch in the master bedroom is designed to provide light in the room. _____

 _____ .

5. Describe the location of the three switches in the four-way switch system. _____

 _____ .

6. Give the complete specifications associated with the tub in the master bath. (Change all dimensions and abbreviations to feet and inches, and whole words.) _____

 _____ .

7. Give the complete specifications associated with the tub in bath 2. (Change all dimensions and abbreviations to feet and inches, and whole words.) _____

 _____ .

8. How many water closets are there in this partial floor plan?
 _____ .

9. Describe the location of the smoke detector. _____
 _____ .

10. How many bathroom sinks are there, and what are their shapes? _____

PROBLEM 5–3 Given the plumbing pipe symbols on page 136, place the name of each symbol on the blank line provided below or to the side of the symbol.

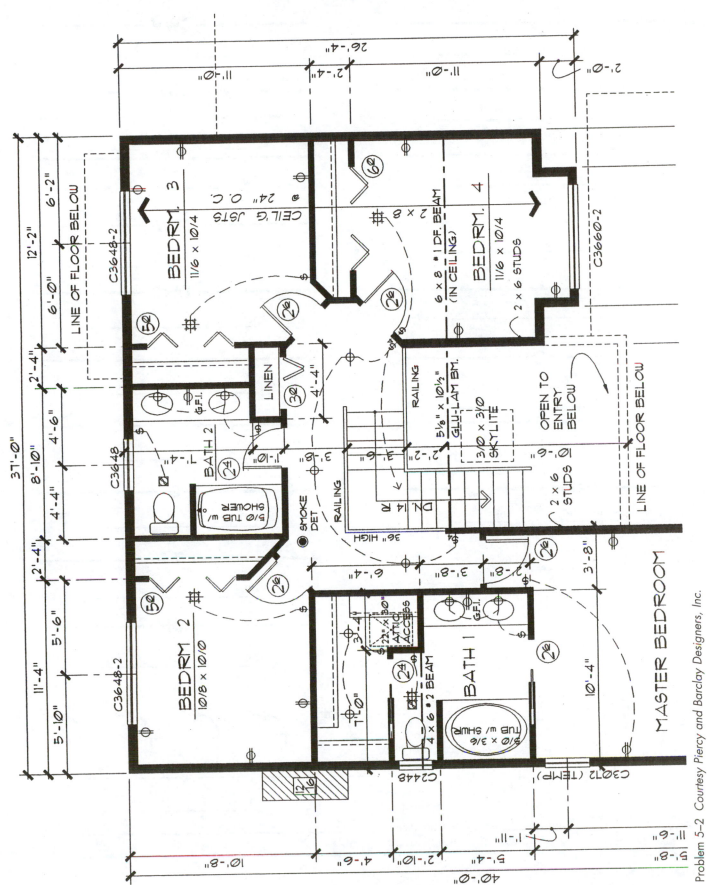

1) _____

2) _____

3) _____

4) _____

5) _____

6a) _____ 6b) _____

6c) _____

7a) _____ 7b) _____

7c) _____

8a) _____ 8b) _____

9) _____

10) _____

11) _____

12) _____

13) _____

CWV
14) _____

SD

S
15) _____

SW
16) _____

ICW
17) _____

DWS
18) _____

F
19) _____

20) _____

G
21) _____

T
22) _____

23) _____

24) _____ 25) _____ 26) _____ 27) _____ 28) _____

29) _____

30) _____

Problem 5–3

PROBLEM 5–4 Answer the following questions as you read the partial plumbing plan below.

1. Describe the plumbing system shown in this partial floor plan. _____

_____ .

2. What is the size of the hot-water line? _____
_____ .

3. What is the size of the cold-water line? _____
_____ .

4. What is the size and type of pipe used from the meter to the union? _____ .

5. What is the size and type of pipe from the union to the water-heater junction? _____ .

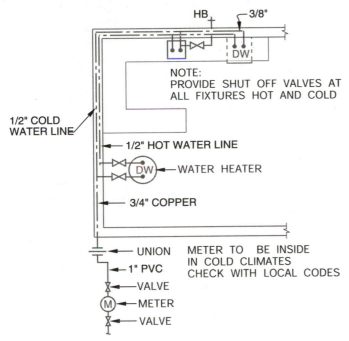

Problem 5–4

PROBLEM 5–5 Describe the plumbing system shown in this partial floor plan. _____

_____ .

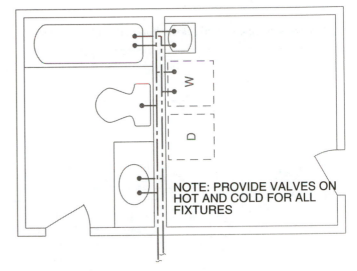

Problem 5–5

PROBLEM 5–6 Describe the plumbing system shown in this partial floor plan. _____

_____ .

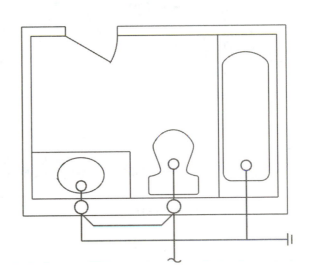

Problem 5–6

PROBLEM 5–7 Answer the following questions as you read the residential plumbing plan below.

1. What is the size and type of pipe from the street to the meter?
_____ .

2. What size pipe runs from the meter to the water-heater junction? _____ .

3. What size pipe is used for the hot- and cold-water system?
_____ .

4. What do the following abbreviations mean?

WH _____
HB _____
CO _____
CI _____

5. What is the size and type of pipe used in the drainage system to the CO? _____ .

6. What is the size and type of pipe that goes to the sewer?
_____ .

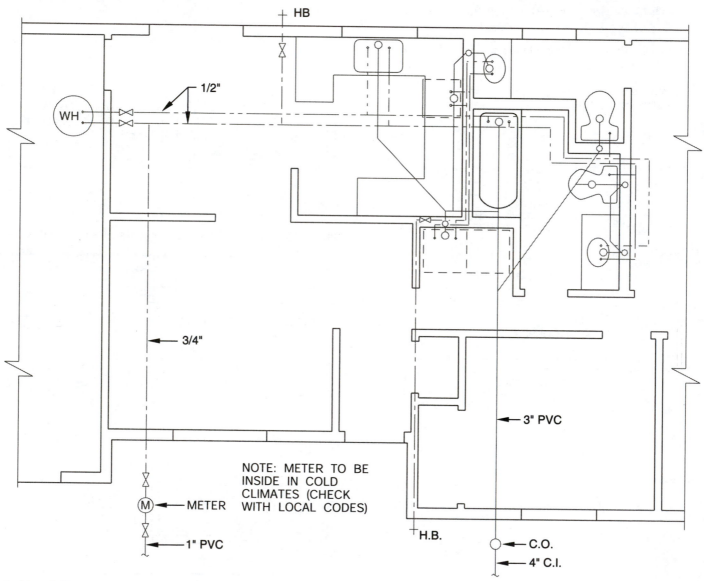

Problem 5–7

PROBLEM 5–8 Answer the following questions as you read the residential HVAC plan below.

1. Give the complete specifications for the furnace.

 _____ .

2. What is the total estimated heat loss in this home? _____
 _____ .

3. What is the size of the main duct that runs from the furnace to the ducts that supply the individual areas?

 _____ .

4. What are the sizes of the ducts that supply the following rooms:

 Living room _____ To both lower bedrooms ___
 Dining room _____ To each bedroom _____
 Kitchen _____ Master bedroom _____
 Entry _____

5. What is the size of the duct that runs from the return-air register to the furnace? _____ .

6. What is the size of the return-air register? _____
 _____ .

7. What is the size of the warm-air registers in the following rooms?

 Living room _____ Master bedroom _____
 Dining room _____ Main bath _____
 Kitchen _____ Master bath _____

8. What do the following abbreviations mean?

 BTU _____
 cfm _____
 RA _____

9. What is the estimated cfm at the warm-air registers in the following rooms?

 Living room _____ Master bath _____
 Dining room _____ Master bedroom _____
 Kitchen _____

10. What is the BTU dispersal in each of the following rooms?

 Living room _____ Master bedroom _____
 Dining room _____ Master bath _____
 Kitchen _____ Main bath _____

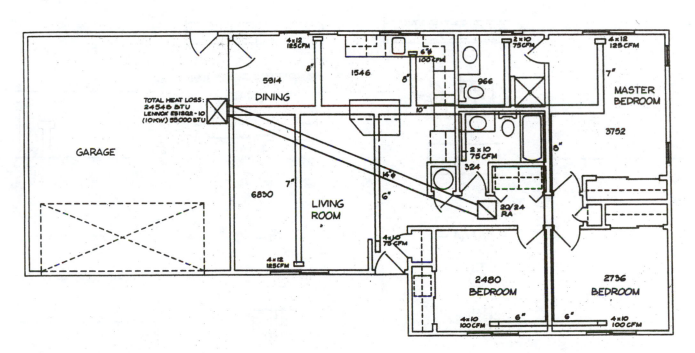

Problem 5–8

PROBLEM 5–9 Given the following HVAC symbols, place the name or identification of the symbol on the blank line provided below or next to each symbol.

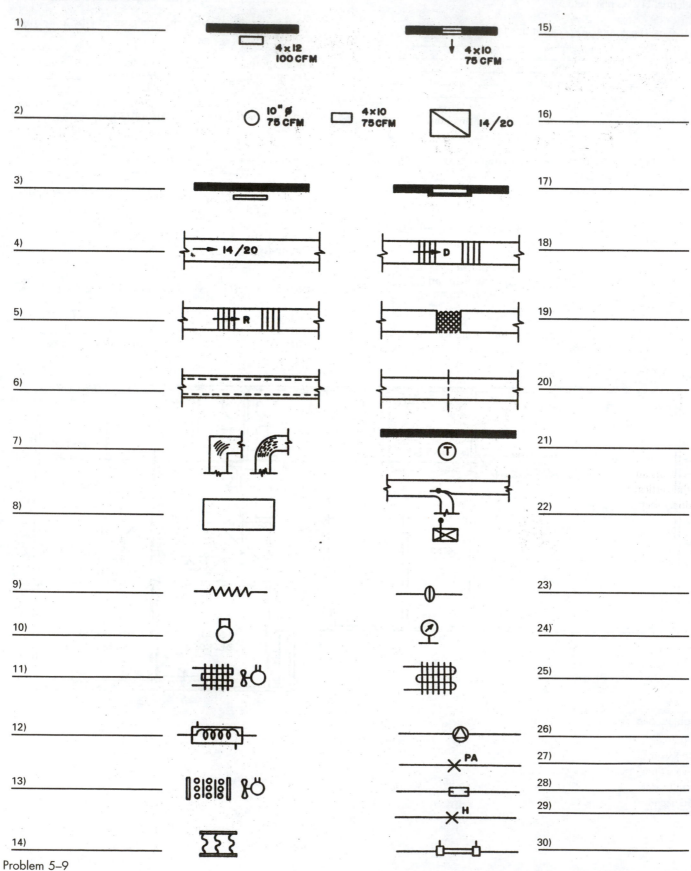

1) _____

2) _____

3) _____

4) _____

5) _____

6) _____

7) _____

8) _____

9) _____

10) _____

11) _____

12) _____

13) _____

14) _____

15) _____

16) _____

17) _____

18) _____

19) _____

20) _____

21) _____

22) _____

23) _____

24) _____

25) _____

26) _____

27) _____

28) _____

29) _____

30) _____

Problem 5–9

Reading Elevations

CHAPTER OVERVIEW

This chapter covers the following topics:

- Required elevations
- Types of elevations
- Elevation scales
- Surface materials in elevations
- Test
- Problems

Elevations are an essential part of the design and drafting process. The *elevations* are a group of drawings that show the exterior of a building. An elevation is an orthographic drawing that shows one side of a building. Elevations are projected as shown in Figure 6–1. Elevations are drawn to show exterior shapes and finishes as well as the vertical relationships of the building levels. By using the elevations, sections, and floor plans, the exterior shape of a building can be determined.

REQUIRED ELEVATIONS

Four elevations are required to show the features of a building. On a simple building only the front, rear, and one side elevation may be provided. On a building of irregular shape, several additional elevations may be provided to show features that may have been hidden in one of four basic elevations. If a building has walls that are not at 90° to each other, a true orthographic drawing could be very confusing. In the orthographic projection, part of the elevation is distorted. Elevations of irregularly shaped structures are usually expanded so that a separate elevation of each different face is drawn. Figure 6–2 shows the overall elevation with the left half of the structure distorted. Figure 6–3 shows the true shape of the left portions of the structure. Because of the shape of the structure, the roof may not appear in true shape in either of these views. The print reader must use both the elevations and the roof framing plan to determine the shape of the roof.

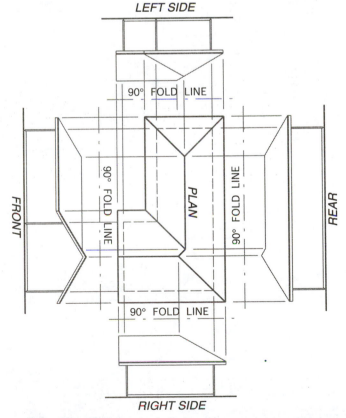

Figure 6–1(a) Elevations are orthographic projections showing each side of a structure.

TYPES OF ELEVATIONS

Elevations can be drawn as either presentation drawings or working drawings. Presentation drawings are drawings that are a part of the initial design process and may range from sketches to very detailed drawings intended to help the owner and lending institution understand the basic design concepts. See Figure 6–4.

Working elevations are part of the working drawings and are drawn to provide information for the building team. This includes information about roofing, siding, openings, chimneys, land shape, and sometimes even the depth of footings, as shown in Figure 6–5. When used with the floor plans, the elevations provide information for the contractor to determine surface areas. Once surface areas are known, exact quantities of material can be determined. The elevations are also necessary when making heat-loss calculations. The elevations are used to determine the surface area of walls and wall openings for the required heat-loss formulas.

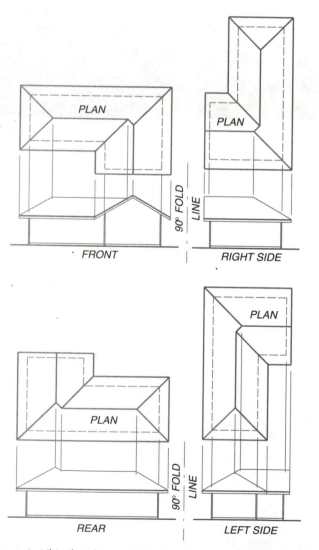

Figure 6–1(b) The placement of elevations is usually altered to ease viewing. Group elevations so that 90° rotation exists between views.

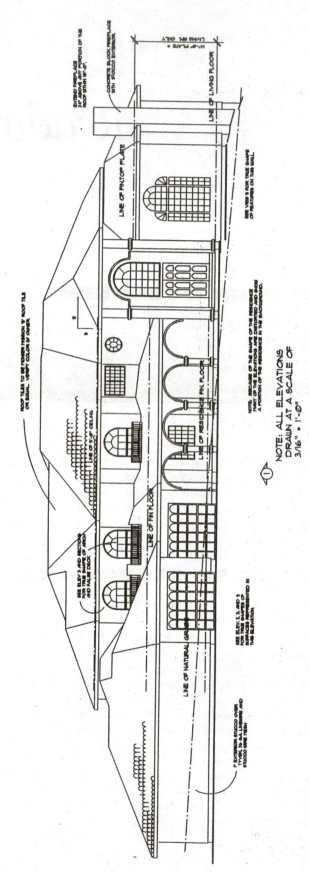

Figure 6–2 Using true orthographic projection methods for a structure with an irregular shape will result in distortion of part of the elevation.

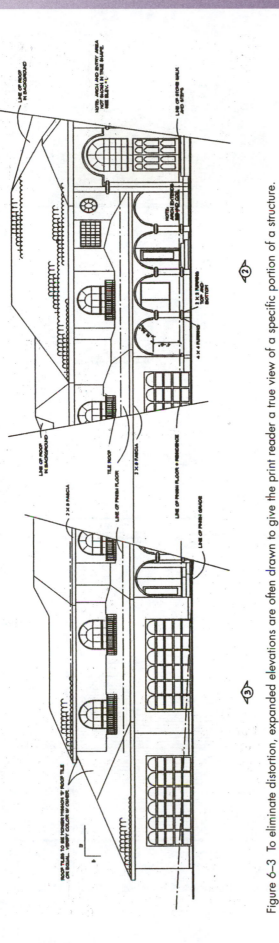

Figure 6–3 To eliminate distortion, expanded elevations are often drawn to give the print reader a true view of a specific portion of a structure.

ELEVATION SCALES

Elevations are typically drawn at the same scale as the floor plan. For most plans, this means a scale of 1/4" = 1'–0" is used. Some floor plans for multifamily and commercial projects may be laid out at a scale of 1/16" = 1'–0" or even as small as 1/32" = 1'–0". When a scale of 1/8" or less is used, very little detail is placed on the drawing, as seen in Figure 6–6. Depending on the complexity of the project or the amount of space on a page, the front elevation may be drawn at 1/4" scale and the balance of the elevations drawn at a smaller scale.

SURFACE MATERIALS IN ELEVATION

The materials that are used to protect the building from the weather need to be shown on the elevations. This information is considered under the categories of roofing, wall coverings, doors, and windows.

ROOFING MATERIALS

Several common materials are used to protect the roof. Among the most frequently used are asphalt shingles, wood shakes and shingles, clay and concrete tiles, metal sheets, and built-up roofing materials.

Asphalt Shingles. Asphalt shingles come in a variety of colors and patterns. Also known as composition shingles, they are made of fiberglass backing and covered with asphalt and a filler with a coating of finely crushed particles of stone. The asphalt waterproofs the shingle and the filler provides fire protection. The standard shingle is a three-tab rectangular strip. The upper portion of the strip is coated with self-sealing adhesive and is covered by the next row of shingles. The lower portion of a three-tab shingle is divided into three flaps that are exposed to the weather.

Composition shingles are also available in random width and thickness to give the appearance of cedar shakes. Both types of shingles can be used in a variety of conditions on roofs having a minimum slope of 2/12. The lifetime of shingles ranges from 20-, 25-, 30-, and 40-year guarantees.

Shingles are specified on drawings in note form listing the material, the weight, and the underlayment. The color and manufacturer may also be specified. This information is often omitted in residential construction to allow the contractor to purchase a suitable brand at the best cost. A typical callout might be:

- 235# COMPOSITION SHINGLES OVER 15 # FELT.
- 300# COMPOSITION SHINGLES OVER 15 # FELT.
- ARCHITECT 80 'DRIFTWOOD' CLASS 'A' FIBERGLASS SHINGLES BY GENSTAR WITH 5–5/8" EXPOSURE OVER 15# FELT UNDERLAYMENT WITH 30-YEAR WARRANTY.

Asphalt and fiberglass shingles are usually shown on drawings as seen in Figure 6–7.

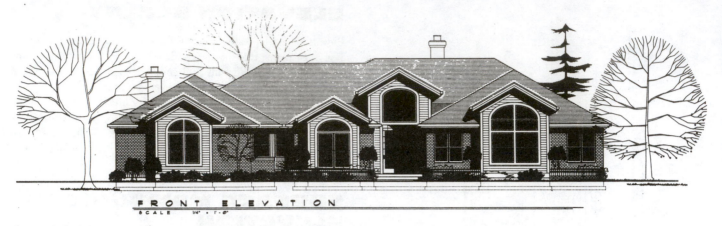

Figure 6–4 Presentation elevations are highly detailed drawings with little material specified. Exterior building materials, landscaping, and shading are drawn. *Courtesy of Piercy and Barclay Designers, Inc.*

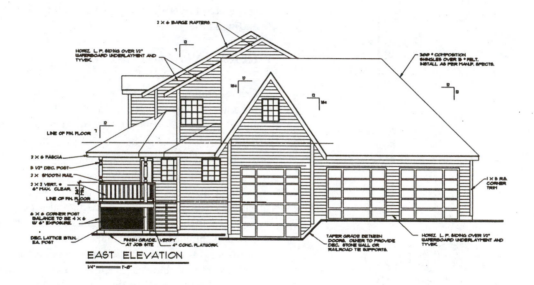

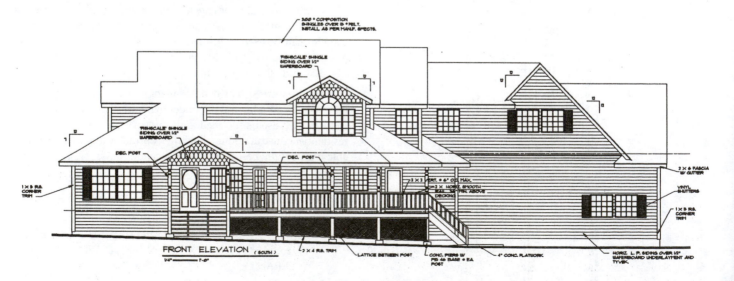

Figure 6–5 Working elevations show portions of the exterior building materials and other information needed by the construction crews.

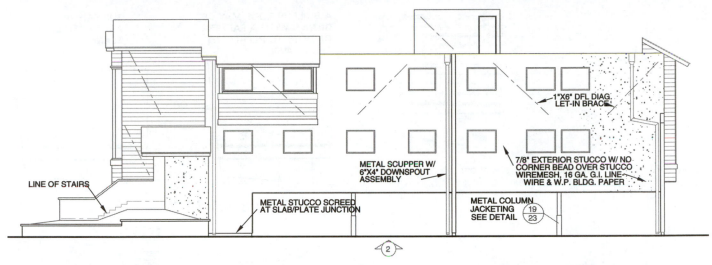

Figure 6–6 Elevations of large structures are typically drawn at a small scale such as 1/16" = 1'–0", with very little detail shown. Details are often provided to supplement the elevations. *Courtesy Kenneth D. Smith Architect and Associates, Inc.*

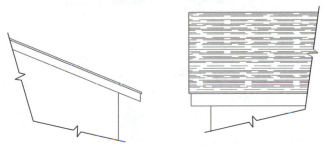

Figure 6–7 Asphalt and composition shingles.

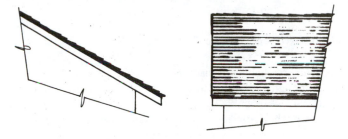

Figure 6–8 Wood shakes and shingles.

Wood Shakes and Shingles. Wood shingles are made of cedar and may cost as much as one-third more than composition shingles. Wood shingles have a lifetime of 20 years, but this varies if the shingles are not made of old-growth timber. Other materials, such as Masonite, are also used to simulate shakes. These materials are specified on plans in note form listing the material, underlayment, and the amount of shingle exposed to the weather. A typical specification for wood shingles:

MEDIUM CEDAR SHAKES OVER 15# FELT W/ 15# × 18" WIDE FELT BETWEEN EACH COURSE. LAY WITH 10–1/2" EXPOSURE.

Wood shakes are often represented on drawings as shown in Figure 6–8.

Tile. Tile is the material most often used for homes on the high end of the price scale or where the risk of fire is extreme. Although tile can cost twice as much as the better grades of asphalt shingle, it offers a lifetime guarantee. Tile is available in a variety of colors, materials, and patterns. Clay, concrete, and metal are the most common materials. Clay and concrete tiles can weigh as much as four times more than asphalt tiles and require larger framing members to support their weight. In elevation, the tile is typically called out in a note listing the manufacturer, tile pattern and shape, material, color, and underlayment. A typical note on the elevations might resemble:

MONIER BURNT TERRA COTTA MISSION S ROOF TILE OVER 15# FELT AND 1 × 3 SKIP SHEATHING. USE A 3" MIN. HEAD LAP AND INSTALL AS PER MANUF. SPECIFICATIONS.

Tile is often represented on elevations as seen in Figures 6–9 and 6–10.

Metal. Metal shingles and panels are common on many types of roofs. Metal shingles would usually be represented in a manner similar to asphalt shingles. Metal panels come in many styles.

A typical specification for metal roofing should include the manufacturer and the roofing type, gage, style, and color. A note on an elevation would resemble:

16" WIDE, 24 GA. MAXIMA ROOF SYSTEM W/2" RIBS BY MCELROY. METAL ROOF PANELS INSTALLED AS PER MANUF. SPECIFICATIONS.

Built-up Roofs. Built-up roofing, or hot tar roofs, are used on very low-pitched roofs. Because of the low pitch and the lack of surface texture, built-up roofs are usually outlined and left blank. Occasionally a built-up roof will be covered with 2"- or 3"-diameter rock. The drawing technique for this roof can be seen in Figure 6–11. A note on an elevation would resemble:

3-PLY BUILT-UP ROOF W/ HOT ASPHALT BETWEEN EACH LAYER, COVERED W/ PEA GRAVEL. INSTALL AS PER MANUF. SPECS.

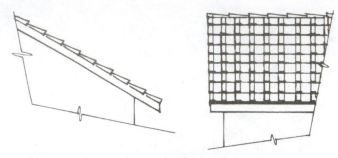

Figure 6–9 Flat tile representation on elevations.

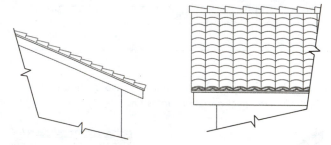

Figure 6–10 Spanish-style tile roofing.

Skylights. Skylights are made of either flat glass or domed plastic. Although they come in a variety of shapes and styles, skylights usually resemble those shown in Figure 6–12. Depending on the pitch of the roof, skylights may or may not be drawn. Unless the roof is very steep, a rectangular skylight will appear almost square. The flatter the roof, the more distortion there will be in the size of the skylight.

WALL COVERINGS

Exterior wall coverings are usually made of wood, wood substitutes, masonry, metal, plaster or stucco. Each has its own distinctive look in elevation.

Wood. Wood siding can either be installed in large sheets or in individual pieces. Plywood sheets are a popular wood siding because of the low cost and ease of installation. Individual pieces of wood provide an attractive finish but usually cost more than plywood. This higher cost results from differences in material and the labor to install each individual piece.

Plywood siding can have many textures, finishes, and patterns. Textures and finishes are not shown on the elevations but may be specified in a general note. Patterns in the plywood are usually shown. The most common patterns in plywood are T1-11, reverse board and batten, and plain or rough-cut plywood. Plywood siding is indicated with a note to specify the thickness, pattern, and underlayment. A typical note on the elevations is:

5/8" T1-11 PLY SIDING WITH GROOVES AT 4" O.C. OVER 15 # FELT.

Figure 6–13 shows common methods of illustrating plywood siding. Lumber siding comes in several types and is laid in many patterns. Among the most common lumber for siding are cedar,

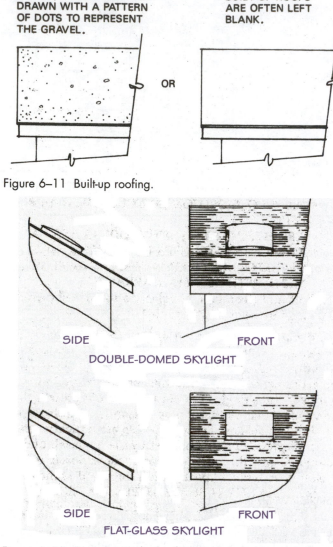

Figure 6–12 Common methods of representing glass and plastic skylights.

redwood, pine, fir, spruce, and hemlock. Common styles of lumber siding are tongue and groove, bevel, and channel siding. Figure 6–14 shows common types of siding. Each of these materials can be installed in a vertical, horizontal, or diagonal position. The material and type of siding must be specified in a general note on the elevations. The pattern in which the siding is to be installed must be shown on the elevations in a manner similar to that in Figure 6–15. The type of siding and the position in which it is laid affect how the siding appears at a corner. Figure 6–16 shows two common methods of corner treatment.

In addition to sheets and individual boards, wood shingles are also used as a siding material. Wood shingles can be installed either individually or in panels. Shingles are often shown on plans, as seen in Figure 6–17.

Wood substitutes. Hardboard, fiber cement, aluminum, and vinyl siding can be produced to resemble lumber siding. Hardboard siding is generally installed in large sheets similar to

T1-11 CAN BE DRAWN WITH LINES PLACED AT ABOUT 8" APART.

BATT-ON-BOARD MAY BE DRAWN WITH PAIRS OF PARALLEL LINES ABOUT 8 TO 12" APART.

WHEN R.C. PLY IS USED, NO SURFACE MATERIAL IS SHOWN.

T1-11 PLY *BATT-ON-BOARD* *ROUGH-CUT (R.C.) PLYWOOD*

Figure 6–13 Typical methods of representing plywood siding.

plywood but is represented in elevations with more detail than plywood or lumber siding. It is represented using methods similar to those used for drawing lumber siding. Each of the major national wood distributors has also developed siding products made from wood by-products that resemble individual pieces of beveled siding. Strands of wood created during the milling process are saturated with a water-resistant resin binder and compressed under extreme heat and pressure. The exterior surface has an embossed finish to resemble the natural surface of cedar. Most engineered lap siding are primed to provide protection from moisture prior to installation.

Fiber cement siding products are also a popular wood substitute because of their durability. Engineered to be resistant to moisture, cold, insects, salt air, and fire, fiber cement products, such as DuraPress by ABTco and Hardiplank by James Hardie, are used in many areas of the country as an alternative to wood and plaster products. Available in widths of 6–1/2, 7–1/2 and 9–1/2 (165, 190, and 240 mm) or 4' × 8' (100 × 200 mm), sheets, fiber cement products can reproduce smooth or textured wood patterns as well as cedar plywood panels and stucco. Products are installed similar to their wood counterparts and offer a 50-year warranty. Figure 6–18 shows an example of fiber cement bevel siding.

Aluminum and vinyl siding also resemble lumber siding in appearance, as shown in Figure 6–19. Aluminum and vinyl siding are drawn similar to their lumber counterpart.

A B

C D E F G H

Figure 6–14 Common types of siding: (A) bevel; (B) rabbeted; (C) tongue and groove; (D) channel shiplap; (E) V shiplap; (F, G, H) these types can have a variety of appearances, depending on the width of the boards and battens being used.

VERTICAL **HORIZONTAL LAP** **DIAGONAL**

Figure 6–15 Typical methods of representing wood siding.

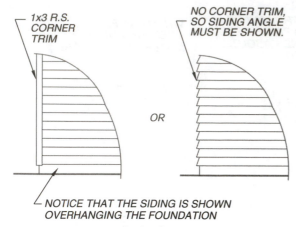

Figure 6–16 Common methods of corner treatment.

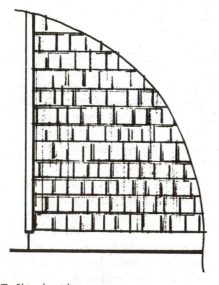

Figure 6–17 Shingle siding.

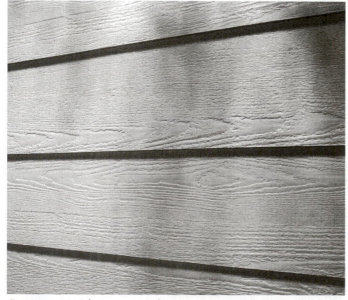

Figure 6–18 Fiber-cement siding provides excellent protection from moisture, insects, and other natural elements.

SIDING UNDERLAYMENT

Each of the preceding siding materials, including plywood sheets, can be placed over an underlayment for additional insulation purposes based on regional preferences. An underlayment must be placed under siding materials, such as shingles and vinyl siding, to provide support for the siding. Orientated strand board (OSB) and plywood are the most common underlayments for the siding. When the OSB or plywood is omitted, the siding is installed directly over the vapor barrier and studs. Tyvek and 15# felt are the most common materials used to protect the underlayment and framing members from moisture. Tyvek and 15# felt can be used interchangeably with the trade names of other vapor barriers. Examples of siding material that might be specified on the exterior elevations include the following:

- HORIZONTAL SIDING OVER 1/2" (13 MM) OSB AND TYVEK.
- HORIZONTAL SIDING OVER 3/8" (10 MM) PLYWOOD AND 15# FELT.
- HARDIPLANK LAP SIDING OVER 1/2" (13 MM) OSB AND TYVEK.
- HARDIE SHINGLESIDE W/ 8" (200 MM) MAX. EXPOSURE OVER 1/2" (13 MM) OSB AND TYVEK.
- LP HORIZ. LAP SIDING OVER 1/2" (13 MM) OSB AND TYVEK.

MASONRY

Masonry finishes can be made of brick, concrete block, or stone.

Bricks and concrete blocks come in a variety of sizes, patterns, and textures. The elevations represent the pattern on the drawing,

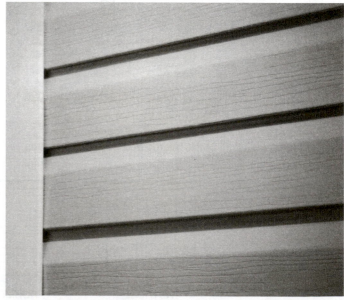

Figure 6–19 Vinyl and aluminum siding are manufactured to resemble their wood counterparts. *Courtesy ABTco., Inc.*

and the material and texture in the written specifications. Methods for drawing bricks are shown in Figure 6–20. Concrete blocks, or CMUs as they are usually referred to, are used in residential construction above and below grade because of their weather-resistant features. Figure 6–21 shows methods of representing some of the various concrete blocks. Bricks are specified in a note similar to:

> BRICK VENEER OVER 1" AIR SPACE AND TYVEK W/ 26 GA. METAL TIES @ 24" O.C. @ EA. STUD.

Concrete blocks are specified on elevations with a note that indicates the type, grade, pattern, and reinforcement. A typical note might read:

> 8 × 8 × 16 GRADE 'A' SPLIT FACE SCORED CMU W/#4 DIA. 18" O.C. EA. WAY.

Stone or rock finishes also come in a wide variety of sizes and shapes and are laid in a variety of patterns, as shown in Figure 6–22. Stone or rock may be either natural or artificial. Both appear the same in elevation. Stone, brick, and concrete are each specified by a note to describe the material, the airspace required, and the backing material. A note that might describe the material is:

> STONE VENEER OVER 1" AIRSPACE, WITH 15# FELT AND 26 GA. METAL TIES @ 24" O.C. EACH STUD.

Although primarily a roofing material, metal can be used as an attractive wall covering. Metal in elevation will look similar to lumber siding and will be specified in a note.

Plaster or Stucco. Although primarily used in areas with little rainfall, plaster or stucco can be found throughout the country. No matter what the pattern, stucco is typically represented as shown in Figure 6–23.

Stucco often has a metal corner bead at each corner to reinforce the stucco. This bead may be omitted to provide a rustic look. A common note often found on elevations is as follows:

> 1" MISSION TEXTURE STUCCO WITH NO CORNER BEAD OVER 26 GA. LINEWIRE @ 16" O.C. W/ STUCCO WIRE MESH OVER 15# FELT.

Similar in appearance to stucco or plaster are exterior insulation and finishing systems (EIFS) such as Dryvit. Typically a rigid insulation board is used as a base for a fiberglass-reinforced base coat. A weather-resistant colored finish coat is then applied by trowel to seal the structure. Shapes made out of insulation board can be added wherever three-dimensional details are desired.

DOORS

On elevations, doors are drawn to resemble the type of door specified in the door schedule. Figure 6–24 shows how common types of doors are often seen in elevation.

WINDOWS

Windows are represented in elevation by the type of material of which the frame is made. Aluminum, vinyl, and wood are the most

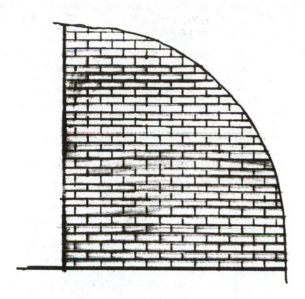

Figure 6–20 Brick as seen in elevation.

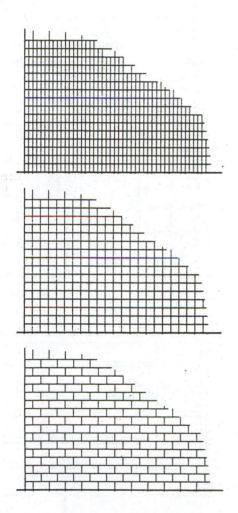

Figure 6–21 Concrete block represented in elevation.

common frame materials, the style of window can also be determined from the elevation. Figure 6–25 shows common types of windows that might be found on elevations. Window information is not specified on elevations unless the window is located in a vaulted area that could not be represented on a floor plan. Some municipalities require that symbols be placed on the elevations that include the window and door size. These elevation symbols are the same as those placed on the floor plan to relate the door and window to the respective schedule.

RAILS

A 36" (900 mm) high guardrail is required whenever a porch, balcony, deck, or floor is 30" (750 mm) above the ground or another floor.

Rails can either be solid to match the wall material or open. Open rails are made of wood, wrought iron, and steel tubes or cables. Intermediate rails or ornamental closures are required to be placed so that a 4" (102 mm) sphere cannot pass through the rails. Rails are represented on elevation similar to those shown in Figure 6–26.

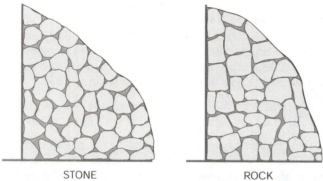

STONE ROCK

Figure 6–22 Stone and rock in elevation.

Figure 6–23 Plaster or stucco in elevations.

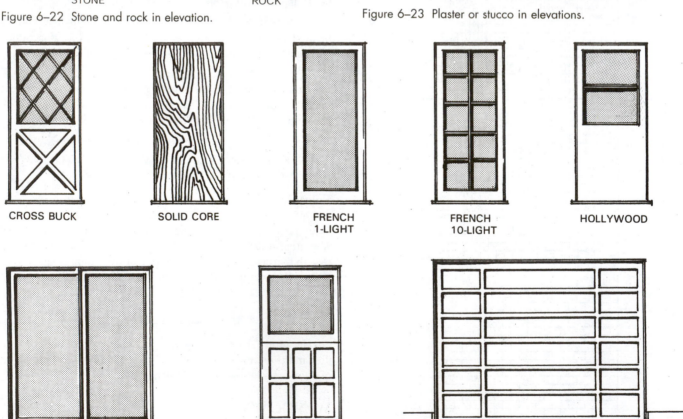

CROSS BUCK SOLID CORE FRENCH 1-LIGHT FRENCH 10-LIGHT HOLLYWOOD

SLIDING DUTCH DOOR GARAGE

Figure 6–24 Common doors as they are shown in elevation. The floor plan and schedules contains all the technical information.

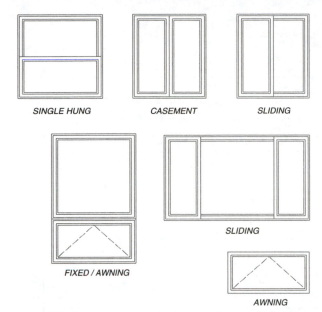

Figure 6–25 Common types of windows shown on elevations.

Figure 6–26 Typical open railing.

CHIMNEY

Several different methods can be used to represent a chimney. Figure 6–27 shows examples of wood and masonry chimneys. The chimney material is specified in a similar manner to the exterior siding. A metal chimney cap or spark arrester is often specified on the elevations.

FOOTINGS

If the structure is built on a level lot, the line of the footing is usually omitted. On a sloping job site, the line of footing can help the foundation crew visualize the grading required to place the foundation. Although the line type may vary, the footing is usually represented as shown in Figure 6–28.

DIMENSIONS

Dimensions are usually kept to a minimum on elevations. Most offices use the elevations to show sizes of major components, with the majority of dimensions placed on the sections where construction materials can be better seen because of the larger scale at which the sections are drawn.

Dimensions most often seen on elevations show the vertical relationship of the floor levels to each other. Other major changes in shape, such as cantilevers and overhangs, can also be shown. The relationship of the chimney to the roof or other portions of the structure within 10' (3000 mm) of the chimney are usually specified on the elevations. Examples of dimensions to show major shapes in elevations can be seen in Figure 6–28.

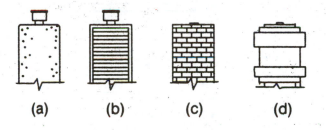

Figure 6–27 Common methods of representing chimneys in elevation: (a) stucco; (b) wood siding; (c) brick; and (d) decorative masonry.

ALTERNATE ELEVATIONS

Many plans for homes that will be constructed in a subdivision are designed to be built more than once. A set of plans can provide alternate elevations so that minor changes can be made to the exterior to give the effect of building a different house plan. The plan can also be flopped or mirrored to change the appearance of the same home. Figure 6–29, Figure 6–30, and Figure 6–31 show three different elevations for the same floor plan. The designer can specify on the site plan which elevation and which orientation of the plan is to be used. Careful coordination is required by the print reader to verify which option of the plan is to be built on a specific site.

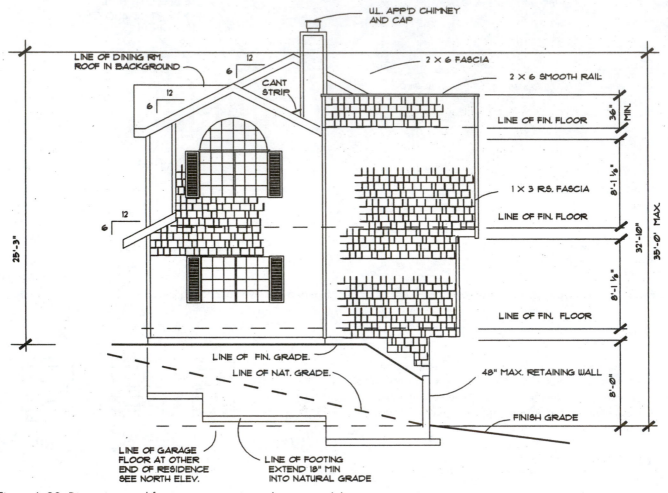

Figure 6–28 Dimensions and footing are sometimes shown to aid the construction crew.

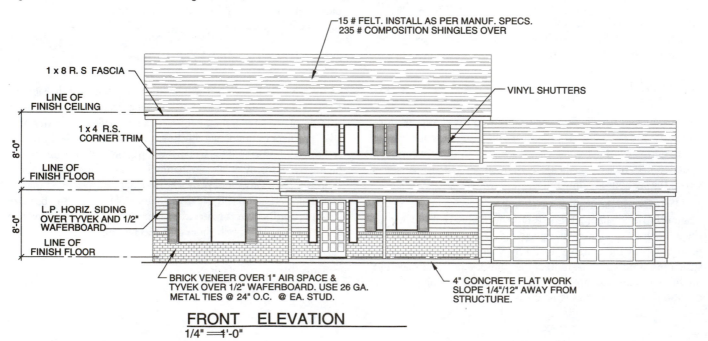

FRONT ELEVATION
1/4" = 1'-0"

Figure 6–29 A set of plans may contain multiple elevations for the same floor plan to create contrast in a subdivision.

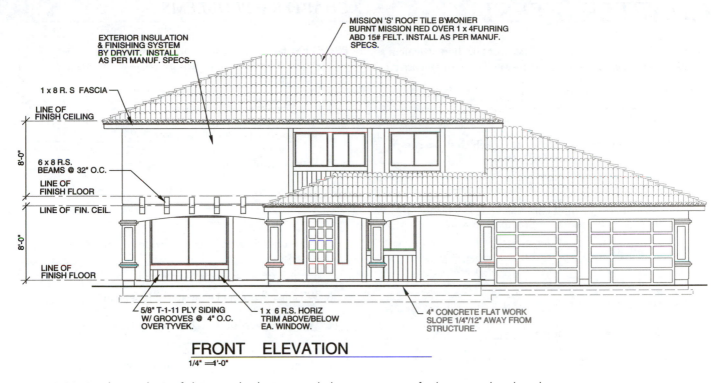

Figure 6–30 By altering the roof shape and siding material, the appearance of a home can be altered.

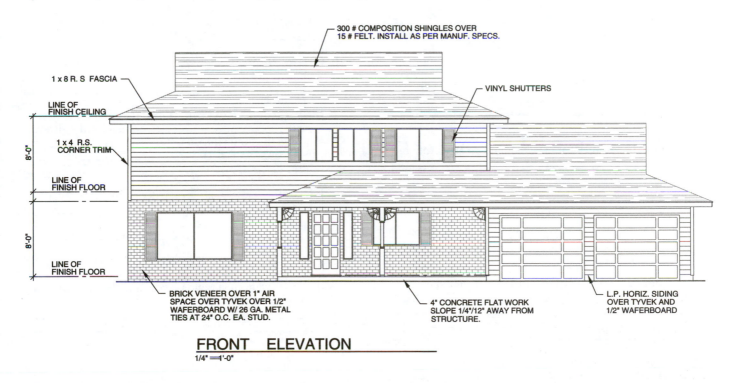

Figure 6–31 Alternate elevation require the print reader to carefully coordinate the elevations with other drawings in the drawing set.

CHAPTER 6 TEST

Fill in the blanks below with the proper word or short statement as needed to complete the sentence or answer the question correctly.

1. What is the purpose of exterior elevations? _____ _____ _____ .

2. Of the two major types of elevations, which will a construction worker be most likely to encounter? _____ _____ _____ .

3. What would be the most common scale at which you would expect the front elevation to be drawn?

 a. 1/8" = 1'–0" _____ .

 b. 1" = 10' _____ .

 c. 1/4" = 1'–0" _____ .

 d. same scale as the floor plan _____ .

4. What are the two major types of wood siding? _____ _____ _____ .

5. List four major types of roofing. _____ _____ _____ _____ .

6. What material will need to be specified to order a tile roof? _____ _____ _____ .

7. List four dimensions that may be found on an elevation. _____ _____ _____ _____ .

8. What are the two major weights of composition shingles? _____ _____ .

9. List four major types of siding that may be found on elevations. _____ _____ _____ _____ .

10. List situations in which fewer than four and more than four elevations would be drawn. _____ _____ _____ _____ .

CHAPTER 6 PROBLEMS

PROBLEM 6–1 Use the floor plan shown in Figure 3–1(a), (b), and (c) and the elevation shown on page 151 to answer the following questions.

1. What size corner trim is used? _____ .

2. What size of fascia will be used? _____ .

3. What type of roofing will be used? _____ .

4. What underlayment will be needed to support the siding? _____ _____ .

5. What underlayment will be used for the roof? _____ _____ _____ .

6. What is the ceiling height in the basement? _____ .

7. What thickness of roof sheathing will be used? _____ _____ .

8. What do the dashed lines represent below the grade line? _____ _____ .

9. What is the height of the ceiling above the main floor? ___ _____ .

10. How will the brick veneer be attached to the wall? _____ _____ _____ .

11. Use the floor plans in Figure 3–1(a), (b), and (c) to determine the approximate surface area of the heated wall area shown in the front elevation. _____ _____ _____ .

12. What is the approximate area of door and window openings located in the heated walls? _____ _____ _____ .

13. A 1 gal. can of sealer will cover 50 sq. ft. Approximately how many cans will be required to seal the basement wall shown in the front elevation and to seal the total basement wall? _____ _____ .

14. What is the percentage of openings to wall area for heat loss of the front elevation? _____ _____ _____ .

15. Approximately how many feet of fascia will be required for the front of the house if 12" overhangs are used? _____ _____ _____ .

PROBLEM 6–2 Use the floor plan and elevation shown on page 151 to answer the following questions.

1. What is the thickness of the exterior siding? _____ .

2. Who is the manufacturer of the finish roofing? _____
_____ .

3. How far will the stucco walls extend past the windows?
_____ .

4. List the various sizes of trim to be used. _____

_____ .

5. What type of siding will be used to accent the upper windows? _____
_____ .

6. What gage of line wire will be used to support the stucco?

_____ .

7. What is the height of the living room ceiling? _____
_____ .

8. How will the decorative trim in the Spanish model be constructed? _____
_____ .

9. Why are the stucco corners rounded? _____
_____ .

10. This residence is being built in a subdivision with a height limitation of 25'–0" max. If the roof is built at a 6/12 pitch, what is the height of the ridge? _____
_____ .

11. Determine how many feet of each size of trim will need to be purchased for the front elevation. _____

_____ .

12. The roof tile is 13" wide. How many tiles will be required to form the first course of the upper and lower roofs on the front elevation? _____

_____ .

13. How many sheets of T1-11 plywood will be required to provide the trim on the front elevation? _____

_____ .

14. If the horizontal siding is laid with a 5" exposure, how many individual pieces will be required between each window?

_____ .

15. Would there be less scrap with 8', 10', or 12' lumber when installing the siding between the bath and bedroom window?

_____ .

Reading Cabinet Elevations

CHAPTER OVERVIEW

This chapter covers the following topics:

- Types of millwork
- Reading cabinet drawings
- Keying cabinet elevations to floor plans

- Test
- Problems

Cabinet construction is an element of the final details of a structure known as millwork. Millwork is any item that is considered finish trim or finish woodwork. For example, the custom plans for a residential or commercial structure may show very detailed and specific drawings of the finish woodwork in the form of plan views, elevations, construction details, and written specifications. Plans of a house that is one of many to be built with a group of houses may show only floor plan views of cabinetry, giving the building contractor the flexibility of being able to using available millwork without strict requirements placed on selection. Other factors that determine the extent of millwork drawings on a set of plans are the requirements of specific lenders and local code jurisdictions.

TYPES OF MILLWORK

Millwork can be designed for appearance or for function. When designed for appearance, ornate and decorative millwork may be created with a group of shaped wooden forms placed together to capture a style of architecture. There are also vendors that manufacture a wide variety of prefabricated millwork moldings that are available at less cost than custom designs (see Figure 7–1). Millwork that is designed for function can be very plain in appearance and is also less expensive than standard sculpted forms. Sometimes wood millwork can be replaced with plastic or ceramic products. For example, in a public restroom or in a home laundry room, a plastic strip can be used around the wall at the floor to protect the wall. This material stands up to abuse better than wood. In some cases drawings are made for specific millwork applications. There are as many possible

details as there are design ideas. The following discussion provides a general example of the items to help define the terms.

BASEBOARDS

Baseboards are placed at the intersection of walls and floors and are generally used to protect the wall from damage, as shown in Figure 7–2. Figure 7–3 shows some standard molded baseboards.

Figure 7–1 Prefabricated millwork installed in a restaurant. *Courtesy Cumberland Woodcraft Co., Inc., Carlisle, PA.*

Wainscots

For a wall finish in which the material on the bottom portion of the wall is different from that on the upper portion, the lower portion is the *wainscot* and the material used is *wainscoting*. Wainscots may be used on the interior or exterior of the structure. Exterior wainscoting is often brick veneer. Interior wainscoting can be any material that is used to divide walls into two visual sections. For example, wood paneling, plaster texture, ceramic tile, wallpaper, or masonry can be used as wainscoting. Figure 7–4 shows the detail of wood wainscot with plywood panels. The plywood panel may have an oak or other hardwood outer veneer to match the surrounding hardwood material. This is a less expensive method of constructing an attractive wood wainscot than with the hardwood panels shown in Figure 7–5.

CHAIR RAIL

The *chair rail* has traditionally been placed horizontally on the wall at a height where chair backs would otherwise damage the wall. See Figure 7–6. Chair rails are found in the dining room, den, office, or in other areas where chairs are frequently moved against a wall. Chair rails can be used in conjunction with wainscoting. In some applications the chair rail is an excellent division between two different materials or wall textures. Figures 7–7 shows sample chair rail moldings.

CORNICE

The cornice is decorative trim placed in the corner where the wall meets the ceiling. A cornice can be a single shaped wood member, called cove or crown molding, as seen in Figure 7–8, or the cornice can be a more elaborate structure made up of several individual wood members, as shown in Figure 7–9. Cornice boards traditionally fit into specific types of architectural styles, such as English Tudor, Victorian, or colonial. Figure 7–10 shows some standard cornice moldings. In most construction, where contemporary architecture or cost-saving is important, wall-to-ceiling corners are left square.

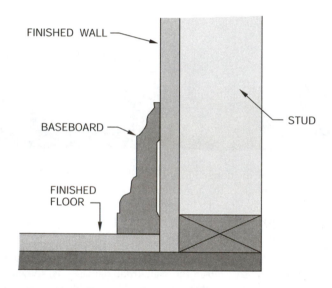

Figure 7–2 Typical baseboard installation.

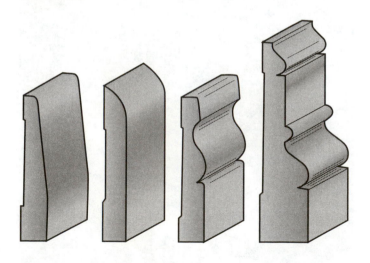

Figure 7–3 Examples of standard baseboards. *Courtesy Hillsdale Sash & Door Co., Inc.*

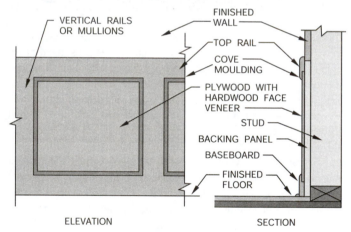

Figure 7–4 Plywood panel wainscot installation.

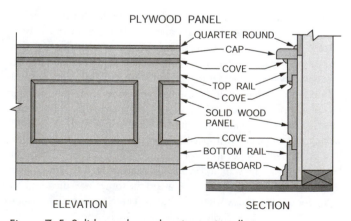

Figure 7–5 Solid wood panel wainscot installation.

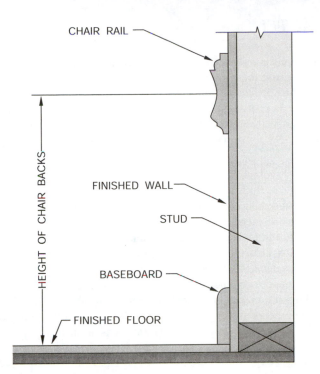

Figure 7–6 Chair rail.

Figure 7–7 Standard chair rails. *Courtesy Hillsdale Sash & Door Co., Inc.*

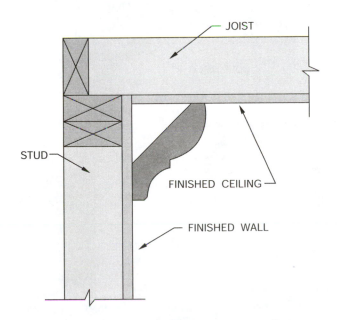

Figure 7–8 A typical individual-piece cornice installation.

CASINGS

Casings are the members that are used to trim around windows and doors. Casings are attached to the window or doorjamb (frame) and to the adjacent wall, as shown in Figure 7–11. Casings may be decorative to match other moldings or plain to serve the functional purpose of covering the space between the door or window jamb and the wall. Figure 7–12 shows a variety of standard casings.

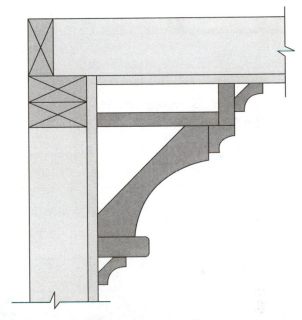

Figure 7–9 A multiple-piece cornice installation.

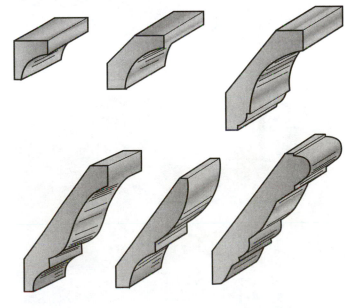

Figure 7–10 Standard cornice (cove and ceiling). *Courtesy Hillsdale Pozzi, Inc.*

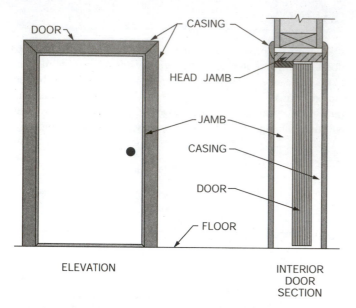

ELEVATION INTERIOR DOOR SECTION

Figure 7–11 Typical door casing installation. Window casings are applied in the same manner.

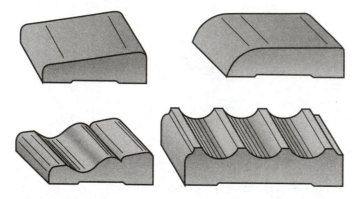

Figure 7–12 Standard casings.
Courtesy Hillsdale Sash & Door Co., Inc.

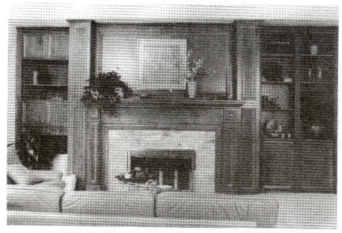

Figure 7–13 A fireplace mantel and bookshelf cabinetry. *Photo by Bruce Davies, courtesy Park Place Wood Products, Inc.*

MANTELS

The *mantel* is an ornamental shelf or structure that is built above a fireplace opening, as seen in Figure 7–13. Mantel designs vary with individual preference. Mantels can be made of masonry as part of the fireplace structure, of ornate, decorative wood moldings, or even of a rough-sawn length of lumber bolted to the fireplace face. Figure 7–14 shows a traditional mantel application.

BOOKSHELVES

Book and display shelves may have simple construction with metal brackets and metal or wood shelving, or they can be built detailed as fine furniture. Bookshelves are commonly found in such rooms as the den, library, office, or living room. Shelves that are designed to display items other than books are also found in almost any room of the house. A common application is placing shelves on each side of a fireplace, as seen in Figure 7–13. Shelves are also used for functional purposes in storage rooms, linen closets, laundry rooms, and any other location where additional storage is needed.

RAILINGS

Railings are used for safety at stairs, landings, decks, and open balconies from which people might fall. Railings can also be used as decorative room dividers or for special accents. Railings can be built enclosed or open and are constructed of wood or metal. Enclosed rails are often the least expensive to build because they require less detailed labor than open rails. A decorative wood cap is typically used to trim the top of enclosed railings (see

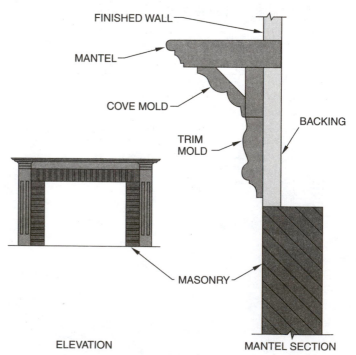

ELEVATION MANTEL SECTION

Figure 7–14 Traditional mantel.

Figure 7–15). Open railings can be one of the most attractive elements of interior design. Open railings can be as detailed as the designer's or craftsperson's imagination. Detailed open railings built of exotic hardwoods can be one of the most expensive items in the structure. Figure 7–16 shows some standard railing components.

READING CABINET DRAWINGS

One of the most important items for buyers of a new home is the cabinets. The quality of cabinetry can vary greatly. Cabinets are used for storage and as furniture. Kitchen cabinets have two basic elements: the base cabinet and the upper cabinet (see Figures 7–17 and 7–18). Drawers, shelves, cutting boards, pantries, and appliance locations are found in the kitchen cabinets. Bathroom cabinets are called vanities, linen cabinets, and medicine cabinets (see Figure 7–19). Other cabinetry can be found throughout a house, such as in utility or laundry rooms for storage. For example, a storage cabinet above a washer and dryer is common.

CABINET TYPES

There are as many cabinet styles and designs as the individual can imagine. However, there are only two general types of cabinets based upon their method of construction. These are modular, or prefabricated cabinets, and custom cabinets.

MODULAR CABINETS

The term modular refers to prefabricated cabinets because they are constructed in specific sizes called modules. The best use of modular cabinets is when a group of modules can be placed side by side in a given space. Most modular cabinet vendors offer different door styles, wood species, or finish colors on their cabinets. Modular cabinets are sized in relationship to standard or typical applications, although many modular cabinet manufacturers can make cabinet components that fit nearly every design situation.

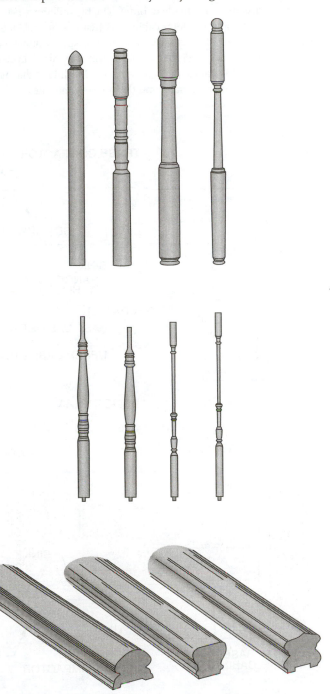

Figure 7–16 Examples of standard railing components. *Courtesy Hillsdale Pozzi Co.*

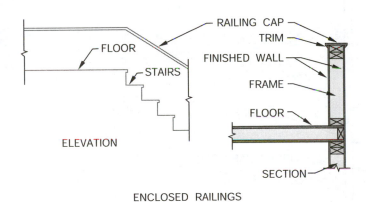

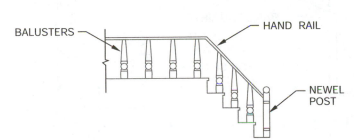

Figure 7–15 Railings.

The modular cabinet layout begins with standard manufactured cabinet components, which include wall (or upper) cabinets, base cabinets, vanity cabinets, tall cabinets, and accessories. Modular cabinets incorporate the individual units into the floor plan based upon the manufacturer's sizes and specifications. The actual floor plans look the same as any of the cabinet representations presented in Chapter 20.

CUSTOM CABINETS

The word *custom* means made to order. The big difference between custom cabinets and modular cabinets is that custom cabinets are generally fabricated locally in a shop to the specifications of an architect or designer, and after construction they are delivered to the job site and installed in large sections. Modular cabinets are often manufactured nationally and delivered in modules.

One of the advantages of custom cabinets is that their design is limited only by the imagination of the architect and the cabinet shop. Custom cabinets may be built for any situation, such as for any height, space, type of exotic hardwood, type of hardware, geometric shape, or other design criteria.

CABINET OPTIONS

Some of the cabinet design alternatives that are available from either custom or modular cabinet manufacturers include:

- door styles, materials, and finishes.
- self-closing hinges.
- a variety of drawer slides, rollers, and hardware.
- glass cabinet fronts for a more traditional appearance.
- wooden or metal range hoods.

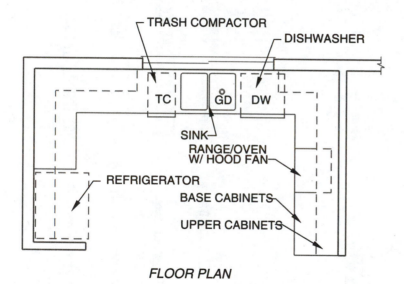

FLOOR PLAN

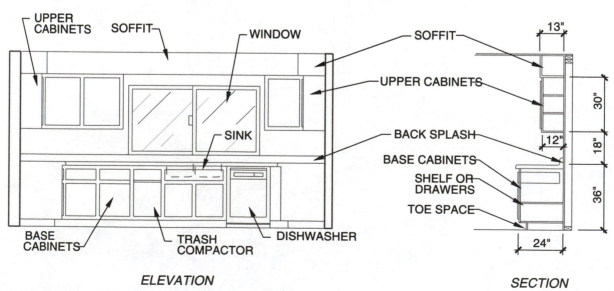

ELEVATION

SECTION

Figure 7–17 Components of kitchen cabinets.

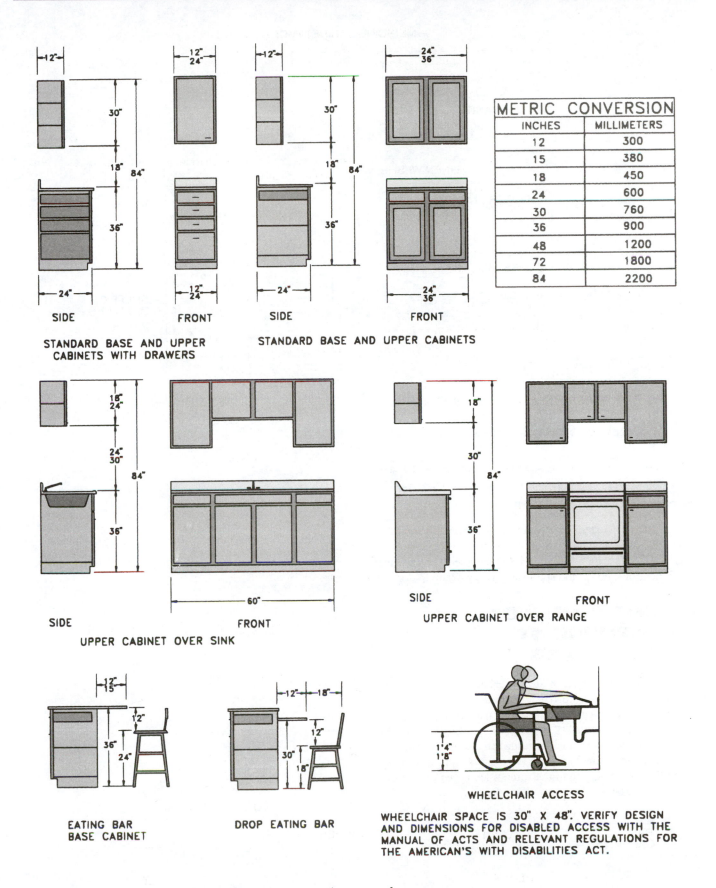

METRIC CONVERSION

INCHES	MILLIMETERS
12	300
15	380
18	450
24	600
30	760
36	900
48	1200
72	1800
84	2200

STANDARD BASE AND UPPER CABINETS WITH DRAWERS

STANDARD BASE AND UPPER CABINETS

UPPER CABINET OVER SINK

UPPER CABINET OVER RANGE

EATING BAR BASE CABINET

DROP EATING BAR

WHEELCHAIR ACCESS

WHEELCHAIR SPACE IS 30" X 48". VERIFY DESIGN AND DIMENSIONS FOR DISABLED ACCESS WITH THE MANUAL OF ACTS AND RELEVANT REGULATIONS FOR THE AMERICAN'S WITH DISABILITIES ACT.

Figure 7–18 Standard cabinet dimensions. All metric equivalents are soft conversions.

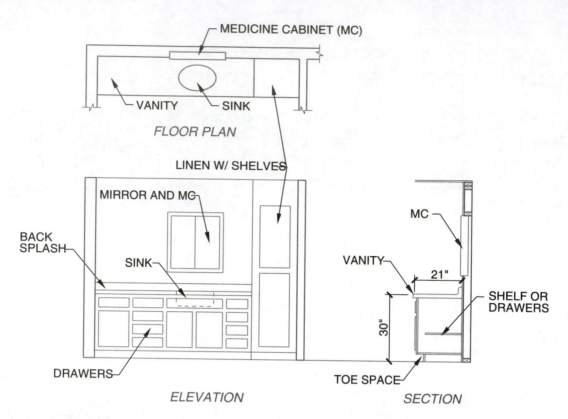

Figure 7–19 Components of bathroom cabinets.

- specially designed pantries, appliance hutches, and a lazy Susan or other corner cabinet design for efficient storage.
- bath, linen storage, and kitchen specialties.

Cabinet elevations or exterior views are developed directly from the floor plan drawings. The purpose of the elevations is to show how the exterior of the cabinets will look when completed and to give general dimensions, notes, and specifications. See Figure 7–20.

KEYING CABINET ELEVATIONS TO FLOOR PLANS

Several methods may be used to key the cabinet elevations to the floor plan. In Figure 7–20, the designer keyed the cabinet elevations to the floor plans with room titles, such as KITCHEN CABINET ELEVATIONS and BATH AND UTILITY ELEVATIONS. In Figure 7–21 an arrow with a letter inside can also be used to correlate the elevation to the floor plan. For example, in Figure 7–22 the E and F arrows pointing to the vanities are keyed to letters E and F that appear below the vanity elevations.

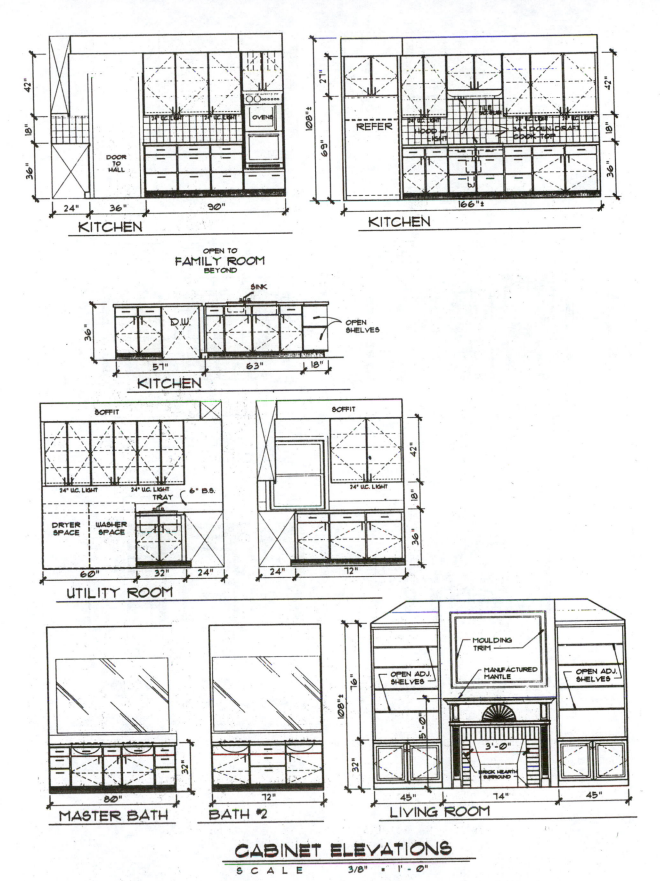

Figure 7–20 Cabinet elevations keyed to the floor plans with room titles. *Courtesy Piercy & Barclay Designers, Inc.*

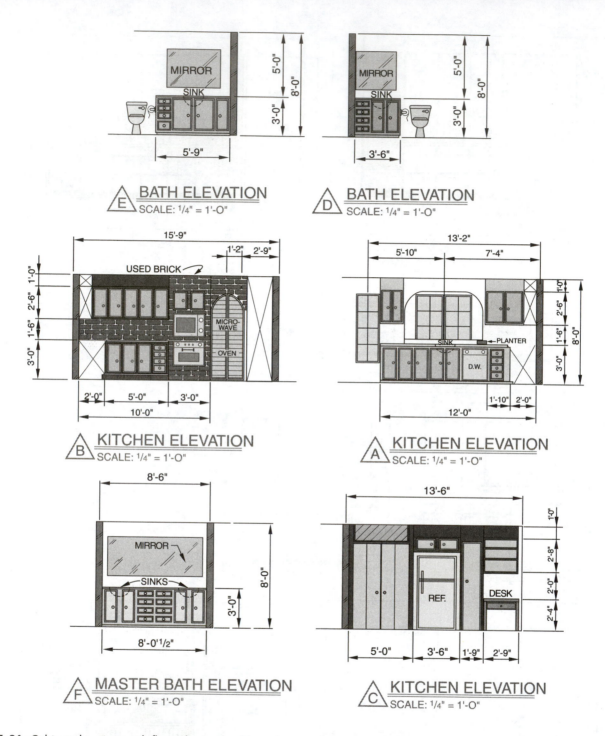

Figure 7–21 Cabinet elevations with floor plan and cabinet elevation location symbols.

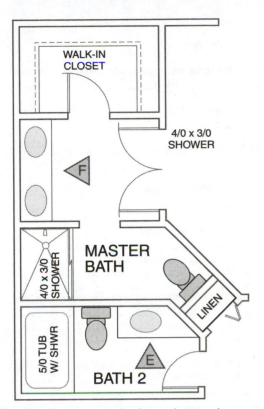

Figure 7–22 The floor plan and cabinet elevation location symbol, placed on the floor plan. Look at Figure 7–21 to see the cabinet location symbol on the related cabinet elevations. *Courtesy Madsen Designs.*

CHAPTER 7 TEST

1. Cabinet construction is an element of the final details of a structure known as _____ .

2. Define millwork. _____

 _____ .

3. The millwork placed at the intersection of walls and floors, that is used to protect the wall from damage is called the _____ .

4. A _____ is the material on the bottom portion of the wall when the wall finish of the bottom portion is different from the material on the upper portion.

5. Name the millwork item that has traditionally been placed horizontally on the wall at a height where chair backs would otherwise damage the wall. _____ .

6. The millwork that is a decorative trim placed in the corner where the wall meets the ceiling is called the _____
 _____ .

7. The members that are used to trim around doors and windows are called _____ .

8. An ornamental shelf or structure that is built above a fireplace opening is called a _____ .

9. Rails are recommended at any rise that measures _____
 _____ or is _____ or more stair risers.

10. Name the two basic elements of kitchen cabinets. _____
 _____ .

11. Bathroom cabinets where the sink is located are called
 _____ .

12. Describe modular cabinets. _____
 _____ .

13. Describe custom cabinets. _____

 _____ .

14. List at least three purposes of cabinet elevations. _____

 _____ .

15. Explain at least two ways that cabinet elevations can be keyed to the floor plan. _____

 _____ .

CHAPTER 7 PROBLEMS

PROBLEM 7–1 Given the following millwork component drawings, place the name of the type of millwork in the blank provided below each drawing.

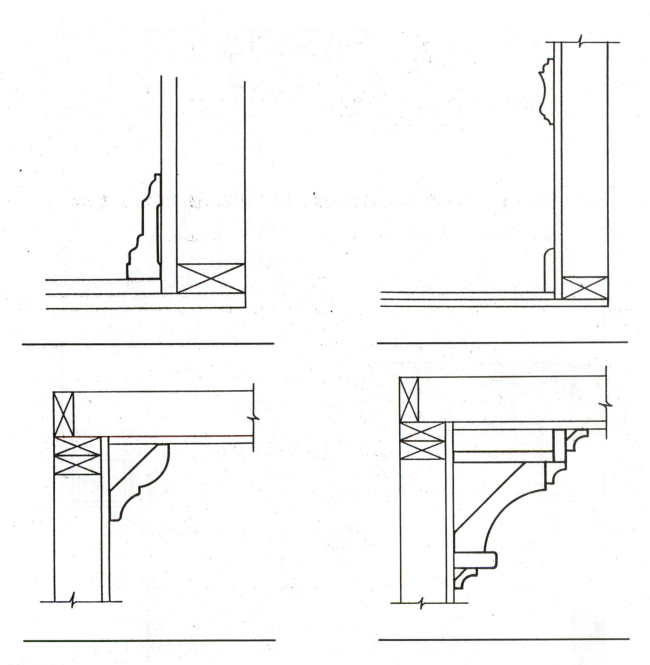

Problem 7–1

PROBLEM 7–2 Given the kitchen floor plan, cabinet elevation, and section through the cabinets shown, place the name of each component and the correct standard cabinet dimensions on the blanks provided.

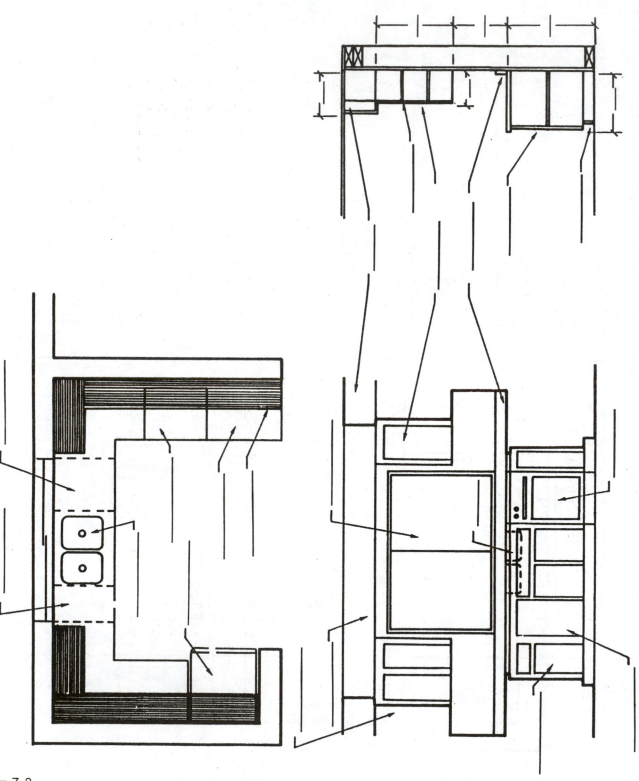

Problem 7–2

PROBLEM 7–3 Given the bathroom floor plan, cabinet elevation, and section through the cabinets shown, place the name of each component and the correct standard cabinet dimensions on the blanks provided.

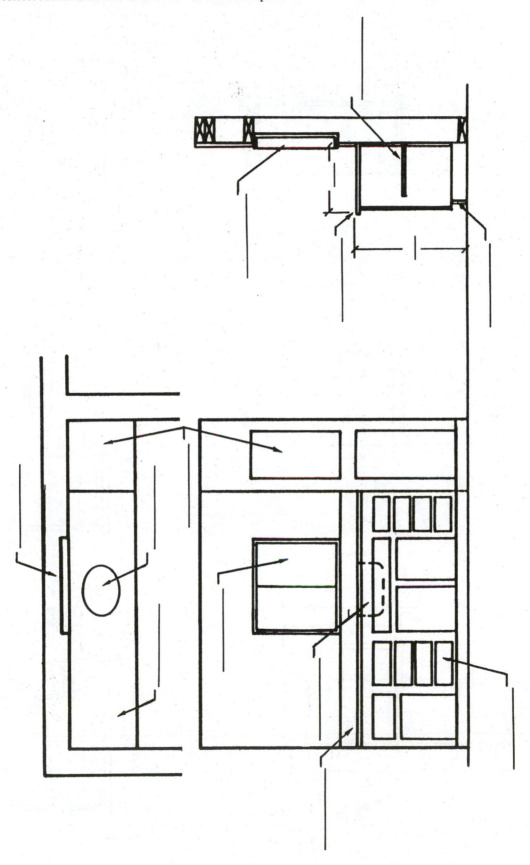

PROBLEM 7–4 Given the standard base and upper cabinet detail shown, provide the standard dimensions in the blanks provided.

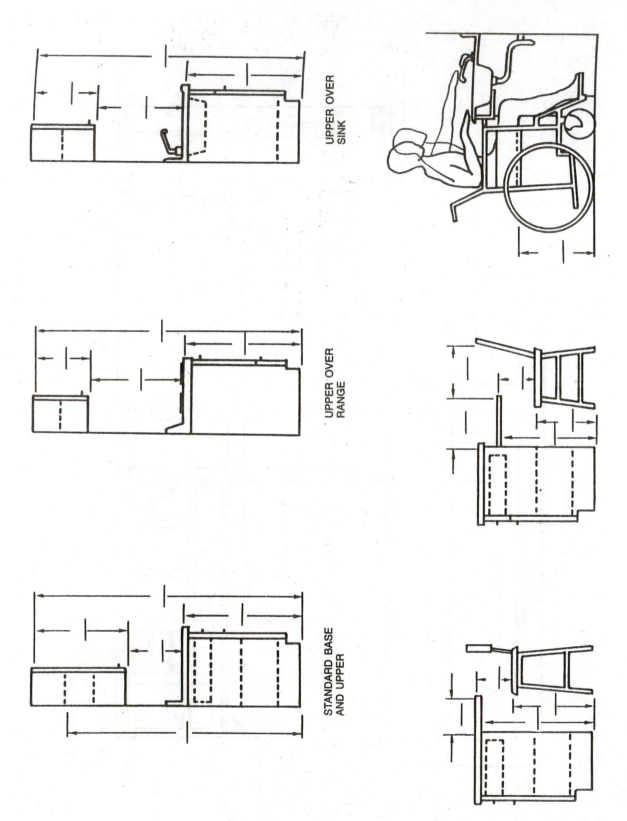

UPPER OVER SINK

UPPER OVER RANGE

STANDARD BASE AND UPPER

PROBLEM 7–5 Given the standard upper cabinet detail over the range shown, provide the standard dimensions in the blanks provided.

Problem 7–5

PROBLEM 7–6 Given the standard upper cabinet detail over the sink shown, provide the standard dimensions in the blanks provided.

Problem 7–6

PROBLEM 7–7 Given the partial floor plans and correlated cabinet elevations shown on pages 173–175, answer the following questions:

1. How are the cabinet elevations keyed to the floor plans?

 _____ .

2. List the appliances found in the kitchen. _____

 _____ .

3. How far does the eating bar project out from the base cabinet? _____ .

4. Describe the kitchen sink. _____

 _____ .

5. How many drawers are in the kitchen cabinets? (Note: The units that look like drawers at the range and sink are blank fronts; drawers cannot be placed in an area occupied by such appliances or fixtures as a sink or range.) _____
 _____ .

6. What is specified about the sides of the ovens? _____
 _____ .

7. What is the dimension of the soffit above the kitchen upper cabinets? _____
 _____ .

8. What is the total dimension from the floor to the ceiling in the kitchen? (show your calculations) _____
 _____ .

9. How do you know whether the refrigerator is included in the construction or is to be purchased later by the buyer?

 _____ .

10. What scale was used to draw the cabinet elevations? _____
 _____ .

11. Is there a backsplash specification given in the kitchen? If yes, what is the specification? _____

 _____ .

12. Which bathroom has a built-in medicine cabinet with mirror?
 _____ .

13. How many bathroom sinks (lavatories) are there in the three bathrooms? _____ .

14. How many drawers are there in bathroom 1? _____ .

15. How many cabinet doors are there in bathroom 1? _____ .

16. How many drawers are there in bathroom 2? _____ .

17. How many cabinet doors are there in bathroom 2? _____ .

18. How many drawers are there in bathroom 3? _____ .

19. How many cabinet doors are there in bathroom 3? _____ .

20. Describe the mirrors in bathroom 3. _____
 _____ .

21. What is the purpose of the KNEE SPACE in bathroom 3?

 _____ .

22. Give the specification provided for bathroom vanity and backsplash material. _____

 _____ .

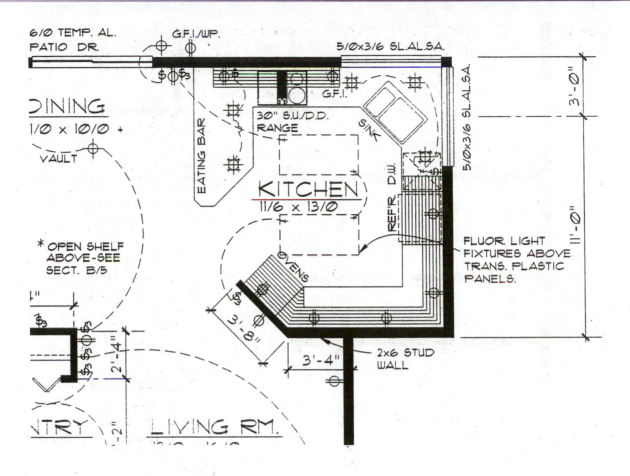

6/0 TEMP. AL.
PATIO DR.

G.F.I./W.P.

5/0x3/6 SL.AL.SA.

DINING
1/0 × 10/0 +
VAULT

EATING BAR

30" S.U./D.D.
RANGE

KITCHEN
11/6 × 13/0

SINK

REF'R D.W.

5/0x3/6 SL.AL.SA.

* OPEN SHELF
ABOVE—SEE
SECT. B/5

3'-0"

11'-0"

FLUOR. LIGHT
FIXTURES ABOVE
TRANS. PLASTIC
PANELS.

G.F.I.

OVENS

3'-8"

2'-4"

3'-4"

2×6 STUD
WALL

NTRY

LIVING RM.

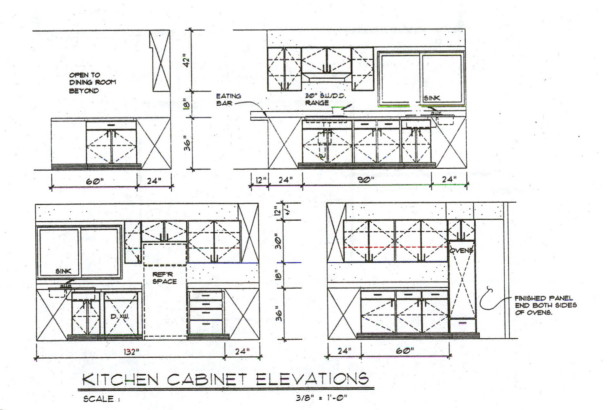

OPEN TO
DINING ROOM
BEYOND

42"

18"

36"

60"

24"

EATING
BAR

30" S.U./D.D.
RANGE

SINK

12"

24"

90"

24"

SINK

REF'R
SPACE

D. W.

132"

24"

12"

30"

18"

36"

OVENS

FINISHED PANEL
END BOTH SIDES
OF OVENS.

24"

60"

KITCHEN CABINET ELEVATIONS

SCALE : 3/8" = 1'-0"

Problem 7–7

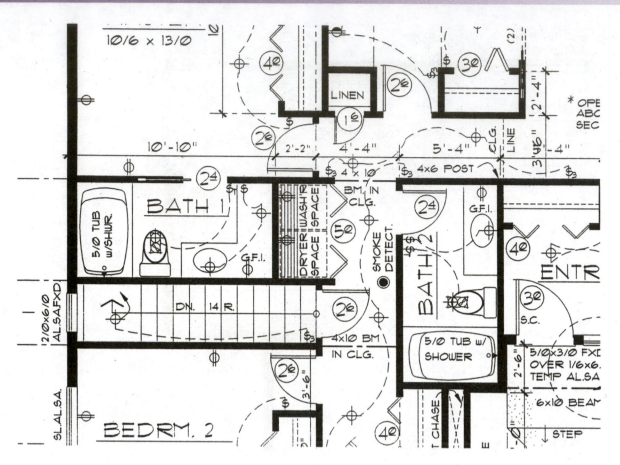

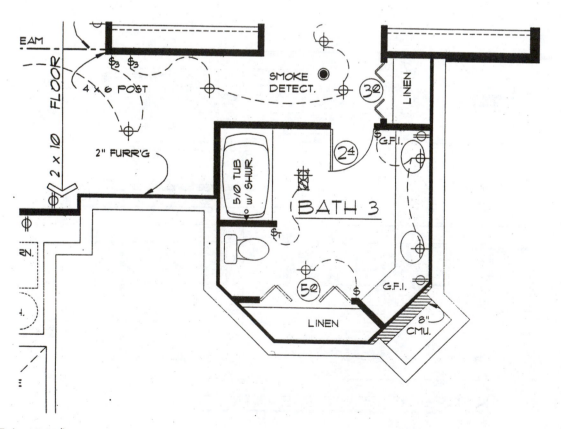

Problem 7–7 (continued)

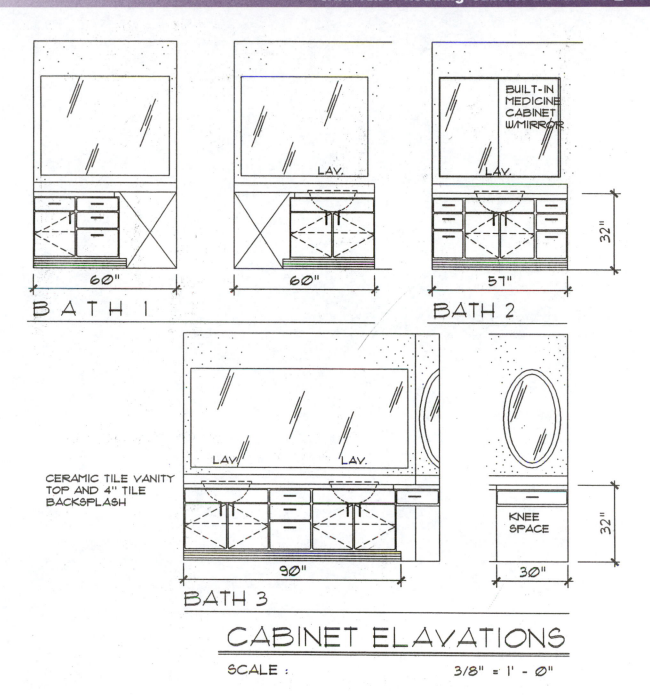

BATH 1 60"

BATH 2 60" 57" 32"

BUILT-IN MEDICINE CABINET W/MIRROR

LAV.

CERAMIC TILE VANITY TOP AND 4" TILE BACKSPLASH

LAV. LAV.

KNEE SPACE

BATH 3 90" 30" 32"

CABINET ELAVATIONS

SCALE : 3/8" = 1' - 0"

Problem 7–7 (continued)

Framing Methods, Structural Components, and Framing Plans

CHAPTER OVERVIEW

This chapter covers the following topics:

- Framing methods
- Structural components
- Reading framing plans

- Test
- Problems

FRAMING METHODS

More so than any other drawing, reading framing plans requires a thorough understanding of the materials and the process of construction. To read these drawings and see how the building is to be constructed requires an understanding of basic construction principles.

Several different types of framing systems and materials are represented on construction drawings. Wood, masonry, and concrete are the most common materials used in the construction of residential and small office buildings. With each material several different framing methods can be used to assemble the components. Wood is the most widely used material for the framing of houses and apartments. The most common framing systems used with wood include balloon, platform, and post and beam. There are also several variations of platform framing to provide better energy efficiency.

BALLOON FRAMING

Although balloon framing is not widely used, a knowledge of this system can prove helpful if an old building is being remodeled. With the balloon framing method, the exterior studs run from the top of the foundation to the top of the highest level. Because the wall members are continuous from the foundation to the roof, fewer horizontal members are used. Because of the long pieces of lumber needed, a two-story structure is the maximum that can be built easily using balloon framing. Floor framing at the midlevel is supported by a ledger set into the studs. Structural members were usually spaced at 12", 16", or 24" (300, 400, or 600 mm) on center.

Although the length of the wood gave the building stability, it also caused the demise of the system. The major flaw with balloon framing is fire danger. A fire starting in the lower level could race quickly through the cavities formed in the wall or floor systems of the building.

PLATFORM FRAMING

Platform, or Western platform, framing is the most common framing system now in use. The system gets its name from the platform created by each floor as the building is being framed. The framing crew is able to use the floor as a platform to assemble the walls for that level. Platform framing grew out of the need for the fireblocks in the balloon framing system. The fireblocks that were placed individually between the studs in balloon framing became continuous members placed over the studs to form a solid bearing surface for the floor or roof system.

Building with the Platform System. With the foundation and floor system in place, the framing materials for the walls can be laid out on the floor. The wall members are aligned, the windows are framed, and even the siding can be installed while the wall is lying on the floor. Once assembled, the wall can be slid into position and tilted into its vertical position. With all the walls in position that will be used to support the upper level, the next floor level can be started. As in the balloon system, studs are placed at 12", 16", or 24" (300, 400, or 600 mm), with 16" (400 mm) o.c. the most common spacing. Figure 8–1 shows materials typically used with Western platform construction.

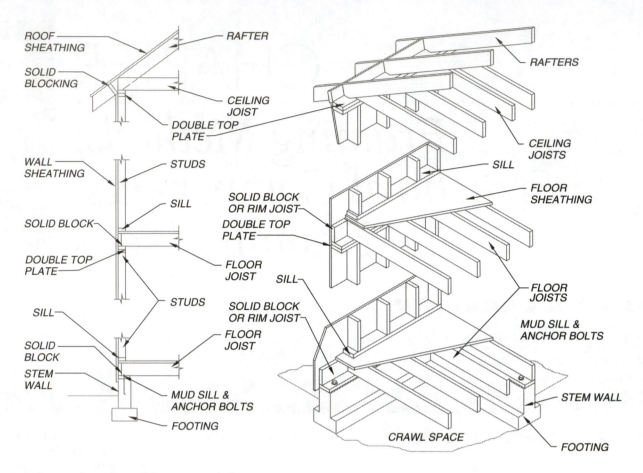

Figure 8–1 Structural members of the western platform system.

STEEL FRAMING

Steel framing is becoming increasingly competitive with wood framing techniques in residential construction. Lower energy cost, higher strength, and insurance considerations are helping steel framing companies make inroads into residential markets. Because exterior walls are wider, insulation of R-30 can be used for exterior walls. Steel framing also has excellent properties for resisting stress from snow, wind, and seismic forces, as well as termite and fire damage.

Many residential steel structures incorporate techniques similar to western platform construction methods. Steel studs, as in Figure 8–2, are used to frame walls. Walls are normally framed in a horizontal position on the floor and then tilted into place and bolted together. Steel trusses are typically used to provide design flexibility because they require no interior bearing walls. Trusses can also be assembled on the ground and then lifted into place.

POST-AND-BEAM FRAMING

Post-and-beam construction places framing members at greater distances apart than platform methods. In residential construction, posts and beams are usually spaced at a minimum of 48" (1200 mm) on center. Although the system uses less lumber than other methods, the

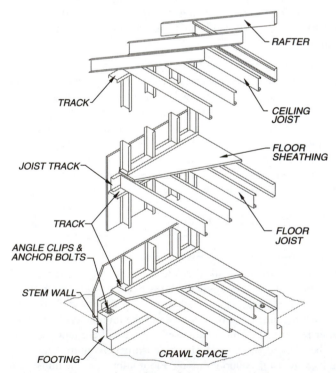

Figure 8–2 Structural members of the western platform system composed of steel members.

required members are larger. Sizes vary depending on the span, but beams 4" or 6" (100 mm or 150 mm) and wider are typically used. The subflooring and roofing over the beams is commonly 2 × 6, 2 × 8, or 1–1/8" (50 × 150, 50 × 200, or 28 mm) T&G plywood.

Post-and-beam construction can offer great savings in both lumber and nonstructural materials. This savings results from careful planning of the locations of the posts and the doors and windows located between them. Savings also result by having the building conform to the modular dimensions of the material being used. Figure 8–3 shows common structural members of post-and-beam framing. Although an entire home can be framed with this method, many contractors use the post-and-beam system for supporting the lower floor when no basement is required and roof systems, and then use conventional framing methods for the walls and upper levels.

TIMBER CONSTRUCTION

Although timber framing has been used for over 2,000 years, the system was not widely used for the last 100 years. The development of balloon framing methods with its smaller materials greatly reduced the desire for timber methods. Many homeowners are now returning to timber framing methods for the warmth and coziness timber homes tend to create. The length and availability of lumber affect the size of the frame. Although custom sizes are available for added cost, many mills no longer stock timbers longer than 16' (4800 mm). If laminated timbers are used, spans are not a consideration. The method for lifting the timbers into place may also affect the size of the frame. Beams are often lifted into place by brute force, by winch, by forklift, or by crane. The method of joining the beams at joints affects the frame size. Figure 8–4 shows common timber components.

CONCRETE MASONRY CONSTRUCTION

Concrete masonry units (CMUs) are a durable, economical building material that provides excellent structural and insulation values. Concrete blocks are used primarily in warmer climates, from Florida to southern California, as an aboveground building material. CMUs can be waterproofed with cement-based paints and used as the exterior finish, or they can be covered with stucco. Waterproof wood furring strips are normally attached to the interior side of the block to support sheetrock. In areas with cooler climates, concrete blocks are often used only for below-grade construction.

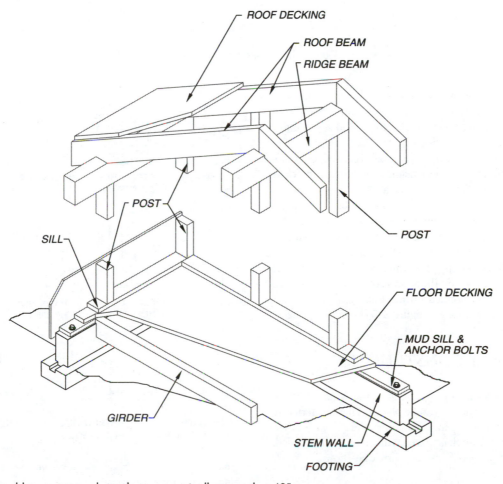

Figure 8–3 Post and beam structural members are typically spaced at 48" o.c.

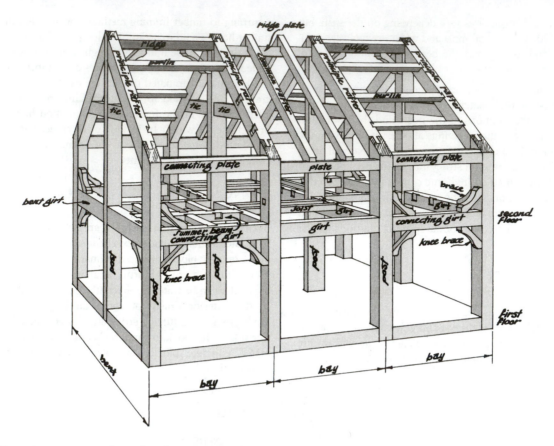

Figure 8–4 Typical components of a timber home. *Courtesy Timberpeg Post and Beam Homes.*

CMUs come in a wide variety of patterns and shapes. The most common sizes are 8 × 8 × 16 (200 × 200 × 400 mm), 8 × 4 × 16 (200 × 100 × 400 mm), and 8 × 12 × 16 (200 × 300 × 400 mm). Nominal block widths are 4", 6", 8", 10", and 12" (100, 150, 200, 250, and 300 mm), and lengths are 6", 8", 12", 16", and 24" (150, 200, 300, 400, 600 mm). Each dimension of a concrete block is actually 3/8" (10 mm) smaller to allow for a 3/8" (10 mm) mortar joint. In addition to the exterior patterns, concrete blocks come in a variety of shapes, as shown in Figure 8–5. These shapes allow for the placement of steel reinforcement bars, or steel reinforcing mesh. Reinforcing is required at approximately 48" (1200 mm) o.c. vertically. Horizontal reinforcement is approximately 16" (400 mm) o.c., but the exact spacing depends on the seismic or wind stresses to be resisted. Reinforcement is specified on the framing plan and also shown in a cross section and detail. Figure 8–6 shows components of CMU construction.

SOLID MASONRY CONSTRUCTION

One of the most popular features of brick is the wide variety of positions and patterns in which it can be placed. These patterns are achieved by placing the bricks in various positions to each other. The position in which the brick is placed will alter what it is called. Figure 8–7 shows the names of common brick positions.

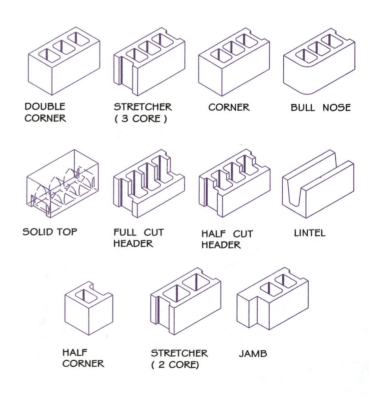

DOUBLE CORNER STRETCHER (3 CORE) CORNER BULL NOSE

SOLID TOP FULL CUT HEADER HALF CUT HEADER LINTEL

HALF CORNER STRETCHER (2 CORE) JAMB

Figure 8–5 Common shapes of concrete masonry units.

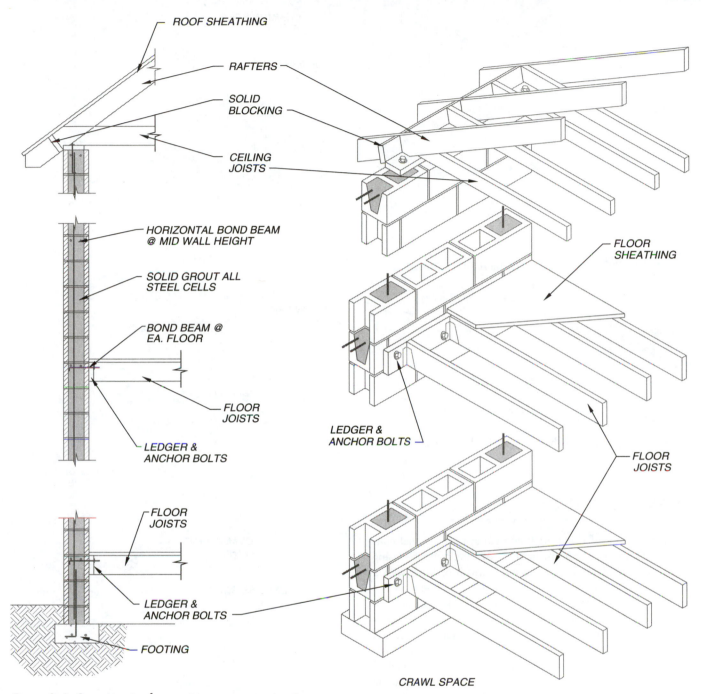

Figure 8–6 Components of concrete masonry construction.

Bricks can be placed in various positions to form a variety of bonds and patterns. A *bond* is the connecting of two wythes to form stability within the wall. The pattern is the arrangement of the bricks within one wythe. The Flemish and English bonds in Figure 8–8 are the most common methods of bonding two wythes or vertical sections of a wall that is one brick thick. The Flemish bond consists of alternating headers and stretchers in every course. A course of brick is one row in height. An English bond consists of alternating courses of headers and stretchers. The headers span between wythes to keep them from separating.

Masonry walls must be reinforced using methods similar to those used with concrete blocks. The loads to be supported and the stress from wind and seismic loads determine the size and spacing of the rebar to be used and are established by the architect or engineer. If a masonry wall is to be used to support a floor, a space one wythe wide will be left to support the joists. When a roof framing system is to be supported on masonry, a pressure-treated plate is usually bolted to the brick, similar to how a plate is attached to a concrete foundation. Figure 8–9 shows how floor and roof members are typically attached to masonry.

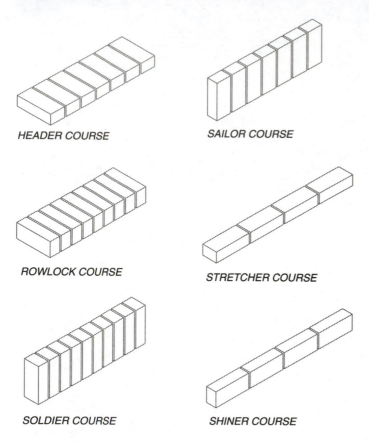

HEADER COURSE

SAILOR COURSE

ROWLOCK COURSE

STRETCHER COURSE

SOLDIER COURSE

SHINER COURSE

Figure 8–7 The position in which a brick is placed alters the name of the unit.

MASONRY VENEER

A common method of using brick and stone in residential construction is as a *veneer*, a nonstructural covering material. Using brick as a veneer offers the charm and warmth of brick with a lower construction cost than structural brick. If brick is used as a veneer over a wood bearing wall, for example, the amount of brick required is half that of structural brick. Care must be taken to protect the wood frame from moisture in the masonry. Brick veneer is installed over a 1" (25 mm) airspace and a vapor barrier, such as a layer of 15# felt, is applied to the framing. The veneer is attached to the framing with 26-gage metal ties at 24" (600 mm) o.c. along each stud. Figure 8–10 shows an example of how masonry veneer is attached to a wood frame wall.

INSULATED CONCRETE FORM CONSTRUCTION

Originally used to form foundation walls, insulated concrete forms (ICFs) are now being used to provide an energy-efficient wall framing system for an entire structure. Poured concrete is placed in expanded polystyrene (EPS) forms that are left in place to create a superinsulated concrete wall system. Forms are placed in a pattern similar to concrete blocks and then filed with steel reinforcing and

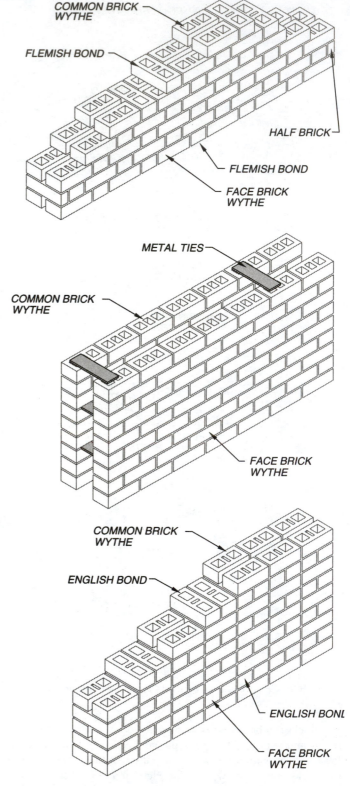

COMMON BRICK WYTHE

FLEMISH BOND

HALF BRICK

FLEMISH BOND

FACE BRICK WYTHE

METAL TIES

COMMON BRICK WYTHE

FACE BRICK WYTHE

COMMON BRICK WYTHE

ENGLISH BOND

ENGLISH BONL

FACE BRICK WYTHE

Figure 8–8 Brick walls can be strengthened by metal ties or bricks connecting wythes. The most common types of brick bonds are the Flemish and English.

concrete. Forms 6" and 8" (150 and 200 mm) wide × 16" (400 mm) high × 48" (1200 mm) long are available. The concrete in the forms creates a pattern similar to post-and-beam construction. Vertical concrete posts are created at 12" (300 mm) on center, and horizontal concrete beams are created at 16" (400 mm) o.c. Solid concrete webs are created between the posts and beams at the center of the forms.

Expanded polystyrene forms (EPFs) provide a stable base for attaching interior and exterior finishing materials and help to create the high-energy efficiency of the system. The thermal mass of the concrete and the R-20 value of the EPF give the energy efficiency. Depending on the width of the wall and finishing materials, the total R-value can range from R-30 to R-50. The system also excels by reducing air leakage and air infiltration into the structure. Structures constructed from ICF average 0.1 air exchange per hour (ACH) compared with 0.4 ACH for wood framed walls. Figure 8–11 shows wall construction using ICF methods.

ENERGY-EFFICIENT CONSTRUCTION

No matter what system of construction is used, energy efficiency can be a part of the construction process. Some of the following construction techniques may seem like excessive protection, and depending on the area of the country, some of the methods would be inappropriate. The examples given are simply examples of various methods that have been used and found effective for special conditions. The goal of energy-efficient construction is to decrease the dependence on the heating system. This is best done by the use of caulking, vapor barriers, and insulation. Energy-efficient framing methods will be discussed later in this chapter.

Caulking. Caulking normally consists of filling small seams in the siding or the trim to reduce air drafts. In energy-efficient construction, caulking is added during construction at all seams or intersections of floors and walls to further reduce the chance of air

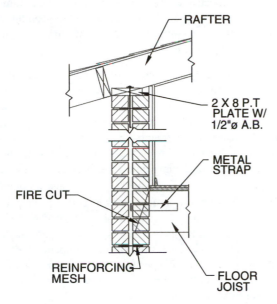

Figure 8–9 Attaching floor and roof framing members to a masonry wall.

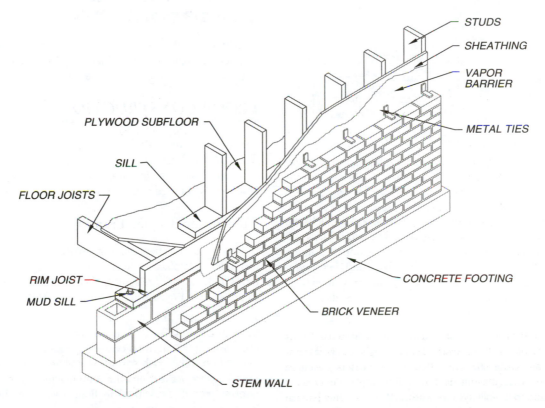

Figure 8–10 Brick is typically used as a non-load-bearing veneer attached to wood or concrete construction with metal ties.

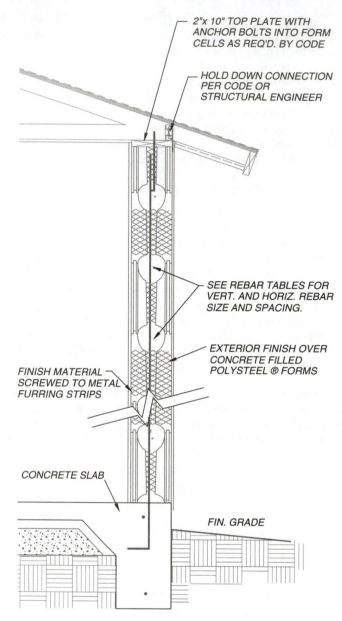

2"x 10" TOP PLATE WITH ANCHOR BOLTS INTO FORM CELLS AS REQ'D. BY CODE

HOLD DOWN CONNECTION PER CODE OR STRUCTURAL ENGINEER

SEE REBAR TABLES FOR VERT. AND HORIZ. REBAR SIZE AND SPACING.

EXTERIOR FINISH OVER CONCRETE FILLED POLYSTEEL ® FORMS

FINISH MATERIAL SCREWED TO METAL FURRING STRIPS

CONCRETE SLAB

FIN. GRADE

Figure 8–11 Components of insulated concrete from construction. *Courtesy American Polysteel Forms.*

infiltration. These beads of caulk keep air from leaking between joints in construction materials. It may seem like extra work for a small effect, but caulking is well worth the effort. Caulking involves minimal expense for material and labor. Caulking is typically specified in note form rather than being shown on drawings. Most plans include a set of written specifications that dictate the type of caulking and its location.

Vapor Barriers. For an energy-efficient system, airtightness is critical. The ability to eliminate air infiltration through small cracks is imperative if heat loss is to be minimized. Vapor barriers are a very effective method of decreasing heat loss. Building codes require 6 mil thick plastic to be placed over the earth in the crawl space and paper to be placed on the interior surfaces of the wall and ceil-

ing insulation. Many energy-efficient construction methods use these precautions and add a continuous vapor barrier to the walls. This added vapor barrier is designed to keep exterior moisture from the walls and insulation. To be effective, the vapor barrier must be lapped and sealed to keep air from penetrating through the seams in the plastic. Care should be taken to seal the laps in the vapor barrier.

The vapor barrier can be installed in the ceiling, walls, and floor system for effective air control to prevent small amounts of heated air from escaping. All the effort required to keep the vapor barrier intact at the seams must be continued wherever an opening in the wall or ceiling is required.

Insulation. Many energy-efficient construction methods depend on added insulation to help reduce air infiltration and heat loss. Some of these systems require not only adding more insulation to the structure, but also adding more framing material to contain the insulation. Insulation requirements vary for each area of the country. Insulation requirements are increasingly being tied to the efficiency of the heating or cooling unit. Most local codes now set up insulation standards for furnaces with 80 percent efficiency or greater.

Wall openings are also limited by some codes, placing a maximum of between 17 and 22 percent of the heated wall area in openings. These openings include doors, windows, and skylights. Typically a set of plans indicates the amount of openings either on the floor plan or on the list of specifications. It is important for the print reader to find the existing opening-to-wall percentage before making substitutions in window sizes.

STRUCTURAL COMPONENTS

As with every phase of print reading, framing plans include their own terminology. The terms referred to in this chapter are basic for structural components of floors, walls, and roofs.

FLOOR CONSTRUCTION

Two common methods of framing the floor system are conventional joist and post and beam. In some areas of the country it is common to use post-and-beam framing for the lower floor when a basement is not used and conventional framing for the upper floor.

Conventional Floor Framing

Conventional, or stick framing involves the use of members 2" (50 mm) wide placed one at a time in a repetitive manner. Basic terms in this system are *mudsill, floor joist, girder,* and *rim joist.* Each can be seen in Figure 8–12 and throughout this chapter.

Floor joists can range in size from 2 × 6 (50 × 150 mm) through 2 × 14 (50 × 350) and may be spaced at 12", 16", or 24" (300, 400, or 600 mm) on center depending on the load, span, and size of joist to be used. A spacing of 16" (400 mm) is most common. Because of the decreasing supply and escalating price of sawn lumber, several alternatives to floor joists have been developed. Four common substitutes are open-web trusses, I joists, laminated veneer lumber, and steel joists.

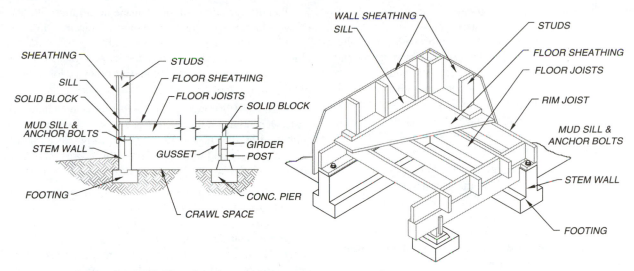

Figure 8–12 Conventional, or stick floor, framing at the concrete perimeter wall.

The *mudsill*, or *base plate*, is the first of the structural lumber used in framing the home. The mudsill is the plate that rests on the masonry foundation and provides a base for all framing. Because of the moisture content of the concrete and soil, the mudsill is required to be pressure-treated or made of foundation-grade redwood or cedar. Mudsills are set along the entire perimeter of the foundation and attached to the foundation with anchor bolts. The size of the mudsill is typically 2" × 6" (50 × 150 mm). Anchor bolts are required to be a minimum of 1/2" × 10" (13 × 250 mm). Bolts 5/8" and 3/4" (16 and 19 mm) in diameter are also common. Bolt spacing of 6'-0" (1800 mm) is the maximum allowed by the IRC. Areas of a structure that are subject to lateral loads or uplifting will reflect bolts at a much closer spacing based on the engineer's load calculations.

Floor Beams. With the mudsills in place, the girders can be set to support the floor joists. Girder is another name for a beam. The girder is used to support the floor joists as they span across the foundation. Girders are usually sawn lumber, 4" or 6" (100 or 150 mm) wide, with the depth determined by the load to be supported and the span to be covered. Sawn members 2" (50 mm) wide can often be joined together to form a girder. If only two members are required to support the load, members can be nailed, according to the nailing schedule provided in the IRC. If more than three members must be joined to support a load, most building departments require them to be bolted together so the inspector can readily see that all members are attached. Another form of built-up beam is a flitch beam, which consists of steel plates bolted between wood members. Because they are labor-intensive and heavy, and because of the availability of engineered wood beams, flitch beams are becoming less popular.

In areas such as basements where a large open space is desirable, laminated wood beams called *glu-lam beams* are often used. They are made of sawn lumber that is glued together under pressure to form a beam stronger than its sawn lumber counterpart. Beam widths of 3–1/8", 5–1/8", and 6–3/4" (80, 130, and 170 mm) are typical in residential construction. Although much larger sizes are

available, depths typically range from 9" through 16–1/2" (229–419 mm) at 1–1/2" (38 mm) intervals. As the span of the beam increases, a *camber*, or curve, is built in to help resist the tendency of the beam to sag when a load is applied. Glu-lams are often used where the beam will be left exposed because they do not drip sap and do not twist or crack, as a sawn beam does as it dries.

Engineered wood girders and beams are common throughout residential construction. Unlike glu-lam beams, which are laminated from sawn lumber such as a 2 × 4 or 2 × 6 (50 × 100 or 50 × 150 mm), parallel strand lumber (PSL) is laminated from veneer strips of fir and southern pine, which are coated with resin and then compressed and heated. Typical widths are 3–1/2", 5–1/4", and 7" (90, 130, and 180 mm). Depths range from 7" through 18" (175–450 mm). PSL beams have no crown or camber.

Laminated veneer lumber (LVL) is made from ultrasonically graded Douglas fir veneers, which are laminated with all grains parallel to each other with exterior-grade adhesives under heat and pressure. LVL beams come in widths of 1–3/4" (45 mm) and 3–1/2" (90 mm) and depths ranging from 5–1/2" through 18" (140–450 mm). LVL beams offer performance and durability superior to that of other engineered products and often offer the smallest and lightest wood girder solution.

Steel girders can be used where foundation supports must be kept to a minimum and offer a tremendous advantage over wood for total load that can be supported on long spans. Steel beams are often the only type of beam that can support a specified load and still be hidden within the depth of the floor framing. They also offer the advantage of no expansion or shrinkage due to moisture content. Steel beams are named for their shape, depth, and weight. A steel beam with the designation W16 × 19 represents a wide-flange steel beam with the shape of an I. The number 16 represents the approximate depth of the beam in inches, and the 19 represents the approximate weight of the beam in pounds per linear foot. Floor joists are usually set on top of the girder, but they can be hung from the girder with joist hangers.

Posts are used to support the girders. As a general rule of thumb, a 4 × 4 (100 × 100 mm) post is typically used below a girder 4" (100 mm) wide, and a post 6" (150 mm) wide is typically used below a girder 6" (150 mm) wide. Sizes can vary, depending on the load and the height of the post. LVL posts ranging in size from 3–1/2" through 7" (90–175 mm) are increasingly being used for their ability to support loads. A 1–1/2" (38 mm) minimum bearing surface is required to support a girder resting on a wood or steel support, and a 3" (75 mm) bearing surface is required if the girder is resting on concrete or masonry.

Steel columns can be used in place of a wooden post, depending on the load to be transferred to the foundation. Because a wooden post will draw moisture out of the concrete foundation, it must rest on 55# felt. Sometimes an asphalt roofing shingle is used between the post and the girder. If the post is subject to uplift or lateral forces, a metal post base or strap may be specified on the plans to attach the post firmly to the concrete.

Floor Joists. Once the framing crew has set the support system, the floor joists can be set in place. *Floor joists* are the structural members used to support the subfloor, or rough floor. Floor joists usually span between the foundation and a girder, but, as shown in Figure 8–13, a joist may extend past its support. This extension is known as a *cantilever.*

Trusses that resemble an I are often referred to as I-joists and are a high-strength, lightweight, cost-efficient alternative to sawn lumber. I-joists form a uniform size, have no crown, and do not shrink. They come in depths of 9–1/2", 11–7/8", 14", and 18" (240, 300, 360, and 450 mm). I-joists are able to span greater distances than comparable-sized sawn joists and are suitable for spans up to 40' (12 000 mm) for residential uses.

Webs can be made from plywood, laminated veneer lumber (LVL), or oriented strand board (OSB). OSB is increasingly being used to replace lumber products and is made from wood fibers arranged in a precisely controlled pattern; the fibers are coated with resin and then compressed and cured under heat. Holes can be placed in the web to allow for HVAC ducts and electrical requirements based on the manufacturer's specifications.

Laminated veneer lumber is made from ultrasonically graded Douglas fir veneers, which are laminated together. LVL joists are 1–3/4" (45 mm) wide and range in depth from 5–1/2" through 18" (140–450 mm). LVL joists offer superior performance and durability to other engineered products and are designed for single-span or multispan uses that must support heavy loads.

Figure 8–14 shows floor construction using engineered floor joists. Depending on the loads to be supported, when the joists are supported by the sill, blocks may need to be placed beside each joist to provide additional support. Figure 8–15 shows another common method of supporting an engineered floor joist.

Open-web floor trusses are a common alternative to using 2 × (50 ×) sawn lumber for floor joists. Open-web trusses are typically spaced at 24" (600 mm) o.c. for residential floors. Open web trusses are available for spans up to 38' (11 400 mm) for residential floors. The horizontal members of the truss are called top and bottom chords respectively, and are typically made from 1.5 × 3 (40 × 75 mm) lumber laid flat. The diagonal members, called webs, are made of wood or tubular steel approximately 1" (25 mm) in diameter. As the span or load on the joist increases, the size and type of material used are increased. Pairs of 1.5" × 2.3" (40 × 60 mm) laminated veneer lumber are used for the chords of many residential floor trusses.

When steel joists are used to support the floor, a 6" × 6" × 54 mil L clip angle is bolted to the foundation to support the track that will support the floor joists, as shown in Figure 8–16. Building codes require a minimum of 1/2" (13 mm) bolts and a clip angle at 6'–0" (1800 mm) o.c. to be used to attach the angle to the concrete. Eight #8 screws are required to attach the angle to the floor joist track. Floor joist are then bolted to the track using two #8 screws at each joist. Additional fasteners should be used if winds exceed 90 mph.

Floor Bracing. Because of the height-to-depth proportions of a joist, it will tend to roll over onto its side as loads are applied. To resist this tendency, a rim joist or blocking is used to support the joist. A *rim joist,* which is sometimes referred to as a band or header, is usually aligned with the outer face of the foundation and mudsill. Some framing crews set a rim joist around the entire perimeter and then end-nail the floor joists.

Blocking in the floor system is also used at the center of the joist span. Spans longer than 10' (3000 mm) must be blocked at center span to help transfer lateral forces from one joist to another and then to the foundation system. Another use of blocking is at the end of the floor joists at their bearing points. The blocks help keep the entire floor system rigid and are used in place of the rim joist. Blocking is also used to provide added support to the floor sheathing.

Subflooring. Floor sheathing is installed over the floor joists to form the subfloor. The sheathing provides a surface for the base plate of the wall to rest on. Plywood and oriented strand board (OSB) are the most common materials used for floor sheathing. Depending on the spacing of the joists, plywood with a thickness of 1/2", 5/8", or 3/4" (13, 16, or 19 mm) with an APA grade of EXP 1 or 2, EXT, STRUCT I-EXP-1, or STRUCT 1-EXT is used for sheathing. EXT represents exterior grade, STRUCT represents

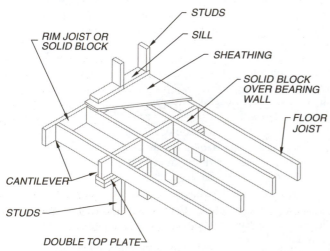

Figure 8–13 A floor joist or beam that extends past its supporting member is cantilevered.

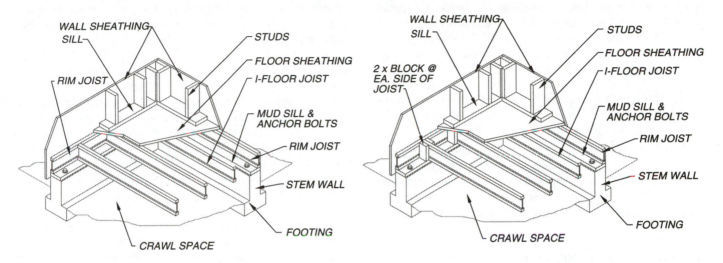

Figure 8–14 Floor joist to sill connections using engineered lumber.

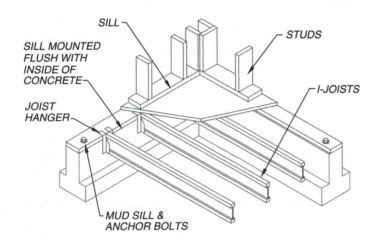

Figure 8–15 Engineered floor joist can be supported using metal hangars.

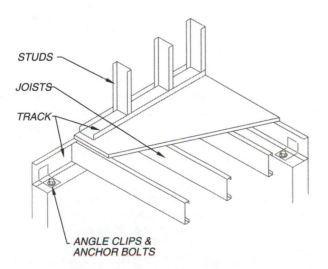

Figure 8–16 Floor construction using steel floor joist.

structural, and EXP represents exposure. Plywood also is printed with a number to represent the span rating, which represents the maximum spacing from center to center of the supports. The span rating is listed as two numbers, such as 32/16, separated by a slash. The first number represents the maximum recommended spacing of supporters if the panel is used for roof sheathing and the long dimension of the sheathing is placed across three or more supports. The second number represents the maximum recommended spacing of supports if the panel is used for floor sheathing and the long dimension of the sheathing is placed across three or more supports. Plywood is usually laid so that the face grain on each surface is perpendicular to the floor joist. This provides a rigid floor system without having to block the edges of the plywood. Floor sheathing that will support ceramic tile is typically 32/16 APA span rated and 15/31" thick or span rated 40/20" and 19/32" (15 mm) thick.

Once the subfloor has been installed, an underlayment for the finish flooring is put down. The underlayment is not installed until the walls, windows, and roof are in place, making the house weathertight. The underlayment provides a smooth impact-resistant surface on which to install the finished flooring. Underlayment is usually 3/8" or 1/2" (9 or 13 mm) APA underlayment GROUP 1, EXPOSURE 1 plywood, hardboard, or waferboard. Hardboard is typically referred to as medium- or high-density fiberboard (MDF or HDF) and is made from wood particles of various sizes that are bonded together with a synthetic resin under heat and pressure. The underlayment may be omitted if the holes in the plywood are filled. APA STURD-I-FLOOR rated plywood 19/32" through 1–3/32" (15–28 mm) thick can also be used to eliminate the underlayment.

Post-and-Beam Construction

Terms to be familiar with when working with post-and-beam floor systems include girder, post, decking, and finished floor. Each can be seen in Figure 8–17. Notice there are no floor joists with this system.

A mudsill is installed with post-and-beam construction just as with platform construction. Once set, the girders are also

placed. With post-and-beam construction the girder is supporting the floor decking instead of floor joists. Girders are usually 4 × 6 (100 × 150 mm) beams spaced at 48" (1200 mm) o.c., but the size and spacing can vary depending on the loads to be supported. As with conventional methods, posts are used to support the girders. Typically a 4 × 4 (100 × 100 mm) is the minimum size used for a post, with a 4 × 6 (100 × 150 mm) post used to support joints in the girders. With the support system in place, the floor system can be installed.

Decking is the material laid over the girders to form the subfloor. Typically decking is 2 × 6 or 2 × 8 (50 × 150 or 50 × 200 mm) tongue and groove (T&G) boards or 1–3/32" (28 mm) APA-rated 2-4-1 STURD-I-FLOOR EXP-1 plywood T&G floor sheathing. The decking is usually finished similarly to conventional decking with a hardboard overlay.

FRAMED-WALL CONSTRUCTION

You will be concerned with two types of walls: bearing and nonbearing. A bearing wall supports not only itself but also the weight of the roof or other floors constructed above it. A bearing wall requires some type of support under it at the foundation or lower floor level in the form of a girder or another bearing wall. Nonbearing walls are sometimes called partitions. A nonbearing wall serves no structural purpose. It is a partition used to divide rooms and could be removed without causing damage to the building. In post-and-beam construction, any exterior walls placed between posts are nonbearing walls.

Bearing and nonbearing walls made of wood or engineered lumber are both constructed using a sole plate, studs, and a top plate. Each can be seen in Figure 8–18. The sole, or bottom, plate is used to help disperse the loads from the wall studs to the floor system. The sole plate also holds the studs in position as the wall is being tilted into place. Studs are the vertical framing members used to transfer loads from the top of the wall to the floor system. Typically 2 × 4 (50 × 100 mm) studs are spaced at 16" (400 mm) o.c. and provide a nailing surface for the wall sheathing on the exterior side and the sheetrock on the interior side. Studs 2 × 6 (50 × 150 mm) are often substituted for 2 × 4 studs (50 × 100 mm) to provide added resistance for lateral loads and to provide a wider area to install insulation. Engineered studs in 2 × 4 or 2 × 6 (50 × 100 mm or 50 × 150 mm) are also available in 8', 9', and 10' (2400, 2700, and 3000 mm) lengths. Engineered studs are made from short sections of stud-grade lumber that have had the knots and splits removed. Sections of wood are joined together with finger joints. The top plate is located on top of the studs and is used to hold the wall together. Two top plates are required on bearing walls, and each must lap the other a minimum of 48" (1200 mm). This lap distance provides a continuous member on top of the wall to keep the studs from separating. An alternative to the double top plate is to use one plate with a steel strap at each joint in the plate. The top plate also provides a bearing surface for the floor joists from an upper level or for the roof members. When steel studs are used, a track is placed above the studs and fastened with a minimum of two #8 screws to each stud. The size of the screws will vary depending on the gage of the track and the thickness of the steel studs.

Sheathing

OSB and plywood sheathing are primarily used as an insulator against the weather and also as a backing for the exterior siding. Sheathing may be considered optional, depending on your area of the country. When sheathing is used on exterior walls, it provides what is called double-wall construction. In single-wall construction, wall sheathing is not used, and the siding is attached over a vapor

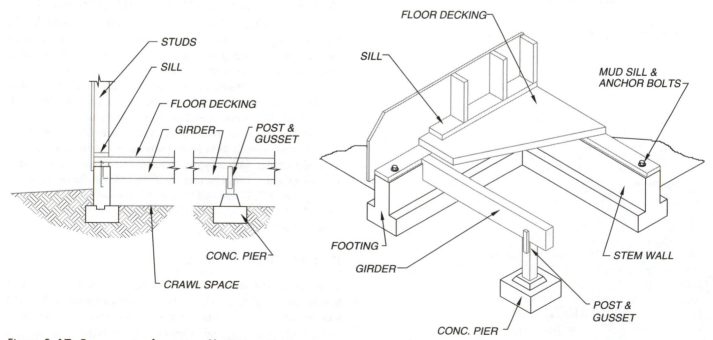

Figure 8–17 Components of a post-and-beam construction.

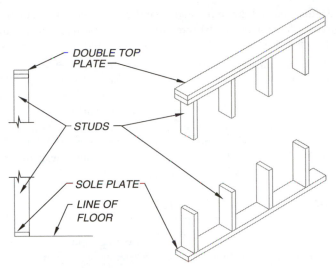

Figure 8–18 Standard wall construction uses a double top plate on the top of the wall, a sole plate at the bottom of the wall, and studs.

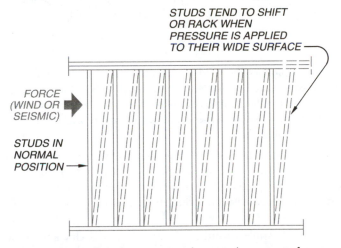

Figure 8–19 Wall racking occurs when wind or seismic forces push the studs out of their normal position. Plywood panels can be used to resist these forces and keep the studs perpendicular to the floor. These plywood panels are called *shear* or *braced* wall panels.

barrier, such as Tyvek, Pinkwrap, Typar, or the traditional 15# felt placed over the studs. The cost of the home and its location will have a great influence on whether wall sheathing is to be used. In areas where double-wall construction is required for weather or structural reasons, 3/8" (10 mm) plywood is used on exterior walls as an underlayment. Plywood sheathing should be APA-rated EXP 1 or 2, EXT, STRUCT 1, EXT 1, or STRUCT 1 EXT. Many builders prefer to use 1/2" (13 mm) OSB for sheathing in place of plywood.

The design of the home may require the use of plywood sheathing for its ability to resist the tendency of a wall to twist or rack. Racking can be caused by wind or seismic forces. Plywood used to resist these forces is called a *shear panel* or a *braced wall panel*. See Figure 8–19 for an example of racking and how plywood can be used to resist this motion.

An alternative to plywood for shear panels is to use let-in braces to stiffen the studs. A notch is cut into the studs, and a 1" × 4"

(25 × 100 mm) brace is laid flat in this notch at a 45° angle to the studs. If plywood siding rated APA Sturd-I-Wall is used, no underlayment or let-in braces are required.

Blocking for structural or fire reasons is now no longer required unless a wall exceeds 10' (3000 mm) in height. Blocking is often installed for a nailing surface for mounting cabinets and plumbing fixtures. Blocking is sometimes used to provide extra strength in some seismic zones.

Framing Members for Wall Openings

In addition to the wall components mentioned, there are several other terms that the drafter needs to be aware of. These are terms that are used to describe the parts used to frame around an opening in a wall: *headers*, *subsill*, *trimmers*, *king studs*, and *jack studs*. Each can be seen in Figure 8–20.

A header in a wall is used over an opening such as a door or window. When an opening is made in a wall, one or more studs must be omitted. A header is used to support the weight the missing studs would have carried. The header is supported on each side by a trimmer. Depending on the weight the header supports, double trimmers may be required. The trimmers also provide a nailing surface for the window and the interior and exterior finishing materials. A king stud is placed beside each trimmer and extends from the sill to the top plates. It provides support for the trimmers so that the weight imposed from the header can only go downward, not sideways. Each member can be seen in Figure 8–20.

Between the trimmers is a subsill located on the bottom side of a window opening. It provides a nailing surface for the interior and exterior finishing materials. Jack studs, or cripples, are studs that are not full height. They are placed between the sill and the sole plate and between a header and the top plates.

MASONRY WALL CONSTRUCTION

Concrete block and brick construction offers many advantages over traditional wood structures. A structure made of masonry is practically maintenance-free and can last for centuries, providing a durable, economical building material with excellent structural and insulation values. CMU walls are usually single-wythe, but they can be combined with a wythe of decorative stone or brick. CMUs can be waterproofed with clear waterproof sealers, cement-based paints can be used as the exterior finish, or the walls can be covered with stucco. Pressure-treated wood furring strips can be attached to the interior side of the block to support sheet rock, or the interior surface can be left exposed. Concrete blocks are also used for below-grade construction, which is discussed in Chapter 10.

Grades

Four classifications are used to define concrete blocks for construction. These include hollow, load bearing (ASTM C 90), solid load bearing (ASTM C 145), and non-load-bearing blocks (ASTM C 129), which can be either solid or hollow blocks. Solid blocks must be 75% solid material in any cross sectional plane. Blocks are also classified by their weight as normal, medium, and lightweight

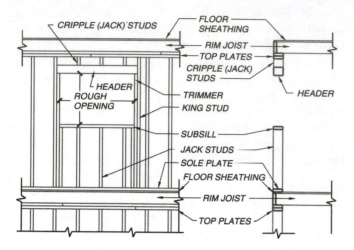

Figure 8–20 Construction components at an opening.

blocks. The weight of the block is affected by the type of aggregate used to form the unit. Normal aggregates, such as crushed rock and gravel, produce a block weight of between 40 and 50 lbs. (18 and 23 kg) for an 8 × 8 × 16 block. Lightweight aggregates include: coal cinders, shale, clay, volcanic cinders, pumice, and vermiculite. Use of a lightweight aggregate will produce approximately a 50% savings in weight.

Walls made of CMUs are able to qualify for up to a 4-hour fire rating. The type of aggregate used in the block and the thickness of the block dictate the fire rating. Blocks made with pumice in a minimum of 6" (150 mm) wide units produce a 4-hour rating.

Common Sizes

CMUs come in a wide variety of patterns and shapes. In the United States, the standard module for concrete masonry units is 4". Standard inch-pound blocks are manufactured to 4", 6", 8", 10", and 12" nominal widths, 4" and 8" heights and 8" and 16" lengths. The most commonly used sizes are 8" and 16" blocks, with 8 × 8 × 16 the industry standard. Each dimension of a concrete block is actually 3/8" smaller to allow for a 3/8" mortar joint in each direction

Metric Block Sizes

The size of metric block will depend on whether the block size is based on soft or hard conversion. The initial switch to the metric blocks for many United States manufacturers was to relabel their inch-pound products with the equivalent metric dimensions. Soft conversion requires no physical change in product size. An 8 × 8 × 16 would be relabeled as a 203 × 203 × 406. This relabeling of inch-pound block is referred to as a *soft conversion*. A designer working with a 4" design module would now be working with a design module of 101.6.

With *hard metric conversion*, masonry blocks are manufactured to metric specifications based on a 100-mm module. Hard metric conversion requires the use of new molds to produce blocks that are 200 × 200 × 400 mm. Metric (hard) blocks are manufactured to nominal dimensions of 100, 200, 250, and 300 mm

widths, 100 and 200 mm heights, and 200 and 400 mm lengths. Actual dimensions are 10 mm smaller than the nominal size to allow for the vertical and horizontal mortar joints.

To minimize cutting and labor costs, concrete block structures should be kept to their modular size. When using the standard 8 × 8 × 16 (200 × 200 × 400 mm) CMU, structures that are an even number of feet long should have dimensions that end in 0" or 8". For instance, structures that are 24'-0" or 32'-8" are each modular. Walls that are an odd number of feet should end with 4". Walls that are 3'-4", 9'-4", and 15'-4" are all modular, but a wall that is 15'-8" long requires blocks to be cut.

BRICK CONSTRUCTION

Bricks are made in varied colors and textures by pressing various types of clay, shale, and a combination of oxides in a mold of a desired shape and size. Brick is usually produced in red, brown, and gray tones. Common surfaces include smooth, water or sandstruck, scored, wire-cut, combed, and roughened. Bricks can also be finished with a ceramic glaze, providing a polished finished in any color.

Brick Types

Bricks are produced in solid, cored, and hollow units. Cored units are considered to be solid if a minimum of 75% of the cross sectional area is solid. A brick is hollow if at least 60% of the cross sectional area is solid. Vertical cores are placed in bricks to reduce the weight of the brick.

Common or *building brick* is most widely used in the construction industry. Face brick is produced to standards that produce units in specific sizes, textures, and colors. Other types of brick used in construction include the following:

Adobe brick is made from a mixture of natural clay and straw that is placed in molds and dried in the sun. These units require protection from rain and subsurface moisture unless a moisture-proofing agent is added.

Back-up brick is inferior units used in applications where they can't be seen; for example, behind face brick.

Fire brick is brick with a high resistance to high temperature, used for the facing material of the firebox of a fireplace.

Hollow brick tile is a masonry unit that is cored in excess of 25% of the gross cross sectional area.

Nail-on brick is a flat unit used for interior applications where solid masonry can't be structurally supported.

Paving brick is a masonry unit with a hard, dense surface used for floor applications.

Sewer brick is a unit with a low absorption rate used for sewer or storm drain applications.

The type of brick to be used is normally indicated on the floor and elevations as well as in written specifications. The surface of the

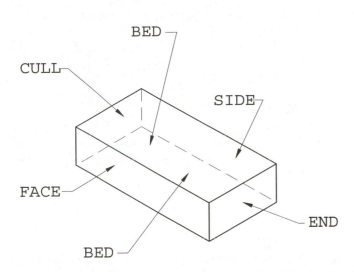

Figure 8-21 Each surface of a brick is named to indicate how it is to be positioned.

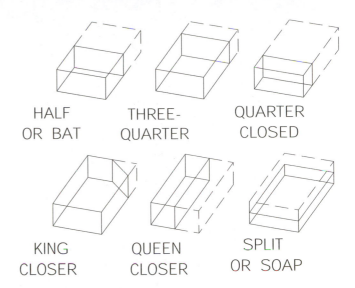

Figure 8-22 Bricks can be cut into varied shapes based on the pattern used to position each unit.

brick to be exposed is also often specified. Each surface of a unit has a specific name, as shown in Figure 8-21. The surface name is often referred to in written specifications to determine which surface will be displayed or cut. For some applications, the mason must cut units to meet the design criteria. Common methods of cutting brick are illustrated in Figure 8-22.

Brick Quality

Strength, appearance, and durability determine the quality of brick. The quality is specified in the written specifications. Common brick is classified into three grades, determined by the weather conditions it will be required to withstand. Grade SW is for severe weather conditions, which include heavy rains or sustained below-freezing conditions. Grade MW is for moderate weather conditions for use in areas with moderate rainfall and some freezing conditions. Grade NW is for use in areas with negligible weathering from minimal rainfall and above-freezing temperatures.

Face brick is rated for durability of exposure and is available in grades SW and MW. It is also identified by the ASTM specifications, which dictate the range allowed in size, texture, color, and structural quality. *FBA* grade brick is nonuniform in the size, color and texture of each unit. Grade *FBS* brick allows variations in mechanical perfection with a wide range of color variation. Grade *FBX* has the highest degree of mechanical perfection and is the most controlled for color variation.

Hollow brick is classified by SW or MW as well as by factors that affect its appearance. Graded *HBA* is nonuniform in size, color, and texture. Grade *HBS* is more controlled than HBA brick but allows for some size variation and a wide color range. Grade HBX has the highest degree of mechanical perfection with the least variation in size and the smallest range in color.

Brick Shapes and Placement. Common shapes of brick are shown in Figure 8-23. One of the most popular features of brick is the

wide variety of positions and patterns that can be created. These patterns are achieved by placing the brick in various positions relative to each other. The position in which the brick is placed will alter what the brick course is called. Figure 8-7 illustrates common brick positions and their names. Figure 8-24 shows examples of how these patterns would be represented. Common patterns for laying masonry units are illustrated in Figure 8-25. The brick pattern is represented and specified on the elevation.

Wall Construction. Bricks can be placed in any of the positions shown in Figures 8-24 and 8-25 to form a wall, as well as a variety of bonds and patterns. Masonry units are laid in rows called *courses* and in vertical planes called *wythes*. Single-wythe walls are made with structural bricks with steel reinforcing placed according to local codes to resist lateral loads. Brick walls normally consist of two wythes, with an air space of 2"–3" between each wythe. This type of construction is referred to as a *cavity wall*. Rigid foam insulation can be placed against the inner wythe to increase the R-value of the wall. If the space is filled with grout, it is called a *grouted cavity* wall. Reinforcing steel can be placed in the air space between wythes and then surrounded by solid grout.

If the wythes are connected, the wall is referred to as a *solid wall*. A bond is the connection between the wythes to add stability to the wall so that the entire assembly acts as a single structural unit. It can be made by either wire ties or by masonry members. The Flemish and English bonds of Figure 8-8 are the most common methods of bonding two wythes together. The Flemish bond consists of alternating headers and stretchers in each course. (A course of masonry is one unit in height.) An English bond consists of alternating courses of headers and stretchers. In each case the header spans between wythes to keep the wall from separating. The bonding course is usually placed at every sixth course.

The cavity between wythes is typically 2" (50 mm) wide and creates approximately a 10" (250 mm) wide wall with masonry

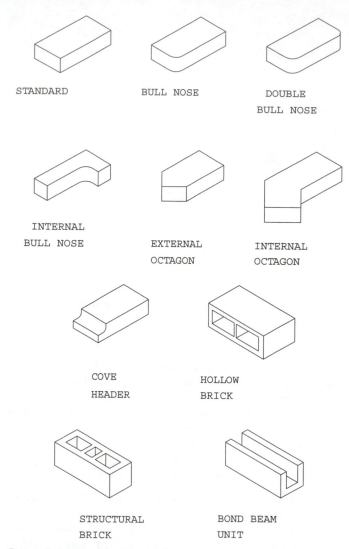

STANDARD

BULL NOSE

DOUBLE
BULL NOSE

INTERNAL
BULL NOSE

EXTERNAL
OCTAGON

INTERNAL
OCTAGON

COVE
HEADER

HOLLOW
BRICK

STRUCTURAL
BRICK

BOND BEAM
UNIT

Figure 8-23 Standard brick shapes.

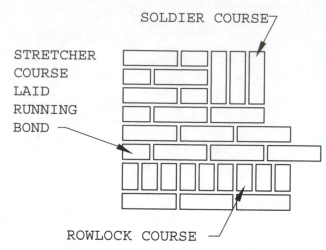

STRETCHER
COURSE
LAID
RUNNING
BOND

SOLDIER COURSE

ROWLOCK COURSE

Figure 8-24 Brick patterns are represented and specified in exterior elevations

Brick is very porous and absorbs moisture easily. Some method must be provided to protect the end of the joist from absorbing moisture from the masonry. The end of the joist is wrapped with 55# felt and set in a 1/2" (13 mm) air space. The interior of a masonry wall also must be protected from moisture. A layer of hot asphaltic emulsion can be applied to the inner side of the interior wythe and a furring strip can be attached to the wall. In addition to supporting sheet rock or plaster, the space between the furr strips can be used to hold batt or rigid insulation.

An alternative method of attaching a floor to a brick wall is with the use of a pressure-treated ledger bolted to the wall with the bolts tied to the wall reinforcing. The joists are connected to the ledger with metal hangers. Figure 8–27 shows an example of the use of a ledger. When a roof framing system is to be supported on masonry, a pressure-treated plate is usually bolted to the brick in a manner similar to the way a plate is attached to a concrete foundation.

Brick Joints

The joints between each course of brick must be specified on the construction drawings in the exterior elevations and details. In addition to the type of joint being specified for decorative purposes, joints must also be used to relieve stress in the wall. Walls longer than 200' (60 000 mm) or in a building having two or more wings must have expansion joints. An *expansion joint* is a seam placed in a wall to relieve cracking caused by expansion or contraction. Rather than causing random cracks throughout the brick, the stress is relieved in the expansion joint. Two common methods of constructing an expansion joint in brick walls are shown in Figure 8–28.

MASONRY REPRESENTATION

Brick and concrete blocks are represented on plan views with bold lines used to represent the edges of the masonry. Thin lines for hatching are placed at a 45° angle to the edge of the wall. The type, size, and reinforcement are specified in note form but are not represented on the drawings (see Figure 8–29).

exposed on both the exterior and interior surfaces. The air space between wythes provides an effective barrier to moisture penetration to the interior wall. Weep holes must be provided in the lower course of the exterior wythe to allow moisture to escape. Rigid insulation can be applied to the interior wythe to increase the insulation value of the air space in cold climates. Care must be taken to keep the insulation from touching the exterior wythe so that moisture is not transferred to the interior. Metal ties are embedded in mortar joints at approximately 16" (400 mm) to tie each pair of wythes together.

If a masonry wall is to be used to support a floor, a space one-wythe wide will be left to support the joist similar to Figure 8–26. Joists are required to be strapped to the wall so that the wall and floor will move together under lateral stress. The strap is specified on the framing plan and the details. The end of the joist must be cut on an angle. This cut is called a *fire cut* and will be specified in the details. If the floor joists were to be damaged by fire, the fire cut allows the floor joist to fall out of the wall, without destroying the wall.

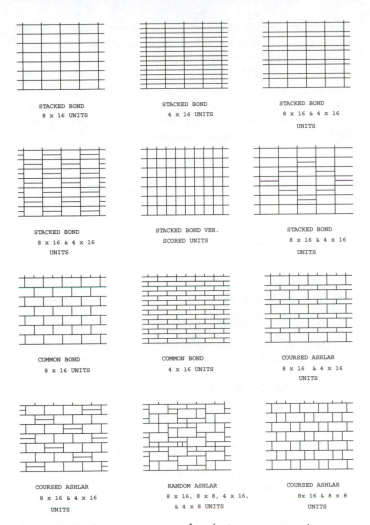

Figure 8–25 Common practices for placing masonry units.

The size and location of concrete block walls are dimensioned on the floor plan or framing plan. Concrete block is dimensioned from edge to edge of walls. Openings in the wall are also located by dimensioning to the edge.

The scale of the drawing affects the drawing method used to represent masonry shown in sections and details. At scales under 1/2" = 1'–0", the wall is usually drawn just as in plan view. At larger scales, details typically reflect the cells of the block. Figure 8–30 shows methods of representing concrete block in cross section. Figure 8–31 shows an example of a section and the notes that usually accompany concrete block construction.

When CMUs have to support loads from a beam, a pilaster is placed in the wall to carry the loads. A *pilaster* is a thickened area of wall used to support gravity loads or to provide lateral support to the wall when the wall is to span long distances. Figure 8–32 presents a detail showing the size and thickness of a pilaster. Details similar to Figure 8–32 are also required to show reinforcement connections at each intersection and where different materials are joined to the blocks.

Steel Reinforcement

Masonry units are excellent for resisting forces from compression, but they are poor for resisting forces in tension. Steel is excellent for resisting forces of tension, but it tends to buckle under forces of compression. The combination of these two materials forms an

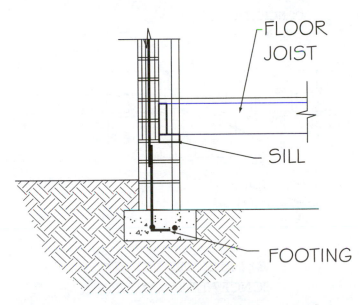

Figure 8–26 If a masonry wall is to be used to support a floor, a space one wythe wide is left to support the joist.

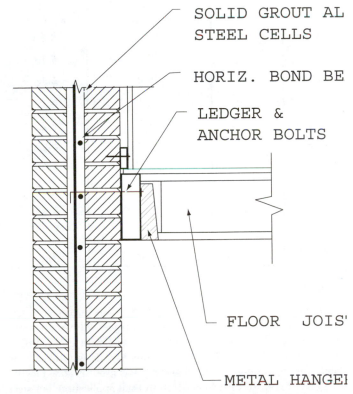

SOLID GROUT AL
STEEL CELLS

HORIZ. BOND BE

LEDGER &
ANCHOR BOLTS

FLOOR JOIS'

METAL HANGE!

Figure 8–27 A double-wythe brick wall with a floor system support by a wood ledger.

excellent unit for resisting great loads from lateral and vertical forces. Reinforced masonry structures are stable because the masonry, steel, grout, and mortar bond together so effectively. Loads that create compression on the masonry are transferred to the steel. By careful placement of the steel, the forces will result in tension on the steel and be safely resisted.

Rebar Sizes and Shapes

Reinforcing bars can be either smooth or deformed. Smooth bars are primarily used for joints in floor slabs. Because the bars are smooth, the concrete of the slab does not bond easily to the bar. This allows the concrete to expand and contract along a horizontal plane. Bars used for reinforcing masonry walls are usually deformed so that the concrete will bond more effectively with the bar. This prevents slippage as the wall flexes under pressure. The deformations are small ribs that are placed around the surface of the bar. Deformed bars range in size from 3/8" to 2-1/4" (10 to 57 mm) in diameter. Bars are referenced on plans by a number rather than a size. A number represents the size of the steel in approximately 1/8" increments. Inch sizes don't readily convert to metric sizes. Steel reinforcing bars conform to ASTM A615-78A or to ASTM A615M standard for metric reinforcing bars. Each standard governs the size and the physical characteristics of rebar. Common sizes of steel are shown in the Table 8–1:

TABLE 8–1 COMMON BAR SIZES OF STEEL (INCH-POUND AND METRIC)			
BAR SIZE	INCH-POUND	NOMINAL DIA. (IN. / MM)	BAR SIZE METRIC
# 3	0.375	9.5	# 10
# 4	0.50	12.7	# 13
# 5	0.625	15.9	# 16
# 6	0.75	19.1	# 19
# 7	0.875	22.2	# 22
# 8	1.00	25.4	# 25
# 9	1.13	28.7	# 29
# 10	1.27	32.3	# 32
# 11	1.41	35.8	# 36
# 14	1.69	43.0	# 43
# 18	2.26	57.3	# 57

Steel Placement

Reinforcing steel is required in all masonry walls in seismic zones C, D, E, and F. Wall reinforcing is held in place with wire ties and by filling each masonry cell containing steel with grout. When exact locations within the cell are required by design, the steel is wired into position, so that it can't move as grout is added to the cell. The placement of steel varies with each application, but steel reinforcement is placed on the side of the wall that is in tension. The location of steel in relation to the edge of the wall must be specified in the wall details.

Vertical Reinforcing. Vertical reinforcing is required at 48" (1200 mm) o.c. with a maximum spacing of 24" (600 mm) if stacked-bond masonry is used. IBC requires a vertical piece of steel to be placed within 16" (400 mm) from each end of a wall. Vertical steel is represented in details similar to Figure 8–27. Additional vertical reinforcing is usually specified at the edges of openings in walls to serve the same function as a post in wood construction. For small loads, two vertical bars in the same cell may be sufficient. As loads

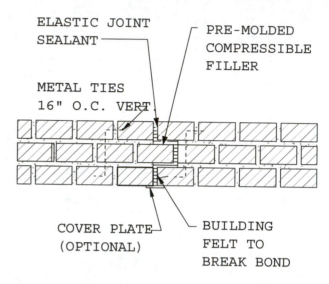

EXPANSION JOINT IN
STRAIGHT BRICK WALL

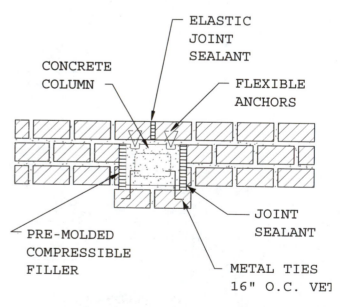

EXPANSION JOINT IN
CONCEALED COLUMN

Figure 8–28 Two methods of constructing expansion joints to relive cracking in masonry walls.

increase, the size of the vertical bond and the number of bars used will increase. Horizontal ties are normally added when four or more vertical bars are required to keep the bars from separating.

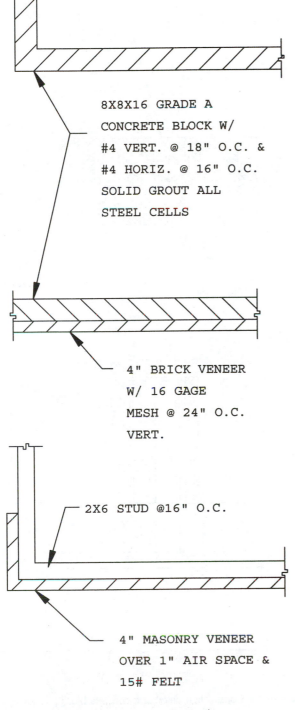

8X8X16 GRADE A
CONCRETE BLOCK W/
#4 VERT. @ 18" O.C. &
#4 HORIZ. @ 16" O.C.
SOLID GROUT ALL
STEEL CELLS

4" BRICK VENEER
W/ 16 GAGE
MESH @ 24" O.C.
VERT.

2X6 STUD @16" O.C.

4" MASONRY VENEER
OVER 1" AIR SPACE &
15# FELT

Figure 8–29 Representing masonry units in plan view.

Horizontal Reinforcing. Horizontal reinforcement is usually specified at 16" (400 mm) o.c., but the exact spacing depends on the seismic or wind loads to be resisted and is designed by the engineer for each specific use. In addition to the horizontal steel required by the building code, extra steel is usually placed at the midpoint of a wall between each floor level. Generally two bars are placed at the midpoint of each wall level, forming a reinforced area referred to as a bond beam. Extra reinforcing is also added where each floor or roof level intersects the wall. A 16" (400 mm) deep bond beam with two pieces of steel at the top and bottom is a standard method of constructing the bond beam at floor and roof levels. An 8" (200 mm) deep bond beam with two pieces of steel is also placed at the top of concrete block walls. Another common location for a bond beam is over the openings for doors and windows. A 16" (400 mm) minimum depth with four pieces of steel is normally provided similar to Figure 8–33. The exact depth, quantity of rebar, and ties will be specified on the drawings based on the load to be supported and the span of the bond beam.

Steel Overlap. Because of the limits of construction, steel must often be lapped to achieve the desired height or length. In-line steel bars are lapped and wired together so that individual bars can act as one. Figure 8–34 shows an example of a detail with lapped steel. Depending on the loads to be resisted, the prints may show laps to be welded. The amount of lap required at steel intersections can be found in the details or in the written specifications of the drawings. Where the information is placed depends on the complexity of the project. The intersection of a wall at the foundation, for example, is a typical place where steel is lapped. The plans may include a note indicating the desired overlap of steel, such as a #5 bar with a 36 diameter lap, or the plans may specify the exact lap, such as 23" on the drawing. Laps of steel based on diameter are listed in Table 8–2:

Rebar Representation

The construction drawings should specify the quantity of bars, the bar size by number, the direction the steel runs, and the grade on the drawings where steel is referenced. On drawings, such as the framing plan, walls are drawn, but steel is not drawn. Steel specifications are generally included in the wall reference, as shown in Figure 8–29. When shown in section or detail, steel is represented by a bold line, which can be solid or dashed depending on office practice. When steel is shown in end view, it is represented by a solid circle.

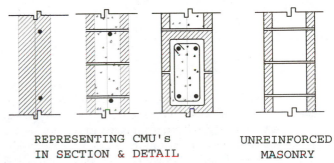

REPRESENTING CMU's
IN SECTION & DETAIL

UNREINFORCED
MASONRY

Figure 8–30 Methods of representing CMUs in sections and details.

Figures 8–30 through 8–34 show common examples of representing steel in detail. Steel direction is specified using the terms vertical, horizontal, or diagonal lines. Occasionally the letters *E.W.* or *E/W* are used to indicate that the steel is running each way (horizontal and vertical).

When hooks or ties are represented in a detail, specification such as:

#3 TIES W/3 @ 8/16" O.C.

indicates that the ties are to be a #3 diameter with spacings of 8" and 16". The pattern is then shown in a detail similar to Figure 8-34. Notice that the three bars at the top and bottom are placed at 8" spacings and the bars in the middle of the column are spaced at 16" o.c.

Locating Steel

Dimensions and notes are used to show the location of the steel from the edge of the masonry. The drawings may provide a note in the calculations such as:

7– #5 HORIZ. @ 3" UP/DN.

Depending on the engineer and the type of stress to be placed on the masonry, the location may be given from edge of masonry to edge of steel or from edge of masonry to center of steel. To distin-

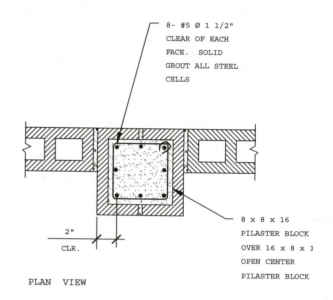

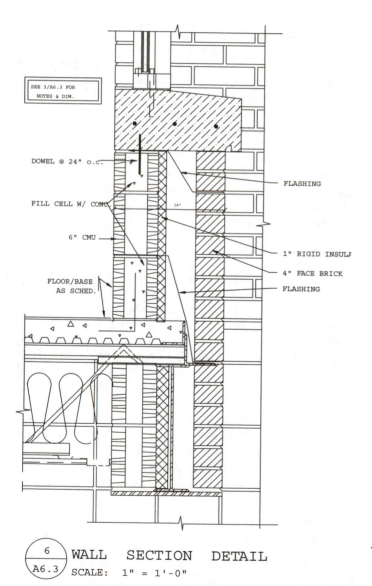

Figure 8–31 Representing brick and CMUs in detail. *Courtesy G. Williamson Archer A.I.A., Archer & Archer, P.A.*

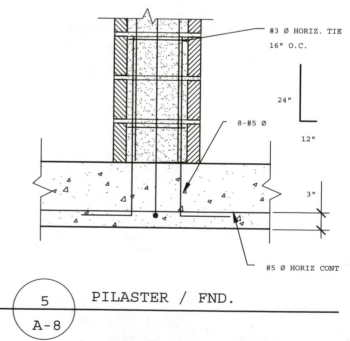

Figure 8–32 Construction detail of a concrete block pilaster.

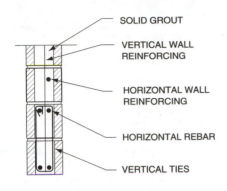

WALL HEADER

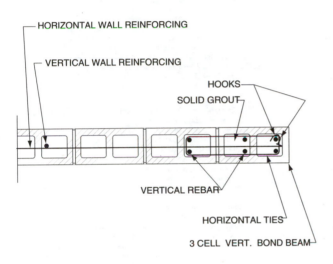

WALL OPENING

Figure 8–33 Concrete block over-and-beside openings require special reinforcement. Above an opening, horizontal steel is held together with vertical ties. Vertical reinforcing beside the opening is held in place by horizontal lines.

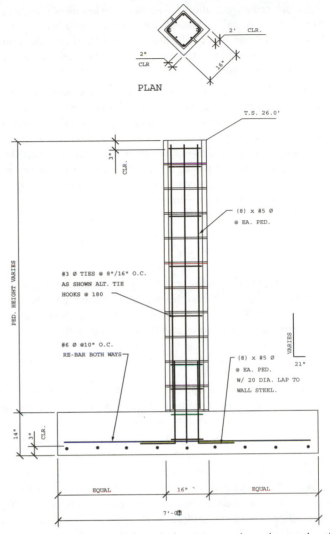

Figure 8–34 Representing steel placement and overlap in detail.

guish the edge of steel location, the term *clear* or *CLR.* is added to the dimension. In addition to the information in the details, steel is also referenced in the written specifications. The written specifications detail the grade and strength requirements for general areas of the structure such as walls, floors, columns, or retaining walls. Figure 8–35 shows an example of steel specifications that accompany a small office structure.

Mortar and Grout

Mortar used to bond masonry products and steel is composed of portland cement, sand, lime, and clean water. Other materials can be added to the mix to increase its ability to bond to masonry units and steel. Mortar mix is normally governed by ASTM C144. The strength of the mortar is of critical importance to the strength of the masonry wall and is specified on the architectural drawings

TABLE 8–2 INCHES OF LAP CORRESPONDING TO THE NUMBER OF BAR DIAMETERS

# OF DIA.	SIZE OF BAR								
	#3	#4	#5	#6	#7	#8	#9	#10	#11
20	6	10	13	15	18	20	23	26	29
22	8	11	14	17	20	22	25	28	32
24	9	12	15	18	21	24	28	31	34
30	12	15	19	23	27	30	34	39	43
32	12	16	20	24	28	32	37	41	46
36	14	18	23	27	32	36	41	46	51
40	15	20	25	30	35	40	46	51	57
48	18	24	30	36	42	48	55	61	68

and the written specifications. Type M and S are most often used for exterior walls and are suitable for walls above or below grade. Type N or S mortar is normally used for load-bearing walls, while type O mortar is used for nonbearing walls. The mortar is usually specified in the masonry wall details.

In addition to the strength and makeup of the mortar, the type of joint is usually specified. Joints used with masonry units are similar to the joints used with brick construction. Grout is composed of the same components as mortar, but the grading is slightly different. Grout is specified as fine or coarse and governed by ASTM C33. Specifications are placed on the drawings or in the project manual to control the proportions of elements in grout. Figure 8–35 shows an example o common mortar notes placed on the working drawings of a concrete block structure.

ROOF CONSTRUCTION

Roof framing includes both conventional and truss framing methods. Each has its own special terminology, but many terms apply to both systems. These common terms are described first, followed by the terms for conventional and truss framing methods.

Basic Roof Terms.

Roof terms common to conventional and trussed roofs include eave, cornice, eave blocking, fascia, ridge, sheathing, finishing roofing, flashing, and roof pitch dimensions.

The *eave* is the portion of the roof that extends beyond the walls. The *cornice* is the covering that is applied to the eaves. Common methods for constructing the cornice can be seen in Figure 8–36. *Eave* or *bird blocking* is a spacer block placed between the rafters or truss tails at the eave. This block keeps the spacing of the rafters or trusses uniform and keeps small animals from entering the attic. It also provides a cap to the exterior siding, as seen in Figure 8–37.

A *fascia* is a trim board placed at the end of the rafters or truss tails and usually perpendicular to the building wall. It hides the truss or rafter tails from sight and also provides a surface where the gutters may be mounted. The fascia can be made from either 1× or 2× (25× or 50×) material and is typically 2" (50 mm) deeper than the rafters or truss tails. The fascia may be omitted for economic reasons and replaced with a deeper gutter to hide the rafter tails. At the opposite end of the rafter from the fascia is the ridge. The ridge is the highest point of a roof formed by the intersection of the rafters or the top chords of a truss (see Figure 8–38).

Roof sheathing is similar to wall and floor sheathing but can be either solid or skip. The area of the country and the finished roofing to be used determine which type of sheathing is used. For solid sheathing, 1/2" (13 mm) thick CDX plywood or 1/2" (13 mm) OSB is generally used. CDX is the specification given by Engineering Wood Association to designate standard-grade plywood. It provides an economical, strong covering for the framing, as well as an even base for installing the finished roofing.

Skip sheathing is used with either tile or shakes. 1 × 4s (25 × 100 mm) are laid perpendicular to the rafters with a 4" (100 mm) space between each piece of sheathing. A water-resistant

REINFORCING

1. ALL REINFORCING STEEL TO BE ASTM A615 GRADE 60, EXCEPT TIES, STIRRUPS & DOWELS TO MASONRY TO BE GRADE 40. W. W. F. SHALL CONFIRM TO ASTM A185 AND SHALL BE 6X6-W1.4XW1.4 WWF MATS.

2. FABRICATE AND INSTALL REINF. STEEL ACCORDING TO THE "MANUAL OF STANDARD PRACTICE FOR DETAILING REINFORCED CONCRETE STRUCTURES" ACI STANDARD 315.

3. PROVIDE 2'-0" X 2'-0" CORNER BARS TO MATCH HORIZ. REINFORCING IN POURED IN-PLACE WALLS AND FTGS. @ ALL CORNERS AND INTERSECTIONS.

4. SPLICES IN WALL REINFORCING SHALL BE LAPPED 30 DIAMETERS (2'-0" MINIMUM AND SHALL BE STAGGERED AT LEAST 4' AT ALTERNATE BARS.

5. ALL OPENINGS SMALLER THAN 30" X 30" THAT DISRUPT REINFORCING SHALL HAVE AN AMOUNT OF REINFORCING EQUAL TO THE AMOUNT DISRUPTED PLACED BOTH SIDES OF OPENING & EXTENDING 2'-0" EA. SIDE OF OPENING.

6. PROVIDE THE FOLLOWING REINFORCING AROUND WALL OPENINGS LARGER THAN 30" X 30":
 A. (2) #5 OVER OPENING X OPENING WIDTH PLUS 2'-0" EACH SIDE.
 B. (2) #5 UNDER OPENING X OPENING WIDTH PLUS 2'-0" EACH SIDE.
 C. (2) #5 EACH SIDE OF OPENING X FULL STORY HEIGHT.
 D. PROVIDE 90 DEGREE HOOK FOR BARS AT OPENINGS IF REQUIRED EXTENSION PAST OPENING CANNOT BE OBTAINED.

7. PROVIDE (2) #4 CONTINUOUS BARS AT TOP AND BOTTOM AND AT DISCONTINUOUS ENDS OF ALL WALLS.

8. PROVIDE (2) #5 X OPENING DIMENSION PLUS 2'-0" EACH SIDE AROUND ALL EDGES OF OPENINGS LARGER THAN 15" X 15" IN STRUCTURAL SLABS AND PLACE (1) #4 x 4'-0" AT 45 DEGREES TO EACH CORNER.

9. PROVIDE DOWELS FROM FOOTINGS TO MATCH ALL VERTICAL WALL, PILASTER, AND COLUMN REINFORCING (POURED-IN-PLACE COLUMNS AND WALLS). LAP 30 DIAMETERS OR 2'-0" MINIMUM.

10. ALTERNATE ENDS OF BARS 12" IN STRUCTURAL SLABS WHENEVER POSSIBLE.

11. ALL WALL REINFORCING TO BE PLACED IN CENTER OF WALL UNLESS SHOWN OTHERWISE ON THE DRAWINGS.

CONCRETE BLOCK

1. DESIGN F'M = 1500 PSI FOR SOLID GROUTED WALLS, 1350 PSI FOR WALLS WITH REINFORCED CELLS ONLY GROUTED.

2. ALL CMU UNITS TO BE GRADE N TYPE 1 LIGHTWEIGHT UNITS PER ASTM C90 DRY TO INTERMEDIATE HUMIDITY CONDITION PER TABLE NO. 1.

3. MORTAR TO BE PER IBC TABLE 2103.7(1) TYPE S OR PER MANUFACTURER'S RECOMMENDATION TO REACH CORRECT STRENGTH. GROUT TO HAVE MIN. STRENGTH TO MEET DESIGN STRENGTH AND MADE WITH 3/8" MINUS AGG.

4. CONTRACTOR TO PREPARE AND TEST 3 GROUTED PRISMS & 3 UNGROUTED PRISMS PER EVERY 5000 SQUARE FEET OF WALL, DURING CONSTRUCTION.

5. ALL WORK SHALL CONFORM TO SECTION 2103 THROUGH SECTION 2109 OF THE LATEST INTERNATIONAL BUILDING CODE.

6. REINFORCING FOR MASONRY TO BE ASTM A615 GR. 60 PLACED IN CENTERS OF CELLS AS FOLLOWS (UNLESS OTHERWISE INDICATED):
 A. VERTICAL: 1- #5 @ 48" O.C. PLUS 2- #5'S FULL HEIGHT EACH SIDE OF OPENINGS, UNLESS SHOWN OTHERWISE ON DRAWINGS.
 B. HORIZ.: 1- #5 @ 48" O.C. (FIRST BOND BEAM 48" FROM GROUND FLOOR) PLUS 2- #4'S AT TOP OF WALL AND AT EACH INTERMEDIATE FLOOR LEVEL.
 C. LINTELS: LESS THAN 4'-0" WIDE---2- #4'S IN BOTTOM OF 8"DEEP LINTEL. 4'-0" TO 6'-0" WIDE----2- #4'S IN BOTTOM OF 16" DEEP LINTEL.
 D. CORNERS AND INTERSECTIONS: 1- 24" X 24" CORNER BAR AT EACH BOND BEAM SAME SIZE AS HORIZONTAL REINFORCING.

7. GROUT ALL CELLS FULL @ EXTERIOR OR LOAD-BEARING WALLS. GROUT ALL CELLS THAT CONTAIN REINFORCING OR EMBEDDED ITEMS.

8. ELECTRICAL BOXES, CONDUIT AND PLUMBING SHALL NOT BE PLACED IN ANY CELL THAT CONTAINS REINFORCING.

9. SEE DRAWINGS FOR ADDITIONAL REINFORCING.

BRICK

1. ASSUMED F'M 1800 PSI MINIMUM.

2. EXTERIOR BRICK TO BE GRADE SW AND INTERIOR BRICK TO BE GRADE MW.

3. MORTAR TO BE TYPE S AT BRICK VENEER AND TYPE M AT REINFORCED BRICKWORK, GROUT TO HAVE MINIMUM COMPRESSIVE STRENGTH AT 28 DAYS OF 2000 PSI AND BE MADE WITH 3/8" MINUS AGGREGATE.

4. ALL WORK SHALL CONFORM TO CHAPTER 21 OF THE IBC.

STRUCTURAL & MISCELLANEOUS STEEL

1. DETAILING, FABRICATION & ERECTION SHALL CONFORM TO THE STEEL CONSTRUCTION MANUAL OF AISC.

2. ALL STEEL TO BE A36 EXCEPT AS NOTED.

3. ALL WELDS TO BE MADE BY CERTIFIED WELDERS TO AWS STANDARDS WITH E70XX ELECTRODES.

4. UNLESS NOTED OTHERWISE, BOLTS TO BE A325N FOR STEEL TO STEEL CONNECTIONS & A449 FOR A. B. . DRILLED A. B.TO BE "PARABOLT", "KWIKBOLT" OR APPROVED EQUAL.

5. ALL STRUCTURAL TUBING TO BE ASTM A500 GRADE B. FY=46 KSI. ALL STEEL PIPE TO BE ASTM A501 (FY = 36 KSI) OR ASTM A53, TYPE E OR S, GRADE B (FY = 35 KSI).

Figure 8–35 Written specifications for steel reinforcing, concrete block, and brick construction are often placed with the structural drawings. *Courtesy Van Domelan/Looijenga/McGarrigle/Knauf Consulting Engineers.*

sheathing must be used when the eaves are exposed to weather. This usually consists of plywood rated CCX or 1" (25 mm) T&G decking. CCX is the specification for exterior-use plywood. The finished roofing is the weather-protection system. Roofing can include built-up roofing, asphalt shingles, fiberglass shingles, cedar, tile, or metal panels. For a complete discussion of roofing materials see Chapter 9.

Pitch, span, and overhang are dimensions needed to define the *angle*, or steepness, of the roof. Each can be seen in Figure 8–39. *Pitch* is the ratio between the horizontal run and the vertical rise of the roof. The *run* is the horizontal measurement from the outside edge of the wall to the centerline of the ridge. The *rise* is the vertical distance from the top of the wall to the highest point of the rafter being measured. The *span* is the measurement between the inside edges of the supporting walls. The *overhang* is the horizontal measurement between the exterior face of the wall and the end of the rafter tail.

Conventional Roof Framing Terms.

Conventional, or stick, framing methods involve the use of wood members placed in repetitive fashion. Stick framing involves the use of such members as ridge board, rafter, and ceiling joists.

The ridge board is the horizontal member at the ridge that runs perpendicular to the rafters. The ridge board is centered between the exterior walls when the pitch on each side is equal. The ridge board resists the downward thrust resulting from gravity trying to force the rafters into a V shape between the walls. The ridge board does not support the rafters but is used to align the rafters so that their forces are pushing against each other.

Rafters are the sloping members, made from sawn or engineered lumber, used to support the roof sheathing and finished roofing. Rafters are typically spaced at 12", 16", or 24" (300, 400, or 600 mm). O.C. with 24" (600 mm) spacing most common. There are various kinds of rafters, including common, hip, valley, and jack rafters. Each can be seen in Figure 8–40.

A *common rafter* is used to span and support the roof loads from the ridge to the top plate. Common rafters run perpendicular to both the ridge and the wall supporting them. The upper end rests squarely against the ridge board, and the lower end receives a notch and rests on the top plate of the wall. The notch, or bird's mouth, is cut in the rafter at the point where the rafter intersects a beam or bearing wall. This notch increases the contact area of the rafter by placing more rafter surface against the top of the wall.

Hip rafters are used when adjacent slopes of the roof meet to form an inclined ridge. The hip rafter extends diagonally across the common rafters and forms an exterior roof corner. The hip is inclined at the same pitch as the rafters. A valley rafter is similar to a hip rafter. It is inclined at the same pitch as the common rafters that it supports. *Valley rafters* get their name because they are located where adjacent roof slopes meet to form a valley. *Jack rafters* span from a wall to a hip or valley rafter. They are similar to a common rafter but span a shorter distance. A section specifies only common, hip, and valley rafters.

Rafters settle because of the weight of the roof and because of gravity. As the rafters settle, they push supporting walls outward. These two actions, downward and outward, require special members to resist these forces. These members include ceiling joists,

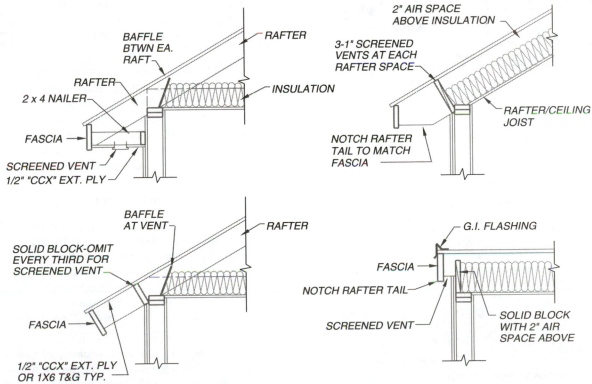

Figure 8–36 Typical methods of constructing a cornice.

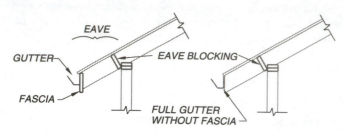

Figure 8–37 Eave components.

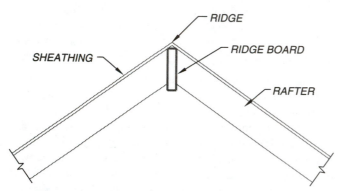

Figure 8–38 Ridge construction.

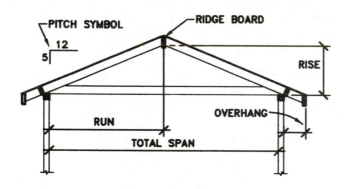

Figure 8–39 Roof dimensions needed for construction.

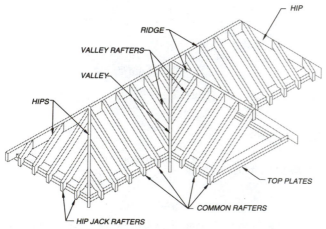

Figure 8–40 Roof members in conventional construction.

ridge bracing, collar ties, purlins, and purlin blocks and braces. Each can be seen in Figure 8–41.

Ceiling joists span between the top plates of bearing walls to resist the outward force placed on the walls from the rafters. Ceiling joists also support the finished ceiling. *Collar ties* are also used to help resist the outward thrust of the rafters. They are usually the same size as the rafters and placed in the upper third of the roof.

Ridge braces are used to support the downward action of the ridge board. The brace is usually a 2 × 4 (50 × 100 mm) spaced at 48" (1200 mm) O.C. maximum set at 45° maximum to the ceiling joist. A *purlin* is a brace used to provide support for the rafters as they span between the ridge and the wall. The purlin is usually the same size as the rafter and is placed below the rafter to reduce the span. As the rafter span is reduced, the size of the rafter can be reduced. A *purlin brace* is similar to a ridge brace and is used to transfer weight from the purlin to a supporting wall. A scrap block of wood is used to keep the purlin from sliding down the brace. When there is no wall to support the ridge brace, a strongback is added. A *strongback* is a beam placed over the ceiling joist to support the ceiling and roof loads (see Figure 8–42).

If you are working with a set of plans that has a vaulted ceiling, you must be familiar with two other terms. These are rafter/ceiling joist and ridge beam. Both can be seen in Figure 8–43. A *rafter/ceiling joist*, or *rafter joist*, is a combination of rafter and ceiling joist. The rafter/ceiling joist is used to support both the roof loads and the finished ceiling. Typically a 2 × 10 (50 × 250 mm) or 12" (300 mm) rafter/ceiling joist is used. This allows room for 8" or 10" (200 or 250 mm) of insulation and 2" (50 mm) of airspace above the insulation.

A ridge beam is used to support the upper end of the rafter/ceiling joist. Because there are no horizontal ceiling joists, metal joist hangers must be used to keep the rafters from separating from the ridge beam.

The final terms to be familiar with for a stick roof are header and trimmer. Both are terms that are used in wall construction, and they have a similar function when used as roof members (see Figure 8–44). A *header* at the roof level consists of two members nailed together to support rafters around an opening, such as a skylight or chimney. *Trimmers* are two full rafters nailed together to support the roofing on the inclined edge of an opening.

Truss Roof Construction Terms

A *truss* is a component used to span large distances without intermediate supports. Trusses can be either prefabricated or job-built. Prefabricated trusses are commonly used in residential construction. Assembled at the truss company and shipped to the job site, the truss roof can be set in place quickly. The size of the material used in trusses is smaller than with conventional frames. Residential truss members need only be 2 × 4s (50 × 100 mm) set at 24" (600 mm) on center.

Job-built trusses are similar to prefabricated trusses except the framing crew builds the trusses on-site. Job-built trusses are laid out on the floor and then lifted into place. Although this method

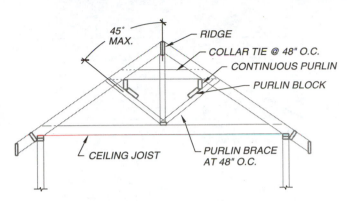

Figure 8–41 Common roof supports.

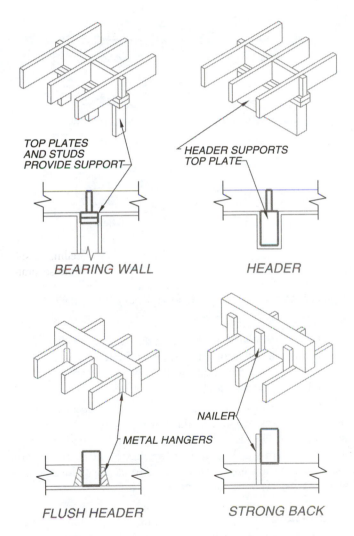

Figure 8–42 Common methods of supporting loads include bearing walls, headers, flush headers, and the strongback. When a header is used, the loads rest on the header. With a flush header, the ceiling joists are supported by metal hangers. A piece of scrap wood is used to hang the ceiling joist to the strongback.

is only slightly faster than conventional framing, it has the advantage of using smaller members to build the trusses.

Several shapes and types of trusses are available for residential and commercial use. Each can be seen in Figure 8–45. The most commonly used truss in residential construction is the W or Fink truss. On many plans it is commonly called a *standard truss*, which is used to frame gabled roofs. A *gable-end wall truss* is used to form the exterior ends of the roof system and is aligned with the exterior side of the end walls of a structure. This truss is more like a wall than a truss, with the vertical supports spaced at 24" (600 mm) o.c. to support exterior finishing material. A *girder truss* is used on houses with an L- or U-shaped roof where the roofs intersect. To form a girder truss, the manufacturer typically bolts two or three standard trusses together. The manufacturer determines the size and method of constructing the girder truss.

The *cantilevered truss* is used where a truss must extend past its support to align with other roof members. Cantilevered trusses are typically used where walls jog to provide an interior courtyard or patio. A *stub truss* can be used where an opening will be provided in the roof or the roof must be interrupted. The shortened end of the truss can be supported by either a bearing wall, a beam, or by a header truss. A *header truss* has a flat top that is used to support stub trusses. The header truss has a depth to match that of the stub truss and is similar in function to a girder truss. The header truss spans between and is hung from two standard trusses. Stub trusses are hung from the header truss.

Hip trusses are used to form hip roofs. Each succeeding truss increases in height until the full height of the roof is achieved and standard trusses can be used. The height of each hip truss decreases as they get closer to the exterior wall, which is perpendicular to the ridge. Hip trusses must be 6' (1800 mm) from the exterior wall to achieve enough height to support the roof loads.

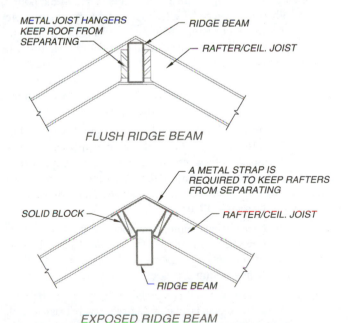

Figure 8–43 Common connections between the ridge beam and rafters. The ridge may be exposed or hidden.

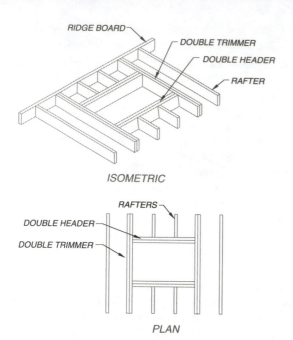

Figure 8–44 Framing around an opening in the roof requires the use of a header and trimmers.

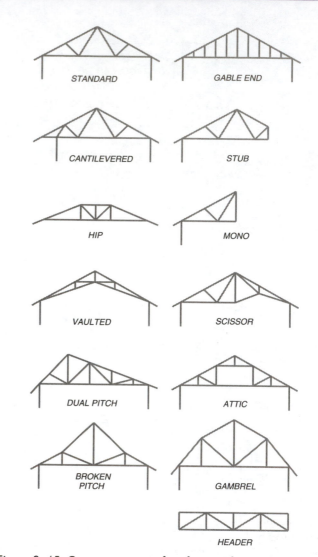

Figure 8–45 Commmon types of roof trusses for residential construction.

Figure 8–46 shows where hip trusses could be used to frame a roof. The exact distance will be determined by the truss manufacturer. A *mono truss* is a single pitched truss, which can often be used in conjunction with hip trusses to form the external 6' (1800 mm) of the hip. A mono truss is also useful in blending a one-level structure with a two-level structure.

If a vaulted roof is desired, vaulted or scissor trusses can be used. *Vaulted* and *scissor trusses* have inclined bottom chords. There must be at least a two-pitch difference between the top and bottom chord. If the top chord is set at a 6/12 pitch, the bottom chord usually cannot exceed a 4/12 pitch. A section is usually provided to give the exact requirement for the vaulted portion of the truss. If a portion of the truss needs to have a flat ceiling, it may be more economical to frame the lowered portion with conventional framing materials, a process often referred to as *scabbing on*. Although this process requires extra labor at the job site, it might eliminate a third bearing point near the center of the truss.

It is important to remember, when a truss roof is used, there are no ceiling joists, rafters, or any of the other members seen in Figure 8–41. Instead of these common members, a truss is formed from top and bottom chords and webs. Other members associated with a truss roof are ridge blocks, hurricane ties, and truss connectors. Each can be seen in Figure 8–47.

The *top chord* is the inclined member used to support the sheathing and finished roof material. The *bottom chord* is the horizontal member that resists the outward forces on the top chord and supports the finished ceiling.

Because a truss is a self-contained unit, no ridge board is required. Instead, a block is placed between each truss to help maintain uniform spacing and provide a nailing surface for the plywood at the ridge. Figure 8–48 shows truss connections typically shown on sections.

Truss clips, or *hurricane ties*, resist the tendency to lift the truss and roof off the wall from wind pushing upward on the eave. This clip transfers the force of any wind uplift acting on the trusses down through the walls and into the foundation.

The truss connector is not shown or specified on a set of drawings. These are shown only on the drawings produced by the truss manufacturer. The plans drawn by the architect or designer show what type of truss is desired. The drawings provided by the truss manufacturer show how the truss is constructed, with lumber sizes and the types of connectors to be used.

Metal Hangers

Metal hangers are used on floor, ceiling, and roof members. These hangers are used to keep structural members from separating. Several common types of connectors are used in light construction. These connectors keep beams from lifting off posts, keep posts from lifting off foundations, or hold one beam or joist to another. The methods used to represent these items on blueprints can be seen in Figure 8–42 and 8–48.

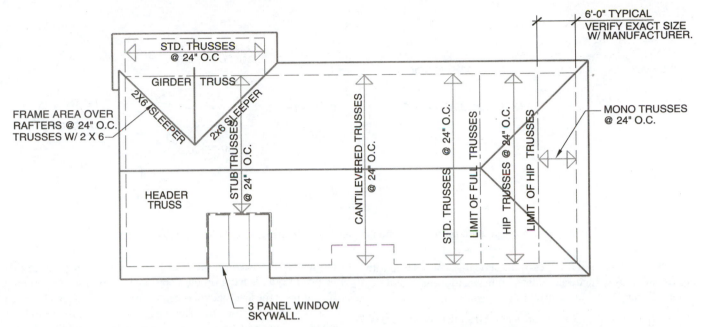

Figure 8–46 Standard, girder, stub, cantilever, hip, and mono trusses can each be used to form different roof shapes.

ENERGY-EFFICIENT FRAMING

Throughout this chapter you've been introduced to several framing methods and many different framing materials. This section will introduce you to a framing method that combines the materials presented so far. Since the early 1980s, many framers have substituted 2 × 6 (50 × 150 mm) studs at 24" (600 mm) spacing to allow for added insulation in the wall cavity. Many long-held framing practices have been altered to allow for greater energy savings. The new framing practices are usually referred to as *advanced framing techniques* (AFT) in the building codes.

AFT systems eliminate nonstructural wood from the building shell and replace it with insulation. Wood has an average resistive value for heat loss of R-1 per inch of wood compared with R-3.5 through R-8.3 per inch of insulation. Reducing the amount of wood in the shell increases the energy efficiency of the structure. Advanced framing methods usually include 24" (600 mm) stud spacing, insulated corners, insulation in exterior walls behind partition intersections, and insulation headers. Many codes limit advanced framing methods to one-level construction. For a multilevel residence, advanced methods can be used on the upper level, and the spacing can be altered to 16" (400 mm) for the lower floor.

The insulation that is added to corners, wall intersections, and headers must be equal to the insulation value of the surrounding wall. Figure 8–49 shows examples of framing intersections using advanced framing techniques. Figure 8–50 shows examples of how insulated headers can be framed. Advanced framing methods also affect how the roof will intersect the walls. Figure 8–51 compares standard roof and wall intersection with those of advanced methods.

Structural insulated panels (SIPs) have been used for decades in the construction of refrigerated buildings, where thermal effi-

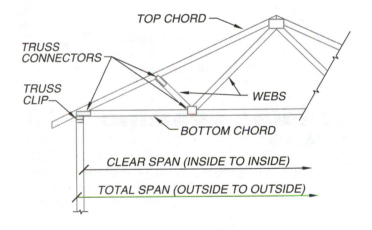

Figure 8–47 Truss construction members.

ciency is important. SIPs have also been used in residential construction since the 1930s as part of research projects. Their popularity increased as energy costs rose through the 1980s, and they have become an economical method of construction in many parts of the country.

SIPs are composed of a continuous core of rigid foam insulation, which is laminated between two layers of structural board with an adhesive to form a single, solid panel. Expanded polystyrene (EPS) foam is used as the insulation material, and OSB is used for the outer shell of the panel. Panels with an EPS core and drywall skin are available for timber-framed structures. EPS retains its shape throughout the life of the structure, to offer uniform resistance to air

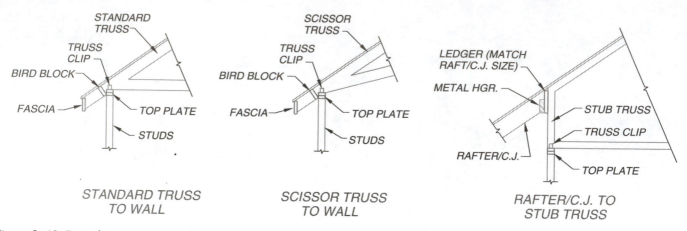

Figure 8–48 Typical truss connections as seen on sections and the metal connectors used to hold the trusses.

infiltration and increased R values over a similar-size wood wall with batt insulation. Although values differ somewhat for each manufacturer, an R value of 4.35 per inch of EPS is common.

In addition to their energy efficiency, SIPs offer increased construction savings by combining framing, sheathing, and insulation procedures into one step during construction. Panels can be made in sizes ranging from 4'–24' (1200–7200 mm) long and 8' (2400 mm) high, depending on the manufacturer and design requirements. SIPs can be precut and custom-fabricated for use on the most elaborately shaped structures. Panels are quickly assembled on-site by fitting splines into routed grooves in the panel edges, as seen in Figure 8–52. Door and window openings can be precut during assembly or cut at the job site. A chase is typically installed in the panels to allow for electrical wiring.

READING FRAMING PLANS

A *framing plan* is a drawing used to show the dimensions, framing members, and methods of resisting seismic and wind loads for a specific level of a structure. Office practice and the complexity of the structure determine the exact contents of the plan.

When a simple one-level house using truss roof construction is drawn, architectural and structural information can often be combined on the floor plan, as in Figure 8–53. For a custom multilevel structure, a separate plan is usually provided to explain the roof framing as well as the architectural and structural requirements of each level. The floor plans (see Chapters 3 and 4) are typically used to explain architectural information (see Figure 8–54). The framing plan is used to show the location of all walls and openings, header sizes, and structural connectors. Section markers to indicate where sections and details have been drawn are also placed on a framing plan. Figure 8–55 shows the framing plan that corresponds to the floor plan in Figure 8–54.

When the floor plan is completed, it is with the thought that a cutting plane passed through the structure and removed the upper portion of the structure. The floor plan is drawn as if the viewer is looking down at the floor. When the framing plan is drawn, the information is placed on the floor plan, but with the premise that the print reader is lying on the floor looking up to see the framing that supports the level above. When the main framing plan is drawn for a two-level structure, the plan shows the walls for the main floor and the beams and floor joists needed to frame the floor/ceiling above the main floor. The framing plan for the upper level shows the walls on the upper floor and the members used to form the ceiling if western platform-construction methods are used.

Rafters and other roof members are shown on the roof framing plan. If a room has a vaulted ceiling, the rafter/ceiling joist are typically shown on the framing plan. If the roof system is framed using trusses, these are often shown on the upper framing plan. If a complex roof shape is used, the trusses are shown on the roof framing plan. The floor system used to support the main floor is shown on the foundation plan. Chapter 10 introduces the foundation and floor framing systems.

FRAMING MEMBERS

A key element of the framing plan is to show and specify the location of headers, beams, posts, joists, and trusses used to frame the skeleton by the use of notes and symbols.

Headers are located over every opening in a wall. Headers over a door or window are typically not drawn and are referenced by a note. A beam is placed to control the span of a joist or rafter, or under a concentrated load, and is represented by parallel dashed lines. Often the specification for the size and strength is placed parallel to the member.

Each beam and header will be supported by multiple studs, a post, or a steel column, depending on the loads to be supported. When a post or column is hidden in a wall, it may or may not be drawn. Posts or columns inside a room are represented using line quality to match that used to represent walls. Specifications for the post size or for connecting hardware are often specified on a 45° angle. Figure 8–56 shows common methods of specifying beams and posts.

Joists, rafters, and trusses are usually represented by a thin line with an arrow at each end. Many companies draw the line representing these members so that it extends from bearing point to

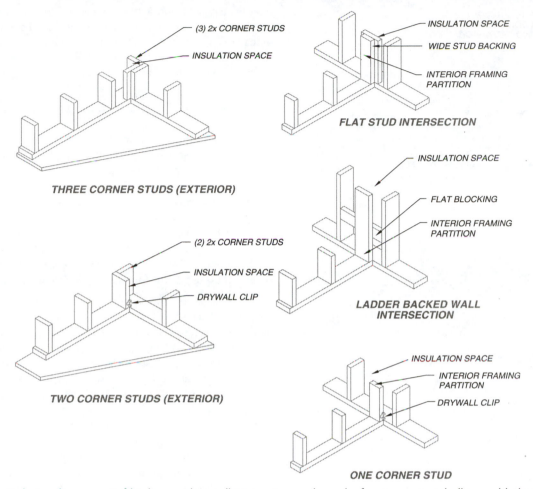

Figure 8–49 Reducing the amount of lumber used at wall intersections reduces the framing cost and allows added insulation to be used.

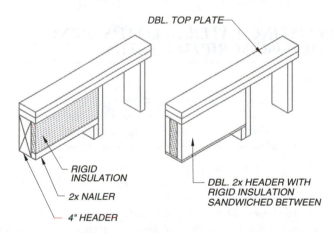

Figure 8–50 Rigid insulation placed behind or between headers increases the insulation value of a header from R-4 to R-11.

bearing point. An alternative method is to show the joist symbol centered between the bearing points. The specification for the member is usually written parallel to the line and should include the size, type, and spacing of the member. If metal hangers are to

be used to connect a joist to a beam, a note listing the connector is typically placed on a 45° angle and should include the size or model number and the manufacturer. If a vaulted ceiling is to be provided, the line dividing the vault from the flat ceiling must be drawn, located, and specified. Figure 8–57 shows common methods of representing joists, trusses, and vaulted ceilings.

SEISMIC AND WIND RESISTSNCE

If you're working with plans for a structure to be built in an area of high wind or seismic risk, the method of resisting these loads must be respresented. A framing plan separate from the floor plan is generally used to keep the floor plan from becoming too difficult to read. Plywood shear panels, extra blocking, metal angles, and metal connectors to tie posts of one level to members below them are common methods of resisting the forces caused by earthquakes or high winds.

Plywood shear panels are usually specified by a local note pointing to the area of the wall to be reinforced. If several walls are to receive shear panels, a note to explain the construction of the panels can be placed as a general note, with a shortened local note used merely to locate their occurrence. Horizontal metal straps

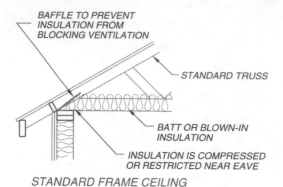

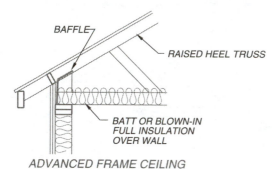

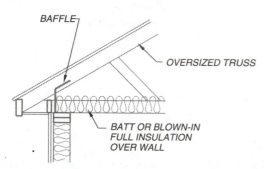

Figure 8–51 By altering the bearing point of a truss or rafter, the ceiling insulation can be carried to the outer edge of the exterior wall to reduce heat loss.

Figure 8–52 Structural insulated panels are joined to each other with tongue-and-groove seams. *Courtesy Insulspan.*

may be required to strengthen connections of the top plate or to tie the header into wall framing. These straps can be represented by a line placed on the side of the wall with a note to specify the manufacturer, the size, and the required blocking. Where walls can be reinforced with a let-in brace, a bold diagonal line is usually placed on the wall.

Metal straps used to tie trimmers, king studs, or posts of one level to another are usually represented on each layer of the framing plan by a bold line where they occur. This vertical strap is usually shown and specified on the framing plan for each level being connected. The specification usually includes the manufacturer, size, and required nailing. Figure 8–58 shows common methods used to represent shear panels, let-in braces, and metal straps. Straps are also shown in sections and details, as in Figure 8–59, or they can be shown on the exterior elevations. When the lowest floor level is to be attached to the foundation level, the metal connector is often represented by a cross. Common methods of representing these ties on the foundation plan can be seen in Chapter 10.

Floors and roof members are often tied into the wall system to help resist lateral loads. In addition to the common nailing used to connect each member, metal angles are used to secure the truss or rafter to the top plate. Where lateral loads are severe, blocking is added between the trusses or rafters to keep these members from bending under lateral stress. These areas where joists or rafters are stiffened to resist bending from lateral loads are often referred to as a *diaphragm*. The size, location, framing method, angles, and blocking for the diaphragm must be clearly specified on the framing plan. The angles are typically represented in a section or detail but are not drawn on the framing plan. They are usually specified by a note that indicates the manufacturer, model number, spacing, and which members are to be connected. Areas that are to receive special blocking are usually indicated on the framing plan. Figure 8–60 shows how a diaphragm can be represented on a framing plan.

RESISTING LATERAL LOADS USING CODE-PRESCRIPTIVE PATHS

An alternative to having an engineer design the method of resisting lateral loads is to use the prescriptive path provided by the building code. To successfully work with plans that incorporate wind and seismic resistance based on the p[rescriptive path of the IRC requires an understanding of several basic terms.

The terms braced wall lines and braced wall panels are used to describe methods of resisting wall loads. Each exterior surface of a residence is considered a *braced wall line*. Figure 8–61 shows a simple structure with four exterior walls (braced wall lines). As wind is applied to a structure, the natural tendency is for the wall to change from a rectangle to a parallelogram. If wind force is applied to surface 1, wall lines 2 and 4 will be used to resist the force. Because the wind force can come from any direction, each surface must be reinforced to resist the force that may be applied to the adjoining surface.

Three methods are approved by most building departments for reinforcing a braced wall line. These methods include braced wall panels, alternative braced wall panels, and portal frames.

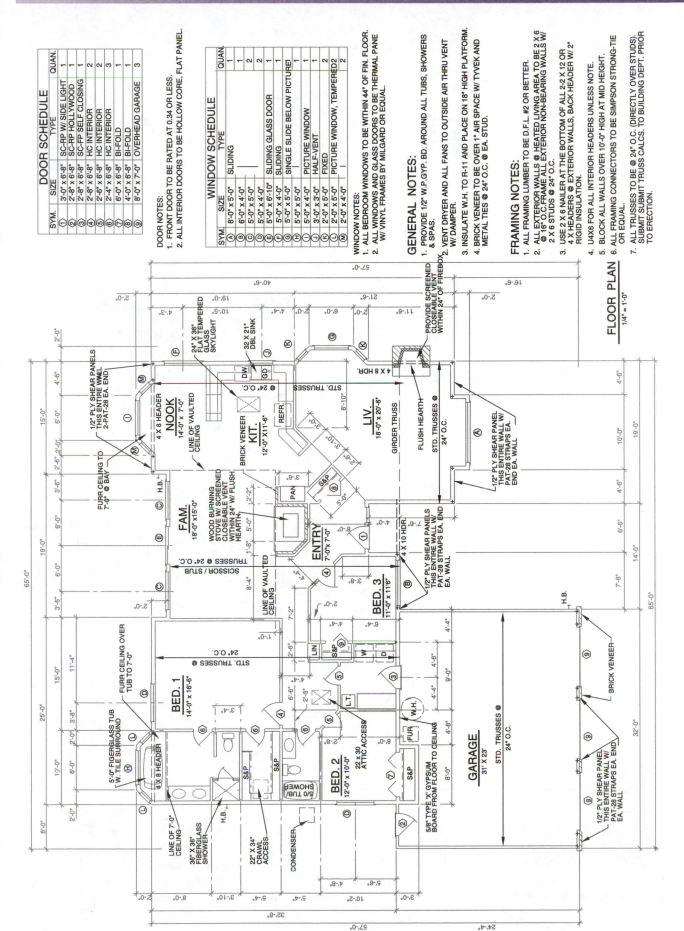

Figure 8-53 For a simple residence the structural information can be shown on the floor plan. *Courtesy Steve Bloedel.*

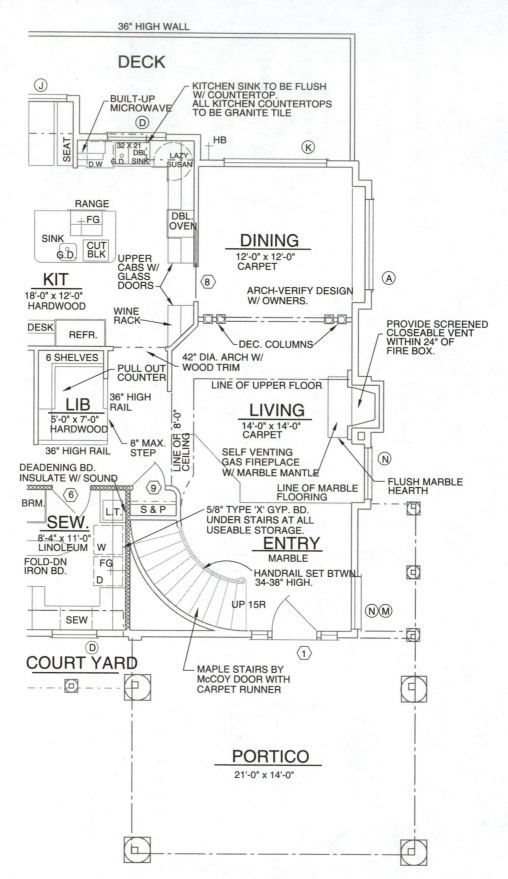

Figure 8–54 For a detailed set of plans, only architectural information is placed on the floor plan.

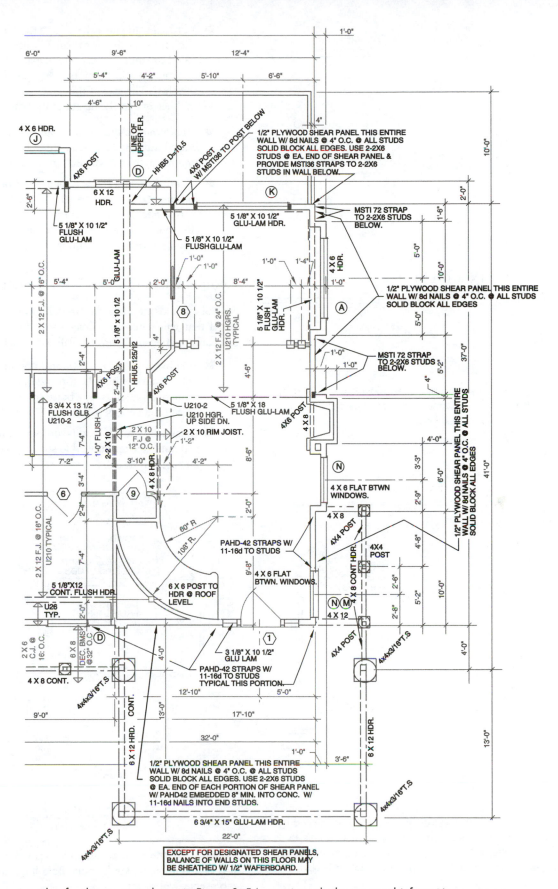

Figure 8–55 The framing plan for the structure shown in Figure 8–54 contains only the structural information.

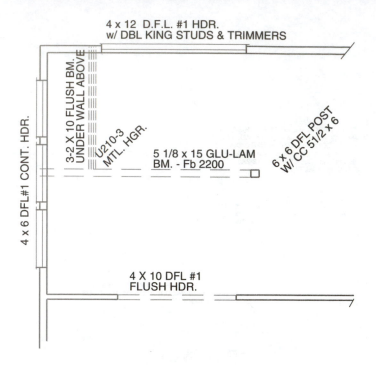

Figure 8–56 Headers over a door or window are specified by note but not drawn. Headers over wall openings or between walls must be drawn and specified.

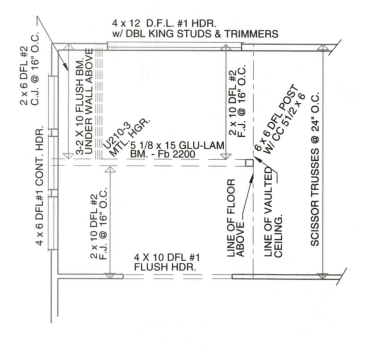

Figure 8–57 Joist, rafters, and trusses are each represented by an arrow that shows the direction of the span, with a note to specify the type, size, and spacing of the framing member. Posts are often specified on an angle so that the notation is obvious.

■ A *braced wall panel* (BWP) is a method of braced wall line reinforcement that uses panels with a minimum length of 48" (1200 mm) to resist lateral loads. The minimum length of braced panels can be reduced if the entire wall is sheathed. The size of the panel reduction is based on the wall height and the height of the wall opening.

■ An *alternative braced wall panel* (ABWP) is a method of braced wall line reinforcement that uses panels with a minimum length of 2'-8" (800 mm) to resist lateral loads.

■ A *portal frame* (PF) is a method of braced wall line reinforcement that uses panels 22–1/2" (570 mm) wide to resist lateral loads. Portal frames are not mentioned in the IRC, but are accepted by most building departments when based on APA specifications.

Components of Braced Wall Construction

Several methods are allowed by building codes for constructing the panel that will reinforce a braced wall line. IRC-approved construction methods for a braced wall panel include:

■ Nominal 1 × 4 (25 × 100 mm) continuous diagonal let-in brace that is let into the top and bottom plates and a minimum of three studs. The brace cannot be placed at an angle greater than 60° or less than 45° from horizontal.

■ Diagonally placed wood boards with a net thickness of 5/8" (16 mm) that are applied to studs spaced at a maximum of 24" (600 mm) o.c.

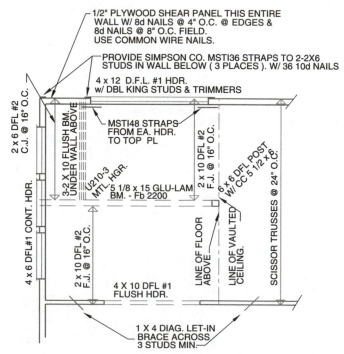

Figure 8–58 Material for resting lateral loads are usually specified on the framing plan by note. Bold lines are often used to represent metal straps.

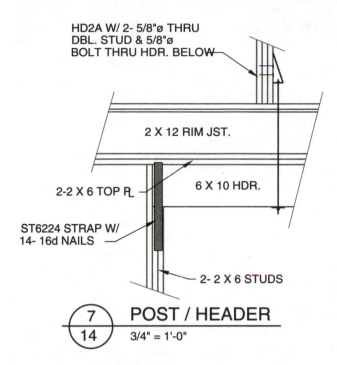

HD2A W/ 2- 5/8"ø THRU
DBL. STUD & 5/8"ø
BOLT THRU HDR. BELOW

2 X 12 RIM JST.

2-2 X 6 TOP PL.

6 X 10 HDR.

ST6224 STRAP W/
14- 16d NAILS

2- 2 X 6 STUDS

7 / 14 POST / HEADER 3/4" = 1'-0"

Figure 8–59 Metals straps and hold-down anchors, specified on the framing plan, are typically detailed to show exact placement.

- Structural wood sheathing with a minimum thickness of 5/16" (8 mm) over studs placed at 16" (400 mm) o.c. or 3/8" (9.5 mm) structural sheathing over studs spaced at 24" (600 mm).

- 1/2" (12.7 mm) or 25/32" (19.8 mm) structural fiberboard sheathing panels 4' × 8' (1200 × 2400 mm) applied vertically over studs placed at 16" (406 mm) o.c.

- Gypsum board 1/2" (12.7 mm) thick × 4' (1200 mm) wide over studs spaced at 24" (600 mm).

- Particleboard wall sheathing panels.

- Portland cement plaster on studs placed at 16" (400 mm) o.c.

- Hardboard panel siding.

If the walls are made rigid to keep their rectangular shape, a second tendency will occur. The edge of the wall panel nearest the load (the wind) will start to lift and rotate around the edge of the panel that is farthest from the load. Figure 8–62 shows this tendency. Plans typically show other types of information to be specified about the reinforced wall panel. Required information includes:

- framing members to be used to reinforce the ends of the wall panel.

- methods of attaching the wall panel to the sill plate.

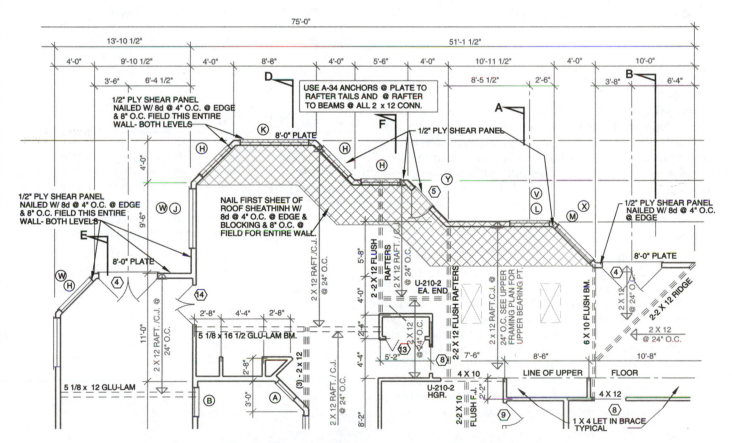

Figure 8–60 Special nailing and reinforced connections between the roof and wall are used to resist lateral forces and must be shown on the framing plan. Because the rear face of the home has very few walls, the engineer is using the roof to keep the walls square. The walls support the weight of the roof, and the roof resists the lateral loads. *Courtesy Megan Jefferis.*

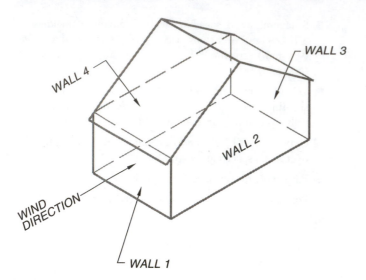

Figure 8–61 A simple structure with four exterior walls (braced wall lines). As wind is applied to the structure, the natural tendency is for the wall to change from a rectangle to a parallelogram. If wind force is applied to surface 1, wall lines 2 and 4 will be used to resists the force.

- methods of attaching the sill to the stem wall.
- methods of reinforcing the foundation that will support the wall panel.

Representing Wall Reinforcement on a Framing Plan

One of the requirements for building using prescriptive methods is that the location of wall panels must be clearly marked on the framing drawings. When the code that governs your area is used, prescriptive construction methods can be summarized and given in a table to represent the materials that will be required to reinforce the walls and foundation. Figure 8–63 shows an example of a table for specifying braced walls, alternative braced walls, and portal frames for a one-level home. Figure 8–64 shows how lateral materials can be referenced on a framing plan.

Figure 8–65 shows a one-story residence with braced wall panels. Compare the drawing with the home in Figure 8–53. The residence in Figure 8–53 shows lateral support that was designed by calculating the actual wind loads that will affect the structure. Comparing that home with the results of using building codes' prescriptive paths in Figure 8–65 will show that minor changes were required in the placement of some windows, and the addition of the storage area in the upper-left corner of the home. These changes were required to provide adequate space for braced panels. As a general rule, using the prescriptive code may save the initial cost of engineering but require more material to resist the loads.

DIMENSIONS

Chapter 4 introduced the process of placing dimensions on the floor plan. The process for placing dimensions on the framing plan is exactly the same. If a separate framing plan is to be drawn, the floor plan is usually not dimensioned; instead, all dimensions are placed on the framing plans. In addition to walls, doors, and windows, the location of framing members often needs to be dimensioned. Beams that span between an opening in a wall are located by the dimensions that locate the wall. Beams in the middle of a room must be located by dimensions.

Where joists extend past a wall, the length of the cantilever must be dimensioned. Joist size or type often varies when an upper level only partially covers another level. The limits of the placement of joists should also be dimensioned on a floor plan. Figure 8–66 shows how the location of structural members can be clarified for the framer.

NOTES

The use of local notes to specify materials on the framing plan has been mentioned throughout this chapter. Many plans contain general notes on the framing plan to ensure compliance with the code that governs construction. These framing notes can be placed on the framing plan, with the sections and details, or on a separate specifications page that is included with the working drawings. Figure 8–67 shows common notes that might be included with the framing plan. Figure 8–68 shows common nailing specifications based on the IRC. Notes such as those are often included to ensure quality construction.

SECTION REFERENCES

The framing plans are used as reference maps to show where cross sections have been cut. Detail reference symbols are also placed on the framing plan to help the print reader understand material that is being displayed in the sections. (Chapter 11 will further explain section tags and their relationship to the sections and framing plans.) Figure 8–60 shows examples of section markers.

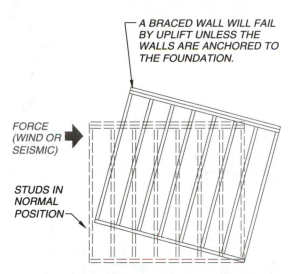

Figure 8–62 If walls are made rigid to keep their rectangular shape, a second tendency will occur. The edge of the wall panel nearest the load (the wind) will start to lift and rotate the wall around the edge of the panel that is farthest from the load.

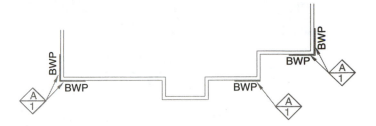

Figure 8–64 Material for resisting lateral loads can be specified on the framing plan and referenced to a table similar to Figure 8–63.

BRACED WALL SCHEDULE

	MARK	WALL COVERING	EDGE NAILING	FIELD NAILING	PANEL SUPPORT	STRUCTURAL CONNECTORS
BRACED WALL PANEL	A	48" MIN. x 1/2" CD EXT. PLY 1 SIDE UNBLOCKED	8d @ 6" O.C	8d @ 12" O.C.	2 - 2 x 6 STUDS @ EA. END OF PANEL	PAHD42 TO CONC.
ALTERNATIVE BRACED WALL PANEL	B	2'-8" MIN. x 1/2" CD EXT. PLY 1 SIDE UNBLOCKED	8d @ 6" O.C	8d @ 12" O.C.	2 - 2 x 6 STUDS @ EA. END OF PANEL	HPAHD22 TO CONC.
PORTAL FRAME	C	CD EXT. PLY 1 SIDE -BLOCKED EDGE	2 ROWS OF 8d @ 3" O.C	8d @ 12" O.C.	4 x 4 POST @ EA. END OF PANEL	1-MSTA18 STRAP EA. SIDE EA. END OF PANEL TO 4 x 12 MIN HDR. (4 STRAPS MIN EA. END OF FRAME).
INTERIOR BWP	D	1/2" x 48" GYPSUM BOARD EACH SIDE OF WALL W/ 5d COOLER NAILS @ 7" O.C. MAXIMUM W/ BLOCKED EDGES (1/2" x 96" LONG IF 1 SIDE ONLY) .				

HOLD - DOWN SCHEDULE

	MARK	HOLD - DOWN	CONNECTIONS	FOUNDATION REINFORCING
	0	NONE REQUIRED	———————	DBL JOIST OR BEAM BELOW. SEE FOUNDATION PLAN
BRACED WALL PANEL	1	PAHD42 STRAP	(16) 16d OR (3) 1/2"0 M.B.	PROVIDE MIN. OF (2) 1/2"0 A. B.
ALTERNATIVE BRACED WALL PANEL	2	HPAHD22 STRAP	(19) 16d OR (3) 1/2"0 M.B.	PROVIDE (3) 1/2"0 A.B. @ 1/5 POINTS OF SILL W/ 1- #4 3" DN FROM TOP OF WALL & 1 - #4 3" UP FROM BOTTOM OF FOOTING. PROVIDE 1-#4 VERT @24" O.C. IN STEM WALL.
PORTAL FRAME	3	HTT22 STRAP & SSTB24 BOLT TO CONCRETE	(32) 16d SINKERS W/ 2" MAX OFFSET FROM POST FACE TO BOLT CENTERLINE	PROVIDE (3) 1/2"0 A.B. @ MUDSILL W/ 2-2x6 SILL W/ 2 - #4 - 3" UP FROM BOTTOM OF 15" x 7" FTG. EXTEND STEEL 10'-0" AROUND FOOTING CORNER. PROVIDE 1 #4 VERT. @EA. SSTB24 CONNECTOR

Figure 8–63 Tables are often used to specify the materials to be used to resist lateral shear. This table shows the material needed to resist lateral loads for a one-level residence. If a table is to be used, it should be near the framing plan.

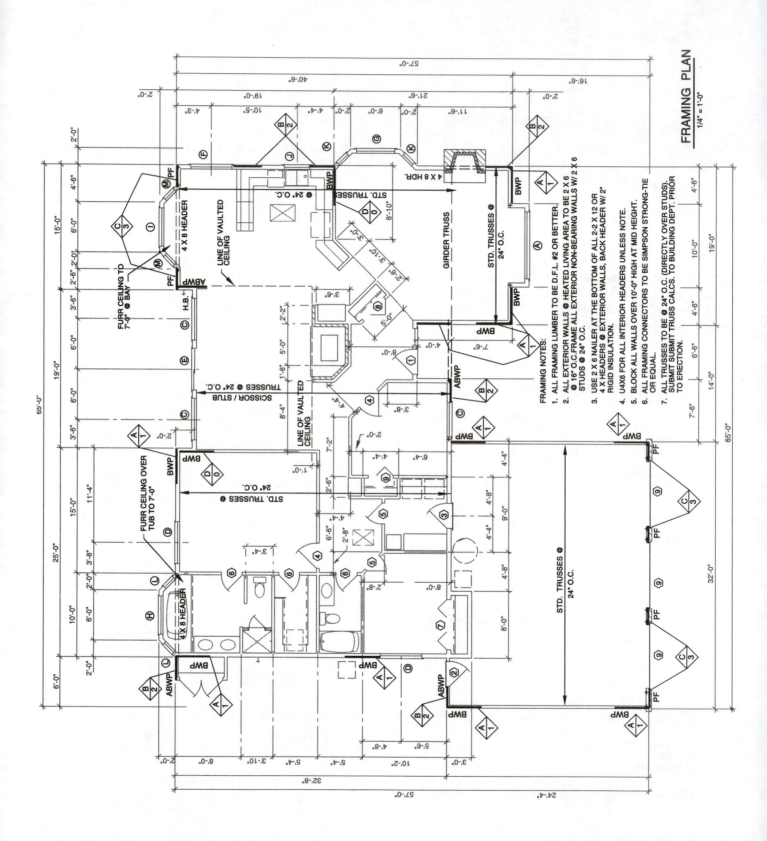

Figure 8–65 Representing the material to resist lateral loads using prescriptive design methods. The same home can be seen in Figure 8–53, where the loads were resisted by calculaing the actual load on the structure.

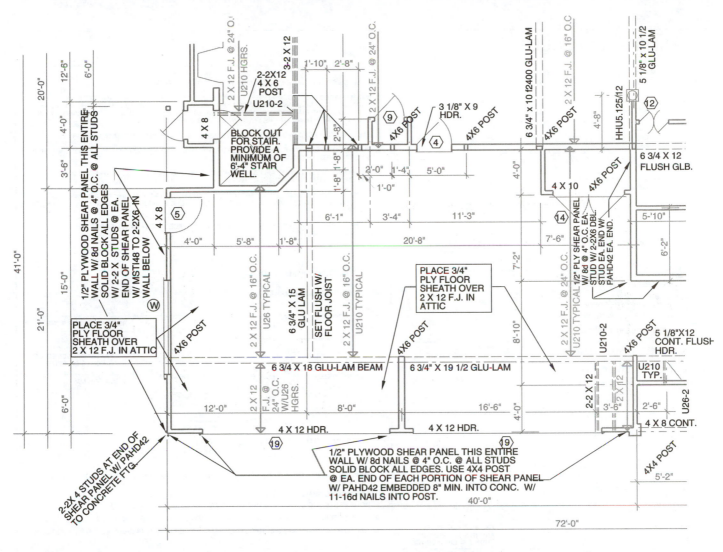

Figure 8–66 The location of beams and posts are usually dimensioned on the framing plan. *Courtesy Aaron Jefferis.*

FRAMING NOTES:

NOTES SHALL APPLY TO ALL LEVELS. FRAMING STANDARDS ARE ACCORDING TO 2000 I.B.C.

1. ALL FRAMING LUMBER TO BE D.F.L. #2 MIN. ALL GLU-LAM BEAMS TO BE fb2400, V-4, DF/DF.

2. FRAME ALL EXTERIOR WALLS W/ 2 x 6 STUDS @ 16" O.C. FRAME ALL EXTERIOR NON-BEARING WALLS W/ 2 x 6 STUDS @ 24" O.C. USE 2 x 4 STUDS @ 16" O.C. FOR EXTERIOR UNHEATED WALLS AND FOR ALL INTERIOR WALLS UNLESS NOTED. ALL INT. HDRS TO BE 4 x 6 DFL#2 UNLESS NOTED.

3. ALL EXTERIOR HDRS. TO BE (2) 2x12 UNLESS NOTED. USE 2 x 6 NAILER AT THE BOTTOM OF ALL 2-2X12 OR 4 X HDR. @ EXTERIOR WALLS. BACK HDR .W/ 2" RIGID INSULATION.

4. PLYWOOD ROOF SHTG. TO BE 1/2" STD. GRADE 32/16 PLY. LAID PERP. TO RAFT. NAIL W/ 8 d'S @ 6" O.C. @ EDGES & 12" O.C. AT FIELD.

5. ALL SHEAR PANELS TO BE 1/2" PLY NAILED W/ 8 d'S @ 4" O.C. @ EDGE AND BLK. & 8 d'S @ 8" O.C. @ FIELD.

6. LET-IN BRACES TO BE 1 x 4 DIAG. BRACES @ 45 FOR ALL INTERIOR LOAD-BEARING WALLS. (CROSS 3 STUDS MIN).

7. BLOCK ALL WALLS OVER 10'-0" HIGH AT MID HEIGHT.

8. FLOOR SHTG TO BE 3/4" STD. GRADE T. & G. PLY. LAID PERP. TO FLR. JOIST. NAIL W/ 10 d'S @ 6" O.C. @ EDGES & BLK. & 12" O.C. @ FIELD. COVER W/ 3/8" HARDBOARD.

9. NOTCHES IN THE ENDS OF JOIST SHALL NOT EXCEED 1/4 OF THE JOIST DEPTH. HOLES DRILLED IN JOIST SHALL NOT BE IN THE UPPER OR LOWER 2" OF THE JOIST. THE DIA. OF HOLES DRILLED IN JOIST SHALL NOT EXCEED 1/3 THE DEPTH OF THE JOIST.

10. PROVIDE DOUBLE JOIST UNDER AND PARALLEL TO LOAD BEARING WALLS.

11. BLOCK ALL FLOOR JOIST AT SUPPORTED ENDS AND @ 10'-0" O.C. MAX. ACROSS SPAN.

12. ALL FRAMING CONNECTORS TO BE SIMPSON CO. OR EQUAL.

Figure 8–67 General notes can be used to ensure that minimum standards established by building codes will be maintained.

NAILING SCHEDULE

TAKEN FROM 1997 UBC TABLE 23-II-B-1

CONNECTION	NAILING[1]
1 JOIST TO SILL OR GIRDER, TOE NAIL	3- 8d
2 BRIDGING TO JOIST, TOENAIL EACH END	2- 8d
3 1 X 6 SUBFLOOR OR LESS TO EACH JOIST, FACE NAIL	2-8d
4 WIDER THAN 1 X 6 SUBFLOOR TO EA. JOIST, FACE NAIL	3-8d
5 2" SUBFLOOR TO JOIST OR GIRDER, BLIND AND FACE NAIL	2-16d
6 SOLE PLATE TO JOIST OR BLOCKING TYPICAL FACE NAIL SOLE PLATE TO JOIST OR BLOCKING, @ BRACED WALL PANELS	16d @ 16" O.C. 3- 16d PER 16"
7 TOP PLATE TO STUD, END NAIL	2-16d
8 STUD TO SOLE PLATE	4- 8d , TOENAIL OR 2- 16d , END NAIL
9 DOUBLE STUDS, FACE NAIL	16d @ 24" O.C.
10 DOUBLED TOP PLATES, TYPICAL FACE NAIL DOUBLE TOP PLATES, LAP SPLICE	16d @ 16" O.C. 8- 16d
11 BLOCKING BETWEEN JOIST OR RAFTERS TO TOP PLATE, TOENAIL	3- 8d
12 RIM JOIST TO TOP PLATE, TOENAIL	8d @ 6" O.C.
13 TOP PLATES, LAPS & INTERSECTIONS, FACE NAIL	2-16d
14 CONTINUOUS HEADER, TWO PIECES	16d @ 16" O.C. ALONG EACH EDGE
15 CEILING JOIST TO PLATE, TOE NAIL	3-8d
16 CONTINUOUS HEADER TO STUD, TOE NAIL	4-8d
17 CEILING JOIST, LAPS OVER PARTITIONS, FACE NAIL	3-16d
18 CEILING JOIST TO PARALLEL RAFTERS, FACE NAIL	3-16d
19 RAFTERS TO PLATE, TOE NAIL	3-8d
20 1" BRACE TO EA. STUD & PLATE FACE NAIL	2-8d
21 1" x 8" SHEATHING OR LESS TO EA. BEARING, FACE NAIL	2-8d
22 WIDER THAN 1" x 8" SHEATHING TO EACH BEARING, FACE NAIL	3-8d
23 BUILT-UP CORNER STUDS	16d @ 24" O.C.
24 BUILT-UP GIRDER AND BEAMS	20d @ 32" O.C. @ TOP & BTM. AND STAGGERED 2-20d @ ENDS & @ EACH SPLICE
25	2-16d 2" PLANKS @ EACH BEARING
26 WOOD STRUCTURAL PANELS AND [2] PARTICLEBOARD SUBFLOOR, ROOF AND WALL SHEATHING TO FRAMING:	
19/32 - 3/4"	8d COMMON OR 6d DEFORMED SHANK
1/2" AND LESS	6d COMMON OR DEFORMED SHANK
7/8 "- 1"	8d COMMON OR DEFORMED SHANK
1 1/8"- 1 1/4"	10d COMMON OR 8d DEFORMED SHANK
COMBINATION SUBFLOOR-UNDERLAYMENT TO FRAMING:	
3/4" AND LESS	6d DEFORMED SHANK
7/8"- 1"	8d DEFORMED SHANK
1 1/8" - 1 1/4"	10d COMMON OR 8d DEFORMED SHANK
27 PANEL SIDING TO FRAMING:[2]	
1/2" OR LESS CASING NAILS.	6d CORROSION-RESISTANT SIDING OR
5/8"	8d CORROSION-RESISTANT SIDING OR
28 FIBERBOARD SHEATHING [3]	
1/2"	No. 11 GA. [4] 6d COMMON NAILS No. 16 GA. [5]
25/32"	No. 11 GA. [4] 8d COMMON NAILS No. 16 GA. [5]
29. INTERIOR PANELING:	
1/4"	4d [6]
25/32"	6d [7]

1. COMMON OR BOX NAILS MAY BE USED WHERE OTHERWISE STATED.

2. NAILS SPACED @ 6" O.C. @ EDGES, 12" O.C. @ INTERMEDIATE SUPPORTS EXCEPT 6" @ ALL SUPPORTS WHERE SPANS ARE 48" OR MORE. FOR NAILING OF WOOD STRUCTURAL PANEL AND PARTICLEBOARD DIAPHRAGMS AND SHEAR WALLS SEE SPECIFIC NOTES ON DRAWINGS. NAILS FOR WALL SHEATHING MAY BE COMMON, BOX OR CASING.

3. FASTENERS SPACED 3" O.C. @ EXTERIOR EDGES & 6" O.C. @ INTERMEDIATE SUPPORTS.

4. CORROSION -RESISTANT ROOFING NAILS W/ 7/16" DIA. HEAD & 1 1/2" LENGTH FOR 1/2" SHEATHING & 1 3/4" LENGTH FOR 25/32" SHEATHING..

5. CORROSION-RESISTANT STAPLES W/ NOMINAL 7/16" CROWN & 1 1/8" LENGTH FOR 1/2" SHEATHING & 1 1/2" LENGTH FOR 25/32" SHEATHING..

6. PANEL SUPPORTS @ 16" (20" IF STRENGTH AXIS IN THE LONG DIRECTION OF THE PANEL, UNLESS OTHERWISE MARKED). CASING OR FINISH NAILS SPACED 6" ON PANEL EDGES, 12" @ INTERMEDIATE SUPPORTS.

7. PANEL SUPPORTS @ 24". CASING OR FINISH HAILS SPACED 6" ON PANEL EDGES, 12" AT INTERMEDIATE SUPPORTS.

WOOD STRUCTURAL PANEL ROOF

SHEATHING NAILING SCHEDULE (1)

			ROOF FASTENER ZONE (2)		
			1	2	3
			FASTENING SCHEDULE (INCHES ON CENTER)		
WIND REGION	NAILS	PANEL LOCATION	X 25.4 FOR MM		
GREATER THAN 90 MPH (145 km/h)	8d COMMON	PANEL EDGES [3]	6	6	4 (4)
		PANEL FIELD	6	6	6 (4)
GREATER THAN 80 MPH (129 km/h) TO 90 MPH (145 km/h)	8d COMMON	PANEL EDGES [3]	6	6	4
		PANEL FIELD	12	6	6
80 MPH (129 km/h) OR LESS	8d COMMON	PANEL EDGES [3]	6	6	6
		PANEL FIELD	12	12	12

1. APPLIES ONLY TO MEAN ROOF HEIGHTS UP TO 35 FT (10 700 MM). FOR MEAN ROOF HEIGHTS 35 FEET (10 700 MM), THE NAILING SHALL BE DESIGNED.

2. ROOF FASTENING ZONES ARE SHOWN BELOW.

3. EDGE SPACING ALSO APPLIES OVER ROOF FRAMING AT GABLE-END WALLS.

4. USE 8d RING-SHANK NAILS IN THIS ZONE IF MEAN ROOF HEIGHT IS GREATER THAN 25' (7600mm).

Figure 8–68 The building codes provide specifications that regulate each connection specified on the framing plans. Providing a nailing schedule with the working drawings will eliminate having to specify nailing for each drawing. *Courtesy Residential Designs.*

CHAPTER 8 TEST

Fill in the blanks below with the proper word or short statement as needed to complete the sentence or answer the question correctly.

1. What framing system has studs that extend from the foundation to the ceiling of the tallest level? _____ _____ .

2. What are the disadvantages in the framing system of question 1? _____ _____ .

3. What framing system uses timbers placed at approximately 48" on center? _____ _____ .

4. What is the most common method of using brick in residential construction? _____ .

5. What is the nominal size of common concrete blocks? __ _____ .

6. What factors influence how much reinforcing will be used in a wall made of CMU? _____ _____ .

7. List three common uses for concrete blocks. _____ _____ _____ .

8. Identify the framing system that provides a level base for workers to construct walls. _____ _____ .

9. What is the main goal of energy-efficient construction? ___ _____ .

10. What are the three main components of energy-efficient construction? _____ _____ _____ .

11. What is used to keep the structure from lifting off the foundation? _____ _____ .

12. What is the purpose of the mudsill? _____ _____ .

13. What is the maximum angle and spacing at which ridge and purlin braces are set? _____ _____ .

14. List the three main structural members of a stick-framed roof. _____ .

15. What is the typical method used to increase the bearing surface of a rafter where it rests on a wall? _____ _____ .

16. The horizontal member above a window is called a _____ and the horizontal member below a window is a _____ .

17. List and describe two methods of keeping a wall from wracking. _____ _____ .

18. List the three main members of a roof truss. _____ _____ _____ .

19. A horizontal member used to decrease the span of a rafter is called a _____ .

20. List two components of a truss used at a connection. Describe what the member connects and where it is typically specified. _____ _____ .

21. List two types of walls. _____ _____ .

22. A horizontal member placed above the ceiling joist to support roof loads is called a _____ .

23. A _____ is used to support the horizontal support member below a window.

24. What is the purpose of a purlin? _____ _____ .

25. A _____ is used to support rafters at openings in a roof, such as a skylight.

26. List two types of studs that are used to support the structural member over a window. _____ _____ .

27. List and describe the three main members of a wall. _____ _____ .

28. Describe the difference between a wythe and a course of a brick or masonry wall. _____ _____ .

29. What structural member is used to support the floor joists? _____ .

30. What member is used to support floor sheathing in a post-and-beam floor? _____ _____ .

31. List eight patterns of laying brick in a wall. _____ _____ .

32. The member used to keep furry vermin out of the attic where the rafters and wall intersect is a _____ .

33. What is used to keep a floor joist from rolling over? _____ _____ .

34. What are the two actions of rafters, and what members are used to provide a reaction? _____ _____ .

35. Describe the difference between ridge blocking and a ridge board. _____ _____ .

36. A floor joist that extends past its support is a _____ joist.

37. What three members are used in the support of a girder to transfer the loads into the soil? _____ _____ .

38. A framing member that combines the role of a ceiling joist and a rafter is a _____ .

39. What is the minimum lap of top plates in a wall? _____ _____ .

40. When the exterior siding is applied directly to the studs the process is known as _____ _____ .

41. What is used to divert water from intersections of roofs to walls? _____ _____ .

42. The highest part of a roof is a _____ .

43. What keeps the purlin from sliding down the brace? _____ _____ .

44. List four common types of trusses in residential construction. _____ _____ .

45. List the required R value for the following items assuming an 80-percent efficient furnace:
 Walls _____ .
 Floor _____ .
 Flat ceiling _____ .
 Vaulted ceiling _____ .

FRAMING METHODS

46. Explain two advantages of platform framing. _____ _____ .

47. List five methods that can be used to frame a residence. _____ _____ _____ _____ _____ .

48. How is brick used in residential construction? _____ _____ .

49. Why would a post-and-beam construction roof be used with platform construction walls? _____ _____ .

50. List three qualities that make steel framing a popular residential method. _____ _____ .

51. List four classififcations of CMUs. _____ _____ .

52. Sketch two methods of framing a header with advance framing technology. Label each major component.

53. How is moisture removed from a masonry cavity wall? ___ _____ .

54. What are two materials used to reinforce concrete block construction? _____ _____ .

55. How do a girder, aheader, and a beam differ? _____ _____ .

56. List the differences between a rim joist and solid blocking at the sill. _____ _____ .

57. Define the following abbreviations.
 PSL _____ .
 OSB _____ .
 LVL _____ .
 MDF _____ .
 EXP _____ .
 HDF _____ .
 APA _____ .
 EXT _____ .
 STRUCT _____ .

58. How is a foundation post protected from the moisture in the concrete support? _____ _____ .

59. Blocking is required in walls over how many feet high? ___ _____ .

60. List four common materials suitable for residential beams and girders. _____

_____.

61. What do the numbers 4/12 mean when placed on a roof pitch symbol? _____
_____.

62. List and define four types of rafters. _____

_____.

63. Define the four parts of a truss. _____

_____.

64. What two elements are applied to wood to make an engineered wood product? _____
_____.

65. Label and define the members supporting the loads around a window. _____
_____.

66. Where shoud rafters be specified on the working drawing? _____
_____.

67. How are the alternatives for locating trusses different from the alternatives for locating rafters? _____
_____.

68. What are the options for locating ceiling joists on the construction drawings? _____
_____.

69. You're looking at the main level framing plan of a two-story residence. What framing members would you expect to find? _____

_____.

70. How is a braced wall panel attached to the foundation? ___
_____.

71. What foundation reinforcement is required for a portal frame? _____
_____.

72. What is the most common method of constructing a brcaed wall panel in your area? _____
_____.

73. What nailing is required for interior wall braces using 1/2" gypsum board? _____
_____.

74. What size, method, and spacing are required if two studs will be nailed together to form a post.? _____
_____.

75. What size nails are required to attach the edge of 1/2" plywood to trusses? _____
_____.

CHAPTER 8 PROBLEMS

PROBLEM 8–1 Use the framing plan shown in Figure 8–53 to answer the following questions:

1. What will tie the left corner of the garage to the foundation? _____.

2. What type of framing system will be used to frame the roof? _____.

3. Describe the material used to keep the front living room wall from wracking. _____
_____.

4. When does this home require wall blocking, and where was the information found? _____
_____.

5. What is specified to support the trusses that span over the nook/kitchen/living rooms, and what is it? _____
_____.

PROBLEM 8–2 Use the framing plan shown in Figure 8–55 and the floor plan in Figure 8–54 to answer the following questions:

1. Three beams are used to support the roof over the portico. List the sizes and lengths of the three beams. _____
_____.

2. Metals straps will be used to join the header over the front door to the posts on each side of the door. Describe the strap and the required fasteners. _____
_____.

3. A dashed line is shown on the floor plan of the sewing room. What does the dashed line represent? _____
_____.

4. The floor plan shows a curved stair will be built. Describe the radius to be used to construct the wall beside the stair. _____

5. What will be the underlayment for the siding material where no shear panels are required? _____
_____.

PROBLEM 8–3 Use the framing plan shown in Figure 8–60 to answer the following questions:

1. Describe the edge and field nailing for the plywood shear panels. _____
_____.

2. How will the rafters be attached to the top plates? _____
_____.

3. What size and spacing is used for the rafters? _____
_____.

4. A portion of the plan shows an area with a grid pattern in it parallel to the rear walls. What does this pattern represent?

5. What is the length of the area described in the last question?
_____ .

PROBLEM 8–4 Use the table in Figure 8–63 and the plan in Figure 8–53 to answer the following questions about the framing plan shown in Figure 8–65:

1. What will tie the front-left corner of the garage to the foundation? _____
_____ .

2. What type of framing system will be used to frame the roof? _____
_____ .

3. Desribe the material used to keep the front living room wall from wracking. _____
_____ .

4. What is specified to support the trusses that span over the nook/kitchen/living rooms, and what is it? _____
_____ .

5. Who will supply the framing anchors used on the structure?
. _____ .

6. How are braced wall panels connected to the foundation?
_____ .

7. The face of the garage is reinforced using C/3 panels. Describe how the panels are constructed. _____
_____ .

8. An alternative braced wall panel is specified. How would you assume it is constructed? _____
_____ .

9. What size header is used to form a portal frame, and how is it connected to the support post? _____
_____ .

10. Alternative braced wall panels have two 2 × 6 studs at each end of the panel. How is the plywood sheathing connected to the studs? _____
_____ .

PROBLEM 8–5 Use the notes in Figure 8–67 and Figure 8–68 to answer the following questions about the home constructed in Figure 8–53:

1. What type of lumber will be used to frame the structure?
_____ .

2. What size header will be used over the A window in the living room and how should they be connected to each other? _____
_____ .

3. How will exterior walls be constructed? _____
_____ .

4. A floor joist under the bathroom floor needs to be notched for a pipe. What is the largest notch that is allowed? _____

5. What will be used to form the floor, and how is it to be attached to the floor joist? _____
_____ .

6. What will support interior bearing walls and how should they be attached to the foundation sill? _____
_____ .

7. What code covers the construction? _____
_____ .

8. How are double top plates joined together? _____
_____ .

9. How are rafters joined to the top plate?_____
_____ .

10. How is the roof sheathing at an exposed overhang nailed to trusses when winds greater than 90 mph are expected? .

PROBLEM 8–6 Use Problems 8–6(a), (b), and (c) to answer the following questions:

1. What size header is used to support the ceiling joists in the garage ceiling? _____
_____ .

2. What size header is used over the garage doors? _____
_____ .

3. Two 2 × 10 are specified parallel to the left side of the fireplace in the family room. What do they support? _____
_____ .

4. Posts are used to support the porch roof. What will be used to connect the header to the post?_____
_____ .

5. What size floor joists are used to support the upper floor?
_____ .

6. Compare the information on the floor and framing plans. If you were the framer, which plan would you rather work with? Explain your answer. _____
_____ .

7. What will be used to frame the ceiling over bedroom #1?
_____ .

8. What size ridge beam is used in bedroom #1? _____
_____ .

9. What will be used to frame the ceiling over bed 3? _____
_____ .

10. A BWP is shown on the left side of bed 3. What will support it in the floor system? _____
_____ .

11. What size post is specified to support the ridge beam in bedroom #1? _____
_____ .

12. A BWP is shown on the left side of bedroom #1. What will support it in the floor system? _____
_____ .

13. If the nailing schedule from the last problem is used for this home, how will the rafter/ceiling joist be attached to the ridge? _____
_____ .

14. Explain the beam specification that is used to support the ceiling over the stairs. _____
_____ .

15. What size header is used at the closet door in bed 3? _____
_____ .

16. Blocking is specified for the left side of the basement. Why is it there? _____
_____ .

17. How is the basement finished in the party room? _____
_____ .

18. What size floor joists will support the living room floor?
_____ .

19. How is the rim joist attached to the basement wall? _____
_____ .

20. How is the header that supports the living/family room floor supported? _____
_____ .

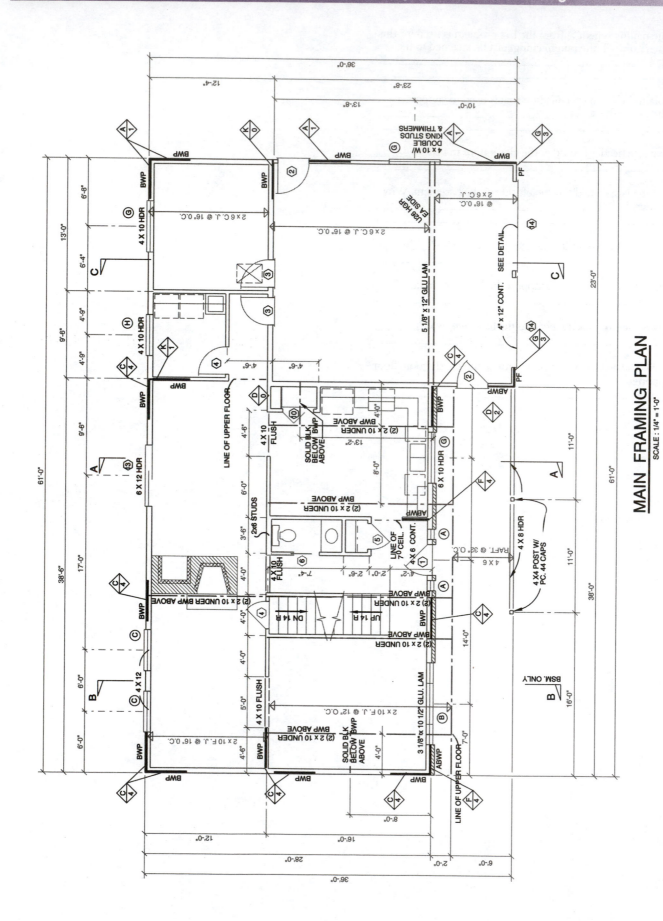

MAIN FRAMING PLAN

SCALE : 1/4" = 1'-0"

Problem 8-6(a)

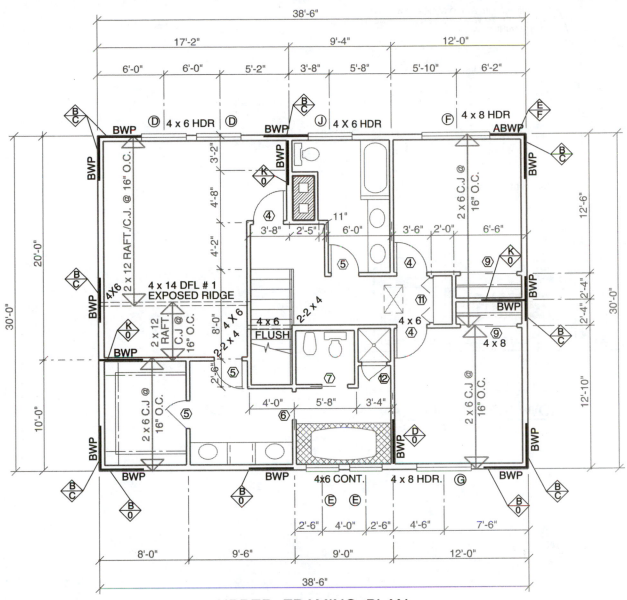

UPPER FRAMING PLAN

SCALE : 1" = 1'-0"

Problem 8–6(b)

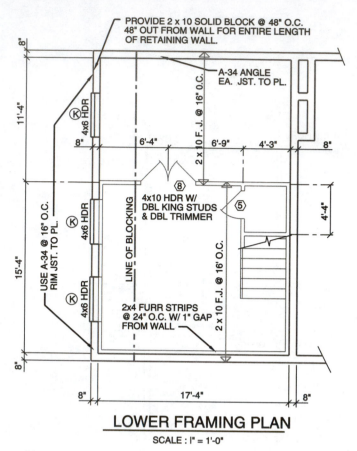

PROVIDE 2 x 10 SOLID BLOCK @ 48" O.C.
48" OUT FROM WALL FOR ENTIRE LENGTH
OF RETAINING WALL.

A-34 ANGLE
EA. JST. TO PL.

2 x 10 F. J. @ 16" O.C.

K̇ HDR

4x6 HDR

8"

6'-4"

6'-9"

4'-3"

8"

11'-4"

8"

LINE OF BLOCKING

USE A-34 @ 16" O.C.
RIM JST. TO PL.

15'-4"

K̇ HDR

4x6 HDR

⑧

4x10 HDR W/
DBL KING STUDS
& DBL TRIMMER

⑤

4'-4"

2 x 10 F.J. @ 16' O.C.

K̇ HDR

4x6 HDR

2x4 FURR STRIPS
@ 24" O.C. W/ 1" GAP
FROM WALL

8"

8"

17'-4"

8"

LOWER FRAMING PLAN

SCALE : 1" = 1'-0"

Problem 8–6(c)

Reading Roof Plans

Information concerning the framing and finishing of a roof is contained on several drawings. The floor plan, elevations, sections, and roof plans all contain some information about the roof structure. The type of roof framing method must be considered before looking for specific roofing information.

ROOF FRAMING METHODS AND DRAWINGS

In Chapter 8 you were introduced to framing methods. Floor plans, elevations, sections and roof plans each reflect the different framing method used, the finishing materials, and the shape of the roof.

FLOOR PLANS

If a separate framing plan is not provided, the ceiling joists or the trusses can be specified on the floor plan, as shown in Figure 9–1. If ceiling joists are specified on the floor plan, it indicates a stick roof is to be used. The size, spacing, and span for ceiling members can be determined from the floor plan. If a ceiling is to be vaulted, the rafters/ceiling joists can also be specified on the floor plan. Information is then determined from the sections and roof plan about the rafters, purlins, and other support members of the upper roof area.

When trusses are used to frame a roof, their location is often shown only on a floor plan. Because of the simplicity of construc-

tion, the direction, spacing, and type of truss can be specified on the floor plan, and the truss manufacturer then provides the information needed to build the trusses. The intersections for a girder truss, hip, or Dutch hip roof may also be shown on a floor plan, as shown in Figure 9–2.

ELEVATIONS

Although no structural information is usually shown, the elevations can be used to gain valuable information to help understand the shape of the roof. The elevations show the shape, angle, and finishing materials of the roof. Hips, valleys, and other roof configurations are often easily visualized by looking at the elevations rather than by looking at the roof plans. Figure 9–3 shows how roof intersections can be seen on elevations.

SECTIONS

Roof construction for a specific area can best be seen in the sections. These drawings show the framing member size and type for each major area of the roof. Sections also show the vertical relationships of each roof area and how the surfaces intersect with each other. The sections are often used for a simple roof system in place of a roof plan. By showing the size and direction of members on the floor plan and the intersections and vertical relationships on the section, a roof plan may be unnecessary.

ROOF PLANS

The roof plans provide a view looking down on the entire structure. The plan of the roof area may be either a roof plan or a roof framing plan. For some types of roofs a roof drainage plan may also be drawn.

A roof plan is used to show the shape of the roof and the size and direction of its major construction materials. Other materials, such as the roofing material, vents and their location, and the type of underlayment, are also typically specified on the roof plan and can be seen in Figure 9–4. Roof plans are typically drawn at a scale smaller than the scale used for the floor plan.

ROOF FRAMING PLANS

Roof framing plans are usually required on complicated residential roof shapes and with most commercial projects. A roof framing

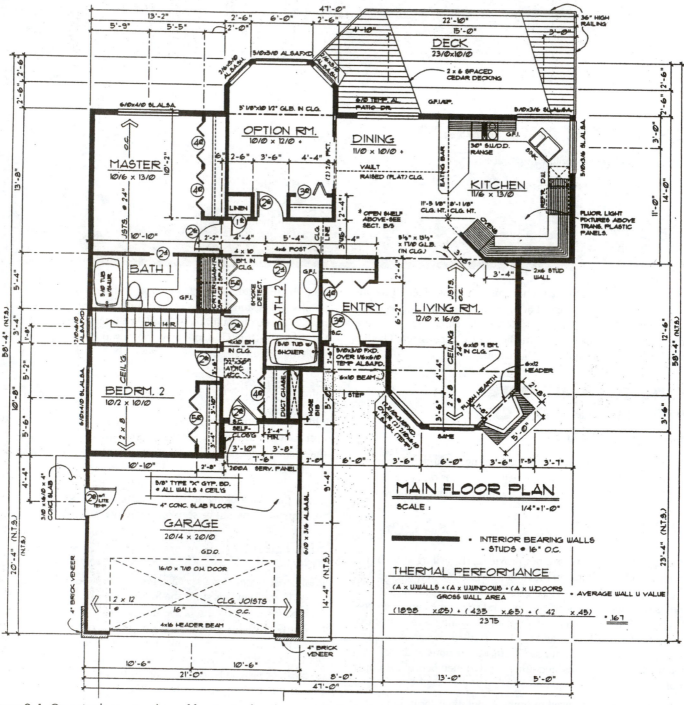

Figure 9–1 On a simple structure the roof framing is often shown on the floor plan. *Courtesy of Piercy and Barclay, Inc.*

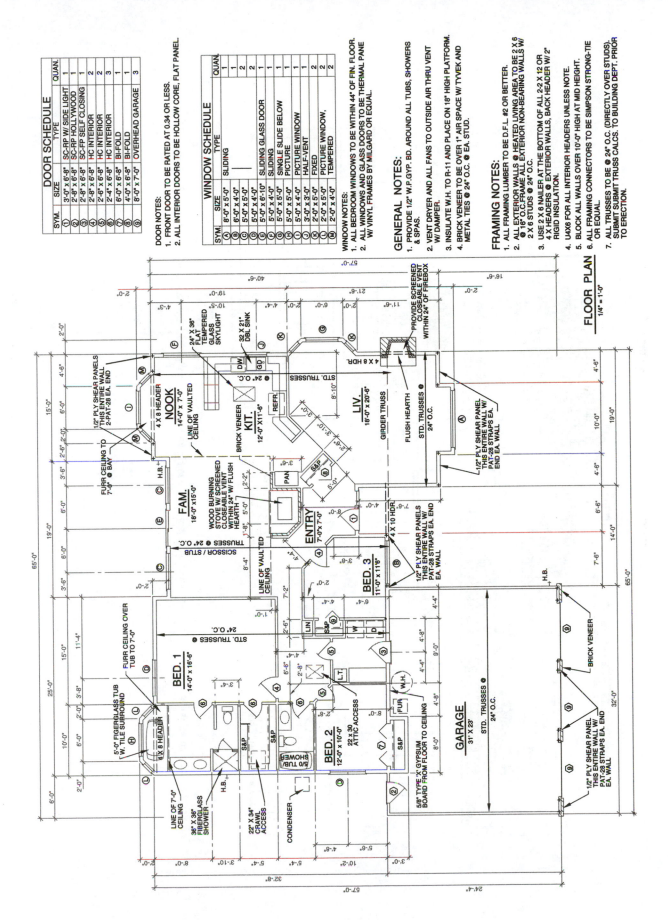

Figure 9–2 For a simple residence the structural information about a truss roof can be shown on the floor plan. *Courtesy Steve Bloedel.*

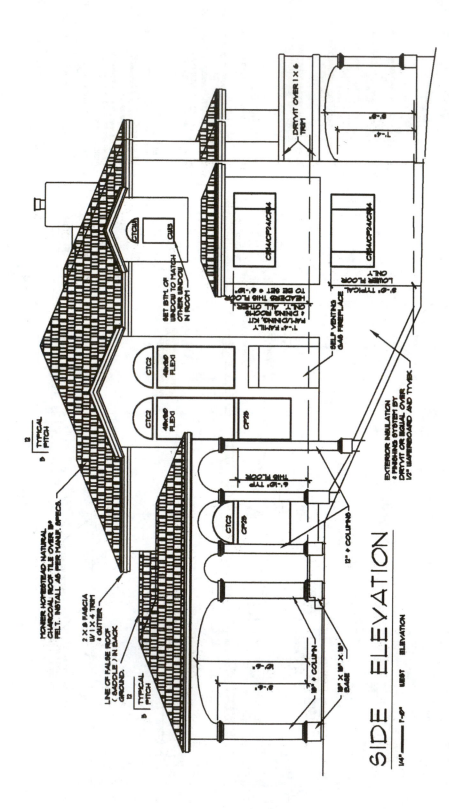

SIDE ELEVATION

1/4" ————— 1'-0" WEST ELEVATION

Figure 9–3 The elevations can be helpful in viewing the shapes shown on a roof plan. See Figure 9–4 for a roof plan of this elevation. *Courtesy of Residential Designs.*

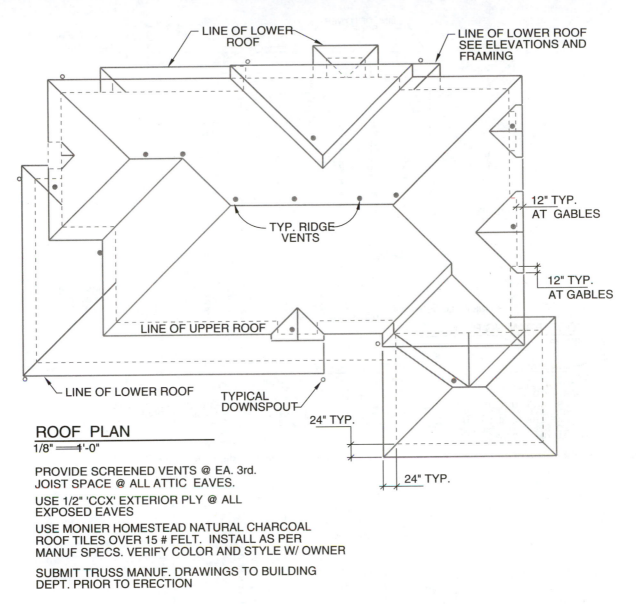

LINE OF LOWER ROOF

LINE OF LOWER ROOF SEE ELEVATIONS AND FRAMING

12" TYP. AT GABLES

TYP. RIDGE VENTS

12" TYP. AT GABLES

LINE OF UPPER ROOF

LINE OF LOWER ROOF

TYPICAL DOWNSPOUT

24" TYP.

24" TYP.

ROOF PLAN
1/8" = 1'-0"

PROVIDE SCREENED VENTS @ EA. 3rd. JOIST SPACE @ ALL ATTIC EAVES.

USE 1/2" 'CCX' EXTERIOR PLY @ ALL EXPOSED EAVES

USE MONIER HOMESTEAD NATURAL CHARCOAL ROOF TILES OVER 15 # FELT. INSTALL AS PER MANUF SPECS. VERIFY COLOR AND STYLE W/ OWNER

SUBMIT TRUSS MANUF. DRAWINGS TO BUILDING DEPT. PRIOR TO ERECTION

Figure 9–4 A roof plan is drawn to show the shape of the roof.

plan shows the size and direction of every construction member required to frame the roof. Figure 9–5 shows an example of a roof framing plan. A residential roof framing plan, similar to Figure 9–6, shows each member required to frame the roof.

ROOF DRAINAGE PLANS

A roof drainage plan is a plan showing how water will be diverted over and away from the roof system. The roof drainage plan typically shows ridges or valleys in the roof, roof drains, and downspouts. On a residence this information may be placed on the roof plan. Because of its simplicity, the plan is usually drawn at a scale much smaller than the floor plan.

ROOF PITCHES

Roof *pitch*, or *slope*, is a description of the angle of the roof that compares the horizontal run to the vertical rise. The slope is shown on the elevations and sections. The intersections that result from various roof pitches can be seen on the roof plan. On a roof plan for a structure with equal roof pitches, the intersection, or *ridge*, is formed halfway between the two walls supporting the rafters. When the roof pitches are unequal or the supporting walls are at different heights, the ridge is not in the center of the support walls. The sections and elevations are necessary to help visualize how the roof planes will be formed. The pitch can also determine the size of the rafter to be used. When a rafter is at an angle of 30° or less from vertical, the roof member can be considered a wall member rather than a rafter.

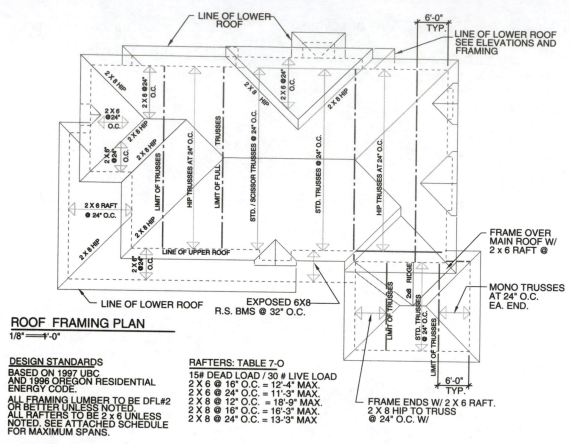

DESIGN STANDARDS
BASED ON 1997 UBC
AND 1996 OREGON RESIDENTIAL
ENERGY CODE.
ALL FRAMING LUMBER TO BE DFL#2
OR BETTER UNLESS NOTED.
ALL RAFTERS TO BE 2 x 6 UNLESS
NOTED. SEE ATTACHED SCHEDULE
FOR MAXIMUM SPANS.

RAFTERS: TABLE 7-O
15# DEAD LOAD / 30 # LIVE LOAD
2 X 6 @ 16" O.C. = 12'-4" MAX.
2 X 6 @ 24" O.C. = 11'-3" MAX.
2 X 8 @ 12" O.C. = 18'-9" MAX.
2 X 8 @ 16" O.C. = 16'-3" MAX.
2 X 8 @ 24" O.C. = 13'-3" MAX

ROOF FRAMING PLAN
1/8" = 1'-0"

Figure 9–5 A roof framing plan is used to show the framing members for the roof shown in Figure 9–4.

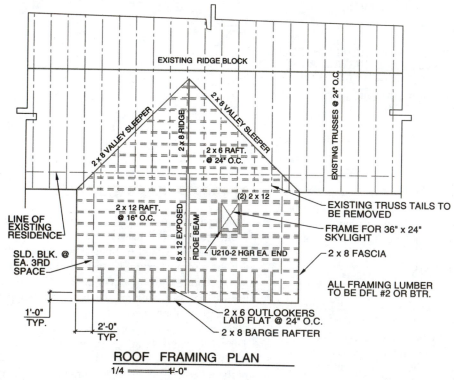

ROOF FRAMING PLAN
1/4 = 1'-0"

Figure 9–6 For complicated roofs a roof framing plan may be drawn to show the size and location of every structural member.

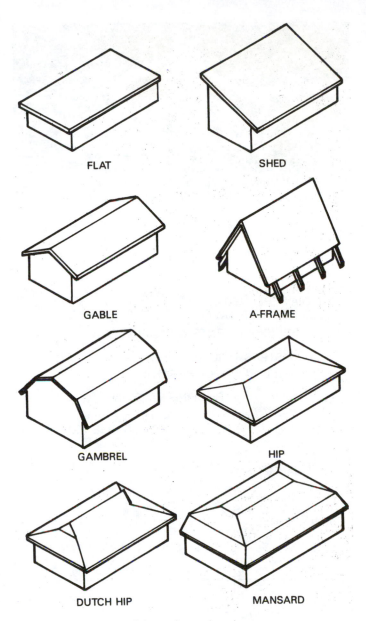

Figure 9–7 Common roof shapes for residential structures.

ROOF SHAPES

By changing the roof pitch the shape of the roof can be changed. Common roof shapes include flat, shed, gable, A frame, gambrel, hip, Dutch hip, and mansard. Each can be seen in Figure 9–7.

FLAT ROOFS

The flat roof is a very common style of roof in areas with little rain or snow. The flat roof is economical to construct because ceiling joists are eliminated and rafters are used to support both the roof and ceiling loads. Figure 9–8 shows the common materials used to frame a flat roof. Figure 9–9 shows how a flat roof can be represented on the roof plan.

Often the flat roof has a slight pitch in the rafters. A pitch of 1/8" per ft. is often used to help prevent water from ponding on the roof. As water flows to the edge, a metal diverter is usually placed at the eave to prevent dripping on walkways. A flat roof often has a *parapet*, or false wall, surrounding the perimeter of the roof. This wall can be used for decoration or for protection of mechanical equipment.

SHED ROOFS

A shed roof, as seen in Figure 9–10, offers the same simplicity and economical construction methods of a flat roof, but does not have the drainage problems associated with a flat roof. Figure 9–11 shows the construction methods for shed roofs. The shed roof may be constructed at any pitch. When seen in plan view, the shed roof resembles Figure 9–12.

GABLE ROOFS

A gable roof is one of the most common types of roof used in residential construction. Figure 9–13 shows the construction of a gable roof system. The gable can be constructed at any pitch, with the choice of pitch limited only by the roofing material. Figure 9–14 shows how a gable roof is typically represented in plan view. Many plans use two or more gables at 90° angles to each other. The intersections of gable surfaces are called valleys and are specified on the roof plan.

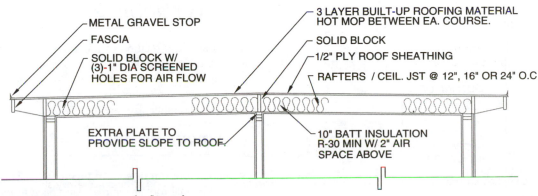

Figure 9–8 Common construction components of a flat roof.

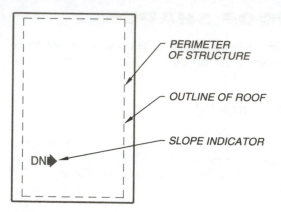

Figure 9–9 Flat roof in plan view.

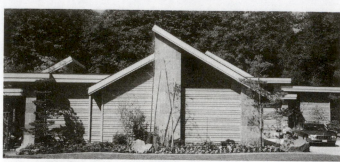

Figure 9–10 Many contemporary homes combine flat and shed roofs to create a pleasing design. *Courtesy LeRoy Cook.*

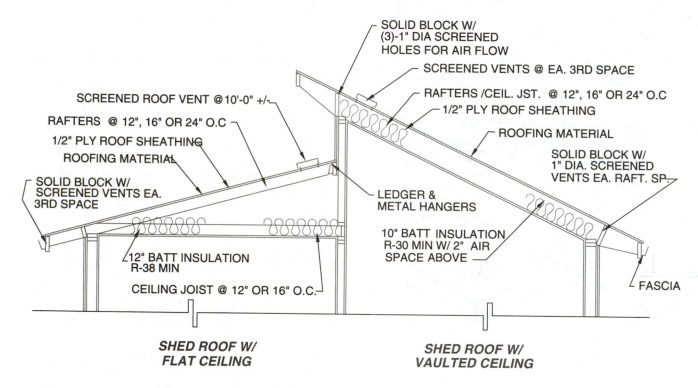

SOLID BLOCK W/
(3)-1" DIA SCREENED
HOLES FOR AIR FLOW

SCREENED VENTS @ EA. 3RD SPACE

RAFTERS /CEIL. JST. @ 12", 16" OR 24" O.C

1/2" PLY ROOF SHEATHING

ROOFING MATERIAL

SOLID BLOCK W/
1" DIA. SCREENED
VENTS EA. RAFT. SP.

SCREENED ROOF VENT @10'-0" +/-

RAFTERS @ 12", 16" OR 24" O.C

1/2" PLY ROOF SHEATHING

ROOFING MATERIAL

SOLID BLOCK W/
SCREENED VENTS EA.
3RD SPACE

LEDGER &
METAL HANGERS

10" BATT INSULATION
R-30 MIN W/ 2" AIR
SPACE ABOVE

12" BATT INSULATION
R-38 MIN

CEILING JOIST @ 12" OR 16" O.C.

FASCIA

**SHED ROOF W/
FLAT CEILING**

**SHED ROOF W/
VAULTED CEILING**

Figure 9–11 Common construction components of shed roofs.

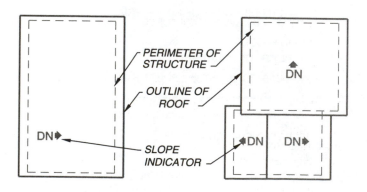

PERIMETER OF
STRUCTURE

OUTLINE OF
ROOF

SLOPE
INDICATOR

DN

DN

DN

Figure 9–12 Shed roof shapes in plan view.

A-FRAME ROOFS

An A frame is a method of framing walls as well as a system of framing roofs. An A-frame structure uses rafters to form its supporting walls, as shown in Figure 9–15. The roof plan for an A frame is very similar to the plan for a gable roof. However, the materials and rafter sizes are usually quite different.

GAMBREL ROOFS

A gambrel roof can be seen in Figure 9–16. The gambrel roof is a very traditional roof shape that dates back to the colonial period. The lower level is covered with a steep roof surface that connects

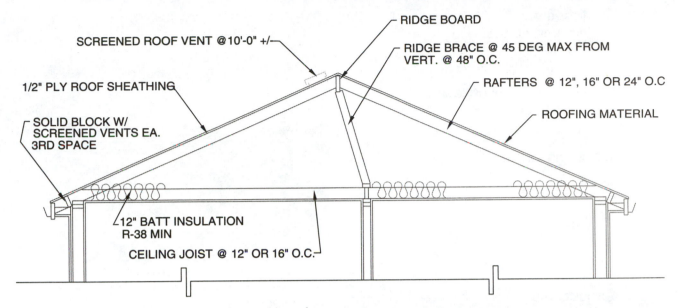

RIDGE BOARD

SCREENED ROOF VENT @10'-0" +/—

RIDGE BRACE @ 45 DEG MAX FROM VERT. @ 48" O.C.

1/2" PLY ROOF SHEATHING

RAFTERS @ 12", 16" OR 24" O.C

SOLID BLOCK W/ SCREENED VENTS EA. 3RD SPACE

ROOFING MATERIAL

12" BATT INSULATION R-38 MIN

CEILING JOIST @ 12" OR 16" O.C.

Figure 9–13 Common construction materials for a gable roof.

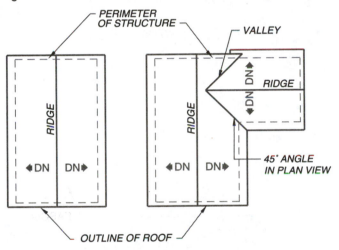

PERIMETER OF STRUCTURE

VALLEY

RIDGE

RIDGE

DN

DN

◀DN DN▶

RIDGE

◀DN DN▶

45° ANGLE IN PLAN VIEW

OUTLINE OF ROOF

Figure 9–14 Gable roof in plan view.

Figure 9–16 The gambrel roof is often used to enhance the traditional appearance of a residence. *Courtesy Michael Jefferis.*

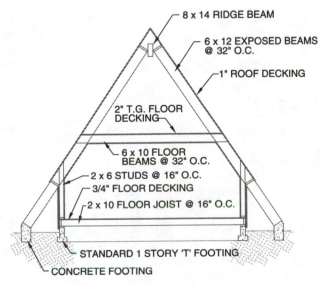

8 x 14 RIDGE BEAM

6 x 12 EXPOSED BEAMS @ 32" O.C.

1" ROOF DECKING

2" T.G. FLOOR DECKING

6 x 10 FLOOR BEAMS @ 32" O.C.

2 x 6 STUDS @ 16" O.C.

3/4" FLOOR DECKING

2 x 10 FLOOR JOIST @ 16" O.C.

STANDARD 1 STORY 'T' FOOTING

CONCRETE FOOTING

Figure 9–15 Common components of A-frame construction.

to a roof system with a slighter pitch. By covering the lower level with roofing material rather than siding, the height of the structure appears shorter than it is. This roof system can also be used to reduce the cost of siding materials because it uses less expensive roofing materials. Figure 9–17 shows common construction methods, and Figure 9–18 shows a plan view of a gambrel roof.

HIP ROOFS

The hip roof of Figure 9–19 is a traditional roof shape. A hip roof has many similarities to a gable roof, but instead of having two surfaces the hip roof has four. The intersection between each surface is called a hip. If built on a rectangular structure, the hips form two points with a ridge spanning between them. When hips are placed over an L- or T-shaped structure, an interior intersection is formed that is called a valley. The valley of a hip roof is the same as the valley for a gable roof. Hip roofs can be seen in plan view in Figure 9–20.

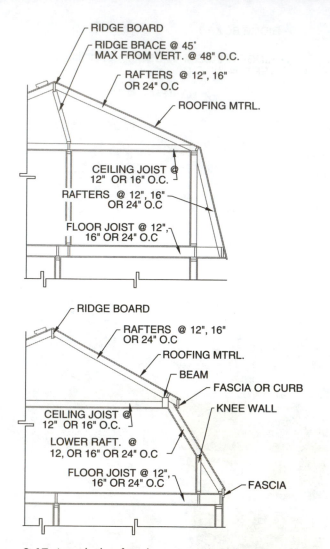

RIDGE BOARD

RIDGE BRACE @ 45°
MAX FROM VERT. @ 48" O.C.

RAFTERS @ 12", 16"
OR 24" O.C

ROOFING MTRL.

CEILING JOIST @
12" OR 16" O.C.

RAFTERS @ 12", 16"
OR 24" O.C

FLOOR JOIST @ 12",
16" OR 24" O.C

RIDGE BOARD

RAFTERS @ 12", 16"
OR 24" O.C

ROOFING MTRL.

BEAM

FASCIA OR CURB

KNEE WALL

CEILING JOIST @
12" OR 16" O.C.

LOWER RAFT. @
12, OR 16" OR 24" O.C

FLOOR JOIST @ 12",
16" OR 24" O.C

FASCIA

Figure 9–17 A gambrel roof can be constructed with or without a fascia or curb between the upper and lower roofs.

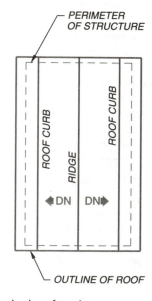

PERIMETER OF STRUCTURE

ROOF CURB

ROOF CURB

RIDGE

DN

DN

OUTLINE OF ROOF

Figure 9–18 Gambrel roof in plan view.

Figure 9–19 A hip roof is a traditional roof shape used to provide shade on all sides of a structure. *Courtesy Masonite Corporation.*

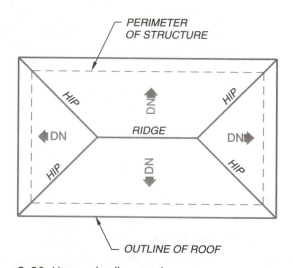

PERIMETER OF STRUCTURE

HIP

DN

HIP

DN

RIDGE

DN

HIP

DN

HIP

OUTLINE OF ROOF

Figure 9–20 Hips and valleys in plan view.

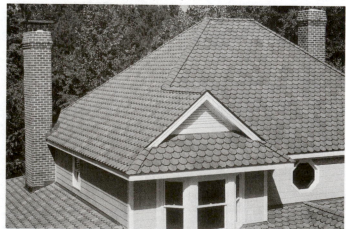

Figure 9–21 A Dutch hip is a combination of a hip and a gable roof. *Courtesy CertanTeed Roofing.*

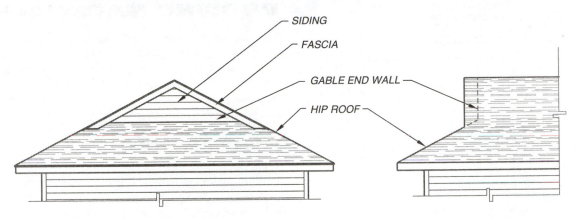

Figure 9-22 A wall is formed between the hip and gable roofs.

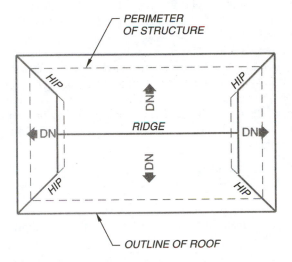

Figure 9-23 Dutch hip roof in plain view.

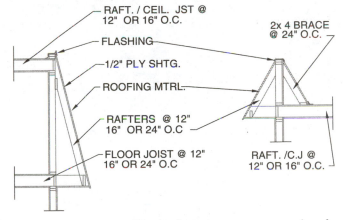

Figure 9-24 Mansard roofs are used to help disguise the height of a structure. *Courtesy Megan Jefferis.*

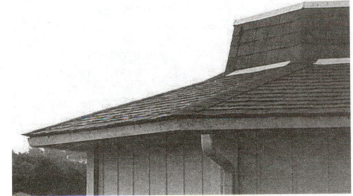

Figure 9-25 Common methods of constructing a mansard roof.

DUTCH HIP ROOFS

The Dutch hip roof is a combination of a hip and a gable roof (see Figure 9-21). The center section of the roof is framed in a method similar to that for a gable roof. The ends of the roof are framed with a partial hip that blends into the gable. A small wall is formed between the hip and the gable roofs, as seen in Figure 9-22. On the roof plan, the shape, distance, and wall location must be shown, similar to the plan in Figure 9-23.

MANSARD ROOFS

The mansard roof is similar to a gambrel roof, but has the angled lower roof on all four sides rather than just two (see Figure 9-24). The mansard roof is often used as a parapet wall to hide mechanical equipment on the roof, or it can be used to help hide the height of the upper level of a structure. Mansard roofs can be constructed in many different ways. Figure 9-25 shows two common methods of constructing a mansard roof. The roof plan for a mansard roof resembles the plans shown in Figure 9-26.

DORMERS

A dormer is an opening framed in the roof to allow window placement. Dormers are most frequently used on traditional-style roofs, such as the gable or hip. Figure 9-27 shows one of the many ways that dormers can be constructed. Dormers are usually shown on the roof plan, as seen in Figure 9-28.

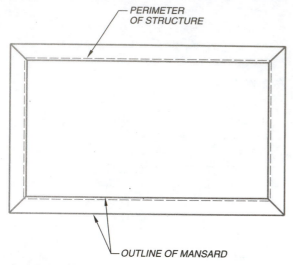

Figure 9–26 Mansard in plan view.

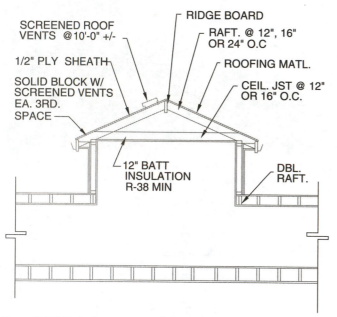

Figure 9–27 Typical components of dormer construction.

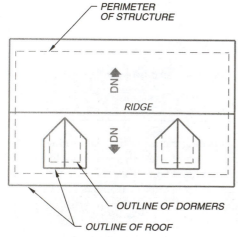

Figure 9–28 Dormers in plan view.

ROOFING MATERIALS

The material to be used on the roof depends on the pitch, exterior style, weather, and cost of the structure. Common roofing materials include built-up roofing, composition and wood shingles, clay, and cement tiles, and metal panels. When ordering or specifying these materials, the term "square" is often used. A square is used to describe an area of roofing that covers 100 sq. ft. (9.3 m²).

BUILT-UP ROOFING

Built-up roofing of felt and asphalt is used on flat or low-sloped roofs below a 3/12 pitch. When the roof has a low pitch, water will either pond or drain very slowly. To prevent water from leaking into a structure, built-up roofing is used because it has no seams. On a residence, a built-up roof may consist of three alternate layers of felt and hot asphalt placed over solid roof decking. The decking is usually plywood. In commercial uses, a four- or five-layer roof is used to provide added durability. Gravel is often used as a finishing layer to help cover the felt. On roofs with a pitch over 2/12, coarse rocks 2" or 3" (50 or 75 mm) in diameter are used for protecting the roof and for appearance. When built-up roofs are to be specified on the roof plan, the note will usually include the number of layers, the material to be used, and the size of the finishing material. A typical note would be:

■ 3 LAYER BUILT-UP ROOF WITH HOT ASPHALTIC EMULSION BTWN. LAYERS WITH 1/4" (6 mm) PEA GRAVEL.

Other roofing materials suitable for low-sloped (1/4 /12 minimum pitch) roofs and typical specifications include:

■ MODIFIED BITUMEN—MODIFIED BITUMEN SHEET ROOFING BY JOHN MANVILLE OR EQUAL OVER 2 LAYERS OF UNDERLAYMENT PER ASTM D226 TYPE I CEMENTED TOGETHER.

■ SINGLE-PLY THERMOPLASTIC—THERMOPLASTIC SINGLE-PLY ROOF SYSTEM BY SARNAFIL OR EQUAL INSTALLED PER ASTM D4434.

■ SPRAYED POLYURETHANE FOAM—SPF ROOFING BY MAINLAND INDUSTRIAL COATINGS, INC. APPLIED PER ASTM 1029.

■ LIQUID APPLIED COATING—GREENSEAL LIQUID WATERPROOFING MEMBRANE OR EQUAL INSTALLED PER MANUF. SPECS.

Each material can be applied to a roof with minimum pitch of 1/4/12. Mineral surface roll roofing can be used on roofs with a minimum pitch of 1/12.

SHINGLES

Asphalt, fiberglass, and wood are the most typical types of shingles used as roofing materials. Most building codes and manufacturers require a minimum roof pitch of 4/12 with an underlayment of one

layer of 15# felt. Asphalt and fiberglass shingles can be laid on roofs as low as 2/12 if two layers of 15# felt are laid under the shingles and if the shingles are sealed. Wood shingles must usually be installed on roofs having a pitch of at least 3/12. Asphalt and fiberglass are similar in appearance and application.

Asphalt shingles come in a variety of colors and patterns. Also known as composition shingles, they are typically made of fiberglass backing and covered with asphalt and a filler with a coating of finely crushed particles of stone. The asphalt waterproofs the shingle, and the filler provides fire protection. The standard shingle is a three-tab rectangular strip weighing 235 lbs. per square. The upper portion of the strip is coated with self-sealing adhesive and is covered by the next row of shingles. The lower portion of a three-tab shingle is divided into three flaps that are exposed to the weather

Composition shingles are also available in random width and thickness to give the appearance of cedar shakes (see Figure 9–29). These shingles weigh approximately 300 lbs. per square. Asbestos cement shingles are also available; they weigh approximately 560 lbs. per square, depending on the manufacturer and the pattern used.

Shingles are typically specified on drawings in note form listing the material, the weight, and the underlayment. The color and manufacturer may also be specified. This information is often omitted in residential construction to allow the contractor to purchase a suitable brand at the best cost. A typical callout would be:

- 235-lb. composition shingles over 15# felt.
- 300-lb. composition shingles over 15# felt.
- Architect 80 "Driftwood" class A fiberglass shingles by Genstar with 5–5/8" exposure over 15# felt underlayment with 30-year warranty.

Wood is also used for shakes and shingles. Wood shakes are thicker than shingles and are also more irregular in their texture (see Figure 9–30). Wood shakes and shingles are generally installed on roofs with a minimum pitch of 3/12 using a base layer of 15# felt. An additional layer of 15#. × 18" (450 mm) wide felt is also placed between each course or layer of shingles. Wood shakes and shingles can be installed over solid or spaced sheathing. The

weather, material availability, and labor practices affect the type of underlayment used.

Depending on the area of the country, shakes and shingles are usually made of cedar, redwood, or cypress. They are also produced in various lengths. When shakes or shingles are specified on the roof plan, the note will usually include the thickness, the material, the exposure, the underlayment, and the type of sheathing. A typical specification for wood shakes would be:

- Med. cedar shakes over 15# felt w/15# × 18" wide felt between each course. Lay with 10–1/2" exposure.

Other materials, such as Masonite and metal, are also used to simulate shakes. Metal is sometimes used for roof shingles on roofs with a 3/12 or greater pitch. Metal provides a durable, fire-resistant roofing material. Metal shingles are usually installed using the same precautions applied to asphalt shingles. Metal is typically specified on the roof plan in a note listing the manufacturer, type of shingle, and underlayment.

CLAY AND CEMENT TILES

Tile is the material most often used for homes on the high end of the price scale or where the risk of fire is extreme. Although tile may cost twice as much as the better grades of asphalt shingle, it offers a lifetime guarantee. Tile is available in a variety of colors, materials, and patterns. Clay, concrete, and metal are the most common materials (see Figures 9–31(a) and 9–31(b)).

Roof tiles are manufactured in both curved and flat shapes. Curved tiles are often called Spanish tiles and come in a variety of curved shapes and colors. Flat, or barr, tiles are also produced in many different colors and shapes. Tiles are installed on roofs having a pitch of 2–1/2/12 or greater. Tiles can be placed over either spaced or solid sheathing. If solid sheathing is used, wood strips are generally added on top of the sheathing to support the tiles. Tiles are generally specified on the roof plan in a note, which lists the manufacturer, style, color, weight, fastening method, and underlayment. A typical note on the roof plan might be:

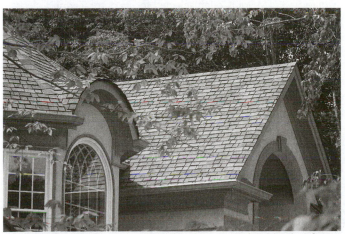

Figure 9–29 300-lb. composition shingles are made with tabs of random width and length. *Courtesy Elk Roofing.*

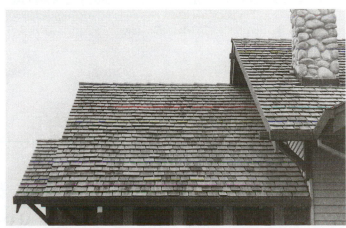

Figure 9–30 Cedar shakes are a rustic but elegant roofing material. *Courtesy Elk Roofing.*

- Monier burnt terra cotta mission's roof tile over 15# felt and 1 × 3 skip sheathing. Use a 3" minimum head lap and install as per manufacturer's specifications.

METAL PANELS

Metal roof panels provide a water- and fireproof material that comes with a warranty for a protected period that can range from 20–50 years. Panels are typically produced in either 22- or 24-gage metal in widths of either 18" or 24" (450 or 600 mm) (see Figure 9–32). The length of the panel can be specified to meet the needs of the roof in lengths up to 40' (12 000 mm), and are manufactured in many colors and patterns and can be used to blend with almost any material. Steel, stainless steel, aluminum, copper, and zinc alloys are most typically used for metal roofing.

Steel panels are heavier and more durable than other metals but must be covered with a protective coating to provide protection from rust and corrosion. A baked-on acrylic coating typically provides both color and weather protection. Stainless steel does not rust or corrode, but is more expensive than steel. Stainless steel weathers to a natural matte-gray finish. Aluminum is extremely lightweight and does not rust. Finish coatings are similar to those used for steel. Copper has been used for centuries as a roofing material. Copper roofs weather to a blue-green color and do not

rust. When metal roofing is specified on the roof plan, the note will usually include the manufacturer, the pattern, the material, the underlayment, and the trim and flashing. A typical note would be:

- Amer-X-9 ga. 36"-wide, kodiak brown metal roofing by American Building Products or equal. Install over 15# felt as per manuf. specs.

LINES AND SYMBOLS

Several different types of lines and symbols must be understood when reading roof plans. These include the lines used to represent roof supports, roof shapes, structural materials, nonstructural materials, and written specifications.

SUPPORTS

Exterior walls, interior bearing walls, purlins, beams, and outlookers are the supports for the roof structure. Each can be shown on the roof plan. Exterior walls are generally shown with bold dashed lines. Interior bearing walls are often represented using thin dashed lines similar to those used to represent the exterior walls. Purlins are often represented with thin dashed lines in a long-short-long pattern. Beams and outlookers are usually represented

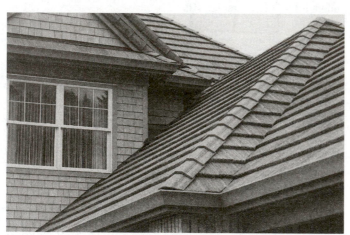

Figure 9–31(a) Tile is an excellent choice for a roofing material because of its durability. *Courtesy Tim Taylor.*

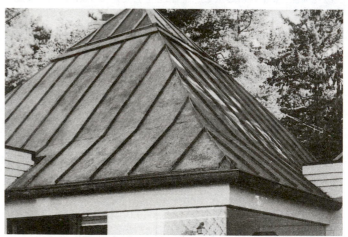

Figure 9–32 Metal is often selected for its durability and pleasing appearance. *Courtesy LeRoy Cook.*

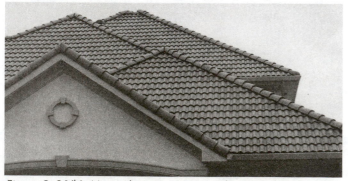

Figure 9–31(b) Many tile patterns are made to simulate Spanish clay tiles. *Courtesy Tim Taylor.*

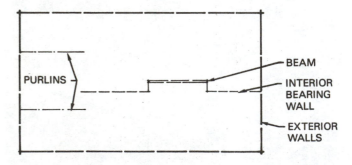

Figure 9–33 Common methods of representing roof supports in plan view.

with two thin parallel lines. Figure 9–33 shows these methods for drawing each type of roof support.

ROOF SHAPE

Changes in the shape of the roof, such as ridges, hips, Dutch hips, and valleys, are also represented with solid lines. Each can be seen in Figure 9–34.

Notice in Figure 9–34 that the shape of the roof changes dramatically as the width between the walls is changed.

STRUCTURAL MATERIALS

The type of plan you are working with determines the method used to represent structural material. If you are working with a roof plan the rafters or trusses are typically represented as seen in Figure 9–35. A thin line is typically used to represent the direction of the roof members, and a note specifies the size and spacing. If a roof framing plan is drawn, thin lines in a long-short-long pattern are often used to represent the rafters. Beams and other structural members are usually shown with thin dashed lines, as seen in Figure 9–36.

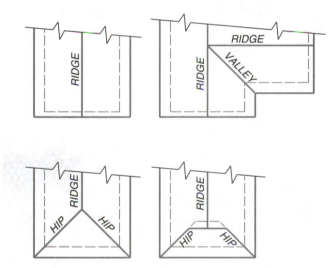

Figure 9–34 Changes in roof shape are shown with thick, solid lines.

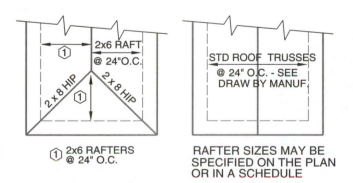

Figure 9–35 Rafters or trusses can be represented on the roof plan by a thin line showing the proper direction and span.

NONSTRUCTURAL MATERIALS

Vents, chimneys, skylights, solar panels, diverters, cant strips, slope indicators, and downspouts are the most common materials shown on the roof plan. The *saddle* is a small gable built behind the chimney to divert water away from the chimney. Common methods of representing each of the nonstructural materials can be seen in Figure 9–37. These materials are usually not shown on a roof framing plan.

ROOF VENTILATION AND ACCESS

Attic ventilation is typically specified on the roof plan, but the exact number of vents is often determined at the job site by the

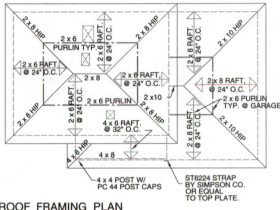

Figure 9–36 A typical method of representing members on a roof framing plan.

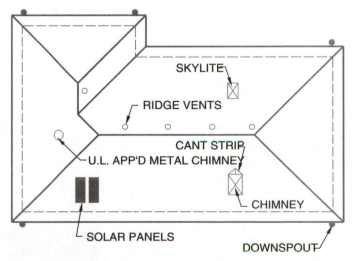

Figure 9–37 Common nonstructural members as they are often represented on a roof plan.

roofing crew. The *attic* is the space formed between the ceiling joists and the rafters. The IRC requires that the attic space be provided with vents that are covered with 1/4" screen mesh. These vents must have an area equal to 1/150 of the attic area. This area can be reduced to 1/300 of the attic area if a vapor barrier is provided on the heated side of the attic floor and half of the required vents are placed in the upper half of the roof area.

The method used to provide the required vents varies throughout the country. Vents may be placed in the gabled end walls near the ridge. This allows the roof surface to remain vent-free. In other areas, a continuous vent is placed in the eaves, or a vent may be placed in each third rafter space.

The plan must also specify how to get into the attic space. The actual opening into the attic is usually shown on the floor plan. The size of the access opening is 22 × 30 (550 × 750 mm) with 30" (750 mm) minimum headroom.

DIMENSIONS

The roof plan and framing plan typically show very few dimensions. Only the overhangs and openings are dimensioned. These can even be specified in note form rather than with dimensions.

NOTES

As with the other drawings, notes on the roof or framing plans can be divided into general and local notes. General notes might include the following:

- vent notes.
- sheathing information.
- roof covering.
- eave sheathing.
- pitch.
- rafter size and spacing if uniform.

Material often specified in local notes includes the following:

- skylight type, size, and material.
- metal anchors.
- chimney caps.
- solar panel type and size.
- framing materials.
- cant strips.
- metal diverters.

CHAPTER 9 TEST

Fill in the blanks below with the proper word or short statement as needed to complete the sentence or answer the question correctly.

1. What are two uses for a mansard roof? _____ .

2. What roof shape has four equal planes? _____ .

3. What roof shape combines hip and gable roof features? _____ .

4. What is an interior corner formed by two intersecting roofs called? _____ .

5. The area constructed to frame a window into an attic area is called a _____ .

6. What is an exterior corner formed by two intersecting roofs called? _____ .

7. List five areas where information about a roof can be found. _____ .

8. The horizontal member of the roof system used to resist the outward thrust of the rafters is a _____ _____ .

9. What is the minimum pitch that should be used with a flat roof? _____ .

10. On what drawing would you expect to see all rafters shown? _____ .

11. What information would you expect to find on a roof plan? _____ .

12. What roof shape uses the roof to form the exterior walls? _____ .

13. What member is used with flat roofs to connect the rafters to a wall that extends above the wall? _____ _____ .

14. When shed roofs are used, what keeps water from running down the wall at the wall/roof intersection?_____ _____ .

15. How would you expect the roof shape to be represented on a roof plan? _____ .

16. List five different materials that are suitable for very low-sloped roofs. _____ _____ .

17. What underlayment is most often used with composition shingles? _____ .

18. A cedar shake roof is to be applied to a roof. What is generally placed between each course of shingles? _____ _____ .

19. Name a traditional-style roof that dates back to colonial times. _____ .

20. What is the most durable type of metal roof panels? _____ .

CHAPTER 9 PROBLEMS

PROBLEM 9–1 Use the drawing shown on page 244 to answer the following questions:

1. Identify the type of drawings that accompany this quiz.

 a. _____ .
 b. _____ .

2. Two different framing systems are provided with this plan. What are they?

 a. _____ .
 b. _____ .

3. What size roof vents will be used? _____ .

4. What will prevent water from building up behind the chimney? _____ .

5. What size ridges will be used? _____ .

6. Other than the ridges, what members are listed to provide support for the rafters? _____ .

7. What is the size of the overhang at the gable end walls? _____ .

8. What size and type of skylight will be used? _____ _____ .

9. What type and spacing of trusses will be used? _____ _____ .

10. Who will supply the metal straps? _____ _____ .

11. What size rafter supports are used over the garage? _____ _____ .

12. A 4 × 14 ridge must be ordered. Approximately how long should it be? _____ .

13. How many lineal feet of 4 × 8 should be ordered to support the front porch roof? _____ .

14. What will be the finished roofing material? _____ .

15. How many lineal feet of 2 × 10 will be required to frame the garage ridge? _____ .

PROBLEM 9–2 Use the drawings shown on page 245 to answer the following questions:

1. What roof shape will be used for this residence? _____ _____ .

2. How many roof downspouts will be required? _____ _____ .

3. What will the finish roofing material be? _____ _____ .

4. List the required overhang sizes. Which is the most typical? _____ .

5. What size rafters will be used? _____ .

6. How many skylights must be purchased? _____ .

7. At what scale were these drawings originally drawn? _____ _____ .

8. What size members will be used to frame the skylights? _____ .

9. What type and grade of rafters will be used? _____ .

10. What size will the ridge boards be? _____ .

PROBLEM 9–3 Use the drawings shown on page 246 and 247 to answer the following questions:

1. What size rafters will be used over the living room? _____ _____ .

2. What will support the ceiling joist between the family room and the kitchen? _____ .

3. What size fascias will be used? _____ .

4. What spacing of ceiling joists will be used in the kitchen? _____ .

5. All hips will be _____ .

6. How many rafters will be required to frame the garage? _____ .

7. How many ridge vents will need to be ordered? _____ _____ .

8. List two sources to find the roofing material. _____ _____ .

9. How many downspouts will be required? _____ _____ .

10. What length of ceiling joist will be used over the garage? _____ .

PROBLEM 9–4 Use the plan in Figures 9–3, 9–4, and 9–5 to answer the following questions:

1. What code governs this project? _____ .

2. What type of lumber will be used for this project? _____ _____ .

3. What is the dead load that was used to design the roof? _____ .

4. What is the assumed maximum span for 2 × 6 rafters at 24" o.c.? _____ .

5. How many different types of trusses will the project require? _____ .

6. What type of roof sheathing will be used? _____ .

7. What will the finished roofing material be? _____ .

8. What style of roof will be used on this project? _____ .

9. What pitch will be used to frame this roof? _____ .

10. What size fascia will be used? _____ .

11. At what point must the truss drawings be provided to the building department? _____ .

12. How many gables does this roof contain? _____ .

13. What size hips are to be used? _____ .

14. What company will supply the finished roofing materials? _____ .

15. The right side of the lower roof contains a courtyard with exposed rafters. What size are the rafters? _____ .

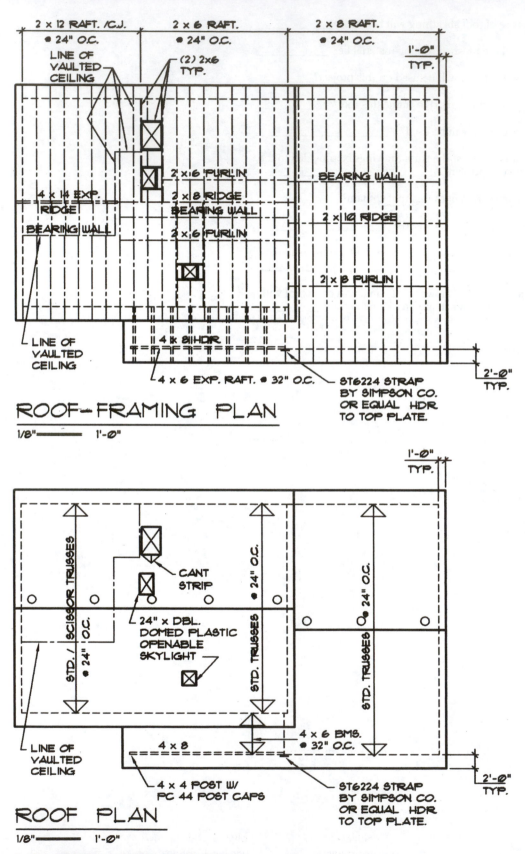

2 x 12 RAFT. /C.J.
● 24" O.C.
LINE OF
VAULTED
CEILING

2 x 6 RAFT.
● 24" O.C.
(2) 2x6
TYP.

2 x 8 RAFT.
● 24" O.C.
1'-Ø"
TYP.

2 x 6 PURLIN

BEARING WALL

4 x 14 EXP.
RIDGE

2 x 8 RIDGE
BEARING WALL

2 x 1Ø RIDGE

BEARING WALL

2 x 6 PURLIN

2 x 8 PURLIN

LINE OF
VAULTED
CEILING

4 x 8 HDR

4 x 6 EXP. RAFT. ● 32" O.C.

ST6224 STRAP
BY SIMPSON CO.
OR EQUAL HDR
TO TOP PLATE.

2'-Ø"
TYP.

ROOF-FRAMING PLAN

1/8" ▬▬▬ 1'-Ø"

1'-Ø"
TYP.

STD. / SCISSOR TRUSSES
● 24" O.C.

● 24" O.C.

STD. TRUSSES
● 24" O.C.

STD. TRUSSES

CANT
STRIP

24" x DBL.
DOMED PLASTIC
OPENABLE
SKYLIGHT

LINE OF
VAULTED
CEILING

4 x 8

4 x 6 BMS.
● 32" O.C.

4 x 4 POST W/
PC 44 POST CAPS

ST6224 STRAP
BY SIMPSON CO.
OR EQUAL HDR
TO TOP PLATE.

2'-Ø"
TYP.

ROOF PLAN

1/8" ▬▬▬ 1'-Ø"

1. ALL FRAMING LUMBER TO BE D.F.L. ● 2
2. ALL EXPOSED EAVES TO BE COVERED W/ 1/2" 'CCX' EXT. PLY.
3. ROOF SHEATHING TO BE 1/2" STD. GRADE 32/16 PLYL LAID PERP. TO TRUSSES ●
 NAILED W/ 8d 'S ● 6" ●EDGE AND 8d'S ● 12" O.C. ● FIELD.
4. SUBMIT TRUSS DRAWINGS TO BUILDING DEPT. PRIOR TO ERECTION.

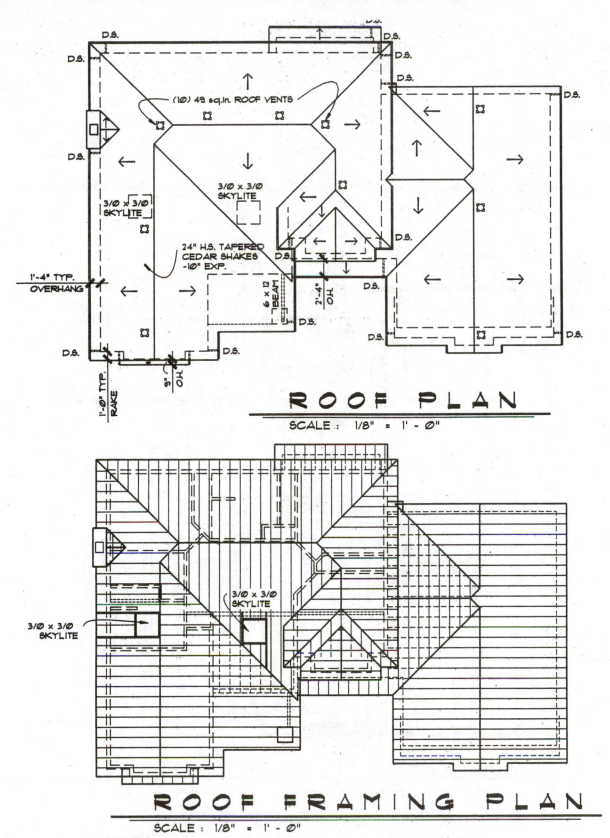

(10) 49 sq.in. ROOF VENTS

D.S.

3/0 x 3/0 SKYLITE

3/0 x 3/0 SKYLITE

24" H.S. TAPERED CEDAR SHAKES -10" EXP.

6 x 12 BEAM

2'-4" O.H.

1'-4" TYP. OVERHANG

1'-0" TYP. RAKE

9" O.H.

R O O F P L A N
SCALE : 1/8" = 1' - 0"

3/0 x 3/0 SKYLITE

3/0 x 3/0 SKYLITE

R O O F F R A M I N G P L A N
SCALE : 1/8" = 1' - 0"

NOTES :
1. ALL RAFTERS TO BE 2 x 8 #2 & BTR DF/L @ 24" O.C.
2. ALL HIP AND RIDGE BOARDS TO BE 2 x 10 #2 DF/L.
3. DOUBLE FRAMING AT ALL ROOF PENETRATIONS.

Problem 9-2

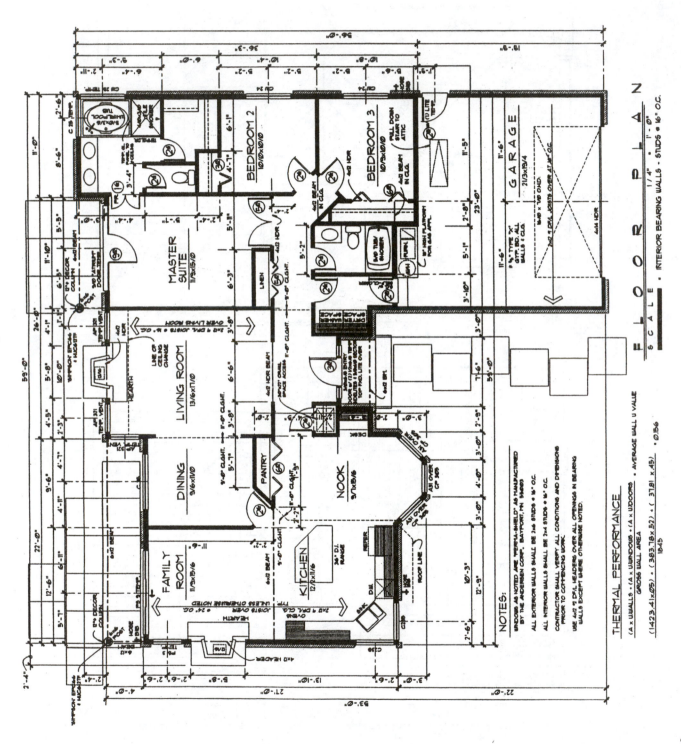

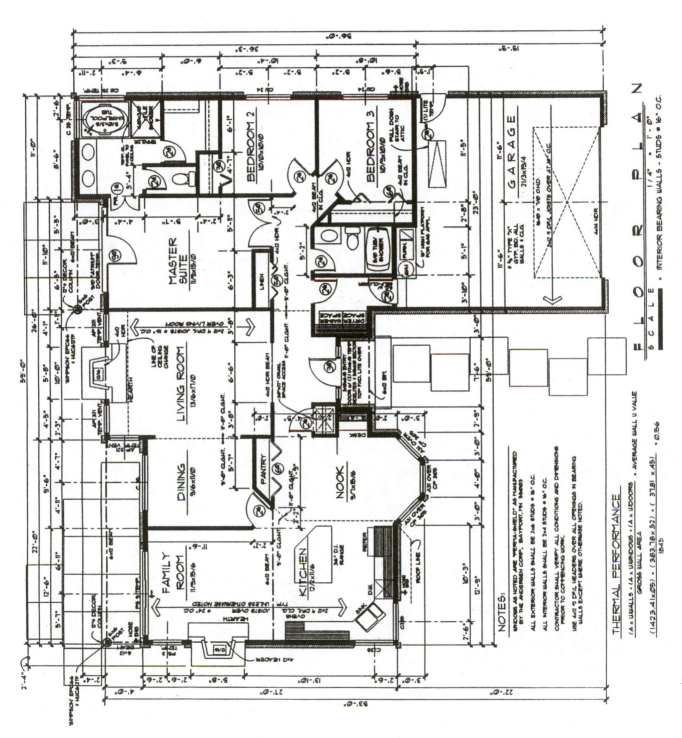

CHAPTER 10

Foundation and Floor Systems

CHAPTER OVERVIEW

This chapter covers the following topics:

- Foundation systems
- Soil considerations
- Types of foundations
- Dimensioning foundation components
- Floor systems

- Crawl space floor systems
- Reading a foundation plan
- Test
- Problems

FOUNDATION SYSTEMS

The foundation provides a base to distribute the weight of the structure onto the soil. The weight, or loads, must be evenly distributed over enough soil to prevent the load from compressing it.

In addition to resisting the loads from gravity, the foundation must resist floods, winds, and earthquakes. Where flooding is a problem, the foundation system must be constructed for the possibility that much of the supporting soil may be washed away. The foundation must also be able to resist any debris that may be carried by flood waters.

The forces of wind on a structure can cause severe problems for a foundation. If the structure is not properly anchored to the foundation, the walls can be ripped away by wind, which tries to push a structure not only sideways but upward as well. Because the structure is securely bonded together at each intersection, wind pressure builds under the roof overhangs and inside the structure and causes an upward tendency. Proper foundation construction resists this upward movement.

Depending on the risk of seismic damage, special design considerations may be required of a foundation. Although earthquakes cause both vertical and horizontal movement, it is the horizontal movement that causes the most damage to structures. The foundation system must be built so that it can move with the ground yet keep its basic shape. Steel reinforcing and welded wire mesh are often required to help resist or minimize damage from the movement of the earth.

SOIL CONSIDERATIONS

The nature of the soil supporting the foundation must be considered when reading a foundation plan. A concrete support may at first appear to be oversized until the nature of the soil is taken into account. The texture of the soil and the tendency of the soil to freeze influence the construction of the foundation system.

SOIL TEXTURE

The texture of the soil will affect its ability to resist the load of the foundation. The bearing capacity of the soil determines the amount of weight a square foot of soil can support. The bearing capacity of soil depends on its composition and the moisture content. The International Residential Code (IRC) provides five basic classifications for soil:

Crystalline bedrock	12,000 psf (574.8 kPa)
Sedimentary and foliated rock	4,000 psf (191.6 kPa)
Sandy gravel and/or gravel	3,000 psf (143.7 kPa)
Sand, silty sand, clayey sand, silty gravel, and clayey gravel	2,000 psf (95.8 kPa)
Clay, sandy clay, silty clay clayey silt, silt, sandy silt	1,500 psf (47.9 kPa)

The allowable bearing capacity will need to be determined by a soils engineer if the building department believes soil with an allowable bearing of less than 1,500 psf is likely to be present. A soil bearing pressure of 2,000 psf is the design value used for most residential construction when the site conditions are not known.

In residential construction, the type of soil can often be determined from the local building department. In commercial construction, a soils engineer is usually required to study the various types of soil at the job site and make recommendations for foundation design. The soil bearing values are often listed on the foundation plan so the contractor can better understand the size of the material. In addition to the texture, the tendency of freezing must also be considered.

The five common classifications are used to define natural, undisturbed soil; construction sites, however, often include soil that has been brought to the site or moved on the site. Soil that is placed over the natural grade is called fill material. Fill material is often moved to a site when an access road is placed in a sloping site, as in Figure 10–1. After a few years, vegetation covers the soil and gives it the appearance of natural grade. Footings resting on fill material will eventually settle under the weight of a structure. All discussion of foundation depths in this text refers to the footing depth into the natural grade.

COMPACTION

Fill material can be compacted to increase its bearing capacity. Compaction is typically accomplished by vibrating, tamping, rolling, or adding a temporary weight. Proper compaction lessens the effect of settling and increases the stability of the soil, which increases the load-bearing capacity. The effects of frost damage are minimized in compacted soil because penetration of water into voids in the soil is minimized. Moisture content is the most important factor in efficient soil compaction because moisture acts as a lubricant to help soil particles move closer together.

FREEZING

Don't confuse ground freezing with blizzards. Even in the warmer southern states, ground freezing can be a problem. A foundation must be built to a depth where the ground is not subject to freezing. Water in the soil expands as it freezes and then contracts as it thaws. Expansion and shrinking of the soil will cause heaving in the foundation. As the soil expands, the foundation can crack. As the soil thaws, water that cannot be absorbed by the soil can cause the soil to lose much of its bearing capacity, causing further cracking of the foundation. In addition to geographic location, the type of soil also affects freezing. Fine-grained soil is more susceptible to freezing because it tends to hold moisture. A foundation must rest on stable soil so that the foundation does not crack.

Figure 10–1 As access roads are created, soil is often cut away and pushed to the side of the roadway, creating areas of fill. Unless the foundation extends into the natural grade, the structure will settle.

WATER CONTENT

The amount of water the foundation will be exposed to, as well as the permeability of the soil, must also be considered in placing the foundation. As the soil absorbs water, it expands, causing the foundation to heave. In areas of the country with extended periods of rainfall, there is little variation in the soil moisture content; this minimizes the risk of heaving caused by soil expansion. Greater danger results from shrinkage during periods of decreased rainfall. In areas of the country that receive only minimal rainfall, followed by extended periods without moisture, soil shrinkage can cause severe foundation problems because of the greater moisture differential.

Concrete slab on grade is used primarily in dry areas from southern California to Texas, where the contrast between the dry soil under the slab and the damp soil beside the foundation creates a risk of heaving at the edge of the slab. If the soil beneath the slab experiences a change of moisture content after the slab is poured, the center of the slab can heave. Heaving can be resisted by proper drainage and reinforcing placed in the foundation and throughout the floor slab.

Surface water and groundwater must be properly diverted from the foundation so that the soil can support the building load. Proper drainage also minimizes water leaks into the crawl space or basement, reducing mildew and rotting. Most codes require the finish grade to slope away from the foundation at a minimum slope of 6" (150 mm) within the first 10' (3050 mm). A 3-percent minimum slope is preferable for planted or grassy areas; a 1-percent slope is acceptable for paved areas.

Gravel or coarse-grained soils can be placed beside the foundation to increase percolation. In damp climates, a drain is often required beside the foundation at the base of a gravel bed to facilitate drainage. As the amount of water in the soil surrounding the foundation is reduced, the lateral loads imposed on the foundation are also reduced. The pressure of the soil becomes increasingly important as the height of the foundation wall is increased. Foundation walls enclosing basements should be waterproofed. Asphaltic emulsion is often used to prevent water from penetration into the basement. Floor slabs below grade are required to be placed over a vapor barrier.

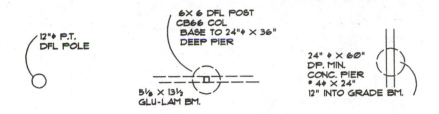

FOUNDATION PLAN REPRESENTATION

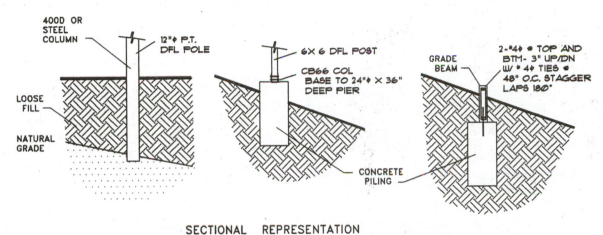

SECTIONAL REPRESENTATION

Figure 10–2 Common types of pilings used to transfer loads onto firm soil.

TYPES OF FOUNDATIONS

The foundation is usually constructed of pilings, continuous footings, or grade beams.

PILINGS

Piling foundations are used when conventional trenching equipment cannot be used safely or economically. A *piling* is a type of foundation system that uses a column to support the loads of the structure. Three common piling systems are shown in Figure 10–2. In each system beams are placed below each bearing wall and are supported on a steel column or wood post that is in turn supported by a concrete piling. The piling is usually round and may extend several feet below the ground. In some areas a pressure-treated wooden pole or steel column may be driven into the ground until it rests on solid soil, and this is also called a piling. This type of foundation system is typically used for hillside or beach residential construction where erosion might be a problem, similar to the system shown in Figure 10–3.

CONTINUOUS OR SPREAD FOUNDATIONS

A common type of foundation used in residential and light commercial construction is a continuous or spread foundation. This

Figure 10–3 A piling foundation is often used when a job site is too steep for traditional foundation methods. *Courtesy Megan Jefferis.*

type of foundation consists of a footing and wall. The footing is the base of the foundation system and is used to displace the building loads over the soil. Figure 10–4 shows footings and how they are usually presented on foundation plans. Footings are made of poured concrete and placed so that they extend below the freezing level. Figure 10–5 shows common footing sizes and depths

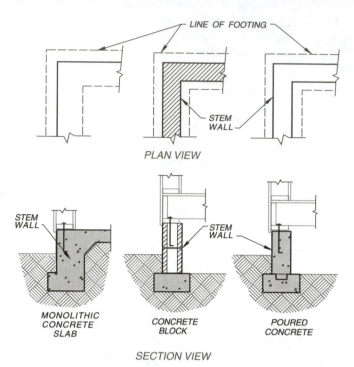

Figure 10–4 A footing used to spread building loads evenly into the soil is represented on the foundation plan by hidden lines.

required by the IRC. The strength of the concrete must also be specified; this is based on the location of the concrete in the structure and its chance of freezing. Figure 10–6 lists typical values.

For areas of soft soil or fill material, reinforcement steel is placed in the footing. Concrete is extremely durable when it supports a load and is compressed but very weak under tension.

If the footing is resting on fill material, the bottom of the concrete footing will bend. As the footing bends, the concrete will be under tension. Steel is placed near the bottom of the footing to resist the forces of tension in concrete. This reinforcing steel, or rebar, is not shown on the foundation plan but is specified in a note giving the size, quantity, and spacing of the steel. The size of rebar is represented by a number indicating the approximate diameter of the bar in eighths of an inch. A 1/4"-diameter rebar is 2/8" or a #2 diameter; a 1/2"-diameter bar is a #4. IRC allows only rebar that is a #4 diameter or larger to be considered as reinforcing, with the use of smaller steel considered as nonreinforced concrete. See Chapter 8 for a listing of steel sizes and numbers and their metric equivalents.

Steel rebar for foundations may be smooth, but most uses of steel require deformations to help the concrete bind to the steel. The strength of the steel used for foundation rebar can vary. Common grades associated with residential construction are grades 40, 50, 60, and 75. Figure 10–7 shows the forms set for a reinforced footing.

The material used to construct the foundation wall and the area in which the building is to be located will affect how the wall and footing are tied together. If the wall and footing are made at different times, a #4 bar must be placed at the top of the stem wall and a #4 bar must be placed near the bottom of the footing. A concrete slab resting on a footing must have a #4 bar at the top and bottom of the footing. The foundation wall and footing can also be

strengthened by placing a keyway in the footing. The keyway is formed by placing a 2 × 4 (50 × 100 mm) in the top of the concrete footing while the concrete is still wet. Once the concrete has set, the 2 × 4 (50 × 100 mm) is removed, leaving a keyway in the concrete. When the concrete for the wall is poured, it will form a key by filling in the keyway. If a stronger bond is desired, steel is often used to tie the footing to the foundation wall. Both methods of attaching the foundation wall to the footing can be seen in Figure 10–8. Footing steel is not drawn on the foundation plan but is specified in a note giving the size, grade, overlap, and the quantity. Details are usually provided to aid in the placement of the steel similar to Figure 10–9. In residential construction the designer depends on the knowledge of the concrete crew for placement of hooks and bends according to Concrete Reinforcing Steel Institute standards.

GRADE BEAMS

To provide added support for a foundation in unstable soil, a grade beam can be used in place of the foundation, as shown in Figure 10–2. The grade beam is similar to a wood beam that supports loads over a window. The grade beam is placed under the soil below the stem wall and spans between stable supports. The support can be stable soil or pilings. The depth and reinforcing required for a grade beam are determined by the load to be supported and are sized by an architect or engineer. A grade beam resembles a footing when drawn on a foundation plan. Steel reinforcing will be specified by notes and referenced to details rather than on the foundation plan.

FIREPLACE FOOTINGS

A masonry fireplace needs to be supported on a footing. The IRC requires the footing to be a minimum of 12" (300 mm) deep. The footing is required to extend 6" (150 mm) past the face of the fireplace on each side. Figure 10–10 shows how fireplace footings are represented on the foundation plan.

VENEER FOOTINGS

If masonry veneer is used, the footing must be wide enough to provide adequate support for the veneer. Depending on the type of veneer material to be used, the footing is typically widened by 4"–6" (100–150 mm). Figure 10–11 shows common methods of providing footing support for veneer.

FOUNDATION WALL

The foundation wall is the vertical wall that extends from the top of the footing to the first floor level of the structure, as shown in Figure 10–12. The foundation wall is usually centered on the footing to help equally disperse the loads being supported. The height of the wall extends a minimum of 8" (200 mm) above the ground and reflects the minimum distance required between wood-framing members and grade. The required width of the wall varies depending on the soil loads, height of the wall, and the material used. A width of 6" (150 mm) is standard for plain concrete, and 8" (200 mm) for plain masonry walls. The required width of the

MINIMUM WIDTH OF CONCRETE OR MASONRY FOOTINGS (INCHES) (A)

LOAD BEARING VALUE OF SOIL (PSF)

	1,500	2,000	2,500	3,000	3,500	4,000
Conventional wood frame construction						
1-story	16	12	10	8	7	6
2-story	19	15	12	10	8	7
3-story	22	17	14	11	10	9
4" brick veneer over wood frame or 8" hollow concrete masonry						
1-story	19	15	12	10	8	7
2-story	25	19	15	13	11	10
3-story	31	23	19	16	13	12
8" solid or fully grouted masonry						
1-story	22	17	13	11	10	9
2-story	31	23	19	16	13	12
3-story	40	30	24	20	17	15

For SI: 1 inch 5 25.4 mm, 1 pound per square foot 5 47.88 Pa.

MINIMUM WIDTH OF STEM WALL (B)

Plain Concrete	Minimum Width
Walls less than 4'–6" (1372 mm)	6" (152 mm)
Walls greater than 4'–6" (1372 mm)	7.5" (191 mm)

Plain Masonry	
Solid grout or solid units	6" (152 mm)
Nongrouted units	8" (203 mm)

MINIMUM FOOTING DEPTH

Minimum Code Value	6" (152 mm)
Recommended 2-story	8" (203 mm)
Recommended 3-story	10" (254 mm)

*Values vary based on the type of soil. Verify local requirements with your building department.

MINIMUM FOOTING DEPTH INTO NATURAL GRADE (D)

Minimum Code Value	12" (305 mm)
Recommended 2-story	18" (457 mm)
Recommended 3-story	24" (610 mm)

*Values vary based on the frost depth and the type of soil. Verify local requirements with your building department.

Figure 10–5 (a) Minimum footing requirements based on the International Residential Code/2000. *Copyright © 2000, Courtesy International Code Council, Inc.*

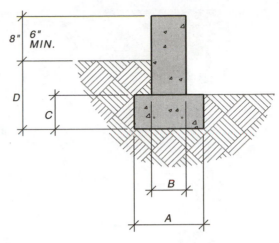

Figure 10–5 (b) *Copyright © 2000, Courtesy International Code Council, Inc.*

MINIMUM COMPREHENSIVE STRENGTH WEATHER POTENTIAL

TYPE OR LOCATION OF CONCRETE	NEGLIGIBLE	MODERATE	SEVERE
Basement walls and foundations not exposed to weather.	2500	2500	2500
Basement slabs and interior slabs on grade, except garage floor slabs	2500	2500	2500
Basement walls, foundation walls, exterior walls, and other vertical concrete work exposed to weather.	2500	3000	3000
Porches, concrete slabs and steps exposed to the weather, and garage flkoor slabs.	2500	3000	3000

Figure 10–6 Compressive strength of concrete, based on the International Residential Code. *Copyright © 2000, Courtesy International Code Council, Inc.*

wall varies depending on the wall height and the type of soil. Figure 10–5 shows common wall dimensions. Common methods of forming the footing and stem wall can be seen in Figure 10–12. Figure 10–13 shows the forms for a poured concrete stem wall.

In addition to concrete block and poured concrete foundation walls, many companies are developing alternative methods of forming the stem wall. Blocks made of expanded polystyrene foam (EPS) or other lightweight materials can be stacked into the desired position and fit together with interlocking teeth. EPS block forms can be assembled in a much shorter time than traditional form work and remain in place to become part of the finished wall.

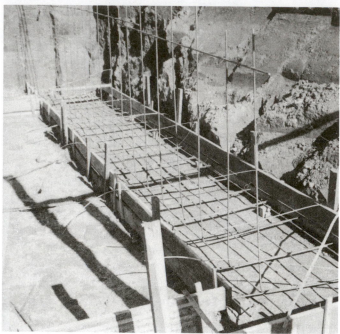

Figure 10–7 Forms set in preparation for pouring the concrete for the footing. Horizontal and vertical steel has been placed to tie the stem wall to the footing. *Courtesy of Matthew Jefferis.*

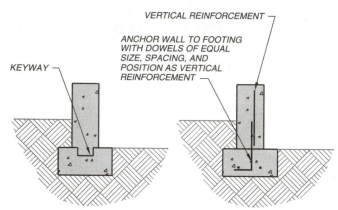

Figure 10–8 The footing can be bonded to the foundation wall with a key or with steel.

Reinforcing steel can be set inside the block forms in patterns similar to traditional block walls. Once the forms are assembled, concrete can be pumped into the forms using any of the common methods of pouring. The finished wall has an R-value between R-22 and R-35, depending on the manufacturer. Figure 10–14 shows a foundation being built using EPS forms.

The top of the foundation wall must be level. When the building lot is not level, the foundation wall is often stepped. This helps reduce the material needed to build the foundation wall. As the ground slopes downward, the height of the wall is increased, as shown in Figure 10–15. Foundation walls may not step more than 24" (600 mm) in one step. Wood framing between the wall and any floor being supported may not be less than 14" (350 mm) in height. The foundation wall will also change heights for a sunken floor. Figure 10–16 shows how a sunken floor can be represented on a foundation plan. Steel anchor bolts are placed in the top of the wall

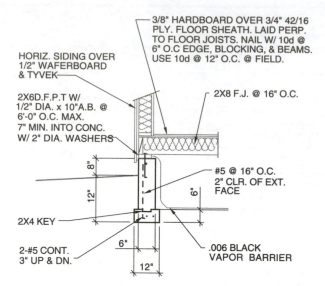

TYPICAL JOIST FOUNDATION DETAIL

Figure 10–9 When steel is required in the foundation, it is usually specified in a general note on the foundation plan and detail.

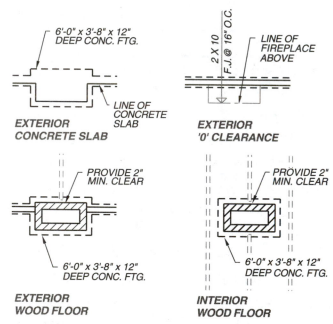

Figure 10–10 A masonry fireplace is required to have a 12" (300 mm) deep footing that extends 6" (150 mm) past the face of the fireplace. A wood stove, a zero-clearance fireplace, or a gas fireplace is not required to have a footing, but the outline of the unit should be represented on the foundation plan if it extends beyond the foundation.

to secure the wood mudsill to the concrete. If concrete blocks are used, the cell in which the bolt is placed must be filled with grout. Minimum standards for placing anchor bolts include:

| Mimimum diameter | 1/2" Ø (13 mm) |
| Minimum depth into concrete | 7" (178 mm) |

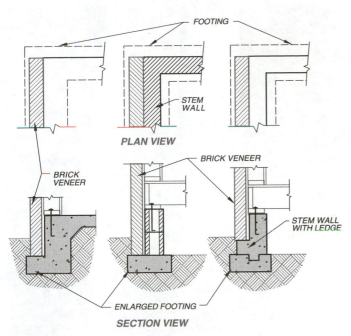

Figure 10–11 Standard methods of providing support for veneered walls.

Maximum spacing (1 story)	6'–0" (180 mm)
Maximum spacing (2 story)	4'–0" (1200 mm)

In addition to the common spacing for bolts to attach the mudsill to the concrete, the bolts must be within 12" (300 mm) from the end of the plate. The mudsill is required to be pressure-treated or made of some other water-resistant wood so that it does not absorb moisture from the concrete. A 2" (50 mm) round washer is placed over the bolt projecting through the mudsill before the nut is installed to increase the holding power of the bolt. The mudsill and anchor bolts are not drawn on a foundation plan but are specified in a local note near the stem wall. Examples of each can be seen in Figure 10–16.

The mudsill must also be protected from termites in many parts of the country. Among the most common methods of protection are the use of metal caps between the mudsill and the wall, chemical treatment of the soil around the foundation, and chemically treated wood near the ground. The metal shield is not drawn on a foundation plan, but is specified in a local note near the stem wall.

If the house is to have a wood flooring system, some method of securing support beams to the foundation must be provided. Typically a cavity or beam pocket is built into the foundation wall. The cavity provides a method of supporting the beam and helps tie the floor and foundation system together. A 3" (75 mm) minimum amount of bearing surface must be provided for the beam. A 1/2" (13 mm) airspace is provided around the beam in the pocket for air circulation. Air must also be allowed to circulate under the floor system. To provide ventilation under the floor, vents must be set into the foundation wall. Vents must be installed to provide 1 sq. ft. of ventilation for each 150 sq. ft. (0.67 m²/100 m²) of crawl space. To

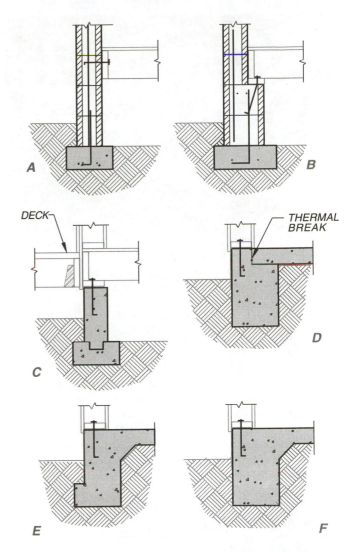

Figure 10–12 Common methods of forming stem walls. (A) Concrete masonry units, with a pressure-treated ledger to support a wood floor joist. (B) Floor joists supported on a pressure-treated sill with concrete masonry units. (C) Floor joists supported by a pressure-treated sill with a joist supporting a wood deck hung from a ledger. (D) Concrete floor slab supported on a foundation with an isolation joint between the stem wall and slab to help the slab maintain heat. (E) Stem wall with projected footing. (F) Stem wall and foundation of equal width. Although more concrete is used, it can be formed quickly, saving time and material.

supply ventilation under the floor, vents must be set into the foundation wall. In addition to minimum size requirements, vents must be provided within 3'–0" (900 mm) of each corner to provide air current throughout the crawl space. If an access opening is not provided in the floor, an 18 × 24 (450 × 600 mm) opening will be needed in the foundation wall for access to the crawl space under the floor.

When required by the IRC or if the foundation is for an energy-efficient structure, insulation is often added to the wall. Two-inch (50 mm) rigid insulation is used to protect the wall from cold

Figure 10–13 Once the concrete is poured, anchor bolts are placed in preparation for placement of the wood sill. Once the floor has been placed, the soil can be placed against the stem wall to form the finish grade. *Courtesy Richard Schmitke.*

weather. This can be placed on either side of the wall. If the insulation is placed on the exterior side of the wall, the wall will retain heat from the building. Figure 10–16 shows how the crawl access, vents, and girder pockets are represented on a foundation plan.

In addition to supporting the loads of the structure, the foundation walls also must resist the lateral pressure of the soil pressing against the wall. When the wall is over 24" (600 mm) in height, vertical steel is usually added to the wall to help reduce tension in the wall. Horizontal steel is also added to foundation walls in same seismic zones to help strengthen the wall. Wall steel is not shown on the foundation plan but is specified in a note similar to that used for footing steel.

RETAINING WALLS

Retaining or basement walls are primarily made of concrete blocks or poured concrete, although the IRC allows wood to be used. The material used depends on labor trends in your area. Regardless of which material is used, basement walls serve the same functions as the shorter foundation walls. Because of the added height, the lateral forces acting on the side of these walls are magnified. This lateral soil pressure tends to bend the wall inward, thus placing the soil side of the wall in compression and the interior face of the wall in tension. To resist this tensile stress, steel reinforcing may be required by the building department for concrete walls and CMU walls. The seismic zone will also affect the size and placement of reinforcing steel. On a foundation plan this steel is specified in a note similar to the note used for wall steel.

The footing for a retaining wall is usually 16" (400 mm) wide and either 8" (200 mm) or 12" (300 mm) deep. The depth depends on the weight to be supported. Steel is extended from the footing into the wall. At the top of the wall, anchor bolts are placed in the wall in the same method as with a foundation wall. Anchor bolts for retaining walls are typically placed more closely than for shorter walls, and metal angles are added to the anchor bolts to make the tie between the wall and the floor joist extremely rigid. Figure 10–17 shows how the connection might be represented on a foundation plan.

Figure 10–14 Blocks made of expanded polystyrene foam provide both a permanent form for pouring the stem wall and insulation to prevent heat loss. *Courtesy American Polysteel Forms.*

LINE OF STEP

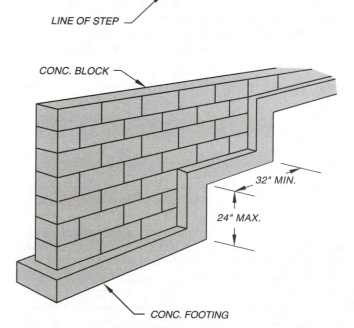

CONC. BLOCK

32" MIN.

24" MAX.

CONC. FOOTING

Figure 10–15 The footing and foundation wall are often stepped on sloping lots to save material.

To reduce soil pressure next to the footing, a drain is installed. The drain is set at the base of the footing to collect and divert water from the face of the wall. The area above the drain is filled with gravel so that subsurface water percolates easily, down to the drain and away from the wall. By reducing the water content of the soil, the lateral pressure on the wall is reduced. The drain is usually not drawn on the foundation plan but must be specified in a note.

No matter what the soil condition, the basement wall must be protected to reduce moisture passing through the wall into the living area. The IRC specifies two levels of basement wall protection as damp-proofing and waterproofing. Each method must be applied to the exterior face of a foundation wall that surrounds habitable space. The protection must be installed from the top of the footing to the grade. A masonry or concrete wall can be damp-proofed by adding 3/8" (9.5 mm) portland cement parging to the exterior side of the wall. The parging must then be protected by a bituminous coating, acrylic modified cement, or a coat of surface-bonding mortar. Materials used to waterproof a wall can also be applied. In areas with a high water table or other severe soil or water conditions, basement walls surrounding habitable space must be waterproofed. Concrete and mortar walls are water-

proofed by adding a 2-ply hot-mopped felt, 6-mil polyethylene, or 40-mil polymer-modified asphalt; 6-mil (0.15 mm) polyvinyl chloride; or 55# (25 kg) roll roofing. Additional provisions are provided by the IRC for ICF for wood foundation walls.

Adding windows to the basement can help cut down the moisture content of the basement. This sometimes requires adding a window well to prevent the ground from being pushed in front of the window. Figure 10–17 shows how a window well, or areaway as it is sometimes called, can be represented.

Like a foundation wall, the basement wall needs to be protected from termites. The metal shield will not be drawn on the foundation plan but should be called out in a note.

TREATED-WOOD BASEMENT WALLS

Pressure-treated lumber can be used to frame both crawl space and basement walls. Treated-wood basement walls allow for easy installation of electrical wiring, insulation, and finishing materials. Instead of a concrete foundation, a gravel bed is used to support the wall loads. Gravel is required to extend 4" (100 mm) on each side

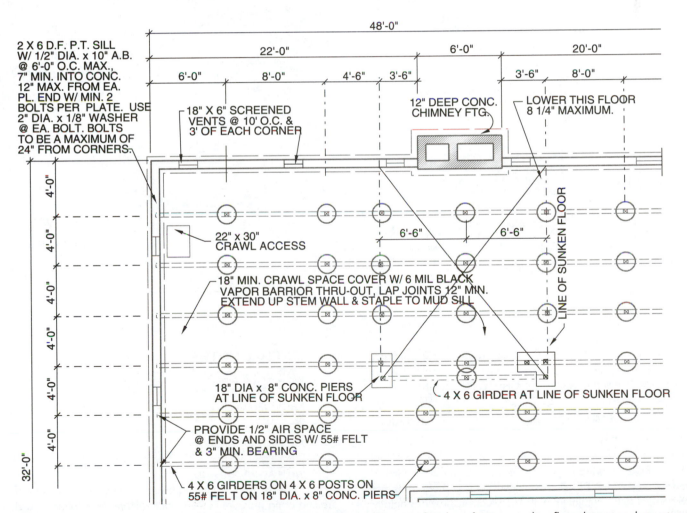

Figure 10–16 Common components of a foundation plan are vents, crawl access, fireplace footing, sunken floor, beam pockets, stem wall, footings, and piers.

of the wall and be approximately 8" (200 mm) deep. A 2× (50 mm) pressure-treated plate is laid on the gravel, and the wall is built of pressure-treated wood, as seen in Figure 10–18. Pressure-treated 1/2" (13 mm) thick C-D grade plywood with exterior glue is laid perpendicular to the studs, covered with 6 mil (0.15 mm) polyethylene and sealed with an adhesive.

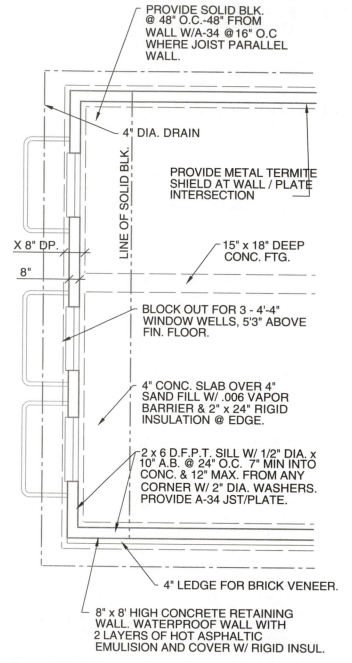

PROVIDE SOLID BLK. @ 48" O.C.-48" FROM WALL W/A-34 @16" O.C WHERE JOIST PARALLEL WALL.

4" DIA. DRAIN

PROVIDE METAL TERMITE SHIELD AT WALL / PLATE INTERSECTION

LINE OF SOLID BLK.

15" x 18" DEEP CONC. FTG.

X 8" DP.

8"

BLOCK OUT FOR 3 - 4'-4" WINDOW WELLS, 5'3" ABOVE FIN. FLOOR.

4" CONC. SLAB OVER 4" SAND FILL W/ .006 VAPOR BARRIER & 2" x 24" RIGID INSULATION @ EDGE.

2 x 6 D.F.P.T. SILL W/ 1/2" DIA. x 10" A.B. @ 24" O.C. 7" MIN INTO CONC. & 12" MAX. FROM ANY CORNER W/ 2" DIA. WASHERS. PROVIDE A-34 JST/PLATE.

4" LEDGE FOR BRICK VENEER.

8" x 8' HIGH CONCRETE RETAINING WALL. WATERPROOF WALL WITH 2 LAYERS OF HOT ASPHALTIC EMULISION AND COVER W/ RIGID INSUL.

Figure 10–17 Common elements that are shown on a foundation with a basement. If a window is to be placed in a full-height basement wall, a window well to restrain the soil around the window is required. Blocking is placed between floor joists that are parallel to the retaining wall. The blocking provides rigidity to the floor system, allowing lateral pressure from the wall to be transferred into the floor system.

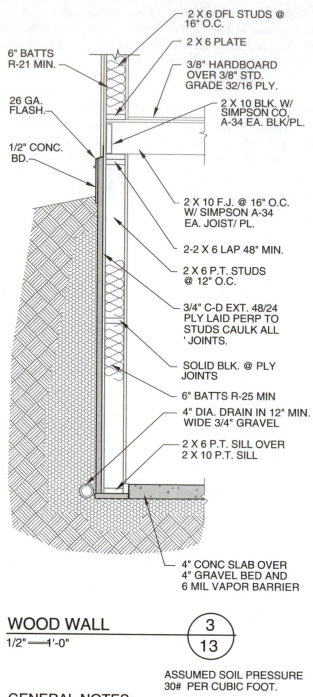

2 X 6 DFL STUDS @ 16" O.C.

2 X 6 PLATE

3/8" HARDBOARD OVER 3/8" STD. GRADE 32/16 PLY.

2 X 10 BLK. W/ SIMPSON CO. A-34 EA. BLK/PL.

6" BATTS R-21 MIN.

26 GA. FLASH.

1/2" CONC. BD.

2 X 10 F.J. @ 16" O.C. W/ SIMPSON A-34 EA. JOIST/ PL.

2-2 X 6 LAP 48" MIN.

2 X 6 P.T. STUDS @ 12" O.C.

3/4" C-D EXT. 48/24 PLY LAID PERP TO STUDS CAULK ALL ' JOINTS.

SOLID BLK. @ PLY JOINTS

6" BATTS R-25 MIN

4" DIA. DRAIN IN 12" MIN. WIDE 3/4" GRAVEL

2 X 6 P.T. SILL OVER 2 X 10 P.T. SILL

4" CONC SLAB OVER 4" GRAVEL BED AND 6 MIL VAPOR BARRIER

WOOD WALL

1/2" = 1'-0"

3
13

ASSUMED SOIL PRESSURE 30# PER CUBIC FOOT.

GENERAL NOTES:

WATER PROOF EXTERIOR SIDE OF WALL WITH 2 LAYER HOT ASPHALTIC EMULSION COVERED WITH 6 MIL. VAPOR BARRIER.

PROVIDE ALTERNATE BID FOR 2" RIGID INSULATION ON EXTERIOR FACE FOR FULL HEIGHT.

ALL MATERIAL BELOW UPPER TOP PLATE OF BASEMENT WALL TO BE PRESSURE PRESERVATIVELY TREATED IN ACCORDANCE WITH AWPA-C22 AND SO MARKED.

Figure 10–18 Stem walls and basement retaining walls can be framed using pressure-treated wood with no foundation. The size and spacing of members are determined by the loads being supported and the height of the wall.

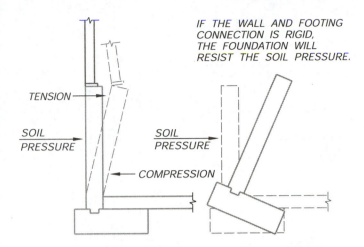

Figure 10–19 When a wall is not held in place at the top, soil pressure will attempt to move the wall inward. The intersection of the wood and concrete walls is called a hinge point because of the tendency to move.

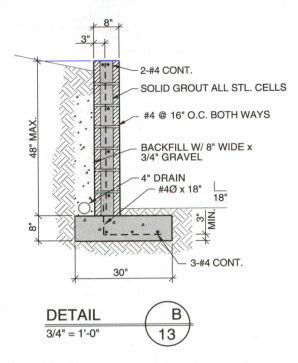

DETAIL B / 13
3/4" = 1'-0"

Figure 10–20 Detail of a partial-height retaining wall.

PARTIAL HEIGHT RETAINING WALLS

When a structure is built on a sloping site, the masonry wall may not need to be full height. Although less soil is retained than with a full-height wall, more problems are encountered. Figure 10–19 shows the tendencies for bending for this type of wall. Because the wall is not supported at the top by the floor, the soil pressure must be resisted through the footing. This requires a larger footing than for a full-height wall. If the wall and footing connection is rigid enough to keep the wall in position, the soil pressure will try to overturn the whole foundation. The extra footing width is required to resist the tendency to overturn. Figure 10–20 shows the detail required to represent a partial height wall. Figure 10–21 shows how a restraining wall will be represented on a foundation plan. Depending on the slope of the ground being supported, a key may be required, as in Figure 10–22. A keyway on the top of the footing has been discussed. The key is added to the bottom of the footing to help keep it from sliding as a result of soil pressure against the wall. Generally the key is not shown on the foundation plan but is shown in a detail of the wall.

INTERIOR SUPPORTS

Foundation walls and footings are typically part of the foundation system that supports the exterior shape of the structure. Interior loads are generally supported on spot footings, or *piers*. Pier depth is generally required to match that of the footings. The placement of piers is determined by the type of floor system to be used. The size of the pier depends on the load being supported and the soil bearing pressure. Piers are usually drawn on the foundation plan with dotted lines, as shown in Figure 10–23.

In addition to the exterior footings and interior piers, footings may also be required under braced walls. Braced walls and braced wall lines were introduced in Chapter 8. On the framing plan, when the distance between braced wall lines exceed 35'–0" (10 360 mm), an interior braced wall line must be provided. A beam or double joist is required to support the interior braced wall line. At the foundation level, when the distance between the footings for braced wall lines exceeds 50'–0" (15 240 mm), a continuous footing must be provided below the braced wall. A continuous footing must be provided below all multilevel braced walls in seismic zones D_1 and D_2.

A final consideration of foundation walls and footings is the placement of each by a garage door. For small openings such as a 36" (900 mm) door, the footing is continued under the door opening. The stem wall is cut to allow access to the garage without having to step over the wall each time the garage is entered. For a large opening such as the main garage door, in areas of the country with low seismic risk, the footing is not continuous across the door opening. In areas at risk of seismic activity, the footing must extend across the entire width of the door. The continuous footing helps the walls on each side of the door to act as one wall unit. The stem wall is cut to allow the concrete floor to cover the stem wall, providing a smooth entry into the garage.

METAL CONNECTORS

Metal connectors are often used at the foundation level. How the connector is used determines how it is specified. Figure 10–21 shows how these connectors can be specified on the foundation plan.

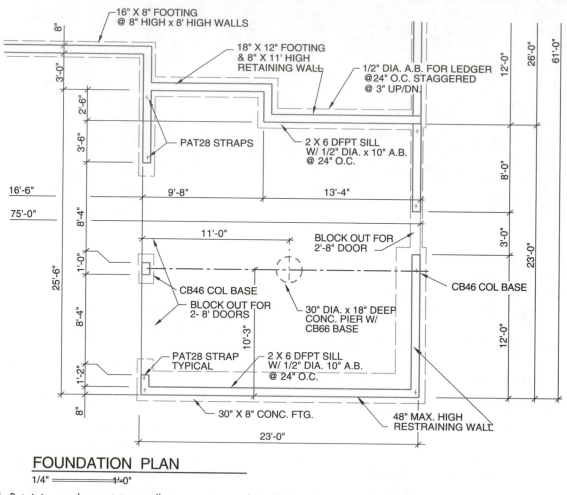

FOUNDATION PLAN

1/4" = 1'-0"

Figure 10–21 Retaining and restraining walls are represented similarly to footings and stem walls. Because of the added height, the width is typically specified on the foundation plan, and the building components are specified in a detail or section.

DIMENSIONING FOUNDATION COMPONENTS

The line quality for the dimension and leader lines is the same as what was used on the floor plan. Jogs in the foundation wall are dimensioned using the same methods used on the floor plan. Most dimensions for major shapes are exactly the same as those seen on the floor plan. The only variation is where a floor or bay window might cantilever past the foundation, as seen in Figure 10–24.

A different method is used to dimension the interior walls, however. Foundation walls are dimensioned from face to face rather than from face to center, as on the floor plan. Footing widths are usually dimensioned center to center. Each type of dimension can be seen in Figure 10–25.

FLOOR SYSTEMS

The foundation plan not only shows the concrete footings and walls, but also the members that are used to form the floor. Two common types of floor systems are typically used in residential

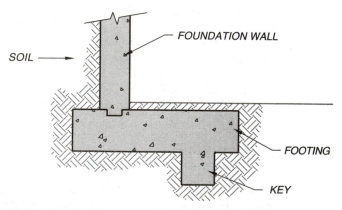

Figure 10–22 Soil pressure will attempt to make the wall and footing slide across the soil. A key may be provided on the bottom of the footing to provide added surface area to resist sliding.

construction. These include floor systems with a crawl space or cellar below the floor system, and a floor system built at grade level. Each has its own components and information that must be put on a foundation plan.

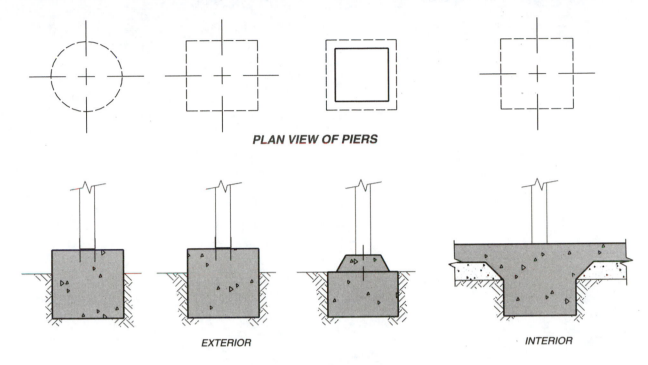

PLAN VIEW OF PIERS

EXTERIOR

INTERIOR

PIERS IN SIDE ELEVATION

Figure 10–23 Concrete piers are used to support interior loads. Codes require wood to be at least 6" (152 mm) above grade, which means that piers must also extend 6" (152 mm) above grade.

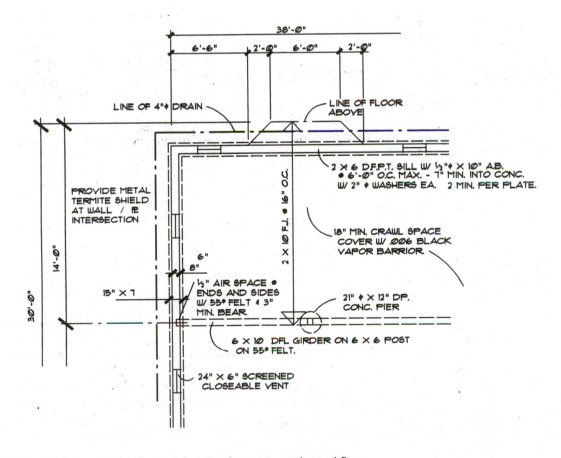

Figure 10–24 Typical dimensions required to locate a bay window or a cantilevered floor.

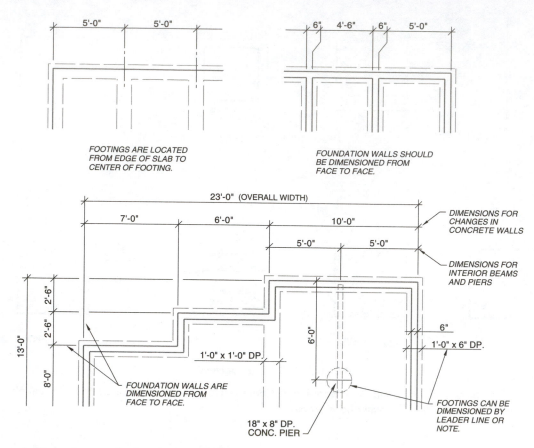

Figure 10–25 Dimensioning techniques for foundation plans.

ON-GRADE FOUNDATIONS

A concrete slab is often used for the floor system of either residential or commercial structures. A concrete slab provides a firm floor system with little or no maintenance and generally requires less material and labor than conventional wood floor systems. The floor slab is usually poured as an extension of the foundation wall and footing, as shown in Figure 10–26. Other common methods of pouring the foundation and floor system are shown in Figure 10–27.

A 3–1/2" (90 mm) concrete slab is the minimum thickness allowed by the IRC for residential floor slabs. The slab is used only as a floor surface and is not used to support the weight of the walls or roof. If load-bearing walls must be supported, the floor slab must be thickened, as shown in Figure 10–28. If a load is concentrated in a small area, a pier may be placed under the slab to help disperse the weight, as seen in Figure 10–29.

Slab Joints

Depending on the size of the slab, joints can be placed in the slab. To help control possible cracking, three types of joints can be placed in the slab: control, construction, and isolation joints. See Figure 10–29. A *control* or *contraction joint* does not prevent cracking, but it does control where the cracks will develop in the slab. Control joints can be created by cutting the fresh concrete or sawing the concrete within 6 to 8 hours of placement. Joints are usually one-quarter of the slab depth. Because the slab has been weakened, any cracking due to stress will result along the joint. The American Concrete Institute (ACI) suggests, for a 4" (100 mm) slab, joints need to be placed at approximately 10' (3000 mm) intervals. The locations of control joints are usually specified in note form for residential slabs. The spacing and method of placement can be specified in the general notes for the foundation plan.

Construction Joints

When concrete construction must be interrupted, a construction joint is used to provide a clean surface where work can be resumed. Because a vertical edge of one slab has no bond to the next slab, a keyed joint is used to provide support between the two slabs. The key is formed by placing a beveled strip that is about one-fifth of the slab thickness and one-tenth of the slab thickness in width to the form used to mold the slab. The method used to form the joint is specified in note form on the foundation notes, but the concrete crew determines the location.

Isolation Joints

An *isolation* or *expansion joint* is used to separate a slab from an adjacent slab, wall, or column, or some other part of the structure. The joint prevents forces from an adjoining structural member from being transferred into the slab, causing cracking. Such a joint

also allows for expansion of the slab caused by moisture or temperature. Isolation joints are usually between 1/4" and 1/2" (6 mm and 13 mm) wide. The location of isolation joints should be specified on the foundation plan. Because of the small size of residential foundations, isolation joints are not usually required.

SLAB PLACEMENT

The slab can be placed above, below, or at grade level. Residential slabs are often placed above grade for hillside construction to provide a suitable floor for a garage. A platform made of wood or steel materials can be used to support a lightweight concrete floor slab. Concrete is considered lightweight depending on the amount of air that is pumped into the mixture during the manufacturing process. Above-grade residential slabs are typically supported by a wood-framed platform covered with plywood sheathing. Ribbed metal decks are typically used for heavier floors found in commercial construction. The components of an above-ground concrete floor are noted on a framing plan but not drawn. The foundation plan shows the columns and footings used to support the increased weight of the floor. An example of a framing plan to support an above-ground concrete slab can be seen in Figure 10–30. The foundation plan for the same area can be seen in Figure 10–31. The construction process requires details similar to those in Figure 10–32.

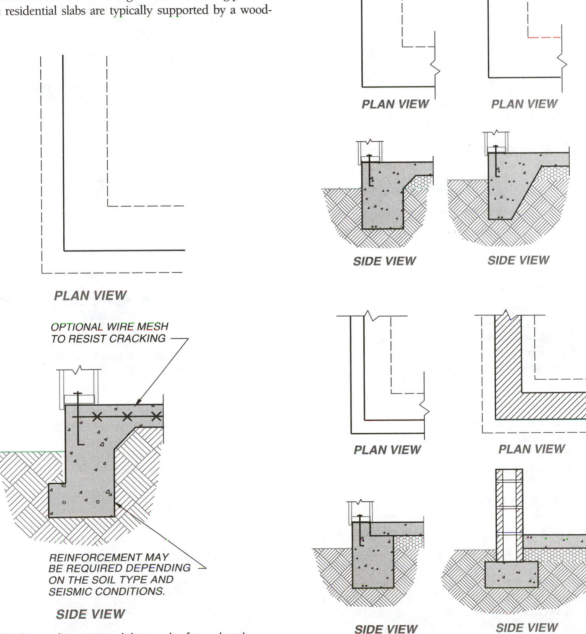

PLAN VIEW

OPTIONAL WIRE MESH TO RESIST CRACKING

REINFORCEMENT MAY BE REQUIRED DEPENDING ON THE SOIL TYPE AND SEISMIC CONDITIONS.

SIDE VIEW

Figure 10–26 On-grade concrete slabs can be formed at the same time the footing and stem wall are poured.

PLAN VIEW **PLAN VIEW**

SIDE VIEW **SIDE VIEW**

PLAN VIEW **PLAN VIEW**

SIDE VIEW **SIDE VIEW**

Figure 10–27 On-grade slab and wall intersection variations.

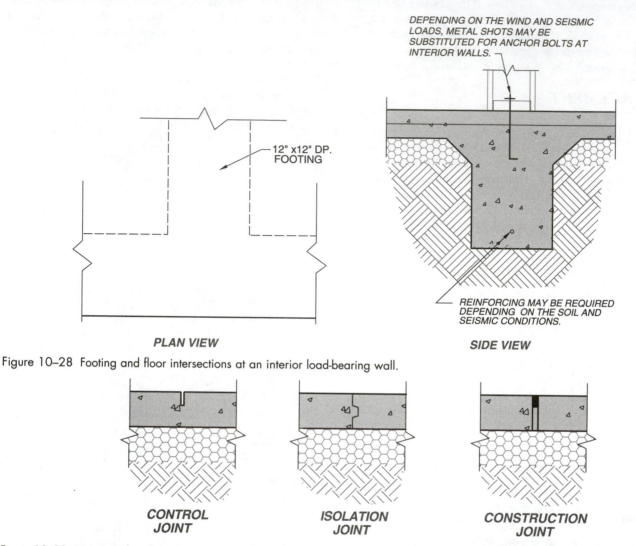

DEPENDING ON THE WIND AND SEISMIC LOADS, METAL SHOTS MAY BE SUBSTITUTED FOR ANCHOR BOLTS AT INTERIOR WALLS.

12" x12" DP. FOOTING

REINFORCING MAY BE REQUIRED DEPENDING ON THE SOIL AND SEISMIC CONDITIONS.

PLAN VIEW

SIDE VIEW

Figure 10–28 Footing and floor intersections at an interior load-bearing wall.

CONTROL JOINT

ISOLATION JOINT

CONSTRUCTION JOINT

Figure 10–29 Joints are placed in concrete to control cracking. A control joint is placed in the slab to weaken the slab and cause cracking to occur along the joint rather than throughout the slab. When construction must be interrupted, a construction joint is formed to increase bonding with the next day's pour. Isolation joints are provided to keep stress from one structural material from cracking another.

Slabs built below grade are most commonly used in basements. When used at grade, the slab is usually placed just above grade level. Most building codes require the top of the slab to be 8″ (203 mm) above the finish grade to keep structural wood away from the ground moisture.

SLAB PREPARATION

When a slab is built at grade, approximately 8″–12″ (200–300 mm) of topsoil and vegetation is removed to provide a stable, level building site. Excavation usually extends about 5' (1500 mm) beyond the building size to allow for the operation of excavating equipment needed to trench for the footings. Once forms for the footings have been set, fill material can be spread to support the slab. The IRC requires the slab to be placed on a 4″ (100 mm) minimum base of compacted sand or gravel fill. The area for which the building is designed dictates the type of fill material that is used. The fill material provides a level base for the concrete slab and helps eliminate cracking in the slab caused by settling of the ground under the slab. The fill material is not shown on the foundation plan but is specified with a note. A typical note to specify the concrete and fill material might read:

4″ CONC. SLAB OVER .006 VISQUEEN OVER 1″ SAND FILL OVER 4″ COMPACTED GRAVEL FILL.

SLAB REINFORCEMENT

When the slab is placed on more than 4″ (100 mm) of uncompacted fill, welded wire fabric should be specified to help the slab resist cracking. Spacings and sizes of wires of welded wire fabric are identified by style and designations. A typical designation specified on a foundation plan might be: 6 × 12—W16 × W8, where:

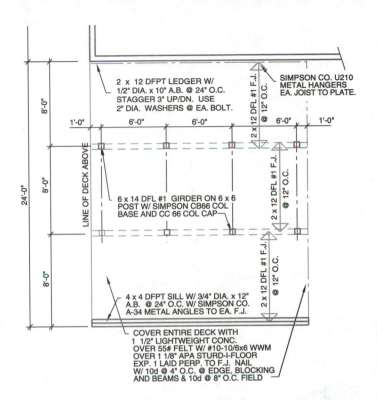

Figure 10–30 An above-ground concrete floor is often used for a garage floor and driveway for hillside residential construction. The framing plan shows the framing of the platform used to support the concrete slab.

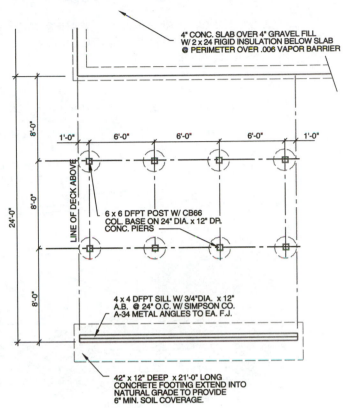

Figure 10–31 The foundation for an above-ground concrete slab shows the support piers for the framing pattern.

6 = longitudinal wire spacing

12 = transverse wire spacing

16 = longitudinal wire size

8 = transverse wire size

The letter *W* indicates smooth wire. *D* can be used to represent deformed wire. Normally a steel mesh of number 10 wire in 6″ (150 mm) grids is used for residential floor slabs. A note to specify reinforced concrete and fill material might read:

4″ CONC. SLAB W/6 × 6 W12 × 12 WWM OVER .006 VISQUEEN OVER 1″ SAND FILL OVER 4″ COMPACTED GRAVEL FILL.

Figure 10–33 shows an example of the mesh used in concrete slabs.

Steel reinforcing bars can be added to a floor slab to prevent bending of the slab due to expansive soil. While mesh is placed in a slab to limit cracking, steel reinforcement is placed in the concrete to prevent cracking because of bending. Steel reinforcing bars can be laid in a grid pattern near the surface of the concrete that will be in tension from bending. The placement of the reinforcement in the concrete is important to the effectiveness of the reinforcement. The amount of concrete placed around the steel is referred to as *coverage.* Proper coverage strengthens the bond between the steel and concrete, and also protects the steel from corrosion if the concrete is exposed to chemicals, weather, or water. Proper coverage is also important to protect the steel from damage by fire. If steel is required to reinforce a residential concrete slab, the foundation plan will include specifications for the size, spacing, coverage, and grade of bars to be used.

POST-TENSIONED CONCRETE REINFORCEMENT

The methods of reinforcement mentioned thus far assume that the slab will be poured over stable soil. Concrete slabs can often be poured over unstable soil by using a method of reinforcement known as post-tensioning. Post-tensioning allows concrete slabs to be poured on grade over expansive soil.

Two methods of post-tensioning are usually used for residential slabs: flat slab and ribbed slab. The *flat slab* method uses steel tendons ranging in diameter from 3/8″–1/2″ (10–13 mm).

The exact spacing and size of tendons will be specified on the foundation plan based on the loads to be supported and the strength and conditions of the soil. When required, the tendons can be represented on the foundation plan, as seen in Figure 10–34. Details are also provided to indicate how the tendons will be anchored, as well as to show the exact locations of the tendons. Figure 10–35 is an example of a tendon detail. In addition to representing and specifying the steel throughout the floor system, the drafter will need to specify the engineer's requirements for the strength of the concrete, the period when the concrete is to be

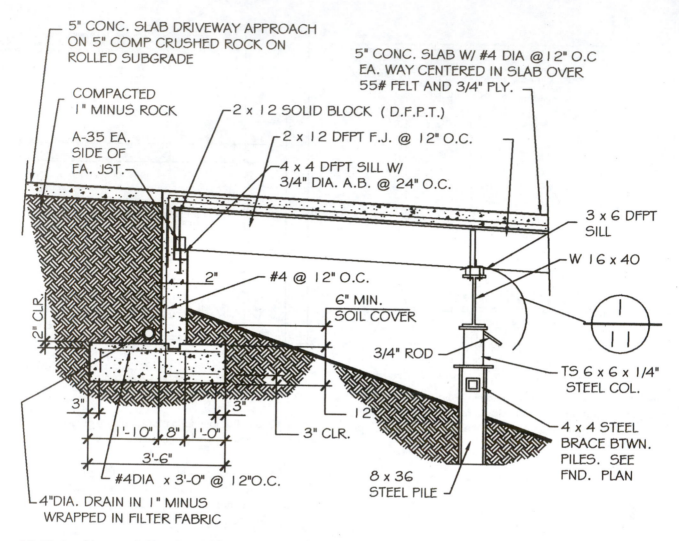

Figure 10-32 In addition to the framing and foundation plans, details are used to clarify the concrete reinforcement.

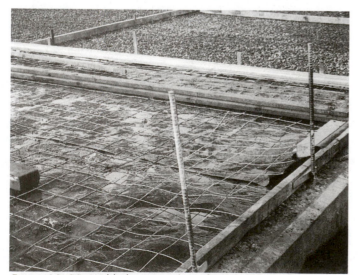

Figure 10–33 Welded wire mesh is often placed in concrete slabs to reduce cracking.

stressed, as well as what strength the concrete should achieve before stressing.

A second method of post-tensioning an on-grade floor slab is with the use of concrete ribs or beams placed below the slab. These beams reduce the span of the slab over the soil and provide increased support. The width, depth, and spacing are determined by the engineer based on the strength and condition of the soil and the size of the slab. Figure 10–36 shows an example of a beam detail required to show the reinforcing. Figure 10–37 is an example of how these beams could be shown on the foundation plan.

MOISTURE PROTECTION

In most areas the slab is required to be placed over 6-mil polyethylene sheet plastic to protect the floor from ground moisture. When a plastic vapor barrier is to be placed over gravel, a layer of sand should be specified to cover the gravel fill to avoid tearing the vapor barrier. An alternative is to use 55# rolled roofing in place of the plastic. The vapor barrier is not drawn on the foundation plan, but is specified with a note on the foundation plan.

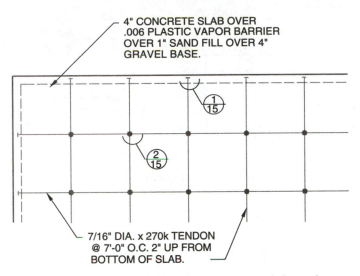

4" CONCRETE SLAB OVER
.006 PLASTIC VAPOR BARRIER
OVER 1" SAND FILL OVER 4"
GRAVEL BASE.

7/16" DIA. x 270k TENDON
@ 7'-0" O.C. 2" UP FROM
BOTTOM OF SLAB.

Figure 10–34 When a concrete slab is post-tensioned, the tendons and anchors used to support the floor slab are represented on the foundation plan.

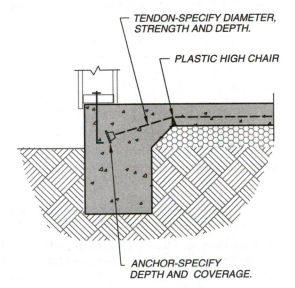

TENDON-SPECIFY DIAMETER, STRENGTH AND DEPTH.

PLASTIC HIGH CHAIR

ANCHOR-SPECIFY DEPTH AND COVERAGE.

Figure 10–35 Tendon details are drawn to reflect the design of the engineer.

SLAB INSULATION

Depending on the risk of freezing, some municipalities require the concrete slab to be insulated to prevent heat loss. The insulation can be placed under the slab or on the outside of the stem wall. When it is placed under the slab, a 2 × 24" (50 × 600 mm) minimum rigid insulation material should be used to insulate the slab. An isolation joint is typically provided between the stem wall and the slab to prevent heat loss through the stem wall. When placed on the exterior side of the stem wall, the insulation should extend past the bottom of the foundation. Care must be taken to protect exposed insulation on the exterior side of the wall. This can usually be done by placing a protective covering such as 1/2" (13 mm) cement board over the insulation. Insulation is not shown on the foundation plan but is represented by a note, as shown in Figure 10–38, and specified in sections and footing details.

PLUMBING AND HEATING REQUIREMENTS

Plumbing and heating ducts must be placed under the slab before the concrete is poured. On residential plans, plumbing is usually not shown on the foundation plan. Generally the skills of the plumbing contractor are relied on for the placement of required utilities. Although piping runs are not shown, terminations such as floor drains are often shown and located on a concrete slab plan. Figure 10–38 shows how floor drains are typically represented. If heating ducts will be placed under the slab, they are usually drawn on the foundation plan.

CHANGES IN FLOOR ELEVATION

The floor level is often required to step down to meet the design needs of the client. A stem wall is formed between the two floor levels and should match the required width for an exterior stem wall. The lower slab is usually thickened to a depth of 8" (200 mm) to support the change in elevation. Figure 10–38 shows how a lowered slab can be represented. The step often occurs at what will be the edge of a wall when the framing plan is complete.

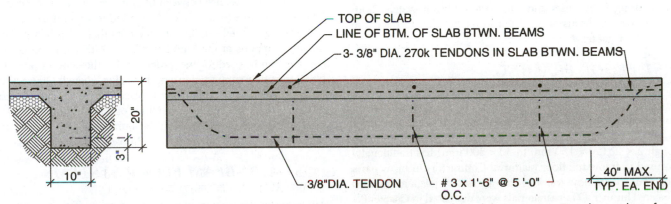

TOP OF SLAB
LINE OF BTM. OF SLAB BTWN. BEAMS
3- 3/8" DIA. 270k TENDONS IN SLAB BTWN. BEAMS

20"

3"

10"

3/8"DIA. TENDON

3 x 1'-6" @ 5 '-0" O.C.

40" MAX.
TYP. EA. END

Figure 10–36 Concrete beams can be placed below the floor slab to increase the effect of the slab tensioning. Details must be referenced to determine how the steel will be placed in the beam, as well as how the beam steel will interact with the slab steel.

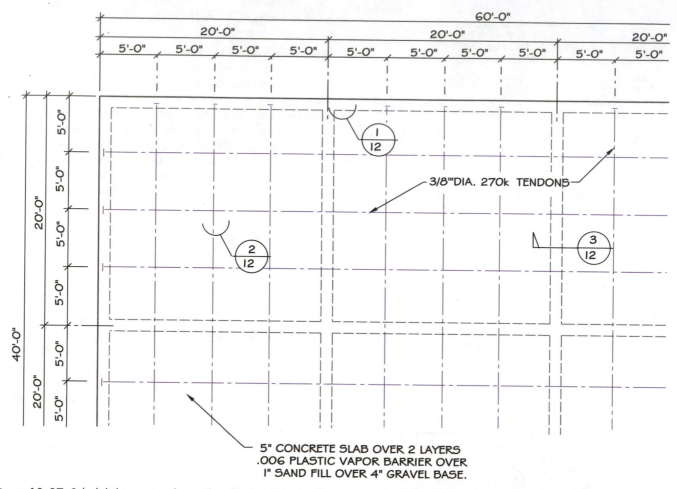

Figure 10–37 Sub-slab beams are located on the foundation plan using methods like those used to represent an interior footing.

CRAWL SPACE FLOOR SYSTEMS

The crawl space is the area formed between the floor system and the ground. Building codes require a minimum of 18" (450 mm) from the bottom of the floor to the ground and 12" (300 mm) from the bottom of beams to the ground. Two common methods of providing a crawl space below the floor are the conventional method using floor joists and the post-and-beam system. Both floor systems are discussed in detail in relationship to the entire structure in Chapter 7.

JOIST FLOOR FRAMING

The most common method of framing a wood floor is with wood members called *floor joists*. Floor joists are used to span between the foundation walls. Sawn lumber ranging in size from 2 × 6 through 2 × 12 (50 × 150 mm to 50 × 300 mm) has traditionally been used to frame the floor platform. Contractors in many parts of the country are now framing with trusses or joists made from engineered lumber. (These materials were discussed in Chapter 8.) The floor joists are usually placed at 16" (400 mm) on center, but the spacing of joists may change depending on the span, the material used, and the load to be supported.

To construct this type of floor, a pressure-treated sill is bolted to the top of the foundation wall with the anchor bolts that were placed when the foundation was formed. The floor joists can then be nailed to the sill. With the floor joists in place, plywood floor sheathing is installed to provide a base for the finish floor.

When the distance between the foundation walls is too great for the floor joists to span, a girder is used to support the joists. A *girder* is a horizontal load-bearing member that spans between two or more supports at the foundation level. Either a wood or steel member can be used for the girder and for the support post. The girder is usually supported in a beam pocket where it intersects the foundation wall. A concrete pier is placed under the post to resist settling. Figure 10–39 shows methods of representing the girders, posts, piers, and beam pocket on the foundation plan. An example of a joist foundation can be seen in Problem 10–2.

POST-AND-BEAM FLOOR SYSTEMS

A post-and-beam floor system is built using a standard foundation system. Rather than having floor joists span between the founda-

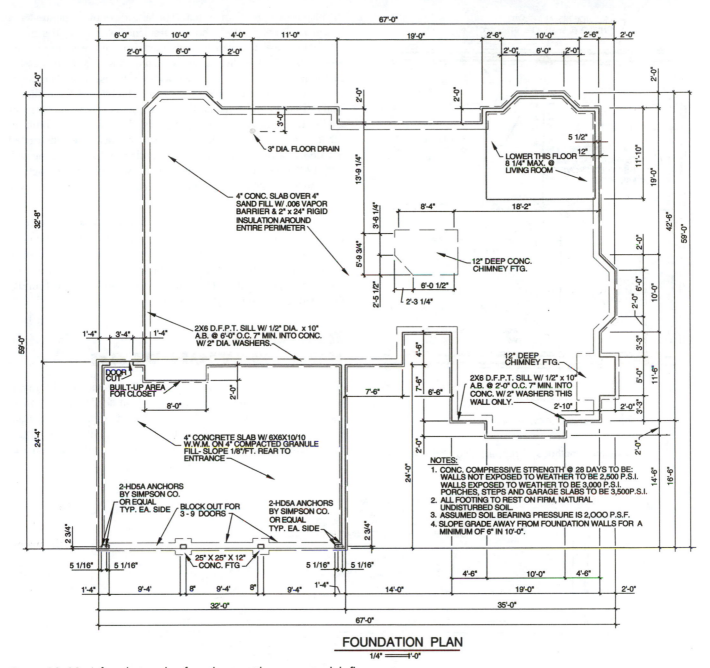

FOUNDATION PLAN
1/4" = 1'-0"

Figure 10–38 A foundation plan for a home with a concrete-slab floor system.

tion walls, a series of beams is used to support the subfloor. The beams are usually placed at 48" (1200 mm) on center, but the spacing can vary depending on the size of the floor decking to be used. Generally 2" (50 mm) thick material is used to span between the beams to form the subfloor.

The beams are supported by wooden posts where they span between the foundation walls. Posts are usually placed about 8' (2400 mm) on center, but spacing may vary depending on the load to be supported. Each post is supported by a concrete pier. An example of a post-and-beam foundation can be seen in Problem 10–3.

COMBINED FLOOR METHODS

Floor and foundation methods may be combined depending on the building site. This is typically done on partially sloping lots when part of a structure may be constructed with a slab and part of the structure with a joist floor system, as seen in Problem 10–4.

A home with a partial basement will require the use of a concrete floor in the basement area, with either a joist or post-and-beam floor system over the crawl space. A joist floor for the crawl space is easier to match the floor over the basement area. Problem 10–4 shows a residence that has a partial basement. The right portion of

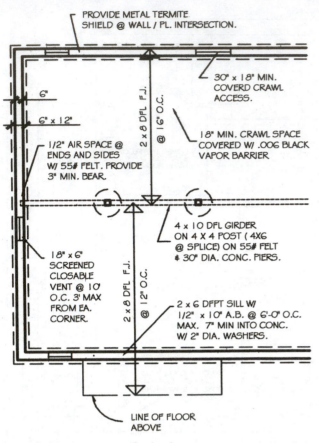

PROVIDE METAL TERMITE. SHIELD @ WALL / PL. INTERSECTION.

30" x 18" MIN. COVERD CRAWL ACCESS.

6"

6" x 12"

1/2" AIR SPACE @ ENDS AND SIDES W/ 55# FELT. PROVIDE 3" MIN. BEAR.

18" MIN. CRAWL SPACE COVERED W/ .006 BLACK VAPOR BARRIER.

2 x 8 DFL F.J. @ 16" O.C.

4 x 10 DFL GIRDER ON 4 X 4 POST (4X6 @ SPLICE) ON 55# FELT & 30" DIA. CONC. PIERS.

18" x 6" SCREENED CLOSABLE VENT @ 10' O.C. 3' MAX FROM EA. CORNER.

2 x 8 DFL F.J. @ 12" O.C.

2 x 6 DFPT SILL W/ 1/2" x 10" A.B. @ 6'-0" O.C. MAX. 7" MIN INTO CONC. W/ 2" DIA. WASHERS.

LINE OF FLOOR ABOVE

Figure 10–39 Common methods of representing and specifying floor joist components in plan view.

the plan uses a joist floor system. The left side of the structure has a basement. Problem 10–5 shows a residence with a full basement. The entire basement can be constructed using the methods that were introduced earlier, when concrete floors were discussed. Problem 10–6 shows a residence with a full basement. The major difference between Figures 3-1(b) and 3–1(c) is that the retaining wall does not totally enclose the basement. This type of basement is ideal for homes built on sloping sites. The basement is built on the low side of the site, allowing the lower walls to be constructed of wood. Notice on each side of the foundation that a retaining wall 48" (1200 mm) high has been added. The wall allows the length of the wall 8'-0" (2400 mm) high to be reduced, allowing the lower floor to be treated as an on-grade slab.

One component typically used when floor systems are combined is a ledger. A ledger is used to provide support for the floor joists and subfloor when they intersect the concrete. Unless felt is placed between the concrete and the ledger, the ledger must be pressure-treated lumber. The ledger can be shown on the foundation plan as shown in Figure 10–40.

READING A FOUNDATION PLAN

Although you have been exposed to the basic concepts of foundation plans, interpreting a plan can still be a challenge. To understand a foundation plan fully, you must view other plans first. Check the floor plan or roof framing plan to see what type of framing system was used on the roof. If trusses were used, you can

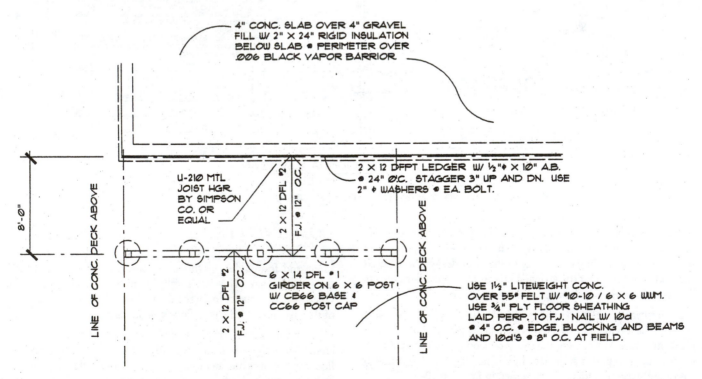

4" CONC. SLAB OVER 4" GRAVEL FILL W/ 2" X 24" RIGID INSULATION BELOW SLAB @ PERIMETER OVER .006 BLACK VAPOR BARRIOR

8'-0"

LINE OF CONC. DECK ABOVE

U-210 MTL JOIST HGR BY SIMPSON CO. OR EQUAL

2 X 12 DFL #2 F.J. @ 12" O.C.

2 X 12 DFPT LEDGER W/ 1/2"⌀ X 10" A.B. @ 24" Ø.C. STAGGER 3" UP AND DN. USE 2" ⌀ WASHERS @ EA. BOLT.

2 X 12 DFL #2 F.J. @ 12" O.C.

6 X 14 DFL #1 GIRDER ON 6 X 6 POST W/ CB66 BASE & CC66 POST CAP

LINE OF CONC. DECK ABOVE

USE 1½" LITEWEIGHT CONC. OVER 55# FELT W/ #10-10 / 6 X 6 W.W.M. USE ¾" PLY FLOOR SHEATHING LAID PERP. TO F.J. NAIL W/ 10d @ 4" O.C. @ EDGE, BLOCKING AND BEAMS AND 10d'S @ 8" O.C. AT FIELD.

Figure 10–40 A wood ledger is used to connect a wood floor to a concrete slab. The line used to represent the ledger varies with each set of plans.

expect no bearing walls throughout the center of the house, and thus no girders are required to support roof loads.

Skim the plan to determine the type of floor framing system being used. Become familiar with above-grade concrete, below-grade concrete, and girders and their supports. A quick viewing of the sections can be helpful at this point.

Once the lower floor framing system is determined, you should begin to see members characteristics of the system. Look for general notes that can set standards for the entire job that are different from the norm. Once you understand the overall components of the plan, look at the local notes to see specific requirements for this specific job. Don't make the mistake of assuming that all post-and-beam or joist foundations are always the same.

CHAPTER 10 TEST

Fill in the blanks below with the proper word or short statement as needed to complete the sentence or answer the question correctly.

1. What are the two major parts of a continuous foundation system? _____

_____ .

2. List five forces that a foundation must withstand.

_____ .

3. How can the soil texture influence a foundation?

_____ .

4. List the two major types of material used to build foundation walls. _____
_____ .

5. What type of stress requires steel to be placed in footings?
_____ .

6. What size footing should be used with a full-height basement wall? _____ .

7. What influences the size of piers? _____

_____ .

8. Describe the difference between a full-height retaining and a partial height restraining wall. _____

_____ .

9. What is considered common soil bearing pressure for most residential construction? _____
_____ .

10. Is steel placed near the soil side or air side of a retaining wall?
_____ .

11. What is the common spacing for girders in a post-and-beam floor system? _____
_____ .

12. What can be done to reduce the size of a concrete slab and to aid workers? _____

_____ .

13. What keeps floor joists from lifting off the foundation?

_____ .

14. What is the common spacing for floor joists? _____
_____ .

15. What is the common spacing for piers supporting the girders in a post-and-beam foundation and a joist foundation?

_____ .

16. What is the soil bearing capacity of sandy clay? _____
_____ .

17. What is the difference between cut and fill? _____

_____ .

18. What danger does soil freezing present to a structure?

_____ .

19. What is placed under a concrete slab to increase percolation?

_____ .

20. What is the advantage of a piling foundation? _____

_____ .

21. What is the minimum footing depth of a two-story footing placed on sandy soil? _____
_____ .

22. What is the minimum footing width of a two-story footing placed on sandy soil? _____
_____ .

23. Describe the size and the location of the rebar tyically used to bind the footing to the stem wall. _____
_____ .

24. What concrete strength is required for interior concrete slabs placed in moderate weather? _____
_____ .

25. A 4'–8" × 2'–0" chimney is to be built. What is the minimum size required for the footing? _____
_____ .

26. What information about the footing steel can you expect to find specified on the foundation plan? _____
_____ .

27. Forms are to be set for a 30" stepped footing. Are they legal?
_____ .

28. What is the maximum spacing for anchor bolts for one-story and two-story construction? _____
_____ .

29. How much space must be supplied if a girder will be supported by a stem wall? _____
_____ .

30. What are the major components of a wood retaining wall?
_____ .

31. What is used to support above-grade concrete slabs? _____
_____ .

32. What does the following specification represent: 8 × 8—W10 × 8? _____ .

33. What advantage does post-tensioning of slabs offer when compared to a normal on-grade slab? _____ _____ .

34. How is slab insulation typically protected? _____ _____ .

35. A 7–1/2" step is specified for a slab. What is the normal thickness of the slab at the step? _____ _____ .

CHAPTER 10 PROBLEMS

PROBLEM 10–1 Use the drawing shown on page 277 to answer the following questions:

1. What type of floor system is used? _____ _____ .

2. What size floor drain will be installed? _____ _____ .

3. What size will the garage slab be? _____ _____ .

4. What is the soil bearing pressure of the job site? _____ _____ .

5. Give the size of the fireplace footing. _____ _____ .

6. What is the depth of the living room recess? _____ _____ .

7. How far are the footings to extend into the ground for the two-story and for the one-story portions of the house? _____ _____ .

8. What is the overall size of the structure? _____ _____ .

9. How many piers are required to support roof or wall loads within the structure? Give the sizes of the pipes. _____ _____ _____ .

10. How many piers are required to support roof or wall loads on the exterior of the structure? Give the size of the piers. _____ _____ .

Use the floor plan in Figure 3–1 and the appropriate table in Chapter 8 to answer questions 11 through 15.

11. How will the ABWP in the front left corner of the house be attached to the foundation? _____ _____ .

12. How will the wall between the living room and family room be reinforced? _____ _____ .

13. How will the wall reinforcing at the front corner of the garage be attached to the concrete? _____ _____ .

14. Describe the foundation reinforcing required for the left side of the garage. _____ _____ .

15. How is the front face of the garage anchored to the concrete? _____ .

PROBLEM 10–2 Use the drawing shown on page 278 to answer the following questions:

1. What type of floor system is used? _____ _____ .

2. What is the soil bearing pressure of the job site? _____ _____ .

3. What is the overall size of the garage? _____ _____ .

4. How many piers are required to support roof loads or wall loads within the structure? Give the size of the piers. _____ _____ _____ .

5. List the compressive strengths of concrete to be used on this structure. _____ _____ .

6. What is the spacing of the anchor bolts? _____ _____ .

7. How many vents need to be supplied for this residence? _____ .

8. Determine the girder size and support required. _____ _____ _____ .

9. What size members are used to span between the girder and the stem wall? _____ .

10. What type and grade of framing lumber will be used? ____ _____ .

11. Show your work and determine the area of the crawl space if 6" walls are used. _____ _____ _____ .

12. What is the total amount of slope in the garage slab? _____ _____ .

13. How much concrete is required to pour the slab? _____ _____ .

14. If five extra joists are ordered for rim joist and blocking, how many 16'-long floor joists need to be ordered? _____ _____ .

15. How many linear feet of foundation will be poured for one level and two level? _____ .

Use the floor plan in Figure 3–1 and the appropriate table in Chapter 8 to answer questions 16 through 20.

16. Why is a footing and stem wall provided 22'–4" from the right rear corner? _____ _____ .

17. How will the wall between the garage and shop be reinforced? _____ _____ .

18. How is the face on the right side garage wall anchored to the concrete? _____ _____ .

19. How will the footing for the ABWP in the front left corner of the garage be reinforced? _____ _____ .

20. What will support the ABWP that is 13'–0" from the left side of the the entry? _____ _____ .

PROBLEM 10–3 Use the drawing shown on page 279 to answer the following questions:

1. What type of floor system is used? _____ _____ .

2. What is the soil bearing pressure of the job site? _____ _____ .

3. How many piers are required to support roof loads or wall loads within the structure? Give the size of the piers. _____ _____ _____ .

4. Determine the girder size and support required to support the floor loads. _____ _____ _____ .

5. What size door is on the left side of the garage? _____ _____ .

6. What size floor joist will be used with this floor system? _____ .

7. What size washers will be used with the anchor bolts? _____ .

8. What type of fill material will be used under the garage slab? _____ .

9. What is the minimum height of the crawl space? _____ _____ .

10. At what scale was this print drawn? _____ _____ .

11. How much concrete will be required to pour all of the interior piers? _____ _____ _____ _____ .

12. If the lower left corner of the house had a finish grade elevation of 10'–2", what would be the elevation of the ground 10'–0" away from the structure? _____ _____ .

13. If the lower left corner of the house had a finish grade elevation of 10'–2", what is the elevation of the floor if 1–5/8" decking is used? _____ _____ .

14. What is the area of the fireplace footing? _____ _____ .

15. How many anchor bolts should be purchased? _____ _____ .

Use the floor plan in Figure 3–1 and the appropriate table from Chapter 8 to answer questions 16 through 20.

16. How will the portal frame at the front of the garage be attached to the concrete? _____ _____ .

17. How many anchor bolts are required for the ABWP in the front left corner of the house where it is attached to the foundation? _____ _____ .

18. How will the strap at the wall between the shop and utility room be attached to the support post? _____ _____ .

19. What size footing is required, and how will the footing for the front face of the garage be reinforced? _____ _____ .

20. Why is the BWP listed as A/1 required? _____ _____ .

PROBLEM 10–4 Use the drawing shown on page 280 to answer the following questions:

1. What type of floor system is used? _____ _____ .

2. What is the soil bearing pressure of the job site? _____ _____ .

3. Determine the girder size and support required to support the floor loads. _____ _____ .

4. What size door is on the right side of the garage? _____ _____ .

5. What size floor joist will be used with this floor system? _____

6. What spacing will be used with the anchor bolts around the basement wall? _____ .

7. What type of fill material will be used under the garage slab? _____ .

8. What size steel could be used to reduce the stem wall thickness? _____ .

9. What are the window wells to be made of? _____ _____ .

10. How thick is the wall on the right side of the basement? _____ .

11. What is the area of the basement slab? _____ _____ .

12. How many blocks are required to be cut to support the concrete wall at the right side of the basement?_____ _____ .

13. How many 16' long floor joists will need to be ordered to support the floor above the basement? _____ _____ .

14. How many 14' long floor joist will need to be ordered to support the floor above the basement? _____ _____ .

15. How many vents will need to be ordered? _____ _____ .

Use the floor plan in Figure 3–1 and the appropriate table from Chapter 8 to answer questions 16 through 20.

16. Why is the BWP at the left rear corner different from the BWP at the right end of the structure? _____ _____ .

17. What is used to resist uplift of the front porch roof? _____ _____ .

18. The BWP between the storage room and the family room is specified, but no anchorage is specified. The boss is not around, the concrete is setting, and you must make the decision. How will you anchor this wall to the footing? _____ _____ _____ .

19. What will tie the floor joists to the basement walls? _____ _____ .

20. How will the BWPs at the basement level be attached to the concrete? _____ _____ .

PROBLEM 10–5 Use the drawing shown on page 281, the floor plan in Figure 3–1, and the appropriate table in Chapter 8 to answer the following questions:

1. What type of basement wall is used for this home? _____ _____ .

2. How will the basement wall be protected from moisture? _____ .

3. How will the floor joists be anchored to the mudsill? _____ _____ .

4. What is the size and spacing of the anchor bolts at the retaining wall? _____ _____ .

5. What is the size and spacing of the anchor bolts at the stem wall for one-level construction? _____ _____ .

6. What size footing is required under the front face of the garage? _____ _____ .

7. What size footing is required to support the footing under the wall dividing the family room and storage room? _____ _____ .

8. What size piers support the porch roof? _____ _____ .

9. What type of mudsills are used? _____ _____ .

10. What size stem walls are specified? _____ _____ .

11. How will the multilevel BWP be attached to the concrete? _____ .

12. Ho will the footing for the portal frames be reinforced? _____ .

13. Describe the PSI of the garage. _____ _____ .

14. What size footing will support the retaining wall? _____ _____ .

15. If this house were built in your area, what would most likely be used to build the wall? _____ _____ .

16. Solid blocking is specified on the left end of the basement wall. What purpose does it serve? _____ _____ .

17. What size bolts are used to attach the single-level ABWP to the foundation? _____ _____ .

18. Describe the location for reinforcing steel if 6" stem walls are to be used. _____ _____ .

19. What is the maximum distance from a wall corner that anchor bolts can be located? _____ _____ .

20. How are the posts at the end of the single-story BWPs attached to the concrete? _____ _____ .

PROBLEM 10–6 Use the drawing shown on page 282, detail 10–20, the floor plan in Figure 3–1, and the appropriate table in Chapter 8 to answer the following questions:

1. How is the basement different from the basement in Problem 10–5. _____ _____ .

2. How will a three-level wood wall be anchored to the concrete? _____ _____ .

3. What size footing will support the partial height retaining wall? _____ _____ .

4. What spacing will be used to attach the mudsills to the full-height retaining wall? _____ _____ .

5. If this home were constructed in your area, would drainage be required around the perimeter? If so, describe what material is usually used. _____ _____ .

6. How will the garage slab be protected from cracking? _____ _____ .

7. How will the sills for two-level wood walls be anchored to the concrete? _____ _____ .

8. What type of mudsill is used and how is it anchored for portal frames? _____ _____ .

9. How will the one-level wood walls be anchored to the concrete? _____ _____ .

10. What will protect the basement slab from moisture? _____ _____ .

11. Why does the footing at the front face of the garage need to extend the entire width? _____ _____ .

12. If this home were built in your area under current codes, what soil bearing pressure would you assume? _____ _____ .

13. How many anchor bolts are required to attach the multi-level BWPs? _____ _____ .

14. How many anchor bolts are required to attach the single-level BWPs? _____ _____ .

15. How many anchor bolts are required to attach the single-level BWPs? _____ _____ .

16. How is the stem wall attached to the footing at the single-level ABWP? _____ _____ .

17. How will the end post in the braced wall line on the left side of the garage be attached to the foundation? _____ _____ .

18. How will the partial height retaining wall be reinforced? _____ .

19. Describe the steel that will be placed in the footing for the partial height retaining wall. _____ _____ .

20. Although it is not specified, what size and spacing for anchor bolts would you use for the partial height wall? _____ _____ .

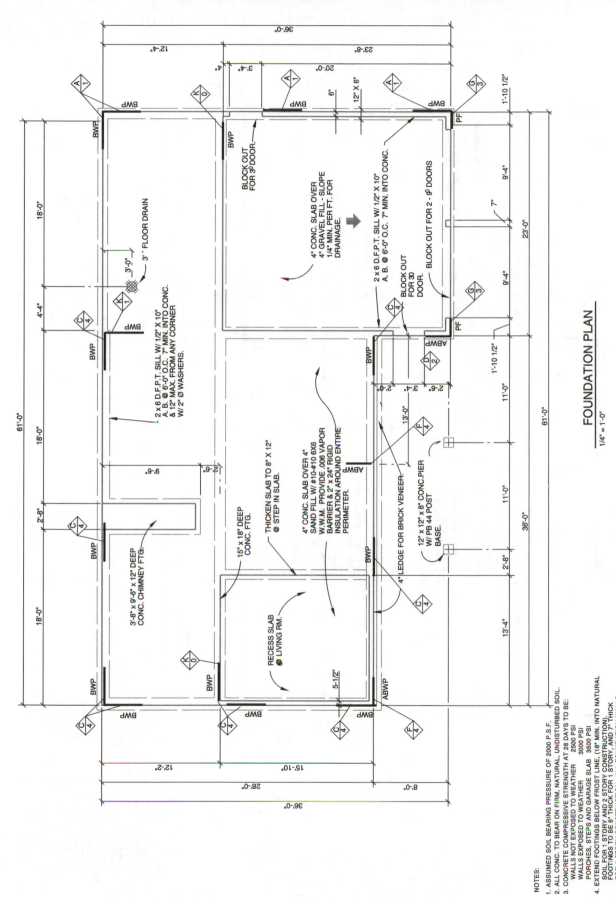

FOUNDATION PLAN
1/4" = 1'-0"

Text visible within the drawing:

- 2 x 6 D.F.P.T. SILL W/ 1/2" X 10" A.B. @ 6'-0" O.C. 7" MIN. INTO CONC. & 12" MAX. FROM ANY CORNER W/ 2" Ø WASHERS.
- 3" FLOOR DRAIN
- BLOCK OUT FOR 3⁰ DOOR.
- 4" CONC. SLAB OVER 4" GRAVEL FILL - SLOPE 1/4" MIN. PER FT. FOR DRAINAGE.
- 2 x 6 D.F.P.T. SILL W/ 1/2" X 10" A.B. @ 6'-0" O.C. 7" MIN. INTO CONC.
- BLOCK OUT FOR 30 DOOR.
- BLOCK OUT FOR 2 - 9⁰ DOORS
- 3'-8" x 9'-6" x 12" DEEP CONC. CHIMNEY FTG.
- 15" x 18" DEEP CONC. FTG.
- THICKEN SLAB TO 8" X 12" @ STEP IN SLAB.
- 4" CONC. SLAB OVER 4" SAND FILL W/ #10-#10 6X6 W.W.M. PROVIDE .006 VAPOR BARRIER & 2" x 24" RIGID INSULATION AROUND ENTIRE PERIMETER.
- 4" LEDGE FOR BRICK VENEER.
- 12" x 12" x 8" CONC. PIER W/ PB 44 POST BASE.
- RECESS SLAB @ LIVING RM.

Dimensions visible: 36'-0", 12'-4", 23'-8", 3'-4", 20'-0", 4", 6", 12" X 6", 1'-10 1/2", 18'-0", 4'-4", 18'-0", 9'-6", 2'-8", 18'-0", 9'-6", 5-1/2", 13'-4", 2'-8", 11'-0", 38'-0", 11'-0", 1'-10 1/2", 2'-6", 3'-4", 2'-0", 13'-0", 9'-4", 7", 23'-0", 9'-4", 61'-0", 61'-0", 12'-2", 15'-10", 28'-0", 8'-0", 36'-0"

NOTES:

1. ASSUMED SOIL BEARING PRESSURE OF 2000 P.S.F.
2. ALL CONC. TO BEAR ON FIRM, NATURAL, UNDISTURBED SOIL.
3. CONCRETE COMPRESSIVE STRENGTH AT 28 DAYS TO BE:
 - WALLS NOT EXPOSED TO WEATHER 2500 PSI
 - WALLS EXPOSED TO WEATHER 3000 PSI
 - PORCHES, STEPS AND GARAGE SLAB 3500 PSI
4. EXTEND FOOTINGS BELOW FROST LINE, (18" MIN. INTO NATURAL SOIL FOR 1 STORY AND 2 STORY CONSTRUCTION). FOOTINGS TO BE 6" THICK FOR 1 STORY, AND 7" THICK FOR 2 STORY CONSTRUCTION. ALL FOUNDATION WALLS TO BE 8" WIDE, UNLESS STEEL IS PROVIDED WITHIN 2" BUT NOT CLOSER THAN 1" FROM THE FACE OF THE WALL AWAY FROM THE SOIL. STEEL TO BE 2- #3'S HORIZONTAL.
5. THE GRADE AWAY FROM THE FOUNDATION WALLS TO FALL A MIN. OF 6" WITHIN THE FIRST 10 FEET.

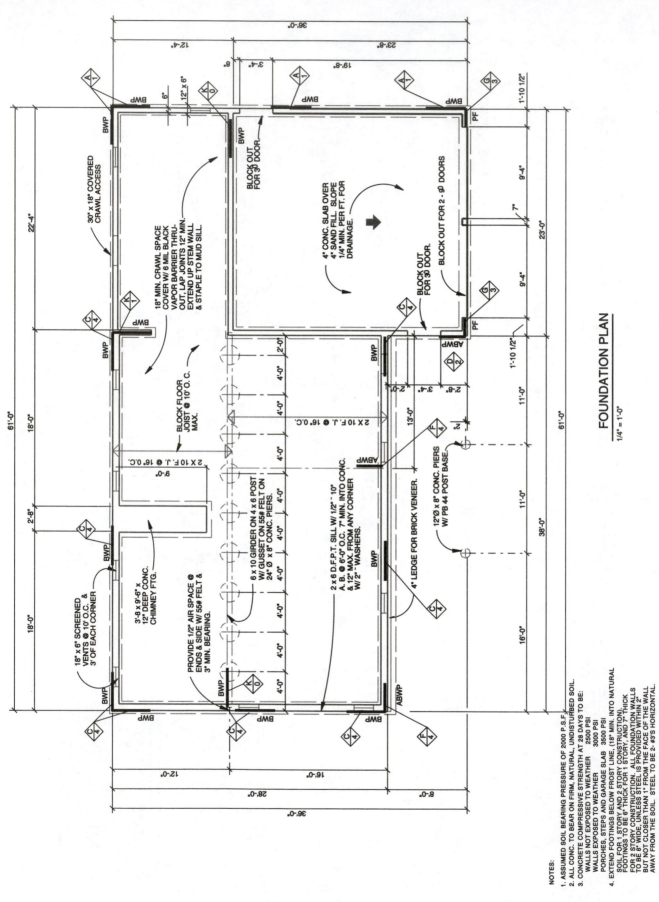

FOUNDATION PLAN

1/4" = 1'-0"

NOTES:

1. ASSUMED SOIL BEARING PRESSURE OF 2000 P.S.F.
2. ALL CONC. TO BEAR ON FIRM, NATURAL, UNDISTURBED SOIL.
3. CONCRETE COMPRESSIVE STRENGTH AT 28 DAYS TO BE:
 WALLS NOT EXPOSED TO WEATHER 2500 PSI
 WALLS EXPOSED TO WEATHER 3000 PSI
 PORCHES, STEPS AND GARAGE SLAB 3500 PSI
4. EXTEND FOOTINGS BELOW FROST LINE. (18" MIN. INTO NATURAL
 SOIL. FOR 1 STORY AND 2 STORY CONSTRUCTION).
 FOOTINGS TO BE 6" THICK FOR 1 STORY, AND 7" THICK
 FOR 2 STORY CONSTRUCTION. ALL FOUNDATION WALLS
 TO BE 8" WIDE, UNLESS STEEL IS PROVIDED WITHIN 2"
 BUT NOT CLOSER THAN 1" FROM THE FACE OF THE WALL.
 AWAY FROM THE SOIL. STEEL TO BE 2 - #3'S HORIZONTAL.
5. THE GRADE AWAY FROM THE FOUNDATION WALLS TO FALL
 A MIN. OF 6" WITHIN THE FIRST 10 FEET.
6. ALL FRAMING LUMBER TO BE DOUGFIR LARCH # 2.

Problem 10–2

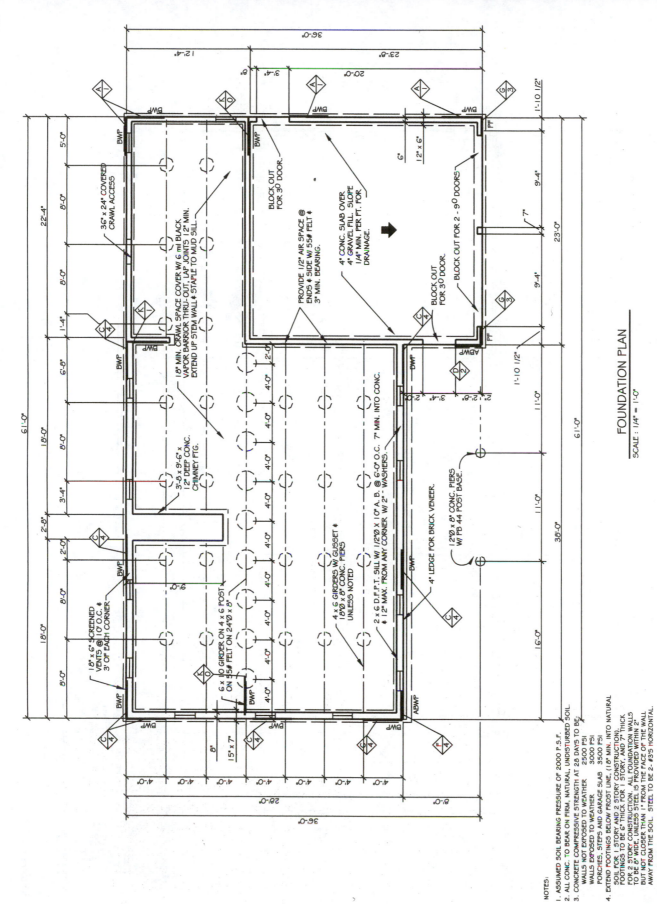

FOUNDATION PLAN

SCALE : 1/4" = 1'-0"

NOTES:
1. ASSUMED SOIL BEARING PRESSURE OF 2000 P.S.F.
2. ALL CONC. TO BEAR ON FIRM, NATURAL, UNDISTURBED SOIL.
3. CONCRETE COMPRESSIVE STRENGTH AT 28 DAYS TO BE:
 WALLS NOT EXPOSED TO WEATHER 2500 PSI
 WALLS EXPOSED TO WEATHER 3000 PSI
 PORCHES, STEPS AND GARAGE SLAB 3500 PSI
4. EXTEND FOOTINGS BELOW FROST LINE, (18" MIN. INTO NATURAL
 SOIL FOR 1 STORY AND 2 STORY CONSTRUCTION).
 FOOTINGS TO BE 6" THICK FOR 1 STORY, AND 7" THICK
 FOR 2 STORY CONSTRUCTION. ALL FOUNDATION WALLS
 TO BE 6" WIDE, UNLESS STEEL IS PROVIDED WITHIN 2"
 BUT NOT CLOSER THAN 1" FROM THE FACE OF THE WALL
 AWAY FROM THE SOIL. STEEL TO BE 2- #35 HORIZONTAL.
5. THE GRADE AWAY FROM THE FOUNDATION WALLS TO FALL
 A MIN. OF 6" WITHIN THE FIRST 10 FEET.
6. ALL FRAMING LUMBER TO BE DOUGFIR LARCH # 2.

Problem 10-3

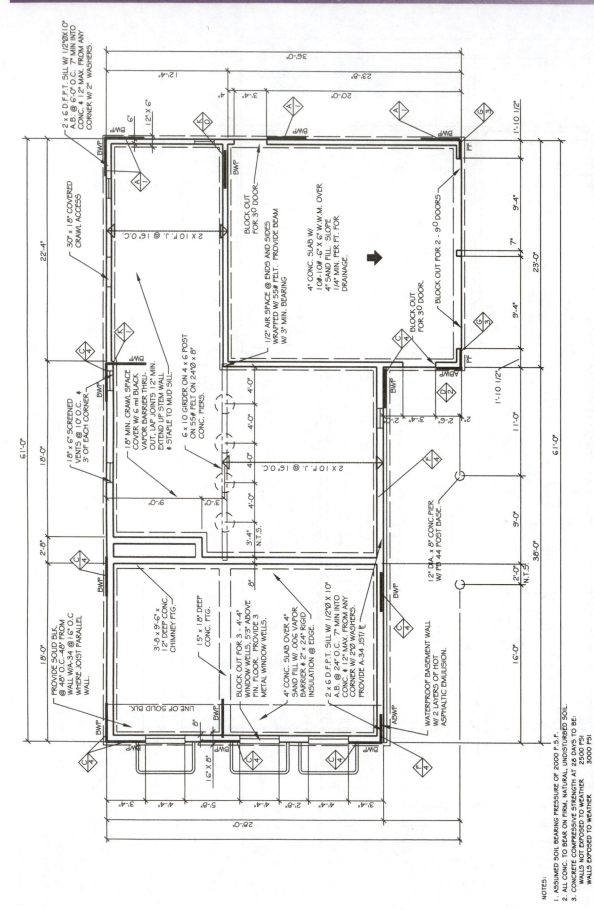

FOUNDATION PLAN

1/4" = 1'-0"

NOTES:
1. ASSUMED SOIL BEARING PRESSURE OF 2000 P.S.F.
2. ALL CONC. TO BEAR ON FIRM, NATURAL, UNDISTURBED SOIL.
3. CONCRETE COMPRESSIVE STRENGTH AT 28 DAYS TO BE:
 WALLS NOT EXPOSED TO WEATHER 2500 PSI
 WALLS EXPOSED TO WEATHER 3000 PSI
 PORCHES, STEPS AND GARAGE SLAB 3500 PSI
4. EXTEND FOOTINGS BELOW FROST LINE. (18" MIN. INTO NATURAL
 SOIL FOR 1 STORY AND 2 STORY CONSTRUCTION).
 FOOTINGS TO BE 6" THICK FOR 1 STORY, AND 7" THICK
 FOR 2 STORY CONSTRUCTION. ALL FOUNDATION WALLS
 TO BE 8" WIDE, UNLESS STEEL IS PROVIDED WITHIN 2"
 BUT NOT CLOSER THAN 1" FROM THE FACE OF THE WALL
 AWAY FROM THE SOIL. STEEL TO BE 2 - #35 HORIZONTAL.
5. THE GRADE AWAY FROM THE FOUNDATION WALLS TO FALL
 A MIN. OF 6" WITHIN THE FIRST 10 FEET.

Problem 10-4

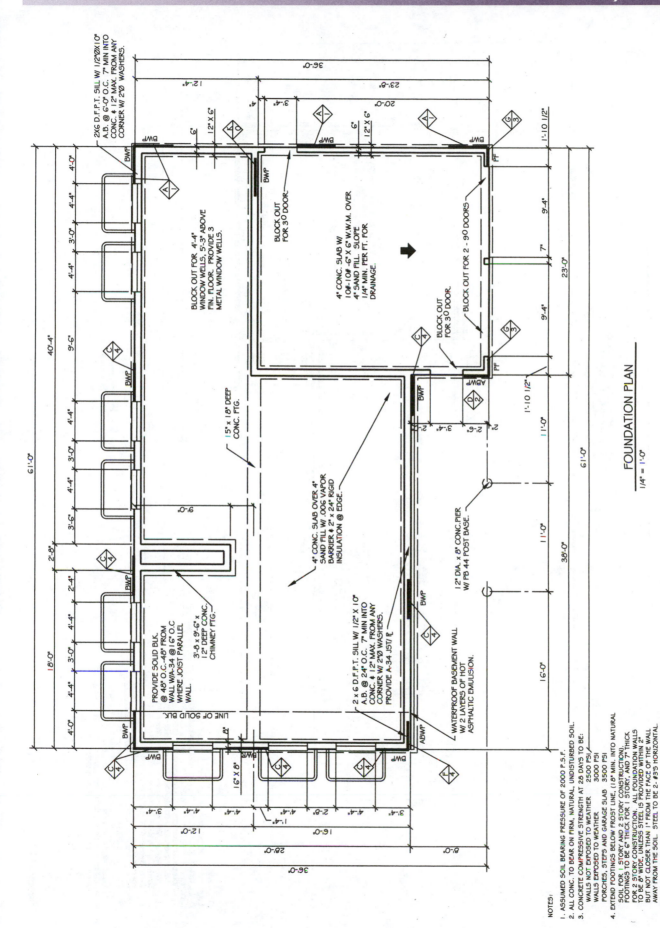

FOUNDATION PLAN
1/4" = 1'-0"

NOTES:
1. ASSUMED SOIL BEARING PRESSURE OF 2000 P.S.F.
2. ALL CONC. TO BEAR ON FIRM, NATURAL, UNDISTURBED SOIL.
3. CONCRETE COMPRESSIVE STRENGTH AT 28 DAYS TO BE:
 WALLS NOT EXPOSED TO WEATHER 2500 PSI
 WALLS EXPOSED TO WEATHER 3000 PSI
 PORCHES, STEPS AND GARAGE SLAB 3500 PSI
4. EXTEND FOOTINGS BELOW FROST LINE, (18" MIN. INTO NATURAL
 SOIL FOR 1 STORY AND 2 STORY CONSTRUCTION),
 FOOTINGS TO BE 6" THICK FOR 1 STORY, AND 7" THICK
 FOR 2 STORY CONSTRUCTION. ALL FOUNDATION WALLS
 TO BE 8" WIDE, UNLESS STEEL IS PROVIDED WITHIN 2"
 BUT NOT CLOSER THAN 1" FROM THE FACE OF THE WALL
 AWAY FROM THE SOIL. STEEL TO BE 2 - #3'S HORIZONTAL.
5. THE GRADE AWAY FROM THE FOUNDATION WALLS TO FALL
 A MIN. OF 6" WITHIN THE FIRST 10 FEET.
6. ALL FRAMING LUMBER TO BE DOUGFIR LARCH # 2.

Problem 10-5

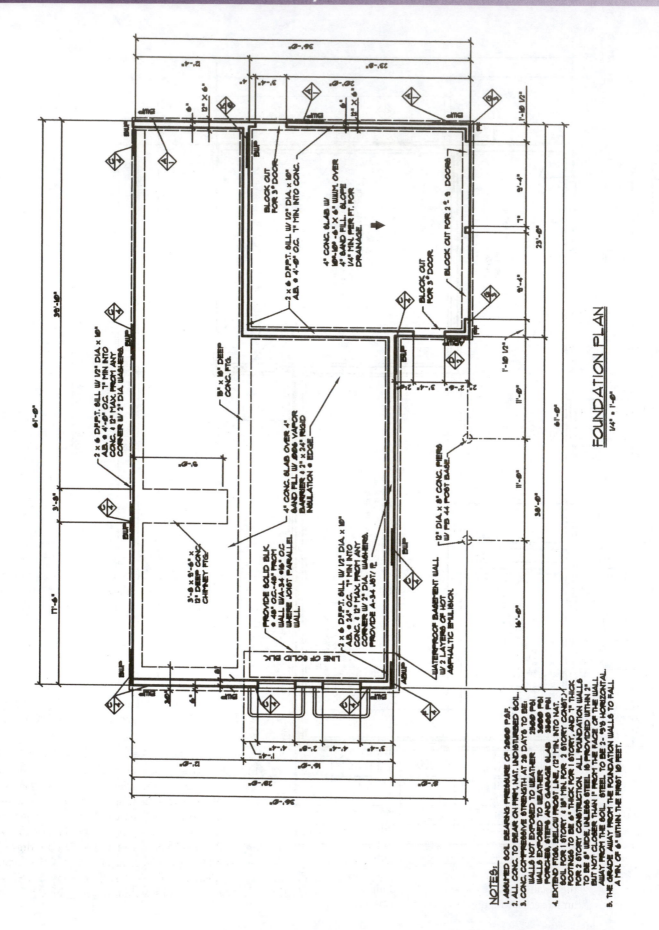

FOUNDATION PLAN
1/4" = 1'-0"

Problem 10-6

CHAPTER 11

Reading Sections and Details

CHAPTER OVERVIEW

This chapter covers the following topics:

- Types of sections
- Scale
- Section alignment

- Reading sections
- Test
- Problems

Sections are drawn to show the vertical relationships of the structural materials called for on the floor, framing, and foundation plans. The sections show the methods of construction for the framing crew. Before working with sections, it is important to understand the different types of sections, their common scales, and the relationship of the cutting plane to the section.

TYPES OF SECTIONS

Three types of sections may be included in a set of plans: full sections, partial sections, and details.

For a simple structure, only one section might be required to explain fully the types of construction to be used. A full section is a section that cuts through the entire building. A full section can be seen in Figure 11–1. A structure can have several full sections, depending on the different types of construction materials and techniques used. An alternative to using several full sections is to use a full section showing typical framing techniques and a partial section. The partial section can be used to show atypical construction methods, such as variations of the roof or foundation. Figure 11–2 shows a partial section. Depending on the complexity of the project, details or enlargements of a section may also be required. An area of the section where several items intersect or where many small items are required are examples of when a detail might be required. An example of a foundation detail can be seen in Figure 11–3. When details are drawn, a section is often drawn with very little information placed on it. This section serves as a reference map to indicate how the details relate to each other. An example of this type of section can be seen in Figure 11–4, with a portion of

the related details seen in Figure 11–5. Each detail is specified by a letter over a number. The bottom number indicates on which page the detail can be found. The upper letters specify the detail location on the page. Some companies use numbers instead of letters, but the principle remains the same.

By combining the information on the framing plans and the sections, the contractor should be able to make accurate estimates of the amount of material required and the cost of completing the project. To help make the sections easier to read, sections have become somewhat standardized in several areas. These include the areas of scales and alignment.

SCALE

Sections are typically drawn at a scale of 3/8" = 1'–0". Scales of 1/8" or 1/4" may be used for supplemental sections requiring little detail. A scale of 3/4" = 1'–0" or larger may be required to draw some construction details.

The primary section is usually drawn at a scale of 3/8" = 1'–0". The main advantage of using this scale is the ease of distinguishing each structural member. At a smaller scale separate members, such as the finished flooring and the rough flooring, are difficult to read. Without good clarity, problems can arise at the job site. Often, if more than one section must be drawn, the primary section is drawn at 3/8" = 1'–0" and the other sections are drawn at 1/4" = 1'–0". By combining drawings at these two scales, typical information can be placed on the 3/8" section, and the 1/4" sections are used to show variations with little detail.

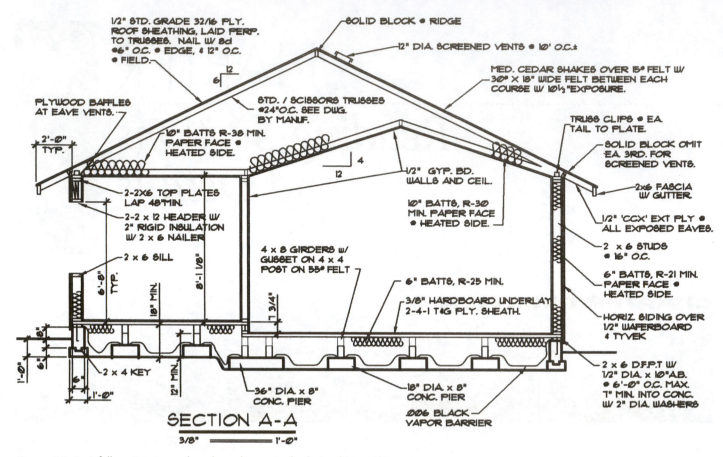

1/2" STD. GRADE 32/16 PLY.
ROOF SHEATHING, LAID PERP.
TO TRUSSES. NAIL W/ 8d
@6" O.C. @ EDGE, & 12" O.C.
@ FIELD.

SOLID BLOCK @ RIDGE

12" DIA. SCREENED VENTS @ 10' O.C.±

MED. CEDAR SHAKES OVER 15# FELT W/
30# X 18" WIDE FELT BETWEEN EACH
COURSE W/ 10½" EXPOSURE.

PLYWOOD BAFFLES
AT EAVE VENTS.

STD. / SCISSORS TRUSSES
@24"O.C. SEE DWG.
BY MANUF.

TRUSS CLIPS @ EA.
TAIL TO PLATE.

2'-0"
TYP.

10" BATTS R-38 MIN.
PAPER FACE @
HEATED SIDE.

SOLID BLOCK OMIT
EA. 3RD. FOR
SCREENED VENTS.

4
12

1/2" GYP. BD.
WALLS AND CEIL.

2x6 FASCIA
W/ GUTTER

2-2X6 TOP PLATES
LAP 48"MIN.

10" BATTS, R-30
MIN. PAPER FACE
@ HEATED SIDE.

1/2" 'CCX' EXT PLY @
ALL EXPOSED EAVES.

2-2 x 12 HEADER W/
2" RIGID INSULATION
W/ 2 x 6 NAILER

2 x 6 STUDS
@ 16" O.C.

2 x 6 SILL

4 x 8 GIRDERS W/
GUSSET ON 4 x 4
POST ON 55# FELT

6" BATTS, R-21 MIN.
PAPER FACE @
HEATED SIDE.

6'-8"
TYP.

8-1½"

6" BATTS, R-25 MIN.

HORIZ SIDING OVER
1/2" WAFERBOARD
& TYVEK

18" MIN.

7 3/4"

3/8" HARDBOARD UNDERLAY
2-4-1 T&G PLY. SHEATH.

2 x 4 KEY

12" MIN.

1'-0"

6"

36" DIA x 8"
CONC. PIER

18" DIA x 8"
CONC. PIER

2 x 6 D.F.P.T W/
1/2" DIA. x 10"A.B.
@ 6'-0" O.C. MAX.
7" MIN. INTO CONC.
W/ 2" DIA. WASHERS

1'-0"

.006 BLACK
VAPOR BARRIER

SECTION A-A

3/8" = 1'-0"

Figure 11–1 A full section is used to show the vertical relationships within a structure.

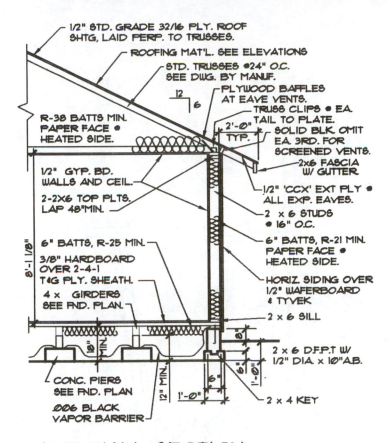

1/2" STD. GRADE 32/16 PLY. ROOF
SHTG. LAID PERP. TO TRUSSES.

ROOFING MAT'L. SEE ELEVATIONS

STD. TRUSSES @24" O.C.
SEE DWG. BY MANUF.

PLYWOOD BAFFLES
AT EAVE VENTS.

TRUSS CLIPS @ EA.
TAIL TO PLATE.

SOLID BLK. OMIT
EA. 3RD. FOR
SCREENED VENTS.

2x6 FASCIA
W/ GUTTER

1/2" 'CCX' EXT PLY @
ALL EXP. EAVES.

2 x 6 STUDS
@ 16" O.C.

6" BATTS, R-21 MIN.
PAPER FACE @
HEATED SIDE.

HORIZ. SIDING OVER
1/2" WAFERBOARD
& TYVEK

2 x 6 SILL

2 x 6 D.F.P.T. W/
1/2" DIA. x 10" A.B.

2 x 4 KEY

R-38 BATTS MIN.
PAPER FACE @
HEATED SIDE.

1/2" GYP. BD.
WALLS AND CEIL.

2-2x6 TOP PLTS.
LAP 48" MIN.

6" BATTS, R-25 MIN.

3/8" HARDBOARD
OVER 2-4-1
T&G PLY. SHEATH.

4 x GIRDERS
SEE FND. PLAN.

CONC. PIERS
SEE FND. PLAN

.006 BLACK
VAPOR BARRIER

TYP. WALL SECTION
3/8" ══════════════ 1'-0"

Figure 11–2 A partial section shows the construction methods for a specific area of a structure to supplement a full section.

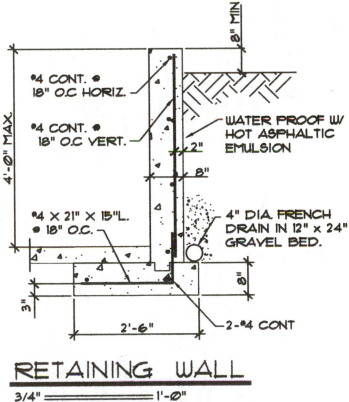

8" MIN.

#4 CONT. @
18" O.C. HORIZ.

#4 CONT. @
18" O.C. VERT.

4'-0" MAX.

#4 X 21" X 15" L.
@ 18" O.C.

WATER PROOF W/
HOT ASPHALTIC
EMULSION

2"

8"

4" DIA. FRENCH
DRAIN IN 12" x 24"
GRAVEL BED.

8"

3"

2'-6"

2-#4 CONT

RETAINING WALL
3/4" ══════════════ 1'-0"

Figure 11–3 Many parts of a structure need more clarity than can be gained in a full or partial section. Details are part of a job to provide clarity.

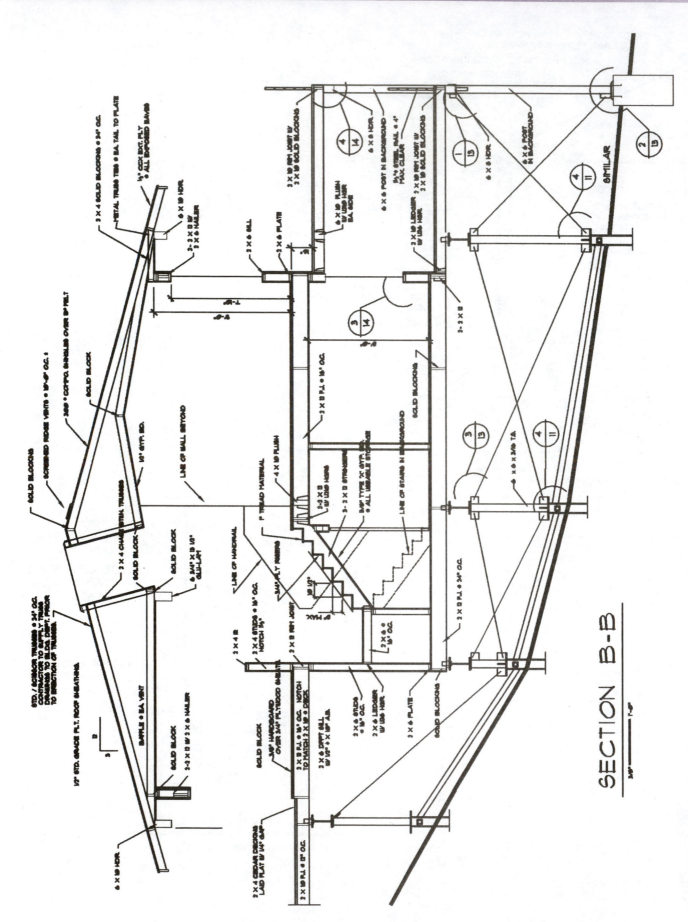

SECTION B-B

Figure 11-4 On a complicated project a section may be used to provide a reference map to show how construction details relate to the overall project.

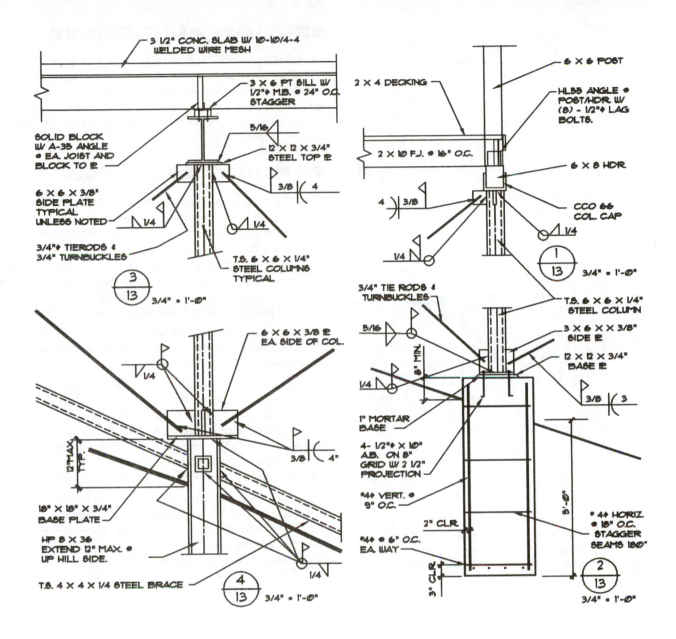

Figure 11–5 Details provide an enlarged view of construction methods.

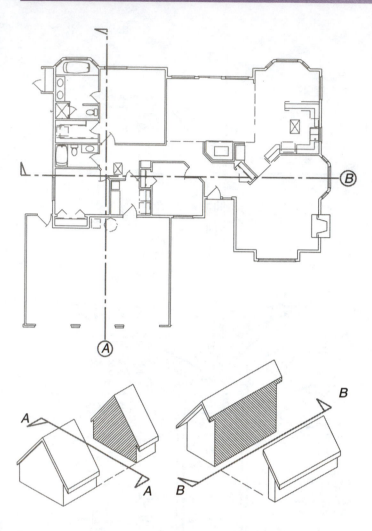

Figure 11–6 The cutting plane on the framing plan shows the direction from which the section is to be viewed. Always try to keep the cutting-plane arrows pointing to the left or to the top of the page.

SECTION ALIGNMENT

When reading sections, as with other parts of the plans, the drawing is read from the bottom or right side of the page. The cutting plane on the floor or framing plan shows which way the section is being viewed. The arrows of the cutting plane normally point to the top or left side of the paper, depending on the area of the building being sectioned. See Figure 11–6.

READING SECTIONS

Before trying to gain information from the sections, study the floor, foundation, and framing plans and elevations to gain a general understanding of the structure. Look for general information such as how many floors will be constructed. For each level in the sections, a floor or framing plan should be available to provide sizes and layout. Determine the main material used to construct walls. The use of wood or metal studs and brick or concrete blocks will affect what you should be expecting to find as you enter the sections.

As you study the sections, determine how many have been drawn, and make sure you can find a cutting plane on the floor or framing plan.

Once you feel comfortable with the basic layout of the structure, examine the main section and look for basic materials used to construct the floor, walls, and roofs. Now compare the main section to the other sections and try to determine why the other sections were drawn. The sections may only show shape variation from one area of the building to another. A variety of building materials may be seen only by drawing these additional sections.

Having determined general knowledge of the structure relating to its shape and basic materials, you can now search the sections for specific information. The sections show information about connections, intersections of structural members, and other information necessary to construct the structure.

CHAPTER 11 TEST

Place the name of the framing member in the space provided on the drawings on this page. Do not give specific sizes, such as 1/2" plywood, but answer in general terms, such as "roof sheathing."

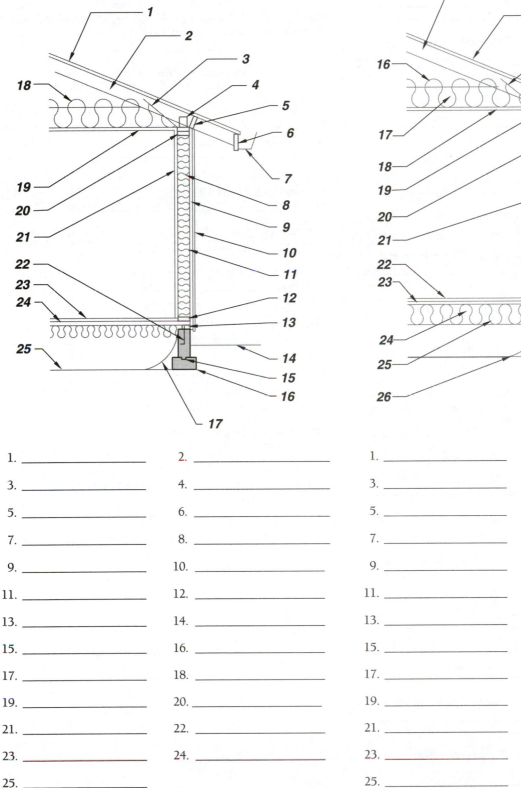

1. _____ 2. _____
3. _____ 4. _____
5. _____ 6. _____
7. _____ 8. _____
9. _____ 10. _____
11. _____ 12. _____
13. _____ 14. _____
15. _____ 16. _____
17. _____ 18. _____
19. _____ 20. _____
21. _____ 22. _____
23. _____ 24. _____
25. _____

1. _____ 2. _____
3. _____ 4. _____
5. _____ 6. _____
7. _____ 8. _____
9. _____ 10. _____
11. _____ 12. _____
13. _____ 14. _____
15. _____ 16. _____
17. _____ 18. _____
19. _____ 20. _____
21. _____ 22. _____
23. _____ 24. _____
25. _____ 26. _____

CHAPTER 11 PROBLEMS

PROBLEM 11–1 Use Figure 11–1 to answer the following questions:

1. What type of trusses will be used? _____
 _____ .

2. What type of floor system will be used? _____
 _____ .

3. What is the required depth of exterior footing? _____
 _____ .

4. What size girders are used? _____
 _____ .

5. What is the pitch of the bottom chord that forms the vaulted ceiling? _____
 _____ .

6. Will the foundation be created using a mono pour? _____
 _____ .

7. What will keep ground moisture from building up in the residence? _____
 _____ .

8. List the different values required for batt insulation. _____
 _____ .

9. What is the required spacing for anchor bolts? _____
 _____ .

10. What will the siding be placed over? _____
 _____ .

PROBLEM 11–2 Use Figures 11–4 and 11–5 to answer the following questions:

1. What size floor joists will be used? _____
 _____ .

2. What are the ceiling heights? _____
 _____ .

3. What size post will support the deck? _____
 _____ .

4. What detail will explain how a wood floor beam will attach to support posts? _____
 _____ .

5. What detail will explain how a steel floor beam will attach to support columns? _____
 _____ .

6. What detail will explain how a steel column will attach to support pilings? _____
 _____ .

7. What detail will explain how a wood post will attach to concrete support pilings? _____
 _____ .

8. 3/4" tie rods and turnbuckles are used to provide lateral support to the lower levels of this home. How do the tie rods and turnbuckles attach to the columns? _____
 _____ .

9. How will the steel columns attach to the concrete footings?
 _____ .

10. Give the size of the steel braces placed between the steel pilings parallel to the ground. _____
 _____ .

11. Give the size of the top plate in Detail 3/13 and explain how the top plate will be attached to the column. _____
 _____ .

12. How will the base plate for the steel column be attached to the steel piling? _____
 _____ .

13. What size verical rebar is required for the concrete footing shown in Detail 2/13? _____
 _____ .

14. What size steel columns are used to support the lower floor?
 _____ .

15. Explain what will attach the floor joists to the steel support beams. _____
 _____ .

16. What type of welds will attach the steel beam to the base plate and support column? _____
 _____ .

17. According to Detail 1/13, how will the 3/4" tie rods be attached to the side plates? _____
 _____ .

18. How will the CCO-66 column cap be attached to the steel column? _____
 _____ .

19. Give the size of the steel piling, and explain how much of it must be visible. _____
 _____ .

20. Describe the placement of the steel in the concrete piers in Detail 2/13. _____
 _____ .

PROBLEM 11–3 Use Section AA, Shown on page 293, to provide answers to the following questions:

1. How many types of floors will be constructed for this structure? _____ .

2. What size are the rafters for the main roof? _____
_____ .

3. What size rafters are used for the porch roof? _____
_____ .

4. What size and type of roof insulation will be used?_____
_____ .

5. What is the plate height for each level? _____
_____ .

6. What size footing will be used at the interior load-bearing wall? _____ .

7. How deep are the exterior footings to be set? _____
_____ .

8. What will the concrete slab be built over? _____
_____ .

9. Give the nail size and spacing for the floor sheathing. ____
_____ .

10. Give the nail size and spacing for the roof sheathing. _____
_____ .

11. How will the foundation be insulated? _____
_____ .

12. What will be the lap of the top plates? _____
_____ .

13. What sizes of fascias will be used? _____
_____ .

14. What is the roof pitch? _____
_____ .

15. If the roof is 30' wide, how high above the top plate will the roof be at the ridge? _____
_____ .

16. How far below the top plate will the bottom of the trusses extend? _____
_____ .

17. What will prevent uplift of the front porch? _____
_____ .

18. What will keep the brick from falling away from the stud wall? _____ .

19. Why would the 26 ga. at the front porch flashing be specified? _____ .

20. The kitchen will have a lowered ceiling. How will this ceiling be supported? _____ .

PROBLEM 11–4 Use Section BB, shown on page 294, to answer the following questions:

1. What type of roofing will be used? _____
_____ .

2. What will the siding be installed over? _____
_____ .

3. What will the underlayment for the brick be? _____
_____ .

4. What size floor joists will be used on the upper floor? ____
_____ .

5. What size floor joists will be used on the lower floor? ____
_____ .

6. What will the crawl space be covered with? _____
_____ .

7. How wide will the stem walls be? _____
_____ .

8. What size post will be used to support the front porch?
_____ .

9. If the window headers are set at 6'–8", will they be o.k.?

_____ .

10. What thickness of floor sheathing will be used on the upper floor? _____
_____ .

11. What thickness of floor sheathing will be used on the lower floor? _____
_____ .

12. List the R values for the following members of this house:

 Roof _____

 Upper floor _____

 Lower floor _____

 Walls _____

13. What size girders are to be used? _____
_____ .

14. Will 15# felt be suitable underlayment for the walls? Explain your answer. _____
_____ .

15. What size and spacing of anchor bolts will be used? _____
_____ .

PROBLEM 11–5 Use Section CC, shown on page 295, to answer the following questions:

1. What type of floor system will be used on the lower floor? _____ .

2. What type of roof system will be used? _____ .

3. What spacing is used on the roof trusses? _____ .

4. What size of studs will be used? _____ .

5. List the size of the subfloor. _____ .

6. What will support the main girder? _____ .

7. How will the wallboard be supported by the 4" headers? _____ .

8. The sill is DFPT. What do these letters stand for? _____ .

9. What size and spacing are the rafters over the porch? _____ .

10. What will be used to control airflow through the 4" headers? _____ .

11. What will the exterior siding be placed over? _____ .

12. How will the upper ceiling be finished? _____ .

13. What will provide ventilation to the upper rafters? _____ .

14. What is the height of the kitchen ceiling? _____ .

15. What is the exposure of the finished roofing? _____ .

16. How will the cantilever be protected? _____ .

17. What is the spacing of the upper floor joists under the area with the flat ceiling? _____ .

18. Explain why the upper floor joists on the left side are required to have different spacing than those on the right side. _____ _____ .

19. Will solid blocking or a rim joist be used? _____ .

20. What will hold the upper end of the porch rafters? _____ .

PROBLEM 11–6 Use Section DD, shown on page 296, to answer the following questions:

1. A circle is drawn in the lower left-hand corner. What do the numbers in the circle mean? _____ .

2. How will the retaining walls be reinforced? _____ .

3. What grade of concrete blocks will be used to build the basement wall? _____ .

4. Can the 2 × 4 stud wall in the basement be built right next to the concrete block wall? _____ .

5. How will the CMU containing rebar be treated? _____ .

6. This house is being built in an area of the country that gets 36" of rain a year. Is the basement prepared? Explain your answer. _____ .

7. What size studs will be used in the basement bearing walls? _____ .

8. The lower floor is to be blocked. What are the specifications for the blocking? _____ .

9. Two braces are shown in the attic without any mention of what angle to build them. What is the maximum angle for such braces? _____ .

10. How will exposed eaves be protected from the weather? _____ .

11. What size purlin will be used? _____ .

12. How will the rim joists be connected to the mudsill? _____ .

13. What will support the ceiling joists on the right side of the roof? _____ .

14. Determine the size and spacing of the collar ties. _____ .

15. If the residence is 38' long, how many collar ties will be needed? _____ .

16. If the residence is 38' long, how many sheets of plywood will be needed to cover the floor cantilever? _____ .

17. How will the load-bearing walls in the basement be attached to the floor? _____ .

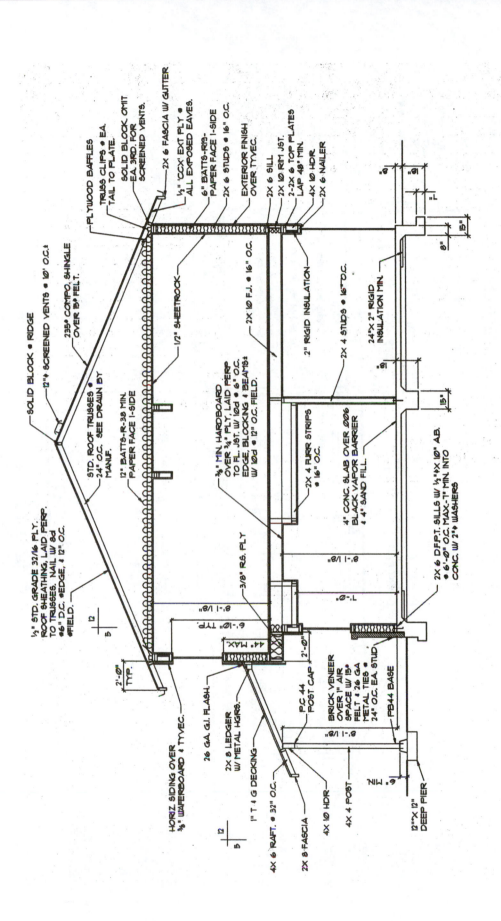

SECTION 'AA'
3/8" = 1'-0"

ALL FRAMING LUMBER TO
BE DFL #2 OR BETTER

Labels (roof/ceiling):
- PLYWOOD BAFFLES
- TRUSS CLIPS ● EA. TAIL TO PLATE.
- SOLID BLOCK OMIT EA. 3RD. FOR SCREENED VENTS.
- 2X 6 FASCIA W/ GUTTER
- 1/2" CCX EXT PLY ● ALL EXPOSED EAVES.
- 6" BATTS-R19- PAPER FACE 1-SIDE
- 2X 6 STUDS ● 16" O.C.
- EXTERIOR FINISH OVER TYVEC.
- 2X 6 SILL
- 2X 10 RIM JST.
- 2-2X 6 TOP PLATES LAP 48" MIN.
- 4X 10 HDR
- 2X 6 NAILER

- SOLID BLOCK ● RIDGE
- 12"⌀ SCREENED VENTS ● 10' O.C.‡
- 235# COMPO. SHINGLE OVER 15# FELT.
- 1/2" SHEETROCK
- 2X 10 F.J. ● 16" O.C.
- 2" RIGID INSULATION
- 2X 4 STUDS ● 16"O.C.
- 24"X 2" RIGID INSULATION MIN.

- STD. ROOF TRUSSES 24" O.C. SEE DRAWN BY MANF.
- 12" BATTS-R-38 MIN. PAPER FACE 1-SIDE
- 3/8" MIN. HARDBOARD OVER 3/4" PLY. LAID PERP TO FL. JST. W/ 10d ● 6" O.C. EDGE, BLOCKING & BEAMS‡ W/ 10d ● 12" O.C. FIELD.
- 2X 4 FURR STRIPS ● 16" O.C.
- 4" CONC. SLAB OVER Ø26 BLACK VAPOR BARRIER & 4" SAND FILL.

- 1/2" STD. GRADE 32/16 PLY. ROOF SHEATHING, LAID PERP. TO TRUSSES. NAIL W/ 8d ● 6" D.C. ●EDGE, & 12" O.C. ●FIELD.
- 3/8" R.S. PLY

- HORIZ. SIDING OVER 3/8" WATERBOARD & TYVEC.
- 26 GA. G.I. FLASH.
- 2X 8 LEDGER W/ METAL HGRS.
- 1" T & G DECKING
- 4X 6 RAFT. ● 32" O.C.
- 2X 8 FASCIA
- 4X 10 HDR
- 4X 4 POST
- PC 44 POST CAP
- BRICK VENEER OVER 1" AIR SPACE W/ 15# FELT & 26 GA METAL TIES ● 24" O.C. EA STUD
- PB44 BASE
- 2X 6 DFPT. SILLS W/ 1/2"X 10" A.B. ● 6'-0" O.C. MAX-7" MIN. INTO CONC. W/ 2"⌀ WASHERS.
- 12"X 12" DEEP PIER

Dimensions:
- 2'-0" TYP.
- 6'-10" TYP.
- 44" MAX.
- 2'-0"
- 8'- 1 1/8"
- 8'- 1 1/8"
- 8'- 1 1/8"
- 7'-0"
- 8'- 1 1/8"
- 15"
- 15"
- 8"
- 8"
- 8"
- 6"
- 7"
- M6

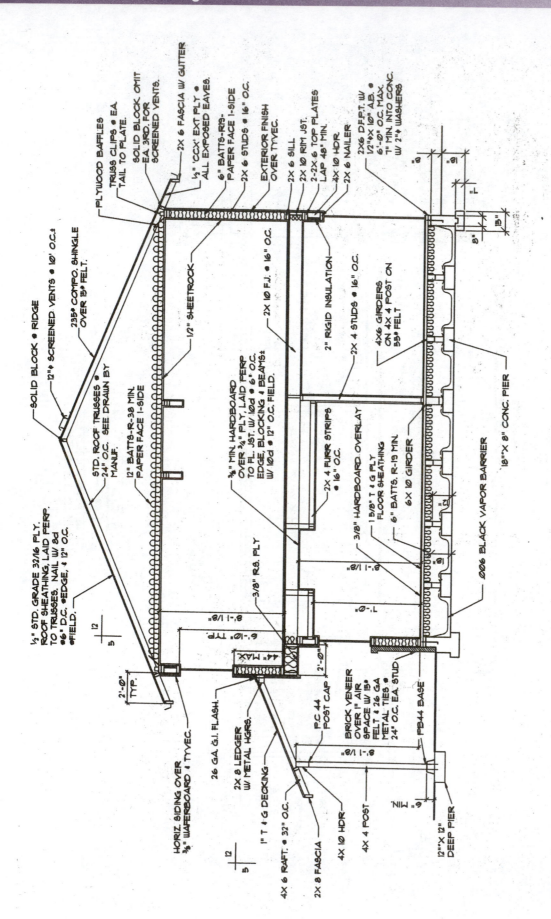

SECTION 'BB'
3/8" = 1'-0"

ALL FRAMING LUMBER TO BE DFL #2 OR BETTER.

Problem 11-4

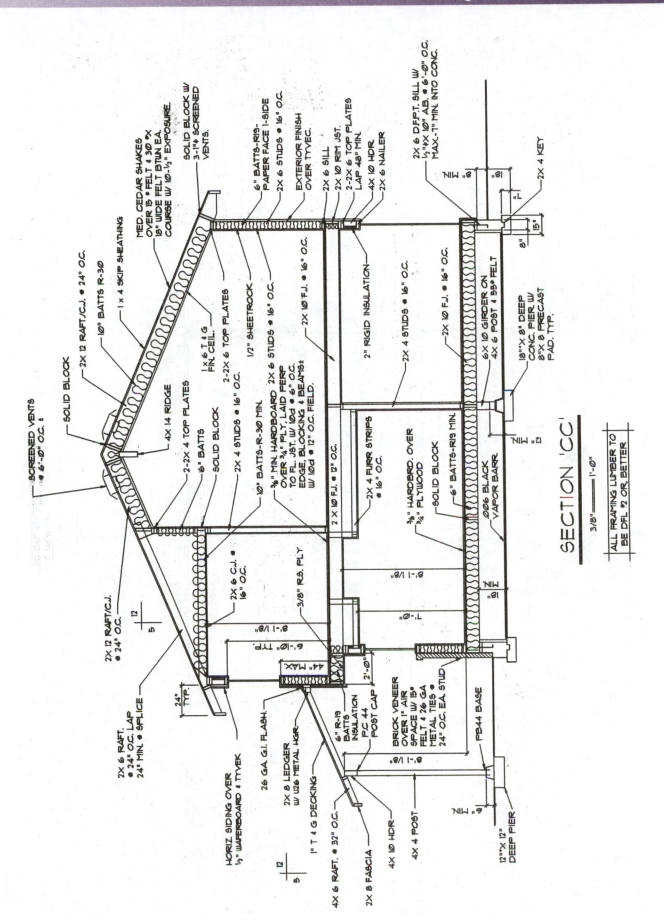

SECTION 'CC'

3/8" = 1'-0"

ALL FRAMING LUMBER TO
BE DFL #2 OR BETTER

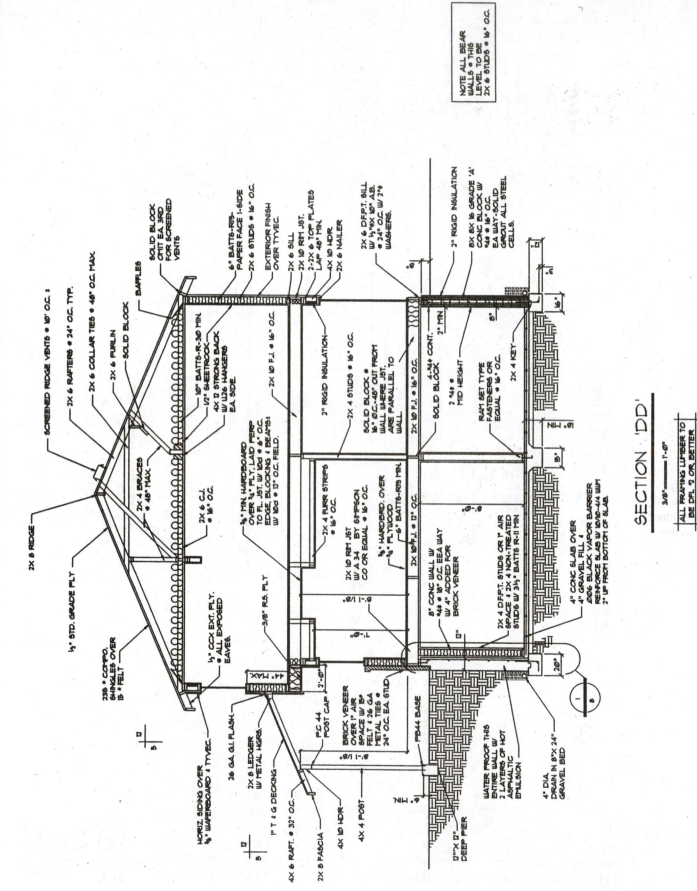

SECTION 'DD'

3/8" = 1'-0"

ALL FRAMING LUMBER TO BE DFL 2 OR BETTER

NOTE: ALL BEAR WALLS ● THIS LEVEL TO BE 2X 6 STUDS ● 16" O.C.

Problem 11-6

CHAPTER 12

Reading Stair Drawings

CHAPTER OVERVIEW

This chapter covers the following topics:

- Stair terminology
- Determining rise and run
- Straight stair construction
- Open stair construction
- U-shaped stairs
- Multilevel stairs
- Exterior stairs
- Test
- Problems

Stairs are represented on two types of drawings within the blueprints: plan views, such as floor or framing plans, and sections. The basic shape, number of treads, and rail locations can usually be determined from the floor plan, as shown in Figure 12–1. The stair section is typically used to show vertical relationships and the structural material to be used.

STAIR TERMINOLOGY

You must be familiar with several basic terms when reading plans relating to stairs. These terms appear in Figure 12–2.

The run is the horizontal distance from end to end of the stairs.

The rise is the vertical distance from top to bottom of the stairs.

The tread is the horizontal step of the stairs. The minimum required tread width is 10" (250 mm). Tread width is the measurement from the face of the riser to the nosing. The nosing is the portion of the tread that extends past the riser.

The riser is the vertical backing between the treads. The maximum allowable rise height is 7–3/4" (194 mm). It is usually made from 1" material for enclosed stairs and is not used on open stairs.

The stringer, or stair jack, is the support for the treads. A 2 × 12 (50 × 300 mm) notched stringer is typically used for enclosed stairs. For an open stair, 4 × 14 (100 × 350 mm) is common, but sizes vary greatly. Figure 12–2 shows the stringers, risers, and treads.

The kick block, or kicker, is used to keep the bottom of the stringer from sliding on the floor when downward pressure is applied to the stringer.

Headroom is the vertical distance measured from the tread nosing to a wall or floor above the stairs. Building codes specify a minimum size.

The handrail is the railing that you slide your hand along as you walk down the stairs. The handrail must have a height between 34" and 38" (850–950 mm) measured vertically from the nose of the treads.

The guardrail is the railing placed around an opening for stairs, porches, or balconies that are 30" (750 mm) or more above another floor. Vertical members of a guardrail must be placed so that a 4" (100 mm) diameter sphere will not pass between them.

Gypsum (GYP.) board 1/2" (13 mm) thick is required by the IRC for enclosing all usable storage space under the stairs. Figure 12–3 shows common stair dimensions.

DETERMINING RISE AND RUN

The IRC dictates the maximum rise of the stairs. To determine the actual rise, the total height from floor to floor must be known. By measuring the floor-to-ceiling height, the depth of the floor joist,

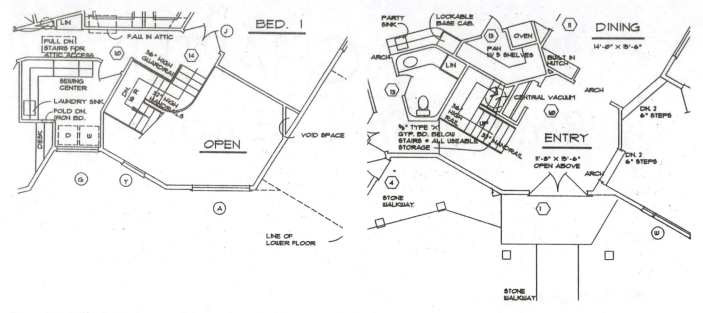

Figure 12–1 The basic shape and the number of steps can usually be determined from the floor plan.

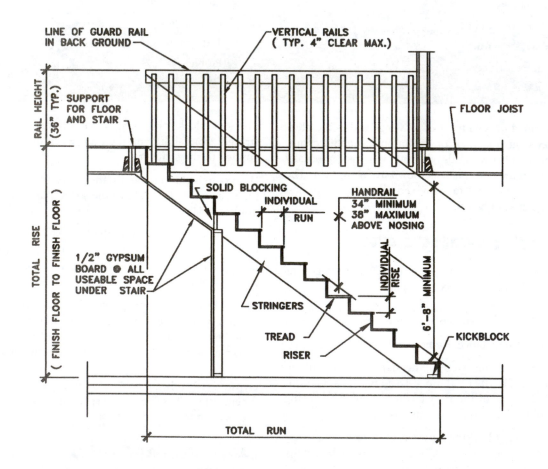

Figure 12–2 Common stair terms.

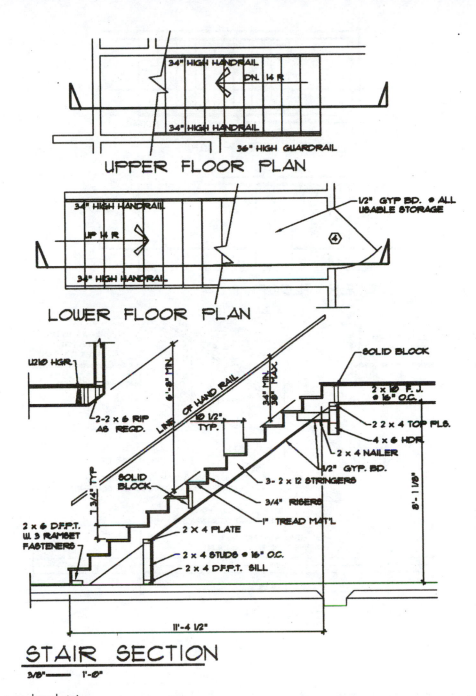

Figure 12–3 Straight-run enclosed stairs.

and the depth of the floor covering, the total rise can be found. The total rise can then be divided by the maximum allowable rise (7–3/4" or 195 mm) to determine the number of steps required.

Once the rise is known, the required number of treads can be found easily because there is always one less tread than the number of risers. A typical stair for a house with 8'–0" (2400 mm) ceilings has 14 risers and 13 treads. If each tread is 10–1/2" (263 mm) wide, the total run can be found by multiplying 10–1/2" (263 mm) (the width) by 13 (the number of treads required).

STRAIGHT STAIR CONSTRUCTION

The straight-run stair is a common type of stair seen in blueprints. It is a stair that goes from one floor to another in one straight run. An example of a straight-run stair can be seen in Figure 12–3.

This basic stair layout supports the weight of the stair materials and those using the stair by the use of stringers. The stringers are usually supported at the upper end by metal hangers that transfer the weight to the upper floor framing. These hangers also resist the natural tendency of gravity to pull down the stringer. Because

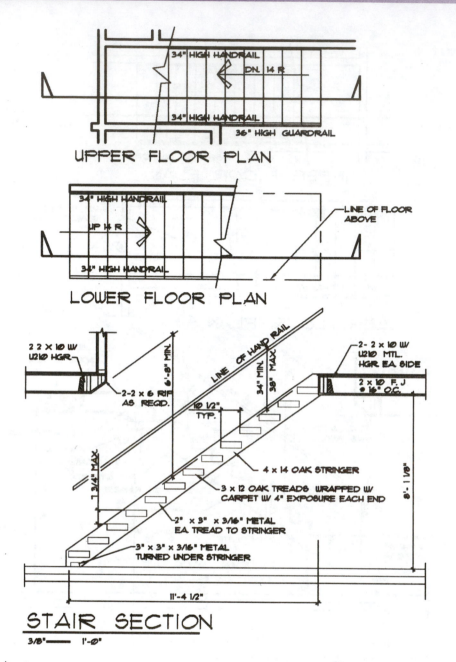

Figure 12–4 Open-tread stairs.

the stairs cannot go downward, force on the stringer tends to make the stringer slide away from the upper support. A kicker or metal angle is used to keep the stringer from sliding along the floor. Each of these members can be seen in Figure 12–2.

OPEN STAIR CONSTRUCTION

An open stairway is similar to the straight enclosed stairway. The major difference is that with the open stair, there are no risers between the treads. This allows viewing from one floor to the next, creating an open feeling. Figure 12–4 shows an open stairway. The open stairway functions in a similar manner to an enclosed stair-

way. Rather than having three 2 × 12 (50 × 300 mm) stringers support the tread, the tread of an open stair is supported between the stringers. The tread can be supported by metal L brackets underneath the tread, or a notch may be cut into the stringer to provide support.

U-SHAPED STAIRS

Rather than going up a whole flight of steps in a straight run, the U-shaped stair layout introduces a landing. The landing is usually located at the midpoint of the run, but it can be off-set depending on the amount of room allowed for stairs on the floor plan. Figure 12–5 shows what a U-shaped stair looks like on the floor plan and in section.

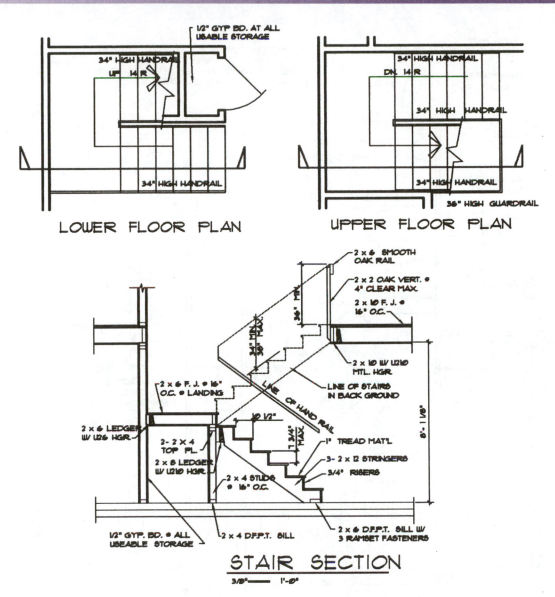

Figure 12–5 U-shaped stairs.

The stairs may be either open or enclosed, depending on the location. The construction of the stair is similar to the layout of the straight-run stair.

MULTILEVEL STAIRS

A multilevel set of stairs similar to Figure 12–6 places the steps connecting one level over a set of steps for another level. This stacking of stair flights is typical of multilevel structures to make efficient use of floor space.

The stacking effect creates a vertical tunnel referred to as a stairwell. The height limits of the stairwell are seen in the section view. While reading the drawings, it is important to determine the means of protecting the stairwell from the spread of fire. If a fire were to start at a lower level, it could race through the structure through the stairwell. Access to the stairs at each level is controlled by a fire-rated door to protect the stairs from fire within the structure and to pro-

tect the structure from fire in the stairwell. The stairwell is also usually required to be protected by a sprinkler system in multilevel structures.

Multilevel stairs can be constructed of either straight or U-shaped stair flights, but the two configurations should not be mixed. The materials of construction can be mixed. It is common to enclose stairs to a basement, but to build open stairs to the upper floors. This allows the view into one area to be restricted or for the control of heat flow.

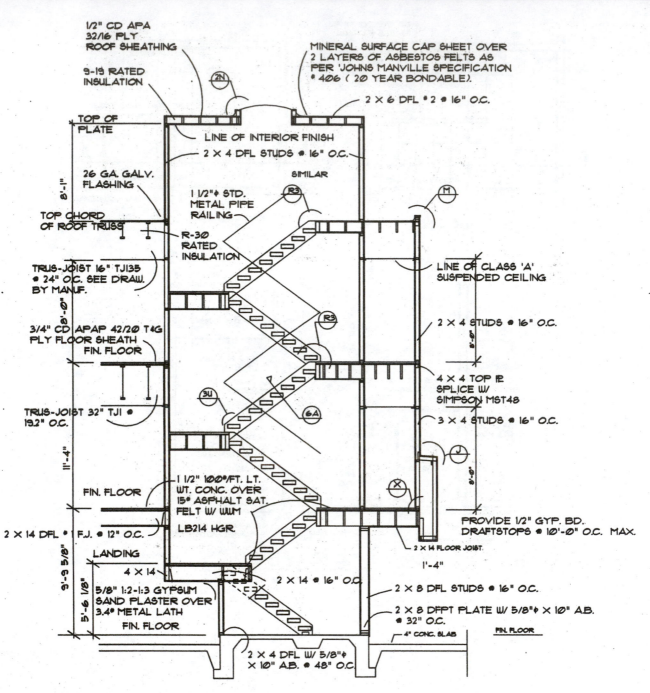

Figure 12–6 Multilevel stairs.

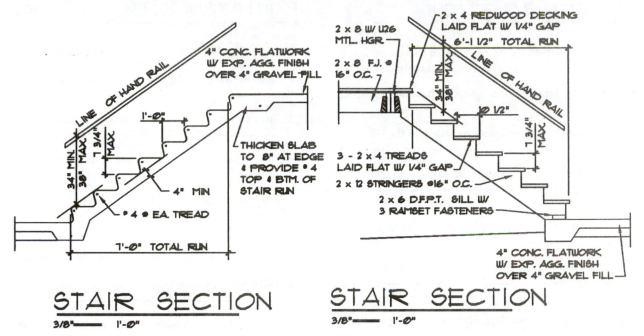

Figure 12–7 Common exterior stairs.

EXTERIOR STAIRS

It is common to need sections of exterior stairs for multilevel homes. Figure 12–7 shows two different types of exterior stairs. Although there are many variations, these two options are frequently used. Both can be constructed by following the procedure for straight-run stairs. There are some major differences in the finishing materials. There is no riser on the wood stairs, and the tread is thicker than the tread of an interior step. Usually the same material that is used on the deck is used for tread material. In many parts of the country, a nonskid material is also specified to cover the treads.

CHAPTER 12 TEST

Fill in the blanks below with the proper word or short statement as needed to complete the sentence or answer the question correctly.

1. What is the legal minimum height for a handrail? _____
 _____ .

2. List the minimum run for a stair according to the IRC. ___
 _____ .

3. What member is placed between the stringers to limit vibrations? _____
 _____ .

4. What is the minimum required headroom over stairs? ____
 _____ .

5. List the minimum spacing between vertical rails of a handrail or guardrail. _____
 _____ .

6. How can the lateral movement of the stairs along the floor be resisted? _____

 _____ .

7. Describe how a stringer is kept in place at the upper end.

 _____ .

8. What term describes the horizontal member of a stair? ___
 _____ .

9. List the maximum rise according to the IRC. _____
 _____ .

10. What is the minimum radius allowed for a spiral stair? ___

 _____ .

CHAPTER 12 PROBLEMS

PROBLEM 12–1 Use Figure 12–1 to answer the following questions:

1. Describe the guardrail required for the main stair. _____
 _____ .

2. List the number of required risers and treads. _____
 _____ .

3. How many risers will be framed in the upper portion of this stair? _____ .

4. If this stair is governed by the IRC, approximately how high is the main landing above the lower floor? _____
 _____ .

PROBLEM 12–2 Use Figure 12–3 to answer the following questions:

1. What type of stair is this? _____
 _____ .

2. Describe how the bottom of the stair is protected from fire.

 _____ .

3. What holds the stringer to the upper floor? _____
 _____ .

4. What will support the floor joists where the stairwell is formed? _____
 _____ .

5. What type of handrail will be used? _____
 _____ .

6. How many treads will be required? _____
 _____ .

7. If the owner changes the tread to 10–3/4", what will the total run be? _____
 _____ .

8. What material will be used for the risers? _____
 _____ .

9. If the owner wants 7–1/4" risers, how many risers will be required if the lower floor has 8' ceilings? _____
 _____ .

10. What supports the lower end of the stringer? _____
 _____ .

PROBLEM 12–3 Use Figure 12–4 to answer the following questions:

1. What type of stair is to be used? _____
 _____ .

2. List the size of the stringer. _____
 _____ .

3. Describe the treads. _____

 _____ .

4. How will the treads be supported? _____

_____ .

5. How will the stringer be supported at the bottom? _____

_____ .

PROBLEM 12–4 Use Figure 12–5 to answer the following questions:

1. What type of stair will be framed? _____

_____ .

2. How will the guardrail be supported? _____
_____ .

3. Determine the thickness of the tread material. _____
_____ .

4. What will support the lower end of the lower stringer? ____
_____ .

5. Describe the stringers. _____
_____ .

6. What do the dotted lines in the section view indicate? ____

_____ .

7. How will the stringers be supported at the upper end? ___

_____ .

8. What would be the required run if a 7" (175 mm) rise were used? Assume an 8'–0" (2400 mm) ceiling. _____

_____ .

9. How will the landing be supported? _____

_____ .

10. What will be used to frame the landing? _____

_____ .

Reading Fireplace Drawings

CHAPTER OVERVIEW

This chapter covers the following topics:

- Fireplace terms
- Floor plan representations
- Exterior elevations
- Foundation plan

- Sections
- Fireplace elevation
- Test
- Problems

The fireplace is typically first encountered on floor plans and elevations. Information may also be contained on the foundation plan. These three drawings contain information about the shape, style, and support of the fireplace. The fireplace section contains information about the materials to be used for construction. Before examining each type of drawing, an understanding of common terms is needed.

FIREPLACE TERMS

Figure 13–1 shows the parts of a fireplace and chimney. Each of these parts should be understood to help you read fireplace drawings.

FIREPLACE PARTS

Eleven terms are used to describe the construction of a fireplace.

Hearth. The hearth is the floor of the fireplace and consists of an inner and outer hearth. The inner hearth is the floor of the firebox. The hearth is made of fire-resistant brick and holds the burning fuel. The outer hearth may be made of any incombustible material. The outer hearth protects the combustible floor around the fireplace. Figure 13–2 shows the minimum sizes for the outer hearth.

Ash Dump. The ash dump is an opening in the hearth into which the ashes can be dumped. The ash dump normally is covered with a small metal plate that can be removed to provide access to the ash pit.

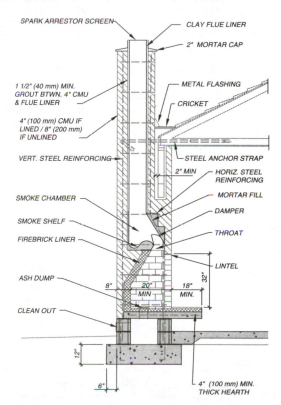

SPARK ARRESTOR SCREEN

CLAY FLUE LINER

2" MORTAR CAP

1 1/2" (40 mm) MIN. GROUT BTWN. 4" CMU & FLUE LINER

4" (100 mm) CMU IF LINED / 8" (200 mm) IF UNLINED

VERT. STEEL REINFORCING

METAL FLASHING

CRICKET

STEEL ANCHOR STRAP

2" MIN

HORIZ. STEEL REINFORCING

SMOKE CHAMBER

SMOKE SHELF

FIREBRICK LINER

ASH DUMP

CLEAN OUT

MORTAR FILL

DAMPER

THROAT

LINTEL

32"

8"

20" MIN.

18" MIN.

12"

6"

4" (100 mm) MIN. THICK HEARTH

Figure 13–1 Common components of a masonry fireplace and chimney.

GENERAL CODE REQUIREMENTS

ITEM	LETTER	IRC 2003
Hearth Slab Thickness	A	4"
Hearth Slab Width (Each side of opening)	B	8" Fireplace opg. < 6 sq. ft. 12" Fireplace opg. ≥ 6 sq. ft.
Hearth Slab Length (Front of opening)	C	16" Fireplace opg. < 6 sq. ft. 20" Fireplace opg. ≥ 6 sq. ft.
Hearth Slab Reinforcing	D	Reinforced to carry its own weight and all imposed loads.
Thickness of Wall or Firebox	E	10" common brick or 8" where a fireback lining is used. Jts. in fireback 1/4" max.
Distance from Top of Opening to Smoke Chamber Edge of Shelf	F	6"
Rear Wall—Thickness	G	6"
Front & Side Wall—Thickness		8"
Chimney Vertical Reinforcing	**H	Four #4 full-length bars for chimney up to 40" wide. Add two #4 bars for each additional 40" or fraction of width or each additional flue.
Horizontal Reinforcing	J	1/4" ties at 18" and two ties at each bend in vertical steel.
Bond Beams	K	No specified requirements. L.A. city requirements and good practice.
Fireplace Lintel	L	Incombustible material.
Walls with Flue Lining	M	Brick with grout around lining 4" min. from flue lining to outside face of chimney.
Walls with Unlined Flue	N	8" solid masonry.
Distance Between Adjacent Flues	O	4" including flue liner.
Effective Flue Area (Based on Area of Fireplace Opening	P	Round lining—1/12 or 50 sq. in. min. Rectangular lining 1/10 or 64 sq. in. min. Unlined or lined with firebrick—1/8 or 100 sq. in. min.
Clearances Wood Frame Combustible Material Above Roof	R	1" when outside of wall or 1/2" gypsum board. 1" when entirely within structure. 6" min. to fireplace opening. 12" from opening when material projecting more than 1/8" for ea. 1". 2' at 10'
Anchorage Strap Number Embedment into Chimney Fasten to Bolts	S	3/16" x 1" 2 12" hooked around outer bar w/6" ext. 4 joists Two 1/2" dia.
Footing Thickness Width	T	12" minimum 6" each side of fireplace wall
Outside Air Intake	U	Optional

*Applies to Los Angeles County and Los Angeles City requirements.
**H EXCEPTION. Chimneys constructed of hollow masonry units may have vertical reinforcing bars spliced to footing dowels, provided that the splice is inspected prior to grouting of the wall.

Figure 13–2(a) General code requirements for fireplace and chimney construction. The letters in the second column will be helpful in locating specific items in Figure 13–2(b).

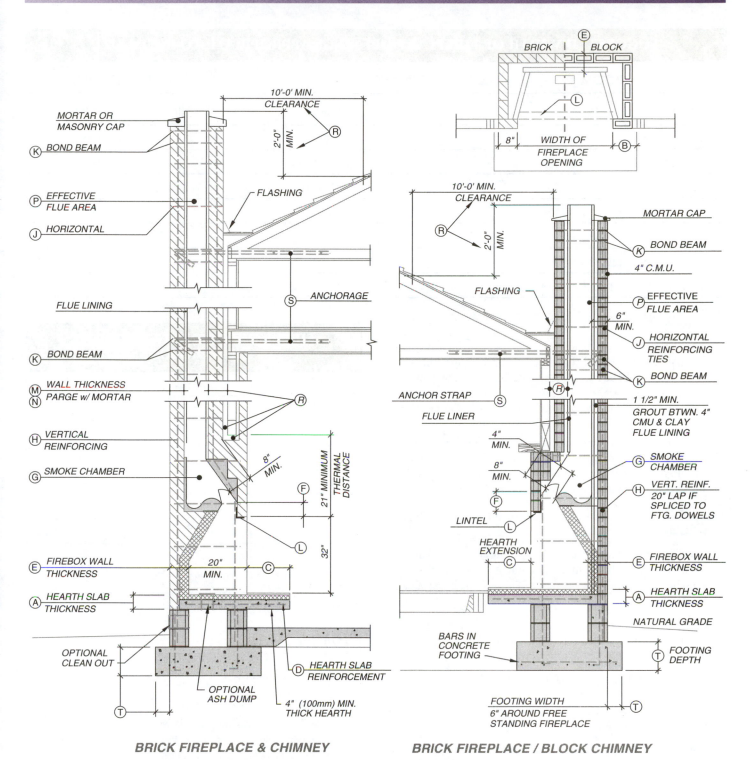

BRICK FIREPLACE & CHIMNEY

BRICK FIREPLACE / BLOCK CHIMNEY

Figure 13–2(b) Brick fireplace and chimney components. The circled letters refer to item references in Figure 13–2(a).

Ash Pit. The ash pit is the space below the fireplace where the ashes can be stored.

Fireplace Opening. The fireplace opening is the area between the side and top faces of the fireplace. Although the size of the opening is very important, it might not be shown on the drawings. The size of the opening is important for the appearance and operation

of the fireplace. If the opening is too small, the fireplace does not produce a sufficient amount of heat. If the opening is too large, the fire can make a room too hot. Figure 13–3 shows suggested fireplace opening sizes compared to room size. The ideal dimensions for a single-face fireplace have been determined to be 36" (900 mm) wide and 26" (660 mm) high.

SUGGESTED WIDTH OF FIREPLACE OPENINGS APPROPRIATE TO ROOM SIZE					
SIZE OF ROOM		IF IN SHORT WALL		IF IN LONG WALL	
(FT.)	(MM)	(IN.)	(MM)	(IN.)	(MM)
10 x 14	(3000 x 4300)	24	(600)	24–32	(600–800)
12 x 16	(3600 x 4900)	28–36	(700–900)	32–36	(800–900)
12 x 20	(3600 x 6100)	32–36	(800–900)	36–40	(900–1000)
12 x 24	(3600 x 7300)	32–36	(800–900)	36–48	(900–1200)
14 x 28	(4300 x 8600)	32–40	(800–1000)	40–48	(1000–1200)
16 x 30	(4900 x 9100)	36–40	(900–1000)	48–60	(1200–1500)
20 x 36	(6100 x 11000)	40–48	(1000–1200)	48–72	(1200–1800)

Figure 13–3

Firebox. The firebox is where the combustion of the fuel occurs. The side should be slanted slightly to radiate heat into the room. The rear wall should be curved to provide an upward draft into the upper part of the fireplace and chimney. The firebox is usually constructed of fire-resistant brick set in fire-resistant mortar. Figure 13–2 shows minimum wall thickness for the firebox.

The firebox depth should be proportional to the size of the fireplace opening. With an opening of 36" × 26" (900 × 660 mm), a depth of 20" should be provided for a single-face fireplace. Figure 13–4 lists recommended fireplace opening-depth proportions.

Lintel. The lintel is a steel angle above the fireplace opening that supports the fireplace face.

Throat. The throat of a fireplace is the opening at the top of the firebox that opens into the chimney. The throat should be able to be closed when the fireplace is not in use. This is done by installing a damper.

Damper. The damper extends the full width of the throat and is used to prevent heat from escaping up the chimney when the fireplace is not in use.

Smoke Chamber. The smoke chamber acts as a funnel between the firebox and the chimney. The shape of the smoke chamber should be symmetrical so that the chimney draft pulls evenly and creates an even fire in the firebox.

Smoke Shelf. The smoke shelf is located at the bottom of the smoke chamber behind the damper. The smoke shelf prevents downdrafts from the chimney from entering the firebox.

Chimney. The chimney is the upper extension of the fireplace and is built to carry off the smoke from the fire. Figure 13–2 shows the minimum wall thickness for chimneys.

FIREPLACE OPENING-TO-DEPTH PROPORTIONS		
WIDTH (W)	HEIGHT (H)	DEPTH (D)
(IN.)	(IN.)	(IN.)
28	24	20
30	24	20
30	26	20
36	26	20
36	38	22
40	28	22
48	32	25

Figure 13–4

CHIMNEY PARTS

The chimney is comprised of several parts important to safe fireplace operation.

Flue. The flue is the opening inside the chimney that allows the smoke and combustion gases to pass from the firebox away from the structure. A flue can be constructed of masonry products or may be covered with a flue liner. Flue sizes are generally required to equal either 1/8" or 1/10" of the fireplace opening. Figure 13–5 shows recommended areas for residential fireplaces of various shapes.

Chimney Liners. A chimney liner is built of fire clay or terra-cotta. The smooth surface of the liner helps to reduce the buildup of soot, which can cause a chimney fire.

Chimney Anchors. The anchors are steel straps that connect the masonry chimney to the framing members at each floor and ceil-

FIREPLACE FLUE SIZE BY AREA

TYPE OF FIREPLACE	WIDTH OF OPENING W (IN.)	HEIGHT OF OPENING H (IN.)	DEPTH OF OPENING D (IN.)	AREA OF FIREPLACE OPENING FOR FLUE DETERMINATION (SQ. IN.)	FLUE SIZE REQUIRED AT 1/10 AREA OF FIREPLACE OPENING	FLUE SIZE REQUIRED AT 1/8 AREA OF FIREPLACE OPENING
	28	24	20	672	8–1/2 x 13	8–1/2 x 17
	30	24	20	720	8–1/2 x 17	13" round
	30	26	20	780	8–1/2 x 17	10 x 18
	36	26	20	936	10 x 18	13 x 17
	36	28	22	1008	10 x 18	10 x 21
	40	28	22	1120	10 x 18	10 x 21
	48	32	25	1536	13 x 21	10 x 21
	60	32	25	1920	17 x 21	21 x 21

Figure 13–5 Recommended flue areas for residential fireplaces.

ing level. Steel straps are embedded into the grout of the chimney or wrapped around the reinforcing steel and then bolted to the framing members of the structure.

Chimney Reinforcement. A minimum of four 1/2" (13 mm) diameter (#4/#13) vertical reinforcing bars should be used in the chimney, extending from the foundation to the top of the chimney. Typically these vertical bars are supported at 18" (450 mm) intervals with 1/4" (6 mm) horizontal ties.

Chimney Cap. The chimney cap is the sloping mortar surface on the top of the chimney. The slope prevents rain from collecting on the top of the chimney.

Chimney Hood. The chimney hood is a covering that is placed over the flue for protection from the elements. The hood can be made of either masonry or metal. The masonry cap is built so that openings allow the prevailing wind to blow through the hood and create a draft in the flue. The metal hood can usually be rotated by wind pressure to keep the opening of the hood downwind and thus prevent rain or snow from entering the flue.

Spark Arrester. The spark arrester is a screen placed at the top of the flue to prevent combustibles from leaving the flue.

FLOOR PLAN REPRESENTATIONS

Common types of wood-burning appliances likely to be encountered when reading plans include: the masonry fireplace, 0-clearance metal fireplace, self-venting fireplace, pellet stove, and wood stove. The representations for each can be seen in Figure 13–6.

The floor plan is used to show the type, location, venting, and floor protection around the fireplace. In a masonry fireplace, dimensions are not shown on the floor plan. Because they are surrounded by wood walls, the 0-clearance fireplace and wood stove are located with dimensions. For all three types, some type of venting is specified to meet the demands of the building code. The floor protection around the fireplace is provided by the hearth. The outline of the hearth is shown on the floor plan, but typically no specific sizes for the hearth are given.

EXTERIOR ELEVATIONS

The exterior elevations are helpful for determining the height of the chimney and its relationship to the roof. The chimney is required by code to extend a minimum of 24" (600 mm) above any portion of the structure within 10'–0" (3000 mm). The elevations are helpful in determining the height of materials that affect the chimney height. The elevations are also useful in determining the exterior finish and shape of the chimney. An example of the fireplace in exterior elevations can be seen in Figure 13–7.

FOUNDATION PLAN

A masonry fireplace is always represented on the foundation plan. Figure 13–8 shows how a foundation for a masonry fireplace is represented. The foundation plan shows the size of the footing to support the fireplace and the location of the chimney.

A metal fireplace or wood stove requires no extra support and is not shown on the foundation plan. If either is built in a chase that projects outside the foundation wall, the projection is shown on the foundation.

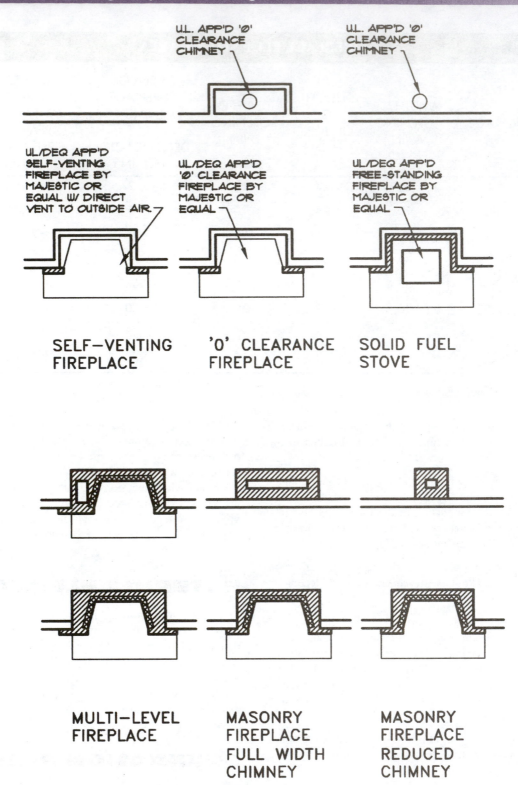

Figure 13–6 Common methods of representing fireplaces and solid fuel stoves on floor plans.

SECTIONS

The sections are the most useful drawings for determining construction materials for the fireplace. Figure 13–9 shows how a masonry fireplace can be represented in a section drawing. A metal fireplace or woodstove is normally not represented in a section.

The section is used to provide a location for dimensions and common materials. The section is the primary drawing for determining all clearances between the chimney and the structure, reinforcement requirements, and general construction guidelines. Always check the scale of the section because the fireplace section is often drawn at a larger scale than the other sections.

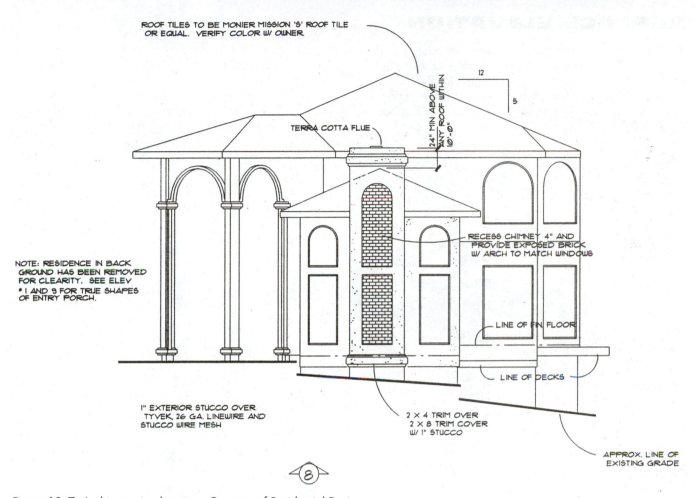

ROOF TILES TO BE MONIER MISSION 'S' ROOF TILE
OR EQUAL. VERIFY COLOR W/ OWNER

TERRA COTTA FLUE

24" MIN. ABOVE
ANY ROOF WITHIN
10'-0"

12

5

RECESS CHIMNEY 4" AND
PROVIDE EXPOSED BRICK
W/ ARCH TO MATCH WINDOWS

NOTE: RESIDENCE IN BACK
GROUND HAS BEEN REMOVED
FOR CLEARITY. SEE ELEV
#1 AND 9 FOR TRUE SHAPES
OF ENTRY PORCH.

LINE OF FIN. FLOOR

LINE OF DECKS

1" EXTERIOR STUCCO OVER
TYVEK, 26 GA. LINEWIRE AND
STUCCO WIRE MESH

2 X 4 TRIM OVER
2 X 8 TRIM COVER
W/ 1" STUCCO

APPROX. LINE OF
EXISTING GRADE

8

Figure 13–7 A chimney in elevation. *Courtesy of Residential Designs.*

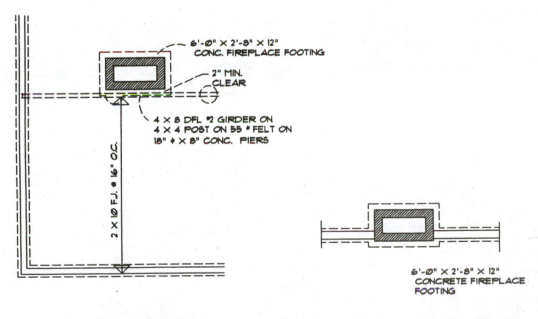

6'-0" X 2'-8" X 12"
CONC. FIREPLACE FOOTING

2" MIN.
CLEAR

4 X 8 DFL #2 GIRDER ON
4 X 4 POST ON 55 # FELT ON
18" ⌀ X 8" CONC. PIERS

2 X 10 F.J. @ 16" O.C.

6'-0" X 2'-8" X 12"
CONCRETE FIREPLACE
FOOTING

FIREPLACE IN
FOUNDATION INTERIOR

FIREPLACE ON
EXTERIOR WALL

Figure 13–8 Masonry chimney representations on the foundation plan.

FIREPLACE ELEVATION

An interior elevation of the fireplace and the surrounding area is often part of a well-drawn set of plans. This drawing shows the finished relationship of the hearth to the floor, the fireplace to the hearth, and the fireplace opening to the mantel. This drawing typically shows all sizes for the trim used to decorate the fireplace. Figure 13–10 shows a fireplace elevation.

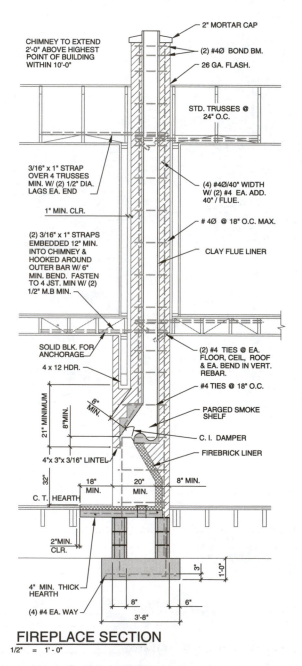

CHIMNEY TO EXTEND 2'-0" ABOVE HIGHEST POINT OF BUILDING WITHIN 10'-0"

2" MORTAR CAP

(2) #4Ø BOND BM.

26 GA. FLASH.

STD. TRUSSES @ 24" O.C.

3/16" x 1" STRAP OVER 4 TRUSSES MIN. W/ (2) 1/2" DIA. LAGS EA. END

(4) #4Ø/40" WIDTH W/ (2) #4 EA. ADD. 40" / FLUE.

1" MIN. CLR.

4Ø @ 18" O.C. MAX.

(2) 3/16" x 1" STRAPS EMBEDDED 12" MIN. INTO CHIMNEY & HOOKED AROUND OUTER BAR W/ 6" MIN. BEND. FASTEN TO 4 JST. MIN W/ (2) 1/2" M.B MIN.

CLAY FLUE LINER

SOLID BLK. FOR ANCHORAGE

(2) #4 TIES @ EA. FLOOR, CEIL, ROOF & EA. BEND IN VERT. REBAR.

4 x 12 HDR.

#4 TIES @ 18" O.C.

21 MINIMUM

8" MIN.

8" MIN.

PARGED SMOKE SHELF

C. I. DAMPER

4"x 3"x 3/16" LINTEL

FIREBRICK LINER

32"

C. T. HEARTH

18" MIN.

20" MIN.

8" MIN.

2"MIN. CLR.

4" MIN. THICK HEARTH

(4) #4 EA. WAY

3"

1'-0"

8"

6"

3'-8"

FIREPLACE SECTION
1/2" = 1'-0"

Figure 13–9 A fireplace detail is often attached to a set of plans to show general construction guidelines.

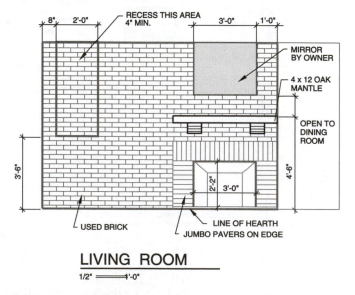

8"

2'-0"

RECESS THIS AREA 4" MIN.

3'-0"

1'-0"

MIRROR BY OWNER

4 x 12 OAK MANTLE

OPEN TO DINING ROOM

3'-6"

4'-6"

2'-2"

3'-0"

USED BRICK

LINE OF HEARTH

JUMBO PAVERS ON EDGE

LIVING ROOM
1/2" = 1'-0"

Figure 13–10 Lettering and dimensions for a fireplace elevation.

CHAPTER 13 TEST

Fill in the blanks below with the proper word or short statement as needed to complete the sentence or answer the question correctly.

1. On which drawing would you expect to see the hearth represented without the size specified? _____ _____.

2. On which drawing would you expect to see the hearth information specified? _____ _____.

3. What term is used to describe the area where the combustion occurs? _____ _____.

4. How does the size of the fireplace opening affect the fire? _____

5. What are the dimensions of a typical firebox? _____ _____.

6. The opening from the firebox to the chimney is called a _____

7. How is a chimney anchored to a structure at each floor? _____

8. If a fireplate is to be located on the short wall of a 13'–6" × 18'–9" (4050 × 5625 mm) family room, how wide would you make the firebox if no size is indicated on the plan? _____

9. A roof is built at a 5/12 pitch. The ridge is 12' (3600 mm) from the chimney. How tall should the chimney be if the floor is 24"(600 mm) above the ground and 8' (2400 mm) high walls are used? Show your work. _____ _____ _____ _____ _____ _____ _____ _____ _____

10. If the chimney in the last question is to be constructed of concrete block, how many courses in height will it be? _____

CHAPTER 13 PROBLEMS

PROBLEM 13–1 Use Figure 13–9 to answer the following questions:

1. What is the clearance between the chimney and the upper floor? _____.

2. What will keep rain from running down the chimney? ___ _____.

3. What size header will support the upper floor? _____ _____.

4. Give the size of the lintel. _____ _____.

5. How will the hearth be reinforced? _____ _____.

6. Will the chimney interior be unlined? _____ _____.

7. What is the spacing of the horizontal reinforcing? _____ _____.

8. To how many trusses will the chimney strap be connected? _____.

9. What material will be used to finish the hearth? _____ _____.

10. How will the footing be reinforced? _____ _____.

PROBLEM 13–2 Use the drawing shown on page 317 to answer these questions:

1. What is the depth of the firebox? _____ _____.

2. How will the flue be finished? _____ _____.

3. What code governs this fireplace? _____ _____.

4. What will control the flow of smoke from the firebox? ___ _____.

5. What are the options for finishing the hearth? _____ _____.

6. How can the rafter size be determined? _____ _____.

7. What is the height of the firebox? _____ _____.

8. How will the hearth be reinforced? _____ _____.

9. How will the support strap be tied to the chimney? _____
 _____ .

10. If the chimney is wider than 84" (2100 mm), how many
 vertical rebars will be required? _____
 _____ .

PROBLEM 13–3 Use Figure 13–10 to answer the following
questions:

1. What type of brick will be used on each side of the firebox?

 _____ .

2. What is the size of the firebox? _____
 _____ .

3. What is the height of the mantel above the finish floor?
 _____ .

4. What is the mantel made of? _____
 _____ .

5. What will surround the fireplace? _____
 _____ .

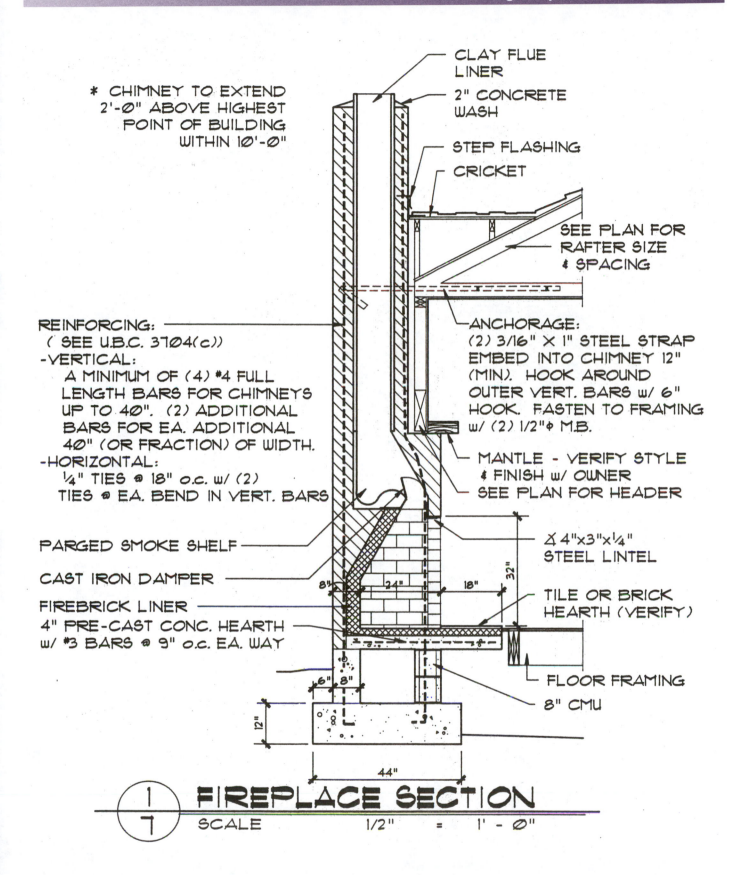

* CHIMNEY TO EXTEND
2'-Ø" ABOVE HIGHEST
POINT OF BUILDING
WITHIN 10'-Ø"

CLAY FLUE
LINER

2" CONCRETE
WASH

STEP FLASHING

CRICKET

SEE PLAN FOR
RAFTER SIZE
& SPACING

REINFORCING:
(SEE U.B.C. 3704(c))
-VERTICAL:
A MINIMUM OF (4) #4 FULL
LENGTH BARS FOR CHIMNEYS
UP TO 40". (2) ADDITIONAL
BARS FOR EA. ADDITIONAL
40" (OR FRACTION) OF WIDTH.
-HORIZONTAL:
¼" TIES @ 18" o.c. w/ (2)
TIES @ EA. BEND IN VERT. BARS

ANCHORAGE:
(2) 3/16" X 1" STEEL STRAP
EMBED INTO CHIMNEY 12"
(MIN). HOOK AROUND
OUTER VERT. BARS w/ 6"
HOOK. FASTEN TO FRAMING
w/ (2) 1/2"φ M.B.

MANTLE - VERIFY STYLE
& FINISH w/ OWNER
SEE PLAN FOR HEADER

∠ 4"x3"x¼"
STEEL LINTEL

PARGED SMOKE SHELF

CAST IRON DAMPER

FIREBRICK LINER

4" PRE-CAST CONC. HEARTH
w/ #3 BARS @ 9" o.c. EA. WAY

TILE OR BRICK
HEARTH (VERIFY)

FLOOR FRAMING

8" CMU

8" 24" 18" 32"

6" 8"

12"

44"

①/⑦ FIREPLACE SECTION

SCALE 1/2" = 1' - Ø"

CHAPTER 14

General Construction Specifications

CHAPTER OVERVIEW

This chapter covers the following topics:

- Construction specifications
- Typical minimum construction specifications
- Test
- Problems

CONSTRUCTION SPECIFICATIONS

Building plans, including all of the elements that make up a complete set of residential or commercial drawings, contain most general and some specific information about the construction of the structure. Information that cannot be clearly or completely provided on the drawing or in schedules is provided in construction specifications. Specifications are an integral part of any set of plans. Specifications may not be required when applying for a building permit for a residential structure, but they are generally needed for loan approval when financing is applied for. Most lenders have their own format for residential construction specifications, although these forms are generally similar. The Federal Housing Administration (FHA) or the Federal Home Loan Mortgage Corporation (FHLMC) has a specification format entitled, "Description of Materials." This specifications form is used widely in a modified or identical manner by most residential construction lenders. The same form is used by Farm Home Administration (FmHA) and by the Veterans Administration (VA). Figure 14–1 shows an FHA Description of Materials form for a typical structure. The set of plans, construction specifications, and building contract together become the legal documents for the construction project. These documents should be prepared very carefully in cooperation with the architect, client, and contractor. Any deviation from these documents should be approved by all three parties. When brand names are used, a clause specifying "or equivalent" may be added. This means that another brand of equivalent value to the one specified may be substituted with the construction supervisor's approval.

TYPICAL MINIMUM CONSTRUCTION SPECIFICATIONS

Minimum construction specifications as established by local building officials vary from one location to the next, and their contents are dependent on specific local requirements, climate, codes used, and the extent of coverage. Verify the local requirements for a construction project as they may differ from those given here. The following are some general classifications of construction specifications.

ROOM DIMENSIONS

- Minimum room size is to be 70 sq. ft.
- Ceiling height minimum is to be 7'-6" in 50 percent of the area except 7'-0" can be used for bathrooms and hallways.

LIGHT AND VENTILATION

- Minimum window area is to be 1/10 floor area with not less than 10 sq. ft. for habitable rooms and 3 sq. ft. for bathrooms and laundry rooms. Not less than one-half of this required window area is to be openable. Every sleeping room is required to have a window or door for emergency exit. Windows with an openable area of not less than 5 sq. ft. with no dimension less than 22" meet this requirement, and the sill height is to be not more than 44" above the floor.

VETERANS ADMINISTRATION, U.S.D.A. FARMERS HOME ADMINISTRATION, AND

U.S. DEPARTMENT OF HOUSING AND URBAN DEVELOPMENT
HOUSING - FEDERAL HOUSING COMMISSIONER OMB Approval No. 2502-0192 (Exp. 6-30-87)

For accurate register of carbon copies, form may be separated along above fold. Staple completed sheets together in original order.

☐ Proposed Construction

DESCRIPTION OF MATERIALS No. _____

(To be inserted by HUD, VA or FmHA)

☐ Under Construction

Property address _____ City _____ State _____

Mortgagor or Sponsor _____ _____
(Name) (Address)

Contractor or Builder _____ _____
(Name) (Address)

INSTRUCTIONS

1. For additional information on how this form is to be submitted, number of copies, etc., see the instructions applicable to the HUD Application for Mortgage Insurance, VA Request for Determination of Reasonable Value, or FmHA Property Information and Appraisal Report, as the case may be.
2. Describe all materials and equipment to be used, whether or not shown on the drawings, by marking an X in each appropriate check-box and entering the information called for each space. If space is inadequate, enter "See misc." and describe under item 27 or on an attached sheet. THE USE OF PAINT CONTAINING MORE THAN THE PERCENTAGE OF LEAD BY WEIGHT PERMITTED BY LAW IS PROHIBITED.
3. Work not specifically described or shown will not be considered unless

required, then the minimum acceptable will be assumed. Work exceeding minimum requirements cannot be considered unless specifically described.
4. Include no alternates, "or equal" phrases, or contradictory items. (Consideration of a request for acceptance of substitute materials or equipment is not thereby precluded.)
5. Include signatures required at the end of this form.
6. The construction shall be completed in compliance with the related drawings and specifications, as amended during processing. The specifications include this Description of Materials and the applicable Minimum Property Standards.

1. EXCAVATION:
Bearing soil, type _____

2. FOUNDATIONS:
Footings: concrete mix _____; strength psi _____ Reinforcing _____
Foundation wall: material _____ Reinforcing _____
Interior foundation wall: material _____ Party foundation wall _____
Columns: material and sizes _____ Piers: material and reinforcing _____
Girders: material and sizes _____ Sills: material _____
Basement entrance areaway _____ Window areaways _____
Waterproofing _____ Footing drains _____
Termite protection _____
Basementless space: ground cover _____; insulation _____; foundation vents _____
Special foundations _____
Additional information: _____

3. CHIMNEYS:
Material _____ Prefabricated *(make and size)* _____
Flue lining: material _____ Heater flue size _____ Fireplace flue size _____
Vents *(material and size)*: gas or oil heater _____; water heater _____
Additional information: _____

4. FIREPLACES:
Type: ☐ solid fuel; ☐ gas-burning; ☐ circulator *(make and size)* _____ Ash dump and clean-out _____
Fireplace: facing _____; lining _____; hearth _____; mantel _____
Additional information: _____

5. EXTERIOR WALLS:
Wood frame: wood grade, and species _____ ☐ Corner bracing. Building paper or felt _____
 Sheathing _____; thickness _____; width _____; ☐ solid; ☐ spaced _____" o. c.; ☐ diagonal; _____
 Siding _____; grade _____; type _____; size _____; exposure _____"; fastening _____
 Shingles _____; grade _____; type _____; size _____; exposure _____"; fastening _____
 Stucco _____; thickness _____"; Lath _____; weight _____ lb.
 Masonry veneer _____ Sills _____ Lintels _____ Base flashing _____
Masonry: ☐ solid ☐ faced ☐ stuccoed; total wall thickness _____"; facing thickness _____"; facing material _____
 Backup material _____; thickness _____"; bonding _____
 Door sills _____ Window sills _____ Lintels _____ Base flashing _____
 Interior surfaces: dampproofing, _____ coats of _____; furring _____
Additional information: _____
Exterior painting: material _____; number of coats _____
Gable wall construction: ☐ same as main walls; ☐ other construction _____

6. FLOOR FRAMING:
Joists: wood, grade, and species _____; other _____; bridging _____; anchors _____
Concrete slab: ☐ basement floor; ☐ first floor; ☐ ground supported; ☐ self-supporting; mix _____; thickness _____";
 reinforcing _____; insulation _____; membrane _____
Fill under slab: material _____; thickness _____". Additional information: _____

7. SUBFLOORING: *(Describe underflooring for special floors under item 21.)*
Material: grade and species _____; size _____; type _____
Laid: ☐ first floor; ☐ second floor; ☐ attic _____ sq. ft.; ☐ diagonal; ☐ right angles. Additional information: _____

8. FINISH FLOORING: *(Wood only. Describe other finish flooring under item 21.)*

LOCATION	ROOMS	GRADE	SPECIES	THICKNESS	WIDTH	BLDG. PAPER	FINISH
First floor							
Second floor							
Attic floor _____ sq. ft.							
Additional information:							

Previous Edition is Obsolete 1 **DESCRIPTION OF MATERIALS**
HUD-92005(10-84) HUD HB 4145.1
VA Form 26-1852 Form FmHA 424-2

Figure 14–1 FHA Description of Materials form. *From Huth,* Understanding Construction Drawings, *Thomson Delmar Learning.*

DESCRIPTION OF MATERIALS

9. PARTITION FRAMING:
Studs: wood, grade, and species _____ size and spacing _____ Other _____
Additional information: _____

10. CEILING FRAMING:
Joists: wood, grade, and species _____ Other _____ Bridging _____
Additional information: _____

11. ROOF FRAMING:
Rafters: wood, grade, and species _____ Roof trusses (see detail): grade and species _____
Additional information: _____

12. ROOFING:
Sheathing: wood, grade, and species _____ ; ☐ solid; ☐ spaced _____ " o.c.
Roofing _____ ; grade _____ ; size _____ ; type _____
Underlay _____ ; weight or thickness _____ ; size _____ ; fastening _____
Built-up roofing _____ ; number of plies _____ ; surfacing material _____
Flashing: material _____ ; gage or weight _____ ; ☐ gravel stops; ☐ snow guards
Additional information: _____

13. GUTTERS AND DOWNSPOUTS:
Gutters: material _____ ; gage or weight _____ ; size _____ ; shape _____
Downspouts: material _____ ; gage or weight _____ ; size _____ ; shape _____ ; number _____
Downspouts connected to: ☐ Storm sewer; ☐ sanitary sewer; ☐ dry-well. ☐ Splash blocks: material and size _____
Additional information: _____

14. LATH AND PLASTER
Lath ☐ walls, ☐ ceilings: material _____ ; weight or thickness _____ Plaster: coats _____ ; finish _____
Dry-wall ☐ walls, ☐ ceilings: material _____ ; thickness _____ ; finish _____ ;
Joint treatment _____

15. DECORATING: (Paint, wallpaper, etc.)

Rooms	Wall Finish Material and Application	Ceiling Finish Material and Application
Kitchen		
Bath		
Other		

Additional information: _____

16. INTERIOR DOORS AND TRIM:
Doors: type _____ ; material _____ ; thickness _____
Door trim: type _____ ; material _____ Base: type _____ ; material _____ ; size _____
Finish: doors _____ ; trim _____
Other trim (item, type and location) _____
Additional information: _____

17. WINDOWS:
Windows: type _____ ; make _____ ; material _____ ; sash thickness _____
Glass: grade _____ ; ☐ sash weights; ☐ balances, type _____ ; head flashing _____
Trim: type _____ ; material _____ Paint _____ ; number coats _____
Weatherstripping: type _____ ; material _____ Storm sash, number _____
Screens: ☐ full; ☐ half; type _____ ; number _____ ; screen cloth material _____
Basement windows: type _____ ; material _____ ; screens, number _____ ; Storm sash, number _____
Special windows _____
Additional information: _____

18. ENTRANCES AND EXTERIOR DETAIL:
Main entrance door: material _____ ; width _____ ; thickness _____ ". Frame: material _____ , thickness _____ "
Other entrance doors: material _____ ; width _____ ; thickness _____ ". Frame: material _____ ; thickness _____ "
Head flashing _____ Weatherstripping: type _____ ; saddles _____
Screen doors: thickness _____ "; number _____ ; screen cloth material _____ Storm doors: thickness _____ "; number _____
Combination storm and screen doors: thickness _____ "; number _____ ; screen cloth material _____
Shutters: ☐ hinged; ☐ fixed. Railings _____ , Attic louvers _____
Exterior millwork: grade and species _____ Paint _____ ; number coats _____
Additional information: _____

19. CABINETS AND INTERIOR DETAIL:
Kitchen cabinets, wall units: material _____ ; lineal feet of shelves _____ ; shelf width _____
Base units: material _____ ; counter top _____ ; edging _____
Back and end splash _____ Finish of cabinets _____ ; number coats _____
Medicine cabinets: make _____ ; model _____
Other cabinets and built-in furniture _____
Additional information: _____

20. STAIRS:

Stair	Treads		Risers		Strings		Handrail		Balusters	
	Material	Thickness	Material	Thickness	Material	Size	Material	Size	Material	Size
Basement										
Main										
Attic										

Disappearing: make and model number _____
Additional information: _____

2

Figure 14–1 (continued)

21. SPECIAL FLOORS AND WAINSCOT: *(Describe Carpet as listed in Certified Products Directory)*

	LOCATION	MATERIAL, COLOR, BORDER, SIZES, GAGE, ETC.	THRESHOLD MATERIAL	WALL BASE MATERIAL	UNDERFLOOR MATERIAL
FLOORS	Kitchen				
	Bath				

	LOCATION	MATERIAL, COLOR, BORDER, CAP. SIZES, GAGE, ETC.	HEIGHT	HEIGHT OVER TUB	HEIGHT IN SHOWERS (FROM FLOOR)
WAINSCOT	Bath				

Bathroom accessories: ☐ Recessed; material _____; number _____; ☐ Attached; material _____; number _____
Additional information: _____

22. PLUMBING:

FIXTURE	NUMBER	LOCATION	MAKE	MFR'S FIXTURE IDENTIFICATION NO.	SIZE	COLOR
Sink						
Lavatory						
Water closet						
Bathtub						
Shower over tub △						
Stall shower △						
Laundry trays						

△☐ Curtain rod △☐ Door ☐ Shower pan: material _____
Water supply: ☐ public; ☐ community system; ☐ individual (private) system.★
Sewage disposal: ☐ public; ☐ community system; ☐ individual (private) system.★
★*Show and describe individual system in complete detail in separate drawings and specifications according to requirements.*
House drain (inside): ☐ cast iron; ☐ tile; ☐ other _____ House sewer (outside): ☐ cast iron; ☐ tile; ☐ other _____
Water piping: ☐ galvanized steel; ☐ copper tubing; ☐ other _____ Sill cocks, number _____
Domestic water heater: type _____; make and model _____; heating capacity _____
_____ gph. 100° rise. Storage tank: material _____; capacity _____ gallons.
Gas service: ☐ utility company; ☐ liq. pet. gas; ☐ other _____ Gas piping: ☐ cooking; ☐ house heating.
Footing drains connected to: ☐ storm sewer; ☐ sanitary sewer; ☐ dry well. Sump pump; make and model _____
_____; capacity _____; discharges into _____

23. HEATING:
☐ Hot water. ☐ Steam. ☐ Vapor. ☐ One-pipe system. ☐ Two-pipe system.
　☐ Radiators. ☐ Convectors. ☐ Baseboard radiation. Make and model _____
　Radiant panel: ☐ floor; ☐ wall; ☐ ceiling. Panel coil: material _____
　☐ Circulator. ☐ Return pump. Make and model _____; capacity _____ gpm.
　Boiler: make and model _____ Output _____ Btuh.; net rating _____ Btuh.
Additional information: _____
Warm air: ☐ Gravity. ☐ Forced. Type of system _____
　Duct material: supply _____; return _____ Insulation _____, thickness _____ ☐ Outside air intake.
　Furnace: make and model _____ Input _____ Btuh.; output _____ Btuh.
　Additional information: _____
☐ Space heater; ☐ floor furnace; ☐ wall heater. Input _____ Btuh.; output _____ Btuh.; number units _____
　Make, model _____ Additional information: _____
Controls: make and types _____
Additional information: _____
Fuel: ☐ Coal; ☐ oil; ☐ gas; ☐ liq. pet. gas; ☐ electric; ☐ other _____; storage capacity _____
　Additional information: _____
Firing equipment furnished separately: ☐ Gas burner, conversion type. ☐ Stoker: hopper feed ☐; bin feed ☐
　Oil burner: ☐ pressure atomizing; ☐ vaporizing _____
　Make and model _____ Control _____
　Additional information: _____
Electric heating system: type _____ Input _____ watts; @ _____ volts; output _____ Btuh.
　Additional information: _____
Ventilating equipment: attic fan, make and model _____; capacity _____ cfm.
　　　　　　　　　　　　kitchen exhaust fan, make and model _____
Other heating, ventilating, or cooling equipment _____

24. ELECTRIC WIRING:
Service: ☐ overhead; ☐ underground. Panel: ☐ fuse box; ☐ circuit-breaker; make _____ AMP's _____ No. circuits _____
Wiring: ☐ conduit; ☐ armored cable; ☐ nonmetallic cable; ☐ knob and tube; ☐ other _____
Special outlets: ☐ range; ☐ water heater; ☐ other _____
☐ Doorbell. ☐ Chimes. Push-button locations _____ Additional information: _____

25. LIGHTING FIXTURES:
Total number of fixtures _____ Total allowance for fixtures, typical installation, $ _____
Nontypical installation _____
Additional information: _____

3

DESCRIPTION OF MATERIALS

Figure 14–1 (continued)

DESCRIPTION OF MATERIALS

26. INSULATION:

Location	Thickness	Material, Type, and Method of Installation	Vapor Barrier
Roof			
Ceiling			
Wall			
Floor			

27. MISCELLANEOUS: (Describe any main dwelling materials, equipment, or construction items not shown elsewhere; or use to provide additional information where the space provided was inadequate. Always reference by item number to correspond to numbering used on this form.) _____

HARDWARE: (make, material, and finish.) _____

SPECIAL EQUIPMENT: (State material or make, model and quantity. Include only equipment and appliances which are acceptable by local law, custom and applicable FHA standards. Do not include items which, by established custom, are supplied by occupant and removed when he vacates premises or chattles prohibited by law from becoming realty.)_____

PORCHES:

TERRACES:

GARAGES:

WALKS AND DRIVEWAYS:
Driveway: width _____ ; base material _____ ; thickness _____"; surfacing material _____ ; thickness _____"
Front walk: width _____ ; material _____ ; thickness _____". Service walk: width _____ ; material _____ ; thickness _____"
Steps: material _____ ; treads _____"; risers _____". Cheek walls _____

OTHER ONSITE IMPROVEMENTS:
(Specify all exterior onsite improvements not described elsewhere, including items such as unusual grading, drainage structures, retaining walls, fence, railings, and accessory structures.)

LANDSCAPING, PLANTING, AND FINISH GRADING:
Topsoil _____" thick: ☐ front yard; ☐ side yards; ☐ rear yard to _____ feet behind main building.
Lawns (seeded, sodded, or sprigged): ☐ front yard _____ ; ☐ side yards _____ ; ☐ rear yard_____
Planting: ☐ as specified and shown on drawings; ☐ as follows:
_____ Shade trees, deciduous, _____" caliper. _____ Evergreen trees. _____' to _____', B & B:
_____ Low flowering trees, deciduous, _____' to _____' _____ Evergreen shrubs. _____' to _____', B & B.
_____ High-growing shrubs, deciduous, _____' to _____' _____ Vines, 2-year _____
_____ Medium-growing shrubs, deciduous, _____' to _____'
_____ Low-growing shrubs, deciduous, _____' to _____'

IDENTIFICATION.—This exhibit shall be identified by the signature of the builder, or sponsor, and/or the proposed mortgagor if the latter is known at the time of application.

Date_____ Signature _____

 Signature _____

Figure 14–1 (continued)

■ Glass subject to human impact is to be tempered glass.

■ Glass doors in shower and tub enclosures are to be tempered glass or fracture-resistant plastic.

■ Attic ventilation is to be a minimum of 1/100 of the attic area, 1/2 in the soffit and 1/2 in the upper area.

■ Bathroom and kitchen fans and dryer are to vent directly outside.

FOUNDATION

■ Concrete mix is to have a minimum ultimate compressive strength of 2000 psi at 28 days and shall be composed of 1 part cement, 3 parts sand, 4 parts of 1" maximum size rock, and not more than 7–1/2 gal. of water per sack of cement.

■ Foundation mud sills, plates, and sleepers are to be pressure treated or of foundation-grade redwood. All footing sills shall have full bearing on the footing wall or slab and shall be bolted to the foundation with 1/2" × 10" bolts embedded at least 7" into the concrete or reinforced masonry, or 15" into unreinforced grouted masonry. Bolts shall be spaced not to exceed 6' on center with bolts not over 12". from cut end of sills.

■ Crawl space shall be ventilated by an approved mechanical means or by openings with a net area not less than 1–1/2 sq. ft. for each 25 linear ft. of exterior wall. Openings shall be covered with not less than 1/4" or more than 1/2" of corrosion-resistant wire mesh. If the crawl space is to be heated, closeable covers for vent openings shall be provided. Water drainage and 6-mil black ground cover shall be provided in the crawl space.

■ Access to crawl space is to be a minimum of 18" × 24".

■ Basement foundation walls with a height of 8' or less supporting a well-drained porous fill of 7' or less, with soil pressure not more than 30 lbs. per sq. ft. equivalent fluid pressure, and with the bottom of the wall supported from inward movement by structural floor systems, may be of plain concrete with an 8" minimum thickness and minimum ultimate compressive strength of 2500 psi at 28 days. Basement walls supporting backfill and not meeting these criteria shall be designed in accordance with accepted engineering practices.

■ Concrete forms for footings shall conform to the shape, lines, and dimensions of the members as called for on the plans and shall be substantial and sufficiently tight to prevent leakage of mortar and slumping out of concrete in the ground contact area.

FRAMING

■ Lumber. All joists, rafters, beams, and posts 2"–4" thick shall be No. 2 Grade Douglas fir-larch or better. All posts and beams 5" and thicker shall be No. 1 Grade Douglas fir-larch or better.

■ Beams (untreated) bearing in concrete or masonry wall pockets shall have air space on sides and ends. Beams are to have not less than 4" of bearing on masonry or concrete.

■ Wall bracing. Every exterior wood stud wall and main cross partition shall be braced at each end and at least every 25' of length with 1 × 4 diagonal let-in braces or equivalent.

■ Joists are to have not less than 1–1/2" of bearing on wood or metal, nor less than 3" on masonry.

■ Joists under bearing partitions are to be doubled.

■ Floor joists are to have solid blocking at each support and at the ends except when the end is nailed to a rim joist or adjoining studs. Joists 2 × 4 or larger are to have bridging at maximum intervals of 8'.

■ Two-in. clearance is required between combustible material and the walls of an interior fireplace or chimney. 1" clearance is required when the chimney is on an outside wall. 1/2" moisture-resistant gypsum board can be used in lieu of the 1" clearance requirement.)

■ Rafter purlin braces are to be not less than 45° to the horizontal.

■ Rafters, when not parallel to ceiling joists, are to have ties that are 1 × 4 minimum spaced not more than 4' on center.

■ Provide a double top plate with a minimum 48" lap splice.

■ Metal truss tie-downs are to be required for manufactured trusses.

■ Plant manufactured trusses (if used) shall be of an approved design with an engineered drawing.

■ Fire blocking shall be provided for walls over 10'–0" in height, for horizontal shafts 10'–0" on center, and for any concealed draft opening.

■ Garage walls and ceiling adjacent to or under the dwelling require 1-hour fire-resistant construction on the garage side. A self-closing door between the garage and dwelling is to be a minimum solid-core construction.

■ Ceramic tile, or other approved material, is to be used in a water-splash area.

■ Building paper, or other approved material, is to be used under siding.

■ Framing in the water-splash area is to be protected by waterproof paper, waterproof gypsum, or other approved substitute.

■ Post-and-beam connections: A positive connection shall be provided between beam, post, and footing to ensure against uplift and lateral displacement. Untreated posts shall be separated from concrete or masonry by a rust-resistant metal plate or impervious membrane and be at least 6" from any earth.

STAIRWAYS

- Maximum rise is to be 8", minimum run 9", minimum head room to be 6'–6", and minimum width to be 30".

- Winding and curved stairways are to have a minimum inside tread width of 6".

- Enclosed usable space under stairway is to be protected by 1-hour fire-resistant construction (5/8" type X gypsum board).

- Handrails are to be from 30"–34" above tread nosing, and intermediate rails are to be such that no object of 5" diameter can pass through.

- Generally, for commercial or public structures, all unenclosed floor and roof openings, balconies, decks, and porches more than 30" above grade shall be protected by a guardrail not less than 42" high with intermediate rails or dividers such that no object of 9" diameter can pass through. Generally, guardrails for residential occupancies may be not less than 36" high. Specific applications are subject to local or national building codes.

ROOF

- Composition shingles on roof slopes between 4/12 and 7/–12 shall have an underlayment of not less than 15# felt. For slopes from 2/12 to less than 4/12, Building Department approval of roofing manufacturers' low-slope instructions is required.

- Shake roofs require solid roof sheathing (in lieu of solid sheathing, spaced sheathing may be used but shall not be less than 1 × 4 with not more than 3" clearance between) with an underlayment of not less than 15# felt with an interlace of not less than 30# felt. For slopes less than 4/12, special approval is required.

- Attic scuttle is to have a minimum of 22 × 30 of headroom above.

CHIMNEY AND FIREPLACE

- Reinforcing: Masonry-constructed chimneys extending more than 7' above the last anchorage point (example: roof line) must have not less than four #4 steel reinforcing bars placed vertically for the full height of the chimney with horizontal ties not less than 1/4" diameter spaced at not over 18" intervals. If the width of the chimney exceeds 40", two additional #4 vertical bars shall be provided for each additional flue or for each additional 40" in width or fraction thereof.

- Anchorage: All masonry chimneys over 18' high shall be anchored at each floor and/or ceiling line more than 6' above grade, except when constructed completely within the exterior walls of the building.

THERMAL INSULATION AND HEATING

- Thermal designs employing the R factor must meet minimum R factors as follows:

 a. Ceiling or roof: R-38, vaulted: R-30.

 b. Walls: R-21, vapor barrier required. Minimum one permeability rating.

 c. Floors over unheated crawl space or basements: R-25 including reflective foil.

 d. Foundation walls: R-11 to 1/2' below exterior finished grade line.

 e. Slab-on-Grade: R-11 around perimeter a minimum of 18" horizontally or vertically.

- Thermal glazing: Heated portions of buildings located in the 5,000 or less degree-day zone do not require thermal glazing on that portion of the glazing that is less than 20 percent of the total area of exterior walls including doors and windows. Heated portions of buildings located in zones over 5,000 degree days shall be provided with special thermal glazing in all exterior wall areas.

- Duct insulation: Supply and return air ducts used for heating and/or cooling located in unheated attics, garages, crawl spaces, or other unheated spaces other than between floors or interior walls shall be insulated with an R-3.5 minimum.

- Heating: Every dwelling unit and guest room shall be provided with heating facilities capable of maintaining a room temperature of 70°F at a point 3' above the floor.

FIRE WARNING SYSTEM

- Every dwelling shall be provided with approved detectors of products of combustion mounted on the ceiling or a wall within 12" of the ceiling at a point centrally located in the corridor or area giving access to and not over 12' from rooms used for sleeping. Where sleeping rooms are on an upper level, the detector shall be placed at the high area of the ceiling near the top of the stairway.

CHAPTER 14 TEST

Fill in the blanks below with the proper word or short statement as needed to complete the sentence or answer the question correctly.

1. Information that cannot be clearly or completely provided on the drawings or in schedules are provided in construction _____ .

2. What do the following acronyms mean?

 FHA _____

 FHLMC _____

 FmHA _____

 VA _____

3. List the three items that become the legal documents for the construction project. _____

 _____ .

4. When a specific product or equivalent is listed in the construction specifications, what does the "or equivalent" mean?

 _____ .

5. List at least three items that can affect the contents of the minimum construction specifications as established by local building officials from one location to another. _____
 _____ .

6. Give the recommended minimum requirements for the following general classifications of construction specifications:

 ■ Minimum room size _____ .

 ■ Minimum ceiling height in 50 percent of the area _____ .

 ■ Bathrooms and hallways can have a ceiling height of
 _____ .

 ■ Minimum window area is to be _____ the floor area with not less than _____ for habitable rooms and _____ for bathrooms and laundry rooms.

 ■ Every sleeping area is required to have a window or door for _____ .

 ■ Windows with an openable area of not less than _____ with no dimension less than _____ meet this requirement, and the sill height is to be not more than _____ above the floor.

 ■ Glass subject to human impact is to be _____ _____ glass.

 ■ Foundation mud sills and sleepers are to be _____ _____ or of _____ redwood.

■ Crawl space shall be ventilated by approved mechanical means or by openings with a net of not less than _____ _____ for each _____ of exterior wall.

■ Joists under bearing partitions are to be _____ .

■ The clearance required between combustible material and the walls of an interior fireplace or chimney is _____ .

■ Provide a double top plate with a minimum _____ _____ lap splice.

■ Fire blocking shall be provided for walls over _____ _____ in height.

■ _____, or other approved material, is to be used under siding.

■ Enclosed usable space under a stairway is to be protected by _____ fire-resistant construction.

■ Handrails for residential construction are to be from _____ above thread nosing, and intermediate rails are to be such that no object _____ in diameter can pass through.

■ Thermal designs employing the R factor must meet minimum R factors as follows: Ceiling or roof _____; walls _____, vapor barrier required with one minimum permeability rating; floors over unheated crawl space or basements _____ including reflective foil; foundation walls _____ to 6" below exterior finished grade; slab-on-grade _____ around perimeter a minimum of _____ horizontally or vertically.

■ Every dwelling unit and guest room shall be provided with heating facilities capable of maintaining a room temperature of _____ at a point 3' above the floor.

■ Every dwelling shall be provided with approved detectors of products of combustion mounted on the ceiling or a wall within _____ of the ceiling at a point centrally located in the corridor or area giving access to and not over _____ from rooms used for sleeping. Where sleeping rooms are on an upper level, the detector shall be placed at the high area of the ceiling near the top of the _____ .

CHAPTER 14 PROBLEMS

PROBLEM 14–1 Given the set of plans shown on pages 328–333, complete the FHA Description of Materials on pages 320–323. Begin by taking information from the prints to start completing the forms. When you have taken as much information as possible from the prints, complete the rest of the information required by using specific materials found in your home, in manufacturer's catalogs available with your instructor (if any), or by finding manufacturer's catalogs from local suppliers. You might consider making copies of the Description of Materials forms to use as a rough draft. The final Description of Materials should be typed or neatly hand-lettered.

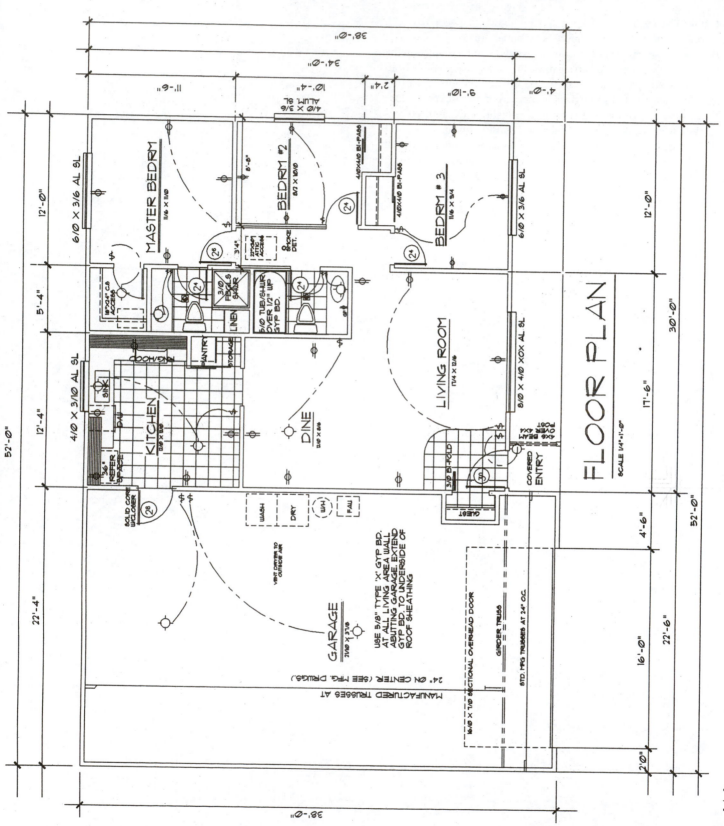

FLOOR PLAN

SCALE 1/4"=1'-0"

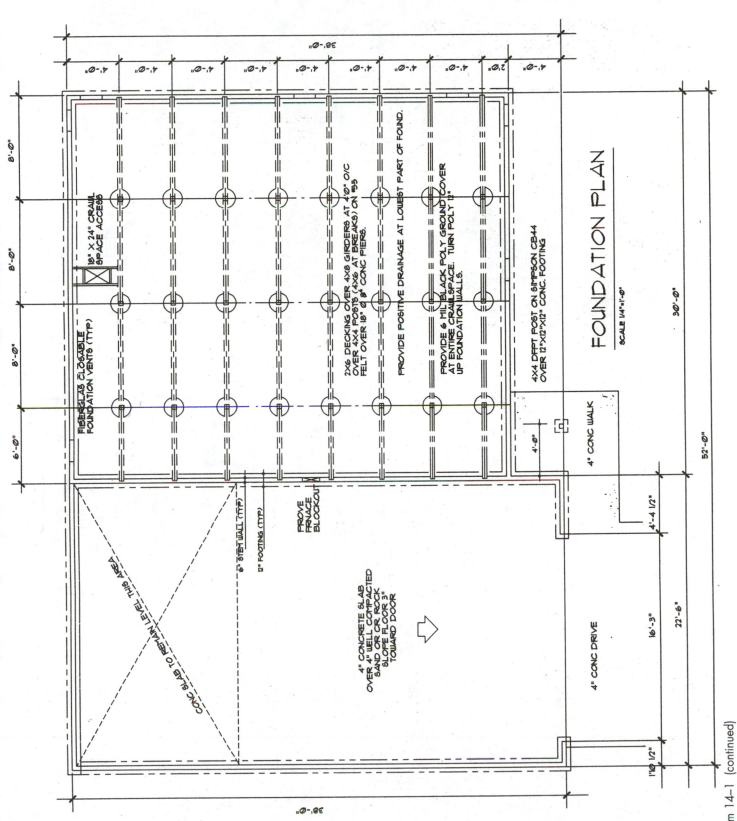

FOUNDATION PLAN
SCALE 1/4"=1'-0"

18" X 24" CRAWL SPACE ACCESS

FIBERGLAS CLOSABLE FOUNDATION VENTS (TYP)

2X6 DECKING OVER 4X8 GIRDERS AT 4'-0" O/C OVER 4X4 POSTS (4X6 AT BREAKS) ON #55 FELT OVER 18" Ø 8" CONC PIERS.

PROVIDE POSITIVE DRAINAGE AT LOWEST PART OF FOUND.

PROVIDE 6 MIL BLACK POLY GROUND COVER AT ENTIRE CRAWLSPACE. TURN POLY 12" UP FOUNDATION WALLS.

4X4 DFPT POST ON SIMPSON CB44 OVER 12"X12"X12" CONC. FOOTING

4" CONC WALK

6" STEM WALL (TYP)

12" FOOTING (TYP)

PROVE FRNACE BLOCKOUT

CONC SLAB TO REMAIN LEVEL THIS AREA

4" CONCRETE SLAB OVER 4" WELL COMPACTED SAND OR CR ROCK SLOPE FLOOR 3" TOWARD DOOR

4" CONC DRIVE

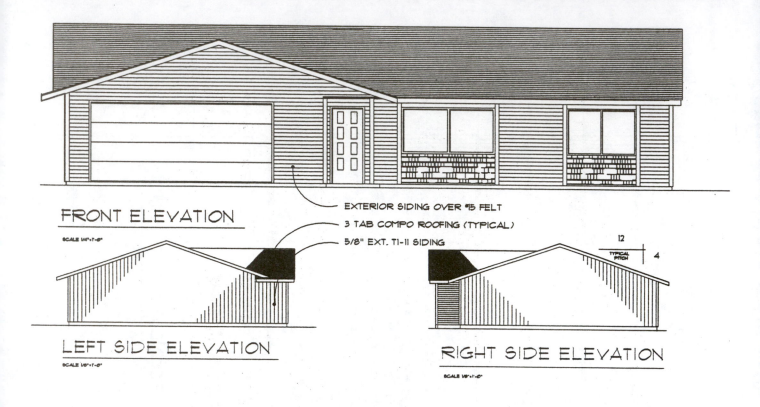

FRONT ELEVATION
SCALE 1/4"=1'-0"

EXTERIOR SIDING OVER #15 FELT
3 TAB COMPO ROOFING (TYPICAL)
5/8" EXT. T1-11 SIDING

LEFT SIDE ELEVATION
SCALE 1/8"=1'-0"

RIGHT SIDE ELEVATION
SCALE 1/8"=1'-0"

12
TYPICAL PITCH
4

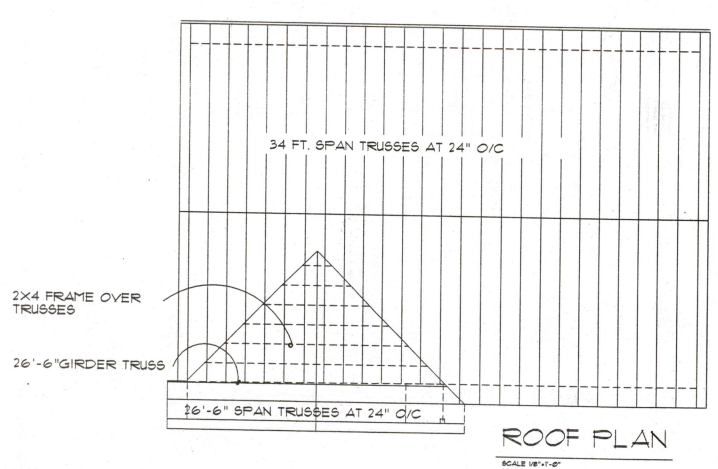

34 FT. SPAN TRUSSES AT 24" O/C

2X4 FRAME OVER TRUSSES

26'-6" GIRDER TRUSS

26'-6" SPAN TRUSSES AT 24" O/C

ROOF PLAN
SCALE 1/8"=1'-0"

Problem 14–1 (continued)

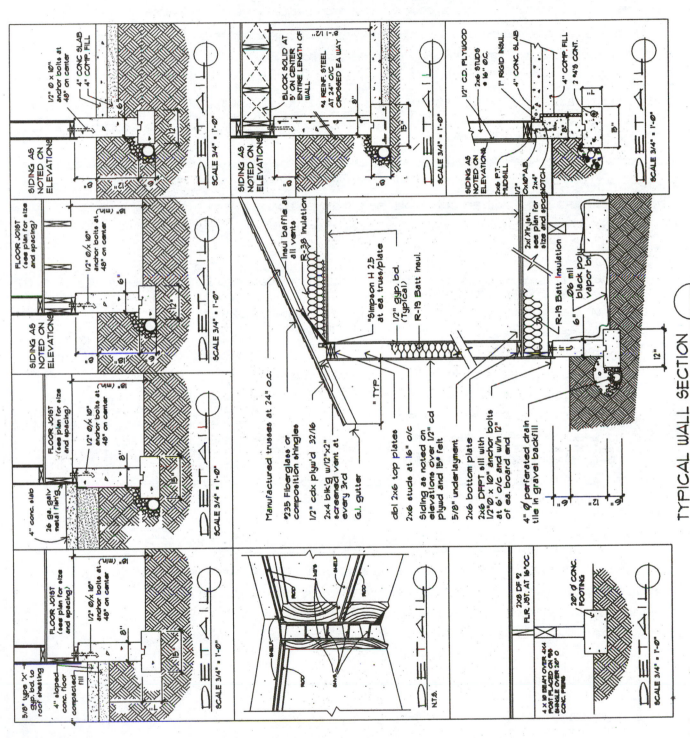

TYPICAL WALL SECTION
Scale 3/4" = 1'-0"

Manufactured trusses at 24" o.c.
#235 Fiberglass or composition shingles
1/2" cdx plyw'd 32/16
2x4 bkg w/12"x2" screened vent at every 3rd
G.I. gutter

Insul baffle at all vents
R-38 Insulation
"Simpson H 2.5 at ea. truss/plate
1/2" gyp. bd. (Typical)
R-19 Batt insul.

dbl 2x6 top plates
2x6 studs at 16" o/c
Siding as noted on elevations over 1/2" cd plywd and 15# felt
5/8" underlayment
2x6 bottom plates
2x6 DFPT sill with 1/2"Ø x 10" anchor bolts at 6' o/c and w/in 12" of ea. board end
4" Ø perforated drain tile in gravel backfill

2xf Xfr jst. see plan for size and spacing
R-19 Batt Insulation
.06 mil black poly vapor bd
6"

12"

DETAIL
SCALE 3/4" = 1'-0"

SIDING AS NOTED ON ELEVATIONS
1/2" Ø x 10" anchor bolts at 48" on center
4" CONC SLAB
4" COMP. FILL
6"
12"

DETAIL
SCALE 3/4" = 1'-0"

BLOCK SOLID AT 5' ON CENTER ENTIRE LENGTH OF WALL
#4 REINF. STEEL AT 24" O/C CROSSED EA WAY
SIDING AS NOTED ON ELEVATIONS
8"
15"

DETAIL
SCALE 3/4" = 1'-0"

1/2" CD. PLYWOOD
2x6 STUDS @ 16" O.C.
1" RIGID INSUL.
4" CONC. SLAB
4" COMP. FILL 2 4/9 CONT.
SIDING AS NOTED ON ELEVATIONS
2x6 P.T. MUDSILL
2x4
6x6#Ø AB
6x14#Ø SPG NOTCH
15"

DETAIL
SCALE 3/4" = 1'-0"

FLOOR JOIST (see plan for size and spacing)
SIDING AS NOTED ON ELEVATIONS
1/2" Ø x 10" anchor bolts at 48" on center
8" (min.)
6"
12"

DETAIL
SCALE 3/4" = 1'-0"

FLOOR JOIST (see plan for size and spacing)
1/2" Ø x 10" anchor bolts at 48" on center
8" (min.)
15"

DETAIL
SCALE 3/4" = 1'-0"

4" conc. slab
26 ga. galv metal flshg

FLOOR JOIST (see plan for size and spacing)
1/2" Ø x 10" anchor bolts at 48" on center
8" (min.)
15"

DETAIL
SCALE 3/4" = 1'-0"

5/8" type 'X' gyp. bd. to roof sheating
4" sloped conc. floor
4" compacted fill

DETAIL
N.T.S.

SHELF
ROD
SHAG?
SHELF
ROD

2x8 DF #2 FLR. JST. AT 16"OC
4 x 10 BEAM OVER 4x4 POST PLACED ON 5#0 SHINGLE OVER 20"0 CONC. PIERS
20"Ø CONC. FOOTING

DETAIL
SCALE 3/4" = 1'-0"

Problem 14–1 (continued)

GENERAL NOTES ..

FOUNDATION

1. FOOTINGS SHALL BEAR ON FIRM UNDISTURBED SOIL WITH MIN DEPTH BELOW FINAL GRADE OF 1'-6" FOR ONE AND TWO STORY AND 2'-0" FOR THREE STORY, UNLESS SHOWN OTHERWISE.

2. FOUNDATION SIZES ARE BASED ON A MINIMUM TOTAL BEARING CAPACITY OF 1500 PSF (ASSUMED)

3. DO NOT EXCAVATE CLOSER THAN 1 1/2 TO 2 SLOPE BELOW FOOTINGS.

CONCRETE

1. ALL CONCRETE USED AT EXTERIOR STEPS, PORCHES, OR CARPORTS SHALL BE 3500 PSI WITH 5-7% AIR ENTRAINMENT. ALL VERTICAL CONCRETE EXPOSED TO WEATHER SHALL BE 3500 PSI WITH 5-7% OF VOLUME AIR ENTRAINED. ALL OTHER CONCRETE EXPOSED TO FREEZE/THAW WEATHER CONDITIONS SHALL BE 2500 PSI WITH 5-7% AIR ENTRAINMENT.

2. CONCRETE METHODS, FORMS, AND SHORES SHALL BE IN ACCORDANCE WITH LATEST A.C.I. STANDARDS.

REINFORCING STEEL

1. REINFORCING BARS (WHEN CALLED OUT) SHALL BE DEFORMED BARS CONFORMING TO A.S.T.M. SPECS.

2. ALL WELDED WIRE FABRIC SHALL CONFORM TO CURRENT A.S.T.M. SPECS.

WOOD

1. ALL SAWN LUMBER SHALL BE DOUGLAS FIR LARCH INSTALLED AS REQUIRED ON NAILING SCHEDULE, ON PLANS, DETAILS AND ON SPECIFICATIONS.

2. GRADING SHALL BE IN ACCORDANCE WITH CURRENT WWPA STANDARD GRADING RULES.

POSTS AND BEAMS GRADE NO. 1

JOISTS AND RAFTERS GRADE NO 2

SILLS, PLATES & BLKG GRADE NO 3

STUDS DOUG FIR STUD GRADE

FLOORS OVER JOIST 5/8" CD DF PLYWD

2X6 T&G SUB-FLOOR GRADE NO. 3

ROOF AND WALL SHTG 1/2" CD PLYWD 32/16

FLOOR UNDERLAYMENT 1/2" PART. BD.

GLUE-LAM BEAMS (fb2200) PER A.I.T.C. INDUSTRIAL GRADE WITH DRY-USE ADHESIVE USE ARCH GRADE FOR EXPOSED BEAMS.

NOTE: SOLID INTERIOR BEAMS VISUALLY EXPOSED SHALL BE "CLEAR" GRADE, FREE OF HEART CENTER. ALL INTERIOR AND EXTERIOR BEARING WALL OPENINGS SHALL HAVE 4 X 12 DF# 1 HEADERS UNLESS NOTED OTHERWISE.

3. PLYWOOD- ALL STRUCTURAL SHEATHING SHALL BE DF PLYWD 32/16 AS INDICATED ON PLANS.

INSULATION

1. ROOFS/ATTICS R-19 WITH VAPOR BARRIER ON WINTER WARM SIDE AT VAULTS
 R-38 WITH VAPOR BARRIER ON WINTER WARM SIDE AT ATTIC SPACES

2. WALLS R-19 (AT EXTERIOR & GARAGE COMMON WALL) WITH VAPOR BARRIER

3. FLOOR OVER UNHEATED SPACE R-19 W/VAPOR BARRIER ON WINTER WARM SIDE

4. BASEMENT WALLS (IF ANY) R-11 TO 12" BELOW EXTERIOR GRADE

5. CONCRETE SLAB ON GRADE R-11 TO 12" BELOW EXTERIOR GRADE

6. FURNACE DUCTS IN UNHEATED CRAWL SPACES R-35

7. CRAWLSPACE INSULATION TO HAVE A FLAME SPREAD RATING OF .25 (MAX.) AND A SMOKE DENSITY RATING OF 450 (MAX.) PER UBC 1713(C)

Problem 14-1 (continued)

NAILING SCHEDULE

CONNECTION NAILING

1. JOIST TO SILL OR GIRDER, TOE NAIL 3-8d
2. BRIDGING TO JOIST, TOE NAIL EACH END 2-8d
3. 2" SUBFLOOR TO JOIST OR GIRDER, BLIND & FACE WALL . 2-16d
4. TOP PLATE TO STUD, END NAIL 2-16d
5. SOLE PLATE TO JOIST OR BLOCKING, FACE NAIL 16d AT 16"OC
6. STUD TO SOLE PLATE . 4-8d TOE NAIL OR
 2-16d END NAIL
7. DOUBLE STUDS, FACE WALL 16d AT 16"OC
8. DOUBLE TOP PLATES, FACE NAIL 16d AT 16"OC
9. TOP PLATES, LAP & INTERSECTIONS, FACE NAIL 2-16d
10. CONTINUOUS HEADER, 2 PIECES 16d AT 16"OC
 ALONG EACH END
11. CEILING JOIST TO PLATE, TOE NAIL 3-8d
12. CEILING JOIST LAPS OVER PARTITIONS, FACE NAIL 3-16d
13. CEILING JOIST TO PARALLEL RAFTERS 3-16d
14. RAFTER TO PLATE, TOE NAIL 3-8d
15. BUILT-UP CORNER STUDS . 16d AT 24"OC
16. PLYWOOD SUBFLOOR . 8d COMMON AT 6"OC
 AT EDGE & 10"OC AT INT.
17. PLYWOOD WALL SHEATHING 8d COMMON AT 6"OC AT
 EDGE & 12"OC AT INT.
18. PLYWOOD ROOF SHEATHING 8d COMMON AT 6" OC AT
 EDGE & 12"OC AT INT.

MISCELLANEOUS

1. EACH SLEEPING ROOM TO HAVE AT LEAST ONE EGRESSABLE WINDOW WITH A MIN NET OPENING OF 20" X 24", 5.7 SQUARE FT. AND A MAX NET SILL HEIGHT OF 44", MEASURED FROM FINISHED FLOOR.

2. PROVIDE OUTSIDE COMBUSTION AIR TO ALL FIREPLACES AND STOVES.

3. ALL TUB AND SHOWERS TO HAVE 1/2" WATERPROOF GYP. BD. AT WALLS AND A HARD MOISURE RESISTANT SURFACE TO A HEIGHT OF 6'0"

4. EXHAUST ALL FANS, RANGES, AND CLOTHES DRYERS TO OUTSIDE AIR

5. ALL WINDOWS AND EXTERIOR GLAZED DOORS SHALL BE GLAZED WITH DUAL PANED INSULATED GLASS AND TEMPERED WHERE SUBJECT TO HUMAN IMPACT.

6. GENERAL CONTRACTOR SHALL BE RESPONSIBLE FOR VERIFYING ALL DIMENSIONS AND CONDITIONS WITH PLANS AND REPORTING ANY DISCREPANCIES TO SUNRIDGE DESIGN BEFORE STARTING WORK

7. THIS STRUCTURE SHALL BE ADEQUATELY BRACED FOR WIND LOADS UNTIL THE ROOF AND WALLS HAVE BEEN PERMANENTLY ATTATCHED TOGETHER AND SHEATHED

8. ALL LUMBER IN PERMANENT CONTACT WITH CONCRETE SHALL BE PRESSURE TREATED WITH A WATER-BORNE PRESERVATIVE.

9. ALL SMOKE DETECTORS CALLED OUT SHALL BE CONNECTED TO HOUSE POWER.(HARD-WIRED)

10. ALL FEDERAL, STATE, AND LOCAL CODES, ORDINANCES AND REGULATIONS SHALL BE CONSIDERED AS PART OF SPECIFICATIONS FOR THIS BUILDING AND SHALL TAKE PREFERENCE OVER ANYTHING SHOWN, DESCRIBED OR IMPLIED WHERE VARIANCES OCCUR.

11. ANY MODIFICATIONS TO THE DESIGN OR COMPONENTS OF THIS BUILDING MAY AFFECT IT'S STRUCTURAL INTEGRITY AND SHOULD BE REVIEWED BY AN ENGINEER PRIOR TO CONSTRUCTION.

DESIGN LOADS

ROOF 30 PSF LIVE LOAD
FLOORS 40 PSF LIVE LOAD
STAIRS 100 PSF LIVE LOAD
GARAGE FLOORS 50 PSF LIVE LOAD
DECKS 60 PSF LIVE LOAD
WIND LOADS 30 PSF EXPOSURE "C"
SEISMIC ZONE II

Problem 14–1 (continued).

Metric in Construction

The following tables are courtesy Metric in Construction Newsletter, published by the Construction Metrication Council of the National Institute of Building Sciences, Washington, DC. Fax: 202-289-1092. E-mail: bbrenner@nibs.org. Internet: www.nibs.org.

▼ UNIT CONVERSION TABLES

SI SYMBOLS AND PREFIXES

Quantity	Unit	Symbol
BASE UNITS		
Length	Meter	m
Mass	Kilogram	kg
Time	Second	s
Electric current	Ampere	A
Thermodynamic temperature	Kelvin	K
Amount of substance	Mole	mol
Luminous intensity	Candela	cd
SI SUPPLEMENTARY UNITS		
Plane angle	Radian	rad
Solid angle	Steradian	sr

SI PREFIXES

Multiplication Factor	Prefix	Symbol
$1\ 000\ 000\ 000\ 000\ 000\ 000 = 10^{18}$	exa	E
$1\ 000\ 000\ 000\ 000\ 000 = 10^{15}$	peta	P
$1\ 000\ 000\ 000\ 000 = 10^{12}$	tera	T
$1\ 000\ 000\ 000 = 10^{9}$	giga	G
$1\ 000\ 000 = 10^{6}$	mega	M
$1\ 000 = 10^{3}$	kilo	k
$100 = 10^{2}$	hecto	h
$10 = 10^{1}$	deka	da
$0.1 = 10^{-1}$	deci	d
$0.01 = 10^{-2}$	centi	c
$0.001 = 10^{-3}$	milli	m
$0.000\ 001 = 10^{-6}$	micro	μ
$0.000\ 000\ 001 = 10^{-9}$	nano	n
$0.000\ 000\ 000\ 000 = 10^{-12}$	pico	p
$0.000\ 000\ 000\ 000\ 000 = 10^{-15}$	femto	f
$0.000\ 000\ 000\ 000\ 000\ 000 = 10^{-18}$	atto	a

CONVERSION FACTORS

To convert	to	multiply by
LENGTH		
1 mile (U.S. statute)	km	1.609 344
1 yd	m	0.9144
1 ft	m	0.3048
	mm	304.8
1 in	mm	25.4
AREA		
1 mile2 (U.S. statute)	km^2	2.589 998
1 acre (U.S. survey)	ha	0.404 6873
	m^2	4,046,873
1 yd^2	m^2	0.836 1274
1 ft^2	m^2	0.092 903 04
1 in^2	mm^2	645.16
VOLUME, MODULUS OF SECTION		
1 acre ft	m^3	1,233.489
1 yd^3	m^3	0.764 5549
100 board ft	m^3	0.235 9737
1 ft^3	m^3	0.028 316 85
	L (dm^3)	28.3168
1 in^3	mm^3	16 387.06
	mL (cm^3)	16.3871
1 barrel (42 U.S. gallons)	m^3	0.158 9873
(FLUID) CAPACITY		
1 gal (U.S. liquid)*	L**	3.785 412
1 qt (U.S. liquid)	mL	946.3529
1 pt (U.S. liquid)	mL	473.1765
1 fl oz (U.S.)	mL	29.5735
1 gal (U.S. liquid)	m^3	0.003 785 412

*1 gallon (UK) approx. 1.2 gal (U.S.)

**1 liter approx. 0.001 cubic meters

To convert	to	multiply by
SECOND MOMENT OF AREA		
1 in^4	mm^4	4,162,314
	m^4	$4{,}162{,}314 \times 10^{-7}$
PLANE ANGLE		
1° (degree)	rad	0.017 453 29
	mrad	17.453 29
1′ (minute)	urad	290.8882
1″ (second)	urad	4.848 137

CONVERSION FACTORS—(Continued)

To convert	to	multiply by
VOLUME RATE OF FLOW		
1 ft³/s	m³/s	0.028 316 85
1 ft³/min	L/s	0.471 9474
1 gal/min	L/s	0.063 0902
1 gal/min	m³/min	0.0038
1 gal/h	mL/s	1.051 50
1 million gal/d	L/s	43.8126
1 acre ft/s	m³/s	1233.49
TEMPERATURE INTERVAL		
1° F	°C or K	0.555 556
		⅚°C = ⅚K
MASS		
1 ton (short)	metric ton	0.907 185
	kg	907.1847
1 lb	kg	0.453 5924
1 oz	g	28.349 52
1 long ton (2,240 lb)	kg	1,016.047
MASS PER UNIT AREA		
1 lb/ft²	kg/m²	4.882 428
1 oz/yd²	g/m²	33.905 75
1 oz/ft²	g/m²	305.1517
DENSITY (MASS PER UNIT VOLUME)		
1 lb/ft³	kg/m³	16.01846
1 lb/yd³	kg/m³	0.593 2764
1 ton/yd³	t/m³	1.186 553
FORCE		
1 tonf (ton-force)	kN	8.896 44
1 kip (1,000 lbf)	kN	4.448 22
1 lbf (pound-force)	N	4.448 22
MOMENT OF FORCE, TORQUE		
1 lbf · ft	N · m	1.355 818
1 lbf · in	N · m	0.112 9848
1 tonf · ft	kN · m	2.711 64
1 kip · ft	kN · m	1.355 82
FORCE PER UNIT LENGTH		
1 lbf/ft	N/m	14.5939
1 lbf/in	N/m	175.1268
1 tonf/ft	kN/m	29.1878
PRESSURE, STRESS, MODULUS OF ELASTICITY (FORCE PER UNIT AREA) (1 Pa = 1 N/m²)		
1 tonf/in²	MPa	13.7895
1 tonf/ft²	kPa	95.7605
1 kip/in²	MPa	6.894 757
1 lbf/in²	kPa	6.894 757
1 lbf/ft²	Pa	47.8803
Atmosphere	kPa	101.3250
1 inch mercury	kPa	3.376 85
1 foot (water column at 32°F.)	kPa	2.988 98

CONVERSION FACTORS—(Continued)

To convert	to	multiply by
WORK, ENERGY, HEAT (1J = 1N · m = 1W · s)		
1 kWh (550ft · lbf/s)	MJ	3.6
1 Btu (Int. Table)	kJ	1.055 056
	J	1,055.056
1 ft · lbf	J	1.355 818
COEFFICIENT OF HEAT TRANSFER		
1 Btu/(ft² · h · °F)	W/(m² · K)	5.678 263
THERMAL CONDUCTIVITY		
1 Btu/(ft · h · °F)	W/(m · K)	1.730 735
ILLUMINANCE		
1 lm/ft² (footcandle)	lx (lux)	10.763 91
LUMINANCE		
1 cd/ft²	cd/m²	10.7639
1 foot lambert	cd/m²	3.426 259
1 lambert	kcd/m²	3.183 099

CONVERSION AND ROUNDING

The conversion of inch-pound units to metric is an important part of the metrication process. But conversion can be deceptively simple because most measurements have implied, not expressed, tolerances and many products (like 2 × 4s) are designated in rounded, easy-to-remember "nominal" sizes, not actual ones. For instance, if anchor bolts are to be embedded in masonry to a depth of 8", what should this depth be in millimeters? A strict conversion (using 1" = 25.4 mm) results in an exact dimension of 203.2 mm. But this implies an accuracy of 0.1 mm (1/254") and a tolerance of ± 0.05 mm (1/508"), far beyond any reasonable measure for field use. Similarly, 203 mm is overly precise, implying an accuracy of 1 mm (about 1/25") and a tolerance of ± 0.5 mm (about 1/50"). As a practical matter, ± 3 mm (1/8") is well within the tolerance for setting anchor bolts. Applying ± 3 mm to 203.2 mm, the converted dimension should be in the range of 200 mm to 206 mm. Metric measuring devices emphasize 10 mm increments and masons work on a 200 mm module, so the selection of 200 mm would be a convenient dimension for masons to use in the field. Thus, a reasonable metric conversion for 8", *in this case,* is 200 mm.

APPENDIX B

Thermal Calculations for Heating/Cooling

DEVELOPMENT OF METHODOLOGY FOR ESTIMATING HEAT LOSS

The basic methodology for estimating residential heat loss today has been in use since the early 1900s. Historically, its primary use was to calculate the design heat load of houses in order to estimate the size of gas and oil heating systems required. Because home designers, builders, and heating system installers did not want to receive complaints from cold homeowners, they commonly designed the heating system for worst-case weather conditions, with a bias toward overestimating the design heat load to ensure that the furnace would never be too small. Consequently, many gas and oil furnaces were oversized.

As early as 1915 an engineer for a gas utility began modifying the design heat load with a degree-day method to estimate annual energy consumption. Oil companies also began using this method to predict when to refill their customers' tanks. Data from this period, for houses with little or no insulation, indicated that the proportionality between annual heating energy requirements and average outside temperature began at 65°F (18°C) in residential buildings. This was the beginning of the 65°F base for degree days. Studies made by the American Gas Association up to 1932 and by the National District Heating Association in 1932 also indicated that a 65°F base was appropriate for houses of the period.

Experience in the 1950s and early 1960s with electrically heated homes indicated that the traditional degree-day procedure was overestimating annual heating loads. This was due primarily to tighter, better-insulated houses with balance temperatures below 65°F, and to more appliances. These later studies led to a modified degree-day procedure incorporating a modifying factor, C. This C factor compensates for such things as higher insulation levels and more heat-producing appliances in the house. The high insulation levels found in homes built to current codes, and those that have been retrofitted with insulation, cause even lower balance tempera-

tures than those of houses built in the 1950s and 1960s. (This history has been adapted from *Standard Heat Loss Methodology*, Bonneville Power Administration.)

TERMINOLOGY

Btu (British thermal unit): A unit of measurement determined by the amount of heat required to raise 1 lb. of water 1° Fahrenheit. Heat loss is calculated in Btu per hour (Btuh).

Compass point: The relationship of the structure to compass orientation. In referring to cooling calculations it is important to evaluate the amount of glass in each wall as related to compass orientation. This is due to the differences effected by solar gain.

Duct loss: Heat loss through ductwork in an unheated space, which has an effect on total heat loss. Insulating those ducts helps increase efficiency.

Grains: The amount of moisture in the air (grains of moisture in 1 cu. ft.). A grain is a unit of weight. Air at different temperatures and humidities holds different amounts of moisture. The effect of this moisture content becomes more of a factor in the southern and midwestern states than in other parts of the country.

Heat transfer multiplier: The amount of heat that flows through each square foot of the building surface. The product depends on the type of surface and whether it is applied to heating or cooling.

Indoor temperature: The indoor design temperature is generally 60°F–70°F.

Indoor wet bulb: Relates to the use of the wet-bulb thermometer inside. A wet-bulb thermometer is one in which the bulb is kept moistened and is used to determine humidity level.

Infiltration: The inward flow of air through a porous wall or crack. In a loosely constructed home, infiltration substantially *increases heat loss*. Infiltration around windows and doors is calculated in CFM per linear foot of crack. Window infiltration greater than 0.5 CFM per linear foot of crack is excessive.

Internal heat gain: Heat gain associated with factors such as heat transmitted from appliances, lights, other equipment, and occupants.

Latent load: The effects of moisture entering the structure from the outside by humidity infiltration or from the inside, produced by people, plants, and daily activities such as cooking, showers, and laundry.

Mechanical ventilation: Amount of heat loss through mechanical ventilators such as range hood fans or bathroom exhaust fans.

Outdoor temperature: Related to average winter and summer temperatures for a local area. If the outdoor winter design temperature is 20°F, this means that the temperature during the winter is 20° or higher 97.5 percent of the time. If the outdoor summer design temperature in an area is 100°F, this means that the temperature during the summer is 100° or less 97.5 percent of the time. Figures for each area of the country have been established by ASHRAE. Verify the outdoor temperature with your local building department or heating contractor.

Outdoor wet bulb: Relates to the use of a wet-bulb thermometer outside. A wet-bulb thermometer is one in which the bulb is kept moistened and is used to determine humidity level.

R factor: Resistance to heat flow. The more resistance to heat flow, the higher the R value. For example, 3–1/2" of mineral wool insulation has a value of R-11; 6" of the same insulation has a value of R-19. R is equal to the reciprocal of the U factor, $1/U = R$.

Sensible load calculations: Load calculations associated with temperature change that occurs when a structure loses or gains heat.

Temperature difference: The indoor temperature less the outdoor temperature.

U factor: The coefficient of heat transfer expressed in Btuh sq. ft./°F of surface area.

STEPS IN FILLING OUT THE RESIDENTIAL HEATING DATA SHEET

Figure B–1 is a completed Residential Heating Data Sheet. The two-page data sheet is divided into several categories with calculations resulting in total heat loss for the structure, shown in Figure B–2. The large numbers alongside the categories refer to the following steps, used in completing the form. Notice that the calculations are rounded off to the nearest whole unit.

STEP 1 Outdoor temperature. Use the recommended outdoor design temperature for your area. The area selected for this problem is Dallas, Texas, with an outdoor design temperature of 22°F, which has been rounded off to 20°F to make calculations simple to understand. The proper calculations would interpolate the tables for a 22°F outdoor design temperature.

STEP 2 Indoor temperature: 70°F.

STEP 3 Temperature difference: 70° − 20° = 50°F

STEP 4 Movable glass windows: Select double glass; find area of each window (frame length × width); then combine for total: 114 sq. ft.

STEP 5 Btuh heat loss: Using 50° design temperature difference, find 46 approximate heat transfer multiplier: 46 × 114 = 5244 Btuh.

STEP 6 Sliding glass doors: Select double glass; find total area of 34 sq. ft.

STEP 7 Btuh heat loss: 34 × 48 = 1632 Btuh.

STEP 8 Doors: Weather-stripped solid wood; 2 doors at 39 sq. ft.

STEP 9 Btuh heat loss: 39 × 30 = 1170 Btuh.

STEP 10 Walls: Excluding garage; perimeter in running feet 132 × ceiling height 8' = gross wall area 1056 sq. ft. Subtract window and door areas – 187 sq. ft. = net wall area 869 sq. ft.

STEP 11 Frame wall: No masonry wall above or below grade. When there is masonry wall, subtract the square footage of masonry wall from total wall for the net frame wall. Fill in net amount on approximate insulation value; 869 sq. ft. frame wall, R-13 (given).

STEP 12 Btuh heat loss: 869 × 3.5 = 3042 Btuh.

STEPS 13–14 No masonry above grade in this structure.

STEPS 15–16 No masonry below grade in this structure.

STEP 17 Heat loss subtotal: Add together items 5, 7, 9, and 12; 11,088 Btuh. Transfer the amount to the top of page 2 of the form.

STEP 18 Ceilings: R-30 insulation (given), same square footage as floor plan, 976 sq. ft. (given).

STEP 19 Btuh heat loss: 976 × 1.6 = 1562 Btuh.

STEP 20 Floor over an unconditioned space: R-19 insulation (given), 97 sq. ft.

STEP 21 Btuh heat loss: 976 × 2.6 = 2538 Btuh.

STEPS 22–23 Basement floor: Does not apply to this house.

STEPS 24–25 Concrete slab without perimeter system: Does not apply to this house.

STEPS 26–27 Concrete slab with perimeter system: Does not apply to this house.

STEP 28 Infiltration: 976 sq. ft. floor × 8' ceiling height = 7808 cu. ft. 0.40 × 7808 cu. ft. ÷ 60 = 52 CFM Infiltration = mechanical ventilation CFM = fresh air intake.

STEP 29 Btuh heat loss: $52 \times 55 = 2860$ Btuh.

STEP 30 Heat loss subtotal: Add items 17, 19, 21, and 29; 20,908 Btuh.

STEP 31 Duct loss: R-4 insulation (given); add 15 percent to item 30: $0.15 \times 20,923 = 3138$. When no ducts are used, exclude this item.

STEP 32 Total heat loss: Add items 30 and 31; 24,046 Btuh.

STEPS IN FILLING OUT THE RESIDENTIAL COOLING DATA SHEET

Figure B–3 is a completed residential cooling data sheet. The two-page data sheet is divided into several categories, with calculations resulting in total sensible and latent heat gain for the structure, shown in Figure B–2, used for heat loss calculations. The large numbers by each category refer to the following steps used in completing the form.

STEP 1 Outdoor temperature: 100°F.

STEP 2 Indoor temperature: 70°F.

STEP 3 Temperature difference: $100° - 70° = 30°F$.

STEPS 4–13 Glass, no shade, double-glazed.

STEP 4 North glass: Including sliding glass door; 81 sq. ft.

STEP 5 Btuh heat gain: $81 \times 28 = 2268$ Btuh.

STEPS 6–7 NE and NW glass: None; house faces N, E, W, S.

STEPS 8–9 East and west glass: None in this plan.

STEPS 10–11 SE and SW glass: None; house faces N, E, W, S.

STEP 12 South glass: 67 sq. ft.

STEP 13 Btuh heat loss: $67 \times 43 = 2881$ Btuh.

STEPS 14–23 Applies to glass with inside shade. This house is sized without considering inside shade. If items 14–23 are used, omit items 4–13.

STEP 24 Doors: Weather-stripped solid wood, 2 doors; 39 sq. ft.

STEP 25 Btuh heat gain: $39 \times 9.6 = 374$ Btuh.

STEP 26 Walls (excluding garage walls): $132' \times 8' = 1056$ sq. ft. $- 187$ sq. ft. $= 869$ sq. ft. net wall area

STEP 27 Frame wall: 869 sq. ft.

STEP 28 Btuh heat gain: $869 \times 2.5 = 2173$ Btuh.

STEPS 29–30 Masonry wall above grade: None in this house.

STEP 31 Sensible heat gain subtotal: Add together items 5, 13, 25, 28. 7696 Btuh heat gain. Transfer the amount to the top of page 2 of the form.

STEP 32 Ceiling: R-30 insulation; 976 sq. ft.

STEP 33 Btuh heat gain: $976 \times 1.7 = 1659$ Btuh.

STEP 34 Floor over unconditioned space: R-19 insulation; 976 sq. ft.

STEP 35 Btuh heat gain: $976 \times 1.2 = 1171$ Btuh.

STEP 36 Infiltration/ventilation: 976 sq. ft. $\times 8' = 7808$ cu. ft. 0.40×7808 cu. ft. $\div 60 = 52$ CFM.

STEP 37 Btuh heat gain: $52 \times 32 = 1664$ Btuh.

STEP 38 Internal heat gain: Number of people (assume 4 for this house); 4×300 Btuh per person $= 1200$ Btuh. Kitchen allowance given 1200 Btuh.

STEP 39 Sensible heat gain subtotal: Add together items 31, 33, 35, 37, and 38; 15,054 Btuh.

STEP 40 Duct gain: $15,054 \times .15 = 2258$ Btuh.

STEP 41 Total sensible heat gain: Add together items 39 and 40; 17,312 Btuh.

STEPS 42–45 Latent load calculations.

STEP 42 Determine the local relative humidity conditions, either wet, medium, medium dry, or dry. Our selected location is medium, which is 35 grains.

STEP 43 Latent load infiltration: 0.68×35 grains $= 52$ CFM (from item 36) $= 1238$ Btuh.

STEP 44 Latent load ventilation: 0.68×35 grains $\times 52$ CFM $= 1238$ Btuh.

STEP 45 Latent load people: 4 people $\times 230$ Btuh $= 920$ Btuh.

STEP 46 Total latent heat gain: Add together items 43, 44, and 45; 3396 Btuh.

STEP 47 Total sensible and latent heat gain: Add together items 41 and 46; 20,708 Btuh.

JOB NAME:		DATE	
ADDRESS:			

1 OUTDOOR TEMP: 20° **2** INDOOR TEMP: 70° **3** TEMP. DIFFERENCE: 50°

4

MOVABLE GLASS WINDOWS	SQUARE FEET	DESIGN TEMPERATURE DIFFERENCE														BTUH HEAT LOSS
		30	35	40	45	(50)	55	60	65	70	75	80	85	90	95	
		HEAT TRANSFER MULTIPLIER														
SINGLE GLASS		39	45	52	58	65	71	78	84	90	97	103	110	116	123	
SINGLE GLASS W/STORM		21	25	28	31	35	38	42	45	49	52	56	59	63	66	
DOUBLE GLASS	114	28	32	37	41	(46)	50	55	60	64	69	73	78	82	87	5244
DOUBLE GLASS W/STORM		16	19	21	24	27	29	32	35	37	40	42	45	48	50	

5

6

SLIDING GLASS DOORS	SQUARE FEET	DESIGN TEMPERATURE DIFFERENCE														BTUH HEAT LOSS
		30	35	40	45	(50)	55	60	65	70	75	80	85	90	95	
		HEAT TRANSFER MULTIPLIER														
SINGLE GLASS		42	48	55	62	69	76	83	90	97	104	110	117	124	131	
SINGLE GLASS W/STORM		22	26	29	33	37	40	44	48	51	55	59	62	66	70	
DOUBLE GLASS	34	29	34	39	43	(48)	53	58	63	67	72	77	82	87	91	1632

7

8

DOORS	SQUARE FEET	DESIGN TEMPERATURE DIFFERENCE														BTUH HEAT LOSS
		30	35	40	45	(50)	55	60	65	70	75	80	85	90	95	
		HEAT TRANSFER MULTIPLIER														
SOLID WOOD		31	36	41	46	51	56	62	67	72	77	82	87	92	97	
SOLID WOOD**	39	18	21	24	27	(30)	33	36	39	42	45	47	50	53	56	1170
METAL URETHANE		23	27	30	34	38	42	45	49	53	57	60	64	68	72	
METAL URETHANE**		13	16	18	20	22	25	27	29	31	33	36	38	40	42	
**Weatherstripped or Storm																

9

10 WALLS

RUNNING FEET		132
CEILING HEIGHT	X	8
GROSS WALL	=	1056
WINDOWS & DOOR AREAS	−	187
NET WALL AREA		869

FRAME WALL	SQUARE FEET	DESIGN TEMPERATURE DIFFERENCE														BTUH HEAT LOSS
		30	35	40	45	(50)	55	60	65	70	75	80	85	90	95	
		HEAT TRANSFER MULTIPLIER														
NO INSULATION		8	10	11	12	14	15	17	18	19	21	22	23	25	26	
R-11, 3" INSULATION		2.7	3.1	3.6	4.0	4.5	4.9	5.4	5.8	6.3	6.7	7.2	7.6	8.1	8.5	
R-13, 3-1/2" INSULATION	869	2.1	2.4	2.8	3.2	(3.5)	3.8	4.2	4.6	4.9	5.3	5.6	5.9	6.3	6.6	3042
R-13 + 1" POLYSTYRENE		1.8	2.1	2.4	2.7	3.0	3.3	3.6	3.9	4.2	4.5	4.8	5.1	5.4	5.7	
R-19 + 1/2" POLYSTYRENE		1.6	1.9	2.2	2.5	2.8	3.0	3.3	3.6	3.8	4.1	4.4	4.7	4.9	5.2	

11 **12**

MASONRY WALL ABOVE GRADE	SQUARE FEET	DESIGN TEMPERATURE DIFFERENCE														BTUH HEAT LOSS
		30	35	40	45	50	55	60	65	70	75	80	85	90	95	
		HEAT TRANSFER MULTIPLIER														
NO INSULATION		16	18	21	23	26	28	31	33	36	38	41	44	46	49	
R-5, 1" INSULATION		4.3	5.0	5.8	6.5	7.2	7.9	8.6	9.4	10.1	10.8	11.5	12.2	13.0	13.7	
R-11, 3" INSULATION		2.3	2.7	3.1	3.5	3.8	4.2	4.6	5.0	5.4	5.8	6.2	6.5	6.9	7.3	
R-19, 6" INSULATION		1.4	1.7	1.9	2.2	2.4	2.6	2.9	3.1	3.4	3.6	3.8	4.1	4.3	4.6	

13 **14**

MASONRY WALL BELOW GRADE	SQUARE FEET	DESIGN TEMPERATURE DIFFERENCE														BTUH HEAT LOSS
		30	35	40	45	50	55	60	65	70	75	80	85	90	95	
		HEAT TRANSFER MULTIPLIER														
NO INSULATION		4.4	5.1	5.9	6.6	7.3	8.1	8.8	9.6	10.3	11.0	11.8	12.5	13.2	14.0	
R-5, 1" INSULATION		2.6	3.0	3.5	3.9	4.3	4.8	5.2	5.7	6.1	6.5	7.0	7.4	7.8	8.3	
R-11, 3" INSULATION		1.8	2.1	2.4	2.7	3.0	3.3	3.6	3.9	4.2	4.5	4.8	5.1	5.4	5.7	
R-19, 6" INSULATION		1.2	1.4	1.6	1.8	2.0	2.2	2.4	2.6	2.8	3.0	3.2	3.4	3.6	3.8	

15 **16**

HEAT LOSS SUBTOTAL	11088

17

Figure B–1 Completed residential heating data sheet. *Courtesy Lennox Industries, Inc.*

		Heat Loss Subtotal from Page 1	11088	**17**

18

CEILING	SQUARE FEET	DESIGN TEMPERATURE DIFFERENCE — HEAT TRANSFER MULTIPLIER														BTUH HEAT LOSS
		30	35	40	45	50	55	60	65	70	75	80	85	90	95	
NO INSULATION		18	21	24	27	30	33	36	39	42	45	48	51	54	57	
R-11, 3" INSULATION		2.6	3.1	3.5	4.0	4.4	4.8	5.3	5.7	6.2	6.6	7.0	7.5	7.9	8.4	
R-19, 6" INSULATION		1.6	1.9	2.1	2.4	2.6	2.9	3.2	3.4	3.7	4.0	4.2	4.5	4.8	5.0	
R-30, 10" INSULATION	976	1.0	1.2	1.3	1.5	1.6	1.8	2.0	2.1	2.3	2.5	2.6	2.8	3.0	3.1	1562
R-38, 12" INSULATION		0.8	0.9	1.0	1.2	1.3	1.4	1.6	1.7	1.8	2.0	2.1	2.2	2.3	.5	

19

20

FLOOR OVER AN UNCONDITIONED SPACE	SQUARE FEET	DESIGN TEMPERATURE DIFFERENCE — HEAT TRANSFER MULTIPLIER														BTUH HEAT LOSS
		30	35	40	45	50	55	60	65	70	75	80	85	90	95	
NO INSULATION		10	11	13	14	16	17	19	21	22	24	25	27	28	30	
R-11, 3" INSULATION		2.4	2.8	3.2	3.6	4.0	4.4	4.8	5.2	5.6	6.0	6.4	6.8	7.2	7.6	
R-19, 6" INSULATION	976	1.6	1.8	2.1	2.3	2.6	2.9	3.1	3.4	3.6	3.9	4.2	4.4	4.7	4.9	2538
R-30, 10" INSULATION		1.1	1.3	1.5	1.7	1.8	2.0	2.2	2.4	2.6	2.8	3.0	3.1	3.3	3.5	

21

22

BASEMENT FLOOR	SQUARE FEET	DESIGN TEMPERATURE DIFFERENCE — HEAT TRANSFER MULTIPLIER														BTUH HEAT LOSS
		30	35	40	45	50	55	60	65	70	75	80	85	90	95	
BASEMENT FLOOR		0.8	1.0	1.1	1.3	1.4	1.5	1.7	1.8	2.0	2.1	2.2	2.4	2.5	2.7	

23

24

CONCRETE SLAB WITHOUT PERIMETER SYSTEM	LINEAR FOOT	DESIGN TEMPERATURE DIFFERENCE — HEAT TRANSFER MULTIPLIER														BTUH HEAT LOSS
		30	35	40	45	50	55	60	65	70	75	80	85	90	95	
NO EDGE INSULATION		25	29	33	37	41	45	49	53	57	61	65	69	73	77	
1" EDGE INSULATION		13	15	17	19	21	23	25	27	29	31	33	35	37	39	
2" INSULATION		6.3	7.4	8.4	9.4	10.5	11.5	12.6	13.6	14.7	15.8	16.8	17.8	18.9	20.0	

25

26

CONCRETE SLAB WITH PERIMETER SYSTEM	LINEAR FOOT	DESIGN TEMPERATURE DIFFERENCE — HEAT TRANSFER MULTIPLIER														BTUH HEAT LOSS
		30	35	40	45	50	55	60	65	70	75	80	85	90	95	
NO EDGE INSULATION		57	67	76	86	95	105	114	124	133	143	152	162	171	181	
1" EDGE INSULATION		34	40	46	52	57	63	69	74	80	86	91	97	103	109	
2" EDGE INSULATION		28	33	37	42	47	51	56	61	65	70	75	79	84	89	

27

An additional infiltration load is calculated **only** if the home is loosely constructed or when window infiltration is greater than .5 CFM per linear foot of crack.

28 INFILTRATION/ VENTILATION

976 FLOOR SQ. FT. x _8_ CEILING HEIGHT = _7808_ CUBIC FT

0.40 x _7808_ CUBIC FT ÷ 60 = _52_ CFM

MECHANICAL VENTILATION CFM = FRESH AIR INTAKE

	CFM	DESIGN TEMPERATURE DIFFERENCE — HEAT TRANSFER MULTIPLIER														BTUH HEAT LOSS
		30	35	40	45	50	55	60	65	70	75	80	85	90	95	
INFILTRATION	52	33	39	44	50	55	61	66	72	77	83	88	94	99	105	2860
MECHANICAL VENTILATION	52	33	39	44	50	55	61	66	72	77	83	88	94	99	105	2860

29

	HEAT LOSS SUBTOTAL	20908	**30**

31

DUCT LOSS	BTUH HEAT LOSS
R-4, 1" Flexible Blanket Insulation: ADD 15% (.15)	3138
R-7, 2" Flexible Blanket Insulation: ADD 10% (.10)	

31

	TOTAL HEAT LOSS	24046	**32**

NOTE: All Heat Transfer Multipliers from ACCA Manual "J" Sixth Edition.

Figure B–1 (continued)

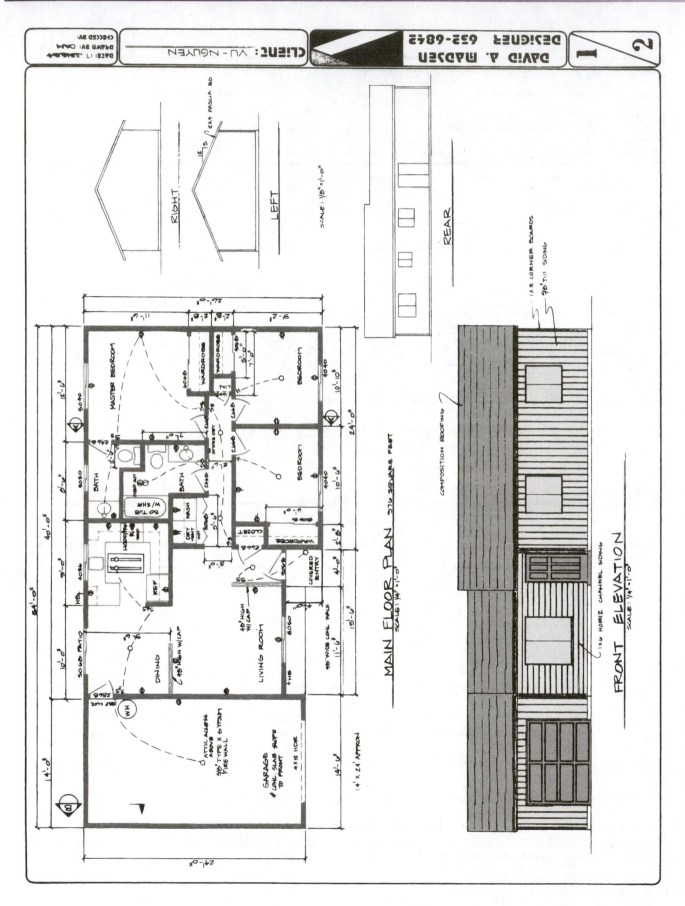

Figure B–2 Sample floor plan heat loss and heat gain calculations. *Courtesy Madsen Designs.*

RESIDENTIAL COOLING DATA SHEET

JOB NAME:		DATE	
ADDRESS:			

OUTDOOR TEMP: 100°	INDOOR TEMP: 70°	TEMP DIFFERENCE: 30°

(¹ Outdoor Temp, ² Indoor Temp, ³ Temp Difference)

SENSIBLE LOAD CALCULATIONS

GLASS NO SHADE		SINGLE						DOUBLE						TRIPLE						BTUH HEAT GAIN
COMPASS POINT	GLASS AREA SQ. FEET	\multicolumn{18}{c\|}{DESIGN TEMPERATURE DIFFERENCE / HEAT TRANSFER MULTIPLIER}																		
		10	15	20	25	30	35	10	15	20	25	(30)	35	10	15	20	25	30	35	
N	81	25	29	33	37	41	45	20	22	24	26	(28)	30	15	16	18	19	20	21	2268
NE & NW		55	60	65	70	75	80	50	52	54	56	58	60	37	38	40	41	42	44	
E & W		80	85	90	95	100	105	70	72	74	76	78	80	55	56	58	59	60	62	
SE & SW		70	74	78	82	86	90	60	62	64	66	68	70	47	49	51	52	53	54	
S	67	40	44	48	52	56	60	35	37	39	41	(43)	45	26	27	29	31	32	33	2881

(row labels 4/5, 6/7, 8/9, 10/11, 12/13)

GLASS INSIDE SHADE		SINGLE						DOUBLE						TRIPLE						BTUH HEAT GAIN
COMPASS POINT	GLASS AREA SQ. FEET	\multicolumn{18}{c\|}{DESIGN TEMPERATURE DIFFERENCE / HEAT TRANSFER MULTIPLIER}																		
		10	15	20	25	30	35	10	15	20	25	30	35	10	15	20	25	30	35	
N		15	19	23	27	31	35	15	17	19	21	23	25	10	12	14	16	17	19	
NE & NW		35	39	43	47	51	55	30	32	34	36	38	40	22	24	26	28	30	31	
E & W		50	54	58	62	66	70	45	47	49	51	53	55	35	36	38	40	42	44	
SE & SW		40	44	48	52	56	60	35	37	39	41	43	45	29	30	32	34	36	38	
S		25	29	33	37	41	45	20	22	24	26	28	30	16	18	20	22	24	26	

(row labels 14/15, 16/17, 18/19, 20/21, 22/23)

DOORS	SQUARE FEET	DESIGN TEMPERATURE DIFFERENCE / HEAT TRANSFER MULTIPLIER						BTUH HEAT GAIN
		10	15	20	25	30	35	
SOLID WOOD		6.3	8.6	10.9	13.2	14.4	15.5	
SOLID WOOD **	39	4.2	5.7	7.3	8.8	(9.6)	10.4	374
METAL URETHANE		2.6	3.5	4.5	5.4	5.9	6.4	
METAL URETHANE **		2.2	3.0	3.8	4.6	5.0	5.4	
** Weatherstripped or Storm								

(row labels 24/25)

26 WALLS

RUNNING FEET	132
CEILING HEIGHT	X 8
GROSS WALL	= 1056
WINDOWS & DOOR AREAS	− 187
NET WALL AREA	869

FRAME WALL	SQUARE FEET	DESIGN TEMPERATURE DIFFERENCE / HEAT TRANSFER MULTIPLIER						BTUH HEAT GAIN
		10	15	20	25	30	35	
NO INSULATION		3.7	5.0	6.4	7.8	8.5	9.1	
R-11, 3" INSULATION		1.2	1.7	2.1	2.6	2.8	3.0	
R-13, 3-1/2" INSULATION	869	1.1	1.5	1.9	2.3	(2.5)	2.7	2173
R-13 + 1" POLYSTYRENE		0.8	1.1	1.4	1.7	1.8	2.0	
R-19 + 1/2" POLYSTYRENE		0.7	1.0	1.3	1.6	1.7	1.8	

(row labels 27/28)

MASONRY WALL ABOVE GRADE	SQUARE FEET	DESIGN TEMPERATURE DIFFERENCE / HEAT TRANSFER MULTIPLIER						BTUH HEAT GAIN
		10	15	20	25	30	35	
NO INSULATION		3.2	5.8	8.3	10.9	12.2	13.4	
R-5, 1" INSULATION		0.9	1.6	2.3	3.1	3.5	3.8	
R-11, 3" INSULATION		0.5	0.9	1.3	1.6	1.8	2.0	
R-19, 6" INSULATION		0.3	0.5	0.8	1.0	1.2	1.3	

(row labels 29/30)

Figure B–3 Completed residential cooling data sheet form. *Courtesy Lennox Industries, Inc.*

| | | Sensible Heat Gain Subtotal from Page 1 | | 7696 | | | | 31 |

CEILING	SQUARE FEET	DESIGN TEMPERATURE DIFFERENCE						BTUH HEAT GAIN
		10	15	20	25	30	35	
		HEAT TRANSFER MULTIPLIER						
No Insulation		14.9	17.0	19.2	21.4	22.5	23.6	
R-11, 3" Insulation		2.8	3.2	3.7	4.1	4.3	4.5	
R-19, 6" Insulation		1.8	2.1	2.3	2.6	2.8	2.9	
R-30, 10" Insulation	976	1.1	1.3	1.5	1.6	(1.7)	1.8	1659
R-38, 12" Insulation		0.9	1.0	1.1	1.3	1.3	1.4	

32 ... **33**

FLOOR OVER UNCONDITIONED SPACE	SQUARE FEET	DESIGN TEMPERATURE DIFFERENCE						BTUH HEAT GAIN
		10	15	20	25	30	35	
		HEAT TRANSFER MULTIPLIER						
No Insulation		1.9	3.9	5.8	7.7	8.7	9.6	
CARPET FLOOR-NO INSULATION		1.3	2.5	3.8	5.1	5.7	6.3	
R-11, 3" INSULATION		0.4	0.8	1.3	1.7	1.9	2.1	
R-19, 6" INSULATION	976	0.3	0.5	0.8	1.1	(1.2)	1.3	1171
R-30, 10" INSULATION		0.2	0.4	0.6	0.7	0.8	0.9	

34 ... **35**

36 INFILTRATION/ VENTILATION

976 FLOOR SQ. FT. x 8 CEILING HEIGHT = 7808 CUBIC FT

0.40 x 7808 CUBIC FT ÷ 60 = 52 CFM

MECHANICAL VENTILATION CFM – FRESH AIR INTAKE

	CFM	DESIGN TEMPERATURE DIFFERENCE						BTUH HEAT GAIN
		10	15	20	25	30	35	
		HEAT TRANSFER MULTIPLIER						
INFILTRATION	52	11.0	16.5	22.0	27.0	(32.0)	38.0	1664
MECHANICAL VENTILATION	52	11.0	16.5	22.0	27.0	(32.0)	38.0	1664

37

INTERNAL HEAT GAIN	BTUH HEAT GAIN
Number of People 4 x 300	1200
Kitchen Allowance	1,200

38 ... **38**

| SENSIBLE HEAT GAIN SUBTOTAL | 15054 |

39

DUCT GAIN	BTUH HEAT GAIN
R-4, 1" Flexible Blanket Insulation: ADD 15% (.15)	2258
R-7, 2" Flexible Blanket Insulation: ADD 10% (.10)	

40 ... **40**

| TOTAL SENSIBLE HEAT GAIN | 17312 |

41

LATENT LOAD CALCULATIONS

Conditions	Outdoor Wet Bulb	Indoor Wet Bulb	Grains
Wet	80	62.5	50
Medium	75	62.5	(35)
Medium Dry	70	62.5	20
Dry	65	62.5	0

42

Based on 75°F Indoor Dry Bulb at 50% RH.

| LATENT LOAD-INFILTRATION | |
| 0.68 x 35 Grains x 52 Infiltration CFM | 1238 |

43 ... **43**

| LATENT LOAD-VENTILATION | |
| 0.68 x 35 Grains x 52 Ventilation CFM | 1238 |

44 ... **44**

| LATENT LOAD-PEOPLE | |
| Number of People 4 x 230 | 920 |

45 ... **45**

| TOTAL LATENT HEAT GAIN | 3396 |

46

| TOTAL SENSIBLE AND LATENT HEAT GAIN | 20716 |

47

Figure B–3 (continued)

GLOSSARY

ACOUSTICS The science of sound and sound control.

ADOBE A heavy clay soil used in many southwestern states to make sun-dried bricks.

AGGREGATE Stone, gravel, cinder, or slag used as one of the components of concrete.

AIR-DRIED LUMBER Lumber that has been stored in yards or sheds for a period of time after cutting. Building codes typically assume a 19-percent moisture content when determining joists and beams of air-dried lumber.

AIR DUCT A pipe, typically made of sheet metal, that carries air from a source such as a furnace or air conditioner to a room within a structure.

AIR TRAP A "U"-shaped piped placed in wastewater lines to prevent backflow of sewer gas.

ALCOVE A small room adjoining a larger room, often separated by an archway.

AMPERE (AMPS) A measure of electrical current.

ANCHOR A metal tie or strap used to tie building members to each other.

ANCHOR BOLT A threaded bolt used to fasten wooden structural members to masonry.

ANGLE IRON A structural piece of steel shaped to form a 90° angle.

APRON The inside trim board placed below a window sill. The term is also used to apply to a curb around a driveway or parking area.

AREAWAY A subsurface enclosure to admit light and air to a basement. Sometimes called a window well.

ASBESTOS A mineral that does not burn or conduct heat; it is usually used for roofing material.

ASHLAR MASONRY Squared masonry units laid with a horizontal bed joint.

ASH PIT An area in the bottom of the firebox of a fireplace to collect ash.

ASPHALT An insoluble material used for making floor tile and for waterproofing walls and roofs.

ASPHALTIC CONCRETE A mixture of asphalt and aggregate, which is used for driveways.

ASPHALT SHINGLE Roof shingles made of asphalt-saturated felt and covered with mineral granules.

ATRIUM An inside courtyard of a structure which may be either open at the top or covered with a roof.

AWNING WINDOW A window that is hinged along the top edge.

BACKFILL Earth, gravel, or sand placed in the trench around the footing and stem wall after the foundation has cured.

BAFFLE A shield, usually made of scrap material, to keep insulation from plugging eave vents. Also used to describe wind- or sound-deadening devices.

BALLOON FRAMING A building construction method that has vertical wall members that extend uninterrupted from the foundation to the roof.

BAND JOIST A joist set at the edge of the structure that runs parallel to the other joist. Also called a rim joist.

BANISTER A handrail beside a stairway.

BASEBOARD The finish trim where the wall and floor intersect, or an electric wall heater that extends along the floor.

BASE COURSE The lowest course in brick or concrete masonry unit construction.

BASE LINE A reference line.

BASEMENT A level of a structure that is built either entirely below grade level (full basement) or partially below grade (daylight basement).

BATT A blanket insulation usually made of fiberglass to be used between framing members.

BATTEN A board used to hide the seams when other boards are joined together.

BATTER BOARD A horizontal board used to form footings.

BAY A division of space within a building, usually divided by beams or columns.

BEAM A horizontal structural member that is used to support roof or wall loads. Often called a header.

BEAMED CEILING A ceiling that has support beams that are exposed to view.

BEARING PLATE A support member, often a steel plate used to spread weight over a larger area.

BEARING WALL A wall that supports vertical loads in addition to its own weight.

BENCHMARK A reference point used by surveyors to establish grades and construction heights.

BEVELED SIDING Siding that has a tapered thickness.

BIBB An outdoor faucet that is threaded so that a hose may be attached.

BILL OF MATERIAL A part of a set of plans that lists all of the material needed to construct a structure.

BIRD BLOCK A block placed between rafters to maintain a uniform spacing and to keep animals out of the attic.

BIRD'S MOUTH A notch cut into a rafter to provide a bearing surface where the rafter intersects the top plate.

BLIND NAILING Driving nails in such a way that the heads are concealed from view.

BLOCKING Framing members, typically wood, placed between joists, rafters, or studs to provide rigidity. Also called bridging.

BOARD AND BATTEN A type of siding using vertical boards with small wood strips (battens) used to cover the joints of the boards.

BOARD FOOT The amount of wood contained in a piece of lumber 1" thick by 12" wide by 12" long.

BOND The mortar joint between two masonry units, or a pattern in which masonry units are arranged.

BOND BEAM A reinforced concrete beam used to strengthen masonry walls.

BOTTOM CHORD The lower, usually horizontal, member of a truss.

BOX BEAM A hollow built-up structural unit.

BRIDGING Cross blocking between horizontal members used to add stiffness. Also called blocking.

BREEZEWAY A covered walkway with open sides between two different parts of a structure.

BROKER A representative of the seller in property sales.

BTU British thermal unit. A unit used to measure heat.

BUILDING CODE Legal requirements designed to protect the public by providing guidelines for structural, electrical, plumbing, and mechanical areas of a structure.

BUILDING LINE An imaginary line determined by zoning departments to specify on which area of a lot a structure may be built (also known as a setback).

BUILDING PAPER A waterproofed paper used to prevent the passage of air and water into a structure.

BUILDING PERMIT A permit to build a structure issued by a governmental agency after the plans for the structure have been examined and the structure is found to comply with all building code requirements.

BUILT-UP BEAM A beam built of smaller members that are bolted or nailed together.

BUILT-UP ROOF A roof composed of three or more layers of felt, asphalt, pitch, or coal tar.

BULLNOSE Rounded edges of cabinet trim.

BUTT JOINT The junction where two members meet in a square-cut joint; end to end, or edge to edge.

BUTTRESS A projection from a wall often located below roof beams to provide support to the roof loads and to keep long walls in the vertical position.

CABINET WORK The interior finish woodwork of a structure, especially cabinetry.

CANTILEVER Projected construction that is fastened at only one end.

CANT STRIP A small built-up area between two intersecting roof shapes to divert water.

CARRIAGE The horizontal part of a stair stringer that supports the tread.

CASEMENT WINDOW A hinged window that swings outward.

CASING The metal, plastic, or wood trim around a door or a window.

CATCH BASIN An underground reservoir for water drained from a roof before it flows to a storm drain.

CATHEDRAL WINDOW A window with an upper edge that is parallel to the roof pitch.

CAULKING A soft, waterproof material used to seal seams and cracks in construction.

CAVITY WALL A masonry wall formed with an air space between each exterior face.

CEILING JOIST The horizontal member of the roof that is used to resist the outward spread of the rafters and to provide a surface on which to mount the finished ceiling.

CEMENT A powder of alumina, silica, lime, iron oxide, and magnesia pulverized and used as an ingredient in mortar and concrete.

CENTRAL HEATING A heating system in which heat is distributed throughout a structure from a single source.

CESSPOOL An underground catch basin for the collection and dispersal of sewage.

CHAMFER A beveled edge formed by removing the sharp corner of a piece of material.

CHANNEL A standard form of structural steel with three sides at right angles to each other forming the letter C.

CHASE A recessed area of column formed between structural members for electrical, mechanical, or plumbing materials.

CHECK Lengthwise cracks in a board caused by natural drying.

CHECK VALVE A valve in a pipe that permits flow in only one direction.

CHIMNEY An upright structure connected to a fireplace or furnace that passes smoke and gases to outside air.

CHORD The upper and lower members of a truss that are supported by the web.

CINDER BLOCK A block made of cinder and cement used in construction.

CIRCUIT BREAKER A safety device that opens and closes an electrical circuit.

CLAPBOARD A tapered board used for siding that overlaps the board below it.

CLEARANCE A clear space between building materials to allow for air flow or access.

CLERESTORY A window or group of windows that are placed above the normal window height, often between two roof levels.

COLLAR TIES A horizontal tie between rafters near the ridge to help resist the tendency of the rafters to separate.

COLUMN A vertical structural support, usually round, and made of steel.

COMMON WALL The partition that divides two different dwelling units.

COMPRESSION A force that crushes or compacts.

CONCRETE A building material made from cement, sand, gravel, and water.

CONCRETE BLOCKS Blocks of concrete that are precast. The standard size is $8 \times 8 \times 16$.

CONDENSATION The formation of water on a surface when warm air comes in contact with a cold surface.

CONDUCTOR Any material that permits the flow of electricity. A drain pipe that diverts water from the roof (a downspout).

CONDUIT A bendable pipe or tubing used to encase electrical wiring.

CONTINUOUS BEAM A single beam that is supported by more than two supports.

CONTRACTOR The manager of a construction project, or one specific phase of it.

CONTROL JOINT An expansion joint in a masonry wall formed by raking mortar from the vertical joint.

CONVENIENCE OUTLET An electrical receptacle through which current is drawn for the electrical system of an appliance.

COPING A masonry cap placed on top of a block wall to protect it from water penetration.

CORBEL A ledge formed in a wall by building out successive courses of masonry.

CORNICE The part of the roof that extends out from the wall. Sometimes referred to as the eave.

COUNTERFLASH A metal flashing used under normal flashing to provide a waterproof seam.

COURSE A continuous row of building material such as shingles, stone or brick.

CRAWL SPACE The area between the floor joists and the ground.

CRICKET A diverter built to direct water away from an area of a roof where it would otherwise collect such behind a chimney.

CRIPPLE A wall stud that is cut at less than full length.

CROSS BRACING Boards fastened diagonally between structural members such as floor joists to provide rigidity.

CULVERT An underground passageway for water, usually part of a drainage system.

CUPOLA A small structure built above the main roof level to provide light or ventilation.

CURTAIN WALL An exterior wall that provides no structural support.

DAMPER A movable plate that controls the amount of draft for a wood stove, fireplace, or furnace.

DATUM A reference point for starting a survey.

DEADENING Material used to control the transmission of sound.

DEAD LOAD The weight of building materials or other unmoveable objects in a structure.

DECKING A wood material used to form the floor or roof, typically used in 1" and 2" thicknesses.

DESIGNER A person who designs buildings but is not licensed as is an architect.

DIVERTER A metal strip used to divert water.

DORMER A structure that projects from a sloping roof to form another roofed area. This new area is typically used to provide a surface to install a window.

DOUBLE HUNG A type of window in which the upper and lower halves slide past each other to provide an opening at the top and bottom of the window.

DOWNSPOUT A pipe that carries rainwater from the gutters of the roof to the ground.

DRAIN A collector for a pipe that carries water.

DRESSED LUMBER Lumber that has been surfaced by a planing machine to give the wood a smooth finish.

DRY ROT A type of wood decay caused by fungi that leaves the wood a soft powder.

DRYWALL An interior wall covering installed in large sheets made from gypsum board.

DRY WELL A shallow well used to disperse water from the gutter system.

DUPLEX OUTLET A standard electrical convenience outlet with two receptacles.

DUTCH HIP A type of roof shape that combines features of a gable and a hip roof.

EASEMENT An area of land that cannot be built upon because it provides access to a structure or to utilities such as power or sewer lines.

EAVE The lower part of the roof that projects from the wall. See cornice.

EGRESS A term used in building codes to describe access.

ELBOW An L-shaped plumbing pipe.

ELEVATION The height of a specific point in relation to another point. The exterior views of a structure.

ELL An extension of the structure at a right angle to the main structure.

EMINENT DOMAIN The right of a government to condemn private property so that it may be obtained for public use.

ENAMEL A paint that produces a hard, glossy, smooth finish.

EQUITY The value of real estate in excess of the balance owed on the mortgage.

EXCAVATION The removal of soil for construction purposes.

EXPANSION JOINT A joint installed in concrete construction to reduce cracking and to provide workable areas.

FABRICATION Work done on a structure away from the job site.

FACADE The exterior covering of a structure.

FACE BRICK Brick that is used on the visible surface to cover other masonry products.

FACE GRAIN The pattern in the visible veneer of plywood.

FASCIA A horizontal board nailed to the end of rafters or trusses to conceal their ends.

FELT A tar-impregnated paper used for water protection under roofing and siding materials. Sometimes used under concrete slabs for moisture resistance.

FIBERBOARD Fibrous wood products that have been pressed into a sheet. Typically used for the interior construction of cabinets and for a covering for the subfloor.

FILLED INSULATION Insulation material that is blown or poured into place in attics and walls.

FILLET WELD A weld between two surfaces that butt at 90° to each other, with the weld filling the inside corner.

FINISHED LUMBER Wood that has been milled with a smooth finish suitable for use as trim and other finish work.

FINISHED SIZE Sometimes called the dressed size, the finished size represents the actual size of lumber after all milling operations, and is typically about 1/2" smaller than the nominal size, which is the size of lumber before planing.

NOMINAL SIZE (IN.)	FINISHED SIZE (IN.)
1	3/4
2	1–1/2
4	3–1/2
6	5–1/2
8	7–1/4
10	9–1/4
12	11–1/4
14	13–1/4

FIREBRICK A refractory brick capable of withstanding high temperatures and used for lining fireplaces and furnaces.

FIREBOX The combustion chamber of the fireplace where the fire occurs.

FIREBRICK A brick made of a refractory material that can withstand great amounts of heat and is used to line the visible face of the firebox.

FIRE CUT An angular cut on the end of a joist or rafter that is supported by masonry. The cut allows the wood member to fall away from the wall without damaging a masonry wall when the wood is damaged by fire.

FIRE DOOR A door used between different types of construction that has been rated as being able to withstand fire for a certain amount of time.

FIREPROOFING Any material that is used to cover structural materials to increase their fire rating.

FIRE RATED A rating given to building materials to specify the amount of time the material can resist damage caused by fire.

FIRE-STOP Blocking placed between studs or other structural members to resist the spread of fire.

FIRE WALL A wall constructed of materials resulting in a specified time that the wall can resist fire before structural damage will occur.

FLASHING Metal used to prevent water leaking through surface intersections.

FLOOR PLUG A 110 convenience outlet located in the floor.

FLUE LINER A terra-cotta pipe used to provide a smooth flue surface so that unburned materials will not cling to the flue.

FOOTING The lowest member of a foundation system used to spread the loads of a structure across supporting soil.

FOOTING FORM The wooden mold used to give concrete its shape as it cures.

FOUNDATION The system used to support a building's loads and made up of stem walls, footings, and piers. The term is used in many areas to refer to the footing.

FROST LINE The depth to which soil will freeze.

FURRING Wood strips attached to structural members that are used to provide a level surface for finishing materials when different-sized structural members are used.

GABLE A type of roof with two sloping surfaces that intersect at the ridge of the structure.

GABLE END WALL The triangular wall that is formed at each end of a gable roof between the top plate of the wall and the rafters.

GALVANIZED Steel products that have had zinc applied to the exterior surface to provide protection from rusting.

GAMBREL A type of roof formed with two planes on each side. The lower pitch is steeper than the upper portion of the roof.

GIRDER A horizontal support member at the foundation level.

GLUED-LAMINATED TIMBER (GLU-LAM) A structural member made up of layers of lumber that are glued together.

GRADE The designation of the quality of a manufactured piece of wood.

GRADING The moving of soil to effect the elevation of land at a construction site.

GRAVEL STOP A metal strip used to retain gravel at the edge of built-up roofs.

GREEN LUMBER Lumber that has not been kiln-dried and still contains moisture.

GROUND FAULT CIRCUIT INTERRUPTER (GFCI OR GFI) A 110 convenience outlet with a built-in circuit breaker. GFCI outlets are to be used within 5'–0" of any water source.

GROUT A mixture of cement, sand, and water used to fill joints in masonry and tile construction.

GUARDRAIL A horizontal protective railing used around stairwells, balconies, and changes of floor elevation greater than 30".

GUSSET A plate added to the side of intersecting structural members to help form a secure connection and to reduce stress.

HALF-TIMBER A frame construction method where spaces between wood members are filled with masonry.

HANGER A metal support bracket used to attach two structural members.

HARDBOARD Sheet material formed of compressed wood fibers used as an underlayment for flooring.

HEAD The upper portion of a door or window frame.

HEADER A horizontal structural member used to support other structural members over openings such as doors and windows.

HEADER COURSE A horizontal masonry course with the end of each masonry unit exposed.

HEADROOM The vertical clearance in a room over a stairway.

HEARTH The fire-resistant floor within and extending a minimum of 18" in front of the firebox.

HEARTWOOD The inner core of a tree trunk.

HIP ROOF A roof shape with four sloping sides.

HORIZONTAL SHEAR One of three major forces acting on a beam, it is the tendency of the fibers of a beam to slide past each other in a horizontal direction.

HOSE BIBB A water outlet that is threaded to receive a hose.

HUMIDIFIER A mechanical device that controls the amount of moisture inside of a structure.

INDIRECT LIGHTING Mechanical lighting that is reflected off a surface.

ISOMETRIC A drawing method which enables three surfaces of an object to be seen in one view, with the base of each surface drawn at 30° to the horizontal plane.

JACK RAFTER A rafter that is cut shorter than the other rafters to allow for an opening in the roof.

JACK STUD A wall member that is cut shorter than other studs to allow for an opening such as a window. Also called a cripple stud.

JAMB The vertical members of a door or window frame.

JOIST A horizontal structural member used in repetitive patterns to support floor and ceiling loads.

KILN DRIED A method of drying lumber in a kiln or oven. Kiln-dried lumber has a reduced moisture content when compared to lumber that has been air dried.

KING STUD A full-length stud placed at the end of a header.

KNEE WALL A wall of less than full height.

LALLY COLUMN A vertical steel column that is used to support floor or foundation loads.

LAMINATED Several layers of material that have been glued together under pressure.

LATTICE A grille made by criss-crossing strips of material.

LEDGER A horizontal member that is attached to the side of wall members to provide support for rafters or joists.

LIEN A monetary claim on property.

LINTEL A horizontal steel member used to provide support for masonry over an opening.

LIVE LOAD The loads from all movable objects within a structure including loads from furniture and people. External loads from snow and wind are also considered live loads.

LOAD-BEARING WALL A support wall that holds floor or roof loads in addition to its own weight.

LOOKOUT A beam used to support eave loads.

MANSARD A four-sided, steep-sloped roof.

MANTEL A decorative shelf above the opening of a fireplace.

MESH A metal reinforcing material placed in concrete slabs and masonry walls to help resist cracking.

METAL WALL TIES Corrugated metal strips used to bond brick veneer to its support wall.

MILLWORK Finished woodwork that has been manufactured in a milling plant. Examples are window and door frames, mantels, moldings, and stairway components.

MINERAL WOOL An insulating material made of fibrous foam.

MODULUS OF ELASTICITY (E) The degree of stiffness of a beam.

MOISTURE BARRIER Typically a plastic material used to restrict moisture vapor from penetrating into a structure.

MONOLITHIC Concrete construction created in one pouring.

MONUMENT A boundary marker set to mark property corners.

MORTAR A combination of cement, sand, and water used to bond masonry units together.

MUSDILL The horizontal wood member that rests on concrete to support other wood members.

MULLION A horizontal or vertical divider between sections of a window.

MUNTIN A horizontal or vertical divider within a section of a window.

NAILER A wood member bolted to concrete or steel members to provide a nailing surface for attaching other wood members.

NEWEL The end post of a stair railing.

NOMINAL SIZE An approximate size achieved by rounding the actual material size to the nearest larger whole number.

NONBEARING WALL A wall that supports no loads other than its own weight. Some building codes consider walls that support only ceiling loads as nonbearing.

NONFERROUS METAL Metal, such as copper or brass, that contains no iron.

NOSING The rounded front edge of a tread that extends past the riser.

ON CENTER A measurement taken from the center of one member to the center of another member.

OUTLET An electrical receptacle that allows for current to be drawn from the system.

OUTRIGGER A support for roof sheathing and the fascia that extends past the wall line perpendicular to the rafters.

OVERHAND The horizontal measurement of the distance the roof projects from a wall.

PARAPET A portion of wall that extends above the edge of the roof.

PARGING A thin coat of plaster used to smooth a masonry surface.

PARQUET FLOORING Wood flooring laid to form patterns.

PARTITION An interior wall.

PARTY WALL A wall dividing two adjoining spaces such as apartments or offices.

PILASTER A reinforcing column built into or against a masonry wall.

PILING A vertical foundation support driven into the ground to provide support on stable soil or rock.

PLANK Lumber that is 1–1/2" to 3–1/2" in thickness.

PLASTER A mix of sand, cement, and water, used to cover walls and ceilings.

PLAT A map of an area of land that shows the boundaries of individual lots.

PLATE A horizontal member at the top (top plate) or bottom (sole plate or sill) of walls used to connect the vertical wall members.

PLENUM An air space for transporting air from the HVAC system.

PLOT A parcel of land.

PLUMB True vertical.

PLYWOOD Wood composed of three or more layers, with the grain of each layer placed at 90° to each other and bounded with glue.

PORCH A covered entrance to a structure.

PORTICO A roof supported by columns instead of walls.

PORTLAND CEMENT A hydraulic cement made of silica, lime, and aluminum that has become the most common cement used in the construction industry because of its strength.

POST A vertical wood structural member usually 4 × 4 (100 × 100 mm) or larger.

PRECAST A concrete component which has been cast in a location other than the one in which it will be used.

PREFABRICATED Buildings or components that are built away from the job site and transported ready to be used.

PRESTRESSED A concrete component that is placed in compression as it is cast to help resist deflection.

PURLIN A horizontal roof member that is laid perpendicular to rafters to help limit deflection.

PURLIN BRACE A support member that extends from the purlin down to a load-bearing wall or header.

QUAD A courtyard surrounded by the walls of buildings.

QUARRY TILE An unglazed, machine-made tile.

QUARTER ROUND Wood molding that has the profile of one-quarter of a circle.

RABBET A rectangular groove cut on the edge of a board.

RAFTER The inclined structural member of a roof system designed to support roof loads.

RAFTER/CEILING JOINT An inclined structural member which supports both the ceiling and the roof materials.

RAKE JOINT A recessed mortar joint.

REBAR Reinforcing steel used to strengthen concrete.

REFERENCE BUBBLE A symbol used to designate the origin of details and sections.

REGISTER An opening in a duct for the supply of heated or cooled air.

REINFORCED CONCRETE Concrete that has steel rebar placed in it to resist tension.

RHEOSTAT An electrical control device used to regulate the current reaching a light fixture. A dimmer switch.

RELATIVE HUMIDITY The amount of water vapor in the atmosphere compared to the maximum possible amount at the same temperature.

RESTRAINING WALL A masonry wall supported only at the bottom by a footing that is designed to resist soil loads.

RETAINING WALL A masonry wall supported at the top and bottom, designed to resist soil loads.

R-FACTOR A unit of thermal resistance applied to the insulating value of a specific building material.

RIBBON A structural wood member framed into studs to support joists or rafters.

RIDGE BOARD A horizontal member that rafters are aligned against to resist their downward force.

RIDGE BRACE A support member used to transfer the weight from the ridge board to a bearing wall or beam. The brace is typically spaced at 48" O.C., and may not exceed a 45° angle from vertical.

RIM JOIST A joist at the perimeter of a structure that runs parallel to the other floor joists.

RISE The amount of vertical distance between one tread and another.

RISER The vertical member of stairs between the treads.

ROLL ROOFING Roofing material of fiber or asphalt that is shipped in rolls.

ROOF DRAIN A receptacle for removal of roof water.

ROUGH FLOOR The subfloor, usually hardboard, which serves as a base for the finished floor.

ROUGH HARDWARE Hardware used in construction, such as nails, bolts, and metal connectors, that will not be seen when the project is complete.

ROUGH IN To prepare a room for plumbing or electrical additions by running wires or piping for a future fixture.

ROUGH LUMBER Lumber that has not been surfaced but has been trimmed on all four sides.

ROUGH OPENING The unfinished opening between framing members that allows for doors, windows, or other assemblies.

ROWLOCK A pattern for laying masonry units so that the end of the unit is exposed.

RUN The horizontal distance of a set of steps or the measurement describing the depth of one step.

SADDLE A small gable-shaped roof used to divert water from behind a chimney.

SASH An individual frame around a window.

SCAB A short member that overlaps the butt joint of two other members used to fasten those members.

SCRATCH COAT The first coat of stucco, which is scratched to provide a good bond surface for the second coat.

SEASONING The process of removing moisture from green lumber by either air- (natural) or kiln-drying.

SEISMIC Earthquake-related forces.

SEPTIC TANK A tank in which sewage is decomposed by bacteria and dispersed by drain tiles.

SERVICE CONNECTION The wires that run to a structure from a power pole or transformer.

SHAKE A hand-split wooden roof shingle.

SHEAR The stress that occurs when two forces from opposite directions are acting on the same member. Shearing stress tends to cut a member just as scissors cut paper.

SHEAR PANEL A plywood panel applied to walls to resist wind and seismic forces by keeping the studs in a vertical position.

SHEATHING A covering material placed over walls, floors, and roofs that serves as a backing for finishing materials.

SHIM A piece of material used to fill a space between two surfaces.

SHIPLAP A siding pattern of overlapping rabbeted edges.

SILL A horizontal wood member placed at the bottom of walls and openings in walls.

SKYLIGHT An opening in the roof to allow light and ventilation that is usually covered with glass or plastic.

SLEEPERS Strips of wood placed over a concrete slab in order to attach other wood members.

SMOKE CHAMBER The portion of the chimney located directly over the firebox that acts as a funnel between the firebox and the chimney.

SMOKE SHELF A shelf located at the bottom of the smoke chamber to prevent downdrafts from the chimney from entering the firebox.

SOFFIT A lowered ceiling, typically found in kitchens, halls, and bathrooms to allow for recessed lighting or HVAC ducts.

SOIL STACK The main vertical wastewater pipe.

SOLDIER A masonry unit laid on end with its narrow surface exposed.

SOLE PLATE The plate placed at the bottom of a wall.

SPECIFICATIONS Written descriptions or requirements to specify how a structure is to be constructed.

SPLICE Two similar members that are jointed together in a straight line, usually by nailing or bolting.

SPLIT-LEVEL A house that has two levels, one about a half a level above or below the other.

SQUARE An area of roofing covering 100 sq. ft.

STACK A vertical plumbing pipe.

STAIRWELL The opening in the floor where a stair will be framed.

STILE A vertical member of a cabinet, door, or decorative panel.

STIRRUP A U-shaped metal bracket used to support wood beams.

STOCK Common sizes of building material as they are sold.

STOP A wooden strip used to hold windows in place.

STRESSED-SKIN PANEL A hollow, built-up member typically used as a beam.

STRINGER The inclined support member of a stair that supports the risers and treads.

STUCCO A type of plaster made from Portland cement, sand, water, and a coloring agent that is applied to exterior walls.

STUD The vertical framing member of a wall that is usually 2 × 4 (50 × 100 mm) or 2 × 6 (50 × 150 mm) in size.

SUBFLOOR The flooring surface that is laid on the floor joist and serves as a base layer for the finished floor.

SUMP A recessed area in a basement floor to collect water so that it can be removed by a pump.

SURFACED LUMBER Lumber that has been smoothed on at least one side.

SWALE A recessed area formed in the ground to help divert ground water away from a structure.

TENSILE STRENGTH The resistance of a material or beam to the tendency of stretch.

TERMITE SHIELD A strip of sheet metal used at the intersection of concrete and wood surfaces near ground level to prevent termites from entering the wood.

TERRA-COTTA Hard-baked clay typically used as a liner for chimneys.

THERMAL CONDUCTOR A material suitable for transmitting heat.

THERMAL RESISTANCE Represented by the letter R, resistance measures the ability of a material to resist the flow of heat.

THERMOSTAT A mechanical device for controlling the output of HVAC units.

THRESHOLD The beveled member directly under a door.

THROAT The narrow opening to the chimney that is just above the firebox. The throat of a chimney is where the damper is placed.

TIMBER Lumber with a cross sectional size of 4 x 6 (100 × 150 mm) or larger.

TOENAIL Nails driven into a member at an angle.

TONGUE AND GROOVE A joint where the edge of one member fits into a groove in the next member.

TRANSOM A window located over a door.

TRAP A U-shaped pipe below plumbing fixtures that holds water to prevent odor and sewer gas from entering the fixture.

TREAD The horizontal member of a stair on which the foot is placed.

TRIMMER Joists or rafters that are used to frame an opening in a floor, ceiling, or roof.

TRUSS A framework made in triangular-shaped segments used for spanning distances greater than is possible using standard components and methods.

VALLEY The internal corner formed between two intersecting roof surfaces.

VAPOR BARRIER Material that is used to block the flow of water vapor into a structure. Typically 6 mil (.006") black plastic.

VENEER A thin outer covering or non-load bearing masonry face material.

VENTILATION The process of supplying and removing air from a structure.

VENT PIPE Pipes that provide air into the waste lines to allow drainage by connecting each plumbing fixture to the vent stack.

VENT STACK A vertical pipe of a plumbing system used to equalize pressure within the system and to vent sewer gases.

VESTIBULE A small entrance or lobby.

WAINSCOT A paneling applied to the lower portion of a wall.

WALLBOARD Large flat sheets of gypsum, typically 1/2"or 5/8" thick, used to finish interior walls.

WATERPROOF Material or a type of construction that prevents the absorption of water.

WATER STRIP A fabric or plastic material placed along the edges of doors, windows, and skylights to reduce air infiltration.

WEEP HOLE An opening normally in the bottom course of a masonry to allow for drainage.

WYTHE A single unit thickness of a masonry wall.

ABBREVIATIONS

Architects, engineers, drafters, and designers use many abbreviations to conserve space. Using standard abbreviations ensures that drawings are interpreted accurately. When several words use the same abbreviation, the use is defined by the location.

acoustic plaster	AC PL
addition	ADD
adhesive	ADH
adjustable	ADJ
aggregate	AGGR
air conditioning	AC
alternate	ALT
alternating current	AC
aluminum	ALUM
American Institute of Architects	AIA
American Institute of Building Designers	AIBD
American Institute of Steel Construction	AISC
American Institute of Timber Construction	AITC
American Plywood Association	APA
American Society of Civil Engineers	ASCE
American Society of Heating, Refrigerating, and Air Conditioning Engineers	ASHRAE
American Society of Landscape Architects	ASLA
American Society for Testing and Materials	ASTM
ampere	AMP

anchor bolt	AB
angle	∠
approximate	APPROX
approved	APPD
architectural	ARCH
asbestos	ASB
asphalt	ASPH
asphaltic concrete	ASPH CONC
automatic	AUTO
balcony	BALC
basement	BASM
Basic National Building Code	BOCA
batten	BATT
beam	BM
bearing	BR
benchmark	BM
better	BTR
beveled	BEV
block	BLK
blocking	BLKG
blower	BLO
board	BD
board feet	BD FT
both sides	BS
both ways	BW
bottom	BTM
bottom of footing	BF
brass	BR
brick	BRK

British thermal unit	BTU	control joint	CJ
bronze	BRZ	copper	COP
building	BLDG	corridor	CORR
building line	BL	countersink	CSK
built-in	BLT-IN	cubic	CU
buzzer	BUZ	cubic feet	CU FT
by	×	cubic feet per minute	CFM
		cubic inch	CU IN
cabinet	CAB	cubic yard	CU YD
cast concrete	C CONC		
cast iron	CI		
catch basin	CB	damper	DPR
caulking	CALK	decibel	DB
ceiling	CLG	decking	DK
ceiling diffuser	CD	degree	° or DEG
ceiling joist	CJ or CEIL JST	detail	DET
cement	CEM	diagonal	DIAG
center	CTR	diameter	∅ or DIA
center to center	C-C	diffuser	DIF
centerline	CL	dimension	DIMEN
centimeter	CM	dishwasher	D/W
ceramic	CER	disposal	DISP
chamfer	CHAM	double hung	DH
channel	C	Douglas fir	DF
check	CHK	downspout	DS
cinder block	CIN BLK	drain	D
circuit	CIR	drinking fountain	DF
circuit breaker	CIR BKR	dryer	D
class	CL	drywall	DW
cleanout	CO		
clear	CLR		
coated	CTD	each face	EF
cold water	CW	each way	EW
column	COL	elbow	EL
combination	COMB	electrical	ELECT
common	COM	elevation	ELEV
composition	COMP	enamel	ENAM
concrete	CONC	engineer	ENGR
concrete masonry unit	CMU	entrance	ENT
conduit	CND	Environmental Protection Agency	EPA
construction	CONST	estimate	EST
Construction Standards Institute	CSI	excavate	EXC
contractor	CONTR	exhaust	EXH
		existing	EXIST
		expansion joint	EXP JT

exposed	EXPO	ground fault circuit interrupter	GFCI
extension	EXTN	gypsum	GYP
		gypsum board	GYP BD
fabricate	FAB		
face of studs	FOS	hardboard	HDB
Fahrenheit	F	hardware	HDW
Federal Housing Administration	FHA	hardwood	HDWD
feet per minute	FPM	header	HDR
finished	FIN	heater	HTR
finished floor	FIN FL	heating	HTG
finished grade	FIN GR	heating/ventilating/air conditioning	HVAC
finished opening	FO	height	HT
firebrick	FBRK	hemlock	HEM
fixture	FIX	hemlock-fir	HEM-FIR
flammable	FLAM	hollow core	HC
flange	FLG	horsepower	HP
flashing	FL	hose bibb	HB
flexible	FLEX	hot water	HW
floor	FLR	hot water heater	HWH
floor drain	FD	hundred	C
floor joist	FL JST		
floor sink	FS	illuminate	ILLUM
folding	FLDG	incandescent	INCAN
foot candle	FC	inch pounds	IN LB
footing	FTG	incinerator	INCIN
foot pounds	FT LB	inflammable	INFL
forced air unit	FAU	inside diameter	ID
foundation	FND	inside face	IF
furnace	FURN	inspection	SP
furred ceiling	FC	install	INST
		insulate	INS
galvanized	GALV	insulation	INSUL
galvanized iron	GI	interior	INT
gage	GA	International Conference of	
garage	GAR	Building Officials	ICBO
girder	GIRD	iron	I
glass	GL		
glue laminated	GLU-LAM	jamb	JMB
grude	GR	joint	JT
grade beam	GR BM	joist	JST
gravel	GVL	junction	JCT
grille	GR	junction box	J-BOX
ground	GND		

kiln dried	KD	natural	NAT
kilowatt	KW	natural grade	NAT GR
kilowatt hour	KWH	noise reduction coefficient	NRC
Kip (1,000 lb.)	K	nominal	NOM
knockout	KO	not applicable	NA
		not in contract	NIC
laboratory	LAB	not to scale	NTS
landing	LDG		
laundry	LAU	obscure	OBS
lavatory	LAV	on center	OC
level	LEV	opening	OPG
light	LT	opposite	OPP
linear feet	LIN FT	ounce	OZ
linen closet	L CL	outside diameter	OD
linoleum	LINO	outside face	OF
living room	LIV	overhead	OVHD
louver	LV		
lumber	LUM	painted	PTD
		panel	PNL
machine bolt	MB	parallel	// or PAR
manhole	MH	part	PT
manufacturer	MANUF	partition	PART
marble	MRB	pavement	PVMT
masonry	MAS	penny	D
material	MAT	per	/
mechanical	MECH	perforate	PERF
medicine cabinet	MC	perimeter	PER
medium	MD	permanent	PERM
membrane	MEMB	perpendicular	\perp or PERP
metal	MTL	pi (3.1416)	Π
meter	M	plaster	PLS
mirror	MIRR	plasterboard	PLS BD
miscellaneous	MISC	plastic	PLAS
mixture	MIX	plate	P or PL
model	MOD	platform	PLAT
modular	MOD	plumbing	PLMB
molding	MLDG	plywood	PLY
motor	MOT	polished	POL
mullion	MULL	polyethylene	POLY
		polyvinyl chloride	PVC
National Association of Home Builders	NAHB	position	POS
National Bureau of Standards	NBS	pound	# or LB
		pounds per square foot	PSF

pounds per square inch	PSI	select structural	SEL ST
precast	PRCST	self-closing	SC
prefabricated	PREFAB	service	SERV
preferred	PFD	sewer	SEW
preliminary	PRELIM	sheathing	SHTG
pressure-treated	PT	siding	SDG
property	PROP	sill cock	SC
pull chain	PC	similar	SIM
pushbutton	PB	single hung	SH
		soil pipe	SP
quality	QTY	solid block	SOL BLK
quantity	QTY	solid core	SC
		Southern Building Code	SBC
radiator	RAD	Southern pine	SP
radius	R or RAD	Southern Pine Inspection Bureau	SPIB
random length and width	R L & W	specifications	SPECS
receptacle	RECP	spruce-pine-fir	SPF
recessed	REC	square	□ or SQ
redwood	RDWD	square feet	ft² or SQ FT
reference	REF	square inch	# or SQ IN
refrigerator	REFR	stainless steel	SST
register	REG	stand pipe	ST P
reinforcing	REINF	standard	STD
reinforcing bar	REBAR	steel	STL
reproduce	REPRO	stirrup	STIR
required	REQD	stock	STK
return	RET	storage	STO
revision	REV	storm drain	SD
ridge	RDG	structural	STR
riser	RIS	structural clay tile	SCT
roof drain	RD	substitute	SUB
roofing	RFG	supply	SUP
rough	RGH	surface	SUR
rough opening	RO	surface four sides	S4S
round	Ø or RD	surface two sides	S2S
		suspended ceiling	SUSP CLG
safety	SAF	switch	SW
sanitary	SAN	symbol	SYM
screen	SCRN	symmetrical	SYM
screw	SCR	synthetic	SYN
second	SEC		
section	SECT	tangent	TAN
select	SEL	tar and gravel	T & G

telephone	TEL
temperature	TEMP
terra-cotta	TC
terrazzo	TZ
thermostat	THRM
thickness	THK
thousand	M
thousand board feet	MBF
threshold	THR
through	THRU
tongue and groove	T & G
top of wall	TW
tread	TR
tubing	TUB
Underwriters' Laboratories, Inc.	UL
unfinished	UNFIN
Uniform Building Code	UBC
United States Department of Housing and Urban Development	HUD
urinal	UR
utility	UTIL
valve	V
vanity	VAN
vapor barrier	VB
vaporproof	VAP PRF
ventilation	VENT
vent pipe	VP
vent stack	VS
vent through roof	VTR
vertical grain	VERT GR
vinyl	VIN
vinyl asbestos tile	VAT
vinyl base	VB
vinyl tile	VT
vitreous	VIT
vitreous clay tile	VCT
volt	V
volume	VOL

wainscot	WSCT
wall vent	WV
washing machine	WM
waste stack	WS
water closet	WC
water heater	WH
waterproof	WP
watt	W
weather stripping	WS
weatherproof	WP
weep hole	WH
weight	WT
welded wire fabric	WWF
white pine	WP
wide flange	W or WF
width	W
window	WDW
with	W/
without	W/O
wood	WD
wrought iron	WI
yellow pine	YP
zinc	ZN

INDEX